IMAGES AND IDENTITY
IN FIFTEENTH-CENTURY FLORENCE

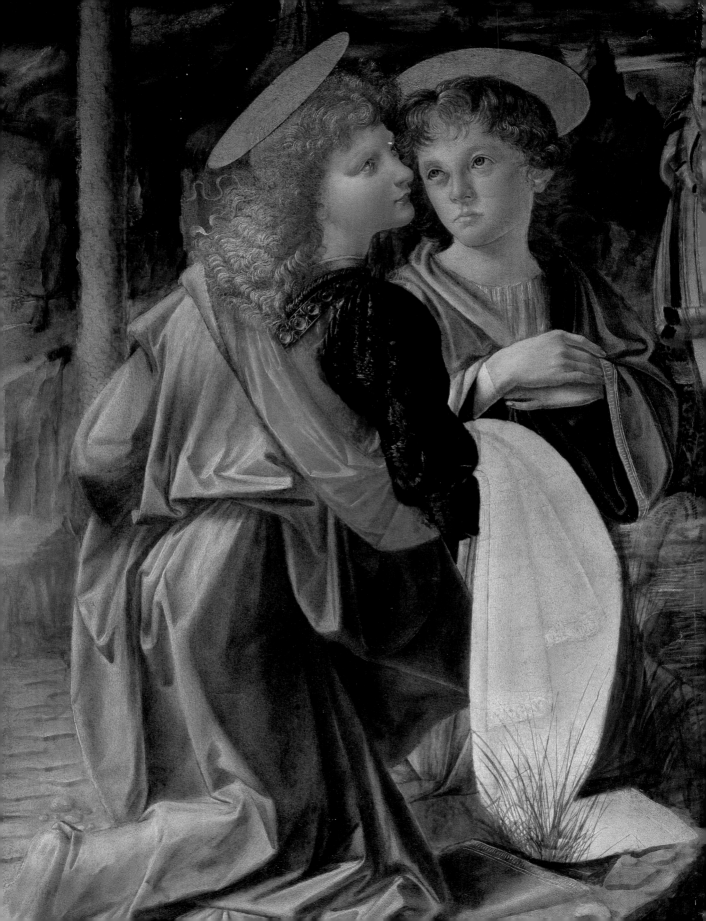

IMAGES AND IDENTITY IN FIFTEENTH-CENTURY FLORENCE

PATRICIA LEE RUBIN

YALE UNIVERSITY PRESS

New Haven & London

Designed by Gillian Malpass

Printed in Singapore

Library of Congress Cataloging-in-Publication Data

Rubin, Patricia Lee, 1951–

Image and identity in fifteenth-century Florence / Patricia Rubin.

p. cm.

Includes bibliographical references and index.

ISBN 978-0-300-12342-5 (cl : alk. paper)

1. Art, Italian–Italy–Florence–15th century. 2. Art, Renaissance–Italy–Florence.
3. Art and society–Italy–Florence–History–15th century. 4. Art patronage–Italy–Florence–History–15th century.
5. Visual perception–History–15th century. I. Title.

N6921.F7R468 2007

709.45′51024–dc22

2006100423

A catalogue record for this book is available from the British Library

FRONTISPIECE
Andrea del Verrocchio and Leonardo da Vinci, *Baptism of Christ*, detail,
panel (whole: 1468 and 1471–ca. 1476, 177 × 151 cm.), Galleria degli Uffizi, Florence.

To the Villa, the barn, and the lake

To Chapter Chapter

Special people and special places,

with love and gratitude

Contents

1 (FACING PAGE) Donatello, Martyrs Door, detail, ca. 1437–43, bronze, 36.5 × 33.5 cm., Old Sacristy, San Lorenzo, Florence.

Foreword and Acknowledgments

BOOK IX OF BENEDETTO VARCHI'S *History of Florence* contains a "digression" from the ordered narration of political events.[1] In it he describes the city and its customs as they were in the recent past – still a living memory, but one to be recorded for posterity. This is perhaps the first social history of Florence, although the association of the greatness of the city with the condition of its citizens and the grandeur of its monuments had a tradition in the social commentary of its chroniclers, which can be traced at least as far as the fourteenth-century *Cronica* by Giovanni Villani.

Varchi's careful observation of the way things were is an interlude in his account of the dramatic events of 1527–9: from the Medici expulsion to the siege of the city by the imperial forces. This pause marks the transition from republic to duchy. The city capitulated in August 1530 and Alessandro de' Medici returned as its ruler. Varchi's passage has a pendant in the history of the arts in an addition that Giorgio Vasari made to the second, 1568, edition of his *Lives of the Artists*. In the Life of the early fifteenth-century painter Dello Delli, Vasari similarly digressed on the subject of past habits. He tells how the citizens of Dello's times "used to have in their apartments great wooden chests," which were painted, as "were also the daybeds, the *spalliere*, and the surrounding moldings."[2] Described as relics, they were still to be found "in all the most noble houses of Florence" despite their outdated look, for there were some who "out of attachment to those old-fashioned customs, which are truly magnificent and most honorable, have not displaced such things in favor of modern ornaments and usages."[3] Vasari's careful recollection of these "old-fashioned" decorations, like Varchi's recording of outmoded clothes, is consciously and conscientiously antiquarian. Both authors evoke a past and create a tradition to be valued but also to be accepted as superseded, separating old (republican) Florence from the modern ducal state of their ruler and patron, Cosimo I.

Varchi acknowledged that these things might seem too familiar or too trivial to be recorded, and that they did not in themselves bring glory to the writer. But he deemed knowledge of these details to be necessary to the understanding of the rest of his history. He noted that with time they would become unknown and that "nothing is so small in a great republic" as to be unworthy of notice.[4]

The history of things taken for granted is indeed difficult to retrieve, particularly as the chief purpose of historical writing, as Varchi implies, has often been defined as the

story of states and statesmen. Florentine historiography favors such research, however, with its tendency to connect manners with civic memory. Florentine history has also favored such research because its public and private archives have been extensively preserved. Owing to a respect for records, institutionalized in a central state archive by Duke Leopold II in 1852, the material for the reconstruction of the social constitution of Florence is relatively abundant and remarkably intact.

Duke Leopold's express wish of encouraging historical studies has been fulfilled. The documentary resources of the Archivio di Stato have been thoroughly mined, although they are far from exhausted. One component of the fascination of Florence as a historical subject is the accessibility of its past, which has allowed it to be revisited and reinterpreted according to the varied aims and interests of its historians. For some the development of its political, institutional, and social structures from the establishment of the commune in the late thirteenth century to that of the duchy in the sixteenth marks the beginning of the modern state, its bureaucracy, and its family organization. For others these are seen as representative of a distant culture, whose relevance is not in providing direct precedents but in demonstrating both continuities and discontinuities in social behavior. The study of the Florentine past allows for the observation, if not the explanation, of political processes and transformations, and for posing questions relating to the nature of historical categorization. What is medieval, late medieval, Renaissance, or modern in a state, its politics, its economy, and its social composition?

It is not my purpose to trace the genealogy of Florentine studies, nor to expose the ideological underpinnings of the resulting research. Insight into these matters can be found in the articles by Samuel K. Cohn, Jr. ("La nuova storia sociale di Firenze," *Studi storici* [1985]), Edward Muir ("The Italian Renaissance in America," *The American Historical Review* [1995]), John Najemy ("Linguaggi storiografici sulla Firenze rinascimentale," *Rivista storica italiana* [1985]), Randolph Starn ("Florentine Renaissance Studies," *Bibliothèque d'humanisme et renaissance* [1970]), in Gene Brucker's introduction to his book on *The Civic World of Early Renaissance Florence* and his chapter on "Florence Redux" in his anthology, *Living on the Edge in Leonardo's Florence*, and in William Connell's introduction to the essays dedicated to Brucker, *Society and Individual in Renaissance Florence*. My own substantial debts to individual authors are declared, if hardly repaid, below and in the Bibliographic Notes to each chapter. I confess at the outset that an unabashed element of exploitation lies at the heart of the project, as one of my principal aims is to take advantage of the rich findings of recent historical scholarship in order to enrich the art-historical understanding of the period.

In so doing I proudly admit to being one among a number of art historians interested in examining the ways that form, style, and subject matter might be related to specific social, political, and institutional contexts. Works such as Diane Zervas's book *The Parte Guelfa, Brunelleschi and Donatello*, Megan Holmes's *Fra Filippo Lippi: The Carmelite Painter*, William Hood's *Fra Angelico at San Marco*, and Adrian Randolph's *Engaging Symbols: Gender, Politics, and Public Art in Fifteenth-century Florence*, for instance, demonstrate the subtle interplay of forces behind what Hood has called the "finely shaded visual codes" characteristic of fifteenth-century Florence.[5] How such codes operated in the

private sphere has been suggested, for example, by Cristelle Baskins, Anne Barriault, Kent Lydecker, and Jacqueline Musacchio in their respective studies: *Cassone Painting, Humanism and Gender in Early Modern Italy*; *"Spalliera" Paintings of Renaissance Tuscany*; "The Domestic Setting of the Arts in Renaissance Florence"; and *The Art and Ritual of Childbirth in Renaissance Italy*. These writers, along with Luke Syson and Dora Thornton in their book *Objects of Virtue: Art in Renaissance Italy*, have also profitably challenged the restrictive boundaries of "fine" and "decorative" as categories for the arts, showing the major importance of objects traditionally classed as "minor." The citations in the Bibliographic Notes not only support or enlarge the points made in each chapter, but indicate how the issues addressed are of vital concern to the discipline of art history.

This book is about the social dynamics of the visual. Dealing with ways of looking, it also shows how different modes of viewing can influence the way things look. Its central conviction is that images served to articulate the identities of fifteenth-century Florentines as instruments of social definition and of cultural expression. The extraordinary volume of exceptionally high-quality objects demanded by Florentines can be explained by the fact that they were required to satisfy important needs and to manifest important bonds and attitudes. That they should be beautiful and decorative was essential, not incidental, to their meaning.

Because of their beauty, the paintings and sculptures of fifteenth-century Florence are now appreciated as works of art. Although justified, the terms of such admiration are anachronistic and their distorting power should be recognized. "Art" as such did not exist in the fifteenth century. The "arts"– or *arti* – were the guilds. Art or *arte* was understood as the skill or the range of skills or techniques exercised by masters of different professions. Painters, sculptors, and builders were craftsmen operating within the guild system as artisans. Their production, however highly prized it might have been for qualities of invention and design, was functional and was most appreciated for its suitability to its purpose. The person paying for the work or "having it made" was as likely to be considered its "maker" as was the craftsman responsible for its manufacture. To discuss things as works of art is to set them in a value system that removes them from the circumstances of their crafting and their original placement. It mistakes why they were requested and how they were handled and viewed. It imposes a misleading modernity on artisans and artifacts. It also tends to set both in a fixed scheme of stylistic development, which can obscure the variety and the nuances of forms in the period.

This is not to deny transformations over time. One of the striking features of the fifteenth century is the amount of change in the visual arts. One of the reasons for studying the century is to note how and why such changes occur. What forces stimulated and what conventions controlled the ambitions of the craftsmen we now call artists? What were the elements of continuity? In his Life of the painter Pietro Perugino, Giorgio Vasari long ago provided a vivid description of what were then seen as the special features of Florence that inspired its craftsmen to perfect their skills. He recalled a ruthlessly competitive atmosphere fuelled by constant criticism, a high regard for quality, a limited marketplace, and personal ambition.[6] He remarked on the independent nature of Florentines, which made them intolerant of mediocrity while concerned for the honor connected

with good and beautiful works irrespective of their makers. This explanation merits further attention. What factors allowed for this independence? How were expressions of individual interest balanced against the maintenance of corporate or civic stability? How was the individual defined or allowed to be defined within the containing structures of state and family? Whose honor was being advanced and what were the criteria to determine beauty and goodness?

Predictably, in gross terms, the majority of works were produced for the rich and powerful: those who had the means to pay for them and to command or to negotiate their positioning in significant spaces. Equally predictably there is a close connection between imagery and ideology. Images and objects could project and, it was hoped, in their permanence, protect the ideals of the Florentine patriciate. At times this was an intimate self-mirroring, as in the portraits, painted furniture, devotional objects, and precious items that decorated domestic settings, where they could be seen as a form of internal coding of class consciousness. At other times these interests could be represented more publicly: for example as ecclesiastical endowments of altars, chapels, and funerary monuments. They could also be expressed corporately or officially in commissions from the Florentine state, guilds, or confraternities. The cultural messages of such commissions could be addressed to a much wider audience, however, publicizing or reinforcing the values held to be the sources of social order and civic honor.

The dominant members of Florentine society dominated the imagery of that society, but they did not completely monopolize it either as owners or as spectators. While the history of the visual arts in the period can plausibly be written as a history of the elite, it need not be written entirely from its point of view. Even within the elite that viewpoint was variable and could depend upon age, status, and gender. But such a history should not neglect the (active and passive) ways that the less affluent and less influential might have engaged with images. It should recognize the mechanisms of their inclusion and the meanings of their exclusion. It should observe the way that even the most exalted among the imaginary population of Florence, the Virgin Mary herself as depicted on devotional panels or altarpieces, for instance, could become the daily companion of the most humble resident of the city. Nor should it forget that the artisans who gave form to the aspirations of the ruling group did not belong to that group: and that those forms were informed by a social dynamic between unequal partners.

What follows is not a social history of the arts in fifteenth-century Florence, but a series of essays whose purpose is to locate the visual arts in the society of that time and place. They embrace definitions of seeing as well as a discussion of the things made to be seen. Although much is surveyed, neither a single story nor a complete one is attempted. My approach has been to balance the analysis of some general trends and major categories of images and modes of viewing against detailed studies of selected cases. A delicate equilibrium – or tension – between protagonists and patterns, characters and conventions is one that emerges from the period itself. Here underlying mechanisms are examined along with specific instances of their operation and their results. My intention is not to produce an exhaustive reading of the imagery of a century; it is to provide keys to further and future readings.

The first section of this book, "Moral Imperatives and Material Considerations," looks at some of the notions of expenditure and exchange that influenced developments in the visual arts as well as the status of those arts. The opening chapter gives an overview of the social organization of the city and the interaction of images and identities with objects and occasions. The second deals with the theory and practice of display in the early fifteenth century. Conventional patterns of expenditure are described, as are some of the factors that altered or enhanced those patterns. These include emerging notions of honorable expenditure that both sustained traditions and encouraged an expansion in the investments made to live well and to be remembered decently. Humanist writings addressed to wealthy and influential citizens justified personal or private "splendor" in terms of civic good, allowing the realm of the material to be moral. They also connected style to substance – a formalism with notable parallels in the visual arts.

The first two chapters outline the mechanisms and motivations of commissions and their ethical justification in emerging civic or civil theories of virtuous display. The third gauges the social placement of the artisans responsible for manufacturing the new splendor. A key question in the study of the period is how social and cultural hierarchies were linked. Despite the growing respect for the visual arts, with a tendency to qualify them as learned rather than as simply mechanical, very few artists made any significant change in their place in the class structure. The gain for painters and sculptors generally did not consist of amassing large fortunes or exercising power or political influence, it was in acquiring prestige. The skilled craftsman could be classed as a famous figure, a person of reputation whose reputation as well as works could serve the city.

The process of honoring and some of its motivations and consequences are the subjects of the chapter on "The Economy of Honor," which takes a single episode as a key to a more general situation. It starts with a description of the bronze roundel showing the Virgin and Child that the sculptor Donatello gave the physician Giovanni di Antonio di Chellino in payment for his medical services. The transaction is registered in an entry in the doctor's record book where Donatello's fame as a sculptor is also remarked. It is a revealing episode that typifies an economy that was not solely monetary, in which prestige, friendship, and obligation were fundamental elements of exchange. It is also an episode that sheds light on the ways that the position of an artist could be defined by his actions as well as his works, and on how a knowing manipulation of social conventions could suggest new terms for that definition.

The images of fifteenth-century Florence had a powerful connection with the imagination of fifteenth-century Florentines. This is not only a matter of fantastic inventiveness as we might understand it (though the art of the time was richly imaginative in that sense as well), but of a form of collective consciousness. In contemporary terms to "put" or "have something before the eyes" – to activate vision – was to activate the process of recollection and reflection. The section of the book on "The Eye and the Beholder" reviews the attitudes that conditioned visual awareness in Florence. The chapters in this and the following section are based on the idea that the roles and relationships articulated by the visual arts can be profitably interpreted through an analysis of the understanding and organization of vision as a conceptual and a compositional matter.

The chapter on "Seeing and Being Seen" surveys the ideas about sight and visual experience that were prevalent in the period and indicates some of the ways that the links made between visibility and identity had an impact on the composition of images as repositories of social memory. It engages directly with Michael Baxandall's influential study of cognitive style. The proposals about the categories and cultural components of viewing made in his book *Painting and Experience in Fifteenth Century Italy* are reconsidered and reworked both to expand their frame of reference and to narrow their application. *Painting and Experience* introduces the "period eye" without pretending to discern all that occurs in its field of vision. The book is explicitly about painting and not about the visual arts in general. A survey, it necessarily stresses the common features of experience rather than detailing the contingencies of particular cases, or setting them within the frame of local demands or expectations. In the fifteenth century, Italy was a geographical not a political designation. As a result of being so broadly placed, Baxandall's treatment of the period does not take into account the way that specific configurations of power might be figured or how the recognition of political and social hierarchies might have influenced pictorial order. By contrast my focus is on works and episodes that typify the dynamics of display in a given city-state. The aim here is to explore the attitudes and assumptions that form the context for the acute visual sensitivity that characterizes the artistic production of the city. I do this in Chapter 4 by describing the social, political, and legal practices that relied on close observation, eyewitness testimony, and the memory of images.

The following chapter on "The Eye of the Beholder" treats vision as a cultural construction. It centers on a reading of the famous verses in Canto x of Dante's *Purgatory* that tell of the poet's reactions to a series of sculpted examples of humility. From an analysis of Dante's text and subsequent commentaries, it is possible to chart some of the stages in the evolution of the discerning viewer and to distinguish critical notions of aesthetic pleasure and artistic authority.

The discriminating I / eye, projecting imaginative experience and reacting to visual encounters, both precedes and supersedes the technical schematization of spatial construction. However important and intriguing it was to many fifteenth-century artists, perspective was merely one compositional device, and it remained complementary to composition. The strategies employed to manipulate space and to capture and fix the viewer's attention were many and varied. They could depend on the type of work as well as the talent of the artist. In their multiplicity they not only created a flexible medium of exchange between the beholder and the object beheld, but they also supplied alternative means of contact between the artist and his public. This chapter analyzes that economy of vision in fifteenth-century Florence.

The chapters in the third part of the book are about "Seeing and Being" and take examples of sacred and secular painting to show how, in given situations, artists composed images that involved their viewers in forms of looking that bound perception to behavior and to expressions of identity (artistic, institutional, and familial).

One pious woman recalled from a sermon: "Examine yourself and you will know for what end God created you: not for riches or for the pomp of this world, but that you

should go and enjoy that blessed glory [of the next]."[7] This commonplace of Christian thought also contains a fundamental belief about identity: the Christian "self" is a soul, whose earthly existence is transient and subject to God's will. For Florentine citizens, however, God's grace not only provided relief from tribulations of the spirit and trials of the flesh, but could be invoked as protection for their daily business, undertaken "in the name of God" or according to the "will of God and the Virgin Mary," as stated on the opening pages of record books. Bargains were struck: one merchant vowed to give a florin in alms each time he failed to keep the holy days as holidays and pledged twenty *soldi* and twenty Paternosters and Ave Marias for each Friday he failed to "abstain from the enjoyment of all carnal pleasures."[8] Mindful of God's favor in conceding his family worldly goods, Filippo Strozzi began his series of projects in Florence "with His things" – endowing and decorating churches and chapels – so that "one day we can come to ours."[9] The celebration of "His things" did not mean neglecting "ours." In commissioned works, the choice and arrangement of subject matter, the inclusion of patron saints and portraits, the selection of an artist, were all means to fuse the particular with the general.

The chapter on "Vision and Belief" considers the ways in which fifteenth-century artists responded to the task of envisioning the sacred and how they engaged the beholders of their works both in the admiration of their skills and in carefully inflected modes of contemplation. Images of sacred subjects constructed a relationship with the sacred. Looking at them properly stimulated that relationship. The conventions governing the design of religious works referred to a theology of vision that united corporeal sight with spiritual understanding. This chapter explains the theory and practices of religious viewing. It evaluates the dynamic between compositional tradition and stylistic innovation. An analysis of altarpieces painted for known places shows how formal nuances responded to functional demands.

The final chapter of the book, "Happy Endings," which focuses on Botticelli's panel of the *Wedding Feast of Nastagio degli Onesti*, analyzes the way in which specific visual forms could serve secular purposes In this painting the order of a successfully celebrated marriage is demonstrated forcefully and literally through the perspective ordering of the composition. It recalls both the story of a wedding, from Boccaccio, and an actual wedding alliance (between the Pucci and the Bini families) that had been brokered by Lorenzo de' Medici. The respective arms of all three families are placed prominently above the piers of the loggia setting of the feast. A study of this panel makes it possible to explore the intersection between real and idealized interests as well as to investigate in detail the way in which images communicate social roles. In it Antonio Pucci and his friends (who are portrayed at the table) could see themselves as creating and sustaining the order of the city. As depicted they remain as proof of its enduring prosperity and honor. The logic of the painting's composition argues their case by literally insisting on a viewpoint that impresses their triumphalist point of view on visual and historical memory.

These essays encompass many topics and they refer to a long tradition of scholarship as well as to new directions in art-historical research, particularly with regard to questions of vision, visuality, and the gendered beholder. Each chapter has a Bibliographic

Note intended to direct readers to the relevant sources and to introduce some primary areas of study. The Bibliographic Notes are necessarily hostages to fortune, given the extent, complexity, and vitality of the literature, which is constantly growing. I present them as starting points for investigation, with aplogies for any inadvertent omission of citations venerable or new. Notes in the text are generally restricted to direct citation of sources and documents.

This book would be inconceivable were it not for the attention that post-war historians have given to the social organization of Florence and to the ways that Florentine social behavior related to the city's political, economic, and institutional structures. In the introduction to *The Civic World of Early Renaissance Florence*, Gene Brucker characterized the study of Florentine history as a "large-scale enterprise."[10] Hardly collective and rarely collaborative, this enterprise has nonetheless been highly productive, returning to memory the once familiar details of daily experience and recovering for history the broader patterns of their significance.

Indeed an interest in patterns or networks is one linking feature of recent studies. The various histories of Florence, those of its institutions, of its government, of its economy, of its families, of its rituals, most often describe their protagonists in terms of interlocking alliances or rivalries of family, faction, and friends. The "spiritual individual" of Jacob Burckhardt's *Civilization of the Renaissance in Italy* has undergone an identity crisis in the century since his birth (or rebirth) in the 1860s. He has returned behind the "veil . . . woven of faith" and regained consciousness of himself as "a member of a race, people, party, family, or corporation," no longer dramatically separated from his predecessor in the Middle Ages.[11] Following current analyses, the modernity of Renaissance man, or woman, does not seem to depend so much on the "development of free personality" as on the way that subjective consciousness consists of juggling potentially conflicting demands and expectations.[12]

The issue is not whether this is a matter of historical continuity or a consequence of the human condition, but how, given the composite nature of identity, images might have acted as role models for fifteenth-century Florentines – as neighbors and kinsmen or kinswomen, daughters, mothers, and wives, or sons, fathers, and husbands. My interest in this process owes much to the delineation of those roles (and others) found in the numerous studies by Christiane Klapisch-Zuber cited in the bibliography, Samuel K. Cohn's *The Laboring Classes in Renaissance Florence*, Dale and F. W. Kent's *Neighbours and Neighbourhood in Renaissance Florence*, Richard Trexler's *Public Life in Renaissance Florence* and *Dependence in Context in Renaissance Florence*, Ronald Weissman's study of confraternities (*Ritual Brotherhood in Renaissance Florence*), and Richard Goldthwaite's and F. W. Kent's fundamental, if contrasting, works on the family (*Private Wealth in Renaissance Florence* and *Household and Lineage in Renaissance Florence*).

The research undertaken for the present book has tended to support Kent's view that the fifteenth century did not see the development of "the isolated nuclear-conjugal unit (newly seceded from a completely corporate clan)" and that "it was possible for Renaissance Florentines . . . to see household and lineage not as opposite ends in a tug of war . . . but as two complementary family institutions . . . each owed an appropriate

loyalty."[13] The material consequences of those loyalties – chapel endowments, palace decorations, and marriage furnishings – are inspected here, as are the ways that they might integrate individual interests with clan identity. They are not, however, read as straightforward documents of family history, but as idealized manifestations – as potent symbols of the enduring ideology of the family.

The obsession with lineage in marriage negotiations, the reliance on family and family ties in business practice, the abiding loyalty to traditional clan territories in the city and the country, and the multi-generational habitation of family houses all combine to challenge Goldthwaite's hypothesis that the isolated nuclear unit was a distinctive feature of Florentine society and therefore one of its claims to stand at the origins of modern social organization. There is evidence, however, that among the members of the elite there was an increasing concentration on marking out their private spaces and affirming their public status through display, and this book is much indebted to Goldthwaite's analysis of the developing culture of consumption and its impact on the "world of goods."[14]

That preservation of the lineage was one of the chief concerns and greatest successes of the families of the Florentine governing class is proven by Anthony Molho's study *Marriage Alliance in Late Medieval Florence*, in which he demonstrates the remarkable resilience of the elite in maintaining its identity over time. Molho adds a quantitative dimension to the consideration of family definition – both Kent's and Goldthwaite's works are case studies. Referring to Lauro Martines's pioneering work *The Social World of the Florentine Humanists*, he also confronts the problem of deciding the weight to give the various components that constituted class consciousness and marked the class divisions in Florence: the fluctuating factors of family antiquity, economic power, political honors, and prestigious marriage alliances that created reputation and that could influence status. The results of his analysis extend the conclusions made by David Herlihy and Christiane Klapisch-Zuber in their study of the declarations made for the 1427 tax assessment, the *catasto* (*Les Toscans et leurs familles*), regarding the concentration of wealth among a restricted group in Florence. While showing the tenacity of those holding wealth and prestige in maintaining their predominance over time, Molho's criteria also reveal the unfixed boundaries of Florentine class divisions. Although hierarchical, Florentine society was far from fixed in a rigid scheme. It was possible for a man like Puccio di Puccio Pucci to use his loyal friendship with Cosimo de' Medici to emerge from the ranks of the minor guildsmen and set his family on a course leading to major wealth and great influence – as is demonstrated in Chapter 7. The tensions inherent in the ambiguities of the city's social definition had the potential to be very disruptive in the real life of the city, but they were also extremely productive in the realm of its imagery, which could be used to try to fix or consolidate desired orders and relationships.

Given the argument that one function of images is to promote or proclaim power, these essays have relied upon the studies of the government and governing class made respectively by Nicolai Rubinstein (*The Government of Florence under the Medici*), Gene Brucker (*The Civic World of Early Renaissance Florence*), Dale Kent ("The Florentine *Reggimento* in the Fifteenth Century," *Renaissance Quarterly* [1975] and *The Rise of the Medici*), and Paula Clarke (*The Soderini and the Medici: Power and Patronage in Fifteenth-*

century Florence). These authors identify the individuals who held power and trace the networks of association – faction, family, and friends – that created and threatened political power over the century and that underlay the transformations of the Florentine government from the late fourteenth to the early sixteenth century. As will be seen, the visual arts were woven into these webs of affiliation, which provided alliances of interest offering support for given artisans or promoting given forms of expression. They were deeply implicated in the systems of patronage that were an intrinsic feature of Florentine society.

A related assumption is that "art patronage," like "art" itself, did not exist as such in the period, and that the label creates a false category of activity that masks or misrepresents a variety of transactions and interactions, which might range from simple payment for a good or a service to an actual client–patron relationship. The former was a regular activity of trade, even if the work that resulted or that was involved implicated values that were not only monetary, such as the mutual honor of the craftsman and his customer. The latter was an enduring tie, which could influence an entire career and include a number of commissions, direct and indirect, but which did not relate to any one specific task. So it might be said that Cosimo de' Medici was Donatello's patron, not only offering him the chance to display his skill on behalf of the Medici family, but using his influence, his bank, and his connections to promote or defend the sculptor's interests over four decades of association. Conversely it should not be said that Cosimo de' Medici was a patron of the arts, despite the enormous expenditures he made to build and decorate the new family palace, the villas in the Mugello and at Careggi, his parish church of San Lorenzo, and his endowments to San Marco, Santa Croce, Bosco ai Frati, and elsewhere. His investments in all of these projects and others cannot and should not be reduced to undifferentiated results of "art patronage." Moreover, although stemming from Cosimo's decisions, these commissions were not necessarily personal or individual. They as often affirmed or expressed Medici family identity as Cosimo's, and even within Cosimo's identity there was a repertory of roles being played out: leading citizen, responsible head of family, devout Christian.

Even without "art" or "art patronage" as such, there are still many reasons for an art historian to find fifteenth-century Florence a desirable subject of study. In my case it has been chosen because of the ample materials it offers to examine the relation between social and visual forms and to look in some detail at the ways that images come to have significance in determined situations and objects exist within economies of meaning. This choice was easily made given the obvious attractions of frequenting a past time and place that made beauty a defining and definitive social value, and of frequently returning to a place where the legacy of that past still lives in its monuments, libraries, and archives.

* * *

ACKNOWLEDGMENTS

I am a devoted and deeply indebted visitor to Florence; this book owes much to the individuals and institutions who safeguard and who so generously share the city's collected and collective memories. My work is based on sources found in the Archivio di Stato and depends on the resources of the Kunsthistorisches Institut, with thanks to the staff of both. I am also indebted to Annamaria Petrioli Tofani, Alessandro Cecchi, Antonio Natali, and Cristina Acidini Luchinat for granting me unique access to the art works in their care and for giving me the benefit of their expertise about those works. I am grateful to the members of the Pucci family for permitting me to study the family archive in a way that deepened my regard for the family's legacy, which lives in their names: Marchesa Cristina Pucci, Marchese Giannozzo Pucci, Marchese Puccio Pucci, and Marchese Alessandro Pucci, who was sadly killed in a car accident in 2000. Like all students of Florentine history, I am a *de facto* pupil of the late Nicolai Rubinstein, the esteemed teacher and honorary citizen of Florence who willingly dispensed his vast knowledge of its archive and its political institutions. I was also aided by conversations with his former apprentices in the art of history, now leaders in the field of Florentine studies: Alison Brown, Dale Kent, F. W. Kent, and Kate Lowe.

Not only does the substance of this book rely upon the gifts gathered in the exceptional community of Villa I Tatti, its very existence is a result of the outpouring of care from the Villa that saw me through emergency surgery in 1999. There are no words adequate to the task of thanking those dear friends among the staff, the Fellows, and the associates of I Tatti who helped me in so many ways at that time and throughout this project, above all the former director, Walter Kaiser, who not only saved, but who has repeatedly enhanced my life. My fond and abiding appreciation embraces all those who are the living heart of I Tatti, but I want explicitly to acknowledge Rosa Molinaro Focosi, Nelda Ferace, Alexa Mason, and Michael Rocke. Fiorella Superbi and Giovanni Pagliarulo performed their usual magic with photographs. William Hood, who saw me through my convalescent winter, has always inspired me as an art historian. Chapter 4 was largely written while I was Paul Hills's guest at the Villino; his intellectual companionship at that and all other times has been invaluable. Other I Tatti friends who deserve particular mention for many and various forms of advice are: Lawrin Armstrong, Rolf Bagemihl, Eve Borsook, Maurizio Campanelli, Giovanni Ciappelli, Samuel K. Cohn Jr., Hubert and Teri Damisch, Georges Didi-Huberman, Nicholas Eckstein, Lorenzo Fabbri, Carlo Falciani, Silvia Fiaschi, Allen Grieco, Margaret Haines, Christiane Klapisch-Zuber, Amanda Lillie, Philippe Morel, Michèle Mulchahey, Jonathan Nelson, Robert Nelson, John Padgett, and Brenda Preyer. The final chapter of the book was drafted while I was Visiting Professor at I Tatti in the autumn of 2004. I want to express my gratitude to Joseph and Françoise Connors for that appointment and for their hospitality, and to the vintage group of Fellows who made my stay so happy and productive.

Studying Florence is an international affair. In Paris I have been welcomed in the Louvre by Dominique Thiébaut and hosted in the "petit palais" by Marcello and Teresa Lombardi. In Brooklyn, Kevin Stayton and his colleague, Elizabeth Easton, opened the

collection and its archive to me. In Washington, I was aided by David Allen Brown and Nicholas Penny at the National Gallery of Art. In London, I have happily consulted the Warburg Institute Library, which offers a mine of information about the topics treated here. Former and present colleagues at the Courtauld Institute of Art have often solved specific problems and assisted me through thoughtful discussion. I am especially obliged to Howard Burns, Joanna Cannon, Peter Carey, Susie Nash, and Deborah Swallow. The Witt and Conway libraries are among the Institute's great assets, and I am very appreciative of the way their photographic holdings were made freely available to me. I have been privileged to teach gifted students, who have in turn taught me and who have willingly shared their research, notably Jill Burke, Caroline Campbell, Peter Dent, Megan Holmes, Sally Korman, and Kevin Murphy. I have also received special assistance and specialist guidance from Antonia Boström, Jane Bridgeman, Doris Carl, Jonathan Davies, Werner Jacobsen, Thomas Kuehn, Antoni Malinowski, Victor Meyer, Peta Motture, Michelle O' Malley, Nick Williams, Carl Strehlke, Paul Taylor, Evelyn Welch, and Paul Williamson.

Teresa Castro was very helpful in the preliminary search for the images that are the visual basis for my arguments. Uschi Payne subsequently took heroic measures to find and to obtain the best illustrations at reasonable costs. Without her efforts the book quite simply could not have been published and my admiration and gratitude for her work are boundless. Research grants from the British Academy and a private foundation contributed substantially to funding the photographic costs. Laura Blom, Stephen Butler, James Harris, Robert Maniura, Scott Nethersole, and Natalia Swiderska all gave indispensable assistance in preparing the manuscript. Virginia Thomas created the index with good humor and exemplary skill. Her involvement with this project was made possible by a grant from the Courtauld Institute of Art Research Committee.

My gifted sister, Andrea Kellner, guaranteed both the sense and style of this book through her careful reading of the manuscript. Gillian Malpass tended to the conception, execution, and production of this book with her justly celebrated talent and grace. I am amazed by her energy, honored by her commitment, and touched by her unfailing patience. Thanks are also due to her associates at Yale University Press: Emily Angus, Bernard Dodd, and Jacquie Meredith. Being willing learners, Darcy and Treacy Beyer instructed me in many things, above all, the true meaning of charity as caring generosity. Their support of this book has been unstinting and inspiring. Work on a project of this sort, if not always a labor of love, is a labor heartily dependent on love, and I thank my fortune for the abundant and cherished support of my family and my constant friends, most happily for me, Deborah Loeb Brice, Caroline Elam, Charles Robertson, Barbara Santocchini, Luke Syson, and Alison Wright.

Note on Money, Measurement, and Dates

MONEY

Sums are quoted in this book as they occur in the sources. Payments, prices, and salaries in fifteenth-century Florence were expressed, according to their context, in one of three different, but interrelated currencies: gold florins, copper- and silver-based coins (*monete di piccioli*), or a money of account (the *lira*). The florin – the coin of commerce and international exchange – was marked with the city's emblem of a lily and its reputation was protected over time by communal legislation. To guard against clipping, the coins were put into circulation by the Mint in sealed leather bags, a practice resulting in the term "sealed florin" (*fiorino di suggello*). In 1433 the government issued a florin with ten per cent higher gold content, the *fiorino largo*. Its value soon increased to be twenty per cent greater than the sealed florin, and in 1464 it was decreed that *fiorini larghi* be used for certain transactions, such as bank deposits and payments for dowries and real estate. By law, bookkeeping and business dealings in florins were permitted only to international merchants, exchange brokers, wool and silk merchants, apothecaries, and furriers (members of the respective guilds of the Calimala, Cambio, Lana, Seta, Speziali, and Pelliciai).

The *libra* or *lira* was the money used for recorded transactions. The *lira* was divided into 20 *soldi*. There were 12 *denari* to a *soldo*. The *lira* could be "a oro," representing a transaction in florins or "a piccioli," relating to a transaction in the silver coinage (*monete di piccioli*), which circulated locally in the form of *denari piccoli* and *quattrini* (worth four *denari*). The actural value of the *monete* depended on the value of their metallic content, and fluctuated with respect to the florin, as did to the value of the *lira*. In the course of the fifteenth century there was a rise in the value of the florin, from around 3½ *lire* to the florin at the beginning of the century to about 7 *lire* to the florin in 1500. In 1400 the florin was worth 76 *soldi*, in 1500 the florin's value was 140 *soldi*. The florin and the Venetian gold ducat were generally equivalent. There is no meaningful exchange rate between fifteenth-century and contemporary currencies; the relation of money to the cost of living can be indicated, however, and it is discussed in Chapter 3, as well as in the references given below.

* * *

MEASUREMENT

The unit used to measure lengths was the *braccio*, which was approximately 58 cm. or just under 2 feet.

DATES

The Florentine year began on March 25. When source material is cited that dates between January 1 and March 25, the year will be given as in the original text, with the modern year in brackets (for example March 20, 1420[21]).

FURTHER REFERENCES

Bernocchi, *Le monete della Repubblica fiorentina*; de Roover, *The Rise and Decline of the Medici Bank*; Frick, *Dressing Renaissance Florence*; Goldthwaite, *The Building of Renaissance Florence*; Zupko, *Italian Weights and Measures*.

Antonio delpolaci

bon...

PART I

Moral Imperatives and Material Considerations

2 (FACING PAGE) Antonio del Pollaiuolo, *Design for a Thurible*,
ca. 1460, pen and wash and red-brown ink, 29 × 20.2 cm.,
Gabinetto Disegni e Stampe, Uffizi, Florence, 942E (recto).

Chapter One

THE IMAGERY OF IDENTITY

THE IMPORTANT MEN OF A MAJOR CLAN gather in a piazza. They are accompanied by their supporters and clients (pls. 3, 4). Grouped around an altar, they discuss and ponder a sacred event. Some turn to greet newcomers. All are grave and dignified. The square is bright and well ordered. It is ornamented with stately architecture, sculpture, and multi-colored marbles. It is a fiction – a painted history on a chapel wall. It is also a fact – a willed and commissioned fact of family honor. It is furthermore a fact of "Firenze bella" as chronicled, for example, by one of its citizens, Benedetto Dei, who listed the subdivisions of his "most glorious and powerful nation," its great and wealthy families, its piazzas, and its calendar of holy feasts celebrated "in honor and reverence to almighty God and for the contemplation and pleasure of the most powerful Florentine people."[1] The inscription over the arch dates the mural to 1490, "when the most beautiful city . . . enjoyed abundance, welfare, and peace." Real people, members of the Tornabuoni clan and their friends, are portrayed in an imagined space and an imagined time, which juxtaposes and overlays events into prophetic and prescriptive continuity. The pictorial order of the *Annunciation to Zacharias* in the Tornabuoni chapel in Santa Maria Novella both represents and symbolizes Florentine social order.

Obviously such a painting does not illustrate the daily experience of fifteenth-century Florentine life however much it might record about its habits and customs and costumes. It is better viewed through its verisimilitude. Being similar to life, it is a figure for the hierarchies, operations, ties, actions, and expectations that constituted life in the period. As such it can be seen as participating in a wider range of metaphorical processes controlling the meanings of Florentine social behavior. The relation of kinsmen, friends, and neighbors, of old to young, of male to female as ordered by the painter's perspective can be related to the ordering structures of cultural consensus – the conventional perceptions of reality. The word "order," with its constellated notions of proportion, harmony, and measure, was applied to definitions of status, of political grouping, of cosmic hierarchy, and of the painter's artifice. Its opposite was disorder, chaos, disintegration: the clamorous horrors of Dante's Hell.

"The world is full of deceit," comments one speaker in Leon Battista Alberti's dialogue on the family.[2] To "test your friends a hundred times" before trusting them was commonplace wisdom. Even once tested, trust was a matter of extreme caution, for a

4 Domenico Ghirlandaio, *Annunciation to Zacharias*, 1490, mural, Tornabuoni chapel, Santa Maria Novella, Florence.

friend should never have so much power that he could "be the cause of your undoing."[3] Alberti warned that "The world is amply supplied with fraudulent, false, perfidious, bold, audacious, and rapacious men. Everything in the world is profoundly unsure. One has to be far-seeing, alert, and careful in the face of frauds, traps, and betrayals."[4] A Florentine born in exile, he had cause to know. When Alessandra Strozzi wrote to her exiled son, Lorenzo, about the recent entry of Piero de' Pazzi, "in great triumph and magnificence," she added that it might mean little, as "sometimes in Florence one appears one thing and does another."[5] Appearances were deceptive. They were also instrumental. They had to be watched, to be guarded, and to be maintained. They generated understanding or purposefully perpetuated misunderstandings between and among individuals, families, and institutions. Creating and participating in images – those of status, rank, role, or character – through rituals of sacred and secular ceremony, through festival display, and through everyday comportment was an essential component of both the city's order and its honor.

In 1427 about 40,000 inhabitants lived loosely enclosed within $5^1/_4$ miles of city wall built between 1284 and 1333 when the population was almost three times as great. The

Black Death of 1348 and subsequent outbreaks of the plague had considerably reduced the number of inhabitants, but in the terms of the day fifteenth-century Florence was still a large and prosperous city. It is possible, however, to walk from the southern gate at Porta Romana to the northern gate of San Gallo in just under an hour (pl. 5). Doing so one crosses many of the important boundaries of the Renaissance city: from the quarter of Santo Spirito on the south of the Arno through those of Santa Croce and San Giovanni on the north. Each quarter contained four wards (*gonfaloni*) demarcating the official fiscal and electoral divisions of the city. One passes through parishes and the neighborhood enclaves of big families, including the Medici. With limited detours such a walk intersects a number of sacred sites and ritual centers, taking in the communal palace in the Piazza della Signoria and then going past the grain market and oratory of Orsanmichele, the bell-tower, the cathedral, and the Baptistery. It encompasses market-places and monasteries. Rich and varied as this route might be, and eventful and charged as it is if one can observe the boundaries and trace the old paths of brotherhood and enmity, it is still a relatively short walk. That distance, which can expand infinitely by association but which is also contained and delimited, is important to remember. A Florentine citizen of the fifteenth century could probably recognize and place, if not identify with frightening precision, many of his fellow citizens and recall their significant actions and gestures and possibly those of their ancestors. This was particularly true of the restricted group of the ruling elite. Benedetto Dei's chronicle enumerating the Florentine patriciate and their palaces and piazzas is proof of this. Knowing each other was a skill necessary for survival as well as prosperity. Small wonder that, in such a small world, being was so intimately bound up with seeming, and that in such of world of

5 Lucantonio degli Uberti, after Francesco Rosselli, *The "Chain" View of Florence*, after 1480, woodcut, Staatliche Museen Preussischer Kulturbesitz, Kupferstichkabinett, Berlin.

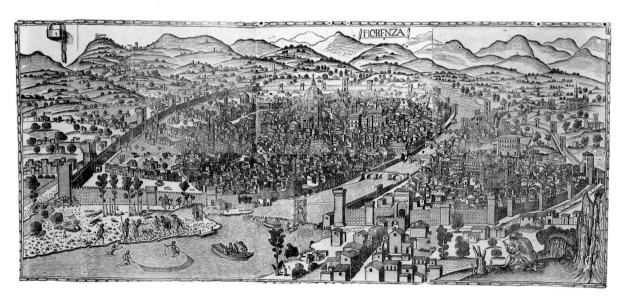

fickle, but familiar appearances, the manufactured imagery of the painter, sculptor, goldsmith, and builder could play an essential part in projecting and fixing meaning.

ACQUIRING HONOR

Florence was a mercantile city. Banking, international trade, and the production of fine wool and of luxury cloths formed the basis of the city's prosperity. Political enfranchisement depended on membership of one of the twenty-one professional guilds. In a society so dependent on business acumen and so well versed in accounting, it comes as little surprise to find that careful computation was given to investing in appearances. Nonetheless, a modern marketplace model of consumption and production is misplaced when dealing with some important forms of exchange within the city, as can be illustrated by examining the case of Piero del Tovaglia, a wealthy silk merchant who made the following calculation: "And I also put it to myself that if I have spent 2,000 ducats on my house for my dwelling place in this world, 500 florins will be a good amount to spend for my dwelling place in the next."[6]

Piero wrote this to the Marquis of Mantua, Lodovico Gonzaga, in May 1471. It seems a neat statement of the practices of expenditure. The amounts Piero allotted for decent accommodation in this life and the next represent sums that were actually spent on houses and on tombs and burial chapels by the leading citizens of Florence. 2,000 florins was exactly what Gherardo di Bongianni Gianfigliazzi paid in 1460 to purchase the large house on the Lungarno that he converted to his family palace.[7] Gherardo left 500 florins to be spent on religious bequests, which his brother Bongianni dedicated to the new family chapel in the choir of their parish church of Santa Trinita, as well as investing the same amount from his own estate to finance commemorative masses in that chapel.[8]

Such sums cover the major areas of outlay for the comfort and honor of the household, the benefit of one's soul, and the perpetuation of memory. They indicate a pricing structure that relates to the representation and maintenance of status, and would seem to set these social requirements into the frame of commercial practices. But a closer analysis of Piero's statement indicates some of the complications in both pricing and placing such activities.

The simple payment of 500 florins did not purchase or furnish Piero's burial chapel, which was to be in the prestigious pilgrimage church of Santissima Annunziata. Piero was not a member of the traditional patronal families of Santissima Annunziata, nor did he live in the neighborhood of that church. His parish was San Firenze, in the quarter of Santa Croce. His brother Francesco was later to be buried at Santa Croce. Piero's involvement with Santissima Annunziata was a result of the relations he was cultivating with the Marquis of Mantua, who had become the somewhat involuntary patron of the building of a new tribune for the church. When it became clear to the Marquis that money owed to him by the Florentine government for his military services would not be paid directly, he agreed to contribute 2,000 florins of the stipend towards the rebuilding of the high altar chapel as a memorial to his father and to the Gonzaga.

Begun in 1444, the project was hindered by complications of design and finance. In May 1469 Piero put himself forward to the Marquis, informing him of current developments. Lodovico duly made him his agent or procurator in Florence, thereby involving the merchant in international politics as he moved between the Signoria, the Servites, Lorenzo de' Medici, and Mantua. For his efforts, in 1471, Lodovico granted Piero and his heirs patronage rights to any new chapels built in the tribune (as long as the Gonzaga arms and *imprese* were displayed) and power over the disposition of burial privileges in the tribune chapels.[9] He was further granted permission to have a floor tomb in the tribune. Piero arranged to place his tomb with the family arms and the emblem of the Marquis in front of the high altar – traditionally the most desirable position in any church. This placement would be well beyond Piero's usual expectations in such an important shrine.

There were six new chapels. Piero chose to endow the chapel of Saint Sigismund, next to the principal chapel of the choir, which was dedicated to a miracle-working image called the Madonna del Soccorso. His notional possession of multiple chapels gave him a position of great power, one gained outside of the normal channels of chapel patronage. Its timing depended on the building history of the church, not Piero's personal history. In the normal chronology of concern, concentrating on death usually came about at the moment of making a will.

The figures mentioned in the letter, though plausible, are partial and relate only indirectly to Piero's endowment of his burial chapel or the value of his house. Eager to advance things in Florence and to please the Marquis, in 1471 Piero offered to spend 500 ducats towards the project. This was the same amount as Lodovico's installments and seems more of a courtly gesture or calculated risk than a candid offer. In the event his money was not used. The tribune was finished in 1477, but it was only in 1484 that Piero began to dispose of the chapel patronage rights and to organize the endowment of his chapel and his own program of self-commemoration. On December 2, 1484 he "gave" one of the chapels to the physician Antonio Benivieni and his heirs. In exchange for this gift, Antonio promised an income from real estate of 10 gold florins a year to be dedicated to dowering orphaned girls from the Foundling Hospital in Piero's name. Both the hospital and the real estate were under the control of Piero's guild, the Silk Guild, whose consuls were to administer this bequest for "the love of God and the salvation of Piero's soul."[10]

Piero made his will that same day. In it he confirmed this arrangement and set out terms for masses at his chapel. He left the patronage rights to his brother Francesco on the condition that he secure an annual income of 10 florins *larghi* to be used as alms from the chapel. As with the money from Antonio Benivieni, this charity was to be dispersed by the Silk Guild in dowering girls from the Foundling Hospital, "pro . . . amore dei et pro remedio anime dicti testatori."[11] In this will the guild was also given the patronage rights to two chapels. There was a further provision to dower girls from the parish of Santa Margherita a Montici, which was near some of Piero's country properties.[12] He modified this will in February 1485, withdrawing the chapel bequests to the guild and giving the Servites the patronage rights over all four of the remaining chapels, on the

condition that from the first of March that year they perform a daily mass in perpetuity for the benefit of Piero's soul at the altar of his chapel (that of Saint Sigismund), and that on the saint's feast day they perform a solemn, sung mass. The Servites were also obliged, in perpetuity, to send eight novices bearing four white candles to Piero's house on the feast of the Purification of the Virgin (February 2). These candles were to be returned to the church for the celebration of the feast of Saint Sigismund (May 1). Should they fail in this duty, there was a penalty of 25 florins *larghi* to be applied by the Servites to furnishing the chapel with vestments, chasubles, cloth altar frontals, and other ornaments.[13] A subsequent will, made on March 15, made no changes to the terms of Piero's pious bequests. It states, however, that he was to be carried to his tomb dressed in the garments of the confraternity of Gesù, which was located in Santa Croce.[14]

Cash played a limited part throughout these transactions. They were shrewdly based on a distribution of assets and exchanges of favors that put income-yielding property to the service of Piero's reputation in posterity. That reputation was being fashioned as pious and charitable, and was forged through his ties with his guild and his neighborhood confraternity as well as with the Servites, who became guardians of his soul and his mortal remains. A minimum of expense guaranteed a maximum of returns. Piero's piety was to be paraded annually through the streets in his life and demonstrated in perpetuity after his death (which occurred in 1487) by the candle-bearing novices. His charity would be remembered annually through the dowries. To civic prominence he added his international contacts, as his association with the Gonzaga was blazoned into the del Tovaglia coat of arms where he had been allowed to incorporate the Gonzaga device of a sunburst.

Piero's final will also gives the value of his "habitation in this life" as estimated to be 1,200 florins *larghi*.[15] The 2,000 ducats mentioned in the letter refer more directly to the Marquis's forced financing of the tribune than to Piero's real estate. 2,000 florins was the amount the Marquis had originally hoped to contribute to the construction of the Santissima Annunziata tribune.

This episode demonstrates both the existence of a sort of formula of expected expenditure, with its due proportions, and the ways that such a formula could be interpreted or modified in a particular case. The mix of financial mechanisms and ritual manifestations is entirely characteristic both of the institutions and of the type of individual concerned (an affluent member of a major guild). It is possible to point out characteristic types of commission in fifteenth-century Florence, and describe how and why they generally occurred. But each rule or tradition, however consciously invoked or unconsciously observed, was subject to numerous variables and exceptions. Piero del Tovaglia both spoke and acted out of a desire to advance financially and politically in a wider sphere by acting as a friend to the Marquis of Mantua. The site of his housing in the afterlife was determined by his patron's involvement with a major building project. The economics here were not based on cash, but on contacts – on relationships between people and institutions. The chief investments were in ritual activities. The calculations were on how to promote a career, as Piero sought to enhance his position in this world while providing for the next.

Piero del Tovaglia's case shows how an individual might work through various institutions to form his social visibility in the present and to fix his memory properly for posterity. And it shows how individual behavior was not divorced from corporate or family roles. Moreover, it indicates how public and private realms, while distinct, were never separate. The grave, though perhaps a fine and private place, was located in a public space. As del Tovaglia's testament proves, any personal provision for the afterlife impinged on the liturgical life of the chosen church, instituting commemorative mass programs and influencing ceremonial schedules. Conversely the house, while enclosing the domestic activities of a family, also accommodated and anticipated in various ways various forms of visitor and visitation. There were to be found the material expressions of personal worth and of the *costumi* – the manners and behavior – of a given family and its members. Certain types of furniture, notably wedding chests, were part of the history of a household and stood as reminders of social ties and obligations. Family identity could be consolidated and commemorated and family honor served by the ordering and embellishing of the house with heraldic emblems and beautiful appointments.

OBJECTS AND OCCASIONS

The investments made for the "dwelling place in this world" and the next (following del Tovaglia's categories) might further be divided into cyclical and occasional. The first were those expected to mark key moments in the life cycle of an individual and a family: birth, marriage, and death. They relate to the most formalized moments and the most explicit traditions of expenditures. The outgoings for marriages (on jewelry and clothing for brides, for example) and the gifts received or given to celebrate births are regularly noted in family record books as part of the lineage memory as well as of domestic accounting. Other goods associated with these events were the fine plate displayed at wedding feasts, linens and precious books of hours that came as part of dowries, furniture, paintings, sculptures to decorate rooms assigned to the new couple, and funeral banners to mark the grave. The ritualistic nature of the exchange of such goods makes their study as much a part of cultural anthropology as of art history. Although they were assigned values, and were part of a family's outgoings and assets, their functional and symbolic importance could easily exceed their financial worth. And however conspicuous, their consumption was not a matter of shopping around for superfluous, but attractive items; it was attached to defined realms of visibility. Indeed the city sought (with limited success) to regulate the outgoings on marriages and funerals through sumptuary legislation.

"Occasional" commissions or expenditures were those prompted by circumstance. The death of a family member, disease, or more general devotional impulses could result in donations to religious or charitable institutions. The record book of Antonio di Lionardo Rustichi, for example, notes that on August 5, 1416 he spent 15 gold florins on a bed for the hospital of Santa Maria Nuova, with its mattress and linens, using money left by his brother; the bed was painted with the family's and the hospital's arms and saints Giovanni Gualberto and Anthony.[16] On April 8, 1419 Antonio paid Mariotto di Cristo-

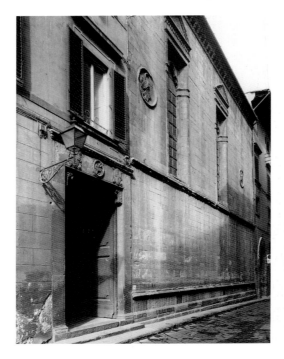

6 Exterior view of the Strozzi sacristy, 1418–23, Santa Trinita, Florence.

7 Strozzi sacristy door, ca. 1426, Santa Trinita, Florence.

fano 6 florins and 12 *soldi* for painting a figure of Saint Giovanni Gualberto with a scene from his life and Antonio's arms on a pier in the church of San Romeo, "per remedio delanime de nostrj passatj" – for the salvation of his ancestors' souls.[17] Grief-stricken by the death of her youngest son, Matteo, Alessandra Strozzi wrote to his elder brother Filippo saying that she wanted to put her own sorrow "to one side as soon as we've done what he asked of us, for the good of his soul."[18] She also reminded him that "you must do what you promised," which was to have a votive image made of him in wax, to be placed in Santissima Annunziata; Filippo had also vowed to have a chasuble made, without specifying a destination for the donation: "it would seem to me good to have it made here. I'd be happy with that, so that he'd have some memorial."[19] Matteo had died in Naples and Filippo later saw to the building of a tomb there. Their combined actions were expressions of mourning and of the need to preserve an honorable memory, while fulfilling all promises made for the care of the souls of the living as well as the dead.

A concern for his own soul is registered in the memorandum made by Girolamo di Carlo di Marco Strozzi (Filippo's cousin) of the pious expenditures he made between 1471 and 1472, which were for a life-size wax votive image given to Santissima Annunziata, a smaller one that he carried on foot to the church of San Clemente above Fiesole, and donations of masses and candles to seven other churches and shrines in and around Florence.[20]

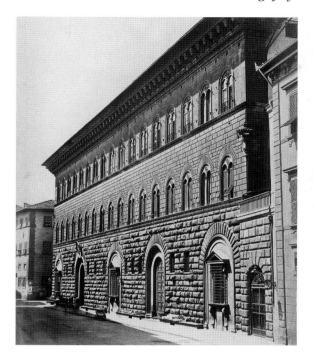

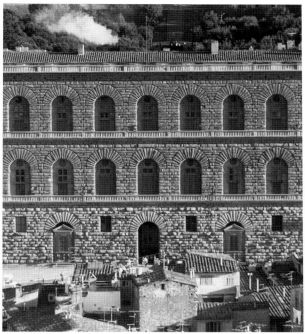

8 Palazzo Medici, ca. 1440–60, Florence.

9 Palazzo Pitti, ca. 1457–66, Florence.

Such "circumstantial" commissions could also be very significant. A descendant or direct heir might become involved in a major commission while executing a testamentary bequest; this was the case with Palla Strozzi's building and decoration of the sacristy chapels at Santa Trinita, which followed from his father's will (pls. 6, 7, 22). Return from exile, family expansion, and political ambition might result in the acquisition or building of a palace or villa, then requiring furnishing and decoration. In broad terms such could be said to be true of the respective cases of Filippo Strozzi and Luca Pitti, both major palace builders. These instances also show how competition could operate as a factor. The seignorial grandeur of the Medici palace was more than answered by the stony mass of Luca Pitti's (pls. 8, 9). In a petition to the Signoria regarding the purchase of a nearby street, it was explained that the size of his family had forced Luca to enlarge his house, so that it could be lodged comfortably and "according to its quality."[21] But it is also true that just as he was quarrying the colossal blocks to build the house in the late 1450s, Luca was building a faction to undermine the carefully constructed edifice of Medicean dominance. One chronicler wrote that in the uncertain times after Cosimo de' Medici's death in 1464 when his son Piero's

> reputation was much diminished . . . Luca Pitti held court at his house, where a great part of the citizens went to consult on matters of government. Amongst the other citizens, M. Agnolo Acciaiuoli and M. Diestisalvi di Nerone, were the most out-

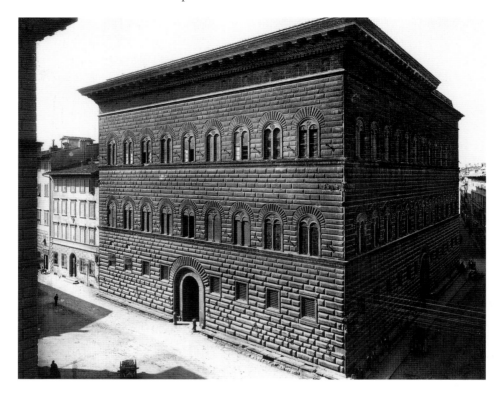

10 Palazzo Strozzi, ca. 1486–1533, Florence.

standing. Though superior to M. Luca in prudence, they consented to his having such prestige, and to increase it they too frequented his house. All this they did to block Piero de' Medici, to whom previously everyone was accustomed to going to consult on public affairs as well as private.[22]

Filippo Strozzi's palace was one of a number of projects undertaken after his definitive return to the city in 1466. His father Matteo had been exiled in 1434, along with many other men of the powerful Strozzi lineage. Matteo died that year, but his sons spent much of their lives in voluntary exile. That became forced in 1458 when a law was passed punishing the sons of those banished in 1434. A pardon was granted to Filippo and his brother in 1466. Filippo's imposing program of repatriation began almost immediately; he used all the resources and resourcefulness of his success as an international banker to make a mark on his native city that would also mark out the eminent position of the Strozzi family. It included embellishments made to his local church (Santa Maria degli Ughi), the reacquisition and rebuilding of ancestral houses in the countryside, gifts and endowments to churches and oratories near those properties, and the endowment and decoration of a burial chapel in Santa Maria Novella. It took fifteen years for Filippo to acquire and clear the site for his palace: from 1474 to 1489, when a model was commis-

sioned from Lorenzo de' Medici's protégé, Giuliano da Sangallo, and the foundations were begun. Situated in traditional Strozzi territory, it commanded a key position at a crossroads of an important ceremonial route (pl. 10). Giuliano da Sangallo and Il Cronaca were associated with the design of the building and the provision of wooden models relating to it, but Filippo Strozzi controlled the construction until his death in 1491, and sought to control it from beyond the grave. His will, preserved in at least six copies, one of them 53 folios long, is obsessively detailed about the transmission of authority for the building and its descent through the family.[23] In erecting this lasting monument to Strozzi honor, Filippo shrewdly enlisted Lorenzo de' Medici's support and advice, eventually naming him in his will among those responsible for seeing the project to completion.[24] The magnificence of the structure could therefore also be seen as contributing to the public good, as an ornament to the city and testament to the prosperity and order of the regime. Nonetheless, the Duke of Ferrara soon noted that Filippo's palace would be "more imposing" than Lorenzo's, making explicit the implicit comparison with the Medici.[25] Both competition and convention lay behind Filippo's intense efforts to manifest his return, spending in the usual ways, but more grandly.

Piero del Tovaglia's handling of his chapel endowment demonstrates how circumstance could relate to cycle. The opportunity arose from his ties to Lodovico Gonzaga at the moment of Lodovico's entanglement with the Florentine government, its resolution came when Piero began to make provisions for his death and established the financial mechanisms that would fund the maintenance of a family chapel and burial space.

This is not to impose a crudely functional model on the operations of patronage or the desire for goods in fifteenth-century Florence. On the contrary: these must be seen as representing an intersection of interests and as expressing complex relationships.

"PIÙ E PIÙ MASSERIZIE"

Works of art were the material components of a wide range of social imagery, which included festivals and funeral processions, parades and jousts, marriage feasts, holy plays, liturgical ceremonies, and civic pomp. They were also, of course, part of daily life, which it seems required "very many" things. So declared one notable householder, Niccolò di Giovanni da Uzzano, when he described his properties to the tax officials in 1427. He recorded "a house . . . in the parish of Santa Lucia de' Magnoli, called the new house . . . with cellars, wells, stables, and a small garden, with very many household goods ["più e più masserizie"] as required by his standing."[26] Niccolò's financial standing, as demonstrated by the same tax declaration, was elevated. With taxable assets of 46,325 florins, 7 *soldi*, and 9 *denari* he counts among the top one per cent of the city's population controlling one quarter of its wealth.[27] His political standing was equally high. He was one of the leading figures of the current regime. A prominent statesman, a recurrent officeholder, and a frequent ambassador, he was described by the city's priors in 1406 as "our most trusted citizen."[28] He took an interest in forwarding the city's reputation as a center of learning, and was active in trying to reopen the university there.

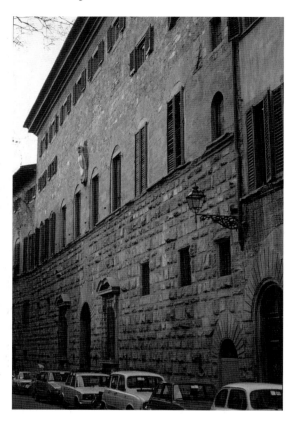

11 Palazzo Capponi delle Rovinate
(da Uzzano), 1420s, Florence.

Niccolò and his brother Agnolo had built the "new house" in the decade preceding
the declaration (pl. 11). An inventory was made when Agnolo died in 1424, document-
ing its division into groups of rooms allotted to each brother and his family (including
chambers/*camere*, antechambers/*anticamere*, studies/*scrittoi*), common spaces (large
halls/*sale*) and service areas (kitchen, storage vaults, stables). This arrangement is found
in palaces throughout the century. The goods divided between their households range
from silver cups to old shoes and include ten paintings: two are of saints, one is a birth
tray, one is simply called a "panel with a painted tabernacle," the rest are images of the
Virgin with the Infant Christ (described simply as "nostra donna"). There was also an
imposing pair of painted wedding chests in Niccolò's ground-floor chamber, each one
measuring $3^1/_2$ *braccia* or roughly 7 feet long: "2 forzieri grandi dipinti di braccia tre e
mezzo l'uno."[29] There were five other pairs of *forzieri*, two still in principal rooms –
Niccolò's upstairs chamber and Agnolo's widow's *camera* – and three other pairs, old and
battered, used for storage in less conspicuous spaces.

 The birth tray had been relegated to a washroom (*guardaspensa*), as was not infre-
quently the case with these talismanic objects, which are found in storage spaces and
backrooms as well as in the main chambers. Used to bring gifts and food to the new
mother, the trays generally had one side decorated heraldically or emblematically, with

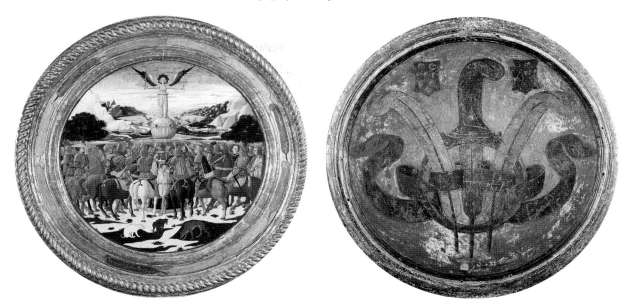

12 and 13 Giovanni di ser Giovanni ("Lo Scheggia"), birth tray with *Triumph of Fame* on one side and Medici emblems on the other, 1449, panel, diameter 92.7 cm., The Metropolitan Museum of Art, New York.

a more elaborate picture on the other side (pls. 12, 13). Some show confinement scenes, but others illustrate episodes from myths, poetry, or ancient history. With gilt frames and colorful, busy, multi-figured surfaces, these celebratory paintings could be highly decorative. Their visibility in a household probably depended on their original cost, their condition, and over time, whether they seemed "old" or "sad" like the other things moved into back rooms or sent to country properties. The number of such trays found in inventories suggests that even numerous and wealthy families did not purchase or receive them for each birth. This is not a sign of indifference to newborn children, who could be supplied with quite substantial wardrobes that included fur-lined robes and silver-buttoned garments as well as coral charms set in silver. Such valuable items are found, for instance, in the careful lists made by Antonio di Lionardo Rustichi when each of his children was sent out to a wet nurse.[30]

In the da Uzzano palace the paintings of saints were in an antechamber designated as Mona Bamba's (Agnolo's widow) and one of the paintings of the Virgin was in Niccolò's upstairs study, where he also kept his "many books in vernacular for reading."[31] The rest were in the *camere* or chambers, including a small panel with shutters that was in the servants' room. No painter is given for any of the paintings in the inventory, as is typical of such documents, which were about the objects as owned not as manufactured. But this also shows that they were identified in terms of their subject and function, not their production. Paintings of the Virgin and Child seem to have been a required part of principal chambers, and as here, could also be found in modest rooms occupied by the servants. The presence of Mary guaranteed or completed the decent furnishing of such

rooms. They made the mother of Christ ever-present as an intercessor and benefactress of the household. At a subconscious level, these wistful images of maternal love might also have had a compensatory function in households where newborns were regularly sent away to wet nurses, supplying an emotional as well as a devotional focus, serving as palliatives for absent children.

The placement of the paintings and the habits of ownership recorded in the da Uzzano inventory conform to what is known from other such documents of the period. What is significant is the supplementary remark of the tax report, associating things with status and specifying the need for "very many" things to satisfy the demands of the rank of an eminent citizen. For one of Niccolò's generation those many things were not paintings and sculpture, they were clothing, linens, armor, sets of silver forks and spoons, silver plate, and massive furnishings.

By contrast the inventory of the Medici palace made after Lorenzo de' Medici's death in 1492 lists over 100 paintings and sculptures, as well as giving a detailed description of the valuable collection of ancient gems and medals. There are painted and sculpted portraits and paintings and statues of profane as well as sacred subjects, and many artists are mentioned. Their names (Giotto, Fra Giovanni [Angelico], Donatello, Bertoldo, Pollaiuolo, Squarcione and "Andrea Squarcione" [Mantegna], Andreino [del Castagno], Masaccio, Pesellino, "Giovanni di Bruggia" [Jan van Eyck], "Pietro Cresci da Bruggia" [Petrus Christus]) are made part of the identity and value of the objects and were in some way a priority for whoever compiled or helped to compile the record. The Medici cultivated their reputation as magnificent, but other inventories document an increase in such goods, with more and different types of painting and sculpture given more and more prominence in patrician interiors. Lorenzo's cousin, Lorenzo di Giovanni di Francesco Tornabuoni, had a room so richly embellished that is was designated "bella" in the 1497 inventory of the Tornabuoni palace.[32] Indeed, the room must have glowed, for it had a gilded pair of embracing infants and two wedding chests with gold-framed *spalliere*, two world maps and an *Adoration of the Magi*, also in gold frames.

In addition to items attached to traditional forms of commission and acquisition, there was the growing category of precious accessories to knowledge and status – above all the gems, cameos, coins, and statues of antiquity, but also modern works, that were collected for display and delectation. Lorenzo de' Medici is known to have been ruthless in his pursuit of things rare and beautiful. He had agents primed to find and purchase antiquities, tapestries, and manuscripts. He virtually kidnapped Uccello's panels of the *Battle of San Romano* (pl. 14) from Damiano Bartolini Salimbeni's house, sending a group of laborers headed by the woodworker Francione to seize them and take them to Lorenzo's house "against [Damiano's] will."[33] One explanation for this behavior was pleasure.

The meaning of pleasure will be investigated in Chapter 5. It is enough here to signal its seriousness as a topic. Coupled with knowledge, desire was a potent aspect of the authority of possession. Lorenzo made his desires widely known. Like his father before him, he acquired reputation along with goods. The architect Filarete included a long passage in the second edition of his *Treatise on Architecture* (which he dedicated to Piero de' Medici) recalling Piero's understanding and enjoyment of the coins with "the effigies

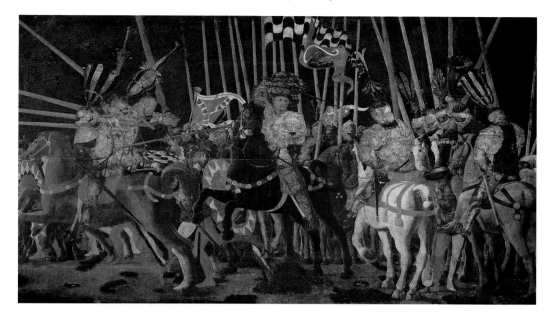

14 Paolo Uccello, *Battle of San Romano*, ca. 1440, panel, 180 × 316 cm., Musée du Louvre, Paris.

and images" of ancient worthies that he owned, describing how the sight of these objects filled Piero's "soul with delight and pleasure" both for the excellence of those represented and for the mastery of those who fashioned them.[34] In a typical vein, one of Lorenzo's agents wrote to his secretary about some tapestries that were available, "because I know that Lorenzo takes pleasure in rare things."[35] On another occasion he wrote about a gem, a cornelian, which seemed to him full of artifice, and which he thought would please Lorenzo, "above all because he understands" such things.[36]

The appreciative ownership of beautifully crafted works, which could also have historical associations (as in the case of ancient coins and gems), represented a selective form of acquisition. Discrimination was at once a model of knowledge (following Aristotelian logic), and, as now, a mechanism of class definition. It could be trained and exercised on the valued vestiges of antiquity that were treasured in private or it could be projected in modern *all'antica* citations as in the surroundings of the Tornabuoni chapel *Annunciation to Zacharias* (pl. 4).

The success of the Florentine elite in mobilizing such privileged possessions to present a vision of the city as a realm of order and beauty – the domain of the Tornabuoni as depicted in their chapel – can be measured by the fact that Florence retains its attraction as a symbol and site of Renaissance culture. The visual languages that evolved in the course of the fifteenth century in Florence continue to present convincing arguments of special achievements. They are arguments that require interpretation and reward investigation. To greet the fifteenth-century Florentine looking out from the painted piazza is to enter a world of imagined realities and to begin a complicated and creative involvement with the past.

Chapter Two

"DELLO SPLENDIDO VIVERE": ON NECESSARY AND HONORABLE EXPENDITURE

LEON BATTISTA ALBERTI DEVOTED THE THIRD BOOK of his dialogue *On the Family* to the subject of domestic economy. The assembled members of the Alberti family discuss the expenditures that pertain to the honor and reputation of the lineage, the *casa*. Leon Battista's cousin Lionardo cites the number of occasions that "our fathers" had undertaken such expenditures:

> building in the temple of Santa Croce, in the temple of the Carmine, in the temple of the Angeli, and in many places within and outside our city, in San Miniato, at the Paradiso, at Santa Caterina, and various others of our public and private buildings like these.[1]

This list is indicative of the collective identity of the lineage and its maintenance through monuments. Various branches of the Alberti had sponsored the building and decoration of the choir of Florence's principal Franciscan church, Santa Croce, where they also had tombs in front of the high altar and in the choir. In his will of 1394, Leon Battista's uncle Gherardo di Benedetto Alberti left a bequest of 800 florins for the building of an oratory dedicated to San Gherardo at the Camaldolite church of Santa Maria degli Angeli. The bequest was fulfilled in 1411. Leon Battista's grandfather Benedetto sponsored a chapel in the sacristy of the Olivetan church of San Miniato al Monte. The endowment included equipping the sacristy with intarsia cupboards and its decoration with a cycle of paintings by Spinello Aretino showing the life of Benedetto's name saint, Benedict (whose rule was followed by the monks of San Miniato). Further donations to the San Miniato sacristy were made by Benedetto's son Bernardo. A member of another branch of the clan, Antonio di Niccolò, obtained papal permission in 1392 to found and endow the extensive monastery dedicated to Saint Bridget of Sweden in the Pian di Ripoli, known as "del Paradiso" after the nearby Alberti family villa of that name. In the neighboring area of Antella, also near an Alberti country property, a kinship group including Leon Battista's grandfather and great-uncle paid for an oratory dedicated to Saint Catherine. These donations date from the height of Alberti influence in the third quarter of the fourteenth century, when the clan was among the wealthiest in Florence. Their enumeration in the

1430s by a member of a family in exile since 1401 and about a family at the time politically and economically disabled, is at once a poignant and a potent reminder of the force of those donations in maintaining family prestige over time. The Alberti reputation remained in "their places," which included some of the principal sacred sites and institutions of the city and its surrounding countryside. It was recalled and proclaimed in the Alberti arms that blazoned these donations (pl. 16).

When asked what "rule or method" might be applied to this kind of spending, the senior member of the gathering, Leon Battista's great-uncle Giannozzo, replies that

> all expenses are either necessary or unnecessary. I call those expenses necessary without which the family cannot be honorably maintained. The man who fails to spend for these purposes harms his own honor and the comfort of his family . . . those expenses made to acquire and to conserve the house, the farm, and the shop. These in turn are the three sources of all that is useful and valuable and needed by the family.

To these essentials he adds "unnecessary expenses," which "give pleasure if undertaken wisely, but which it does no harm to omit. Among these are works like painting the loggia, buying silver, wanting to make one's self magnificent with pomp, through fine clothing, and liberality."[2] This advice, too, related to common practice among the Florentine patriciate, who moved in decorated loggias and who delighted in fine silver and fancy clothing. One of the economic staples of the city was the production of internationally famous luxury cloths.

16 Spinello Aretino, Alberti arms, mural, 1387, sacristy, San Miniato al Monte, Florence.

Leon Battista's attachment to the family values he expounded is recorded in his own will. He bequeathed his Florentine palace, inherited from his grandfather Benedetto Alberti, to his cousin Bernardo di Antonio di Ricciardo. Following a pattern typical of such palace bequests in Florence, this inheritance was strictly entailed to Bernardo's male heirs, and at the extinction of the male line it was to pass to the hospital of Santa Maria Nuova. So that the family should retain its stature in public esteem, he also left 1,000 ducats and income-yielding property to buy and to endow a house in Bologna for one or two young men of the Alberti family to be able to study at the university there in comfort.

Yet however prescriptive and descriptive of forms of behavior it might seem, Alberti's text cannot be taken as a manual about Florentine family life. Its sources and motives were mixed. It was, in part, a bid for recognition and acceptance by his illustrious clan. Leon Battista was one of two illegitimate sons fathered by Lorenzo Alberti with a patrician Genoese widow (Bianca di Carlo Fieschi) during his exile from Florence. Leon Battista was recognized by his father, who made careful provision for his upbringing, but he was never legitimated – possibly because Lorenzo wished to father fully Floren-

tine sons to carry on his name. In 1408, two years after the death of his Genoese consort, he married a Florentine woman, but had no further children. Leon Battista made his own career not as a *paterfamilias* but as a cleric and curial dependant. The first three books of the treatise *On the Family* were written in Rome in three months between 1433 and 1434, before he entered Florence in the entourage of Pope Eugene IV in June 1434. It was, therefore, an affirmation of a citizenship he had not yet experienced, and of a family experience that the circumstances of his birth and his father's death in 1421 had denied him.

Leon Battista's interest in the family was, to a certain extent, academic. One explicit purpose of the treatise, stated in the preface to the third book, was to render the precepts of the ethical literature of antiquity accessible to a wider public, translating ideas from works like Cicero's treatise on moral duties (*De officiis*) and Xenophon's recently rediscovered book on household management (*Oeconomicus*) into the Tuscan language and to Florentine manners. On a biographical level, the treatise represents Leon Battista's preoccupation with his own identity as an Alberti. On a literary level, it represents an attempt to dignify and to codify traditional practices. As an ensemble of opinions and voices, it asserts the centrality of family name and family honor as motivating forces for all meaningful activity. It attaches possessions to social position and it justifies both in terms of a civic and civilized existence, which defines humanity as against bestiality. As such it participated in an increasingly diffused discussion of the virtues of civic life. Included among its topics were justifications of wealth and expenditure, which were highly relevant to a republic largely controlled by its merchant and banker citizens. Sustained by ancient authors, these writings supported conventional and contemporary attitudes and practices. They supplied a secular theory of virtuous possession that could answer traditional theological teachings of the virtues of poverty.

The basic types of both "necessary" and "unnecessary" spending found in the fifteenth century derived from recognized traditions. They were, however, subject to a constant and subtle reshaping that corresponded with or responded to changing political and patronal situations. Recognition of and resistance to change are part of the dynamics of display operating throughout the century. Alliances of fashion coexisted with alliances of family and faction. It is essential to be sensitive to this, even if it is impossible to trace its operations with precision here. Instead I will set forth some of the basic forms and mechanisms relating to investments in honor and memory, with examples to suggest how fashions were followed or ignored.

Those forms and mechanisms were obviously susceptible to financial as well as political factors and to friendships as well as enmity. Meaningful markers of decent living and pious behavior could be modest as well as monumental: donations of candles and wax were far more common than those of chapels and altars. The selection of a given artist for a given task might depend on his position as neighbor or friend as well as his skill in his trade. This could operate on a personal or institutional level. For instance, in his will of 1463 Manno di Giovanni Temperani specified that he was to have a marble tomb and epitaph in his parish church of San Pancrazio. He left it to his neighbor the painter Apollonio di Giovanni, to paint "whatever seems appropriate" to him below it, because

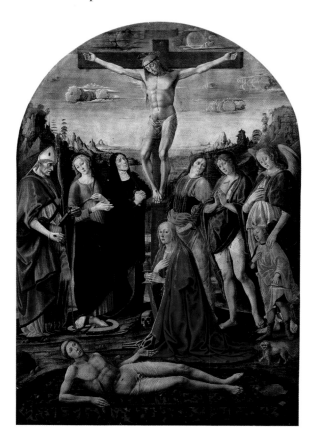

17 Jacopo del Sellaio, *Crucifixion with Saints Lawrence, Frediano, and Catherine of Alexandria, the Virgin, Saints Mary Magdalene, John the Evangelist, and Sebastian, and the Archangel Raphael and Tobias*, 1490, panel, San Frediano in Cestello, Florence.

as a "kind and beloved friend" he had Manno's best interests at heart.[3] Neri di Bicci's surviving record book from the years between March 1453 and April 1475 shows that neighborhood contacts were useful to his career as well. During those years he seems to have been the favored painter for his parish church of San Felice. He produced three altarpieces for the church, gilded and painted the reliquary bust of San Felice, colored a relief figure of the Infant Christ, and supplied the sacristan with a gesso relief of the Virgin and Child.[4] Similarly Jacopo del Sellaio, an active member of the confraternity dedicated to San Frediano, known as the Brucciata, received two commissions for altarpieces for the church of San Frediano: one, a *Pietà with Saints Frediano and Jerome*, was made for the confraternity's chapel; the other, showing the Crucifixion with Saint Lawrence and other saints, was painted in fulfillment of a bequest by a confraternity member, a baker named Lorenzo Passera (pl. 17). Such examples show how the discussion of developments in style over the century must observe the social patterns supporting artists' careers and influencing fashions of representation.

The fortune of Alberti's text on family management gives a good indication that the theory of honorable expenditure itself became an accepted fashion in fifteenth-century Florence. His observations were congenial enough to his Florentine audience that one

copyist of the text of Book III substituted Pandolfini family names for those of the Alberti among the speakers, and this book had its own circulation as Agnolo Pandolfini's advice on family management, "il governo della famiglia." When Giovanni Rucellai included a chapter on that topic in his notebook of advice to his sons, it was largely derived from such a paraphrase of Alberti. Giovanni was an eager collector of maxims that could provide precedents for his own ambitious investments in family honor: his palace and the family loggia, his tomb and the shrine of the Holy Sepulcher in the parish church of San Pancrazio, the façade of the neighboring church of Santa Maria Novella – all blazoned with his arms and emblems (pls. 18, 19, 20). In an entry in his notebook dating to about 1464, Giovanni paraphrased a passage from Cicero's *De officiis*, citing the case of a Roman citizen who gained great favor among the people by virtue of having built a beautiful palace.[5]

As Alberti's list of his ancestors' building activities shows, such large-scale expenditure was precedented. The patterns of ownership and endowment discernible in the fifteenth

19 (ABOVE RIGHT) Leon Battista Alberti, Holy Sepulcher shrine, ca. 1461–7, San Pancrazio, Florence.

18 (ABOVE LEFT) Leon Battista Alberti, façade of Santa Maria Novella, detail showing the Rucellai emblem, ca. 1456–70, Florence.

20 (LEFT) Palazzo Rucellai, detail showing the Rucellai arms, 1450s, Florence.

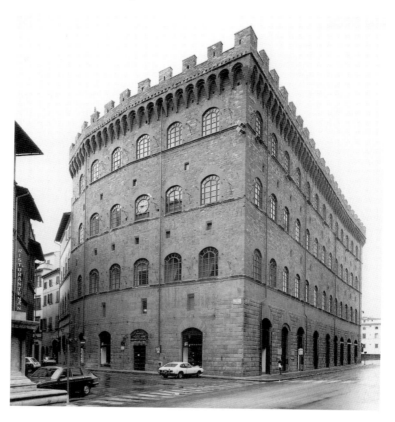

21 Palazzo Spini,
ca. 1290, Florence.

century were fully established in the fourteenth. Typically the first concern of the head of a family would be the proper accommodation of his household, most often in a family enclave or group of houses owned by members of his kin. Occasionally this might be a massive palace such as that built by messer Geri degli Spini at the end of the thirteenth century (pl. 21). Or it might be a more modestly adapted property, displaying, however, the family arms. The head of household would further acquire or develop and husband country holdings, including at least one with a house suited to act as a country residence, a *casa da signore*. The senior members of the family, including widows, would endow chapels and churches in both the city and the country, furnish altars, and eventually see to a proper burial site for themselves and their descendants (or make bequests to extant sites). Other endowments might include the foundation of or support for a hospital or hospice, or the founding or equipping of a small oratory in the city or country. Clerical vestments or altar cloths, bearing the donor's arms, were other frequent gifts. These channels for personal display and pious behavior existed in the fourteenth century and persisted in the fifteenth. They provided a currency of convention, which could determine the exchange value of money and honor and which could delimit the boundaries of propriety and extravagance. Keeping balanced accounts, or seeming to do so, was fundamental to the mercantile mentality of the city.

In the fifteenth as in the fourteenth century prominent families employed a range of strategies to protect and to advance themselves in the volatile worlds of international finance and internal politics. They developed networks of connections and reciprocal favors within the public and fiscal realms of office-holding and tax-paying, and they cultivated parallel networks of family ties through marriage alliances. The success of those strategies is demonstrated by the remarkable rate of survival of Florentine family names over the centuries. Objects were deeply implicated in this process. Often marked with family arms, they served as statements of status and of family groupings, as monuments to permanence and offerings to posterity.

But survival is not the same as stability. Factional upheaval, financial disaster, and the devastations of disease were regular occurrences throughout the history of the city. The fifteenth century saw first the triumph of one political group, headed by Rinaldo degli Albizzi, and then that of another faction, headed by Cosimo de' Medici. Cosimo was sentenced to exile for ten years in September 1433. This sentence was revoked a year later, and upon his return in October 1434, Cosimo and his allies successfully engineered the establishment of a Medicean regime. Although this dominance was frequently challenged, it was maintained over three generations. The consolidation and transmission of Medici power from Cosimo (1389–1464) to his son Piero (1416–1469), and to Piero's son Lorenzo (1449–1492) was a key element in the changes to the visual as well as the political world of fifteenth-century Florence. Over the sixty years of the family's domination there occurred a gradual erosion of republican forms and corporate powers. The Medici and their supporters gained increasing control of the city's institutions: from the councils and committees of its government to its principal charities and confraternities. Their permeation of secular and sacred areas of patronage put the Medici model at the heart of both imitation and competition, of similarity and difference.

Just as they took over and eventually reshaped extant political institutions, the Medici accepted and adapted prevalent patronal modes. An aesthetic of opulence had developed among the elite of the city before the Medici associated their name with magnificence. The altarpiece of the *Adoration of the Magi* (signed and dated on the frame, May 1423) commissioned from Gentile da Fabriano by Palla Strozzi for the family burial chapel and sacristy at Santa Trinita can be taken as emblematic of this taste in the first quarter of the fifteenth century (pl. 22). It was part of Palla's realization of his father Onofrio's testamentary obligation, which left him the task of completing this chapel and sacristy. At the time Palla was one of the richest men in Florence. Although in a letter of March 1422 he complained of the expenses incurred in building and decorating the chapel, he did not spare them.[6] Gentile proclaimed them – employing a wide range of techniques to imitate and to create richness on the altar panel. There is gold *pastiglia* on the crowns, spurs, swords, and other trappings of the kings and their entourage, an eye-catching and light-catching device that would make the altarpiece shimmer when lit by candles. The three kings are depicted as dressed in brocades and velvets, which are literally made of gold and silver. The patterns on these cloths were made by applying paint over metal leaf, which was then scraped away to make the designs. Punch-work, scratched patterns, and mordant gilding add further to the glittering impression of the cavalcade.

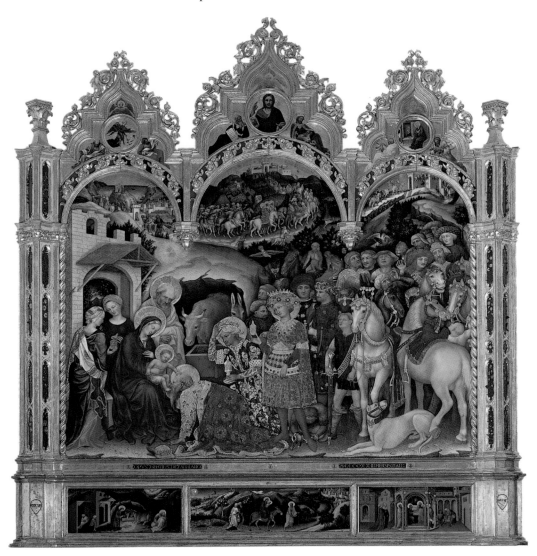

22 Gentile da Fabriano, *Adoration of the Magi*, 1423, panel, 173 × 220 cm., Galleria degli Uffizi, Florence.

The figures standing immediately behind the three kings have been identified as Palla and his son Lorenzo (pl. 23). Lacking secure portraits for comparison, this cannot be verified, but these noble attendants represent the Strozzi if not actually portraying them. The bearded man, "Palla," is shown as a falconer (*strozziere*), alluding to the family name. The action of the page removing the young king's spurs is a gesture of humility that also acts as a reminder of the knighthood conferred upon Palla by the king of Naples in 1415; it refers to the privilege of wearing spurs attached to that honor. The Strozzi presence in the entourage is further signalled by their device, the crescent moon, on the bridle of

23 (FACING PAGE) Gentile da Fabriano, *Adoration of the Magi*, detail of pl. 22.

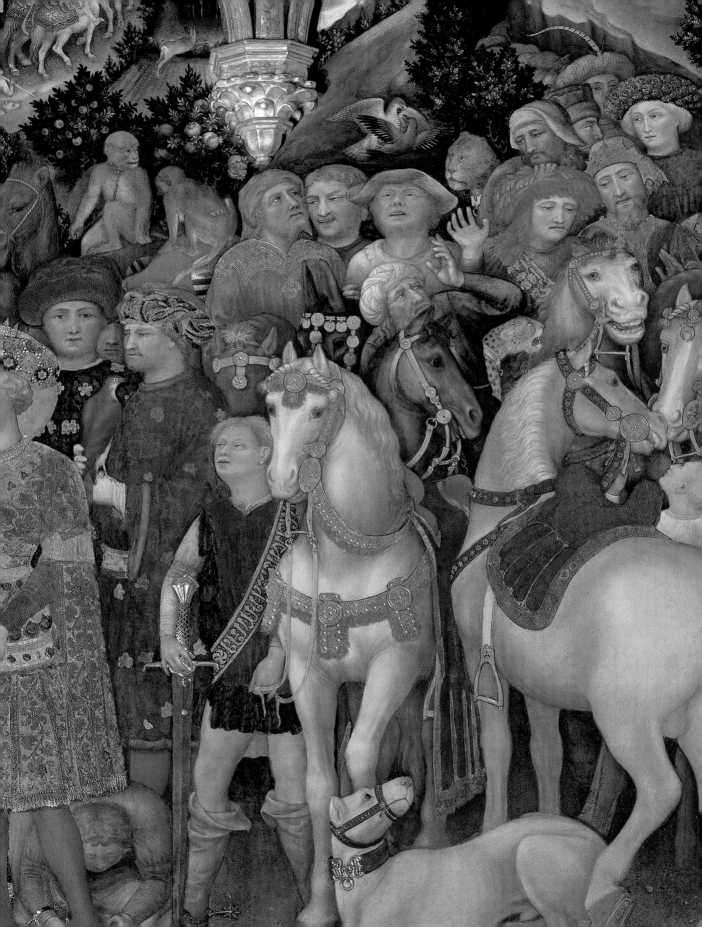

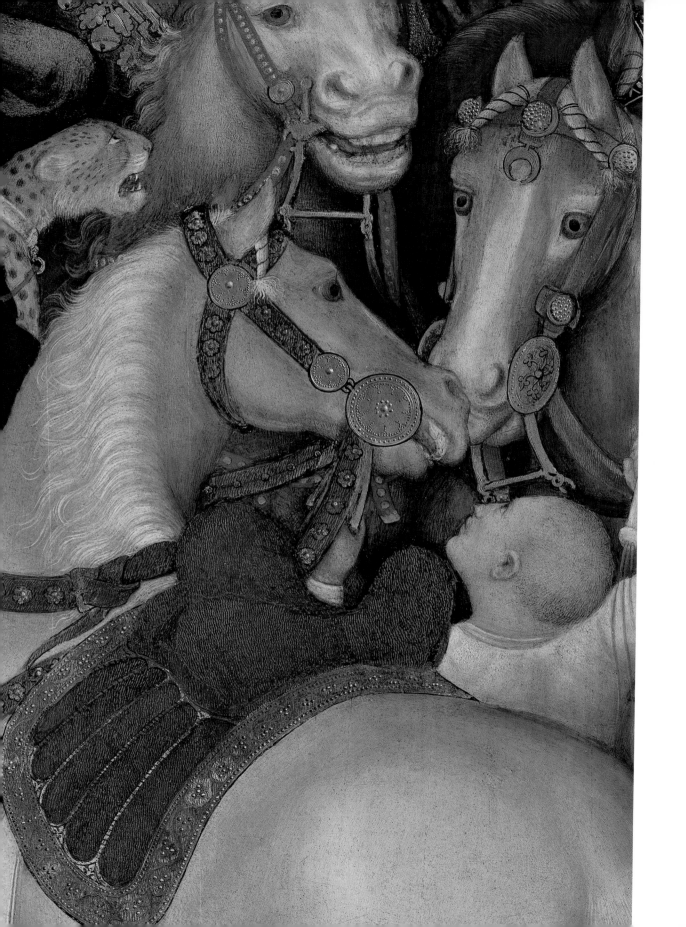

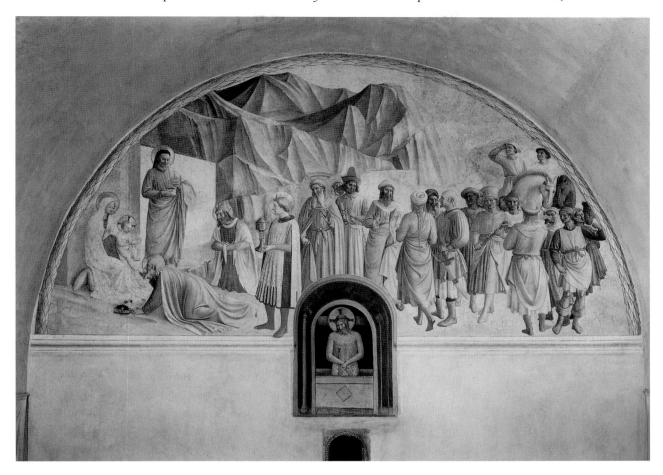

25 Fra Angelico and assistants, *Adoration of the Magi*, ca. 1439–45, mural, cell 39, Museo di San Marco, Florence.

the horse at the far right of the crowd (pl. 24). In expressing their devotion in this splen-did fashion, the Strozzi were shown to be befitting imitators of kings in their solemn, humble submission to the Virgin and Christ, and in their grandeur and status as leading, potentially ruling, citizens. This was a message that the Medici subsequently incorpo-rated in their family imagery. Cosimo had the Adoration of the Magi painted in his private cell in the convent of San Marco (pl. 25). The church of San Marco became Beth-lehem each Epiphany – the feast of the Magi – and it was the devotional focus of the procession organized to celebrate the day. The Medici became protectors of the confra-ternity dedicated to the three kings which was responsible for coordinating the pageant, and which had its meeting place at San Marco. The Journey of the Magi was the subject chosen to decorate the palace chapel, bringing the pageantry of kingship and the imagery of the ages of man into the heart of the Medici household (pl. 26).

The courtly subject of the Strozzi altarpiece and Gentile's production of a catalogue of luxury cloths addressed topics familiar to Florentines by the 1420s. From the mid-

24 (FACING PAGE) Gentile da Fabriano, *Adoration of the Magi*, detail of pl. 22.

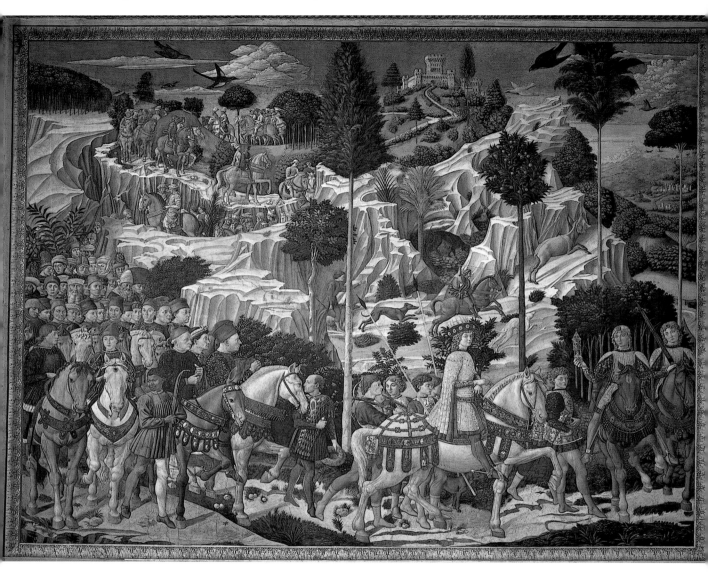

26 Benozzo Gozzoli, *Journey of the Magi*, ca. 1459, mural, east wall, Palazzo Medici chapel, Florence.

fourteenth century the shop of the Cione brothers – Andrea (called Orcagna), Nardo, and Jacopo – had produced works where the honor granted to heavenly figures could practically be measured length by length in the costly fabrics portrayed. This is also true of paintings by Agnolo Gaddi and his shop, or that of Niccolò di Pietro Gerini. The *Coronation of the Virgin* painted for the high altarpiece of the Benedictine nunnery of San Pier Maggiore in ca. 1370, attributed to Jacopo di Cione's shop, is an instance of how the dense patterning of luxury fabrics could express the glory of the heavenly court

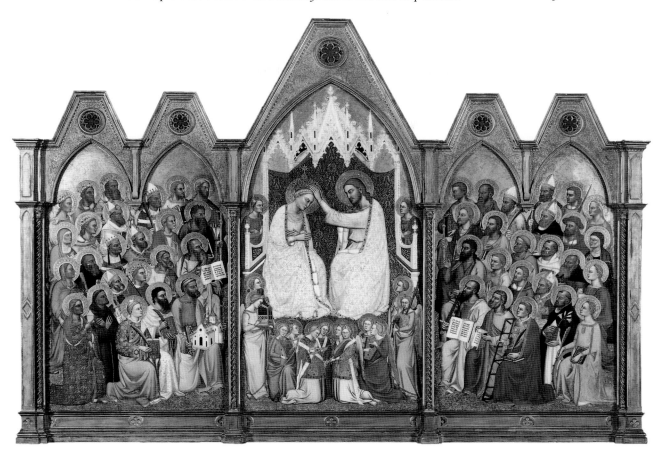

27 Attributed to Jacopo di Cione and workshop, *Coronation of the Virgin*, 1370–1, panel, 206.5 × 113.5 cm. (central panel), 169 × 113 cm. (each side panel), National Gallery, London.

(pl. 27). Clothing, cloth, and jewelry expenditures were a constant feature of family accounting. They were a civic preoccupation; sumptuary laws sought to monitor, if not control, the amounts spent on such goods. Every affluent Florentine could readily calculate what might be the real value of such garments, as well as being able to make a fair estimate of the actual cost of materials such as the gold and silver used to depict them.

The crowning of Mary as the queen of heaven was itself a regal image, which, along with other aristocratic histories, came into fashion in the second half of the fourteenth century. A notable aspect of the story of the true cross as painted in the high altar chapel of Santa Croce, for example, is the interest in the behavior of the empress Helena and her entourage (pl. 28). The popularity of Saint Catherine of Alexandria probably owes something to the same predilection. Supposedly a martyr in the fourth century and considered a patroness of noble families, Saint Catherine, says the *Golden Legend*, was the daughter of a king and instructed in the liberal arts. Learned, beautiful, and gracious,

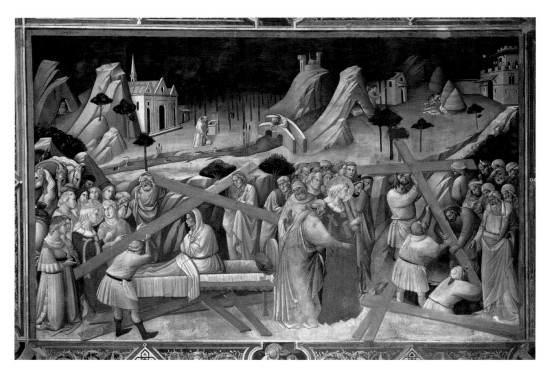

28 Agnolo Gaddi, *Empress Helena Recognizes the True Cross*, ca. 1390, mural, chancel, Santa Croce, Florence.

29 Spinello Aretino, *Mystical Marriage of Saint Catherine of Alexandria*, ca. 1387, mural, Oratory of Saint Catherine, Antella.

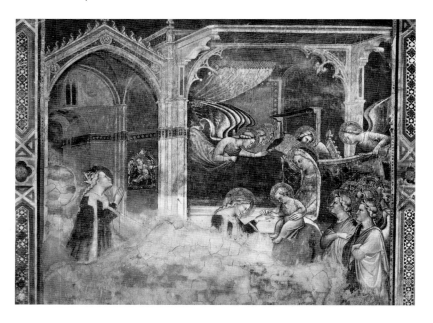

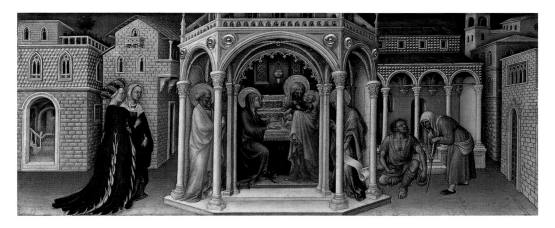

30 Gentile da Fabriano, *Presentation in the Temple*, 1423, panel, 25 × 62 cm., Musée du Louvre, Paris.

she angered the emperor by confuting his scholars. Imprisoned, she inspired the empress and the captain of the king's soldiers to convert. This story of a captured princess and knightly submission has many elements of chivalric romance. There is no trace of Saint Catherine before the tenth century. Her legend gained currency during the Crusades. The selection of such genteel subjects for pious donations in the latter part of the four-teenth century, such as in the Alberti oratory at Antella (pl. 29), can be related to what seems to be a general aristocratization of manners in the 1380s. The previous decade had been one of popular reforms, which came to a head in the 1378 revolution led by disen-franchised cloth workers (the *ciompi*). These changes were stamped out. The major guildsmen and members of leading families revised the electoral system to insure their dominance over the city's political life. An imagery of privileged nobility was well suited to represent the interests of those wishing to consolidate their power and assert their identity as belonging to a ruling elite.

The novelty and impact of the *Adoration* painted for Palla Strozzi was not, therefore, in its luxurious and decorative character, but in the way that the material reality of that luxury was emphasized through Gentile da Fabriano's command of illusionism and the way that both were pointedly personalized by the allusions to the Strozzi among the kings. The shift is from symbolic and generalized representation to specific and partic-ularized references. The pleasure of possessions is a pervasive message of the painting. So, too, is a certain delight in distinguishing between rich and poor, highlife and lowlife, as in the predella scene of the *Presentation in the Temple*, where well-dressed ladies on the left are contrasted with a wretched beggar and a cripple on the right (pl. 30). The pleasure was produced by the artist's skill, but that skill supplied a demand, which was informed by developing ideologies of wealth.

* * *

THE UTILITY OF WEALTH

The Strozzi altarpiece was probably begun by 1421. Just before this, the scholar Leonardo Bruni had produced a Latin translation of the *Economics* then attributed to Aristotle. The earliest surviving copy of the first book, with a dedicatory letter to Cosimo de' Medici, is dated March 24, 1419[20], and a copy of the entire treatise bears the date 1420. A large number of manuscript copies survive from the early 1420s to the 1470s, and the work was printed in 1469 and frequently thereafter, attesting to its immediate and enduring interest in the fifteenth century. Bruni's prefatory words to Cosimo explain some of its possible attractions to his anticipated audience among the Florentine elite: merchants and international financiers like Cosimo de' Medici and Palla Strozzi. Punning on Cosimo's family name, Bruni says that just as "health is the goal of medicine, so it is agreed that wealth is the objective of estate management."[7] He further explains the utility of wealth:

> Wealth is indeed useful, since it is both an embellishment for those who possess it, and the means by which they may exercise virtue. It is also of benefit to one's sons, who can by means of it rise more easily to positions of honor and distinction . . . Therefore for our own sakes, and even more for love of our children, we ought to strive as far as we honorably can to increase our wealth, since it is included by the philosophers among the things that are good, and considered to be related to happiness.[8]

Chapter 6 of the first book of the treatise describes "the four talents that the head of the household [*paterfamilias*] ought to possess with respect to wealth"; they were the capacity to acquire it and to look after it, and to know "how to make his possessions an adornment, and how to enjoy them."[9] Bruni elaborates on these qualities in his notes, reinforcing the point that the head of household should be "the kind of man who will be quick and skilful at making a profit."[10] According to Bruni, "a talent that the head of the household should possess above all others [is] that of making a profit from the fruits of his estates and other business."[11] Business, carried on honorably, is conducive to virtue, and the "enlargement of one's patrimony, provided this be done without injuring anyone, is always deserving of praise."[12] Bruni expanded upon this point in one of his letters, which he devoted to the subject of wealth, writing that it "should be striven after for the sake of virtue, as an instrument . . . for bringing virtue into action."[13] Here philosophy answers theology. Although no reasoning could dispel the uneasy relation of the sins of greed and usury to the activities of money-making and money-lending, such arguments offered a counterbalance to conscience. Not only were profits, honorably made, not culpable, they could be vehicles of virtue.

As *paterfamilias* Bruni managed his own estate much to the advantage of his family. His father was a grain dealer in Arezzo, who seems to have had little social or political consequence there and limited financial resources. Leonardo instead became a Florentine citizen in 1416. At that time he already had such influential supporters among the Florentine governing class that when he was granted citizenship he was also exempted

from taxation. In his petition to the Signoria he had argued that this would give him the security and leisure necessary for him to dedicate himself to his studies. Those studies began to serve the city immediately as he embarked on his *History of the Florentine People*. He served as chancellor of the city from 1427 until his death in 1444. He was careful enough with his household management throughout his career that he managed to amass a small fortune. Proof of both his prosperity and his reputation was the marriage arranged between his only son, Donato, and Alessandra di Messer Michele di Vanni Castellani in 1431. She was the daughter of an eminent branch of an ancient Florentine lineage, and this alliance confirmed Bruni's arrival in the upper echelons of the Florentine social order. He had a marked capacity for the acquisition and nurturing of wealth. His preoccupation with money was noted enough that one eulogist, Poggio Bracciolini, commented upon his "thrift" when summarizing the qualities of Bruni's character in his funeral oration.[14] It was part of his relationship with Palla Strozzi, who wrote to one of his banking partners that Messer Leonardo wished to invest some money safely, "very discreetly and prudently, as always."[15] He added:

> I believe it will be best to use the money in honest matters. You know how to lighten his conscience, always using a reasoned judgement in your dealings with him . . . You, as one who both understands and practises such business, must make what seems to you the best arrangements, for him and for us, and which will maintain his friendship and brotherly feelings. He is happy to deal with our bank, and we must be happy to deal with him.[16]

Palla's recommendation indicates both the dangers of investment, how certain money matters might not be totally exempt from blame, and how the interest resulting from such investment was mutual and personal as well as financial. It also indicates Bruni's importance as a friend.

Through his writings and his service to the state, his judicious and dignified behavior as well as his shrewd exploitation of contacts – social, political, and financial – Bruni fashioned a career and a *curriculum vitae* that made him a leading citizen of his adopted city. At his death in 1444, like previous chancellors, he was given a state funeral. The ceremony, however, was of an unprecedented level. A contemporary recorded that its invention involved consultation with "learned men."[17] They advised the revival of the ancient custom of crowning the corpse with a laurel wreath "on account of his extraordinary talent and learning."[18] The statesman and humanist, Giannozzo Manetti, delivered an "oration of great richness and elegance" to an assembled crowd of dignitaries in the Piazza della Signoria, "from a platform at the head of the bier whereon lay Leonardo dressed in a silk garment of deep red, upon his breast the book in which he had prosecuted to his great glory the History of the Florentine People."[19] Crowds thronged the processional route, such that city officials were forced to use clubs to push them back.

In his will Bruni had specified a simple burial in Santa Croce, "without pomp," with a pure marble tombstone in a place suited to his status.[20] Instead he was buried in a costly monument framed within an *all'antica* arch (pl. 31). His wish to be buried "sine

pompa" could not be observed by the city that wished to celebrate him and to make his history part of its legacy. The pomp, the ritual, and the imagery attending his death were essential to memorializing his life. Descriptions were produced of the impressive, but ephemeral, apparatus of processions and crowded gatherings. Eulogies were written and circulated. The tomb with its effigy of Bruni holding his history sealed the memorial moments for posterity. All these records in words and images combined to create an exemplary figure of the prolific and prosperous state servant. The elaboration of display in the ceremonies and its material record in the monument are proof of the persuasiveness of Bruni's advice as well as his prudent management of his resources and reputation.

Bruni once ridiculed disproportionate expenditure on a tomb. He wrote a letter mocking the pretensions of the apostolic secretary Bartolomeo Aragazzi, who ordered a tomb for himself in his home town of Montepulciano. "What can a tomb, which is a mute thing, do for a wise man?" he asked.[21] Underlying both his criticism of Aragazzi and his own testamentary instruction is a notion of decorous expenditure. Ends and means are to be carefully matched to achieve an honorable result. In his notes to his translation of the *Economics*, he comments on how:

> Wealth will lend adornment and honor . . . if we make our outlays opportunely and gracefully. These will include building a house in keeping with our wealth, having a good staff of servants, sufficient furniture, a decent array of horses and clothing. They will include also generosity to friends, and patronage of public events, such as circus games, gladiatorial shows, and public banquets, all of which, however, should be in proportion to and in keeping with the man's wealth.[22]

This passage not only prescribes proportion, it subtly introduces another theme regarding riches – to measure it adds magnificence. Although the Florentine commune kept lions as active signs of civic fortitude and private citizens held jousts and lavish banquets, Bruni's mention of "circus games, gladiatorial shows, and public banquets" betrays other sources for his notes. This comment derives from discussions of liberality and magnificence in Cicero's *De officiis* and Aristotle's *Nicomachean Ethics*. Cicero criticizes such sponsorship as squandering money on ephemera, but he admits the necessity for those holding public office to spend on such things in order to please the populace, as long as such expense is kept within means.[23] Like much of Bruni's writing, this passage is carefully contrived. It contains a critique of the abuse of power while also enriching the text by deepening its references.

In bringing liberality and magnificence to the discussion of wealth, Bruni enhanced the ethical possibility of possessions. Liberality and magnificence are the subjects of the fourth book of Aristotle's *Nicomachean Ethics*, which Bruni had translated in 1416. According to Aristotle they are the virtues that relate to wealth. The first, liberality, extends "to all the actions that are concerned with wealth."[24] The second, magnificence, only refers "to those that involve expenditure; and in these it surpasses liberality in scale. For, as the name itself suggests, it is a fitting expenditure involving largeness of scale."[25] Because expenditure must be proportionate to means, only the wealthy can be magnif-

31 (FACING PAGE) Bernardo Rossellino, tomb of Leonardo Bruni, ca. 1446–7, marble, Santa Croce, Florence.

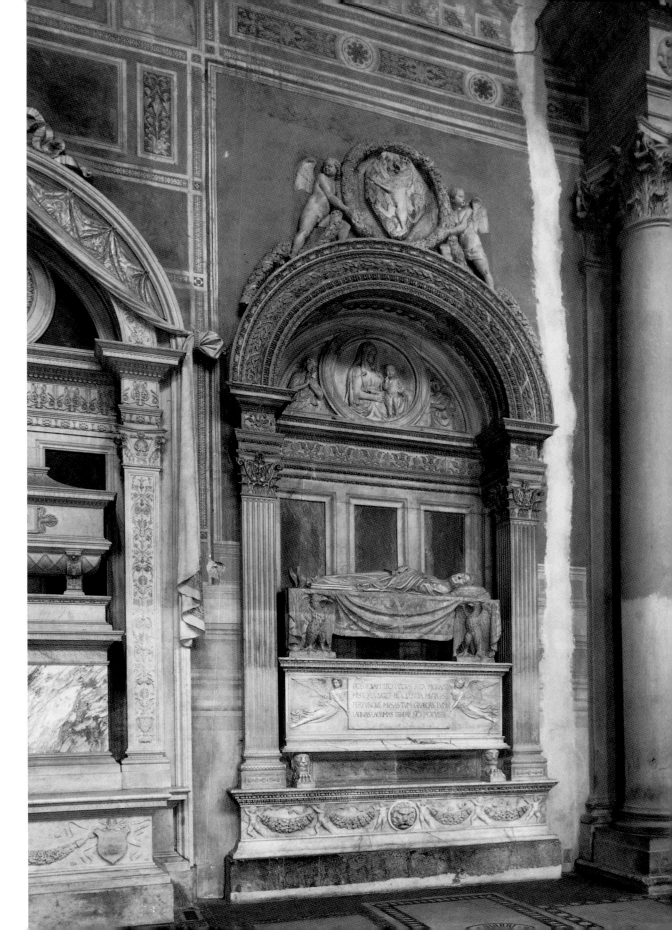

icent and spend on the public benefactions that are "the greatest and most honourable."[26] But the magnificent man will also "furnish his house suitably to his wealth (for even a house is a sort of public ornament)."[27]

The notion of virtuous display inherent in magnificence, with its implications of justified wealth and combination of public and private interest, made it an increasingly exploited term in relation to expenditure. The Medici purposefully cultivated this virtue, encouraging its application to their endeavors. Even as the foundations for the new palace were being excavated, one observer commented that the site itself was magnificent to behold.[28]

Magnificence is a topic of Matteo Palmieri's treatise *On Civil Life*, written in the mid-1430s (pl. 32). In this dialogue, closely following Aristotle, it is described as consisting of great expenditure on notable works and as a virtue that could only be exercised by the rich and powerful. Such expenditures were to be made on honorable and glorious things, not private, but public: the building and decoration of churches, theaters, loggias, public festivals, games, banquets.[29] In his *Summa Theologica*, archbishop, later saint, Antoninus took up this topic as well, insisting, however, that magnificence be deployed in doing things for the honor of God, such as building churches and hospitals, on pilgrimages, and in spending to endow masses.[30]

All of these writings are concerned with giving meaning to money and its manifestations. Like taxes and death (which also vexed fifteenth-century Florentines) this might seem a universal concern. But the trade-based commune was a relatively new political entity, whose practices were far more evolved than its theories. To be governed by money-making professionals rather than by territory-dominating lords changed the priorities of power. The parallel accumulations of influence and wealth required explanation and justification. Bruni cited Aristotle's *Nicomachean Ethics* in defining *pecuniae*, wealth, as everything that is "measured in money."[31] Palmieri devotes a section of Book IV to money ("Delle pecunie"), which, he says "has no utility in itself," but is only a means to acquire things necessary for life.[32] Neither to be hoarded, nor wasted, it is an instrument of exchange, not only for services and goods, but for good itself. Palmieri writes that riches and abundant wealth are the instruments with which worthy men act virtuously. Poverty inhibits such activities, for virtues need to be subsidized by the goods of fortune.[33] As noted above, following Aristotle, both writers assume that wealth is a prerequisite of liberality and magnificence. It must be acquired virtuously and spent well, with due order.[34] While utility (*utile*) was served above all by marriage, family, and friendship – the "absolute necessities" – those things, for Palmieri, could be articulated and embellished by the use of money.

Business account books and family record books demonstrate the power of the money mentality. Merchants like Marco Datini did their business in the name of God and gain.[35] In a book of advice one fourteenth-century merchant wrote that "money is all the help you have, your defense, honor, profit, and ornament."[36] Meticulous itemization of expenses occurs for transactions of all sorts, from company trade deals in the realm of business to major land purchases, dowry expenses, and payments to wet nurses in the realm of family life. Along with the ledgers balancing the credits and debits of business

32 Antonio Rossellino, portrait bust of Matteo Palmieri, 1468, marble, Museo Nazionale del Bargello, Florence.

accounts, a citizen's archive held record books of the daily domestic expenditures. Palmieri opened one book devoted entirely to tax returns. In such books, often cross-referenced between types of accounts and sometimes including separate ledgers for major projects, every pious donation, each commission for the decoration of sacred or secular spaces, was carefully priced. The worth of things was constantly calculated to the last *denaro*.

Even as things were thus quantified, they were also qualified. Money was too danger-ous to be trusted by itself. Giovanni Rucellai warned his sons of its infinite perils, telling them that it was best to diversify, dividing wealth between cash and possessions. The best defense of wealth, he told them, was not in acquiring more money, but in acquiring a good reputation: being loved and honored through good works and good relations with family and neighbors.[37] Palmieri included similar advice in the section of his dialogue discussing friendship, which he said was "above all things the most suited to preserve and maintain riches," nor, he added "is anything more damaging to the stability of for-tunes and great state than hate."[38]

Accountability affected all forms of life and mercantile metaphors were commonly used. Brides were merchandise on the marriage market: that was the term used by Alessandra Strozzi to her son Filippo when describing prospective matches for him.[39]

Friends could become creditors and debtors, depending on the balance of favors offered and owed. As this indicates, accumulating capital was only part of a greater economy of relationships, whose operations depended on other forms of exchange and barter and on other symbols of worth. When Lodovico di Francesco di Benedetto Strozzi went bankrupt, Alessandra Strozzi reported to her son Filippo that his family would remain rich because "they have many houses and landholdings and belongings to the value of 16,000 florins, so that in this case they are losing more reputation than anything else."[40] A more negative appraisal arrived in a subsequent letter where she reports that whether Lodovico and his immediate family remained rich or poor would depend on some of their outstanding debts, but "may God help them, because, in any event they have lost their honor."[41] Honor was a matter of personal credibility. The credit of good reputation might be immeasurable and intangible, but it sustained business interests and supported social transactions. In many cases money was not the object at all: payments in kind were common, as were transfers of credit. Actual price was only one possible factor in calculations of value. There were other standards of measurement: above all usefulness, decency, and honor.

Where Bruni's translation and its notes are mostly about the personal management of wealth, Palmieri's dialogue relates it more programmatically to the public sphere. He does so in the context of usefulness, which is the subject of the fourth book, his "treatise on utility."[42] He divides useful things into three categories. The first are things that are desirable because they are both inherently good and useful: kinship, friendship, a good name, health. From these, Palmieri says, proceed glory, dignity, and an ample and honorable way of life. The next are things sought only for their usefulness: above all wealth, possessions, crops, produce, abundant livestock, servants, and laborers. The third are sought not because they are useful or good in themselves, but for comfort and dignity, and can enhance and ennoble life. In this category are "magnificent dwellings, things built in public, precious chattels, servants, horses, and any luxury of living splendidly."[43]

The last group, which is at the boundary of private and public, is shown to have its benefits to society as a whole. Palmieri expounds upon the comfort and beauty of living splendidly.[44] He returns to his list comprising that manner of life – the splendid houses, endowments, abundant goods, servants, and horses – things that satisfy an appetite for a gracious life ("bellezza di vita") rather than need.[45] Even though they belong to individuals, he says that they are also "highly suited to the general embellishment of the city and create civic beauty, from which there results civic grandeur, honor, and good"; for this reason, he concludes, it is appropriate that they be treated under the heading of common utility rather than private comforts.[46]

This idea is repeated and developed in a section on the beauty and adornment of the city. The "civic embellishments" ("ornamenti civili") listed by Palmieri are grand and magnificent public buildings and the dignified behavior of public magistrates.[47] They include as well the solemn observation of sacred rites, with splendidly arrayed clergy and equally magnificent churches and ornaments. Another part, however, of the city's beauty consists in the "personal ornaments and the splendid way of life of private citizens."[48]

The Florentines had long attached civic pride to public monuments. From the late thirteenth century and through the fourteenth century, civically funded building campaigns had provided the city with its greatly expanded walls and its imposing seat of government, the Palazzo della Signoria (both begun in 1299), and the adjacent loggia for speeches and ceremonies (1376–82). Public funds backed the construction of the cathedral and the maintenance and decoration of the Baptistery. Citizens were expected to be concerned with the embellishment of their city. When holding public office they legislated on matters pertaining to the order and the upkeep of public thoroughfares and piazzas and of the city's principal churches. Income from import duties and taxes was allotted to approved projects. Following a statute of 1294, every will redacted in Florence included an obligatory bequest of at least 3 *lire* to the building funds for the walls and for the cathedral. As members of boards of work (*operai*) citizens were also responsible for the upkeep and decoration of many of the city's churches and chapels, oratories and hospitals. The major guilds acted as administrators for both the business and building matters of appointed churches. The Wool Guild, the Arte della Lana, had overall responsibility for the cathedral, an enterprise so complicated that its governing body became an institution in its own right. The merchants' guild, the Calimala, was responsible for the maintenance and decoration of the Baptistery. These monuments, sites of civic adornment as well as liturgical importance, also became sites of competition as the governing boards of both sought to outdo each other in the embellishment and equipping of the churches.

Confraternities could also assume supervisory duties, as was the case with the parish confraternity, the Brucciata, which took a major role in caring for both the church of Santa Maria del Carmine and that of San Frediano. The guilds and confraternities were often made administrators of estates, entrusted with executing testamentary bequests. The habit of corporate involvement in commissions that acted as civic adornment was long established. Following Cicero's treatise on moral duties, Palmieri suggested that private ornament could be a civic duty as well. In the course of the fifteenth century this ideal was furthered by a series of grandiose palace projects, which punctuated and rearranged the cityscape with monuments marking family pride. By the mid-century the desire to build was so intense that one palace builder, Giovanni Rucellai, could cite the maxim that "men do two important things in life, the first is to procreate, the second is to build."[49]

In his funeral oration for Palmieri, Alamanno Rinuccini praised him for having understood the extent to which riches contributed to a dignified civil life, and for having increased his own patrimony through honest industriousness such that it "sufficed not only for his needs," but brought him fame and ever-increasing honor, allowing him to construct magnificent buildings, and to endow foundations honoring God while maintaining frugality in the rest of life.[50] This was hyperbole. Palmieri, who did endow a chapel in his parish church of San Pier Maggiore and commission its altarpiece, lived his whole life in the house he inherited from his father. His means did not allow for magnificence, but his arguments in its favor became part of his memorialized image. The scale of his vision and its connection to his city are represented in the panorama of the

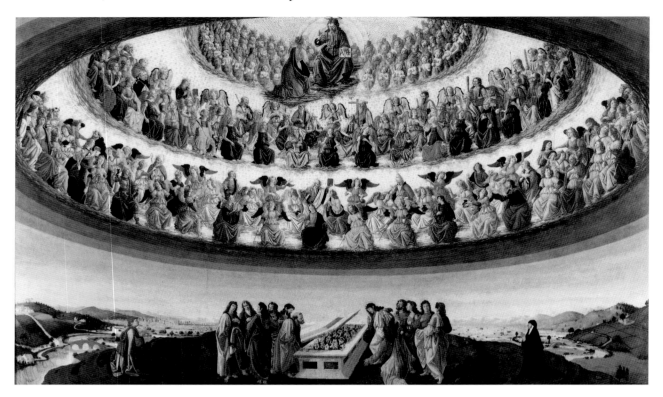

33 Francesco Botticini, *Assumption of the Virgin*, 1475, panel, 228.5 × 377 cm., National Gallery, London.

Arno valley and of Florence that form the background to his altarpiece, a view including Palmieri, his wife, and probably encompassing some of his country holdings (pl. 33).

Rinuccini's praise not only indicates that acquisition of wealth could be considered a virtue of character, it also demonstrates how warmly Palmieri's prescriptions were received. The assertions of positive connections between private outlay and public good offered an attractive resolution of some of the inherent contradictions of the multiple duties and identities of Florentine citizens as family members, guild members, office holders, and Christian believers. The desire to protect and advance one's personal and familial interests might easily conflict with the expectations and demands of public duty. That conflict had often resulted in faction, dissent, violence, and exile. Theories of honorable display, with their prestigious backing of ancient philosophy, offered a means to negotiate the potentially explosive differences between clan coherence and urban coexistence by claiming that private behavior was conducive to public interest. In practice such ideas had no real effect on the divisive nature of the city's political life, but they rationalized the ways that its leading citizens expressed themselves. The language of embellishment justified expenditures on the splendid decoration as well as the building of their houses, on collections of precious objects, books, and manuscripts, which could be represented as useful and necessary ways of articulating worth and dignity.

STYLE AND SUBSTANCE

While the writings discussed above can be classified as prescriptive, that is belonging to a didactic literature of morals and manners, they must also be read as persuasive. They are exercises in rhetoric as well as philosophy: an alliance partly suggested by their sources, above all Cicero, who wrote as an orator.

Style was a subject for these writers. Palmieri's dialogue *On Civil Life* was written with the explicit goal of making the civic teachings of ancient authors (mainly Cicero, but also Aristotle, Quintilian, and others) available to those of his fellow citizens who did not read Latin. It was also meant to repair the damage done to those authors by previous, crude translations. Introducing the dialogue, Palmieri explained that many works had been

> translated into the vernacular, which in the original are elegant, serious, and dignified ... but ... through the ignorance of the translators, have been so corrupted that those, which are extremely worthy in Latin, become laughable. And I would become risible myself, should I wish to demonstrate that the translations of Cicero, Livy, or Virgil, and many other translated authors were in no way similar to the originals; however, they resemble them in the way that a figure copied by the hand of one who had never worked with stylus or brush from the most perfect [figure] by Giotto might resemble the original.[51]

Similarly Aristotle's works existed in previous translations, but Bruni held them to be corrupt and barbarous. He was bringing Cicero, proper Latin eloquence, to the philosophical teachings of Aristotle. His argument in presenting his new translations was that Latin was "abundantly rich, acquainted not only with every form of expression, but with ample embellishments as well."[52] Bruni brought the same formal awareness to his recasting of Florentine history in a classical mode in his *History of the Florentine People*.

These exercises have parallels in the visual realm, not only in celebrations of wealth as virtuous such as that seen in the Strozzi altarpiece, but also in the discerning application of style to subject. Thus in 1401 when Filippo Brunelleschi and Lorenzo Ghiberti designed their panels for the contest for the second set of Baptistery doors, the competing artists found striking compositional and figural modes to express the Old Testament drama of Abraham's sacrifice (pls. 34, 36). Both referred to classical models. Both made statements that can be taken as critical reconsiderations of the style of the panels done for the door completed by Andrea Pisano in 1330 (pl. 35). Their knowing refutation of a preceding manner of expression is comparable to Bruni's critical rejection of earlier translations, which he said seemed done "rather by barbarians than by Latins."[53]

This coincidence of outlook can be related to networks of interest linking patrons and artists. So, for example, Palla Strozzi, like Leonardo Bruni, had been a student of the Greek scholar Manuel Chrysoloras. He was a great promoter of learning in Florence, a supporter of its recently founded university and an eager collector of both Greek and Latin manuscripts. He was also a member of those elected in 1403 by his guild, the

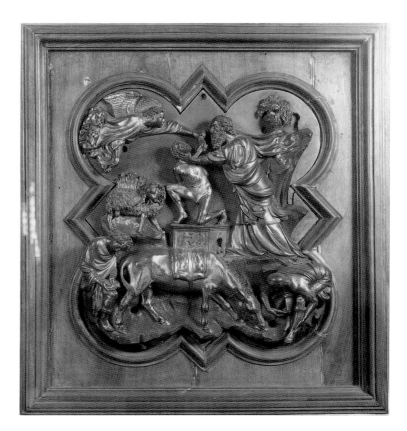

34 (ABOVE) Filippo
Brunelleschi, *Sacrifice of Isaac*,
1401, gilt bronze, 45 × 38 cm.,
Museo Nazionale del Bargello,
Florence.

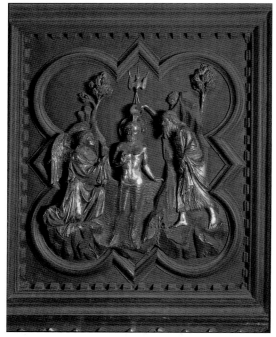

35 Andrea Pisano, *Baptism of
Christ*, 1330, gilt bronze,
50 × 43 cm. (inside the molding).
South Door, Baptistery, Florence

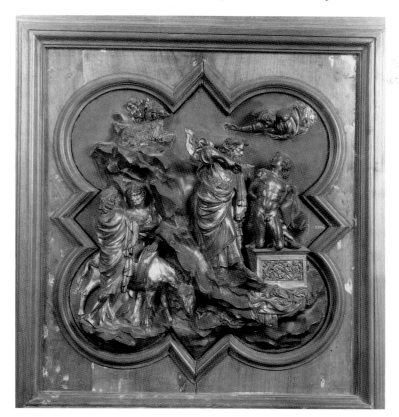

36 Lorenzo Ghiberti, *Sacrifice of Isaac*, 1401, gilt bronze, 45 × 38 cm., Museo Nazionale del Bargello, Florence.

Calimala, to supervise Ghiberti's work on the bronze doors. In turn Ghiberti later supervised work on the wood furnishings of the Strozzi sacristy at Santa Trinita. On December 15, 1426 Palla cancelled a debt of 64 *lire* and 16 *soldi* (first noted in 1423) against the credit "for numerous drawings and services performed by . . . Lorenzo [Ghiberti] up to that date."[54] One of the designs might have been for the door and other architectural finishings in the sacristy (pl. 7). Theirs was not merely a commercial relationship, it involved the favors of friendship. In 1420 Palla's banking firm loaned the goldsmith the considerable sum of 600 florins, which he used towards paying for the purchase of two farms from the Captains of Orsanmichele.[55] In relying on Ghiberti for his projects, as a designer and as a form of artistic advisor, Palla was selecting an exponent of the new, classicizing visual language. The studied elegance of Ghiberti's sculptures parallels the studiously achieved eloquence of Bruni's translations.

Neighborhood and family might have played a part in Palla's patronage of Gentile da Fabriano, who rented his house in Florence from Palla's second cousin, Palla di Palla Strozzi. And though art-historical cliché often labels Gentile as an "International Gothic" artist, and therefore judges him as retrograde in comparison with Brunelleschi, Donatello, and Masaccio, it is far more likely that in the 1420s Gentile's detailed illusionism and mastery of light and texture were viewed as extraordinary and novel.

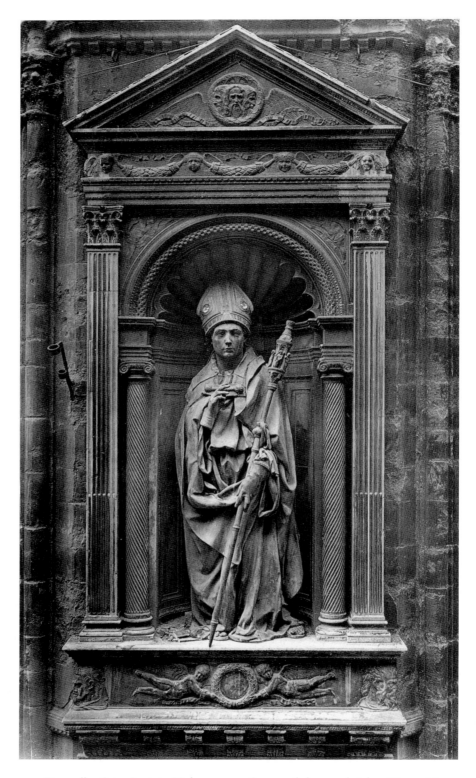

37 Donatello, *Saint Louis in Niche*, ca. 1423. Statue: gilt bronze, height 266 cm., Museo dell'Opera di Santa Croce, Florence. Niche: marble, 560 × 243 cm., Orsanmichele, Florence.

He was more international than Gothic, having arrived from the north of Italy in the entourage of Pope Martin V. Palla di Onofrio's choice of Gentile may be seen as a pictorial pendant to his activity as a collector of ancient texts – also part of an international market in things precious, rare, and rendered desirable by new fashions in learning.

The cases of Donatello, Brunelleschi, and Masaccio reveal similar intersections of friendship and influence. Alberti dedicated the Italian version of his treatise to Brunelleschi, recalling how, on his return to Florence, "I recognized in many, but above all in you, Filippo, and in our great friend the sculptor Donatello . . . a genius for every laudable enterprise in no way inferior to any of the ancients who gained fame in these arts."[56] Between 1420 and 1425 Donatello was employed by the Guelf party to produce a statue of Saint Louis, the Parte's patron saint, for Orsanmichele. Undoubtedly an opportune recognition of the sculptor's talent, the choice of Donatello also recognized a family loyalty to the Parte Guelfa. Donatello's father was exiled from Florence in 1378 as a result of his support for the Guelf cause and was officially listed among the party heroes after the return of the exiles in 1382. In designing the niche, Donatello seems to have been encouraged to employ a definitely *all'antica* vocabulary, for it is not only a cunningly designed frame for the bronze statue, but it is also a bold combination of elements studied from Roman models (pl. 37). A similar idiom was adopted a few years later by Brunelleschi in his design for the Parte's new audience hall. With its classically inspired entablature and giant order of pilasters, this building was one of the first buildings in Florence to use explicitly *all'antica* forms. In selecting Donatello and Brunelleschi and approving their designs, the Parte was articulating its corporate identity in an unmistakably classical language. Just before Donatello's commission, in 1419–20, Leonardo Bruni helped to the revise the Parte statutes. From early in the century Bruni had employed ancient precedents to praise the Guelf party's noble origins and its role in safeguarding the state. The party leadership seems to have welcomed this form of expression and to have programmatically sought to associate its image with the developing image of the Florence as the new Rome.

Felice di Michele Brancacci, who commissioned Masolino and Masaccio to paint his family chapel in Santa Maria del Carmine in the mid-1420s, was a leading member of the Parte Guelfa. He also belonged to the Silk Guild, Brunelleschi's patron for the building of the Ospedale degli Innocenti. Felice later married Palla Strozzi's daughter Maddalena (in 1431). Masaccio was already working for the Carmelites when the Brancacci commission was decided, but Felice's willingness to accept the Masaccio/Masolino partnership might have been conditioned by his connection with the institutions sponsoring other works in the new style.

Masaccio's rapid development from talented newcomer to accomplished exponent of that style owed much to his keen understanding of Donatello's works. This, too, was probably guided by the ties of friendship. Donatello collected one of the payments for Masaccio's altarpiece commission in Pisa in 1426. This documented link between the two confirms a visual sympathy evident in the sculptural forms of Masaccio's figures, whose features and physical presence are indebted to his study of Donatello's statues (pls. 38,

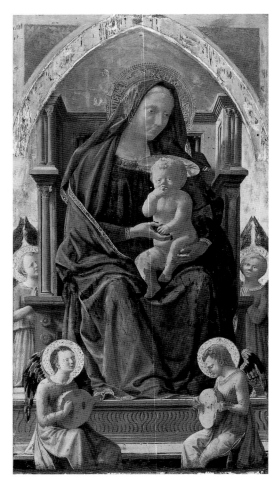

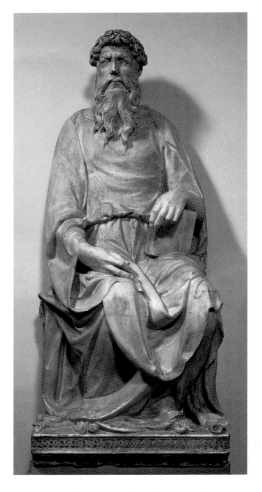

38 Masaccio, *Virgin and Child*, 1426, panel, 135.5 × 73 cm., National Gallery, London.

39 Donatello, *Saint John the Evangelist*, 1408–15, marble, height 210 cm., Museo dell'Opera del Duomo, Florence.

39, 40, 41). Masaccio's direct acquaintance with Brunelleschi can only be inferred, but is also likely. Among his other technical explorations, Brunelleschi experimented with perspective renderings of real space, a curiosity shared by both Masaccio and Donatello. The similarity of Masaccio's depicted architecture to elements of Brunelleschi's buildings suggests close observation, if not direct consultation. This is evident in the fresco of the Trinity at Santa Maria Novella, whose pilaster-framed arch can be compared with Brunelleschi's arcade at the Ospedale degli Innocenti or the remnants of the opening to the chapel he designed at Santa Felicita, probably for Niccolò di Messer Donato Barbadori (pls. 43, 42). The donation of wall paintings as chapels was common. Uncommon was Masaccio's translation of a liturgical definition into a depicted space. Using an

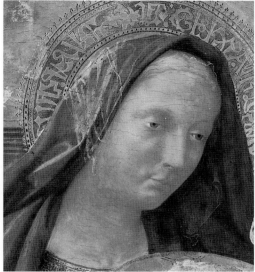

40 Donatello, *Saint George*, ca. 1415–17, marble, 41 Masaccio, *Virgin and Child*, detail of pl. 38.
detail, Museo Nazionale del Bargello, Florence.

all'antica architectural language, he realized metaphors of order, symmetry, and propor-
tion in terms of visual and devotional continuity between an actual spectator, portrayed
donors, intercessory figures, and the symbolized subject of the Trinity. Such reconfigur-
ing of experience through the selection of classical elements shows Masaccio addressing
the issues of the forms and functions of expression that were so compelling to the cham-
pions of the new learning and their supporters.

Bruni's, Alberti's, and Palmieri's audience were the members of the political elite of
Florentine society. These major guildsmen, who also served on boards of work and dom-
inated government offices and political debate, were often those who selected and super-
vised the artists chosen for major projects. The processes of consultation involved could
allow for critical criteria and critical acumen to be developed. And though such men
represented only a limited percentage of the entire population, it was the percentage
that contained the cultural protagonists of the city – those who could determine or at
least substantially influence the expression of all forms of Florentine life. The selection
of artists working in an *all'antica* style for projects involving civic and corporate honor
suggests that formal sensitivity could also become a politics of the visual. One of
Palmieri's modifications to Cicero indicates the importance of artists in fifteenth-century
Florence. In a discussion of the status of various professions, Cicero ranked as becom-
ing to a gentleman "the professions in which either a higher degree of intelligence is
required or from which no small benefit to society is derived – medicine and architec-
ture, for example, and teaching."[57] Palmieri wrote that the arts praised above all others
were those involving industry, prudence, and intelligence, "such as medicine, law, archi-
tecture, and sculpture and any other such praiseworthy and honest endeavor."[58]

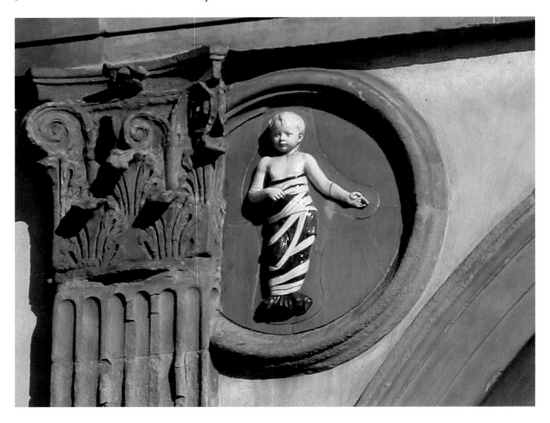

42 Filippo Brunelleschi, Ospedale degli Innocenti, begun 1419, detail of exterior arcade, Florence.

Some of those who undertook private projects and who served on the public guild committees or boards of work were men like Cosimo de' Medici or Palla Strozzi who had an abiding commitment to the new learning. That commitment was translated to the visual realm through the client relationships that developed between those powerful men and innovative artists. Palla Strozzi's friendly support of Ghiberti had its parallel in Cosimo de' Medici's backing of Donatello and Michelozzo. There were others, however, who probably had to cope through pretense or agreement or rapid absorption of the most useful ideas and current catchphrases. The latter were the audience for the vernacular treatises, such as Alberti's books or Palmieri's dialogue. Others probably resented and reacted against these trends. A certain resistance, or possibly indifference, to new ideas is manifest in the visual arts where a differentiated marketplace began to exist. Some artists offered daring and innovative works while others continued to produce variants of familiar forms and yet others found a middle ground. In terms of income and commissions, the leading painters of the early fifteenth century were those like Mariotto di Nardo and Bicci di Lorenzo whose work did not challenge established patterns. When he painted an altarpiece of the Trinity for Niccolò di Roberto Davanzati for the church of the convent of San Michele alla Doccia in Fiesole in 1416, Mariotto di Nardo readily

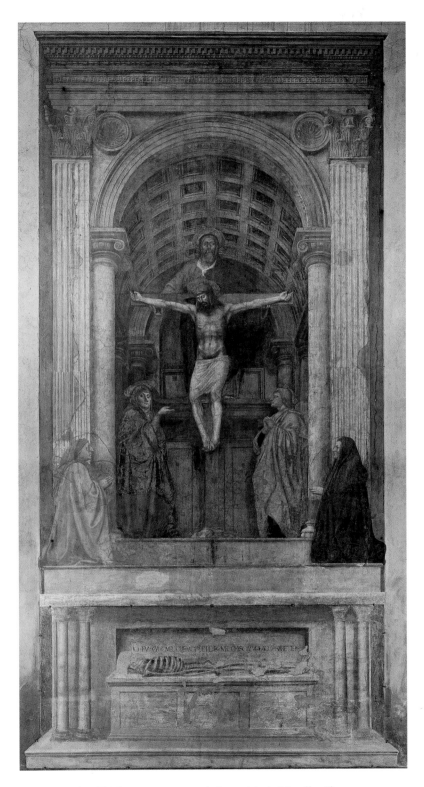

43 Masaccio, *Trinity*, ca. 1427, mural, Santa Maria Novella, Florence.

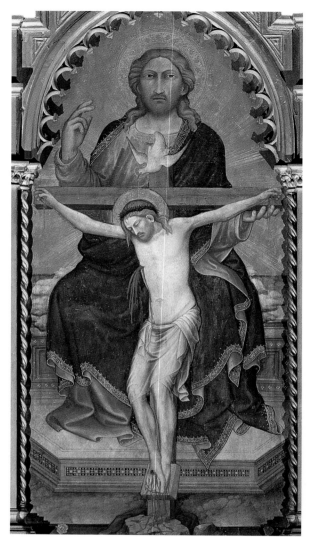

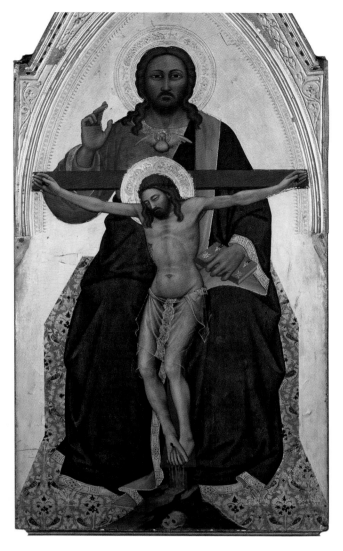

44 Mariotto di Nardo, *Trinity*, 1416, center panel of polyp-
tych, Santa Trinita, Florence.

45 Nardo di Cione, *Trinity*, 1365, center panel of polyptych,
160 × 86 cm., Galleria dell'Accademia, Florence.

referred to preceding versions designed by Jacopo di Cione and his shop, showing that
at that time there was not a demand for radical reinventions like Masaccio's later *Trinity*
at Santa Maria Novella (pls. 44, 45). Bicci di Lorenzo represents the type of artist whose
success was in being both reliable and reassuringly traditional (pl. 46). He inherited his
shop and his style from his father Lorenzo, and passed both on to his son Neri, who
followed fashion in adding *all'antica* ornaments and perspective embellishments, but
with moderation and clear reference to well-tried formulas (pl. 47). Bicci worked on
major projects involving the city's prestige. He was among those commissioned to paint

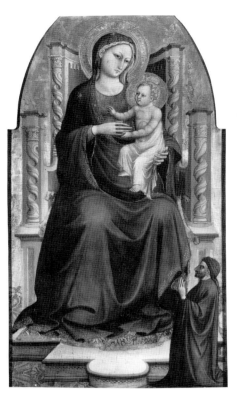

46 Bicci di Lorenzo, *Virgin and Child with Donor, Simone da Spicchio*, 1423–4, panel, Museo della Collegiata, Empoli.

47 (BELOW) Neri di Bicci, *Virgin and Child with Tobias and the Archangel Raphael, and Saints Nicholas, Anthony Abbot, Julian, and Donnino*, 1473, panel, Museo dell'Arte Sacra, San Pietro in Bussolo, Tavarnelle Val di Pesa.

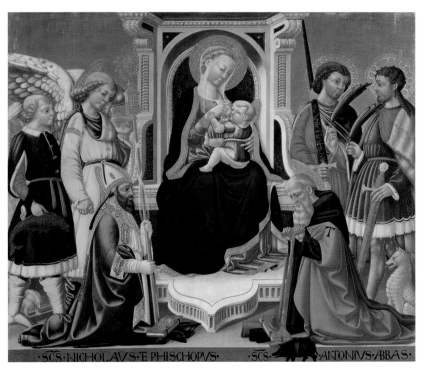

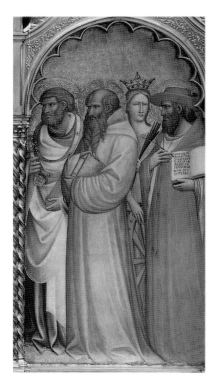

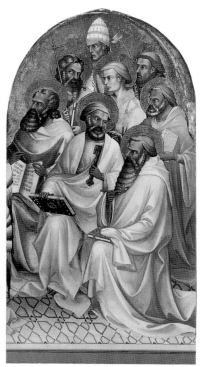

48 (ABOVE LEFT) Giovanni di Marco, called Giovanni dal Ponte, *The Ascension of Saint John the Evangelist with Saints*, ca. 1410–20, right wing of polyptych showing Saints Peter, Romuald, Catherine of Alexandria, and Jerome, panel, 146.4 × 66.2 cm. (whole work: 166.4 × 249.6 cm.), National Gallery, London.

49 (ABOVE RIGHT) Lorenzo Monaco, *Coronation of the Virgin*, detail of pl. 61.

50 Lorenzo Ghiberti, *Temptation of Christ*, ca. 1403–24, gilt bronze, 57.5 × 65 cm. (panel), 39 × 39 cm. (quatrefoil), North Door, Baptistery, Florence.

frescoes of the apostles in the tribune of the Duomo at the time of its consecration by Pope Eugene IV in 1436. He also worked for major figures, such as Niccolò da Uzzano, painting frescoes in the family chapel at Santa Lucia dei Magnoli and working in the new palace Niccolò shared with his brother. The 1427 tax declaration of one of Bicci's colleagues on the Duomo project, Giovanni di Marco (known as Giovanni dal Ponte, from the location of his shop), proves him to be the most prosperous painter of the time. Giovanni's swaying and swathed figures observe the graceful style being popularized by Ghiberti on his first set of doors, which was also followed by Lorenzo Monaco in his paintings (pls. 48, 50, 49). The stylistic range of these artists shows that correlations between humanist ideals and a classicizing aesthetic must be tempered with due caution. Simple oppositions of modern and archaic – "Renaissance" or "Gothic" – are anachronistic. Appreciation of tradition coexisted with the sponsorship of novelty. And novelty could be seen as much in the ornament or beauty of the lavishly draped cloths and intricately patterned compositions of Lorenzo Monaco as in the solid forms and spatial experiments of Masaccio.

For Palmieri and others, Giotto was the paragon of painters. Masaccio acknowledges this in his direct return to the simplicity of Giotto's forms, while others did so in their reference to Giottesque formulae. What separates the early fifteenth century from previous generations is a developing receptivity to such variations and towards a conscious emulation of antiquity. Where there had always been a difference between works that were costly and works that were not, marked differences of style were added to differences of material. Sensibility to artifice was added to the material appeal to sense.

Just as the immediacy of works like Masaccio's *Trinity* proposed a new relationship between real and imagined experience, the arguments of the new learning reformulated the nature of social existence. They posited ideal modes as actual models. Through their care to match style and subject they allied aesthetic values with ethical behavior. This equation of form and function gave great power to form, and one of the noteworthy developments of the fifteenth century is the constant elaboration of form. The palace, for example, became ever more nuanced as a statement of family solidarity, in its façade and in its furnishings, its architectural language, its heraldic displays, its devotional repertoire, and its forms of memory and memorialization through portraits and painted histories. The burial slab, already an honored form of commemoration, could be contrived to be distinguished from others by adopting classical lettering and classical terms of civic worth, as in that designed by Ghiberti for Bartolomeo di Niccolò Valori who died in 1427 (pl. 51). The slab, through its chosen style of *all'antica* lettering, called attention to itself and made a statement beyond the meaning of the single sentence celebrating the "most grave and prudent citizen." In its time this script would have been seen as markedly different from the customary Gothic-style lettering (pl. 52). It is an example of how the formalization of identities could be at once idealized (as in the lettering) and particularized (in the choice of a style of representation). Modernizing an established form, it reveals an awareness of the capacity of imagery to fix identity. It also reveals the ways that enterprising artisans could gain authority as interpreters of social ideals. Ghiberti can be credited as the inventor of this tomb type.

52 (ABOVE) Tomb of the Serristori family, detail, fifteenth century, marble, Santa Croce, Florence.

51 Filippo di Cristofano, after a design by Lorenzo Ghiberti, tomb of Bartolomeo Valori, 1427, marble, 136 × 297 cm., Santa Croce, Florence.

The "new art" of the early fifteenth century bore the same connection to reality as the ideals put forth by the new learning. They were operative fictions, versions of desired ends, not portrayals of actual conditions. It can be argued that fourteenth-century imagery was at times far more realistic than that of the fifteenth century: tender (pl. 53), pathetic (pl. 54), unsparing, and directly observant of social facts (pl. 55). Fourteenth-century art created a parallel world, inviting identification and imitation. The illusionism and artifice of fifteenth-century art suggested a continuity of experience, drawing its viewers directly into a realm of perfected relationships and projected attitudes. Through

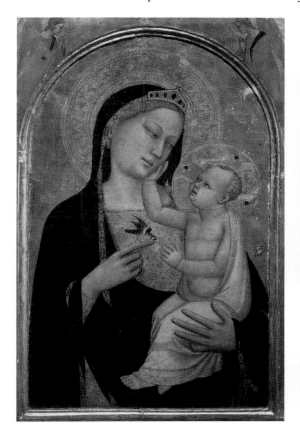

54 Nardo di Cione, *Last Judgment*, 1351–7, mural, detail, Strozzi chapel, Santa Maria Novella, Florence.

53 Bernardo Daddi, *Virgin and Child*, late 1330s, panel, 83 × 54 cm., Berenson Collection, Villa I Tatti, Florence.

55 (RIGHT) Agnolo Gaddi, *Construction of the True Cross*, 1390, mural, detail, chancel, Santa Croce, Florence.

such complicity beautiful ways of being were both realized and memorialized, demonstrating to the present and to posterity how "lo splendido vivere" had been achieved by the honorable expenditures of the worthy citizens of Florence.

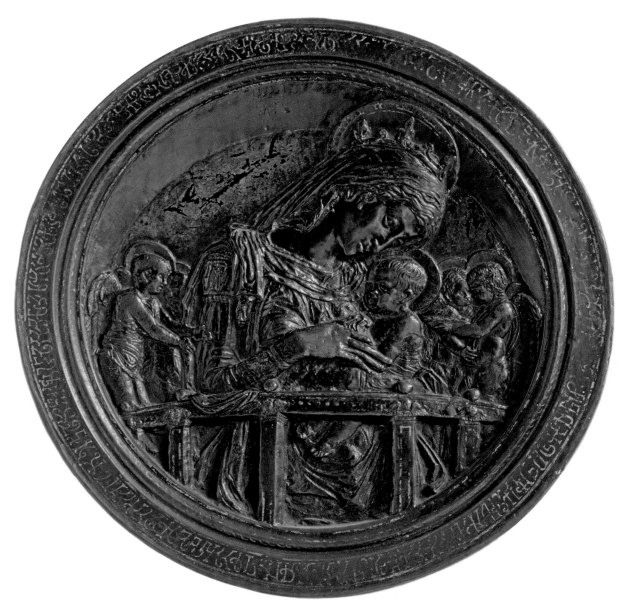

56 Donatello, *Virgin and Child with Angels* ("Chellini Tondo"), ca. 1456, bronze, diameter 28.5 cm., Victoria and Albert Museum, London.

Chapter Three

THE ECONOMY OF HONOR:
DONATELLO AND ARTISTIC PRACTICE

IN AUGUST 1456 THE SCULPTOR DONATELLO presented the physician maestro Giovanni di maestro Antonio di Chellino with a gilt bronze roundel showing the Virgin and Child with attendant angels (pl. 56). The roundel has the form of a dish. Its interior is of measurable yet uncertain and uneven depth, as though alluding to the illusion of a projected space, which is then partly denied by the dense compression of figures. A balustrade curves in front of the group. One angel seems to move out from behind the Virgin's right shoulder. Typically Donatello challenged his chosen limits. Boundaries are defined and defied. The Virgin's halo and the angels' wings push against the extremes of the plate's surface. The Virgin's robe hangs over the balustrade. The concentration of the space and the relative scale of the figures to their frame give the actually diminutive figures an appearance of grandeur and a substantial three-dimensional presence. The object appeals to the sense of touch as well as that of sight. It plays on feeling as a physical and emotional faculty. The Virgin's right hand is at its center. As it comes to rest on her child's arm, her wrist brushes and lifts her breast (pl. 78). Her face leans protectively over the Infant Christ's head. He nestles against her body, clutching the drapery of his mother's robe while looking calmly outwards. To her right one angel watches another, while extending both arms towards the child as though wanting to take up and hold, or at least touch, him. This strong, but unsatisfiable impulse is a key to the onlooker's own state of distanced adoration. Two angels are placed to the other side of the Virgin. One playfully embraces the other, patting the stomach of its companion, who carefully holds out an offering to Christ – a dish within a dish, which is a gift within a gift. Episodes of tenderness and touching mark the entire group; but what is immediate and tangible is also distanced and removed. The balustrade, like a choir screen, sets off the sacred precinct of the Virgin, here crowned as Queen of Heaven. The perspective construction, seen from below, reinforces the viewer's sense of respectful removal. The decorative and inscrutable pseudo-arabic script of the plate's border is emblematic of the roundel's abstraction.

Characteristically Donatello produced an object in which his own artistry is also the subject. Artifice, material, and manufacture are insistently signaled, while, at the same

time, a compelling reality is achieved. In this case the sculptor's skill became currency. Maestro Giovanni noted the receipt of the roundel in his record book:

> I record that on August 27, 1456 while I was treating Donato, called Donatello, the singular and outstanding master of bronze, wood, and terracotta figures who made the large male statue that is above a chapel over the portal of Santa Reparata toward the Servi [Santissima Annunziata] and who had also begun another one nine *braccia* tall, out of his courtesy and in consideration of the medical care that I had given him and was giving him for his illness, gave me a roundel the size of a plate on which was sculpted the Virgin Mary with the Child in her arms and with two angels on each side, all in bronze and hollowed on the outside so that molten glass can be cast on it so that it would make the same figures as those on the other side.[1]

The transaction can be understood simply as an exchange of a good for a service. It was not the first time that maestro Giovanni took payment in this fashion. On August 4, 1435 he recorded that he had been sent 16 *braccia* of lightweight navy blue cloth for numerous medical services given over a number of years to the household of ser Giovanni and ser Martino di Luca Martini. The cloth came with the message that it was for him to have clothing made for his sons. Its value can be estimated at about 16 florins, on the basis of the 6 florins maestro Giovanni paid for the extra 6 *braccia* of fabric he had to purchase in order to make two gowns for his sons.[2] And in November 1445 when he loaned his large silver cup with gilt ornament to Roberto di Giovanni Altoviti, he added that it was the one he had been given some years ago by Giovanni Borsieri for his medical services.[3] This sort of transaction was a normal feature of medical practice. There was no set scale of fees for treatment and cost could depend on a number of factors, including the client's social status, ability to pay, and the length of the physician's attendance. A visit could cost between 5 *soldi* and 1 florin, and a day's attention between 10 *soldi* and 2 florins. In January 1444 Francesco di Matteo Castellani paid 4 *lire*, 13 *soldi*, and 6 *denari* for being cured by maestro Ugolino da Pisa.[4] Some idea of the meaning of these sums might be given by comparing them to the contracts the painter Neri di Bicci made with his baker to bake the bread for his household for a year. In 1456 this cost him less than a florin (2 *lire* and 10 *soldi*), in 1465 it cost him 5 *lire*, or roughly a florin. His "family" included his wife, three sons, a daughter, a serving girl, and shop assistants. The arrangement further allowed for supplies for visitors.[5]

Payment was not always in cash: physicians could prefer the rewards of "honor and utility" to those of grubby necessity. When Cardinal Carlo Forteguerri gave his doctor twelve silver spoons and a silver cloth woven with figures in gold for his treatment of an illness lasting 75 days, the physician noted in his *ricordanze* (November 10, 1473) that "he said that he was not giving them to me in payment, because he knew that I would not have accepted them, but in memory of our long, firm friendship."[6]

The verb *dare*, to give, is used in each instance, including that of Donatello and his doctor. Operating here is a relation between doing and giving – *fare* and *dare* – a relation that can involve mutual or reciprocal honor. The bestowal of a service is acknowledged by gift, which conveys and expresses gratitude beyond the simple calculation of

an established price. This form of exchange combined material worth with moral value. It is one in which calculations of status accompanied those of financial profit. "Good" as well as goods could be accumulated. Above all a good name could be acquired or promulgated. In fifteenth-century Florence honor was an asset and a commodity. From a good name resulted the trust and esteem that could lead to further exchanges resulting in material security or social or political advancement.

Of course when the sculptor Donatello "gave" the physician Giovanni di Antonio the bronze dish in return for medical services, he may well have been paying the doctor in the only way that he could. That Giovanni "had given" and "was giving" Donatello treatment suggests care given over an extended period. Such care fits with the nature of a physician's practice at the time. There were three categories of medical practitioner: physicians, surgeons, and empirics. Only physicians had full university training, and they generally dealt with internal ailments. It would be difficult, however, for artisans like Donatello, who had limited cash or financial reserves, to afford protracted attention from eminent physicians like maestro Giovanni (who had in any event more or less retired from practice). The balancing of debit and credit through the equation of *fare* and *dare* in this case suggests a frame of reference other than that of simple barter. Payment has become gift. Donatello's identity as "singular" and "outstanding" was brought into play, and made a matter of record in maestro Giovanni's account book. The medium of exchange, whose token was the dish, was actually honor. Donatello, as a famous sculptor and as the bestower of a gift, both honored the physician and acquired honor. Maestro Giovanni's kindness and skill in undertaking the cure were more than matched by Donatello in the gift given in lieu of payment. Payment was also personalized, as being uniquely by and from Donatello. A bond of mutual favors and mutual regard was established between the two men. Already entering the humanist canon as an example of excellence and an ornament to his city, Donatello's skill and singularity as a maker of objects were obviously matched by his skill in manipulating their meaning and in using them to accumulate stock of the highest value in his time – that of honorable reputation.

Donatello's gift has a context in the social and economic structures of Florence and the episode is revealing about both the position of the artist and the value of his work within those structures. The object that passed between the sculptor and the physician was unique, but that very uniqueness allows for a number of lessons to be drawn from the observation of the usual and the unusual in the case. The implications of the encounter will be examined first by considering how artists were defined professionally and how they generally fared economically. Then the contrasting resources and position of the physician will be profiled in a return to the details of the episode and its protagonists in order to consider what it reveals about social interaction, the nature of patronage, and the status of the artist in fifteenth-century Florence.

* * *

THE "MIDDLING" CLASSES

In the case of Giovanni di Antonio *maestro* was a form of address. It was the professional title given to physicians. In the case of Donatello, as described in Giovanni's *ricordanze* – "master . . . of bronze, wood, and terracotta" – it was an indication of skill (mastery) and of professional qualification. In regards to craftsmen, "master" was the term applied to any artisan who had finished an apprenticeship, had matriculated in the appropriate guild, and who was thereby qualified to exercise a profession independently. In the fifteenth century the craftsmen in the visual arts were divided and defined according to different types of production and different professional associations. Painters were members of the Arte dei Medici e Speziali (doctors, druggists, and spice dealers, who sold pigments). Woodworkers and stone carvers were members of a designated guild (that of the Maestri di Pietra e Legname), and goldsmiths belonged to the silk guild (the Arte della Seta). There were further specializations within these categories. In addition to painters whose trade might include both panel and mural painting, there were glass painters, book illuminators, card painters, cloth painters, furniture painters (called both *forzerinai* and *dipintori*), not to mention simple house painters. Sculptors also had considerable scope in their trade and training, as the bronze, wood, and terracotta of maestro Giovanni's memorandum about Donatello remind us. They could carve marble or other stone, model (in clay or terracotta, for finished statues or in preparation for bronze), do monumental statuary or cut ornamental detail for architecture. Combinations of these skills were not uncommon. Donatello both carved and modeled. Lorenzo Ghiberti was a member of both the silk guild, as a goldsmith, and that of the stonemasons and carpenters. Antonio del Pollaiuolo was a painter and goldsmith, while Andrea del Verrocchio was a goldsmith, sculptor, and painter – to name some illustrious examples.

The guilds were the basis of the communal organization of the city. Political rights derived from guild membership. The guild also offered support, guaranteed dignified burial, and placed the member in a community of interest. As elsewhere, the guilds functioned to regulate practice, to set standards for training and for the exercise of the trade. They established criteria for workshop organization, and provided mechanisms and guidelines for judgment, appraisal, and arbitration. There were twenty-one guilds, subdivided into seven major and fourteen minor. The major guilds were those representing the learned professions: Judges and Notaries (Giudici e Notai); Doctors and Druggists (Medici e Speziali); the international merchants and bankers (the Calimala and the Cambio); and the traders in cloth goods, the guilds of the Wool Merchants (Lana) and Silk Merchants (Por Santa Maria or Seta), and the Furriers (Vaiai e Pellicciai). They were entitled to the dominant proportion of seats in the governing body of the Signoria (six of the eight officials) and in the collegiate councils. The guild groupings related to political convenience as well as craft specialization. Keeping the guilds to twenty-one in number resulted in mixed corporations such as that of the doctors, druggists, and painters. This lack of special interest intensity is perhaps one explanation for the relative lack of rigidity in guild membership in Florence, where there was much cross-registering, or movement between crafts. While membership was protective it does not seem to

have been unduly restrictive. Although there were differential rates for enrolling – with lower membership fees for children of registered masters, and higher rates for foreigners – membership was open to those from other craft backgrounds and to foreigners. In the Medici e Speziali, for example, the fee was 6 florins for natives and 12 for foreigners. So when an established master like Gentile da Fabriano was offered work in Florence he was able to matriculate (on November 21, 1422) and to accept important commissions such as that from Palla Strozzi for an altarpiece for the family's newly built burial chapel in the sacristy of Santa Trinita (pl. 22; dated May 23, 1423).

Guild membership had important consequences for the status of artists. As members of a major guild, painters were associated with the city's leading men. As lesser members of a great guild, however, they played a relatively limited role in its power structure, rarely being elected to the highest offices or appointed to influential committees. The case of builders and sculptors (in the Arte dei Maestri di Pietra e Legname) was the opposite. They could play major roles in a minor guild. Becoming part of the consular elite of their guild necessarily brought them into the realm of the city's ruling elite. Advancing in the guild hierarchy could be a means to social advancement, and certain families came to control election to offices within the guild – over time gaining wider prominence within Florence and sometimes moving from the building trades to commerce. The family descended from the late fourteenth-century mason-carpenter Antonio di Puccio ascended to the highest levels of influence and affluence in the fifteenth century as told here in Chapter 7. Antonio is recorded as guild consul twelve times and prior twice between 1390 and 1417.[7] Another instance of a family that rose from playing a role in guild politics to taking part in the public life of the city is that of Antonio di Banco and his son, the sculptor Giovanni or Nanni di Banco. Antonio was a stonecutter, sculptor, and supplier employed by the building works of the cathedral. He crowned his career with the prestigious post of chief foreman (*capomaestro*). He served as consul of the guild seven times between 1395 and 1415, attaining a level of respectability and responsibility in his profession and his professional body that made him worthy of literally being "seen" or *veduto* as eligible to be voted on to the city's governing councils.[8] Nanni followed in his father's footsteps, serving as guild consul five times. In 1419 he was elected as one of the three representatives of his quarter to the committee of "Twelve Good Men," the Dodici Bonomini, who advised the Signoria. From his late twenties to his death in 1421, at around thirty-eight years old, he combined public service with a career as a sculptor, doubtless helped in both by the patronage connections established by his father. Nanni's pride in his profession is declared in the sculptures he produced for the guild's niche at Orsanmichele between 1409 and 1417, where he demonstrated his talent in ornamental, three-dimensional, and relief sculpture as well as his almost unprecedented formal knowledge of antique prototypes (pl. 57). As has frequently been observed, the four saints, sculptors who were martyred in the fourth century, have been shown in the guise of Roman philosophers or senators. Four was also the number of guild consuls; the dignity of their office being associated with the dignified bearing of their patron saints. The *gravitas* and formality of the standing saints is matched by the forceful energy and closely observed detail in the predella below, which again shows four figures, this time engaged

58 Nanni di Banco, *I Quattro Santi Coronati*, detail of pl. 57 showing sculptors at work.

as builders and sculptors, representing not only the activities of guild members but also Nanni's skill in giving them enduring life (pl. 58).

The di Banco family is also an example of an artisan lineage, with several generations having been employed as stoneworkers by the Opera del Duomo. They intermarried with the families of others also employed in the cathedral's building works. The di Bancos were settled in the city, living near the church of Sant'Ambrogio. Other multi-generational and intermarried families of stonemasons and carvers were those who came from the small towns near the quarries just north of Florence: Settignano, Fiesole, Maiano. Marriage alliances could reinforce craft associations and they could be profitable unions. Not only did they help to guarantee the transmission of skills and workshop equipment, but parentage bonds could influence or create patronage networks, which could influence the visual, if not the political life of the city. Craft lineages are common among goldsmiths, whose trade based in precious materials demanded a high investment. Lorenzo Ghiberti was trained by his stepfather, and his son and grandson were subsequently goldsmiths. Other families like the Dei, Ghini, Guariente, and Vagliente passed their trade down through generations. Such dynasties can be traced among painters, as in the family that passed a shop from Lorenzo di Bicci (1350–1427) to Bicci di Lorenzo (1373–1452) and finally to Neri di Bicci (1419–1491). Four generations of painters were descended from Masaccio's brother, Giovanni, called Lo Scheggia. But there were equal or even greater numbers of painters particularly, but also sculptors and goldsmiths, whose fathers, brothers, and children were in different trades altogether. Donatello's father, for example, was a woolcarder.

57 (facing page) Nanni di Banco, *I Quattro Santi Coronati*, ca. 1409–17, marble. Statues: each, height ca. 183 cm., Orsanmichele, Florence.

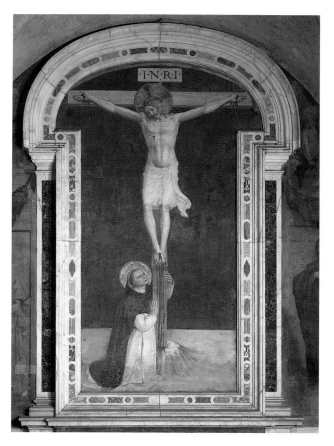

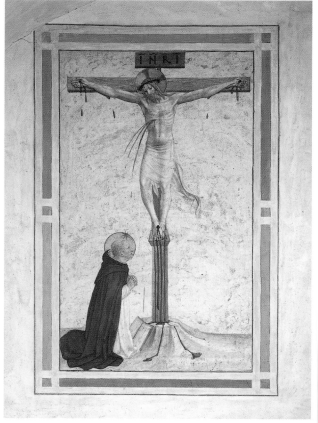

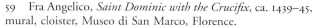

59 Fra Angelico, *Saint Dominic with the Crucifix*, ca. 1439–45, mural, cloister, Museo di San Marco, Florence.

60 Fra Angelico and assistants, *Saint Dominic Praying before the Crucifix*, ca. 1439–45, mural, cell 17, Museo di San Marco, Florence.

Monastic artists, like the Camaldolite Lorenzo Monaco, the Observant Dominican Fra Angelico, or the Carmelite Fra Filippo Lippi, did not come under guild protection or jurisdiction. The matriculated artisan swore an oath of obedience and good practice to his guild, the professed religious made vows to the order. It may be for this reason that Paolo Uccello's painter daughter, Antonia, was also a Carmelite. Though she was technically able to join the painters' guild, the independent, public exercise of her trade would be restricted. As a nun she could be a painter with the institutional support of her order. While monastic artists took commissions from secular institutions and individuals as well as other religious bodies, and trained and used assistants from both realms, they were under ecclesiastical not civic control. Their parent orders could function as patronage networks. Dominican commissions form a significant proportion of Fra Angelico's output, and he in turn served the interests of his order not only in a steady production of altarpieces and wall paintings for Dominican houses, both observant and conventual, but in finding visual formulations for the lived forms of Dominican ritual

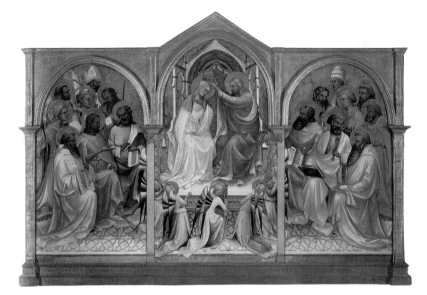

61 Lorenzo Monaco, *Coronation of the Virgin*, ca. 1407–9, panel, 264.9 × 365.8 cm. (220.5 × 115.2 cm. [center panel], 194.5 × 104.8 cm. [left panel], 197.2 × 101.5 cm. [right panel]), National Gallery, London.

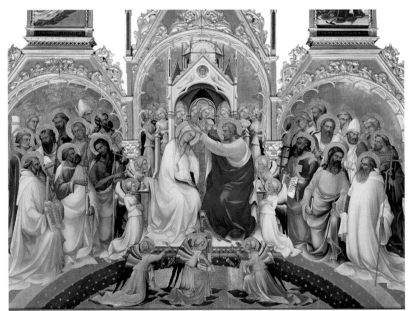

62 Lorenzo Monaco, *Coronation of the Virgin*, detail, 1414, panel, whole work: 447.5 × 506 cm. Galleria degli Uffizi, Florence.

and communal behavior (pls. 59, 60). Lorenzo Monaco, who took his vows in 1391 at Santa Maria degli Angeli, was trained in the monastic scriptorium and illuminated choir books for that church in the 1390s. Although by the late 1390s he had moved outside the monastery to open an independent shop, he maintained his vocation and his ties to the Camaldolites. He painted an altarpiece showing the Coronation of the Virgin for the Camaldolite house of San Benedetto fuori della Porta a Pinti (pl. 61) and the same subject for the high altarpiece for his parent house of Santa Maria degli Angeli (in 1414; pl. 62).

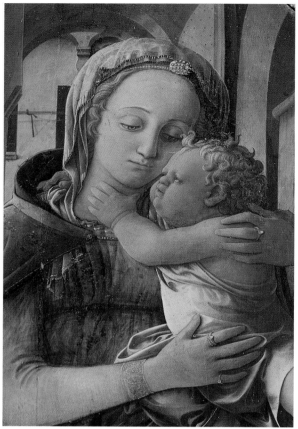

63 Masaccio, *Saint Peter Distributing Alms*, detail of pl. 83.

64 Fra Filippo Lippi, *Virgin and Child*, detail, 1437, panel, whole work: 114 × 65 cm., Galleria di Palazzo Barberini, Rome, in deposit at the Museo Nazionale di Corneto Tarquinia.

Carmelite patronage forms an important backdrop to Fra Filippo Lippi's career, as his artistic consciousness was undoubtedly influenced by the presence of Masaccio working in the cloister to portray the consecration of the church and convent (which took place in April 1422) and later Masaccio and Masolino painting the chapel of the Brancacci family in the church (pl. 63). The former is destroyed, but the latter represents the Carmelites in a mode of painting that made the histories of the past intrude on the present with compelling empathy. Both technical innovation and psychological insistence are key features of Lippi's works (pl. 64). The patronage of his order was a less consistent element in Fra Filippo Lippi's career than in those of other famous friar-painters, but after he left the convent, his clerical status as an ordained priest allowed him to supplement his painter's income with that from benefices. Constantly in debt and frequently in trouble, Lippi often played one form of authority against another. And having

left the security of the cloister, he sought to reconstitute it through the protection of Medici power, still evading the regulations and norms of standard workshop practice.

The differences between the lives and living and painting styles of the three friar painters are indicative of a variety that existed in the wider population of painters, sculptors, builders, and decorators who contributed to the rich visual texture of Florentine life. Still they did so within a general framework of trade procedures based on vocational training, which encouraged the maintenance of recognized standards of skill transmitted from masters to their apprentices. They also did so adhering to commercial norms that related to the ownership or rental and licensing of their working spaces, to the formation of partnerships or *compagnie* for specific projects or specified time spans (usually three years), to the assignment and completion of work by way of contracts or other forms of agreement, and to the guarantee of material quality of their work. Although there was some trade in ready-made objects, such as the devotional panels or tabernacles, usually of the Virgin and Child, that were essential to every properly furnished bedchamber, the dominant production was project-oriented. It would have been impossible for artists to keep expensive materials in stock: the panels, the pigments, the bronze, gold, marble, or *pietra serena* that constituted the major cost of commissions. Given this, the desirability of building up good relations in a neighborhood and with influential clients becomes evident, as that increased chances of work from prominent (and often interconnected) families and local institutions. The "visual artisan" was both handworker and shopkeeper and was concerned with both the manufacture and the marketing of his wares.

What was the place of those artisans in the population as a whole? In the 1427 tax survey (*catasto*) of the 37,246 declared inhabitants, there were 94 with painter given as their occupation. Of those, 58 were probably practicing their trade in Florence at that time, the others were away from the city or were too old to exercise their craft.[9] Tax registers and guild and confraternity lists suggest that there were usually about 40 to 50 painters active at any given time throughout the century, with one or two newly matriculated masters each year. Not surprisingly, given the range of activities, woodworkers and masons were more numerous. In the 1427 *catasto* there were 183 woodworkers (carpenters, bedmakers, box- and chestmakers, that is *legnaiuoli, tavolacciai, cassettai, cofanai*), 105 stoneworkers (*muratori* and *maestri di pietra*, who were layers, setters, and wallers, and *lastraioli, scarpellatori, intagliatori* – the hewers, sculptors, and carvers, who cut and worked stone). In that year there were about 100 goldsmiths (*orafi*), jewellers (*gioiellieri*), and engravers (*intagliatori*).[10]

In the register of the 1457[58] *catasto* which summarizes the tax assessments for Donatello and maestro Giovanni's quarter of San Giovanni there are 1,965 households. Of these 772 give the occupation of the head of household.[11] These break down into 152 headings ranging from innkeeper (*albergatore*) to clog-maker (*zocholaio*). While this gives some idea of the activities of the inhabitants of the quarter it should be noted firstly that households often had many adult members engaged in different occupations, and secondly that those who are defined by their trade in this register tend to be those with the lowest assessments: over half paid the minimum tax of three *soldi*. The members

of major guilds, the wealthiest and the most established names, are usually not defined by profession. Nevertheless a general picture of activities in the quarter emerges from its pages. The heads of household who can be affiliated with the "decorative" trades are: 2 goldbeaters, 12 goldsmiths, 10 painters (including Paolo Uccello), 3 chest-makers (*forzerinai*), one painter of cloth-hangings (*dipintore di sargie*), 1 house painter (*imbiancatore*), 41 woodworkers (*legnaiuoli*), 12 builders or wallers (5 *muratori* and 7 *maestri di murare*), 12 sculptors (1, Michelozzo, named as an *intagliatore*; 11 called *scarpellatori*, including Donatello), and 3 marble-workers (*marmorai*). Even with such an extremely loose and expansive definition of those trades, the combined visual art related component of tax-payers in this large quarter comes to 94, or less than five per cent (4.8 per cent) of the total. Woodworkers of various sorts form the largest group among them, comparable in this quarter to the seemingly popular categories of barbers (33), shoemakers (49), and cloth workers (around 52 involved in weaving and 25 in dyeing). Still, their numbers are greater than the lone gravedigger (*becha morti*), the single maker of bagpipes (*corna muse*), or the schoolteacher (*insegna a leggere a fanciulli*).

How do the assessments of these artisans fit into overall patterns of taxable wealth within the quarter? The total number of households paying between 1 and 10 florins was 488 (or just under 25 per cent of the whole). 53 households were assessed between 10 and 20 florins (2.7 per cent), 12 were assessed between 20 and 30 florins (0.6 per cent), 8 between 30 and 40 florins (0.4 per cent; 1 of them was maestro Giovanni at 33 florins, 6 *soldi*, 11 *denari*), 8 between 40 and 100 florins (3 of those were Pazzi households; 0.4 per cent). Two were assessed at over 100 florins: the heirs of Giovanni d'Amerigo Benci at 132 florins, 10 *soldi*, and 8 *denari* and Cosimo de' Medici at 576 florins, 15 *soldi* and 1 *denaro*. This pattern, with its concentration of wealth among very few, is typical throughout the city and over the century. It also gives a vivid impression of the vast resources of Cosimo de' Medici and the material reality behind the subtle maneuverings and imagery of his power. The register also shows that the patrimony of some old and important families was held more in prestige and reputation than financial assets. All but one of the branches of the ancient Adimari family paid less than 10 florins, similarly the Cavalcanti. It further indicates how family groupings – various households of the same clan – might control considerable wealth, which was subdivided into more modest holdings. This was the case with the Martelli, the Albizzi, and the Villani, for example. Individual affluence was not always the key factor in determining a family's influence, which could result from clan identity and solidarity.

1,394 levies or 71 per cent of the taxable households in the quarter were under 1 florin. Among these were Donatello's former associate and Cosimo de' Medici's favored architect, Michelozzo, who paid 4 *soldi*, and the painter Paolo Uccello, who was assessed at 6 *soldi*. 499 households were assessed at the minimum tax of 3 *soldi a oro*, that is a quarter of all taxpayers and 65 per cent of the 772 with declared occupations in the register. This includes Donatello. The tax, it should be remembered, was not on income, but on all income-producing assets. It does not, therefore, give direct information on what a craftsman might earn, but it does give an indication of where, and how, and with whom he lived, and through the records of outstanding debts and credits, some insight into his

contacts. In the overall distribution of wealth it also shows how the luxuries and lifestyles of a minority of Florentines were crafted and serviced by the labors of the majority.

The meticulously prepared tax declaration of the painter Marco di Filippo (ca. 1403–February 26, 1473) gives a glimpse of a household living at the 3 *soldi* level.[12] A master since the late 1420s, Marco enrolled in the painters' confraternity of Saint Luke in 1428 and he matriculated in the guild of the Medici e Speziali on May 15, 1431. This delay was fairly common. Belonging to the confraternity may have been a way of declaring professional maturity without undertaking the expense of guild matriculation. Having completed training, many young painters worked as salaried assistants to more established masters before attempting or being able to set up their own shops. In 1427 Marco was one of three painters in a partnership (*compagnia*) renting a shop on the Corso degli Adimari. The rent was 7 florins a year, paid to the canons of the cathedral. This was one of four shops on this street, organized into three such *compagnie*, which operated until ca. 1454–7. The present-day Via dei Calzaiuoli, then as now in the commercial heart of the city, runs between the Piazza del Duomo and the Piazza della Signoria and joins its ecclesiastical and civic centers. In the fifteenth century it was occasionally known as the Corso dei Dipintori owing to the cluster of painters' shops. Not surprisingly the painters there specialized in communal clients, decorating armor, and producing banners, pennants, and standards for magistracies and state agencies, including the tax officials. In the 1420s, like most of his colleagues on the street, Marco di Filippo lived on the other side of the Arno, where rents were cheaper (in the parish of Santa Maria a Verzaia). He spent the first half of his career in *compagnie* on the Corso. These *compagnie* were formed by contracts, usually lasting three years, allowing for pooling of resources and equipment. He entered the trade as a junior partner, taking one quarter of the earnings and being responsible for the same proportion of the expenses. By 1447 he was operating his own shop.

In 1458, at a declared age of fifty-four, he was head of a household of eight people. He had moved to the center of the city and lived near, but not in or above his workplace. The separation of working and living spaces was common. Although the reasons for this varied, a chief consideration was probably that rents were generally higher in the commercial zones of the city. Marco di Filippo's house was rented for 11 florins a year from the nearby Hospital of the Bigallo. The rent for his shop was 18 florins a year (to Piero di Antonio Padellaio). He declared that he had previously not been levied for tax; his taxable worth had apparently been too low to qualify. The 1450s seem to have been his most prosperous years. His business later shrunk so that he gave up renting the shop and did his work in the doorway of his house.

The other members of the household in 1458 were his wife, Mona Agnola (forty years old), his two sons, and a daughter, Cammilla (fifteen years old). His eldest son, Filippo, also a painter (of playing cards), was twenty-three and married, to Nanna (aged eighteen). They had a two-year-old daughter, Piera. There was another two-year-old girl, Ginevra, listed as the daughter of Marco's younger son, who was fourteen. A third son, Domenico, was no longer resident with the family. None of the girls were dowered, "due to poverty" ("tutte sono sanza dote per poverta"). Marco had one assistant or apprentice

(*garzone*), who was paid 25 florins a year, and an errand boy (*fattorino*), who cost 4 florins a year. He owed money both for the shop (16 florins) and for the house (30 florins). His other creditors included a goldbeater, a linen draper, and a miller. He was owed 4 florins by a communal client, the town of Colle, and the same amount by a private client, Giuliano Vespucci.

Many items in this declaration recur in those by other artists and allow for some generalizations about artists' ways of living. That the family unit included grown sons, their wives, and their offspring in one dwelling was a standard feature of Florentine life on all levels. Although the roster of bachelor artists contains illustrious names such as Donatello, Masaccio, Brunelleschi, Verrocchio, Leonardo da Vinci, and Michelangelo, staying single was hardly the norm. In the artisan class, where a craftsman's working life might end well before his biological life, family support was social security. A head of household, frail and unable to work, could renounce that position to one of his sons, to be maintained by the younger generation.

Households could be densely populated. In 1481, in his mid-thirties, Sandro Botticelli was one of twenty people counted in the declaration of his father.[13] He remained throughout his life with his brothers and their growing families in the house in the Via Nuova (now Via del Porcellana) that his father had purchased in 1464, which contained his working as well as his living space. Vasari made Piero de' Medici's provision of an allowance for the aged Donatello a topic of praise for both the Medici and for Donatello, who, "as the servant and friend of the Medici family . . . lived happily and without care for the rest of his life."[14] Vasari's anecdote highlights the predicament of artists without children or extended family ties. It records the close ties of Donatello to the Medici, but Donatello, far from living free of family cares or connections, was responsible for supporting his widowed mother Orsa and his sister Tita, also a widow and "without dowry," and her son.[15] In later years his nephew, Giovanni di Bonaiuto Lorini, occasionally acted as his business agent.

Vasari says that Piero's cash provision for Donatello was made when Donatello protested at the responsibilities of administering a country holding that he had been given by the Medici. He did not want to be pestered by peasants, worry about the weather, or the extra tax burden, so Vasari says, and "preferred to die from hunger sooner than to think about them."[16] Whatever the truth of this story about the farm near the Medici villa at Cafaggiolo (which is not found in his tax declaration), Donatello did own a house with a small garden outside of Prato, bought in 1442 for 23 florins.[17] The purchase of a smallholding was one of the primary forms of investment even for those of modest income. While Vasari claims that Donatello did not want to care about crops, most sought the benefit of steady sources of wine, wood, oil, eggs, and produce. Numerous tax declarations by artists include such properties. It was an obvious way for the cash-poor to be rich in provisions. Real estate in the city was also used to generate income. Some artists owned houses that they rented out, while living elsewhere either in rented or owned property.

Taxpayers of all levels in Florence declared themselves to be poor in one way or another. Many were outspoken about sufferings and loss, and tax returns at times seem

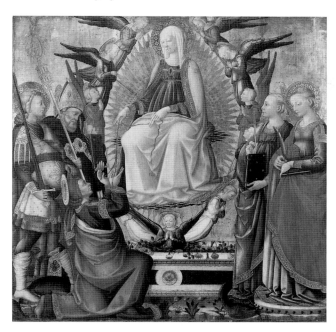

65 Neri di Bicci, *Assumption of the Virgin*, 1467, panel, 164.5 × 165 cm., The John G. Johnson Collection, Philadelphia Museum of Art.

a chronicle of a population made up of the diseased and disabled. Paolo Uccello pathetically, but justifiably, told the tax authorities in 1469 that he was "old and without means of livelihood, and I can no longer work, and my wife is ill."[18] He was seventy-three. In 1458 Sandro Botticelli's father described him unpromisingly as "sickly" ("malsano").[19] Marco di Filippo's statement to the assessors that he was unable to dower his daughters powerfully denoted the extreme modesty of his means, suggesting that he was barely able to live respectably: to provide a dowry would be one of the first acts of a responsible head of family after supplying basic needs.

Not all artists lived in such a reduced way. Where Marco di Filippo represents the lower (but far from the lowest) end of the economic scale, Neri di Bicci is an example of the upper range for painters. He started from a secure base, inheriting his father's practice. He developed that business, and maintained a constant level of production, mainly of formulaic panel paintings of high-quality craftsmanship, both ready-made tabernacles and made-to-order altarpieces (pl. 65). It has been calculated from his *ricordanze* that in the twenty-two years between March 1453 and April 1475 he painted 73 altarpieces (between 3 and 4 a year), 81 tabernacles, and received over 70 other miscellaneous commissions (including painting frescoes and banners, putting color to sculpted reliefs, and doing other tasks such as gilding candlesticks and reliquaries, and restoring and repainting outmoded thirteenth-century panels).[20] He ordinarily had two or three people of different grades working with him – errand boys, assistants, and apprentices – but occasionally had more. He began his career in his father's shop in Via San Salvadore in the Oltrarno quarter of San Frediano. In November 1458 he rented a shop in the more upmarket street of Porta Rossa. He described it as having a working space with a window

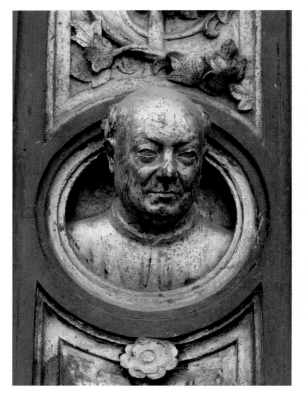
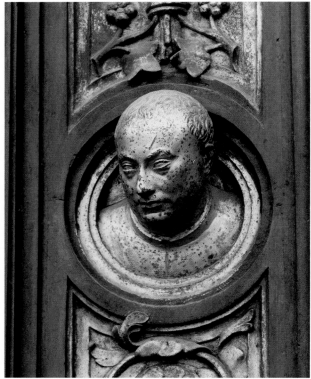

66 Lorenzo Ghiberti, *Self-Portrait*, ca. 1448–52, gilt bronze, East Door, Baptistery, Florence.

67 Lorenzo Ghiberti, *Vittorio Ghiberti*, ca. 1448–52, gilt bronze, East Door, Baptistery, Florence.

giving it light, and also as having a well, a fireplace, a sink, a storage vault, and a loft.[21] It was originally rented for 48 *lire* a year, but the rent was increased by his landlord Mariotto Davanzati first to 13 florins (1463–9) and then 16 florins annually (1470–5).[22] He continued to live in the quarter of San Frediano, where he had been brought up, spending 21 florins a year renting accommodation in Via Santa Chiara. In 1466 he described the house he lived in as having a ground-floor room (*sala*) and chambers (*camere*), a loggia, garden, stable, and storage spaces. The second floor had another room, a chamber, and antechamber. Above this was a floor with a kitchen, a chamber, antechamber, and terrace, with some form of loft space for chickens.[23] He bought and rented out more modest properties on this street as well as investing widely in real estate in the countryside to the west of Florence in the area of Gangalandi near Lastra a Signa. There he owned a house and other farm- and woodland.

Neri's financial acumen seems to have been accompanied by social ambitions for his family. When his daughter was four years old, in 1470, he invested the considerable sum of 815 florins and 15 *soldi* in the communal dowry fund for her.[24] His eldest son Lorenzo was sent to abacus school to learn commercial mathematics and then apprenticed first to a banking house and then to silk merchants. Neri's second son, Antonio, was also

apprenticed to a firm of silk merchants, and his youngest is recorded as learning to read and reckon. He clearly wanted his children to develop business skills, and he may well have had in mind the precedent of the Gaddi family. They were another painting dynasty, descended from the mosaicist Zanobi di Gaddi, to the student of Giotto, Taddeo, to his son Agnolo (ca. 1350–1396) who was a contemporary and competitor of Neri's grandfather. From that generation the family had become successful merchants, gradually working their way into the city's elite.

In Donatello's quarter in 1458 there were only three craftsmen who stood out for their tax payments. They were the goldsmiths Piero di Bartolomeo Sali (assessed at 1 florin, 14 *soldi*) and Vittorio di Lorenzo Ghiberti (assessed at 1 florin, 10 *soldi*), and the sculptor Luca della Robbia (assessed at 1 florin, 7 *soldi*, and 7 *denari*). The first two were prominent members of what could be a highly rewarding trade. Vittorio Ghiberti was the heir to a practice and a patrimony built up by his father, Lorenzo, who twice received the contract for what was probably the most costly commission awarded to a single shop in the fifteenth century, the pro-

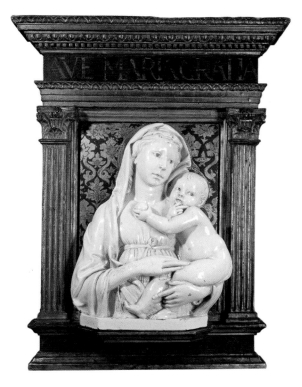

68 Luca della Robbia, *Virgin and Child*, ca. 1455–60, glazed terracotta, 58 × 44 cm., Staatliche Museen zu Berlin.

duction of the gilt bronze doors for the Baptistery. The first set cost 22,000 florins. For this work Lorenzo received the substantial amount of 200 florins a year as advance payment from the supervisory guild of the Calimala. A shrewd careerist, Lorenzo sought and fulfilled other major tasks and seems to have been adept at winning the support of the consuls and work supervisors of various guilds, the *operai*. An equally able social strategist, he sought offices where available. He was a consul of the guild of the stone and woodworkers three times between 1449 and 1453. He borrowed books from the learned set and began writing his own commentaries on the arts. His son became his principal assistant, keeping up the family tradition as goldsmiths (pls. 66, 67).

While Lorenzo Ghiberti made the family fortunes from within the trade taught him by his stepfather, Luca della Robbia was the son of a wool merchant. One brother, Marco, became a partner in a firm of wool merchants. Another, Giovanni, was a notary. Luca was the only one to become a handworker, but he seems to have profited from his family's commercial background, having the expertise to develop and successfully market a new commodity – his invention of glazed, enamelled terracotta (pl. 68). In 1457–8 he had the notable amount of 1,203 florins invested in the communal debt. He never married, and when he died his brother Marco's sons were his heirs: one, Andrea, to the "good will of his shop" and the other, Simone, to his estate. He reasoned that Andrea had already prof-

69 Antonio del Pollaiuolo, *Battle of the Nudes*, detail of pl. 156.

ited greatly and could become yet richer and earn an honorable living and maintain his family through the techniques he had been taught.[25] Although this division resulted in litigation, their uncle clearly held his successful business in great esteem. And it did indeed continue to flourish well into the next century with the involvement of many further family members.

Antonio del Pollaiuolo offers another case of financial success and more than a hint of social ambition. As their name describes, the brothers Antonio and Piero were the sons of a poulterer, who was actually called Jacopo di Antonio dei Benci. Like Donatello, they seem to have lost a true family surname (Donatello's was de' Bardi) and become known by a more humble nickname. They formed their identities in their accomplishments. Antonio used the new technique of printmaking as a medium of self-publicity, signing his name in an *all'antica* tablet placed next to an equally *all'antica* nude in the largest single-sheet engraving made in the fifteenth century (pls. 69, 156). Antonio had trained and practiced successfully as a goldsmith, but joined his painter brother in a partnership, which seems to have been a combined painting and goldsmith's business. They painted for clients as august as the Medici and their allies, the Pucci, and produced bronze tombs for popes Sixtus IV and Innocent VIII. Antonio was able to leave dowries of 1,000 gold ducats to each of his daughters, one of whom married a notary, while the other married a notary's son.[26]

As is clear from such histories, some artists were able to accrue capital, place their children in mercantile apprenticeships, and dower their daughters well enough to attract advantageous marriages, but these are more the exception than the rule. Most artists had very little, if any, disposable income. Given the fact that their earnings usually came in the form of payments made in installments for commissioned projects, rather than regular salaries, and that capital was often tied up in materials, the majority of master artists probably spent most of their lives juggling debits and credits, and much of their income on supplying basic needs of housing, clothing, and food. Very few moved financially beyond the lowest strata of taxpayers. A characteristic lament is that by a painter named Jacopo Lancialotti. He had no shop of his own, but did piecemeal work; he declared that he had "neither property nor any rest day or night."[27] He had eight children and his wife was "eight months pregnant, and every year without fail she produces another child."[28] Others probably remained below even this sad level, not even able to rehearse their miseries to the tax officials. Painters seem to have been more restricted than sculptors and goldsmiths. The price per panel or per wall surface, though variable, never approached the amounts of money involved in the monumental projects available to builders, sculptors, and goldsmiths.

But money, although essential to survival, was not everything in determining success. It was possible to earn fame without gaining much in fortune, as Donatello's example demonstrates. And even having acquired some fortune, artisans usually remained fixed to the status of their birth and education. In general social advance could only occur over generations of shrewdly made marriages and patronage alliances, through the acquisition of a history and eventually of political offices as was the case for the Gaddi family. But such patient rises from the ranks of lower guildsmen to the upper were rare. Even rarer were the family fortunes of the architect, Michelozzo di Bartolomeo, whose father was a tailor from Burgundy and whose son Niccolò became chancellor of the republic. Behind the creation of "the Michelozzi" were the Medici: Michelozzo's service to them as architect was succeeded by Niccolò's as a notary. The latter is an example of the "new men" of the Laurentian era, as well as an instance of how social mobility could be achieved through entry into learned professions.

More common and more significant, however, is the internal dynamic of attaching honor and nobility to being an artist. The mixed values defining respect for self and respect for status in Florentine society operated both vertically and horizontally. The metaphors of high and low, noble and vile were imposed to divide and define social and professional groupings, but they could be qualified. The constituents of status could be defined variably, and those variables could carry different weight in different situations. The upper rank, for example, included families and individuals of great wealth, antiquity, and political power. They may not have had all three: the Medici were wealthy and powerful, but were not regarded as one of the older families of the city. Maestro Giovanni was extremely rich and professionally respectable, but politically and historically marginal – his family origins were not Florentine. The Alberti, Albizzi, and Guicciardini were all families of more distinguished tradition and political prominence than actual financial power. There were distinctions that marked the members of the leading

and the affluent families, which were observed in many forms of contacts and contracts, above all in the marriage negotiations that might consolidate or create alliances.

The retail shopkeepers and the handworkers or craftsmen certainly were classed beneath the financially dominant and politically prominent elite. But as guildsmen these tradespeople were enfranchised and they shared political and economic rights with the upper ranks. They also shared with them a corporate and civic identification with their city. They ranked above those who had no guild representation, the *popolo minuto* of salaried laborers and servants. And although from the perspective of the practitioner of one of the noble, liberal professions such as law or medicine or that of a player in international trade, the craftsman's condition and activities could be defined as lowly, he could still aspire to live "with the labor of his hands and the sweat of his brow . . . honorably and decently as a worthy Florentine guildsman," as was argued of a tailor in a mid-fifteenth-century law case.[29] To the labels of "vile" and "mechanical" traditionally applied to handwork could be opposed notions of dignity and ingenuity. Between noble and base could exist the "middling" or *mediocre*. This was the self-definition sustained by one of the artisan witnesses in the same law case and it was as much a philosophical or ethical title as an economic one.[30] As a distinction it invoked the Aristotelian mean, and brought potent connotations of virtue and good into the service of social definition.

Concern both for equilibrium and fluidity of association are characteristics of fifteenth-century Florence. For a good master to take on the qualities of a good man allowed for freedom of exchange without compromising the constructions or interests of rank. Thus Antonio Manetti could tell the tale of a practical joke engineered by Brunelleschi, "a man of marvelous talent and intellect," and supported by Donatello, "who was of a stature known to all."[31] They were members of a happy band of assorted "men of standing, both of the ruling group and of masters of various ingenious arts, such as are painters, goldsmiths, sculptors and woodworkers, and similar craftsmen" who met to dine together and enjoy each other's company.[32] From such association, which was repeated in religious confraternities, guild committees, consultative panels to boards of works, could emerge the familiarity and the confidence that allowed the ruling group to entrust to those men of marvelous talent and intellect such latitude in the translation of political, personal, and religious ideals into visual form. And thus could both sides be rewarded by results whose goodness was far from middling.

MASTERS OF THEIR ARTS: GIOVANNI DI MAESTRO ANTONIO DI CHELLINO DA SANMINIATO AND DONATO DI NICCOLÒ DI BETTI BARDI

There was no question about the nobility of profession of maestro Giovanni and of his father, maestro Antonio. As physicians they belonged to one of the most prestigious professions of the time. They had undergone an expensive and exhaustive course of study, been examined by a college of doctors, and obtained a degree that licensed them to teach as well as practice medicine. Although not among the famous medical authorities of his day, maestro Giovanni held a respectable place as a physician in Florence. In

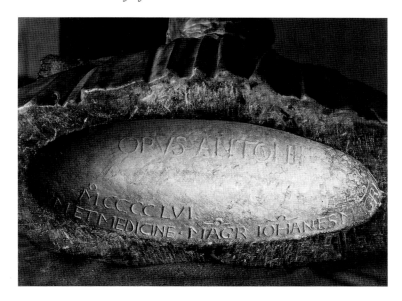

70 Antonio Rossellino, portrait bust of maestro Giovanni di Antonio di Chellino da Sanminiato, detail showing the inscription on the inside rim, 1456, marble, height 51 cm., Victoria and Albert Museum, London.

1401 he became a lecturer in logic and philosophy at the Florentine university, the Studio, and in 1404 he was appointed vice-rector. As a member of the college of doctors of arts and medicine, he continued to assist in the examination of degree candidates through the 1430s, and he is also documented as attending a meeting of the college in 1449.[33] In 1455 he served as consul of his guild, the Medici e Speziali. That maestro Giovanni thought his titles essential to his identity is proven by their inscription on the inside rim of the portrait bust sculpted by Antonio Rossellino in 1456, which names the sitter as "Magister Iohanes Magistri Antonii de Sancto Miniate Doctor Artium et Medicine" (pl. 70). He owned a library equipped with the principal medical texts and works in related philosophical disciplines, as well as "some books to read for pleasure," as declared in his 1427 tax statement.[34] He shared this precious resource with less fortunate colleagues, loaning the books from his collection, noting each loan and its return in his record book.

In the 1430s, as Giovanni began to withdraw from active practice, he seems to have made a protégé of Girolamo di messer Matteo Broccardi da Imola. In September 1438 he was one of Girolamo's three sponsors (*promotores*) for examination. Maestro Girolamo frequently borrowed from his mentor's medical library. This association is one clue to maestro Giovanni's political leanings, for Girolamo da Imola openly and actively supported the Medici against their humanist detractor Francesco Filelfo. After Filelfo was wounded by a hired thug in May 1433, Girolamo was arrested and under torture confessed to being responsible. His fine was paid by Cosimo de' Medici's brother Lorenzo. Giovanni's connections with Neri di Gino Capponi and his family further indicate that his sympathies were Medicean. He was godfather to Neri's grandson (also called Neri di Gino) and Neri was in turn the broker for the marriage of Giovanni's son.[35] Neri was among those who secured Cosimo's return from exile in 1434. He was, however, impor-

tant in his own right, "among the citizens of repute in the government," who had led the city's armies and who was both loved and feared for his power.[36]

In his 1451 tax statement maestro Giovanni declared that he earned nothing from his trade "except the good will" of his fellow citizens.[37] And virtually the only medical activity recorded in his account book, aside from his care for Donatello, was his post as physician to the nuns of Santa Felicita, an appointment dating from ca. 1440 for which he received the annual payment of 4 florins and a pair of capons, as well as the occasional spice cake and kid goat or goose for the feast days such as Easter, All Saints, and Christmas.[38] This was the sort of work that earned good will, and it was often undertaken by doctors as a charitable activity (although in some cases, not this one, it was possible to earn considerable stipends). But maestro Giovanni di Antonio not only had the prestige of his profession to support him, he had extensive financial resources as well. His father, in addition to practicing medicine, had acted as a form of moneylender and had invested widely in property. Giovanni continued these activities with great success. In the 1427 *catasto* he declared a net wealth of 7,613 florins with a tax of 38 florins levied. He was not only the wealthiest man in an affluent profession, he was among richest citizens of Florence. As noted above, in the 1458 *catasto* his assessment of over 33 florins confirmed his place in the top one per cent of Florentine householders. It was the fourth highest levy in his *gonfalone* (Drago) and the thirteenth in the large quarter of San Giovanni. In distinct contrast Donatello was, also as stated above, a three-*soldi* artisan.

As his name indicates, Giovanni's family origins were in San Miniato, a subject city of Florence located about half way between Pisa and Florence. Like many physicians in Florence, Giovanni's father, maestro Antonio, was an immigrant who had successfully sought the more profitable possibilities of the big city. The family had been granted Florentine citizenship, but they retained strong ties to San Miniato. Giovanni had a family house there, and most of his lucrative landholdings were in the surrounding area. Although Giovanni's eldest son Cosimo was buried in the family's Florentine parish church of San Michele Visdomini (in 1451), his wife was buried in the church of San Francesco in San Miniato (in 1437). Maestro Giovanni made his first will in 1425, as suited a man in his mid-fifties. He made another will in 1430, but he did not begin serious preparations for posterity until over twenty years later when further delay would have been imprudent. In the mid-1450s he made a series of testaments and donations. In this he followed the conventional path meant to lead to a good memory of his person and actions on earth and a smoother passage for his soul in purgatory. He obviously thought that this could be done most effectively in San Miniato, for almost all of his major investments in the afterlife were made there. In 1455 he endowed a chapel dedicated to the physician saints Cosmas and Damian in the Dominican church of Santi Jacopo e Lucia there (now the church of San Domenico). It was completed in April 1456.[39] He took over the patronage of a thirteenth-century oratory opposite the church, and built a hospice, both mentioned in his will of July 25, 1458. He made a further bequest of 20 florins to the Società del Corpo di Cristo for the celebration of the feast of Corpus Domini in that will. He funded the building of a dormitory for the friars of San Jacopo, endowed with property in his testament of December 5, 1459. In his will of February

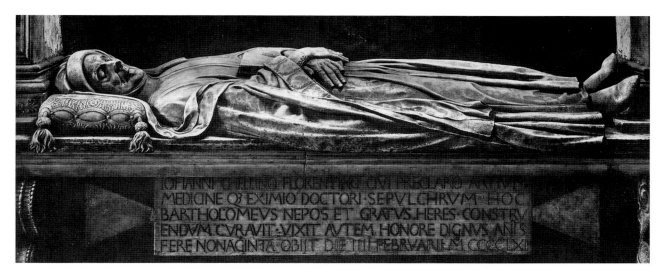

71 Attributed to Bernardo Rossellino, tomb effigy of maestro Giovanni di Antonio di Chellino da Sanminiato, ca. 1462–4, marble, San Domenico, San Miniato.

1460 maestro Giovanni specified that he was to be buried in his chapel in San Jacopo. His funerary monument, completed after his death and substantially altered over time, is attributed to Bernardo Rossellino and his shop. The effigy shows him dressed according to his state (pl. 71). He wears the full-length gown typical of scholars. The turned-up cuffs of his robes show the vair or ermine lining allowed for university graduates. He holds a book, which also records a privilege of his rank: according to sumptuary laws physicians were permitted to hold a book when laid out on the bier. Rather than be a minor figure in a Florentine pantheon, maestro Giovanni promoted his memory in San Miniato. There he could be a dominant figure and impress the townspeople with his costly tomb and pious largesse.

The doctor's patronage profile in Florence demonstrates the subtle distinctions that could be made about rank and station and the range of activities that can be associated with patronage. His name, "from San Miniato," located him outside the ancient and important families of the city. Clothing expenditures in the *ricordanze* do not include the fine silks and other luxury fabrics purchased by Florentine patricians. And despite his wealth maestro Giovanni was not a palace builder. He lived in a large house with a loggia, courtyard, and garden, which he bought from the wool guild and the works office of the cathedral (the Opera del Duomo) in 1433.[40] The major decorative expenditure on the house took place, appropriately, when his son Tommaso married the daughter of a Florentine patrician, Bartolomea di Andreolo di Niccolò di Franco Sacchetti, in 1451 (as noted earlier, this marriage was brokered by another Florentine of ancient descent, Neri di Gino Capponi). At that time Giovanni saw to the furnishing of their *camera*. In Florence, rather than erecting monuments, he built a network of connections. One of his closest business associates was another transplanted Sanminiatese, the enormously

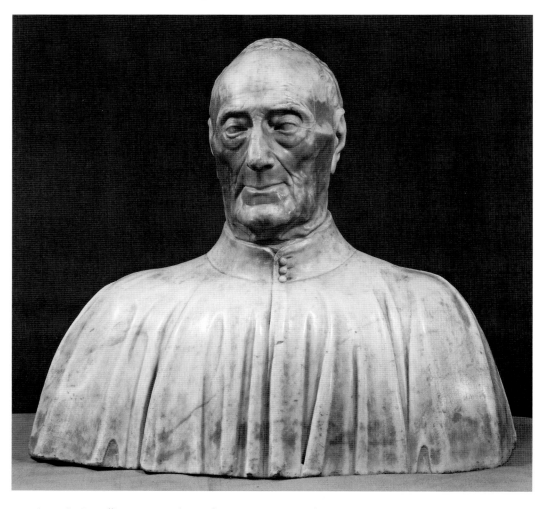

72 Antonio Rossellino, portrait bust of maestro Giovanni di Antonio di Chellino da Sanminiato, 1456, marble, height 51 cm., Victoria and Albert Museum, London.

successful banker, Giovanni Borromei, but he also carefully cultivated the confidence and friendship of members of prominent Florentine families like the Rucellai, Martelli, and Strozzi. He did business deals with them and he loaned them his silver plate for important occasions. He patiently worked to acquire the connections and avoid the enemies that would raise or could threaten his family's status in Florence. He does not seem to have been ambitious politically, but his loans and business transactions tended to favor the ruling Medici faction. His reward was not personal, but familial; his nephew and heir Bartolomeo eventually gained high public office, being elected to the Signoria as a prior in 1478.

It is a fact that maestro Giovanni cured Donatello. But it cannot be taken as a simple matter of fact. By his own declaration, he was no longer a regularly practicing physician.

Earlier in the month (August 3) he noted that he had given 24 *soldi* to maestro Giro-lamo da Imola for treatment given to his son Tommaso.[41] This record is on the same page as his paragraph about his own service to Donatello, two entries above it. He did not undertake Donatello's cure as a matter of course, of daily routine, or duty. He chose to help him, possibly using the calculation of good will to be gained from his fellow cit-izens following the formulation of his 1451 tax declaration. This sort of benevolence would be categorized as charity. But the terms maestro Giovanni uses in describing Donatello's gift and the gift itself transform any intended charitable patronage, with its unequal balance of generous donor and needy recipient, into another dynamic. The asymmetry of means is counterbalanced by a symmetry of honor.

Maestro Giovanni (pl. 72) had wealth and status. Donatello had talent and fame. These two estimable and esteemed old men (Giovanni di Antonio was eighty-six, Donatello was seventy) were also neighbors in the parish of San Michele Visdomini. Maestro Gio-vanni's house was to the north of the cathedral between Via dei Servi and Via Cocom-ero (now Ricasoli). On his return from Padua, Donatello had rented a house and shop from messer Manno di Giovanni Temperani next to the Opera del Duomo, a short dis-tance from the physician's residence.[42] One of Giovanni's family financial disputes was later settled in messer Manno's house.[43] Donatello's nephew, Giovanni di Bonaiuto Lorini, who acted as his guarantor in the rental agreement, was a distant cousin of maestro Giovanni's business associates and friends Bernardo di Taddeo Lorini and his son, Giovanni di Bernardo, and their cousin Antonio di Giovanni Lorini (in 1461 Antonio's sister Gianna married maestro Giovanni's nephew Bartolomeo).[44] They shared friends and contacts among other families in the quarter, most notably the Martelli. The potent triad of friendship, kinship, and neighborhood provides the mechanism that joined Donatello's medical need to maestro Giovanni's medical skill.

That the exchange was business and involved a valuable object explains its appearance in maestro Giovanni's record book. That Giovanni was a meticulous record keeper is obvious in all of his surviving documents: the *ricordanze* and his lengthy autograph tax declarations. Even so the episode is noted with remarkable elaboration. Maestro Giovanni's characterization of Donatello as the foremost sculptor in bronze, wood, and terracotta and his insistence on Donatello's courtesy are unprecedented in the record book. No one else is placed so carefully. No other action is so qualified. It is as though maestro Giovanni wanted to explain something to himself and to his descendants, for both the record book and the roundel would be part of his legacy to his family. The attention to details of definition – who exactly is Donato called Donatello – highlights a tension between standard practice (annotation of all major goods acquired, payment by exchange) and the actual case. With a gift so generous, so courteous, Donatello more than compensated for his cure. As courteous as his gesture might have been, it was also disruptive, because it demanded recognition on its own terms, terms that were highly favorable to the artist. The sense of its oddity is reinforced by the description of the reverse of the roundel and its purpose ("hollowed . . . so that molten glass can be cast on it"), which sounds as though remembered from Donatello's explanation. This was more than a valuable devotional talisman, it was part of the artist's ongoing fascination with

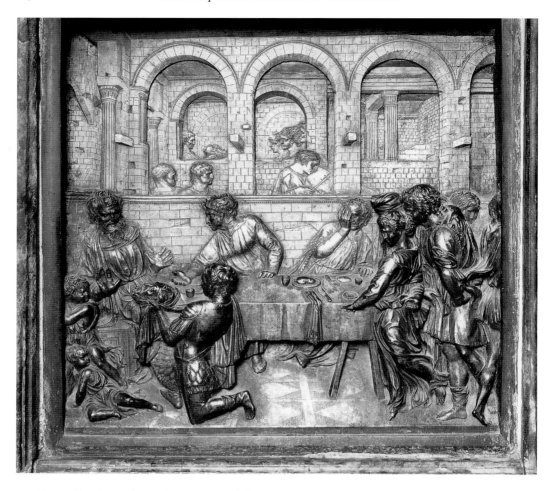

73 Donatello, *Feast of Herod*, ca. 1423–7, gilt bronze, 60 × 60 cm., Baptistery, Siena.

the materials and techniques of his craft. It was also potentially part of his working capital. Once given to maestro Giovanni, the mold could no longer be the origin of a series. Unlike other Virgin and Child compositions by Donatello, which became templates for repetition, this one virtually disappeared from circulation. There are only two modest gesso squeezes and a modified bronze version of the roundel. Passing from Donatello's property it became singular, like its maker.

Donatello was a master of discomfiture. His sculptures come to life through their defiance of the predictable. Figures in his reliefs seem restrained by their enclosing and encasing surfaces, or their actions seem arbitrarily or momentarily cut off by their frames (pl. 73). He proposed paradoxes and staged instabilities that act like chords clamoring for resolution. An over-life-size statue in the round, the ponderous and grave Saint Mark at Orsanmichele is given a pillow for a pedestal (pl. 74). Marble becomes straw matting and bulges disconcertingly from beneath the classical frame resting on it in the niche

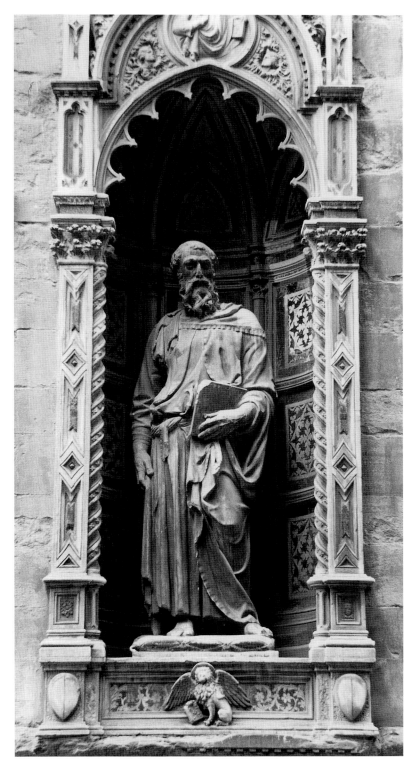

74 Donatello, *Saint Mark*, 1411–13, marble, height 236 cm., Orsanmichele, Florence.

75 Donatello, base of the niche for *Saint Louis*, Orsanmichele, Florence.

designed for Saint Louis at the same shrine (pl. 75). Such tactics of enlivenment are both disturbing and engaging. They take the prevalent terms of order, balance, and harmony and enter into a debate with them, forcing the viewer's participation (pls. 76, 77). Argumentation or dispute was a standard form of learning, as well as a commonplace of daily life and Donatello used it with the quick and irreverent wit for which he became famous. He literally took points of view to compose his works: perspective was one of the tools of his trade. It is integral to the sense and experience of all of his sculptures, which are as candidly illusionistic as they are effectively naturalistic. The success of this strategy of contradictions was acknowledged in an early critical summary of Donatello, who was praised for achieving "great vivacity in both the arrangement and positioning of figures, all of which appear to be in motion."[45]

Donatello's behavior seems to have presented similar challenges. In his life of Cosimo de' Medici, written sometime between 1480 and 1498, Vespasiano da Bisticci singled out Donatello as an example of Cosimo's friendship for all of the painters and sculptors of his day. He tells how Cosimo made sure to keep him in work and provided for his maintenance. Further, since Donatello did not dress as Cosimo wished he might, on one feast day Cosimo sent him a new set of clothes to wear: a rose-tinted cloak and hood and cape. The artist wore them once or twice and then told Cosimo that he did not want to do so any more because he felt that he was being made a figure of fun.[46]

76 and 77 Donatello, Martyrs Door, details, ca. 1437–43, bronze, each, 36.5 × 33.5 cm., Old Sacristy, San Lorenzo, Florence.

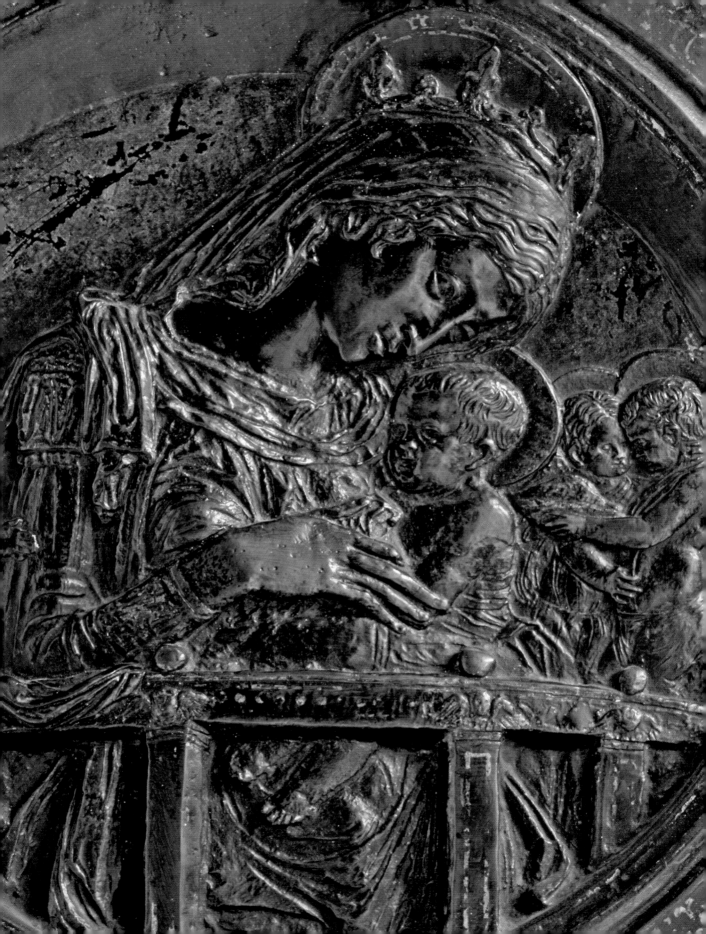

In this episode Cosimo is figuratively as well as literally patronizing. He acts as a sponsor of artistic endeavors, doing so from a presumed position of social and moral superiority. In this story his generous intention is thwarted. As a biographical example it is meant to instruct and amuse the reader by praising the patron/patrician at the artist's/artisan's expense. But there are underlying messages, which are revealing about the definitions of those roles. Cosimo's initiative is actually misguided. Donatello will not wear the robes due an honored citizen. Social positions are stated and shaken and confirmed, by both protagonists. The artist is necessarily the dependent, the client, uncouth in behavior, inferior in wealth and status. Presented as unconventional, he reasserts the convention by refusing to don clothes that do not suit his station. But at the same time that he renounces the sign of one form of respectability he signals his right to respect. He does not allow himself to be made or fashioned or refashioned: the artist's identity remains in his own control, and it depends upon his talent not his fine clothes. This moral tale, or *exemplum*, inserted in Cosimo's biography is a pendant to the documented case of the gift to maestro Giovanni. In both there is a subtle transfer of honor. Donatello is not subservient. He speaks and acts independently. He is able to overturn the wishes of a man as powerful as Cosimo de' Medici.

The historical incident and the historical anecdote both demonstrate the dynamics of honor that could serve as a motivating force for artistic excellence in the period. It is too often said or implied that the visual arts became noble or liberal at this time and that this was a consequence of humanism. Literary men undeniably took up the theme or the topic of the nobility and the hierarchy of the arts. Parallels were made between the visual arts and the learned disciplines, but their mechanical element was never forgotten, and artists remained artisans. As artisans, however, they were granted the possibility of fame and their endeavors were attached to their city's glory in a classicizing literature of civic celebration. But just as important as what humanists wrote, which circulated among a limited, if influential, group, was what they and others could see. Perhaps, to borrow a metaphor from maestro Giovanni's profession, the symptom has been mistaken for the cause. Alberti's treatise on the "new science" of painting was inspired, he wrote, by the genius he recognized in the contemporary artists of Florence. The perspective of history might productively be shifted from the texts that articulate the phenomenon of creativity, to its contexts – to the arena of social interaction where expectations were formed and transformed, where conventions could be affirmed and challenged. It is on this stage that artists like Donatello could play the game of honor and by using their special skills could win the recognition, or *reputazione*, that gave common craftsmen uncommon prominence in their city's cultural identity.

78 (FACING PAGE) Donatello, *Virgin and Child with Angels* ("Chellini Tondo"), detail of pl. 56.

PART II

The Eye and the Beholder

79 (FACING PAGE) Fra Filippo Lippi, *Coronation of the Virgin*, detail of pl. 192, showing Saint Theopista.

Chapter Four

SEEING AND BEING SEEN

IN OCTOBER 1462 FRANCESCO SFORZA, the Duke of Milan, ordered three dozen pairs of eyeglasses from Florence, "because there are many who request of us eyeglasses that are made there . . . since it is reputed that they are made more perfectly [there] than in any other place in Italy."[1] He had previously ordered eighteen pairs, and soon after he died his successor, Galeazzo Maria, ordered fifty more, "perfectly made according to the ages specified in the list."[2] The picture of the bespectacled court with the young and the elderly, near-, far-, and normal-sighted alike sporting their new glasses is in itself interesting to contemplate, but the episode is significant here as an indication of Florentine predominance in technologies of vision (pl. 80).

In the realm of artistic ingenuity, fascination with the phenomenon of seeing underlay Brunelleschi's invention of linear perspective, Ghiberti's book on optics in his *Commentaries*, and Leonardo da Vinci's ceaseless investigation of nature. As Leonardo noted, the eye is "is said to be the window of the soul," and he asked:

> do you not see that the eye embraces the beauties of all the world? It is the master of astronomy, it makes cosmography, it advises and corrects all human arts, it carries men to different parts of the world, it is the prince of mathematics, its sciences are most certain, it has measured the heights and the dimensions of the stars, it has found the elements and their locations. It has predicted future events through the course of the stars, it has created architecture, and perspective, and divine painting . . . The eye is the window of the human body through which the soul views and enjoys the beauties of the world.[3]

The humanist Leon Battista Alberti took a winged eye for his emblem (pl. 81). This choice is explained by his reverence for the eye as

> more powerful than anything, swifter, more worthy . . . It is such as to be the first, chief, king, like a god of human parts. Why else did the ancients consider God as something akin to an eye, seeing all things and distinguishing each separate one.[4]

Lorenzo de' Medici, in the guise of poetic lover, wrote extensively about the "most splendid and amorous eyes" of the lady who captured his heart through the very power of those eyes.[5] He explained how "the image of her beauty . . . descended through [his] eyes

81 Leon Battista Alberti, *Self-Portrait*, 1432–4, bronze, 20.1 × 13.5 cm., National Gallery of Art, Washington, Samuel H. Kress Collection.

into [his] heart, and her eyes had made such an impression that they were always present."[6] He carefully analyzed the delight and the torment of looking at her, listing the causes of his "intent gazing" and explaining its effect of making the eyes happy while the heart "burns with love that never has peace."[7]

While the sighing sonneteer could idealize female eyes, conventional morality distrusted their power, fearing that eye contact could provoke lustful thoughts and lascivious acts. Responsible parents were meant to protect their daughters from unwelcome exposure, and to keep them away from the city's piazzas, and from the windows, balconies, and doors of their own homes. In the public sphere, the officials charged with dealing with sodomy proclaimed that they were "watching with unceasing diligence so that the horrible crime of sodomy might be rooted out of the city and its territory."[8] Using a similar vocabulary of vigilance, Alberti advised fathers to watch over their households so as to responsibly monitor the behavior of their families.[9]

Exhortations to look could also be demonstrative. In a typical passage of praise, one of the city's eulogists urged his readers to see its ancient heritage, to "look . . . carefully" at the Baptistery, for example, as

a temple of outstanding beauty, built in the Roman style. Look at it carefully and you will realize that there is no other example, either in Italy or indeed in all Christendom, that can compete with its extraordinary elegance. Look at the uniform columns inside it . . . Look at the columns and the walls . . . Look at it carefully inside and out . . .[10]

However rhetorical the construction, the imperative was based on observation, and can be related to regular habits of visual engagement with the city and its daily affairs. Leonardo wrote that artists should take note when going about to "see and consider the circumstances and behavior of men in talking, quarrelling, or laughing and fighting together" and also the "actions of the bystanders" including those "who look on."[11] This advice, which presents a picture of artist-observers and active onlookers, recalls a range of possible exchanges – seeing, looking, and watching – taking place in the city's public spaces.

Social control, sexual desire, scientific endeavor were among the areas subject to forms of visual attention. Some modes of viewing and vision were highly theorized. As will be discussed in Chapter 6, religious vision and related types of sacred viewing referred to developed theological and philosophical traditions. Erotic gazing had lofty poetic precedents. The substantial literature treating of spiritual and amorous eyes was matched by the considerable amount of writing devoted to the physical operation of vision, which had become a subject of great interest in university circles in the twelfth and thirteenth centuries. The science of optics (*perspectiva*) provided explanations of the mechanisms of sight that were widely diffused. The reading notes assembled by Ghiberti in his *Commentaries* (from ca. 1447 to his death in 1455) and made by Leonardo starting in the 1480s show that the basic texts were available to artists. Alberti was the first systematically to apply the principles of *perspectiva* – the geometry of vision – to problems of pictorial representation in his treatise *On Painting* (written in Florence in 1435). His work had been preceded by Brunelleschi's experiments in painting panels with calculated renderings of the Piazza della Signoria and the Baptistery, projections that won him the contemporary reputation for discovering "that which painters today call perspective."[12]

This new field – the perspective of depiction as opposed to optical science – generated its own literature of speculation and proof among artists eager to explore and to demonstrate the theoretical basis of their profession. It is a mistake, however, to overstate the place of the technique of perspective construction among the many and various compositional strategies used by Florentine artists. To understand perspective or to be understood as being good at perspective was only one aspect of being an excellent master. So, for example, when Cristoforo Landino praised Masaccio, Donatello, and Uccello for their skill as perspectivists in his commentary to *The Divine Comedy*, he included this as but one of their achievements, which had a number of other facets, such as their ability to imitate nature, to create the impression of relief, and to compose figures and scenes with variety, facility, grace, and charm.[13]

It is equally misguided to refer to Alberti's book as though it were a form of set text or manual for the artists of Florence. Its circulation was probably very limited and its

direct influence must be traced with extreme care. Neither Ghiberti nor Leonardo cite Alberti as an authority on the matter of spatial construction. Ghiberti was concerned with optics as a branch of knowledge necessary to the skilled and learned practice of his art, and excerpted the standard authorities of that science, quoting from the fundamental work written in the early eleventh century by the Islamic natural philosopher Alhazen (*De aspectibus*), and the subsequent treatises written in the thirteenth century by Roger Bacon (*Perspectiva*), John Peckham (*Perspectiva communis*), and Witelo (*Perspectiva*). Leonardo, who dealt with artist's perspective as well as perspective as optics, does not attribute the technique of pictorial construction to Alberti, but speaks of it as a common practice.

The passage of perspective from scholars' studies to artists' shops took more than one route. It was a compelling matter: those artists who engaged with the power of the eye were also engaging with the status of their art. This was not only by applying learning to skill, but by taking command of the beholder's experience, directing the eye in a manner that united perception with reception. Reference to the geometry of vision in the crafting of images reinforced their mimetic power by linking the structure of compositions to the process of cognition. This possibility arose from the fact that according to contemporary psychology, seeing and understanding were connected.

Like optics, human psychology was an established field of learning and learned commentary, in this case descended from Aristotle's book on the soul, *De anima*. Predictably, over the centuries there had been much debate about the nature of perception, but it was generally held that sensory forms or impressions from the five external senses (sight, sound, hearing, touch, smell) were received in a part of the brain containing the power or faculty called "common sense" (pl. 82). This was defined as one of the internal senses, which further included the fantastic or imaginative, the estimative, and the memorative. Broadly, it was considered that the process of cognition occurred as the *imaginatio* composed phantasms or images from the sensory data, which could be acted upon by the faculty called the estimative (in all animals) or the cogitative (in the specifically human or rational soul). The memory was a storehouse of images that could be summoned up to recollect and to reason. Although there were varied interpretations of the process, its structure gave primacy to sight as a means of apprehension. Aristotle had written that "sight . . . most of all the senses, makes us know and brings to light many differences between things."[14] In his commentary on *De anima*, Thomas Aquinas stated that "the sense of sight has a special dignity; it is more spiritual and more subtle than any other sense."[15] These notions were unquestioned in fifteenth-century Florence. Archbishop Antoninus, for example, explained in his *Summa Theologica* that "sight is the most spiritual because it is not altered in sensation, at once the most perfect of the senses and the most common."[16] The poet Feo Belcari opened one of his sacred plays reminding his audience that "the eye is called the first of all the gates through which the intellect apprehends and appreciates."[17]

The physiological, psychological, philosophical, and theological theories regarding the sense of sight, the action of seeing, and access to higher forms of vision provided the underlying logic for the organization and understanding of visual experience. But they

82 Leonardo da Vinci, *Vertical and Horizontal Sections of a Head, Showing One of His Variations on the Three Ventricles, the Location of the Faculties*, ca. 1493–4, red chalk and pen and ink, 20.2 × 14.8 cm., Royal Library, Windsor, 12603 (recto).

do not explain its particular nature for fifteenth-century Florentines. Any attempt to do so must inevitably refer to Michael Baxandall's book on *Painting and Experience in Fifteenth Century Italy*, where he describes the interpretative skills that constituted the "period eye" or "cognitive style": "By this one would mean the equipment that the fifteenth-century painter's public brought to complex visual stimulations like pictures."[18] That equipment included the "culturally relative pressures on perception" – the "patterns, categories, inferences, analogies" used to order visual stimuli.[19] In this analysis pictorial style can be studied as a useful material of social history because

> A society develops its distinctive skills and habits, which have a visual aspect . . . and these visual skills and habits become part of the medium of the painter: correspondingly, a pictorial style gives access to the visual skills and habits, and through these, to the distinctive social experience.[20]

Baxandall calls his book a primer, because in it he offers preliminary or basic instruction in the language of pictorial representation. He does this by exemplifying "the kinds of visual skill a Quattrocento person was distinctively equipped with, and try[ing] to show how these were relevant to painting."[21] The "person" or the "mind" in question does not represent

all fifteenth-century people, but . . . those whose response to works of art was impor-
tant to the artist – the patronizing classes, one might say. In effect this means rather
a small proportion of the population: mercantile and professional men, acting as
members of confraternities or as individuals, princes and their courtiers, the senior
members of religious houses.[22]

Especially in the guise of merchant, confraternity member or cleric, this man was very
influential in the realm of picture ordering and picture appreciating in fifteenth-century
Florence, and his powers and vocabulary of discrimination were probably influenced by
his training in commercial mathematics or attention to the art of preaching, as well as
his pleasure in dancing. These made him alert to volumes and spatial intervals, sensitive
to shapes and to the meanings and decorum of gestures and movement in ways memo-
rably described by Baxandall.

But it can be argued that the reading of pictorial style or social experience as envi-
sioned and as viewed need not be restricted to the notional Renaissance man of the
picture-buying class. Although "the peasants and the urban poor play a very small part
in the Renaissance culture that most interests us now" and were largely disenfranchised,
they were nonetheless churchgoers and piazza frequenters.[23] They were witnesses to sacred
ritual and public spectacle and were meant to be impressed by the attendant imagery
and able to respect its messages about hierarchy and the honorable ordering of society.

It is undeniable that the poor are generally conspicuous by their absence from repre-
sentation in the fifteenth century, but there is a notable exception: the scenes from the
life of Saint Peter painted in the 1420s by Masaccio and Masolino for the Brancacci family
chapel in the church of Santa Maria del Carmine. It is a case worth considering because
it reveals how visibility and viewing relate to social experience.

The neighborhood of the Carmine, near the tenements of Camaldoli, was character-
ized by its high density of working-class and impoverished residents. The church housed
a confraternity that regularly undertook charitable works in the area and that distributed
bread to the poor at Christmas and Easter. The "wretched poor" (*poveri miserabili*), old
and young, the crippled and defenseless – residents of the area – are also present in the
chapel as protagonists in the ever-recurring story of Peter's apostolic mission and as part
of its message of salvation (pls. 83, 84). By means of the paintings, Peter's distribution of
alms and miraculous healing are brought to familiar settings, therefore to be recollected
and imitated in those settings. In one scene a young mother dressed in a tattered robe
holds her bare-bottomed baby in her right arm while receiving charity from Peter with
her left hand. Here the humble are literally higher than the rich. The greedy Ananias lies
dead in front of the woman, struck down when Peter justly accused him of withholding
a portion of his money, as told in Acts (5 : 1–2). The counterpoint to Peter's down-
stretched arm is found in the upward gesture and devout gaze of the wealthy man who
kneels behind him, making an offering. His red robe (like that of Ananias) and the palace
behind him are signs of his status. His position makes him a secondary, but pivotal figure:
his piety mediates poverty, and his means have been converted to social benefit through
religious acts of faith and good works.

83 (FACING PAGE) Masaccio, *Saint Peter Distributing Alms*, ca. 1427, mural, Brancacci chapel, Santa Maria
del Carmine, Florence.

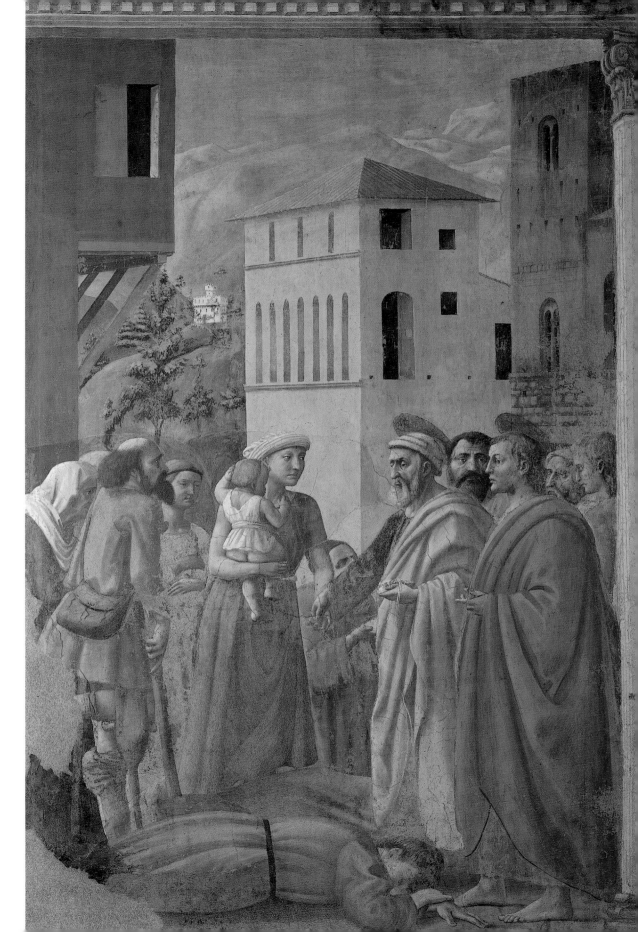

84 Masaccio, *Saint Peter Healing with His Shadow*, ca. 1427, mural, Brancacci chapel, Santa Maria del Carmine, Florence.

The structure of the scene presents an integrated view of secular responsibility and ecclesiastical authority embodied in Peter and John as they carry out their apostolic mission. It is implied that it has continued to be fulfilled in the city by the Carmelites and their parishioners. The latter, of course, included well-to-do citizens, like the Brancacci, the patrons of the chapel, which had been endowed in the name of Peter, the patron saint of its founder, Pietro di Piuvichese Brancacci, who died in 1367. When his descendants saw to the chapel's building and decoration, they performed a pious act contributing to the liturgical life of the church as well as its embellishment, which also testified to their prestige.

In the Ananias episode the impact and immediacy of its charitable messages are reinforced by the thoughtful expression of the man between Peter and John who looks outward (pl. 85). His frontal pose is unusual and it interrupts the rhythm of profiles and three-quarter views of the other faces. Breaking the illusion of recession within the scene, the face insists upon the picture plane. At the same time the out-turned eyes address a

85 (facing page) Masaccio, *Saint Peter Distributing Alms*, detail of pl. 83.

86 Andrea del Castagno, *Last Supper*, ca. 1449, mural, refectory, Sant'Apollonia, Florence.

space beyond the picture, calling attention to the viewer's own act of looking. Masaccio has skillfully called into play a face-to-face encounter, which activates a process of recognition, reminding the viewers (or worshippers) of their positions as witnesses who might identify in various ways with the charity, compassion, and authority of the story set both before and among them.

Such a monumental description of the mix of the city's inhabitants was extraordinary, and must be specifically connected with the position of the Carmine and the Carmelites in their neighborhood. Otherwise the population of sacred and secular images largely excludes any direct reference to the poor. That suppression or removal is a cultural maneuver: it fashioned the ideal city and society in an aestheticized version of the elite. It is a controlling device that pushed the lower orders beyond the margin of representation just as they were being marginalized by the campaigns of palace building and urban development, which increasingly confined them to the city's edges. So as Luca Pitti was building his palace in the 1450s, he felt justified in petitioning the city to allow him to purchase and clear a nearby street used only by "dishonest persons," arguing that it was offensive and a disgrace to the city being placed in the midst of upstanding citizens.[24] He and his family should not suffer the insult of always having "before their eyes such ugly things."[25] Although the role of the poor was indirect, the negation of their visibility was a force in the formation of public discourse and its visual manifestations.

Gender as well as class is a factor to remember in discussing the nature of visual culture and contemporary viewing, and it is absolutely and significantly the case that in the fifteenth century the disembodied "eye" and the normative brain were understood as male. After all, according to the accepted definitions, women were imperfect versions of men, less controlled by reason, and naturally inferior to them. Social ideology assumed male dominance, and male control of the picture field could be considered a logical consequence. Still, even though their powers of understanding might have been conventionally despised, women's place as viewers and as protagonists in the realm of viewing was far from negligible. Manuals of religious instruction addressed to women demonstrate the degree to which they, as mothers and as worshippers, had a place in educating or instructing others as devotional beholders. Nor was the patronizing class entirely male. Women, lay and religious, commissioned works and works were commissioned for female religious institutions, sometimes directly by women, sometimes with male mediation. Whether or not they could also be called cultivated beholders in Baxandall's sense, they certainly participated in the culture and the commerce of beholding.

An examination of works such as the mural of the *Last Supper* painted by Andrea del Castagno on the end wall of the refectory of the convent of Sant' Apollonia (an enclosed Benedictine nunnery) suggests that no concessions to the female eye were made

87 Andrea del Castagno, *Saint Jerome with the Trinity and Saints Paula and (?)Eustochium*, 1453, mural, Corboli chapel, Santissima Annunziata, Florence.

in terms of style or visual complexity; rather it shows how accommodation to a specific form of viewing took place in the composition of the subject matter (pl. 86). Artists did not seem to respond to such commissions with a feminine or feminized manner of painting. Here, for example, Castagno's rugged and austere manner is consistent with his other works, such as the mural of *Saint Jerome's Vision of the Trinity* in the Servite church of Santissima Annunziata (pl. 87). But in each instance the subject is arranged to be seen in a way that enhances its pictorial force and devotional messages. The perspective difficulty in the Servite mural – the foreshortening of the Trinity as it looms over Jerome – represents the saint's apprehension of the theologically difficult concept. The worshipper witnesses the effort, the complexity, and the wondrous quality of the vision all at once (while also admiring the artist's skill at such a rendering of the miraculous vision).

88 Andrea del Castagno, *The Resurrection, the Crucifixion, the Entombment*, ca. 1449, mural, refectory, Sant'Apollonia, Florence.

The Sant'Apollonia mural, with its intense and uncompromising masculinity, confronted the nuns with a similarly dramatic physicality. In this case the rich setting of the scene, enclosed in its own constructed space, articulated the nobility and grandeur of the moment depicted. Difference and separation are asserted by the spatial illusion, by the decoration, by the protagonists shown. The image is immediate, but it is not composed as though continuous with the refectory's actual space. The nuns did not share the mission of the apostles (unlike the friars of the Carmine, for example, who were meant to go out among the people and preach and do good works); the nuns' lives were dedicated to remembrance and prayer. The pictorial ensemble gave them a series of striking images for contemplation and meditation, so as to be able to recall the horror of Judas's betrayal and the perplexity, sorrow, and love of the other disciples. Looking upwards (pl. 88), they could witness the physical incarnation of Christ, with its promise of salvation, and remember the grief and compassion of the female participants in the Passion. The murals are a form of memory device – images that could call to imagination and to cognitive awareness (or consciousness) the fact and the meaning of the Passion. Reception rather than a specific, female form of perception is incorporated into the structure of the scene.

A woman's response to art is recorded in one of the few surviving casual remarks about paintings, where she expresses her opinion about their beauty and possible resale value. Having received some paintings on cloth from her son Lorenzo in Bruges, who does not seem to have paid much attention to them, Alessandra Strozzi wrote that one was of the Magi,

and they are good figures, the other is a peacock, which seems noble [*gentile*] to me, and it is adorned with other foliage. They seem handsome to me: I will keep one of them . . . because according to what you said . . . they cost, one would only get three florins profit here from each; because they are small cloths. If I could sell them well, I would sell both. I will keep the Holy Face, because it is a devout figure and a beautiful one.[26]

Although her critical vocabulary may seem limited now, the range and application of terms is no more restricted than that of her male contemporaries. She appraises the quality of the figures, as good, and characterizes their expression as devout. She applies the word *gentile* to the peacock and foliate ornament, which seems similar to a form of decoration that was recalled by Giovanni Rucellai when he wrote about the ancient mosaics that he had seen in the church of Santo Stefano Rotondo in Rome, with "foliage in clusters and bunches of grapes and inlay and other *gentileze*" and the foliate motifs at Santa Costanza, which he thought was "the most charming, graceful, and *gentile* mosaic not only in Rome, but in the whole world."[27] A comparison of his remarks about things he saw in Rome with Alessandra's about those in her home shows that her descriptive vocabulary was similar to his and is employed to note the same qualities.

Given the generation of feminist study and interest in gender that has passed since Baxandall's book was published, this revision to his list of protagonists is obvious. It suggests the need to add a chapter to his primer to extend the discussion of skills, patterns, categories, and habits to some that might be shared, if not specifically female. Skill in the art of dance, for example, was highly regarded in both men and women. In fact it was one of the few activities that allowed women a public role. Dances were held to honor and to impress diplomatic guests and during the major festivals as well as at wedding feasts. At those times the beautiful young girls and handsome young men of Florence were equally on display, finely dressed and decked out with jewels. Baxandall has suggested ways that the patterns and stylized movements of dance, as recorded in treatises on the subject, might be related to the contemporary understanding of compositional groupings in paintings. He takes the coincidence of patterns between a dance called Venus, composed in the 1460s by Lorenzo de' Medici, and Botticelli's graceful figures in the *Primavera* (pl. 89) as an instance, not to say that the

> particular dance . . . influenced the particular picture: it is that both the dance and the picture of Venus were designed for people with the same habit of seeing artistic groups. The sensibility the dance represents involved a public skill at interpreting figure patterns, a general experience of semi-dramatic arrangements that allowed Botticelli and other painters to assume a similar public readiness to interpret their own groups.[28]

It was also an activity that instructed girls in composing themselves as ingratiating and graceful objects of sight, and in how to judge themselves and each other: an experience of looking that could be transferred to engaged viewing.

89 Sandro Botticelli, *Primavera*, ca. 1478–82, panel, 203 × 314 cm., Galleria degli Uffizi, Florence.

Women were also reputed to have ruinously avid eyes for fashion and finery. A succession of frustrated lawmakers sought to restrain their notorious desire "to decorate themselves with . . . expensive ornaments."[29] Material interest in this sense is well documented in the linen and fine cloths included among dower goods and the clothing inventoried as part of household goods. Spinning, sewing, mending, and making were all female domestic arts. As part of her household duties, Piero de' Medici's wife, Lucrezia, regularly organized the transfer of clothes and bed linens between the family properties, for example; so when she chided her husband for having confused her orders, she carefully specified the location and fabric of the required item.[30] She wrote in a very different tone to Filippo Strozzi, who had made her a gift of a quantity of flax that she had commissioned another friend to purchase, saying that she "had never seen such beautiful flax nor could I have received anything that I desired more."[31] When Filippo's sister was being prepared for marriage, his mother wrote him to detail the clothes the groom was ordering, which included

> a gown of crimson velvet . . . made of silk and a surcoat of the same fabric, which is the most beautiful cloth in Florence . . . And he ordered some crimson velvet to be made up into long sleeves lined with marten . . . And he's having a rose-colored gown made, embroidered with pearls.[32]

90 Domenico Ghirlandaio, *Visitation*, 1485–90, mural, Tornabuoni chapel, Santa Maria Novella, Florence.

This expertise was not exceptional. During the negotiations for his daughter's marriage, one beleaguered father referred to the opinions of the women of the family on the subject of her bridal clothing: "The women have decided that Caterina's dress will be made of blue silk and that the gown will form part of the dowry; this was a wise decision."[33] The wives and daughters of the merchants and professional men of the city had eyes well-schooled in discerning the cut and quality of cloth. No less than the men, they commanded a vocabulary of color and were adept at making discriminations of textures, shades, and shapes. Though not trained in commercial mathematics, they could measure and price such goods, as well as other household commodities.

It can be said, therefore, that at least for the elite, some aspects of social practice (dancing and housekeeping, for example) and material culture (such as cloth and clothing) connected female experience to representation. Alessandra Strozzi's detailed appreciation of her daughter's bridal wardrobe as well as her sharp-eyed inspection of potential daughters-in-law could easily be transferred to a description of the young women of the Tornabuoni and Sassetti clans as pictured in their family chapels (pls. 90, 108). These women and their attendants are literally fashioned. They are characterized by their costume: the cut, the cloth, the color of their garments are detailed to display and to distinguish their station and their status.

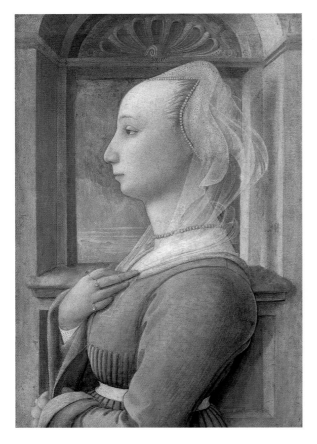

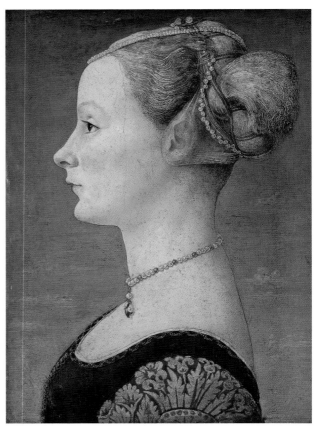

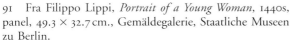

91 Fra Filippo Lippi, *Portrait of a Young Woman*, 1440s, panel, 49.3 × 32.7 cm., Gemäldegalerie, Staatliche Museen zu Berlin.

92 Antonio del Pollaiuolo, *Portrait of a Young Woman*, ca. 1470, panel, 47.6 × 34.5 cm., Museo Poldi Pezzoli, Milan.

Individual portraits were similarly coded. The profile portraits by Fra Filippo Lippi and Antonio del Pollaiuolo, for example, present visual inventories of the garments and jewelry worn by young women at the time of marriage, when they took on their role in the exchange of family honor created by marital alliances (pls. 91, 92). Accessories were significant, and their precise description in these and other works of art suggests enumerative habits of viewing. Not only the clothes – the veil, pearls, rings, and heavy wool dress shown by Lippi, the gold brocade on red velvet, the pearls, and the ruby pendant, shown by Pollaiuolo – but the features are itemized according to desirable qualities. Looking at the pictures is like looking through the eyes of Alessandra Strozzi as she saw the girls available to her son as the "merchandise" on the marriage market. "Big and beautiful," they have high foreheads, fair and healthy complexions, long necks, pink lips.

Modesty and a well-conducted life were the adornments of virtuous women, according to Matteo Palmieri, as he wrote in his book *On Civil Life*, and "the other orna- ments, which are clothing, accessories and adornments should be adequate and in con-

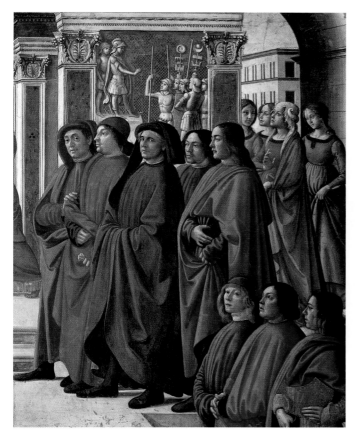

94 Donatello, Martelli arms, 1440s–1450s, marble with traces of polychromy, 130 × 80 cm., Museo Nazionale del Bargello, Florence.

93 Domenico Ghirlandaio, *Annunciation to Zacharias*, detail of pl. 4.

formity with the power and wealth and condition of those wearing them."[34] Clothing consciousness was class consciousness, for both men and women. When Donatello dressed the shield-bearer who heaves up the Martelli arms in a worker's shift, he set the weight of the family's dignity in the context of the moment of display, in an intriguing bit of social commentary (pl. 94). Subversive or sympathetic on Donatello's part, the Martelli pinned this performance of their status to their palace, accepting the terms of its juxtaposition of high and low. By contrast with this potentially volatile image, the stability of the state was unequivocally asserted by Florentine men qualified to hold office when shown in their deep red or purple cloaks, with their *cappucci* or hoods (pl. 93). Simple, but relatively costly, these garments were standard public garb during the life of the republic. Not subject to stylistic whims, this clothing expressed the continuity of civic traditions and of the lineages that constituted its governing class.

It is not surprising that Florentine painters and sculptors took care in detailing dress: showing the type and quality of fabrics, the layers of garments, the belts, the buckles,

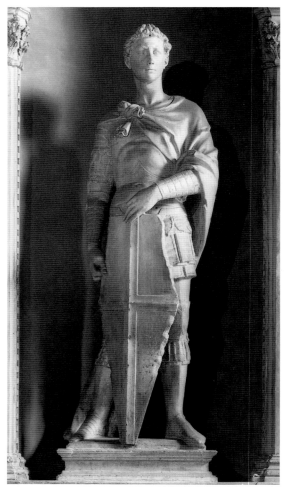

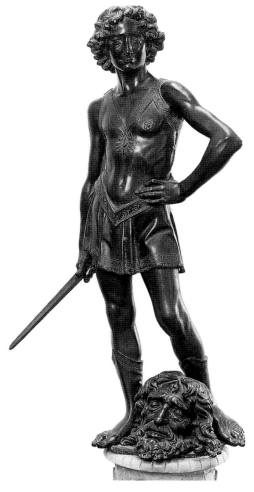

95 Donatello, *Saint George*, ca. 1417, marble, height 209 cm., Museo Nazionale del Bargello, Florence.

96 Andrea del Verrocchio, *David*, ca. 1473–5, bronze, height 126 cm., Museo Nazionale del Bargello, Florence.

the buttons, the borders. Components of the material economy – products of the city's tailors and the goldsmiths and the staple trade of its dealers in second-hand goods – they also had strong representational value. Artists took close notice of costume, whether in devising fanciful or "actual" clothes, in portraits or in portrayals of holy figures. Donatello's statue of Saint George for the niche of the Armorers' Guild at Orsanmichele stands bold and vigilant in a stance determined by his armor, whose components and materials are meticulously represented (pl. 95). Verrocchio clad his bronze *David* with equal attention to detail: the V-necked jerkin is buttoned along the side and hinged at the shoulders (pls. 96, 97, 98). The fit of the garment, tight against the raised left side, looser along the right, responds to the implied motion of the figure. The contrast of the

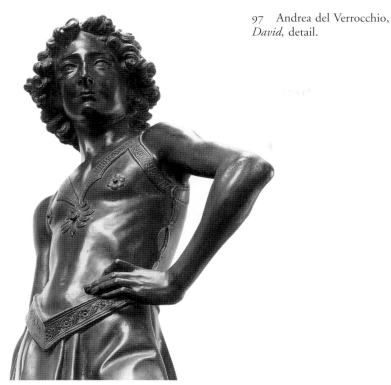

97 Andrea del Verrocchio, *David,* detail.

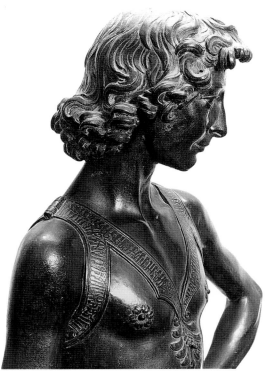

98 Andrea del Verrocchio, *David,* detail.

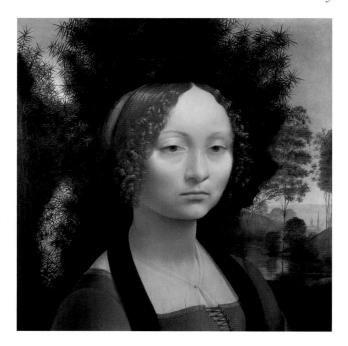

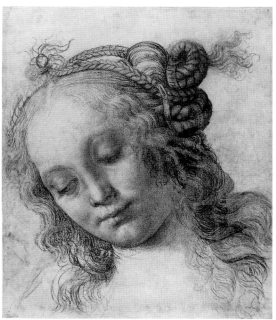

99 Leonardo da Vinci, *Ginevra de' Benci*, ca. 1475–6, panel, 38.1 × 37 cm., National Gallery of Art, Washington, Ailsa Mellon Bruce Fund.

100 Andrea del Verrocchio, *Study of a Female Head*, 1475, black and white chalk, 31.8 × 26.5 cm., Department of Prints and Drawings, British Museum, London, 1895-9-15-785 (recto).

clinging upper garment with the heavy folds below the waist emphasizes the figure's bold and youthful charm, and impresses David's physicality upon the viewer. Even the gossamer shifts of the nymphs of Botticelli's *Primavera* are constructed in distinct layers, with buttons, laces, and fastenings picked out in gold (pl. 89). The undress of the Graces is all the more tantalizing for its relation to actual dress. For these artists, as for others, the logic of clothing was a form of visual reasoning, which confirmed their imitation of nature and could convey messages about role, rank, and character.

The "skills and habits" which gave access to such visual codes and categories were possessed by the women as well as the men of the "patronizing classes." With respect to women, letters and legal documents record them as sharp observers. It is difficult to describe gendered styles of cognition without relying on the behavioral conventions that enforced social stereotypes. Yet even within the bounds of such prescriptions, which made downcast eyes and averted glances the signs of idealized modesty, devout gazing, rapt attention, and steady looking were also permissible attitudes, acknowledging a range of female ways of seeing (pls. 99, 100, 101, 102).

* * *

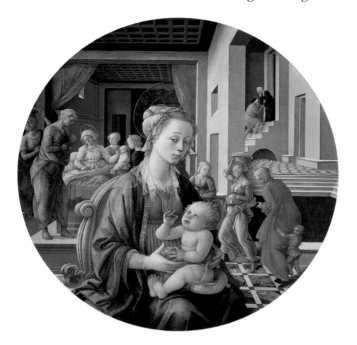

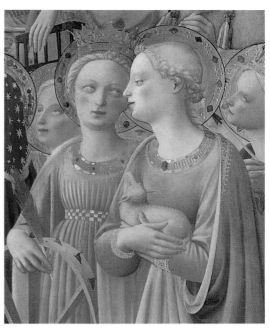

101 Fra Filippo Lippi, *Virgin and Child* ("Bartolini Tondo"), 1452, panel, diameter 135 cm., Galleria Palatina, Palazzo Pitti, Florence.

102 Fra Angelico, *Coronation of the Virgin*, detail of pl. 185.

SCRUTINY: SIGHT AND SOCIAL PRACTICE

The eye had political and legal functions in Florentine society. "To be seen" – *essere veduto* – was to attain eligibility for public office, which was established through "scrutiny," *lo squittino*. Electoral commissions drawn from the governing bodies voted on nominated candidates; the names of those approved by a two-thirds majority were put into bags or purses, to be drawn out when offices became vacant. This process was instituted as the basis of the electoral system in 1328, the result of a reform of the city's government undertaken in order to "eliminate the factions among citizens."[35] The lawmakers explained that their desire was:

> that henceforth those citizens of Florence, who shall be approved by the favorable consensus of the good and law-abiding citizens as worthy and sufficient in their life and customs, may in fair measure achieve and ascend to the honors [of political office], and . . . to prevent those persons whose life renders them unworthy from zealously seeking the governance and rule of the city.[36]

In effect reputation was being scrutinized. Over the centuries many forms of influence, friendship, and connection played their part in proving worth, but the system meant that being seen to be "sufficient in life and customs" was an aspect of being politically visible.

As objects created for ritual observance, and for honor, adornment, and admiration, works of art had a role in this system of sufficiency. For individuals they were part of creating a public persona and family reputation. Cumulatively and collectively they demonstrated the prosperity of the city, "the power, the strength, and the glory that the Florentines have at present," which Benedetto Dei described as "Florentie bella," listing its palaces, piazzas, and churches, so that those "who do not know what Florence looks like" could "learn, understand, consider, and appreciate what this city is like."[37] In a passage reflecting rather critically on the loss of liberty the city experienced during Cosimo de' Medici's regime, Marco Parenti nonetheless described the "joyous, affluent state" and prosperity of the era according to its manifestation in "sumptuous feasts, jousts, pageants, weddings, balls, and banquets," costly clothing, jewels, and "magnificent buildings both inside and outside the city walls"; he commented that "many distinguished Florentines possessed attractive residences appropriate to their station, with furnishings, servants, horses, and the like."[38]

The recollection of appearances played a significant role in legal procedures. The Florentines did not have a single court system. In addition to the three major criminal courts run by the foreign *rectores* appointed for six-month terms (the Podestà, the Captain of the People, the Executor of the Ordinances of Justice), there were, among others, the ecclesiastical and civil courts, such as the archbishop's court, the Merchant's Tribunal (Mercanzia), and the guild courts. These courts followed inquisitorial procedures derived from Late Roman law. In such trials a formulary, or *libellus*, was compiled, containing a statement of the allegations that constructed the case. Witnesses for the defense and the prosecution were then interrogated according to the points set out in the *libellus*.

In the course of the fifteenth century these courts were supplemented, and in large measure supplanted, by citizen magistracies. The tribunal of the Executor of the Ordinances of Justice was abolished after the Medici return from exile in 1434 and that of the Captain of the People ceased to function in 1471. Much of their work had devolved to the Otto di Guardia, which was established in September 1378, in the wake of the Ciompi revolt, with the mission to control public order. Its powers increased substantially over time, and it became the chief criminal magistracy and principal policing organization of the state. The two other criminal magistracies were those of the Onestà and the Officers of the Night, created respectively in 1421 and 1432 (and combined in 1433). The first was mandated to deal with crimes related to prostitution and the second with sodomy. The magistracies did not follow the trial method. Instead they operated with summary justice. While the cases tried before the regular courts could arise in different ways – by accusation, by investigation, by "public fame" – the government agencies punished those found guilty of offences denounced by secret accusation or discovered by surveillance. The Otto could apprehend and convict "on suspicion." Broadly speaking, the gradual erosion of the powers of the courts convened under the foreign rectors represented the strengthening and centralization of the state's control of behavior. It is a change with political and social as well as juridical implications. Rather than depend on the impartiality of external authorities, which was the rationale behind the rotating offices of the rectors' courts, Florentines preferred to rely on their own vigilance.

Despite the changes in authority and differences in procedure, the courts and the magistracies shared notions of proof based on two principal forms of testimony: eyewitness and public opinion (*publica vox et fama*). The latter did not depend on direct knowledge of the crime or case, but was based on what was widely known, reputed, or rumored to be true. While judges and magistrates tested the credibility of both types of witness, their judgments had to be based on determined amounts of proof, which for some offenses were regulated by communal statute. These were normally expressed as equations or equivalents. In the rectors' courts, for example, the accepted testimony of two eyewitnesses and two public fame witnesses could be sufficient to condemn the accused; alternatively confessions and two eyewitness reports could constitute conclusive proof. Similar quotas are found in cases handled by the magistracies. For the Officers of the Night, conviction could result from the confession of at least one of those involved, but it could also result from combinations of the other forms of evidence: the testimony of two eyewitnesses, or of one eyewitness and two of public fame, or four of public fame.[39] The statutes of the magistracy established to prevent grain shortages and generally monitor the trade in food, the Magistratura della Grascia, set out different levels of sufficient proof according to the nature of the disputes or questions being settled (such as two eyewitnesses or one eyewitness and one of public fame for cases involving sums between 10 and 100 *lire*, for those less than 10 *lire*, one of public fame).[40] A woman could be declared a public whore (*pubblica meretrice*) by the testimony of four people of "good repute" and investigated by the officials charged with enforcing public morality, the Ufficiali della Onestà.[41]

Such formulas were not restricted to Florentine legal practice. Neither unique nor original, their pervasive nature is nonetheless remarkable. Whether related to selling bread or being accused of selling sex, the judgment and the levy of fine or other forms of sentencing did not rely on the accumulation or discovery of facts as such, but were based on the plausibility of combined perceptions. Two types of observation – immediate and prolonged – could be put into balance as evidence. Eyewitnesses (*testimoni di veduta*) were called upon to remember what they had seen and experienced. Public fame testimony gathered impressions accumulated over time, sometimes over the course of years. Shaped by the discourses of justice, both referred to shared social imagery. So, for example, the registers of the criminal courts record how "diabolically inspired" deeds were committed by persons of ill-repute.[42] A similar relationship between social stereotypes and legal truth emerges from the records of the testimony given in a suit brought by a woman of artisan status claiming that she was the lawful wife of a wealthy young man. The interrogations of the opposing sides create contrasting pictures. Her witnesses were questioned in terms that created an image of a beautiful, beloved, and betrayed woman in search of truth and honor, while those answering her charges sought to portray a vain, brazen, and promiscuous female who would openly look men in the face, and who had schemed to entrap a well-born lover. The story of their affair and the alleged marriage is constructed from differing viewpoints and with vivid details. Witnesses remember her green dress and his crimson velvet clothing, striking particulars that added substance and circumstance to the evidence.[43] Visualizing, which was an aspect of

memory, was also an element of legal procedure. More generally, the weight given to witness testimony in Florentine systems of proof is indicative of the importance given to the look of things. As with the scrutiny, appearances counted.

A popular tale of a joke played upon a woodworker named Manetto and known as Grasso (the fat man) demonstrates how conclusively being seen could be connected with being. Recounted as a real episode and involving real people, including Brunelleschi and Donatello, the story relates how the hapless Grasso is made to mistake his own iden-tity.[44] At a key moment, when his confusion is turning into self-doubt, Grasso is impris-oned in the name of a debtor named Matteo. The other prisoners, hearing him called Matteo, assumed that he was Matteo, "and since there did not happen to be anyone who knew [Grasso] by sight, and hearing and seeing himself called Matteo by all of them . . . he was nearly convinced that he was someone else."[45]

This moment of transformation hinges on proof by public opinion. Lacking positive eyewitness identification that he is Grasso, he becomes inclined to accept the general view that he is Matteo. Later when Giovanni Rucellai, his friend and client (who was also in on the joke), looks at him steadily and does not recognize him, he accepts the change as certain.[46] Grasso's credulity is the comic underpinning of the story, but, given the circumstances, his confusion was legitimate and, by legal standards, credible. The story dramatizes the social dynamic of identity, which could rest to a substantial degree in the eyes of the beholders.

Advice about behavior was regularly given in terms of its visibility. In his treatise on humility, for example, Savonarola said that: "The humble man should keep his eyes lowered to the ground, especially in the sight of others."[47] The preacher connects the inner and the outward person, and offers guidance in the ways that the humble man could become and be virtuous by practicing the postures of humility. As a Dominican he had a thorough training in the gestures of devotion, and part of his mission was to translate the physical disciplines of spiritual life to lay usage. Fra Angelico, also a Dominican, translated them to exemplary figures for veneration and imitation (pls. 59, 60, 102, 165, 181, 182, 185).

Such messages were not obscure. The premise that connected posture and persona was taken as axiomatic. Addressing Lorenzo di Giovanni de' Medici on the occasion of his marriage with advice about wives, Francesco Barbaro, for example, wrote that the nature and passions of the mind could be known from the face and movements of the body. He then described, or prescribed, how women should demonstrate modesty in all of their actions and in every situation, moving with gentle gravity and avoiding useless contor-tions of the eyes, frequent or unmotivated hand gestures, or any bodily distortions that would bring censure upon them and signify frivolity.[48]

A masculine counterpart was put forth by Matteo Palmieri in his book *On Civil Life*, noting that "it often happens that the greatest vices are known through the smallest signs and one gives true indication of what is in our mind."[49] He noted how arrogance, hu-mility, and sadness could be conveyed by holding the head raised, lowered, or by twist-ing the body. The eyes and eyelids – turning, shutting, moving – could indicate thoughtfulness, hate, joking, suspicion, or sadness. Hand gestures "could almost speak," so powerful were they in signifying intentions.[50]

Notable in the context of social consciousness is the fact that the bodily configuration of virtue is expressed as a figurative vocabulary with fine (and even dangerous) shades of meaning. Palmieri gave careful instructions as to how men should move with appropriate dignity, not so slowly as to seem pompous, or as though in a religious procession, or so precipitately as to make one's garments billow or so quickly as to seem inconstant.[51] In the case of humble demeanor, Savonarola warned against twisting the neck or holding "the head so low as to denote hypocrisy;" instead it should be lowered "moderately without it seeming too obvious or odd."[52]

The body could be the object of public humiliation. The rituals of justice included spectacles of shame, staging punishments that reduced offenders to figures of contempt. Stripped and whipped through the streets, paraded on asses, wearing miters or fool's caps proclaiming their crimes, those who defiled communal morality were in their turn exposed and reviled, their tormented bodies a sign of their sinful condition and the torment a testimony to civic authority. Such penalties were "intended not only to punish those who have erred, but also to strike terror in those who might want to err," as stated in the preamble to a law regarding the Officers of the Night.[53] These horrible punishments created vivid and shocking images of the sort meant to impress memory and imprint moral lessons (according to the traditions and theories of memory and persuasion). They were also a means of forcing or enforcing the recognition of the crime and the guilt of the culprit. It was through encountering others in the cathedral square that the fat man Grasso hoped to be sure that he was himself once again. Though a fiction, this desperate need to be seen refers to the power of face-to-face proof, the *riscontri degli uomini* that could certify identity.[54]

Such penalties could also enlist the symbolic population, as when those convicted of sodomy were tied to the column in the Old Market to be flogged. At the top of the column above them, in meaningful contrast to their abject state, strode Donatello's eight-foot-tall statue of *Dovizia*, the graceful nymph of abundance, who presided over the bustling market as a symbol of the city's prosperity, which was threatened by those who practiced the "cursed and detestable vice" so "harmful to the Republic because of the evils it draws with it."[55]

Public shame could also be portrayed. A communal statute ordered that the Podestà

> shall cause to be painted on the Palace of the Podestà, on the wall of said palace so that it can be seen openly and publicly . . . any merchant or person or other artisan who defaults . . . and who flees or defaults without satisfying his creditors . . . and to have his full name and the name of his guild inscribed in letters large and bold.[56]

The 1415 revision of this law insisted on the intention of bringing lasting disgrace to the defaulter.[57] In 1465 the Signoria renewed the law, stating that it had been instituted for "the best of reasons, because it was found that many abstain from said bankruptcies for fear lest they be painted rather than for any other reason."[58] Instead, the Signori noted that it had become the practice either not to be painted or to have the paintings done in obscure and hidden places. They mandated that the statute be observed, and that the defaulters be painted on their own houses, on the most conspicuous wall. They insisted on the inscription in large letters, fully identifying the person. The importance of the

painting was probably not in producing a close likeness, but in publicizing embarrassment in a way that turned a given person into a known defaulter, and in warning others that they, too, could be seen in this disgraceful way.

Even more infamous were those who betrayed the city, defecting *condottieri* or plotting exiles, like Rinaldo degli Albizzi and seven co-conspirators who were condemned to "perpetual ignominy" by being painted dangling upside down on the front of the palace of the Podestà in 1440, "their figures and pictures represented disparagingly according to life" (also with their full names inscribed in big letters).[59] Andrea del Castagno was the artist chosen; the task earned him the name of Andrea degli Impiccati – Andrea of the Hanged Men. In July 1478 Botticelli was paid 40 gold florins by the Otto di Balìa for "his labor in painting the traitors," the Pazzi conspirators, on the façade of the jail next to the Palazzo della Signoria.[60]

The 1440 paintings showed men who were alive and in exile, so hung in effigy only, with the additional indignity of being upside down. With one exception, the images painted of those involved in the 1478 plot recalled actual executions. Most of the conspirators were captured within two days of the attempted assassination of Lorenzo de' Medici and the murder of his brother on April 26. When taken, they were immediately hanged. By the third day over eighty men had been killed, and there were corpses hanging from the windows of the Palazzo della Signoria, the palaces of the Podestà and of the Captain of the People in a ghastly display of swift, relentless justice. Two of the protagonists, Bernardo Bandini Baroncelli and Napoleone Francese, had escaped. Bernardo was subsequently found in Constantinople. He was returned to Florence by the sultan and then executed (December 28, 1479). His condemnation for the "most bloody murder, abominable sacrilege, and infamous treason" stipulated that he be hanged in the clothing he had been wearing when he was brought from Constantinople.[61] A drawing by Leonardo da Vinci, with careful notes about his dress, confirms that this was the case (pl. 103). The exotic costume associated the sacrilegious traitor with the habits of the infidel: a double condemnation. That these portraits were viewed as representing a serious and lasting degradation is proven by the Otto di Guardia's decision to remove the effigy of Francesco Salviati, the archbishop of Pisa, as part of the peace negotiations with the Pope. This was ordered to eliminate "any cause of detracting from the rank of archbishop."[62]

The effigies painted by Botticelli were memorials to an event and reminders of its consequences. They did not record the entire bloodbath, which had left the people "bewildered with terror," according to a contemporary diarist.[63] Eight participants were singled out for depiction; they were branded with epitaphs that addressed the viewer in verse, in the first person: the corpses speaking out like the lost souls of Dante's *Inferno*, stating their crimes, insisting that the beholder remember the person for their misdeed. Bernardo read: "I am Bernardo Bandini, a new Judas; I was a murderous traitor in church, a rebel deserving an even more brutal death."[64] Botticelli's murals were destroyed in 1494 (along with the 1440 Albizzi images), when the Medici were exiled and those who had been declared rebels under the Medici regime were rehabilitated. This was part of a programmatic erasure of Medicean memory, a *damnatio memoriae* that involved destroying

103 Leonardo da Vinci, *Bernardo Bandini Baroncelli Shown Hanged*, 1479, pen and ink, 19.2 × 7.3 cm., Musée Bonnat, Bayonne, inv. 659.

their votive statues at Santissima Annunziata as well. Both the original commission and the subsequent destruction indicate the strength of the images in structuring historical imagination and in articulating the meaning of events.

* * *

VISUAL TESTIMONY

The figuring of justice through the body shamed and defamed in reality and in effigy is an extreme instance of the connections made between appearances and identity. It shows how the mimetic arts were allied with social representation and how they operated within highly developed systems of visual testimony.

A painting about proof provides an appropriate case for examining this relationship in greater detail. Domenico Ghirlandaio's mural of the *Verification of the Stigmata of Saint Francis* illustrates an episode in the saint's legend when, after his death became known,

> the people flocked together in haste to the scene, so that they could perceive with their bodily eyes that which might remove every doubt from their reasons and add joy to their feelings. Very many of the citizens of Assisi were therefore permitted to examine those sacred Stigmata with their eyes and to kiss them with their lips. Now one of them, a certain learned and intelligent knight named Jerome, a man of great fame and renown, because he had doubts concerning those sacred tokens . . . handled with his own hands the Saint's hands, feet, and side, so that, as he tenderly touched those authentic tokens of the wounds of Christ, he cut away every wound of unbelief from his own heart and from the hearts of all.[65]

Painted by Ghirlandaio and his shop as part of the decoration of Francesco Sassetti's burial chapel at Santa Trinita (done between 1479 and 1485), this scene is directly above Sassetti's tomb. Above it is the story of *Saint Francis before the Sultan*, where the saint prepares to walk into the fire, so that the infidel "may come to know which faith deserves to be regarded as the most certain and holy" (pl. 104).[66] The two stories depict the testing of faith, pairing Saint Francis's "steadfastness of mind" – his confidence in divine guidance – with Jerome's skepticism.[67] The stories are constructed so that the events are doubly affirmed, as witnessed both by internal spectators, the painted participants, and by the external beholders of the scene.

Saint Bonaventure's Life of Saint Francis is the textual source, but there was also a strong pictorial tradition associated with the saint's life. The canonical rendering of the legend was the cycle painted in the early fourteenth century in the nave of the Upper Church at Assisi, the shrine of the saint and the first and principal basilica of the Franciscan Order. At Assisi Jerome kneels in front of the bier conducting his examination of the clearly exposed wound on the saint's side (pl. 105). Though the *Legenda maior* says he is a knight, the *titulus* beneath the mural described him as a "doctor and renowned man of learning," and he is dressed as a doctor, in a long robe with a fur collar.[68] A priest is saying prayers over the body and the bier is immediately surrounded by Franciscans robed as clerical members of a funeral procession. A large crowd presses around, made up of Franciscans, townspeople, and soldiers, eager to see and to guard the precious body of the saint. The church of Santa Maria Porziuncula, the setting named in the *Legenda*, is suggested by an apse and rood screen, hung with lamps and displaying paintings with

104 (FACING PAGE) View of the wall with the tomb of Francesco Sassetti, with the scenes of the *Verification of the Stigmata of Saint Francis* and, above, of *Saint Francis before the Sultan*, 1479–85, Sassetti chapel, Santa Trinita, Florence.

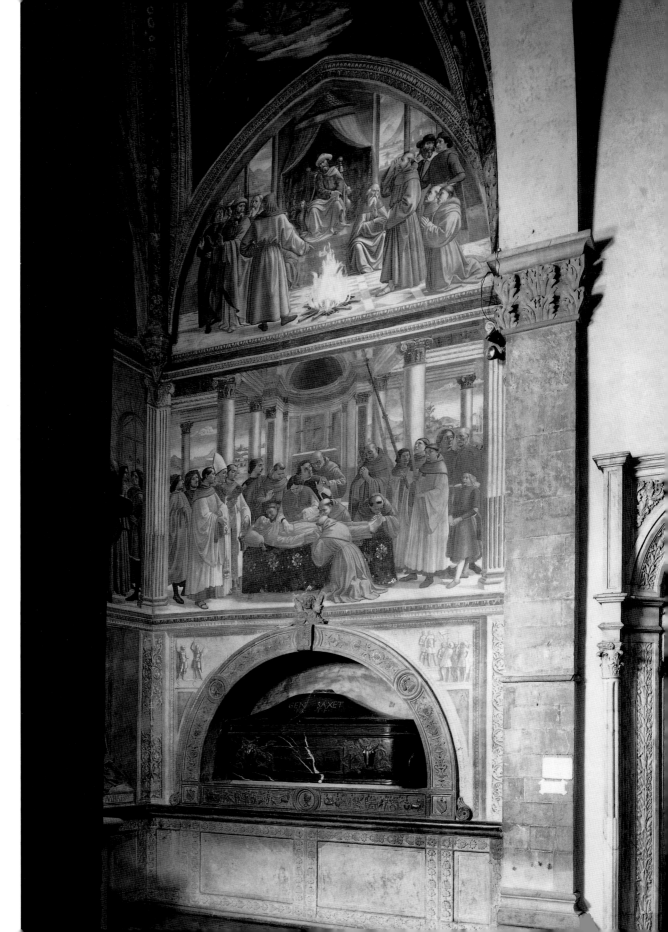

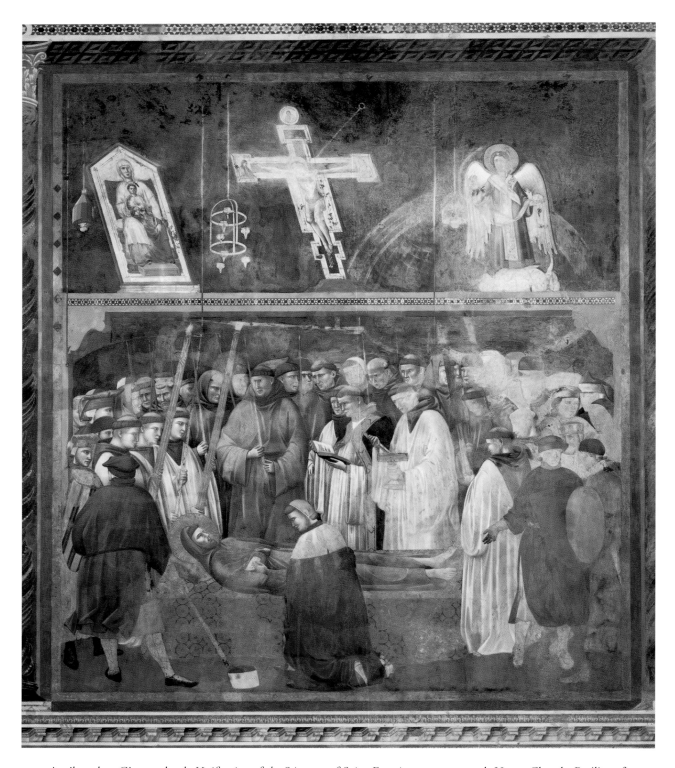

105 Attributed to Giotto school, *Verification of the Stigmata of Saint Francis*, ca. 1300, mural, Upper Church, Basilica of Saint Francis, Assisi.

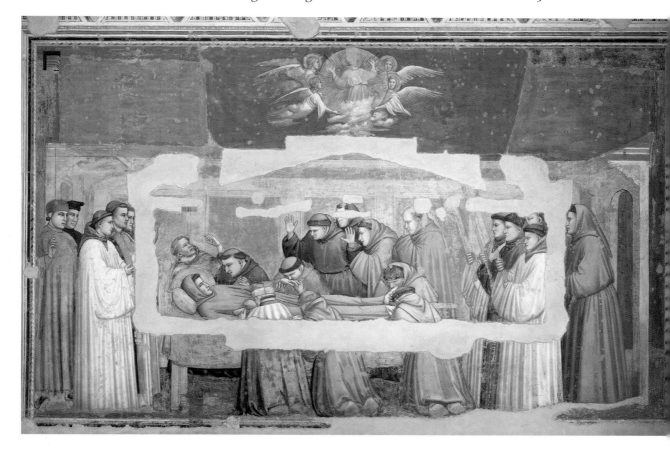

106 Giotto, *Verification of the Stigmata of Saint Francis*, ca. 1325, mural, Bardi chapel, Santa Croce, Florence.

subjects particularly venerated by Saint Francis: a Virgin and Child, a Crucifix, and an Archangel Michael.

The attribution of the Assisi murals is much debated, but Giotto is generally assigned some part. He was familiar with them, as his recasting of the *Verification* in the Bardi chapel at Santa Croce demonstrates (pl. 106). Giotto retained the basic components of the *Legenda* and the painted version at Assisi, but the number of participants is reduced from over 40 to 21. The emotional content of the scene is concentrated in the sorrow and awe of the friars. As at Assisi, Jerome is shown as a doctor and his literal-minded investigation is juxtaposed with the unquestioning love of the Franciscans who kiss the other wounds. The celebrants of the funeral ritual are at either end of the bier. The whole is bracketed by four witnesses, two laymen at the viewer's far left and two Franciscans at the right. The church architecture is simply denoted by a stone wall with a cornice and pilasters and two doors. The friar at the saint's head is probably the brother named Augustine, who is shown experiencing a vision of the ascension of Saint Francis, as recounted in the preceding chapter of the *Legenda*.

Ghirlandaio's composition (pl. 107) takes Giotto's arrangement of the figures surrounding the bier as its narrative core. There is a similar resonance in the scene of *Saint Francis before the Sultan* above, and this resonance with the earlier murals is likely to be deliberate. It is a form of visual affiliation with Giotto's authority and that of Santa Croce (the principal Franciscan church of Florence) which reinforces the proof value of the scenes. Where they have precedents at Santa Croce, the other episodes shown in the chapel do not follow Giotto's schemes so faithfully. The story was largely recomposed by Ghirlandaio for Sassetti, and for Santa Trinita, which was a Vallombrosan church. But on this wall – the memorial wall – that of Francesco Sassetti's tomb, visual memory is activated in a way that asserts continuity.

Ghirlandaio's version is, however, at once more opulent and more circumstantial than its precedents. The church is projected as an arcade in a contemporary, classicizing style, built of precious materials. The landscape vista satisfied a current taste for panorama and also alludes to Lake Trasimeno and the hills near Assisi. The liturgical apparatus of the funeral rite is carefully detailed, as are the clerical vestments and the dress of the lay onlookers. The bishop who has put on his glasses to read the funeral service may be a portrait or a reminder of an actual near-sighted cleric, but it is not necessary to be able to name him in order to be struck by his singularity (pl. 80). This detail of the glasses calls attention to the action of focused looking and to the characterization of looking throughout the scene.

One of Ghirlandaio's important alterations to Giotto's scheme was to place Jerome in the group standing over the saint's body, allowing the beholder to watch him as he inspects the wound. Above him, another layman raises his hand in a gesture of wonder, while turning and looking away. To his left a Franciscan gestures in a similar manner, but, by contrast, his eyes are lowered respectfully and thoughtfully towards the body. This look is repeated by the Franciscan who presses over the man's shoulder.

There are four general categories of seeing in the mural. One is episodic, even anecdotal, part of telling the story, showing figures absorbed in their tasks (like the bishop and the acolytes). Another is confined to the friars, showing a Franciscan or spiritual mode of concentration, which is directed towards the body of the saint. A third is more meditative – picturing seeing as it becomes understanding. This type of contemplative sight frames the composition. It is given to three generations of lay onlookers: the mature man in profile at the left and the older man and the young boy at the far right. Four other figures punctuate the picture by looking out, over, and beyond (the second man from the left, the man standing in front of the column near the saint's head, the man leaning over Jerome, and the second man from the right). They acknowledge other observers, those depicted and those expected as viewers – further and future witnesses to the moment as it is shown happening and as it will recur each time it is seen to happen by each beholder.

This scene, like the others in the chapel, exploits the synchronic possibilities of images. The sacred narratives are recounted in three moments, separate in actual time, but simultaneous as depicted: the first is the historical moment of their occurrence; the second is the moment in history when they were painted; and the third is the moment of their

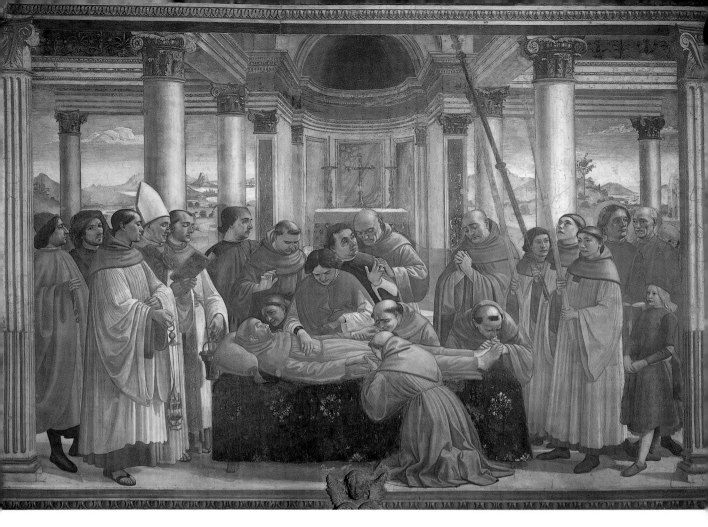

107 Domenico Ghirlandaio, *Verification of the Stigmata of Saint Francis*, 1479–85, mural, Sassetti chapel, Santa Trinita, Florence.

being seen. The first provides the core of each composition, the saint's story, clearly stated and centrally placed. The second is indicated in some cases by the settings, notably in the relocation of the Roman episodes of the Honoring of the Rule and the Resuscitation of the Roman Notary's Son to Florence, to the Piazza della Signoria and the Piazza Santa Trinita respectively (pl. 108) and in most cases by the conspicuous presence of contemporary Florentines as onlookers. The third is partly achieved by the way light is depicted as though transitory, with shadows caught, making the phenomenon of sight part of the description of the scene. But seeing in the moment is most obviously affirmed by the figures who look outward from the scenes as though catching the eye of someone just arriving (pls. 109–12).

This dense interweaving of temporal reference and forms of sight is a visual equivalent to Dante's address to his reader in the opening lines of Canto XIII of *Paradise*, "Let him imagine, who would rightly grasp what I now beheld (and, while I speak, let him hold the image firm as a rock)."[69] Dante, advancing towards the *perfetto veder*, "perfect

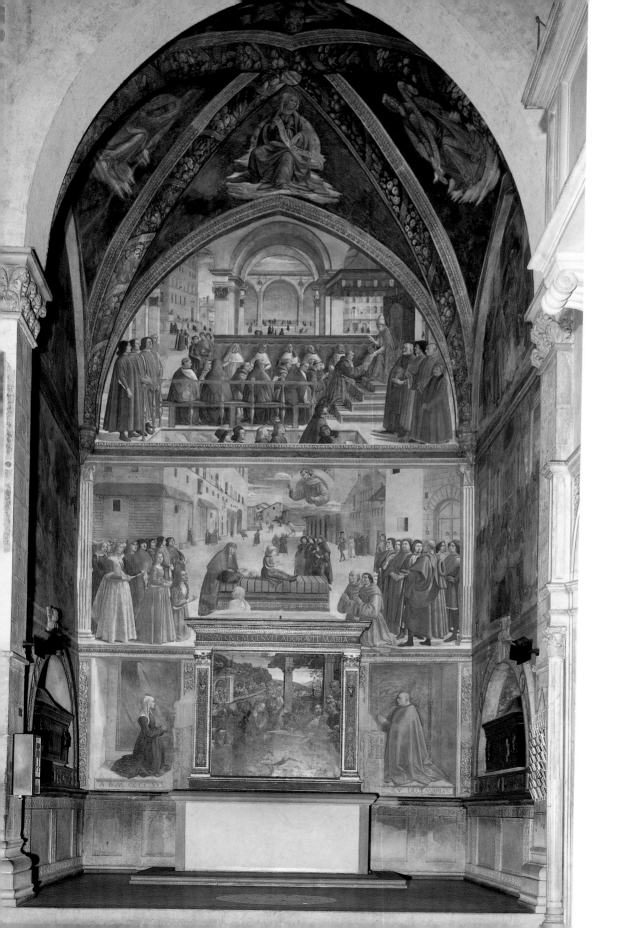

109 Domenico Ghirlandaio, *Verification of the Stigmata of Saint Francis*, detail of pl. 107.

110 Domenico Ghirlandaio, *Saint Francis Renounces His Worldly Goods*, detail, 1479–85, mural, Sassetti chapel, Santa Trinita, Florence.

111 Domenico Ghirlandaio, *Confirmation of the Franciscan Rule by Pope Honorius III*, detail of pl. 108.

112 Domenico Ghirlandaio, *Confirmation of the Franciscan Rule by Pope Honorius III*, detail of pl. 108.

108 (FACING PAGE) View of the altar wall with the scenes of the *Resuscitation of the Roman Notary's Son* and, above, of the *Confirmation of the Franciscan Rule by Pope Honorius III*, 1479–85, Sassetti chapel, Santa Trinita, Florence.

113 Domenico
Ghirlandaio,
*Resuscitation of the Roman
Notary's Son*, detail,
ca. 1479–85, mural, Sassetti
chapel, Santa Trinita,
Florence.

sight" (Canto v.5), of divine truth, urges his reader to see what he has seen, by bringing
it to mind and to understanding as he creates and explains a memory picture. In doing
this, he mixes direct experience with historical example. Ghirlandaio also urges the
beholder to know by seeing and by holding an image in the mind through presenting a
picture as a prompt. This knowledge, or moral learning, should act as the basis for future
action. The outward-looking figures of Ghirlandaio's murals perform the rhetorical func-
tion of the figure Dante of the poem: instead of verbal exhortation they supply visual
cues. Dante's words are a useful gloss on Ghirlandaio's lexicon of looks. Text and image
are structured by common assumptions about cognition and the functions of history:
what is implicit in the painting is explicit in the poem. As will be discussed in the fol-

lowing chapter, the voice of the poet, as author and intermediary, also spoke definitively for the artistic fashioning of vision.

Ghirlandaio included himself in the chapel, at the far right of the *Resuscitation of the Roman Notary's Son* (pl. 113). Portrayed as a conscious object of sight, he made the viewer a witness to his status and that of his work. His brother-in-law and collaborator, Sebastiano Mainardi, gazes at him respectfully as he looks out with easy confidence. Positioned with Francesco Sassetti's friends, he assumed a position among the eminent Florentine citizens of the time. He represented himself as a proud and willing adherent to Francesco Sassetti's project of remembrance.

The chapel was undoubtedly decorated according to Sassetti's wishes. Not only would this be normal practice, but major changes between surviving compositional drawings for the scenes on the altar wall and alterations to some of the murals demonstrate his careful control over the project during its design and execution. In the case of the *Verification*, the portraits of the two men at the far left were added, as was the layman standing behind the bier above the saint's head, and the man looking out at the right; there was a taller figure standing in the place of the child at the far right. This secular invasion is typical of all of the changes, which made the chapel more topical and extended the traditional role of religious narrative (to supply inspirational models for devotional behavior) to include social and civic behavior. It gave the murals and their messages immediacy, which seems to have been a priority. The endowment and decoration of the chapel spanned the violent years of the Pazzi conspiracy and its aftermath. The peaceful and dignified gathering of the Sassetti family and its friends was testimony to the survival of the regime and the endurance of its leading families.

Francesco Sassetti and his wife, Nera Corsi, are portrayed as pious donors, kneeling towards the altar (pl. 108). She is dressed in the modest and sober garb of a matron. He wears the red robe of a Florentine citizen of office-holding status. Their children are portrayed in the murals above, to be seen as witnesses to the stories unfolding before them. The vertical organization of the murals reinforces the message of lineage. It forms a figurative column, with daughters, sons, sons-in-law above Nera and friends and allies above Francesco. Availing himself of Ghirlandaio's skill, Francesco used painting as a medium for the historical perception of his family.

This was not in conflict with the sacred messages of the stories or the liturgical function of the chapel. The maintenance of ritual, its due and decorous observation, was an essential personal and civic duty. Sassetti not only had his chapel richly decorated and supplied with all of the necessary vestments and furnishings, but he endowed it with a lavish liturgical program: daily masses in perpetuity and solemn masses in honor of his patron saint, Francis, on all major feast days, "for the benefit and memory of his soul and those of his ancestors and descendants and for many other good reasons."[70] The funeral rite for Saint Francis being performed on the wall above Francesco Sassetti's tomb was a dramatized reminder – also made in perpetuity – of the ceremonies performed each morning in the chapel. Ghirlandaio composed the funeral with an altar at its center. In Giotto's version of the scene the lifted gaze of the beholder is met by the vision of the saint's soul ascending. The emphasis in the Bardi family chapel at Santa Croce is spiri-

114 Leonardo da Vinci, *Six Studies of Figures for the Adoration of the Magi*, ca. 1481, pen and ink over stylus, 27.7 × 20.9 cm., Département des Arts Graphiques du Musée du Louvre, Paris, 2258 (verso).

tual and pointedly Franciscan. In Sassetti's chapel it is liturgical. The devotional message is inflected in terms flattering to those like Francesco, who recognize that among human deeds almost nothing could be "more pleasing to almighty God or more praiseworthy . . . than the celebration of divine worship."[71] Giotto's narratives invited contemplation, and offered a model of meditative reflection and wondrous reaction for imitation. Ghirlandaio's suggest imaginative participation.

The mix of sacred and civic history, hagiography and family chronicle seen in the Sassetti chapel is particular to its moment and to the specific interests of the patron. It is a strong and often cited instance of the use of representation as a form of social description. But the composition of viewing in terms of subjective interaction was a more general phenomenon. The solicited gaze is a recurrent feature of fifteenth-century art. It had a primary role among the repertory of looks that turned the experience of images into memorable encounters.

The social operations and social consensus of fifteenth-century Florence relied on many forms of visual awareness and accountability, some statutory, some customary. Social consciousness was structured by contemporary notions of imagination: it depended on the ability to call to mind – collectively and individually – a shared imagery to judge both honor and shame, to shape public good and strategically to place private

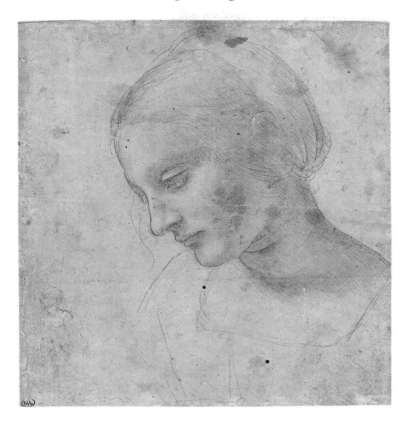

115 Leonardo da Vinci, *Head of a Woman*, ca. 1480, metalpoint heightened with white on pale blue prepared paper, 17.9 × 16.8 cm., Département des Arts Graphiques du Musée du Louvre, Paris, 2376 (recto).

interest. The visual arts participated in this process of social definition, literally reminding Florentines of themselves, making them witnesses to the stances, poses, positions, and material manifestations of the codes and conventions that expressed and enforced the city's identity.

This was possible given the suppositions that art imitated nature, that its purpose was to persuade or instruct, and that it did so through embodiment. In his treatise *On Painting* Alberti wrote that feelings "are known from movements of the body," so that the painter "must know all about the movements of the body," because spectators will be moved "when the men painted in the picture outwardly demonstrate their own feelings as clearly as possible."[72] Alberti's rhetorical conception is directly indebted to the ancient texts on oratory that provided the authority and much of the theoretical substructure for his book, but its applicability relied on widely accepted beliefs about behavior. In his notes on painting Leonardo advised that "a picture or representation of human figures ought to be done in such a way that the spectator may easily recognize, by means of their attitudes, the purpose in their minds."[73] His obsessive research into those attitudes is documented in his drawings (pls. 114, 115).

For both Alberti and Leonardo, the imitation of nature and the expressive power of representation relied upon the connection between the mind and the body, the inner

116 Paolo Uccello, *The Flood*, ca. 1450, mural, cloister, Santa Maria Novella, Florence.

117 Fra Angelico, *Virgin and Child with Saints* ("San Marco altarpiece"), detail of pl. 165.

118 Fra Filippo Lippi, *Virgin and Child with Two Angels*, detail of pl. 175.

person and the outward posture. They both express these ideas as common assumptions, along with the notion that the spectator could easily recognize and interpret intention and character through pose and gesture. They also refer, without qualification, to an assumption that depicted figures have intentions or purposes to communicate.

The particular purpose or message depended upon the situation. The style of delivery depended upon the artist selected. The model of perception related to the category of work, as will be discussed below in Part 3 in connection with devotional and narrative viewing. But in general terms it can be said that the compositions of fifteenth-century Florentine artists were figurative arguments addressed to the sense of sight. It can also be said that over the course of the century the accepted connection between sight and insight was exploited with increasing skill by those artists who made the power of seeing part of their technical arsenal. Manipulating the geometry of spatial construction so as to fix the eyes of the beholders on their works, they composed and guided the viewer's experience. Calculated encounters between the observer and the object in view created subjective links between the onlooker and the looked upon. Sometimes these were measured out by the rules of perspective, as by Paolo Uccello in his mural of *The Flood* in the cloister of Santa Maria Novella (pl. 116), at others they were invited by eye contact, as by the forthright gazes of Fra Angelico's saints (pl. 117) or the coy glances of Fra Filippo Lippi's angels (pl. 118), or prompted by insistent physicality as in Donatello's *David* (pl. 119). These are deliberate provocations, which activate viewing, structuring it as a process of recognition and of self-definition, through difference as well as similarity.

The seeing and being seen of the crafted domain of images replicated and responded to the visual habits of the time – scrutiny, vigilance, witnessing, observing. Those things made to be looked at also contributed greatly to the visual pleasures of the city, confirming its excellence, and the ability of its artists to capture the eyes of beholders with the "desire to see."[74]

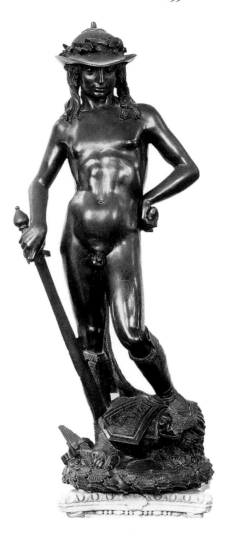

119 Donatello, *David*, 1440s, bronze, height 158 cm., Florence, Museo Nazionale del Bargello.

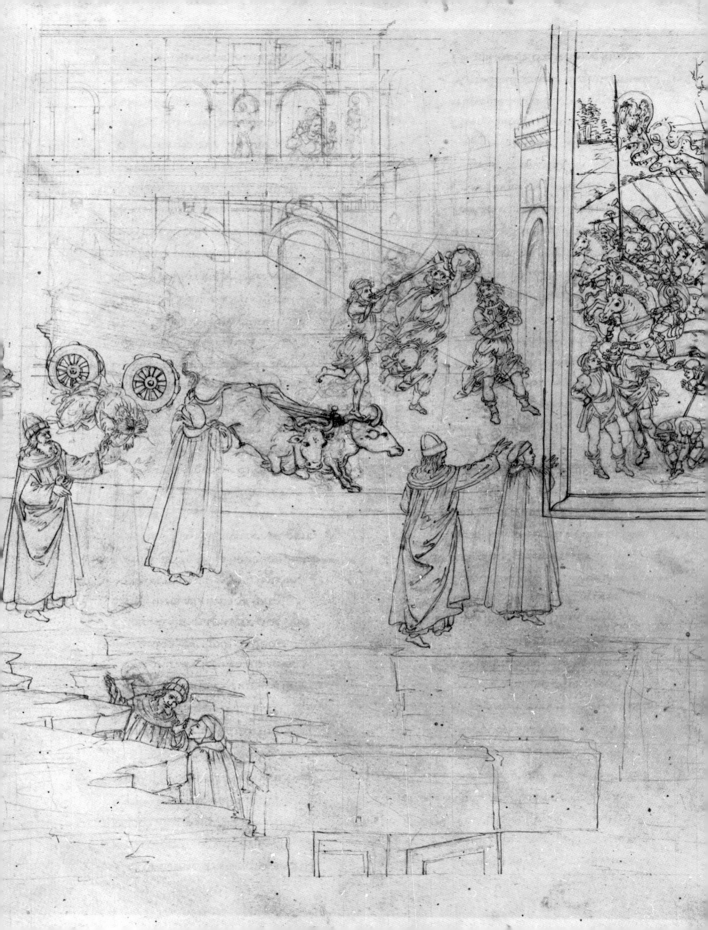

Chapter Five

THE EYE OF THE BEHOLDER

In Canto x of *Purgatory*, Dante and Virgil climb onto the first terrace of Purgatory, a sheer face of white marble "adorned with such carvings that not only Polycleitus but Nature herself would there be put to shame."[1] The carvings display three supreme examples of humility to Dante's admiring gaze: the Virgin accepting the angel's message of the incarnation, David dancing before the Ark of the Covenant, and the emperor Trajan moved to take vengeance for the murder of a poor widow's son.

Dante's viewing of the sculptures occupies the central section of the canto (verses 32–93) and concludes with a reflection on their divine origin: "He who never beheld any new thing wrought this visible speech, new to us because here it is not found."[2] "Visible speech" has a double sense: that of Dante's poetic voice which makes the images visible to the imagination of his readers and that of the sculptures he describes, whose stories speak to him through his eyes.

In his late fourteenth-century commentary, Francesco da Buti pointed out how speaking is naturally audible, not visible, and Dante here "pretends that that which is sculpted in the marble is beyond nature" and can only come from the hand of God. Therefore it is "new to us" in this world, but possible in the other world where speech will not be necessary to understand "the thoughts of others." Buti glosses his own statement by noting that "the same thing happens to us, when we see painted or sculpted a story that we know: it seems to us that the people depicted speak the words, like the angel who seems to say *Ave* to the Virgin Mary, when it is posed well."[3] Cristoforo Landino, basing his remark on Buti, makes a similar observation in his 1481 commentary:

> a statue may be sculpted with such artistry that its gestures show that which it would say if it could speak. It is therefore visible speech because they understood by seeing the gestures and not by hearing the voice. But this speech, which is not new to God . . . is new to us mortals, because it is not found among us.[4]

Dante's striking phrase and the reactions of his commentators acknowledge the experience of looking at represented actions, but direct it to spiritual aims by pointing out the divine crafting of the reliefs. There is an interesting difference between Buti's and Landino's explanations, however, and it is symptomatic of a significant change between the fourteenth- and fifteenth-century commentaries. For Buti comprehending "visible

Botticelli, *Purgatorio, Canto X, Punishment of the Proud*, detail of pl. 130.

speech" depends on recognizing a familiar story, calling to mind words, a mechanism of memory that refers to the traditional justification of religious imagery (as is explicitly noted by another fourteenth-century commentator, who wrote that "murals are the bible of the laity").[5] For Landino comprehension depends on the expressive capacity of the artist and his statement suggests that even mortal artists had the ability to make statues seem to speak. The appreciation of human craft – of artistic excellence – is a defining theme of Landino's work, which sets it apart from its predecessors.

This is emphatically the case in Landino's interpretation of the subsequent verses, where Virgil turns Dante's attention to approaching souls: "while I was taking delight in gazing on the images of humilities so great, and for their Craftsman's sake so precious to behold"; Landino writes that

> Dante paid attention to the examples of humility because that is as should happen with the senses when they choose to follow reason and so he took pleasure in looking. Which means that sense was so obedient to reason that he already took pleasure in virtue and did so without difficulty. And he took pleasure in those images for the love of their maker, that is the master who made them, and this is the historical sense: that the artistry and the authority of the artist moved him to look at them, as we see in ourselves. So that if we are looking at a painting and we hear that it is by the hand of Giotto, the authority of that man has great weight with us. And allegorically it shows that he was looking at the examples of humility for the love of their maker – that is for the love of God.[6]

As did previous commentators, Landino explains the quality of Dante's attention, "that he took delight in looking," because the carvings were God's work. This is the moral or spiritual interpretation of the verse. What is novel, and noteworthy, is his further explanation of the historical or literal sense of the passage, "as we see in ourselves," that the "authority" of a renowned artist increases the appreciation or the pleasure of the viewer. This has the effect of conferring a special kind of recognition upon human artistry by attaching it to the reputation of specific artists.

The evocation of artistry is part of Dante's purpose, hence the beginning of the description, which invokes both Polycleitus and nature. Landino explains that Polycleitus was "very famous among the ancients," and that his name was appropriate, because in Greek it means a "man of great fame."[7] As recalled by the fourteenth-century commentator, Benvenuto da Imola (who cites Aristotle and Pliny), Polycleitus was regarded as the greatest "maker of statues."[8] In his exposition on Aristotle's *Ethics*, Thomas Aquinas explained that "here we call wisdom nothing other than the excellence of the art (i.e. its ultimate perfection) by which a man attains what is ultimate and most perfect in the art."[9] In addition to the potent associations with these revered authorities, above all "the Philosopher," as Dante called Aristotle, and the Angelic Doctor, the name of the Greek sculptor called forth the almost magical capacity to imitate nature that was attributed to ancient artists.

Maintaining the hierarchy that put God's handiwork above the work of nature and the works of those who imitated nature, the passage structures humility in terms of com-

parison and makes ancient art a paragon for the poet's own time. As recognized by Benvenuto da Imola, the very figure of Dante admiring the sculptures could be compared to Virgil's Aeneas at Carthage as he stood in amazement, his eyes fixed on the murals depicting the Trojan war on the walls of Juno's temple.[10] Dante's descriptive passage both evokes and vies with its precedent.

While expressing God's unsurpassable artistry as beyond nature and mortal capacity, Dante draws attention to what is expected of art, that it imitate nature after the fashion of the antique and that it be communicative and moving. The verses that describe Dante's viewing of the reliefs articulate the experience of looking at works of art in terms of an active engagement between the subjects represented and the subjectivity of the viewer. An analysis of this passage is very instructive about how works of art were seen and how artists were regarded in a developing culture of appreciation. In these verses viewing is set within a process of transformation and expressed in the mode of delight. Landino's comment, which associates attention with attribution, is also revealing of the status given to art and artists by the late fifteenth century. What follows will explore these topics firstly by considering the relevance of Dante and Dante's writing to the fifteenth century, next by considering what the *Divine Comedy* can tell us about how vision was understood, and finally by investigating the concept of delight as connected to vision and to the recognition of artistic authority.

THE "POET FOR SHOEMAKERS AND BAKERS"

Expressing an extreme, and highly polemical, verdict on Dante, the arch-humanist Niccolò Niccoli relegated the *Divine Comedy* to being suitable for "druggists to make packages, or rather, for grocers to wrap salted fish" – a writer for "doublet-makers, bakers, and such like."[11] The characterization of Dante as a "poet for shoemakers and bakers," which can be referred to Niccoli's radical reverence for ancient literature, also refers to the wide diffusion of Dante's text. "Il Dante" was the familiar term for the book, and the enthusiasm for it can be measured by the petition made to the city's government in 1373 by citizens wishing to have a year of daily public readings of the "the book that is commonly called *El Dante*" for the benefit of all Florentines.[12] Boccaccio was the first reader appointed to this task, which he began on October 23, 1374. These lectures continued to draw an interested public through successive generations and were popular enough, for example, that on one occasion the lecture had to be moved from the church of Santo Stefano a Ponte to the Duomo, "because there was too little space."[13]

In the preface to his biographies of the "three illustrious Florentine poets" (Dante, Petrarch, and Boccaccio), Giannozzo Manetti noted that the "three most celebrated poets . . . have always enjoyed great fortune such that from the point of view of the common reader, there have never been poets as famous."[14] One supporter explained about the work by "the illustrious and excellent poet, Dante": "that no other invention was more beautiful, more useful, and more subtle than his . . . he depicts human deeds in the vernacular so as to be of greater use to his fellow citizens than would be the case in Latin."[15]

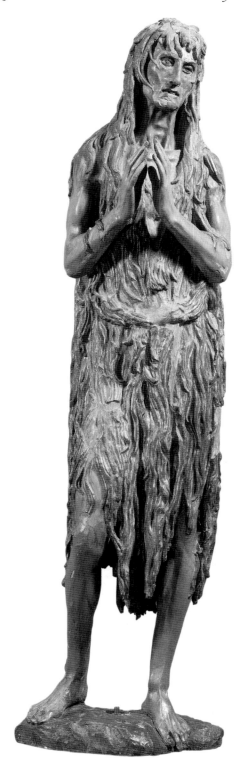

This indicates how vividly Dante's works impressed the imaginations of his readers and how reading Dante was connected with picturing his words. It also shows how this activity was held to be usefully instructive to the general populace. Those who read it intelligently, it was said, would find something about "every art, every science, every philosophy."[16] In his advice to his descendants, Giovanni Morelli advocated learning as the way to achieve the highest honors and placed Dante with Boethius, Cicero, and Aristotle as a means to pleasurably understand "the reason behind things."[17]

One of the strands in the appreciation of Dante as a poet and a public figure was his role in promoting the vernacular as a literary language. He argued for it in his sonnet commentary, the *Convivio*. The defense of the vernacular was not an arid academic debate. It went to the heart of the city's identity and its cultural domination, and it was wedded to its political prestige. Lorenzo de' Medici made this connection openly and forcefully when stating the advantages of the "elegant and noble" Florentine language, which "could still easily reach major perfection, and much more so if some propitious event and the growth of the Florentine empire as well join forces with it – as one must not only hope, but also must strive for with all one's talent and strength on behalf of the good citizens."[18]

The debates around the vernacular, its status with respect to Latin and to other

121 Donatello, *Saint Mary Magdalene*, ca. 1454, wood, height 188 cm., Museo dell'Opera del Duomo, Florence.

Italian dialects, which developed in the reception of the *Divine Comedy*, were conducted in terms of stylistic differentiation and discrimination. These were generally important in articulating a sensitivity to style and giving it a vocabulary and a theoretical structure applicable to the visual as well as the verbal arts. The debates took their terms from classical rhetoric in order to show that the vernacular could convey the same level of meaning as Latin, with the same array of eloquence, or style.

Alberti's treatise *On Painting* demonstrated the way that rhetorical theory could be applied to the visual arts and could supply principles for those who "strive to excel" in that "perfect art."[19] Landino's section on the excellence of Florentine artists in the *Comento* proved how their varied excellence was perceived and could be described, from Masaccio's "pure, unadorned" style to Andrea del Castagno's "love of the difficulty" of his art and of foreshortening, or Fra Filippo Lippi's grace and abundant artifice (pls. 87, 91, 101).[20] Donatello's deployment of style, harsh and rugged in the emaciation of the penitent Magdalene, sweet and graceful for the Annunciate Virgin (pls. 121, 122) shows how he inflected style to meet subject in a manner that parallels Dante's stylistic self-awareness, enjoining the viewer to see how the matter of his art was met by the material of his artifice.[21]

But eloquence was but one aspect of the "vast" knowledge contained in the *Divine Comedy*. Dante had much to teach his fellow citizens who, conveniently choosing to forget the exiled poet's bitter criticism of them

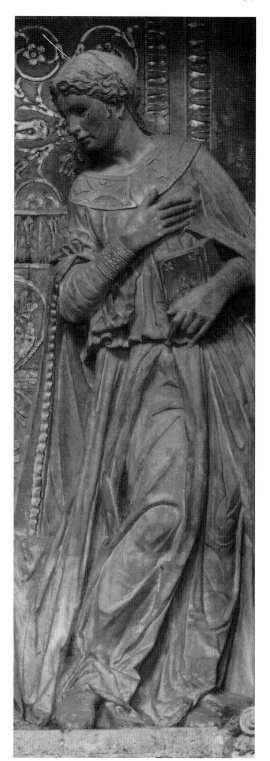

122 Donatello, Cavalcanti *Annunciation*, detail, ca. 1428–33, limestone and gilding, whole work: height 419 cm., Santa Croce, Florence.

as "that thankless, malignant people," found him a reference work and a reference point.[22] Dante's currency is fully documented by Landino's commentary. Landino's was, of course, an interpretative appropriation of the *Divine Comedy*, which must be set in its own context of the cultural politics of Lorenzo de' Medici's Florence. But he had spent well over twenty years reading and lecturing on Dante in public and in the Florentine university before producing this monumental work as a splendid example of the latest textual technology, an illustrated printed book presented to the Signoria of the city. That it was a semi-official enterprise is itself proof that Dante's was a living voice and of the extent to which his words were embedded in the collective consciousness of Florentines.

Dante's works, above all the *Divine Comedy* and his *Rime*, were a staple of chapbook selections, along with portions of commentaries, and even Bruni's life of the poet. His lines were so well known that they were proverbial. "Dice Dante . . .," "Dante says . . ." is a phrase used by the notary Lapo Mazzei in his correspondence with his friend Marco Datini, where the poet is quoted and paraphrased.[23] Lorenzo de' Medici remarked on the "frequent allusions that one hears from holy and excellent men in their public sermons."[24]

Though it is unlikely to have served as a fishwrapper, Dante's *Commedia* may well have been quoted by fishmongers. In Franco Sacchetti's tales, Dante (the poet whose "fame will never diminish") has occasion to admonish successively a blacksmith and a donkey driver who sing his verses too freely and outrage him by mangling his lines.[25] However satirical, Sacchetti's tales are not fantastical and these anecdotes are a measure of how widely the poem was read and recited.

Possession of the *Divine Comedy* and its commentaries could be in modest copies as well as in deluxe, leather-bound illustrated versions on parchment. In any format, Dante's works are a constant among the books inventoried in libraries large and small. Artists known to have had copies of his works include Luca della Robbia, who owned a copy of the *Vita nuova*, and the da Maiano brothers, Benedetto and Giuliano, who had a copy of the *Commedia*; Filippino Lippi counted copies of the *Convivio* and "uno Damte in charta pechora" among the dozen or so books he owned.[26] Snippets from Dante scattered throughout Leonardo da Vinci's notes reveal him to have been a thoughtful reader, recalling Dante's words as popular wisdom and as scientific proof: from observations on human frailty, not to be blown about by the wind ("e non si muta per soffiar di venti"), to information about the motion of water and the workings of geometry.[27] He was mightily impressed by Virgil's exposition on the divine origin of art in Canto XI of *Inferno* where Dante is told to "note well your *Physics*, you will find, after not many pages, that your art, as far as it can, follows her [nature], as the pupil does his master; so that your art is as it were grandchild of God."[28] Leonardo appropriated this reasoning to prove his argument that painting was a

> subtle invention which brings philosophy and subtle speculation to the consideration of the nature of all forms – the sky and the land, plants, animals, grass, and flowers – which are surrounded by shade and light. And truly this is a science and the legitimate issue of nature; for painting is born of nature – or, to speak more correctly, we

123 Leonardo da Vinci, *Landscape*, 1473, pen and brown ink, 19 × 28.5 cm., Gabinetto Disegni e Stampe, Galleria degli Uffizi, Florence, inv. no. 8P.

124 Leonardo da Vinci, *Star of Bethlehem, with Crowsfoot and Wood Anemone*, ca. 1508–13, red chalk and pen and ink, 19.6 × 15.6 cm., Royal Library, Windsor Castle, 12424.

shall call it the grandchild of nature; for all visible things were brought forth by nature, and these her children have given birth to painting. Hence we may justly call it the grandchild of nature and related to God.[29]

These subtle speculations moved Leonardo's hand as he investigated how the elements of nature could be transcribed in light and shadow (pls. 123, 124).

Botticelli was involved in the official portrayal of the poet. He supplied a drawing for the intarsia on one of the doors in the Sala dei Gigli of the Palazzo della Signoria made between December 1478 and December 1480 by Giuliano da Maiano and Francione. The doors paired Dante with Petrarch as presiding figures. A year later, in this magnificently decorated hall, Cristoforo Landino presented his edition of Dante to the Signoria with a laudatory oration.

A penetrating reader of "il Dante," Botticelli was twice called upon to illustrate the *Divine Comedy*. He first supplied drawings for engravings to be included in Landino's edition (pls. 236, 237) and then created a complete pictorial interpretation of the poem in a set of drawings probably done for Lorenzo di Pierfrancesco dei Medici in the 1490s. Taking his cue from Dante's explicit and repeated concern to find forms suitable to his subject, the painter became poet, arriving at distinctive visual answers to his task of translation.

In the drawings the viewer is made to participate in the journey down to the depths of the "woeful realm" in a tortuous, but continuous and visually interconnected route, following Dante and Virgil down precipitous inclines, over and along rocky paths

(pl. 125), and then arduously up the steep terraces of Purgatory (pl. 126) to be lifted into the spheres of heaven, where different forces operate and a new vision is required (pl. 127).[30] Infernal clamor and confusion are pictured in dense and disorienting compositions, often with multiple angles of vision (pl. 128). The drawings demand constant changes in the notional position of the beholder's gaze in order to follow the narrative

125 (FACING PAGE TOP) Sandro Botticelli, *Inferno, Canto XIX, Corruption among the Clergy: Punishment of Simonists*; 126 (FACING PAGE BOTTOM) Sandro Botticelli, *Purgatorio, Canto XIX, Ascent to the Fifth Terrace*; 127 (THIS PAGE TOP) Sandro Botticelli, *Paradiso, Canto I, Ascent to the Heaven of Fire*; 128 (THIS PAGE ABOVE) Sandro Botticelli, *Inferno, Canto XXII, Eighth Circle, Punishment of the Corrupt*; each sheet 1490s, pen and ink, black chalk underdrawing, ca. 32.5 × 47.5 cm., Kupferstichkabinett, Berlin, cod. Hamilton 201.

129 Sandro Botticelli, *Paradiso, Canto* X, *Ascent to the Fourth Planetary Sphere (Heaven of the Sun)*, 1490s, pen and ink, black chalk underdrawing, ca. 32.5 × 47.5 cm., Kupferstichkabinett, Berlin, cod. Hamilton 201.

and to share the alternating bewilderment and comprehension of the figure of Dante. Representing and presenting chaos, each panorama of horrors can be entered and experienced by finding and focusing on Dante, whose own eyes are usually directed downwards. The contrast with the abstraction and clarity of *Paradise* is absolute (pl. 129).

Given the paradoxical task of picturing Dante's progression to beatific vision in *Paradise*, arriving at the point where "power failed the lofty phantasy," Botticelli changed his pictorial exegesis from a literal or historical approach to narrative design to an intellectual or spiritual one.[31] The illustrations to *Paradise* concentrate on the figures of Beatrice and Dante, as Beatrice patiently quietens Dante's agitated mind, since her "proving and refuting had uncovered to me the sweet aspect of fair truth."[32] Rather than guide the viewer to look episodically, across or down through the page, as in the *Inferno* and *Purgatory* sequences, Botticelli's *Paradise* compositions address a direct, centralized gaze, which can then see or share in seeing as Beatrice clears Dante's intellect. Beatrice's attentive look and conspicuous gestures manifest this process of gentle argumentation, as do Dante's attitudes – in turns puzzled, bewildered, dazzled.

Botticelli's command of different levels of looking is demonstrated in his drawing for *Purgatory* X (pl. 130). The entire canto is put before the viewer. The gate of Purgatory is at the center of the bottom of the page, shown closing shut on its massive hinge while Dante and Virgil move up the narrow "cleft in the rock," which bends "one way and the other."[33] Dante, as he had been instructed in the preceding canto, does not look back even as the door resounds. He pays close attention to Virgil, whose character as guide is emphasized throughout the drawing by his outstretched right arm, both pointing Dante

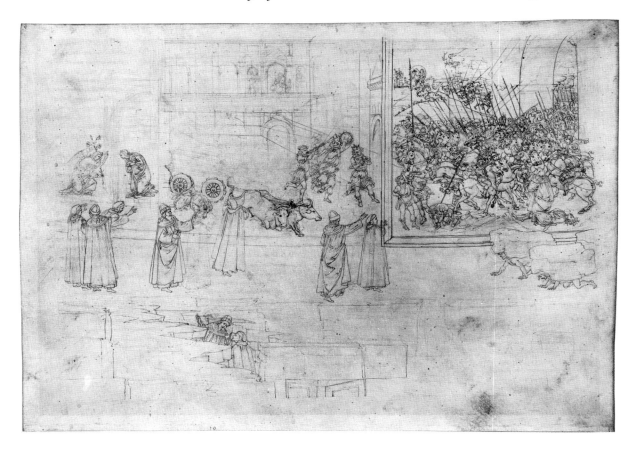

130 Sandro Botticelli, *Purgatorio, Canto X, Punishment of the Proud*, 1490s, pen and ink, black chalk underdrawing, ca. 32.5 × 47.5 cm., Kupferstichkabinett, Berlin, cod. Hamilton 201.

forwards and pointing out the direction of the canto's narrative. The punished proud, who will direct Dante to the next terrace and whom he will interrogate in the next canto, enter at the right, crawling beneath the weight of massive stones. The three reliefs, which take up half of the drawing, are displayed to the viewer, who also observes Dante's viewing.

One aspect of Botticelli's task was to categorically separate the reliefs, represented as majestic works of art, from the representation of the action of narrative. The massive frames, finished in the Trajan scene, denote this by marking them out in a way similar to the reliefs on the east door of the Baptistery (pl. 140). Botticelli did not give his reliefs the *ornamento* of a picture frame, he encased them as had Ghiberti. Also like Ghiberti, he composed his reliefs as conspicuous perspectives, an artistic device that demonstrates his artistry in the imitation of nature. Both the *Annunciation* and *David before the Ark* are scenes where architecture can be expected as part of the traditional iconography (for the *Annunciation*) and of the story (*David*). In the Trajan scene, a massive arch, an

ancient monumental type, sets the history in its time while it creates recession, gives proportion, and controls the trampling throng of horsemen. Each of the stories is separately constructed as an image measured in relation to its bounded edge, in direct contrast to the deliberately unbounded progress of Virgil and Dante around and across the pages of the *Comedy*.

In the drawings for *Purgatory* the ordinary progression along the page is from right to left, following a clockwise ascent of the mountain of Purgatory. This spatial logic is modified here. Virgil leads Dante upwards towards the terrace in the usual direction, but their inspection of the reliefs is arranged from left to right, so that Dante and the beholder of the drawing see the stories in traditional narrative order. Dante is given four postures as he looks at the sculptures: first pointing to the angel, which is the first figure described in the text. He then bends in imitation of what he has seen and is seeing, bowing before Mary, whose words of humble submission "were imprinted in her attitude."[34] Next, as in the canto, at Virgil's prompting, Dante goes past his mentor, to draw near to another story. Botticelli again places him as in the text, before the cart and the oxen drawing the holy Ark. A black chalk variant puts Dante closer to Virgil, but in the inked version Botticelli gave more impetus to the onward movement, displaying Dante in a sequence of realizations and reactions. Dante looks back towards Virgil, with his eyes on axis with the fallen figure of Uzzah in the relief. By signalling this moment Botticelli, like Landino in his gloss, enlarges upon the poem's cryptic line about the Ark, "because of which men fear an office not given in charge."[35] This refers to the biblical account of the procession. In the Bible, Uzzah puts out his hand to steady the Ark, shaken by the oxen, and God smites him dead for his error (2 Samuel 6:6–7). In the drawing, Dante clasps his right hand to his chest in an attitude of shock and sympathy, while pointing upward to David's proud wife Michol, "figured at a window of a great palace . . . looking on, like a woman vexed and scornful" as David dances, "girt up . . . both more and less than king."[36]

The fourth figure of Dante moves to "where [he] was to examine close at hand another story," that of the emperor Trajan.[37] Here Botticelli creates a neat form of double take between his picture of the story and those he has pictured looking at it. Dante's eyes are directed, once again, to a bent-over figure – but this time, unlike all the others he sees whom he may think to imitate, to admire, to pity, or to take as examples, the figure he is looking at is merely one of the soldiers bending down to adjust his boot. Two rather cocky young men at the left edge of the Trajan relief (and along the line of Virgil's raised arm) point to the dramatic center of the story, where the poor widow halts the emperor to plead for vengeance for her murdered son, who is stretched beneath her feet. With this artful gesture, Botticelli made his own image speak visibly about its own legibility, and he does so with a sort of marginal light-hearted note that respects both the seriousness of the messages exhibited to the character of Dante and to the poem's readers, and the mode of delight in which they were to be received.

Botticelli's sophisticated understanding of the poem surely results from his own talent, sympathy, and study. It responds with creative self-reflexivity to the poet's ability to write about things that could be manifested or put before the eyes of his readers. It also corresponds to their desire to look, to see, and to experience the revelatory pleasures of vision.

"OH MEMORY THAT WROTE DOWN WHAT I SAW, HERE SHALL YOUR
WORTHINESS APPEAR!"[38]

The point of the *Divine Comedy* is moral, but its plot is largely visual. It is a poem that describes a vision and is about vision. As the character Dante moves through the instructive landscape of the *Comedy*, he is carefully positioned by the poet to make the reader accept that his protagonist is actually seeing it and all it contains, so that the reader's inner eye can share the experience. Consequently the poem presents extensive testimony about the viewing process as it was understood at the time, and how it could be made imaginatively logical and psychologically effective.

The verb *vedere* is probably the most frequently repeated word in the poem. It is, however, only one of a varied and differentiated vocabulary of sight, which describes both modes of viewing and states of mind, and which follows the transformation of the character Dante as he progresses from a confused state to spiritual illumination, from corporeal to contemplative sight. In the *Divine Comedy* seeing is semantically and stylistically realized by a nuanced lexicon. In addition to *vedere*, to see, the verbs and therefore the actions of sight include: *guardare, riguardare, mirare, rimirare, adocchiare, osservare* (to look or gaze at, to examine, to stare, to notice, to eye or ogle, to observe). The courtly poetry of the mid-thirteenth-century Sicilian school supplied the variant *veggiare*, which Dante used in a prophetic sense. When seeing becomes intellectual vision in *Paradise*, it is inflected through verbs of comprehension.

Dante also employed a range of ocular expressions to suggest forms of attention: *ficcar gli occhi, porre occhi, pascere occhi, volgere* or *rivolgere l'occhi, torcere gli occhi, movere occhi* (as eyes fix upon or are fixed, set on, feast, and are turned, rolled, or moved). As the figure of Dante makes his moral progress through the journey of the poem to arrive at the "new vision" or "perfect vision" in *Paradise*, the simple verb "to see" is supplemented by complex viewing constructions and increasingly elaborate descriptions of eye movements.[39] There are about twice as many such descriptive phrases in *Purgatory* and *Paradise* than in *Inferno*, and those in *Paradise* are often more complex than those in *Purgatory*. This gives direct verbal equivalence to the way that "vision needs must increase" as sight becomes revelation; clarity is not simplicity, it is the intellectual ability to perceive or receive the difficult matters accessible only to the inner eye of the mind.[40]

In the *Divine Comedy* eyes have specific qualities and convey states of mind, including Dante's. For example they were "downcast and ashamed" when he feared he had offended Virgil by importunate questioning or "confused" when his mind was "bewildered."[41] In categories supported by sermon exemplars, the eyes of the people he encounters can be virtuous or vicious. The hypocrites look at Dante with sideways glances, their eyes blocked by their hoods; the desperate and despairing Ugolino della Gherardesca, who cannibalized his sons, has horrible bulging eyes.[42] By contrast eyes can be lovely, happy, and modest. Beatrice, Dante's figure of light and love, is recurrently characterized in terms of her beautiful, laughing, and joyful eyes.[43]

The logic of these looks was supplied by the notion that the passions of the soul – "grace, zeal, pity, envy, love, and shame" – were necessarily manifested by the "window

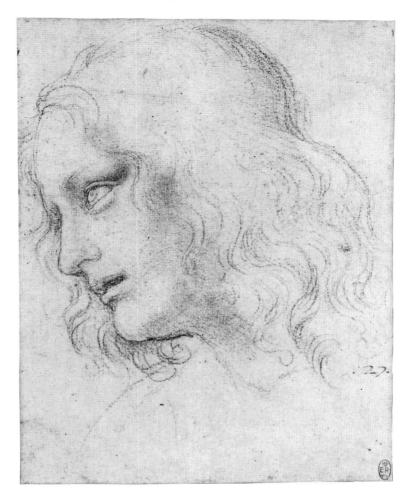

131 Leonardo da Vinci, *Head of Saint Philip for the "Last Supper,"* ca. 1495, black chalk, 19 × 15 cm., Royal Library, Windsor Castle, 12551.

of the eyes," as Dante explained in the *Convivio*.[44] This was not unknown to artists. The phrase was famously repeated by Leonardo da Vinci, whose conviction that the eye "is the window of the soul" made the quality of the gaze an animating force of his compositions and compositional studies (pl. 131).[45] The psychology of the gaze had found pictorial transcription long before Leonardo, however, and was part of the tradition inherited by the fifteenth century. Giotto's works are as rich and precise as Dante's words in their repertory of attentive forms of looking (pls. 132, 133, 134).

The different forms of representation (textual and visual) are linked by their mimetic reference to behavioral conventions and, perhaps more fundamentally, by their common relation to the demands made by the task of figuring or configuring emotions in a way that would color and impress memory. Psychology and rhetoric both supported the idea

132 Giotto, *Saint Francis Renounces His Worldly Goods*, detail of pl. 135, showing a witness.

133 Giotto, *Proof by Fire*, ca. 1325, mural, detail showing a pagan philosopher, Bardi chapel, Santa Croce, Florence.

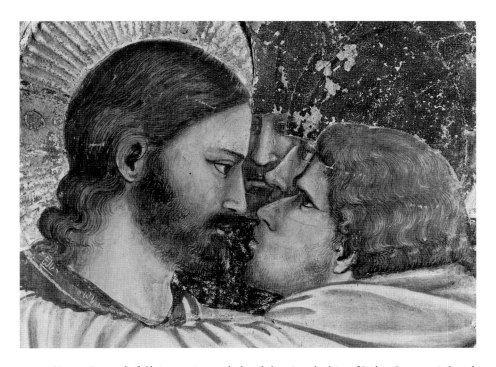

134 Giotto, *Betrayal of Christ*, 1306, mural, detail showing the kiss of Judas, Scrovegni chapel, Padua.

that striking imagery could impress and move an audience. In classical oratory the form known by the Greek term *enargeia*, which meant "vivid illustration" (*perspicuitas*) or "representation" (*representatio*) was a highly prized type of verbal ornamentation, which "thrusts itself upon" the notice of the audience.[46] It was attached to the brilliant (*illustris*) style, "the department of oratory which almost sets the fact before the eyes," as outlined by Cicero.[47] This trope took on new or renewed force when the act of putting things before the eyes, external and internal, was connected with the construction of viewing.

Dante, like many of his contemporaries, was very interested in optics. In addition to his great respect for Aristotle's ideas about sight (set forth by the philosopher in his books *De anima* and *De sensu et sensato*), he was familiar with the commentaries on Aristotle by Thomas Aquinas and Albertus Magnus. He combined information from these sources with a thorough understanding of optical science – the "art known as perspective" – above all Roger Bacon's *Perspectiva*.[48] He included a "digression" on questions relating to sight in the third book of the *Convivio*.

Dante's reliance on the science of optics was far from being a mere recitation of fashionable ideas. It attached the moral purposes of his work to the powers of perception and based them in objective reality and subjective experience. His command of the science and theology of vision certified the truth of his poem, which at times explicitly calls upon optical science by way of explanation, and which also explicitly urges the reader to find that truth through sight. In this as so much else, it is at once a *summa*, a symptom, and a support for allied arts of representation.

In the *Convivio* Dante refers to the intromission theory advanced by the Arab scholar Alhazen in his early eleventh-century treatise *De aspectibus* (also called *Perspectiva*), where it was argued that the eyes receive rays from the surfaces of objects, rather than emitting the rays towards them, the extramission theory inherited from Euclid and Ptolemy. He explains how, given that many things can come to the eye, "truly that which comes by a straight line to the center (*punta*) of the pupil is that which you see truly and which impresses itself on the imaginative faculty."[49] The *imaginativa* was the internal sense that stored the images retrieved for reasoning and for action. The ray passing in a straight line to the eye was the one that Alberti called the centric ray, "undoubtedly the most keen and vigorous . . . it must rightly be called the leader and prince of rays."[50] In Alberti's pictorial perspective, "the place where the centric ray strikes" determines the centric point, and from this the proportional projection or viewpoint.[51]

Part of the calculation of spatial perception in Alberti's system, the straight line of vision was the line of fixed and penetrating looking. It had long been a consciously manipulated element in compositional design. Giotto's rigorous composition of gazes within his paintings, where the internal action of looking directly dramatizes the actions seen by the beholder, relies on an understanding of the power of the direct ray (pl. 135). The quality of heightened attention in the picture field alerts the viewer to focus on the scenes and episodes "put before the eyes" and enhances the pictures' imaginative as well as expressive potential as the spectator enters the psychological interplay of the represented figures.

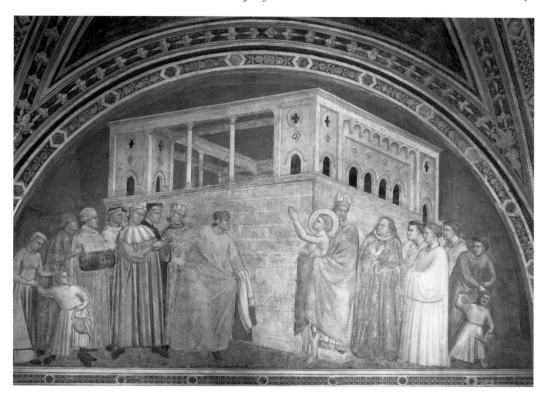

135 Giotto, *Saint Francis Renounces His Worldly Goods*, ca. 1325, mural, Bardi chapel, Santa Croce, Florence.

This lesson was fully absorbed by the fifteenth century, when the technical control of the "eye of the spectator" was taken to a further stage, that of organizing the composition from the spectator's "point of sight" – a construction that Leonardo gave as a rule.[52] He could be describing Masaccio's *Tribute Money* (pl. 136) when he replies to the question

> In what way am I to represent the life of a saint divided into several pictures on one and the same wall, I answer that you must set out the foreground with its point of sight on a level with the eye of the spectators of the scene, and upon this plane represent the more important part of the story large and then, diminishing by degrees the figures, and the buildings on various hills and open spaces, you can represent all the events of the history.

His conclusion, "otherwise do not trouble yourself with it for your whole work will be wrong [*falsa*]," posits the truth value of this method.[53]

For Leonardo perspective was to be "preferred to all the discourses and systems of human learning," because of its certainty of demonstration and its basis in mathematics and physics.[54] A rule of art that derived from the rules of nature, Alberti asserted that it provided the visual arts with a measure for their imitation of nature: "painting aims to

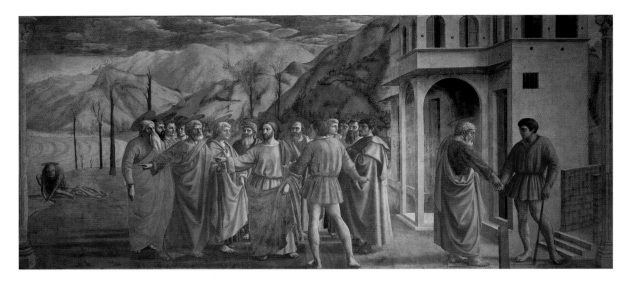

136 Masaccio, *Tribute Money*, ca. 1427, mural, Brancacci chapel, Santa Maria del Carmine, Florence.

represent things seen, let us note how in fact things are seen."[55] As mentioned in the previous chapter, Brunelleschi's biographer credited him with being the first to set down "properly and rationally the reductions and enlargements of near and distant objects as perceived," thereby inventing the science that "painters . . . call perspective" and demonstrating it with views of the Piazza della Signoria and the Baptistery.[56] This occurred in the first decade of the fifteenth century, and it made an immediate impression on Brunelleschi's equally inventive friends Masaccio and Donatello, who took his experiments as a basis for practical application (pls. 136, 137).

Brunelleschi's fifteenth-century biographer insists upon the distinction between rule (*regola*) and the science (*scienza*) that had been discovered or rediscovered and demonstrated. As is clear from Leonardo and Alberti, this demonstrable connection of science to the visual arts was the key to the excitement as it indisputably positioned them with learning. Ghiberti's faith was such that he felt compelled to correct one of Pliny's more famous anecdotes. The ancient author narrated a "clever incident" when Apelles went to see Protogenes's works. Protogenes was absent, so Apelles painted an "extremely fine line" on a panel left on the easel, which Protogenes immediately recognized as by Apelles, answering with another, "still finer," only to be defeated by Apelles's third, which "left no room for any further display."[57] Though he respected his source, and held that what Pliny wrote might be true, Ghiberti was amazed that artists so versed in their fields would be content with such a "weak demonstration." "Speaking as a sculptor," with all due respect for his readers, he gave his opinion, that because Apelles, "who had composed and published books on the art of painting," wanted to show the nobility of that art and how skilled he was, "he took a brush and composed a conclusion in perspective as it belongs to the art of painting," with Protogenes responding in kind and Apelles replying with yet another "conclusion" so perfect that Protogenes conceded defeat.[58] What-

137 Donatello, *Ascension of Christ*, ca. 1427, marble, 41 × 114.5 cm., Victoria and Albert Museum, London.

ever he envisioned with these contesting additions, Ghiberti's definition of a flourish of perspective as a "conclusion," or "demonstration" connects it to philosophical disputation, making it the logical outcome of a reasoned argument, in this case one about the erudition of art.

Ghiberti tells how Apelles acquired his great learning in art by daily composing some such demonstration and how he took his proportions from nature, holding to the "visual power" ("virtù visiva").[59] This was, of course, exactly how he demonstrated his own great learning in the second set of Baptistery doors where he

> strove to observe with all the scale and proportion, and to endeavor to imitate Nature in them as much as I might be capable; and with all the principles which I could lay bare in it and with excellent compositions and rich with very many figures . . . There were ten stories, all in architectural settings in the relation with which the eye measures them, and real to such a degree that if one stands far from them they seem to stand out in high relief. [However] they have very low relief and on the standing planes one sees the figures which are near appear larger, and those that are far off smaller, as reality shows it. And I carried through this whole work with these said rules [of measurement and proportion].[60]

Ghiberti's conception of frame, surface, and subject should not be taken for granted. Freed from the requirement of the quatrefoil surround imposed on the the previous commission, he restructured the relationship between story and spectator by "beginning the work in panels ['quadri']," putting the Old Testament histories into "architectural settings ['casamenti']."[61] The terminology is unusual. The common term for frame was *ornamento*. Ghiberti reserved the word *adornamento* for the foliate ornament with birds and animals on the surrounding frieze. He used *cornice* for the frame for the entire door. Rather than his seeing the casing of the stories as a decorative supplement, the frames of the reliefs provided him with the point of departure for measured projections. In modern Italian, paintings are *quadri*, but Ghiberti's conflation of form with function was novel.

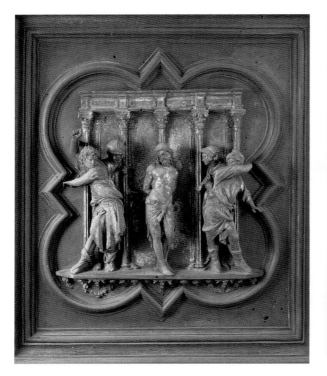

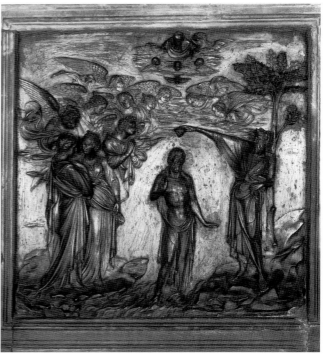

138 Lorenzo Ghiberti, *Flagellation*, ca. 1403–24, gilt bronze, 57 × 65 cm., North Door, Baptistery, Florence.

139 Lorenzo Ghiberti, *Baptism of Christ*, 1417–27, gilt bronze, 60 × 60 cm., Baptistery, Siena.

The viewing premise is different from his previous reliefs, those on the first set of Baptistery doors (pl. 138) or the panels of *Saint John the Baptist Brought before Herod* and the *Baptism of Christ* he made for the font of the Siena Baptistery between 1417 and 1427 (pl. 139). In these the narrative is placed against a neutral backdrop. Figures project outwards, performing the actions of the stories on spatial platforms. There is only a limited gradation of depth in the relief modelling, which is nearly three-dimensional. Put before the eyes with relatively uniform mass, the figures are characterized by tactile virtousity, which draws attention to the carefully worked and gracefully contrasted surfaces: rhythmically entwined drapery, curling locks of hair, modulated muscles, bare flesh made from metal and metalwork armor imitated in bronze.

Many of the formal values of the previous reliefs are maintained in the second set of doors. They demand a different style of viewing, however (pls. 140, 141, 142). Looking has been intellectualized in two fundamental ways. One is in the pictorial construction, which is based on a gradation of dimensionality that makes the appearance of relief as important as actual three-dimensional modelling. The other is in the balance achieved between general formal unity and narrative diversity. With the exception of the *Meeting of Solomon and Sheba*, the panels combine a number of episodes that must be separately discerned for their meaning to be understood.

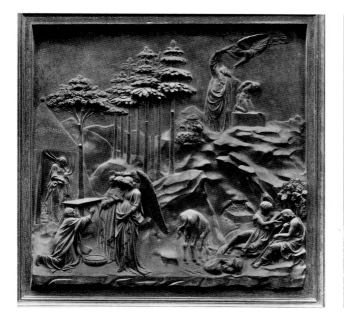

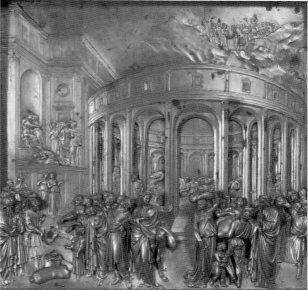

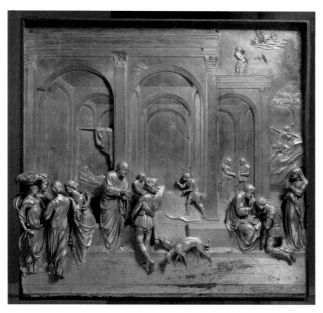

140 (ABOVE LEFT) Lorenzo Ghiberti, *Story of Abraham*, ca. 1424–43, gilt bronze, 73 × 73 cm., East Door, Baptistery, Florence.

141 (ABOVE RIGHT) Lorenzo Ghiberti, *Story of Joseph*, ca. 1424–43, gilt bronze, 73 × 73 cm., East Door, Baptistery, Florence.

142 Lorenzo Ghiberti, *Story of Isaac*, ca. 1424–39, gilt bronze, 73 × 73 cm., East Door, Baptistery, Florence.

In his description of the door, Ghiberti tells how it was divided into ten biblical histories, the ten panels, each of which contains a number of episodes ("istorie cioè effetti"), and he enumerates the *effetti* to be seen in each of the panels.[62] These are constructed to show "how" the episode unfolded, as in the panel (pl. 142) where it is shown

> how Esau and Jacob are born to Isaac and how he sent Esau to hunt and how the mother instructs Jacob and gives him the kid and the skin, and fastens it on his neck

and tells him he should ask the blessing from Isaac, and how Isaac probes his neck and finds it hairy and gives him the blessing.[63]

The panel also shows how Ghiberti can calculate recession, whose units of measurement can be read from the foreground pavement, and how he can build a loggia in the latest *all'antica* mode, and design graceful maidens, realistic hounds, juxtapose old and young, and incorporate antique citation in modern representation.

Effect implies cause, and conversely, in philosophical reasoning the cause can only be known by its effects. In the *Convivio* Dante explains that "every effect retains the nature of its cause" and that "every cause imbues its effect with the goodness deriving from that cause."[64] Ghiberti's chosen term in turn imbues his compositional strategy with a deeper reasoning that explains their perfection as resulting from intellectual operation and as related to the structure of scientific investigation.

When the commission for the second set of doors was being considered Leonardo Bruni wrote a set of recommendations for the *operai* about their decision, with instructions about the program. He said that it would be necessary for whoever was chosen to design them to be "instructed about each history" and he volunteered to supply said instruction.[65] He advised that there be twenty histories from the Old Testament and noted them in detail in a separate letter. As things developed there seems to have been a tug of war in prestige between the erstwhile humanist advisor and the ambitious artist. Ghiberti's claim to have been given license to do as he thought would be most perfect, ornate, and rich resounds with his triumph. But Bruni's brief set aims met by the sculptor. Bruni said that the doors should have two principal qualities, firstly that they be "illustri" and the second that they be "significanti"; he explained that by "illustri" he meant that they should "feed the eye with variety of design"; by significant, that they have an importance "worthy of memory."[66]

Bruni, who certainly knew his Cicero, specified a rhetoric of appeal through the brilliant style, the style that was the most ornate and the most vivid. Ghiberti fulfilled the demand with a set of compositions intended to engage his viewers' eyes through their stylistic charm and to capture them through the manipulations of spatial design. In profiting from the recent innovations in perspective he could well have thought about Dante's eyes,

> . . . well content to look
> To see something new, they were avid of such
> things . . .[67]

*　　*　　*

"SWEET HUE OF ORIENTAL SAPPHIRE . . . TO MY EYES RESTORED DELIGHT"

Seeing was more than a matter of perspective, however. It also had poetic connotations, which were of great importance to the perception of art and the status of artists. Dante himself coined the term *dolce stil novo* for a new manner of verse, "dictated" by love, which he also credited himself with inventing.[68] In the poems of this style, love for an idealized and distant woman acts as an ennobling force. Seeking sweetness and suavity of expression, the poems describe a spiritualized erotics largely enacted through the eyes. The themes of this poetry were supplied by Provençal and Sicilian lyrics, which made the eyes the messengers of the heart and the poet the servant of love and beauty. The difference in the *stil novo* is the transcendent value given to the inspiration of love, often transmitted through vision: through the sight of the beloved lady or through the power of her affectionate gaze.

Whereas Dante's perspectivist optics came from natural philosophy, the visual dynamics of love were based in medical thought about the physiology of sense perception. It was held that a cerebral "spirit" or vapor emanating from purified blood in the brain mediated between the soul (the *anima*) and the organs of the senses and that this spirit – the *pneuma psychikon* or *spiritus animalis* as defined by the tradition going back to the second-century physician Galen – could be carried from the body by light rays extending from the eyes. These rays could capture the eyes or pierce the heart, as Dante describes in the *Vita nuova*:

> Whatever her sweet eyes are turned upon,
> Spirits of love do issue thence in flame,
> Which through their eyes who then may look on them
> Pierce to the heart's deep chamber every one.[69]

The contradiction between the optical construction of sight and the ocular mechanics of desire was allowed to remain unresolved, and the beautiful eyes of fair and gentle ladies continued to bind men's hearts in the lyrical tradition that descended from Dante and Petrarch. Thus Lorenzo de' Medici addressed the eyes of his amorous muse, Simonetta Vespucci, who, like Dante's Beatrice and Petrarch's Laura, was removed from him by her early death: "Eyes, you are certainly within my heart," explaining that "the image of her beauty had already descended through my eyes into my heart, and her eyes had made such an impression that they were always present."[70] And the ardent gazes and love-inspiring looks of the poetic painting of Lorenzo's time take up this imagery to make it visible and part of a sophisticated construction of visual pleasure (pls. 143, 144).

The elevating power of love, vested in sight and seeing by the transformational poetics of the *dolce stil novo*, is the motivating force of Dante's journey through *Purgatory*. Hate was the medium of exchange in Hell. Leaving behind the "blind world" of the *Inferno* and entering the realm where human spirits are purged and prepared to become worthy of heaven, Dante is struck by the sweet sapphire hues of the sky, and "delight" is restored to his eyes.[71] His eyes and heart, saddened by the sights of the *Inferno*, open to pleasur-

143 Sandro Botticelli, *Primavera*, detail of pl. 89.

144 Antonio del Pollaiuolo, *Apollo and Daphne*, ca. 1470, panel, 29.5 × 20 cm., National Gallery, London.

able sensation. In optical terms, the return of color and light supply one explanation for this phenomenon. In his treatise on perspective, Roger Bacon argued, "since we take especial delight in vision, and light and color have an especial beauty beyond other things that are brought to our senses, and not only does beauty shine forth, but advantage and a greater necessity appear."[72]

There is a stylistic as well as a scientific shift in this access of delight, as the rough and harsh refrains of Hell give way to a register of grace with its attendant vocabulary

in the key of sweetness, charm, and grace (*dolce, soave, gentile* are typical adjectives). In Canto x, the angel appears to Dante and Virgil sculpted with "a gentle attitude," and "delight in gazing" was Dante's state of mind as he studied the reliefs.[73] Dante's reaction would seem to anticipate Alberti's prescription for "a 'historia' you can justifiably praise and admire [which] will be one that reveals itself to be so charming and attractive as to hold the eye of the learned and unlearned spectator for a long while with a certain sense of pleasure and emotion."[74] Apart from Alberti's familiarity with Dante, this coincidence has a deeper explanation in moral philosophy and rhetorical theory.

The opening to the fourth canto of *Purgatory* is dedicated to a description of how Dante's experience of becoming totally absorbed in listening and marvelling made him forget time:

> When through impression of pleasure or of pain,
> which some one of our faculties receives,
> the soul is wholly centred thereon,
> it seems that it gives heed to no other of its powers . . .
> and therefore when aught is heard or seen
> which holds the soul strongly bent to it,
> the time passes away and we perceive it not,
> for one faculty is that which notes it,
> and another that which possesses the entire soul,
> the latter as it were bound, the former free.[75]

Landino's comment on these verses takes the case of seeing: "Therefore when the eye sees something that gives it great delight, the soul is completely concentrated on the visual power," without attending to the other faculties.[76]

That pleasure and pain were the motivating forces for all behavior and that "every passion and every action is accompanied by pleasure and pain" are Aristotelian dictates. This pairing was accepted as axiomatic, such that Leonardo da Vinci made a drawing saying that they should be shown "as twins because the one is never separated from the other."[77] Logically enough, Aristotle explained that "to feel delight and pain rightly or wrongly has no small effect on our actions."[78] Being drawn to pleasure was associated with an instinctive drive to what is good or necessary for survival.

In his book *On the Soul*, Aristotle explained that whatever living being has sensory capacity also "has the capacity for pleasure and pain and therefore has pleasant and painful objects present to it, and wherever these are present, there is desire, for desire is appetition of what is pleasant."[79] The dilemma of delight, of course, was the danger of being seduced by sensual pleasures rather than being inspired by intellectual or spiritual matters. Hence Landino explains why the lustful (*lussuriosi*) were condemned to "a place mute of all light": "having greatly sinned with their eyes, which are the guide in love, and having delighted in corporeal beauties, all of which consist in sight, it is suitable that they would be deprived of the sense with which they had sinned."[80] But delight and sight had an integral connection with knowledge. Aristotle opens the *Metaphysics* stating that

All men by nature desire to know. An indication of this is the delight we take in our senses; for even apart from their usefulness they are loved for themselves; and above all the sense of sight . . . The reason is that this, most of all the senses, makes us know and brings to light the differences between things.[81]

Dante quotes Aristotle at the start of the *Convivio* ("As the Philosopher says at the beginning of the First Philosophy, all men desire to know") and Leonardo da Vinci later paraphrased the sentence in his drafts to the introduction of his book *On Painting*: "Good men by nature wish to know."[82]

This conjunction of desire, delight, and knowledge informs the viewing process in Canto x, which is a paradigm for the way that pleasure in the sight of beautiful objects could operate virtuously. Dante's pleasure in viewing comes from the fact that it is connected with the apprehension of good. The moral and didactic function of delight is explained by Francesco da Buti in his comment on the passage: Dante delights in the artistry or artifice of God who made the sculptures so that those who are in Purgatory would think of the virtues opposite to their sins in order that they might recognize their errors, feel proper contrition, and patiently bear their punishments.[83] In Canto x Dante's delight comes from the fact that what he is seeing is good and virtuous action should result from viewing these examples.

Delight was also an instrument of persuasion. "The duty of the orator is composed of instructing, moving and delighting his hearers" was an assumption repeated in all of the rhetorical treatises.[84] In the *Orator*, Cicero categorized the tasks of the "man of eloquence" as being able "to prove, to please and to sway or persuade," and assigned each of these a style of speech: with the middle for pleasure.[85] For Cicero the "beauty of style" was one division of the subject of oratory, requiring that the "language should be ornate . . . in the highest possible degree pleasing and calculated to find its way to the attention of the audience."[86] While holding to the principle of decorum, of suiting style to subject, he also, importantly, allowed for variety in personal styles of speaking. He took the example of sight and of seeing greatness in the arts to prove this point:

> our eyes collect for us an almost countless number of pleasures, whose charm consists in their delighting a single sense in a variety of different ways . . . this observation in the sphere of natural objects can also be transferred to the arts . . . There is a single art of sculpture, in which eminence was attained by Myron, Polyclitus and Lysippus, all of whom were different from one another, yet without the consequence of our desiring any one of them to be different from what he was. There is a single art and method of painting, and nevertheless there is an extreme dissimilarity between Zeuxis, Aglaophon and Apelles, while at the same time there is not one among them who can be thought to lack any factor in his art.[87]

Landino's chapter on "Fiorentini eccellenti in pittura e scultura" in the preface to the *Comento*, which characterizes each artist according to particular qualities of their art, represents the acceptance of this principle of delight in difference, on the part of both artists and their audience in the fifteenth century. That his critical terms were derived in part

from oratory depends on the fact that rhetoric supplied a theory of style as well as a habit of relating style to the visual arts. But their applicability also depended on the communicative premise of those arts: that images could be composed in ways that could capture attention with charm and persuasive force.

In the commentary to *Purgatory* x, Landino gives the concept of delight immediacy, using experience as proof – "as we see in ourselves" – and moving from the authority of God's art to the authorship of Giotto. This represents another form of visible speech: for, as noted above, Landino remarks that "if we are looking at a painting and we hear that it is by the hand of Giotto, the authority of that man has great weight with us."

Dante considered the etymology and meaning of *autore* in the *Convivio*, concluding that it was to be applied to

> any person worthy to be believed and obeyed. And from this comes the word . . .
> *autoritade* that also means the same as 'act worthy of faith and obedience' . . . Among
> the workers and craftsmen of different arts and occupations, the craftsman or true
> operator of that [given art] must be obeyed and believed by all, as one who alone considers the ultimate goal of all the other goals . . . And therefore, because all human
> occupations require one goal . . . the master and artisan who demonstrates and considers it, should be above all obeyed and believed.[88]

When the character Dante recognizes Virgil, "the honor and light of other poets," in the first canto of the *Inferno*, he exclaims: "You are my master and my author. You alone are he from whom I took the fair style that has done me honor."[89] In medieval pedagogy *auctores* was a term given to the canon of books that formed the curriculum. Learning was held to be embedded in the words of the authors. This ideal was still current in the fifteenth century. As expounded in his treatise on the *Study of Literature*, written in the 1420s, Leonardo Bruni held that "the most important rule of study is to see to it that we study only those works that are written by the best and most approved authors [*auctoribus*]" in order to train and nourish the intellect and preserve "purity of taste."[90] The new learning of the *studia humanitatis* altered the canon of *auctores* and its function. In a way announced by Dante's declared relation to Virgil, authors remained sources of wisdom, but the emphasis was increasingly on style. Cicero – "so eloquent! so rich in expression! so polished! so unique in every kind of excellence!" – was chief among them.[91]

Well could Landino invoke the name of Giotto in a similar fashion. Giotto, like Dante, held a lofty and abiding position in the Florentine cultural pantheon. Giotto is named by Dante in the eleventh canto of *Purgatory* among the examples of vainglory, but as subsequent commentators pointed out, "since that time no one in that art has been valued as highly."[92] The extent of his *autorità* is evident in artistic practice. Like the writings of the "proven authors," his paintings were studied for motifs and as models of composition. Cennino Cennini proudly traced his artistic geneaology from Giotto as part of presenting his credentials as the author of the *Libro dell'arte*:

> I was trained in this profession for twelve years by my master, Agnolo di Taddeo of
> Florence; he learned this profession from Taddeo, his father; and his father was chris-

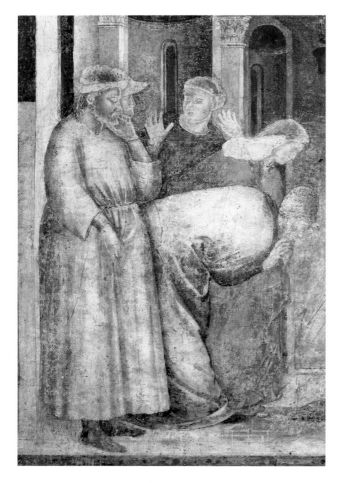

145 Giotto, *Ascension of Saint John the Evangelist*, detail, ca. 1320, mural, Peruzzi chapel, Santa Croce, Florence.

146 Michelangelo, study after figures from Giotto's *Ascension of Saint John the Evangelist*, ca. 1490, pen and ink with stylus underdrawing, 31.5 × 20.5 cm., Département des Arts Graphiques du Musée du Louvre, Paris, 706 (recto).

tened under Giotto, and was his follower for four-and-twenty years; and that Giotto changed the profession of painting from Greek back into Latin, and brought it up to date; and he had more finished craftsmanship than anyone has had since.[93]

The strength of this lineage was such that it gave good reason for Leonardo da Vinci to blame a decline in art after Giotto on the fact that everyone, until Masaccio, "imitated the pictures that were already done."[94]

Respect for his authority, though modified, was not lost in the fifteenth century, when as the modern Apelles, Giotto's name stood for the highest achievement in painting. He continued to be a benchmark for apprentices in that art. A drawing after two figures in the *Ascension of Saint John* in the Peruzzi chapel, for example, proves that the young

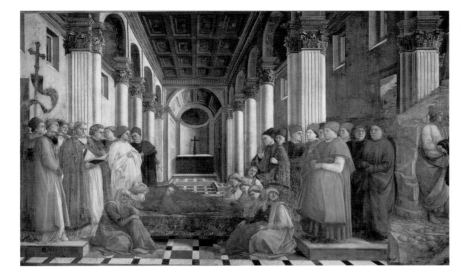

147 Fra Filippo Lippi, *Celebration of the Relics of Saint Stephen*, ca. 1452–64, mural, chancel, cathedral, Prato.

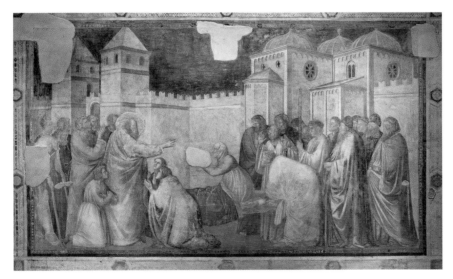

148 Giotto, *Raising of Drusiana*, ca. 1320, mural, Peruzzi chapel, Santa Croce, Florence.

Michelangelo took a keen interest in the lessons to be learned from Giotto (pls. 145, 146). This could well have been his own initiative, but Ghirlandaio's profound understanding of Giotto's compositional and figurative language, discussed in the previous chapter, suggests that this was a regular exercise for Ghirlandaio and his apprentices. Fra Filippo Lippi adapted the dignified and weighty presence of Giotto's heavily draped figures to his own figural repertory, as, for example, in the solemn crowd gathered around Saint Stephen's bier in the mural of the *Celebration of the Relics of Saint Stephen* in the choir chapel of the cathedral at Prato, which can be compared to that gathered to witness Saint John the Evangelist's resuscitation of Drusiana in the Peruzzi chapel at Santa Croce (pls. 147, 148). The whispering maidservants at the right of the *Feast of Herod*, in the same

149 Giotto, *Feast of Herod*, detail, ca. 1320, mural, Peruzzi chapel, Santa Croce, Florence.

150 Fra Filippo Lippi, *Feast of Herod*, detail, ca. 1452–62, mural, chancel, cathedral, Prato.

cycle at Prato, may well be graceful, nymph-like adaptations of Giotto's engaging pair placed in a similar position in that scene in the Peruzzi chapel (pls. 149, 150).

Whether respectful or critical, imitative, adaptive, or inventive, such references to Giotto show that works by his hand carried weight with fifteenth-century viewers and prove the logic of Landino's choice of Giotto literally to authorize the idea of taking delight in "what we see." It fits well into Landino's own project of promoting the excellence of Florence and its accomplished citizenry. It further relates to the very real recognition of artistic authority in the fifteenth century, when artists were increasingly regarded and seeking to be regarded as singular masters, particularly by those held to have expert understanding.

"I CANNOT BUT ENJOY STATUES"

In May 1490 Lorenzo de' Medici instructed his son Piero about an impending visit by the eminent Venetian Ermolao Barbaro, who: "seems to me to be a knowledgeable man ['persona intendente'], who delights ['si dilecti'] in seeing antiquities."[95] Piero was told to show him those collected in the garden and in the study. The very next day Piero sent his father a report about the hospitality he had extended:

> I showed him the house, the coins, the vases and cameos, in sum absolutely every-thing including the garden, which gave him great pleasure, even though I do not think that he understands much about sculpture. But he did like a good deal what he heard of the coins and their age, and all were amazed at the number of such good things.[96]

That the guest should be measured by his ability to appreciate ancient sculpture (in Lorenzo's anticipation as a "persona intendente," which gave him status, in his son's opinion, "non credo s'intenda molto," which qualified his status) is a sign of the way that these cultural goods had become a medium of exchange in subtle negotiations of power, prestige, and honor.

Delight in painting and sculpture is the topic of two chapters in Petrarch's widely read *De remediis utriusque fortunae* (1354–67). The first book of the dialogue offers "Remedies for Prosperity." The protagonists are Reason and Joy, with Reason arguing against the worldly pursuits that distract from well-being. Moderation is the moral of the story, not a complete disregard for the fortune's benefits. These are extensively described by Joy, who is adamant about the delights to be found in the appreciation of pictures and statues, along with those taken in pleasant odors, song and dance, wrestling and elephant-owning, among other occupations.

Whatever its importance to exotic pet ownership, the dialogue had a great impact on the theory of the visual arts. Combined with other writings by Petrarch, the reasoning in the sections on painting and sculpture gave those arts a place and commonplaces in learned discourse. It did so with a refrain of pleasure. Joy insists: "Paintings delight me more than anything," and "I cannot but enjoy statues."[97] While deploring Joy's tendency to forget the "great craftsman," God, Reason usefully picks out the pleasing qualities of both arts and their fascinations, conceding in the case of sculpture that "noble skill joined with noble materials may delight" and that "enjoyment of talent, engaged in with mod-eration, is acceptable."[98] Reason also allows that ancient artists had great fame, "pro-claimed and celebrated by the works of established authors . . . Greatness does not come from nothing, and a great name must be deserved, or appear to be so, in order to be respected by the great."[99]

By the late fifteenth century, respect of the great by the great was part of civic ideol-ogy, promoted by the leading men of the regime, headed by Lorenzo de' Medici, who, as is well known, wielded his ability to understand the arts as an unofficial instrument of state. He made representational politics a highly effective arm of his authority. This began early in his career. In 1477, for example, a committee of Pistoian citizens appealed to him to decide between competing models for a monument to be erected in their cathe-dral in memory of Cardinal Niccolò Forteguerri, "because you have a quite complete

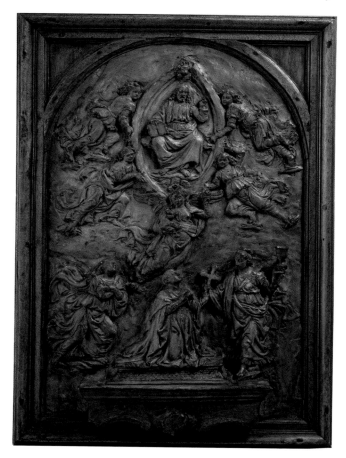

151 Andrea del Verrocchio, model for the Forteguerri Monument, 1477, terracotta, 39.4 × 26.7 cm., Victoria and Albert Museum, London.

understanding of such things and of everything else."[100] Lorenzo chose Andrea del Verrocchio over Antonio del Pollaiuolo, who had been supported by a faction claiming his idea was more beautiful and better crafted. Lorenzo dismissed their judgment as inexpert.

The basis for Lorenzo's decision is unknown. A terracotta sketch model by Verrocchio survives (pl. 151), but Pollaiuolo's proposal is lost. Lorenzo's was not, however, a unilateral bias for Verrocchio. Although Andrea received many major commissions through Lorenzo's patronage, the Medici also owned works by the Pollaiuolo brothers. Lorenzo had enough confidence in Antonio to entrust him to act as a personal messenger, writing to a mutual friend (Giovanni Lanfredini) that he had spoken with Antonio "on a certain matter that he will tell you about."[101] Antonio and his brother Piero had done three large paintings of the labors of Hercules for the *sala grande* of the palace around 1460, part of the decorative patrimony that formed Lorenzo's apprenticeship in the delights of informed ownership. There was also a statuette of *Hercules and Antaeus* by Antonio among the family possessions.

Lorenzo's legacy was considerable and he built on it passionately and programmatically. Not only did he add to the precious collection of gems, vases, and cameos held in the *scrittoio*, but he created a sculpture garden where ancient works were assembled partly with the purpose of providing models for modern artists: a locus to cultivate the skills of understanding as well as those of art. The sculptor Bertoldo di Giovanni was an intimate of the household, as was Michelangelo. Both were set essays in the classical idiom, one in bronze, the other in marble (pls. 152, 153).

But the Medici did not hold a monopoly on art appreciation. Not suprisingly artists were regarded as the professionals, "uomini intendenti" who were traditionally and regularly called upon to appraise finished works, advise commissioning bodies, or serve as consultants to boards of works.[102] They were also likely to be called upon to give opinions in the new and perilous realm of collecting antiquities. Such was the case, for example, of the humanist and historian Poggio Bracciolini, who described himself as "headstrong," that is possessing a "room full of marble heads" and who was being offered

152 Bertoldo di Giovanni, *Battle*, ca. 1479, bronze, 45 × 99 cm., Museo Nazionale del Bargello, Florence.

153 Michelangelo, *Battle of the Centaurs*, ca. 1490–2, marble, 80 × 90.5 cm., Casa Buonarroti, Florence.

statues dubiously attributed to Polycleitus and Praxiteles. Poggio was glad of Donatello's praise for one of the pieces he intended to bring home, as he reported in a letter to his friend Niccolò Niccoli in 1430.[103]

Precisely this form of activity was the catalyst for a wider sharing of knowledge, where desire and delight could be justified in terms of a special understanding attainable by specially refined intellects. In his biography of Niccoli, written in the 1480s, Vespasiano da Bisticci comments on the fact that it was through Niccoli that "Florence acquired many fine works of sculpture of which he had great knowledge as well as of painting," and that among "singular virtues" was his universal judgment, not only in letters, but in painting and sculpture. Along with men of letters, he patronized painters, sculptors, and architects and was a great friend of Brunelleschi, Donatello, Luca della Robbia, and Ghiberti.[104]

An episode recounted by Vespasiano epitomizes the circulation of interests between artists and their patrons and the consequences of such contacts. Niccoli had the fortune to come upon a young man "who had around his neck a chalcedony engraved with a figure by the hand of Polycleitus, a beautiful work," which he acquired from the boy's father for 5 florins (the man was convinced that he had been paid more than double its value).[105] The chalcedony, which Niccoli willingly displayed, soon became celebrated and was purchased from the cash-strapped Niccoli for 200 florins by another avid collector, Ludovico Trevisan, the Venetian Patriarch of Aquileia, when he was in Florence in the mid-1430s. Trevisan's compatriot Paul II (Pietro Barbo) added the gem to his formidable collection in 1465, when he took charge of Trevisan's estate. Lorenzo de' Medici obtained it when he was in Rome as ambassador to the coronation of Pope Sixtus IV, an occasion that afforded him the opportunity to carry away a number of prized antiquities. Whatever the going price, the gem's reputation was of extraordinary and increasing value, In Lorenzo's inventory its worth has increased to 1.500 florins, the second highest among the gems.[106]

The intaglio was soon replicated. It features conspicuously in one of the *tondi* decorating the Medici palace courtyard (pl. 154). The courtyard sculptures have no definite attribution, nor do they form a program, except that of projecting taste: whoever made them subordinated personal style to a Latinate, *all'antica* idiom, speaking a newly forged, emulative language that gave expression to the family's prestige. The Medici did not own the gem when the roundel was made. It is not the record of a possession, but of a position with regard to cultural goods.

Ghiberti, who also remarks on Niccoli's character as one who sought out and studied "many beautiful ancient works," was rapturous about the gem.

And, among the other ancient things [he owned] he had a chalcedony, which was the most perfect work that I ever saw. It was oval shaped, on it there was a figure of a youth holding a knife, with one foot almost kneeling on an altar and seated with his right leg on the altar with his foot resting on the ground, foreshortened with such skill and mastery that it was amazing to see. And in his left hand he had a cloth, in which he held a small idol; it seemed that the youth threatened it with a knife; for all those expert and trained in sculpture and painting, without exception, all said that it was a

154 *Diomedes and the Palladium*, ca. 1459, marble, courtyard, Medici palace, Florence.

155 Lorenzo Ghiberti, *Creation*, detail, ca. 1424–47, gilt bronze, East Door, Baptistery, Florence.

marvellous work with all the measure and proportion that any statue or sculpture should have; it was highly praised by all talented people.[107]

Ghiberti adapted the torso for his figure of Adam in the scene of Creation on the Baptistery doors (pl. 155), thinking perhaps that the doors might, like Dante's marble cliff in *Purgatory*, be "adorned with such carvings that not only Polycleitus but Nature herself would there be put to shame." Leonardo drew the pose and Michelangelo remembered it when he designed the *ignudi* for the Sistine ceiling.

The vast sum assigned it in the Medici inventory is attached to an entry that confirms that the intaglio continued to be seen as marvellous but mysterious. As in Ghiberti's *Commentarii*, the figures are described, not named. Since the eighteenth century the subject (known from copies) has been identified as depicting the Greek hero Diomedes holding the Palladium, a statue sacred to Athena that Ulysses and Diomedes stole from the Trojans after learning from an oracle that Troy would never fall as long as it had the statue. But like so many of the works that constituted the lexicon of perfection in the fifteenth century, it did not have a title or narrative explanation at the time. Instead it had physical allure and an aura of possible meanings that made it available to interpretation and inventive appropriation. Certain ancient figures had iconography and symbolic charge – Hercules as fortitude or Venus as love, for example – but many others were left to imaginative reconfiguration, providing a figural vocabulary for a modern language addressed to those who were able to understand it and to take pleasure in its messages. Comprehension of this formal language by the ingenious and the learned constituted a currency eagerly accumulated by those wishing to hold shares in the volatile market of reputation.

156 Antonio del Pollaiuolo, *Battle of the Nudes*, ca. 1470, engraving, 42.4 × 60.9 cm., Cleveland Museum of Art, Purchase from the late J. H. Wade Fund.

Antonio del Pollaiuolo provides a famous example of the knowing deployment of artistic knowledge in this arena of ambition and appreciation. "Antonio is the chief master of this city and perhaps that there ever was, and this is the opinion shared by all who understand" – so Jacopo d'Orsino Lanfredini wrote to an official in Pistoia in the late 1460s.[108] As Antonio's guarantor in a dispute over payments, Jacopo's understanding may be interpreted as vested interest in this case. But the Lanfredini were steady in their support for the Pollaiuolo brothers, Antonio and Piero. Antonio, for his part, was an ingenious self-publicist, whose signed print of battling nudes is one index to the things that appealed to appreciative eyes (pl. 156).

Exploiting the recent invention of engraving to represent his talents, Antonio also presented his name as part of the work: his authorship and authority are intrinsic to the way his opus would be viewed. Goldsmiths were known as "masters of design" and Antonio, a master *orafo*, abundantly displays his skill at design in the intricacy of the composition and in the marks of the draftsman that create the dramatically activated

forms. Drawing, since Pliny and Vitruvius, was regarded as the foundation of art. Their remarks had entered the humanist canon and are repeated with feeling, for example, by both Petrarch and Ghiberti. In the chapter on statues in his dialogue on *De remediis utriusque fortunae*, Petrarch has Reason explain that "painting and sculpture are really one or . . . if different from each other, do spring from a single source, namely, the art of drawing."[109] Ghiberti's list of learned attainments for artists concludes that both sculptors and painters had to be perfect draftsmen, because "drawing is the foundation and theory of these two arts."[110] *Disegno* was a practical fact of artists' training. But with its historical associations and conceptual possibilities, design was also an expression of art's theoretical foundations. As Ghiberti insisted: "without this theory one can be neither a good sculptor nor painter, the

157 *Horsetamer*, second century after Greek fifth-century BC prototype, marble, Quirinal, Rome.

sculptor as well as the painter is only as good as he is skilled in this theory . . . which cannot be acquired without much study and discipline."[111]

Antonio may have acquired this discipline studying with Ghiberti. In any event it was a theory that he expounded fluently in his drawings and in the engraving where the incised marks read like traces of the draftsman's hand. Some are long and fluid in following the moving contours of the figures, others zig-zag over the surface with variable weight and length to form the design of the pronounced musculature of the battling men or to define the shading and the shadows. The design of the print demonstrates Antonio's command of the nude figure in multiple postures and of pictorial relief, and it does so in a still relatively experimental medium and on an exceptional scale. His signature – an epitaph on an *all'antica* tablet – is placed in perspective illusion. It hangs from a branch just behind the torso of an archer whose stance is based on the Quirinal horsetamer then attributed to Praxiteles (pl. 157). The running figure is a leitmotif in Pollaiuolo's work and occurs elsewhere in classical

158 Bertoldo di Giovanni, *Battle*, detail of pl. 152. 159 Michelangelo, *Battle of the Centaurs*, detail of pl. 153.

sculptures known in Florence, but the model attributed to Praxiteles made the pose canonical.

An invention, no textual source has been convincingly associated with the engraving that gives it a name beyond the text inscribed on it, "OPVS.ANTONII.POLLA/IOLI. FLORENT/TINI." The fact of its being Antonio's work has primacy in terms of attention and ascription of meaning. Placed just at the hip of the archer with a full quiver, at the level of his genitals, it marks the suspense of the scene. Poised to shoot, he has a chance of being the sole survivor of the carnage.

What is the sense of this scene? As in the battle pieces by Bertoldo and Michelangelo, virility and violence are the most evident subjects (pls. 152, 153, 158, 159). The theme of the heroic figure dominates or even obliterates a straightforward narrative. Like the gem described by Ghiberti, their meaning is in their measure. Their perfection is in their poses, which make them exemplars of the artist's mastery of art, his own heroic achievement. The lack of an easily decipherable story associates them all the more closely with the ancient prototypes that inspired them. Admiration may result from a glance, but deeper understanding requires attentive looking and a subtle speculation of the sort advocated by Leonardo da Vinci in order to match their subtle invention. Such an informed gaze, susceptible to instruction and delight and to the virtue that comes from knowledge, is not the product of common or casual sight. It is a powerfully selective cultural construction. In the vocabulary of vision it corresponds to fixed looking, the "gaze of reason." It is a committed style of looking, still and steady looking which results in seeing

and subsequently understanding.[112] A form of perception specific to its time, it defines the Renaissance beholder. When Matteo Palmieri explained the rebirth of the arts in his book on civic life, he said that "the aim of every art is to understand perfectly and to take pleasure in true knowledge through the tranquillity of the intellect which by its nature wishes to know."[113] Rationalizing desire, it is the optic of an elite that eagerly awaited answers to the question:

> What master was he of brush or of stylus
> who drew the forms and lineaments which there
> would make every subtle genius wonder?[114]

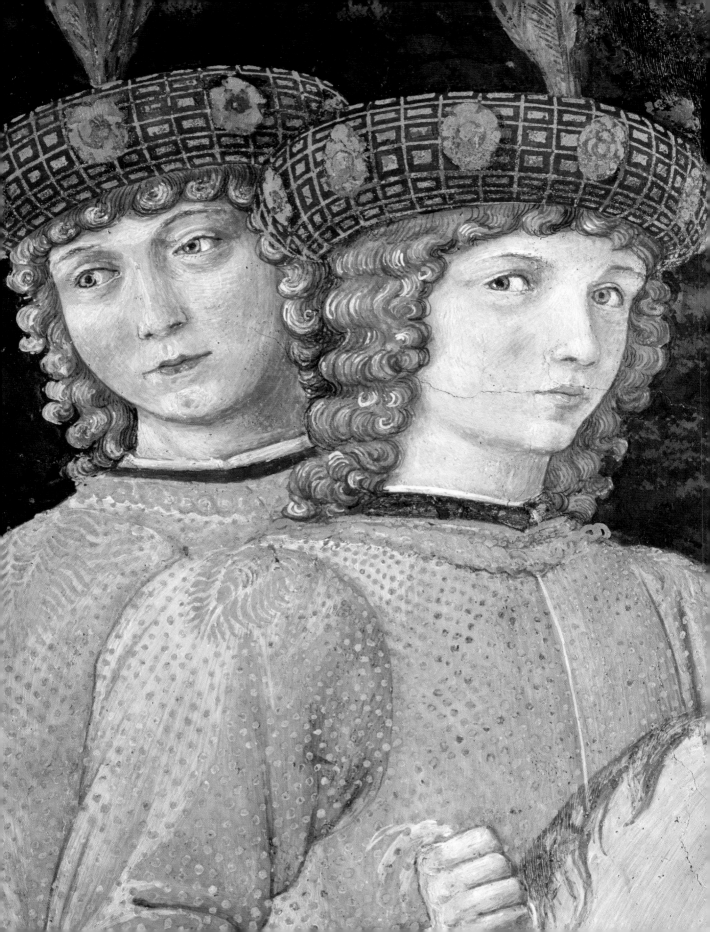

PART III

Seeing and Being

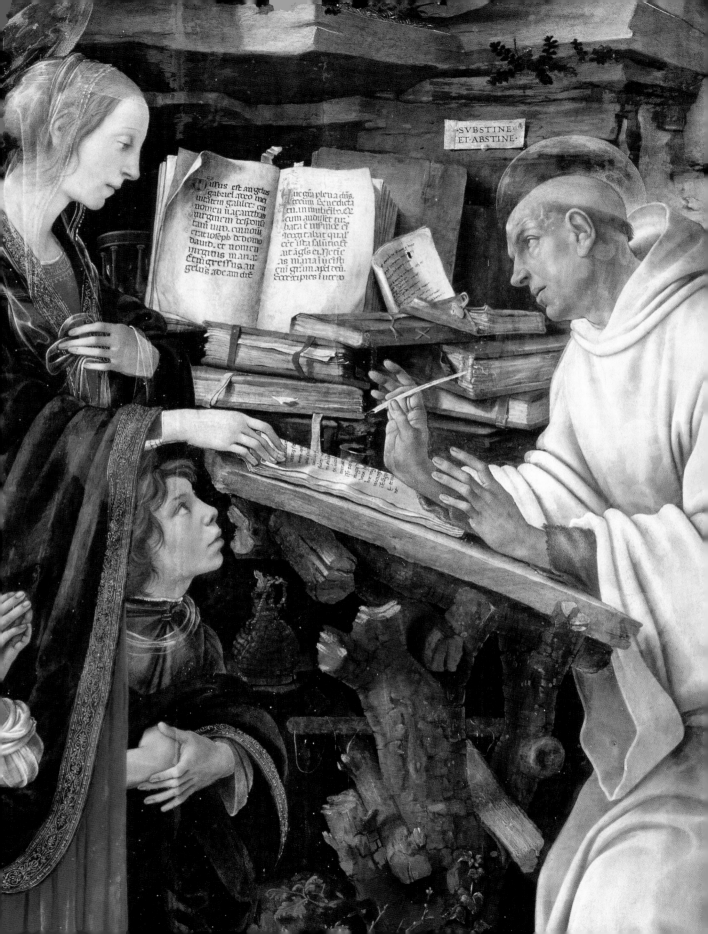

SVBSTINE·
ET·ABSTINE·

Chapter Six

VISION AND BELIEF

JUST AS THE BODY HAS TWO CORPOREAL EYES, so too must the soul have two spiritual eyes, and one should always look towards the glory of paradise and the other to the punishments of hell. And doing so, you will never offend blessed Jesus Christ, having fear for the pain of hell and faith and hope in the blessings of eternal life.[1]

So advised Paolo da Certaldo in his mid-fourteenth-century book of behavioral guidance. Though the spiritual gaze might seem awkwardly bifocal, with one eye raised and the other lowered, the injunction rests on great authority.

The distinction between corporeal and spiritual vision, between seeing with the eyes of the body and those of the soul – received wisdom by Paolo da Certaldo's time – derives from a theology of vision with its origins in the teachings of the Church Fathers. In Book XII of his treatise *On the Literal Meaning of Genesis* (*De genesi ad litteram*; dating from between 404 and 420), Saint Augustine divided sight into three types: corporeal, spiritual, and intellectual. According to this structure, as it was subsequently sustained and elaborated, corporeal vision was the lowest form of seeing, but it still allowed for all reasoning beings to perceive God through his creation. The next two levels defined the ascent of the soul to union with God, from the spiritual sight that could arise from imagination or dreams to intellectual or contemplative vision. The highest type of sight was conceived of as profound insight, achieved inwardly. In the *Summa Theologiae*, Saint Thomas Aquinas, following Augustine, wrote of the beatitude that resulted from contemplation – the action of seeing God – as being the greatest and most pleasurable of human acts.[2]

The journey described in the *Divine Comedy* charts both the extreme difficulty and the ecstatic delight of achieving this type of vision. In its final stages a "new vision was kindled" and Dante at last "surmounting beyond" his own previously limited powers was able to see, to gaze upon, and to comprehend, the glory of God.[3] Led towards this state of grace by his beloved Beatrice, he is also instructed by Saints Thomas Aquinas and Bernard of Clairvaux, whose writings on contemplation and vision provided the learned substance for Dante's poetic imagination. The *Divine Comedy* can be read as an index to the transmission of the theology of vision, translated from scholastic sources to a vernacular text. In the wider context of contemporary religious life, the figure of Dante in

the poem embodies a significant shift in spiritual practices, which were increasingly directed towards lay participation. Not a priest or a monk, Dante is a spiritual pilgrim – a layman in mid-life crisis whose moral confusion gives way to transcendent vision. His is the aspiration of a secular worshipper, who, like the religious professional, could be trained to look both upward and inward and could hope to see "the courts of heaven made manifest."[4]

The poem itself constitutes a form of guidebook or apprenticeship to that experience, as the reader sees Dante seeing and gaining insight. Near the opening of the tenth canto of *Paradise*, as he enters the fourth heaven, the realm of the sun, the poet Dante urges the reader to lift up his sight with him in order to admire God's handiwork in the vault of heaven, "that Master's art, who within Himself so loves it that His eyes never turn from it."[5] Later, in contrast with God's mastery, the poet admits the futility of his own art: "Though I should call on genius, art, and practice, I could not tell it so that it could ever be imagined; but one may believe it and let him long to see it."[6] The disclaimer is in part a literary device, which calls attention to Dante's skill at creating memorable images and to his role as a mediator between theology, experience, and revelation. As such it points to the place of art and the agency of the artist in stimulating imagination and desire, and in bringing the invisible into view. This place was also occupied by the makers of images, the painters and sculptors required to turn their *ingegno*, *arte*, and *uso* to sacred subjects. Their task, like Dante's, was to fashion a connection between vision and visualization, between viewing and the visionary.

This was obviously not a simple matter. The making and the viewing of devotional art referred to a theology of images as well as to the theology of vision. As given canonical formulation by Thomas Aquinas, there was a threefold justification for worship with images: firstly that they had a didactic role, serving "for the instruction of simple people, because they are instructed by them as if by books"; secondly that they had a mnemonic function, "so that the mystery of the Incarnation and the examples of the saints may be the more active in our memory through being daily represented to our eyes"; and finally that they could "excite feelings of devotion, these being aroused more effectively by things seen than by things heard."[7]

These definitions related to doctrines formulated during the iconoclastic controversies of the seventh and eighth centuries. In 787, responding to the vexatious problem of idolatry (the worship of images) with a doctrine of worship with images, the Second Council of Nicaea decreed that "the honor paid to an image traverses it, reaching the model, and he who venerates the image, venerates the person represented in that image."[8] The decree maintained a difference between the contemplation or veneration of the image and the worship of its prototype: the "full adoration [*latria*] . . . which is properly paid only to the divine nature."[9]

Scholastic theologians, notably Aquinas, who was a Dominican, and the Franciscan Bonaventure, modified this dictum to allow that the image of Christ could be venerated with *latria*. Their conclusions became definitive. So, in his chapters on relics and images in his mid-fifteenth-century *Summa Theologica*, Archbishop Antoninus of Florence paraphrased Aquinas's description of "a twofold movement of the mind towards an image,"

one towards the image, such as it is a thing – of wood or stone, or other material – the other toward the image as representing something else.[10] The second, the "image as image," directs attention to its sacred prototype. It does this through stimulating memory, which was understood as a process of mental picturing. Antoninus, closely following Aquinas, concluded that if the images of Christ and the saints are considered as material objects, they are not worthy of veneration. But, if taken as representations, then they are owed adoration.

How did such theories work in practice? In answer to this question, there follows a consideration of some of the ways in which the techniques of devotion were acquired and then a description of ritual viewing to show how they were applied. Subsequently, the relation between visual conventions and compositional innovation is examined. The argument here is that formal change was controlled by functional demands and that traditional viewing structures were generally maintained: the substantial modifications in the look of things did not fundamentally change the way of looking at them. New devices might attract the corporeal eye, shifting attention to artistic skill, but that skill was nonetheless primarily directed to excite the inner eye of spiritual vision. Finally, selected altarpieces depicting the Annunciation and the Virgin and Child with saints and donors are analyzed to show how this was achieved in various ways according to the "genius, art, and practice" of different artists responding to different circumstances as the artists, like Dante, addressed the memory and imagination of their audience.

"THE EYES OF THE WATCHFUL HEART"

The Franciscan author of the immensely popular book of *Meditations on the Life of Christ*, then attributed to Saint Bonaventure, explained his intention as being "to recount a few meditations according to imagined representations, which the soul can comprehend differently, according to how they happened."[11] He enjoined his reader to be present at each event described and to be "attentive to everything."[12] The attention invoked was that of involved, compassionate looking upon imagined pictures, concentrating on the humanity of Christ "directed by the whole light of the mind, [and] by the eyes of the watchful heart."[13]

This emotionally colored visualizing was the basic level of contemplation. The "continuous contemplation of the life of Jesus Christ," identifying with His suffering and sacrifice, was the "most necessary" of all spiritual exercises, which could "lead to the highest level."[14] Such meditations could give "illiterate and simple people" the means to recognize "the greatness and intensity of divine things."[15] The ample category of ignorance not only included the illiterate in the modern sense, but encompassed the great mass of the unlettered – those who could read Italian, but who could not read or write Latin fluently, and who, lacking the proper training, could not (and therefore should not) properly read or interpret scripture.

Though some did. One preacher in Santa Maria Novella in the early fourteenth century thundered against "those many madmen," lowly craftsmen and even women,

"who pretend to expound the Holy Writ. Great is their daring and too serious is their offense!"[16] Instead of indulging in such folly they were advised to make a habit of confessing, of taking communion, hearing mass, keeping good company, praying, reading instructive books, and listening to sermons. The preacher's warning is a reminder that lay involvement with religious matters was both widespread and deeply felt.

Fifteenth-century Florentines – from the most simple to the most sophisticated – had many ways to become skilled in the techniques of seeing the sacred. Attending mass, paying attention to sermons, taking part in feast-day celebrations and in the paraliturgical rituals of confraternities, which were common and expected forms of pious behavior, were all means to assimilate the techniques of veneration. Craftsmen and merchants, members of both the lower and higher guilds, made notebooks with stories of the saints, selections from the great religious thinkers, and collections of prayers and invocations in aid of their meditations and those of their dependants and descendants. The habit of learning from such literature was encouraged from the pulpit. Savonarola, for example, urged his listeners to "read the things of God which excite you to His love," while telling those who protested that they did not know how to read to "Take the crucifix into your room; let that be your book. Believe me, we are moved by our senses. Take, then, the crucifix for your book, and read it, and you will see that that will be the best remedy for preserving the light in you."[17]

In theological terms, Savonarola was referring to the didactic and affective power of images. In practical terms, he refers to the fact that pictures or prints of holy figures were among the bare necessities of Florentine households, found even in the most modest inventories (along with a pot, a bed, and usually some form of storage chest). That they were ardently contemplated is documented by a contemporary account of the "poor woman" living in Camaldoli, who, while praying to the crucifix in her house, saw it break into a sweat.[18] Deemed miraculous, the crucifix was subsequently enshrined in the church of the Carmine.

Those who could read had access to an ever-increasing number of devotional manuals, which, from the third quarter of the century, also circulated in printed form. A subgenre of such pious literature was addressed to the spiritual education of women, both for their own benefit and as mothers responsible for the Christian formation of their children. In his advice on this matter, the Dominican bishop Giovanni Dominici's first rule was to

> have paintings in the house, of holy little boys or young virgins, in which your child when still in swaddling clothes may delight, as being like himself, and may be seized upon by the like thing, with actions and signs attractive to infancy. And as I say for paintings, so I say of sculptures.[19]

In this oft-cited passage from his book on family management, he prescribes how children should be "brought up in the sight" of subjects that act as mirrors, so that they "open their eyes" to virtuous behavior, mirroring themselves in the holy figures and also learning to revere not the figures, but "the truths represented by those figures."[20] According to this pedagogy, children could be formed in imitation of and identification with sacred images. They were also informed in the basic tenet of worship with images, that of venerating the prototype.

A remarkably detailed and very moving account of a spiritual exercise undertaken by a grieving father shows how versed the "ignorant" could be in contemplation and how passionately they could seek its benefits. It also shows how looking with the eyes of the body could lead to seeing with the eyes of the soul.

In June 1406 Giovanni di Pagolo Morelli's eldest son, Alberto, died, with great suffering and without benefit of the last sacrament. Giovanni describes how the nine-year-old boy

> commended himself repeatedly to God and to his mother the Virgin Mary, had the panel of the Lady brought, embracing it with so many devout actions and with so many prayers and vows, that there is no heart so hard as not to be moved to great pity in seeing him.[21]

After his son's death Giovanni constantly had the image of his son before him, in his mind – an active memory – and with it the hope that the boy's soul rested in paradise. Exactly a year later, body and soul wracked by grief, he devised a ritual of prayer and expiation.

In a simple shift, with bare head and knees, and a leather strap or *correggia* around his neck as a mark of humility, Giovanni knelt before a panel with the figure of the crucified Christ to which his son had many times commended his bodily health during his sickness. He prayed, "and in my prayer looking towards it, I began first to imagine and to see in myself my sins," and his eyes were moved to tears as he considered "with how much hard, bitter and dark passion Jesus Christ had been crucified."[22]

Giovanni remained in this state for some time, and then comforted, he took up his prayer, addressing the crucified Christ with his eye, his heart, and his mind. Keeping the image of Christ's suffering before his eyes, and by means of the panel identifying with it, Giovanni repeatedly asked for God's mercy, for himself, and for his son. He records how he passed from oral to silent prayer, employing a vocabulary that insists upon the intensity of his imaginative effort: fixing his gaze upon the image (*fissare con lo sguardo*), looking hard and intensely (*ragguardare*, *scrutare*), observing attentively (*osservare con attenzione*).

His looking proceeded in a purposeful and systematic manner. First, fixing his eyes on Christ's wounds, he asked for mercy. Then, his heart and mind stilled, he turned his eyes to Christ's right, where, "looking at the foot of the cross, I saw the pure and holy blessed Mother," and he considered her pain and sorrow and how his sins had caused this affliction; not daring to speak, he focused his mind on her grief at the cruel death of her son, and "seeing her filled with such great pain," he was stunned and led to think of his own sorrow with such shame that he nearly stopped praying. Instead he remained, "looking hard" ("ragguardando") until he cried, and finally, inspired by God, saying the Salve Regina he began to pray to her in his own "rough words."[23]

This process continued with a similar prayerful and tearful consideration of the figure of Saint John. When Giovanni concluded the ritual of invocation and introspection, of fixed looking and slowly dawning interior illumination, he took the panel in his arms and kissed the crucified Christ and the figures of his mother and the Evangelist, doing

162 Fra Angelico, *Virgin and Child
with Saints* ("San Marco altarpiece"),
detail of pl 165.

reverence to them before going to sleep. He experienced a dream-vision, also recorded
at length, where ultimately the veil was lifted from his eyes, and seeing the splendor of
God, he was shown the spirit of his son in heaven, in answer to his prayers.

Giovanni's consideration of the figures took the form of emotional identification and
physical empathy – an imitative contemplation of the Passion of the sort recommended
in the *Meditations*. His image of Christ on the cross and his imagining of the actual pain
and grief of the figures records how the visual and vision were connected by a highly rit-
ualized form of looking. The holy figures represented on altarpieces and domestic devo-
tional panels could also become present if focused on in the proper spirit, with eyes,
heart, mind, and well-disposed soul. Giovanni did not merely "behold" or "look at" the
figures, he behaved. He put on penitential dress, he adopted a penitential position, and
he directed his gaze, his thoughts, his words, his sorrows, and hopes to each figure in
turn. As he did this a material object – a painted surface – was transformed. The actions
and attitudes brought the figures into Giovanni's life, each activated in turn as example
and advocate. Giovanni, who confessed his ignorance to God, was still able to find appro-
priate words and appropriate procedures to arrive at his contemplative goal.

As described, the figures on Giovanni Morelli's Crucifixion panel conformed to a tra-
ditional arrangement (pl. 162). As made the object of attentive looking, it demonstrates
how the traditional forms contained an essential devotional repertory, allowing for recog-
nition, identification, and response. That the motions of the body corresponded to those
of the soul was a behavioral commonplace. It was also a fixed point in worship, as
described, for example, by Antoninus in the section *De adoratione* in his *Summa Theo-*

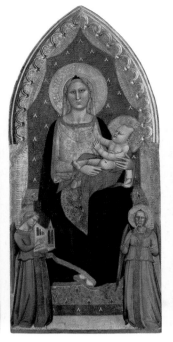

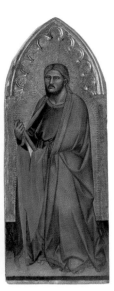

163 Andrea Orcagna, *Virgin and Child with Saints Andrew (or Philip), Nicholas of Bari, John the Baptist, and James*, ca. 1353, panel, 126.5 × 56.5 cm. (center panel), ca. 103 × 37 cm. (each flanking panel), Galleria dell'Accademia, Florence.

logica. But it had a special force in devotional art in defining a mimetic connection between beholders and images. The holy figures were also configurations, given the external or exterior signs of interior worship or pious meditation. If adopted or imitated by the beholder they could aid in arriving at the "reverence, devotion, and mental submission" of true worship.[24] Appealing to the corporeal eyes as embodiments and examples of spiritual attitudes, such figures were agents of spiritual vision.

"FOR OUR CONVERSATION IS IN HEAVEN"

The carpentry and composition of thirteenth- and fourteenth-century cult images – polyptychs with compartmentalized figures and stories – corresponded to the focused process of contemplative viewing. Separate fields of attention were reinforced by framing devices (pls. 163, 164). The Virgin, usually the central figure, and the most potent of advocates, was often shown looking outwards, her eyes inviting the worshipper's gaze, as she presents Christ to view. Flanking figures appear as stereotypes of mature gravity, dignified authority, and virginal beauty, thereby identifying the prototypes with exemplary roles. Some embody modes of meditation and pious reflection. Others invite attention as instances of intercession and compassion. In these cases an imagined eye-to-eye contact

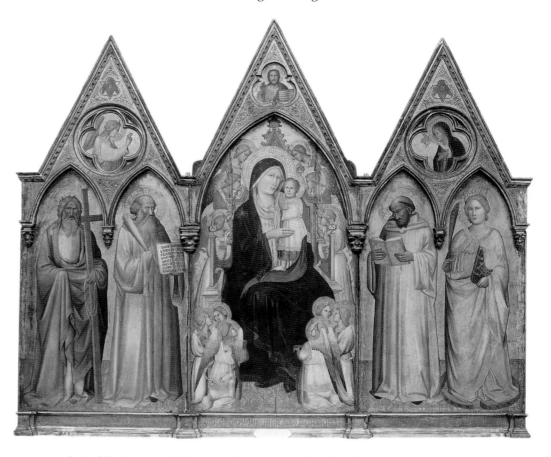

164 Agnolo Gaddi, *Virgin and Child with Saints Andrew, Benedict, Bernard, and Catherine of Alexandria*,
1380s–90s, panel, 205 × 247 cm., National Gallery of Art, Washington, D.C.

produces a sense of immediacy that is frequently offset by iconic, frontal poses – a formal
stance that removes looking from the incidental. Surrounded by gold, the members of
the court of heaven take form against a background of material and metaphorical
splendor.

Idealized, these figures were nonetheless fashioned in resemblance to nature, as
demanded by the contemporary understanding of art. In his commentary to the *Divine
Comedy* (1373–4), for example, Boccaccio took the case of painters to gloss the term *arte*,
writing that they exerted themselves such that a painted figure, "which is nothing but a
bit of color put on a panel with a certain artifice," should be so similar to nature, that
it could deceive the eyes of the beholders.[25] By definition, all products of human inge-
nuity were meant to follow the example of nature, but this requirement had particular
strength in the case of the visual arts because it forged an imitative link between viewer,
image, and the notional prototype represented by the painted surface.

The mimetic and mnemonic relationships that traditionally shaped religious art were
not questioned in the fifteenth century, but they were radically restructured. The early

fifteenth-century experiments with perspective found a powerful means of imitation by using the very rules of nature as a compositional technique. Though viewers were unlikely ever to have been deceived about reality, the new construction implicated or involved them more directly in accepting resemblance, because the act of viewing was allied with the actions of sight. The experience of space was ordered to capture the gaze of the corporeal eye. While gold represented divine glory, materially and symbolically, more naturalistic settings called to mind the immanence of sacred history and God's presence in all earthly things at all times. The continuity implied by perspective did not blur the boundaries between mundane and divine; rather it offered a system that positioned beholders in calculated relationships to the surface that mediated between bodily experience and imaginative projection.

The altarpiece painted by Fra Angelico for the high altar of San Marco between 1438 and 1443 is a virtuoso demonstration of this phenomenon (pl. 165). Cosmas and Damian, the patron saints of the donor Cosimo de' Medici and his family, kneel in the foreground: Damian is rapt in devotion to the Virgin who looks down to meet his gaze; Cosmas, his arms folded in humility, is turned outwards. His submissive glance invites the beholder to contemplate the Virgin, his right hand points to her. Their bodies anchor a triangle, with the Virgin at the apex. The diagonal trajectories of gaze and gesture form a pyramidal construction. The receding pattern of the carpet and the row of saints arranged along each side emphasize the inward and upward momentum that unifies the group in the depicted space. This arrangement notionally places the viewer in an attitude of prayerful veneration, looking up towards the majesty of the enthroned Virgin and Christ. Fictive gold curtains are drawn back to reveal the assembly, with saints Lawrence and Cosmas (the name saints of Cosimo and his brother) looking outwards and seeming to acknowledge the beholder. They stand in a sacred precinct bounded by low walls to the left and right, with a precious curtain behind them. There is a fictive panel of the Crucifixion at the center, positioned as though resting on the predella.

Fra Angelico's powers of deception were deployed on two levels: the openly illusionistic and the totally imaginary. His pictorial strategies solicited the "two-fold movement of the mind" towards the image. Located at the edge of the "real" world, the curtains, the rose garland suspended between them, and the Crucifixion panel in the foreground mark the entry points to an imagined realm of holiness. In their illusionism they call attention to the painting as a product of the artist's craft. The gold background of the *Crucifixion* declares its status as a picture, as opposed to the visionary projection of the beholder's experience revealed beyond it. In their allusions to greater realities, the fictive elements of the painting also define the image as an image, as it calls to mind the Passion and its liturgy, the sacrifice of Christ and its symbolic re-enactment at the altar. The curtain is opened, an act of revelation that mimics the ceremonial exposure of altarpieces.

Playing on different registers of representation, Fra Angelico dramatized and ritualized the beholder's contemplation of the heavenly court, whose magnificent setting honored Cosimo de' Medici's gift to the Dominicans of San Marco and expresses the honor due to the Virgin and Christ. That magnificence and honor were programmatic is documented by a letter written by Domenico Veneziano to Piero de' Medici saying

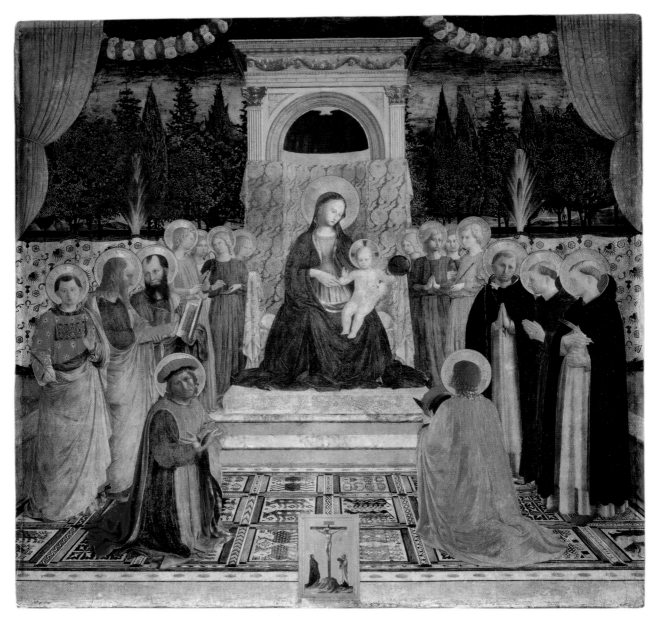

165 Fra Angelico, *Virgin and Child Enthroned with Saints Cosmas and Damian, Lawrence, John the Evangelist, Mark, Dominic, Francis, and Peter Martyr* ("San Marco altarpiece"), 1438–43, panel, 229 × 227 cm., Museo di San Marco, Florence.

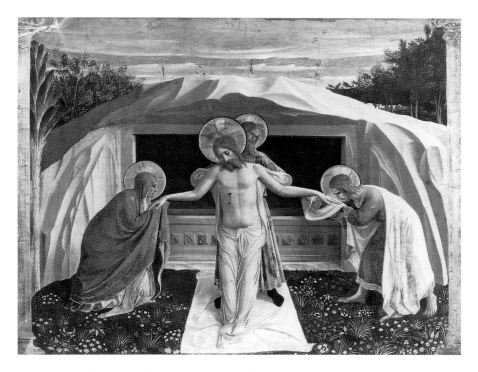

166 Fra Angelico, *Entombment*, 1438–43, panel, 38 × 46 cm., Alte Pinakothek, Munich.

that he had heard that Cosimo had decided to have an altarpiece painted and that he "desired a magnificent work."[26] Domenico, for his part, wished to produce a famous work, which would honor the Medici.[27] Calling the Medici to mind was an important function of the altarpiece, but it was subsidiary to remembering the redemptive cycle of salvation achieved through Mary's motherhood and the death of her son.

The central axis of the altarpiece insists upon this message, as the spectator's eyes could move from Mary's hand pointing to Christ's blessing to the *Crucifixion* and the central panel of the predella below (pl. 166). The panel interrupts the sequence of the lives of Cosmas and Damian in the predella. It shows Christ being laid down before his tomb in a powerfully arranged manner. Christ's torso is displayed with insistent physicality. Blood drips from the wound on his chest, pubic hair shades his belly. His humanity is fully evoked. His spread-armed pose and the shape of the winding sheet below him recollect the cross. His body, which falls backward towards Nicodemus, is drawn towards the waiting tomb in deep perspective. Mary and Saint John form a compassionate frame, bending as they lean to hold and to kiss Christ's wounded hands. The narrative of the Entombment and the story of the Passion are stilled, prompting the viewer to concentrate on their occurrence and their meaning.

In the main panel three of the angels flanking the throne thoughtfully handle the instruments of the Passion, while a fourth has its hands folded in prayer – a grouping

that reinforces the tone of quiet meditation that pervades the painting. Saints Dominic, Francis, and Peter Martyr are shown at the right with clearly described gestures of prayer and reverence. As befits the mission of their Orders, the friars are placed before the worshipper with instructive attitudes, becoming a form of embodied preaching. As a Dominican, Fra Angelico had been trained in the modes of prayer and in the art of preaching that descended from Dominic, who is given primacy in the trio. He is placed nearest the Virgin and faces outwards.

Opposite, to the liturgical right (the onlooker's left), Saint Mark opens his gospel towards Saint John the Evangelist, who looks on respectfully, his pen poised over his book. This type of interaction between the figures constituting the court of heaven is not usual and it is far from casual. Mark's gospel was thought to be the first written, and it was also the gospel that heralded the coming of the kingdom of God in the ministry of Christ. This is the scriptural counterpart to the kingship manifested by the Child, who is shown as the Divine Ruler, holding a globe with a map marked with Jerusalem at its center. Mark, dedicatee of the church of San Marco, and John the Evangelist, patron saint of Cosimo's father, stand above Cosmas – proximity that invites recognition of the intersecting interests of secular and sacred patronage that supported the religious life of the city and defined its citizens' spiritual hopes. The role of the Dominicans as preachers and teachers is stressed by the choice of text inscribed on Mark's book. It is the passage describing Christ teaching in the synagogue and his subsequent sending forth of the disciples with the command that they take "nothing for their journey, save a staff only: no scrip, no bread, no money in their purse" (6:2–8), which is the apostolic foundation of mendicancy. The selection of these verses is a strong reminder of the traditions being followed with renewed zeal by the Observants.

The garden setting, the background sea, the wood of cypresses, cedars of Lebanon, and palms, are in their turn symbolic cues to reflect on Mary. They are a visual recitation of verses from Book XXIV of Ecclesiasticus (which were used in the liturgy of the Virgin) and of the Marian hymn *Ave stella maris* ("Hail thou star of the ocean"). The rose garlands allude to the rosary, a form of prayer promoted by the Dominicans and traditionally attributed to Saint Dominic. As with Dominic's prominent placement – of the friars, he is closest to the Virgin and facing forwards – this implicitly asserts Dominican prerogatives. Mary was the patroness of the Order and the recent establishment of the Observant Dominicans at San Marco was the occasion for the commission of this remarkable altarpiece for their church.

Art history has dubbed the grouping of saints around a central figure (usually the Virgin) in a unified space a *sacra conversazione*. The term, which has been traced to eighteenth-century inventories, entered art-historical parlance in the nineteenth century and has become a common label. While perhaps useful in describing a form, it is misleading in regard to function. In modern usage, "conversation" suggests a discursive model. But the communicative mode of fifteenth-century altarpieces is contemplative. The type of conversation characterizing works such as the San Marco altarpiece is that invoked in Saint Paul's letter to the Philippians: "for our conversation is in heaven; from

whence also we look for the Savior, the Lord Jesus Christ" (3 : 20: "nostra autem con-versatio in caelis est/unde etiam Salvatorem expectamus"). It is one of communion with the sacred.

In altarpieces of this sort the unity of space stands for thematic unity, which conveys the overarching messages of the history of Christ's sacrifice and of salvation. Despite this basis in sacred history, the visual construction of fifteenth-century cult images is not expository. The figures are grouped together in space, but they occupy distinct spheres of attention. Each one is a focus for veneration, for imitation, for reflection, and for directed prayer of the sort undertaken by Giovanni Morelli. They present separate examples and represent distinct advocacies, which could also be supported by separate liturgies. The endowment of an altarpiece normally included provision for masses on different feast days – that of the central mystery and those of the specific holy patrons depicted. The effective and affective potential of each to inspire, impress, and influence the beholder was not a matter of dialogue or debate, but of concentration and penetration of meaning.

The relation of whole to parts in fifteenth-century altarpiece design finds an analogy in the most commonly used sermon form, the *sermo modernus*. The "modern sermon" was developed in the universities in the twelfth and thirteenth centuries and was popularized by the mendicants. It structure consisted of a theme and division. The *thema* was a scriptural passage, usually taken from the liturgy of the day. The sermon opened with the theme, which was then divided and subdivided, with separate phrases or words expounded upon to demonstrate their meaning and their relevance to the day-to-day concerns of the listeners.

It was a commonplace of the preacher's art, set out in the treatises on the *ars predicandi*, that "different things should be preached to different people . . . and different situations call for different styles of address," as stated by the Dominican Humbert of Romans in his manual on the subject.[28] Lay audiences were not taxed with the subtleties of theological reasoning. Yet, however simplified, sermons accustomed them to attending to moralizing interpretations and expansions of meanings, as the truth of the scripture was manifested by the preacher. Listeners were alerted to the web of sacred associations and moral purposes of God's word and his creation.

Altarpieces are not illustrations to sermons, though preachers frequently used images to make their points. "Let us say it by way of images," was, for example, a favorite phrase of the popular Dominican preacher, Giovanni Dominici.[29] But they demanded a comparable form of attention in their combination of framing and fragmentation.

Like sermons, fifteenth-century cult images are normally subdivided into separate units for focused consideration. This division encompasses the principal figures and their subsidiary stories, which expand or "dilate" the material in exemplary narratives, in a manner also familiar from sermons. This viewing structure and its attendant habits of mind – dividing, distinguishing, seeking meaning in detail – are generally applied and applicable even when the styles and compositional strategies of the works are very different. So, for example, a selection of works dating from the 1430s to the 1490s demon-

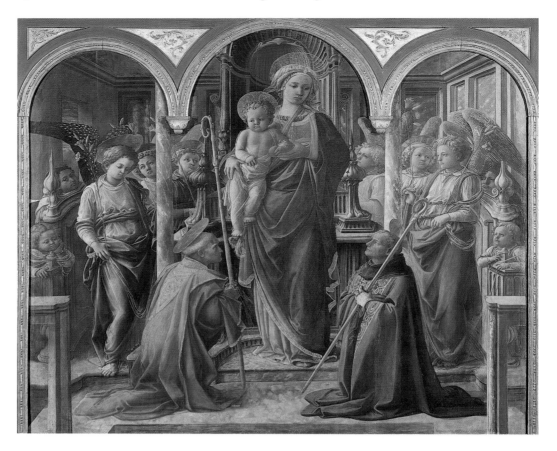

167 Fra Filippo Lippi, *Virgin and Child with Saints Frediano and Augustine* ("Barbadori altarpiece"), ca. 1436–8, panel, 208 × 244 cm., Musée du Louvre, Paris.

strates both the compositional variety and the structural continuity of cult images throughout the century. Paintings as diverse as Fra Filippo Lippi's *Virgin and Child with Saints Frediano and Augustine* (the altarpiece of the Barbadori chapel in the sacristy of the old church of Santo Spirito, ca. 1436–8, now in the Louvre; pl. 167), Domenico Veneziano's *Virgin and Child with Saints Francis, John the Baptist, Zenobius, and Lucy*, once the high altarpiece of Santa Lucia dei Magnoli (ca. 1445–7, now in the Uffizi; pl. 168), Benozzo Gozzoli's altarpiece for the confraternity of the Purification and Saint Zenobius (1461–3, now the National Gallery, London; pl. 169), Sandro Botticelli's *Virgin and Child with Saints John the Baptist and John the Evangelist*, from Giovanni Bardi's chapel in Santo Spirito (1484–5, now in the Gemäldegalerie, Berlin; pl. 203), and Cosimo Rosselli's *Virgin and Child with the Young Saint John the Baptist and Saints James and Peter* (from the Salviati family chapel in the church of Cestello, 1492; now Cenacolo di San Salvi, Florence; pl. 170) follow the same template of attention. The assembled figures generally do not act in relation to each other, but each one performs

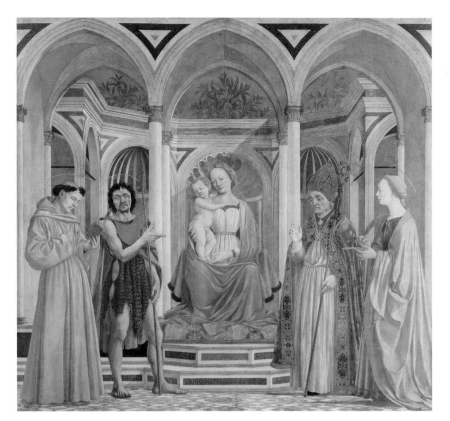

168 Domenico Veneziano,
*Virgin and Child with Saints
Francis, John the Baptist, Zenobius,
and Lucy*, ca. 1445–7, panel,
200 × 216 cm., Galleria degli
Uffizi, Florence.

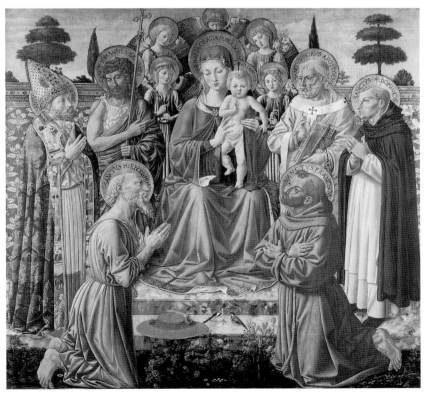

169 Benozzo Gozzoli, *Virgin
and Child with Angels and Saints
Zenobius, John the Baptist, Jerome,
Peter, Dominic, and Francis*,
1461–3, panel, 162 × 170 cm.,
National Gallery, London.

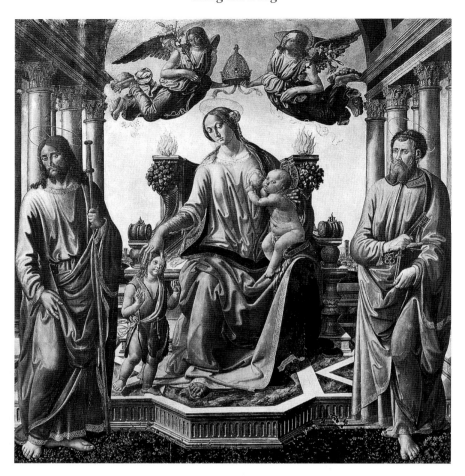

170 Cosimo
Rosselli, *Virgin and
Child with the Young
Saint John the Baptist
and Saints James and
Peter*, 1492, panel,
230 × 190 cm.,
Cenacolo di San
Salvi, Florence.

a separate role of sacred mediation: acting as both a subject and an object of contemplation.

In the *Golden Legend* Jacopo da Voragine lists six reasons for observing the feast of All Saints. The first is to honor the majesty of God and the second is to procure the intercession of the saints. "The third purpose is to increase our confidence; for the glory of the saints, which is placed before our eyes when we celebrate their feast days, augments our hope and assurance."[30] Once mortal, the saints were "exalted by their merits" and "when their feast day is renewed, we are incited to imitate their example."[31] Observance of the feast also recalls the "debt of mutual exchange," just as the saints celebrate in heaven for each sinner who does penance, so their feasts should be celebrated on earth.[32] The final motivation is to procure honor "for their festivity is our dignity. For when we honor our brothers, we honor ourselves, since charity makes all things equal."[33] Cult images placed saints before the eyes of the viewer in a way that corresponded to these purposes. Motivated by devotion and honor they presented and represented holy figures in a way that activated a relationship invoked by prayer and symbolically enacted and renewed by ceremony.

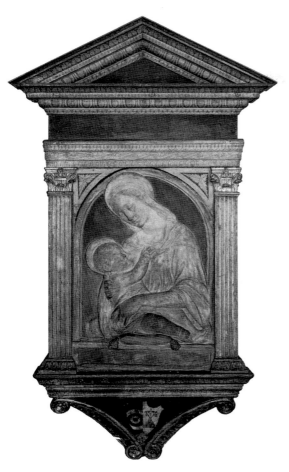

171 Benedetto da Maiano, *Virgin and Child Taber-nacle*, ca. 1480, painted stucco, 137.8 × 77.8 cm., Victo-ria and Albert Museum, London.

172 Filippino Lippi, *Virgin and Child*, ca. 1485, panel, 81.3 × 59.7 cm., The Metropol-itan Museum of Art, The Jules Bache Collec-tion, 1949. (49.7.10).

There were of course many different kinds of works made for devotional purposes in the fifteenth century and they can be associated with distinct forms and habits of looking. Even within altarpieces there was a division between the icon and narrative, that is between the figures of the saints and the depiction of their lives. Histories of the saints were also set forth in monumental cycles on chapel walls, large-scale narratives that staged exemplarity for purposes of commemoration, admiration, and imitation as described in the case of the Sassetti chapel in Chapter 4. Different again were sacred works for the private setting. In the fifteenth century these most commonly showed the Virgin and Child and could range from modest, ready-made panels or gessoed tabernacles known as *cholmi da camera* to deluxe paintings (pls. 171, 172). From the middle of the century there was an expansion in the range of domestic devotional objects which followed the general increase in household belongings and which was allied to new forms of produc-

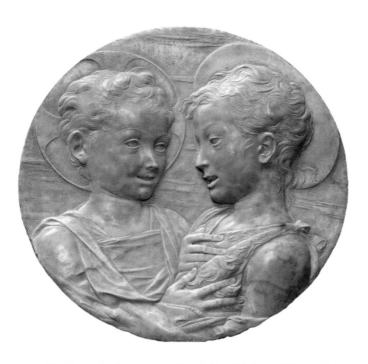

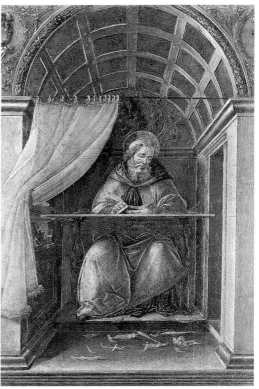

173 Desiderio da Settignano, *The Infant Christ and Young Saint John the Baptist*, ca. 1460, marble, diameter 51 cm., Musée du Louvre, Paris.

174 Sandro Botticelli, *Saint Augustine in His Study*, 1490s, panel, 41 × 27 cm., Galleria degli Uffizi, Florence.

tion. In the case of religious art this included "portrait busts" and statues of saints (pl. 173), glamorous *tondi*, often in elaborately carved gilded frames (pl. 101), and small-scale panels (a type probably inspired by Netherlandish models; pl. 174). The pietistic fervor of the Savonarolan era aided in this multiplication of sacred goods.

Familiar presences, such works served individual prayer and meditation of the sort recommended by preachers such as Giovanni Dominici and Savonarola in their sermons and their instructive treatises. Although not consecrated, the spaces around religious images could be sacralized. Inventories document paintings set up on special tables, with candles and curtains. Though available for para-liturgical rituals such as Giovanni Morelli's, these works are usually less formal in aspect than cult images and are often characterized by an appealing intimacy and close viewing points, seeming to bring the figures into contact with the beholder (pls. 175, 176).

Whether intended for private or public worship, the crafting of sacred subjects, particularly by artists aware of their capacity for artifice, acted as a stimulation of subjectivity similar to that underlying the *Divine Comedy*. The beholder of a devotional work,

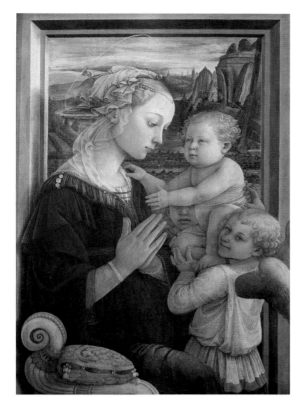

175 Fra Filippo Lippi, *Virgin and Child with Two Angels*, 1465–7, panel, 95 × 62 cm., Galleria degli Uffizi, Florence.

176 Biagio d'Antonio, *Christ Crowned with Thorns*, ca.1475, panel, 46 × 34 cm., Berenson Collection, Villa I Tatti, Florence.

like the reader of Dante's verse, was being prompted to look upward, to fix the eyes on an object of sensory perception while turning the mind – the inner gaze – to something beyond. And like the reader, the viewer was encouraged to "gaze with pleasure and delight."[34]

Artists were bound to very stringent conditions about the physical qualities of their works. Contracts demanded the use of the best pigments while controlling the quality and cost of the most expensive materials, gold and ultramarine blue. Artists were further charged to work with "all due diligence," according to the practice of good masters and to match or exceed their own best works.[35] Their products were expected to give visual satisfaction: to be well-made and beautiful. The emphasis on sensory qualities is not contradictory. Not only was beauty an aspect of honor, but delight was an aspect of devotion.

As Savonarola reminded his congregation, for example, the way to seek relief from life's tribulations and sorrow was to remember Christ's Passion: the contemplation of the image of the Crucifixion was the contemplation of the truth "which comes from the

grace of God . . . and which therefore brings great pleasure."[36] Giovanni Dominici cited
Saints Paul, Ambrose, and Thomas Aquinas in explaining to his listeners that the law of
God had three parts, the first "is charity, the second law is love; the third law is pleas-
ure."[37] In the communicative arts, the theological notion of pleasure – the delight that
comes from the perception of divine grace – was allied with the rhetorical notion of per-
suasion. As Antoninus pointed out in his instructions on preaching, the preacher who
wished to be effective needed to please his listeners so they would be moved to practice
what he preached.[38] The canonical pairing of instruction and delight came from ancient
oratory, which from the time of Augustine had been translated to sacred purposes. So
too had the fundamental principle of adapting speech to the circumstances: who, where,
what, and to whom. "The universal rule, in oratory as in life, is to consider propriety,"
declared Cicero, and decorum demanded that distinctions be made "in respect of place,
time and audience."[39] The practices of piety conditioned fifteenth-century worshippers
to respect the constancy of the liturgy and the unchanging authority of the word of God,
but they also permitted them to be pleasurably and variably addressed.

Florentine artists were skilled in employing the charms of color, of coy glances, of dec-
orative flourishes, and of spatial intricacy to draw sympathetic attention to their works.
They ably met the requirement of presenting the figures of the Virgin, Christ, and the
saints arrayed in the "proper and customary" way.[40] But custom was susceptible to cir-
cumstances, as is evident by looking at some examples of how artists responded to the
task of painting the Annunciation, which, after the Virgin enthroned with saints, was
probably the most common subject for altarpieces in Florence.

"WHAT MANNER OF SALUTATION THIS SHOULD BE?"

The Annunciate Virgin occupied a special place in the devotional life of the city and the
Annunciation had a rich role in the collective imagination. The Florentine calendar began
the new year on the feast of the Annunciation (March 25). In April 1412 the government
decreed that the feast should be observed as the chief holy day of the cathedral. At that
time the cathedral was officially named Santa Maria del Fiore: the *fiore* or flower being
the lily, the symbol of Mary's chastity and the emblem of the city. A play of the Annun-
ciation was staged at San Felice in Piazza on Easter Monday, with lavish costumes, bright
lights, an elaborate machinery of revolving celestial spheres, and the Angel Gabriel flying
down from heaven to deliver the angelic salutation.

A fourteenth-century mural of the Annunciation on the inside front wall of the Servite
church of Santissima Annunziata was a revered cult image and was one of two authori-
tative models for the scene in Florence. The first was the mosaic in the Baptistery. In the
mosaic Gabriel arrives to deliver the message of incarnation to Mary, who is standing
before a niche, which is both her house and her seat. Her slight movement away and
somewhat timorous pose express her being "troubled at his saying," wondering "what
manner of salutation this should be," while her downward gaze and hand over her chest
are gestures of humble acceptance (pl. 177; Luke, 1 : 28–9). Set within a narrative cycle

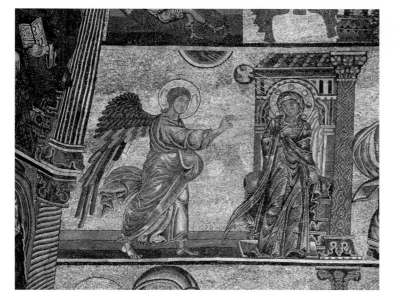

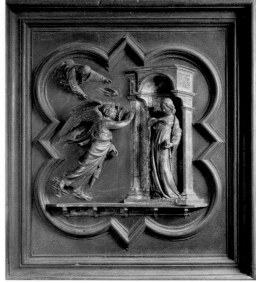

177 *Annunciation*, ca. 1275–80, mosaic, Baptistery, Florence.

178 Lorenzo Ghiberti, *Annunciation*, ca. 1403–24, gilt bronze, 57.5 × 65 cm. (panel), 39 × 39 cm. (quatrefoil), North Door, Baptistery, Florence.

of the life of Christ, this is the story of the Annunciation. Lorenzo Ghiberti ingeniously adopted this precedent in the *Annunciation* he designed for the Baptistery's bronze doors (pl. 178), thereby associating the history of the incarnation with the historical fabric of the building.

The mural of the Annunciation at Santissima Annunziata created the pattern for most Florentine Annunciations painted after the middle of the fourteenth century (pl. 179). It depicts the Virgin seated in a richly appointed room, having left off reading a prayer book as she responds to the angel's greeting and the arrival of the Holy Spirit with the words "Ecce ancilla domini" ("Behold the handmaid of the Lord"; Luke, 1 : 38). Papal indulgences were granted to worshippers at the chapel of the Annunciation in 1361, and there was a surge of replicas and variants from that time. The actual date and author of the mural are unknown. Servite legend connected it to the mid-thirteenth century, the time of the establishment of their Order in Florence, and held that Mary's head had been painted by an angel, making it a "true likeness" of the Virgin. It should be noted that the representation of the Annunciation was commonly called and commissioned as an "Annunciate Virgin" – the *Nunziata* – underlining the fact that the figure of the Virgin was the focus of veneration.[41] By alluding to this mural, the variant and derivative compositions were potentially imbued with some of its powers. That it came to be considered "the" way to picture the *Nunziata* is suggested by its occurrence as a votive image at the church of Ognissanti, commissioned by a grieving mother after the death of her son (pl. 180).

179 *Annunciation*, ca. 1360,
mural, Santissima Annunziata,
Florence.

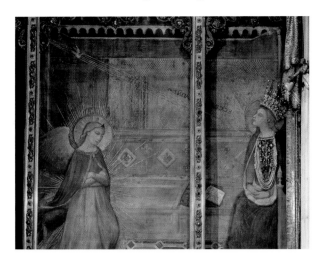

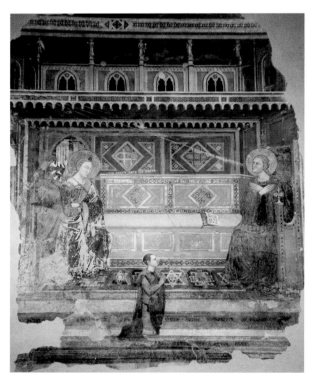

180 *Annunciation*, 1369, mural,
Ognissanti, Florence.

This scheme was radically reformulated by Fra Angelico in the mid-1420s when he painted an altarpiece for his parent house of San Domenico at Fiesole (pl. 181). The rupture was programmatic. The Dominican Observant convent and church were recently founded and their decoration affirmed the values of the Observance (also a recent movement) and its value to Florentine worshippers.

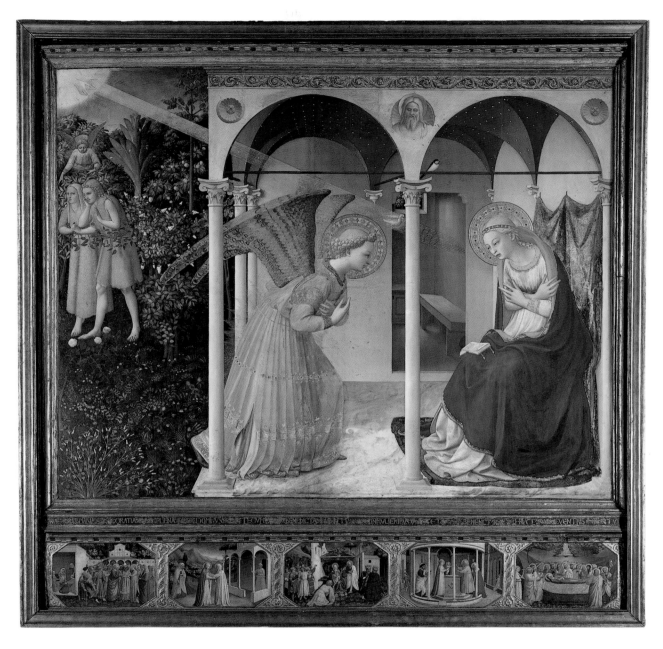

181 Fra Angelico, *Annunciation*, ca. 1426, panel, 194 × 194 cm., Museo del Prado, Madrid.

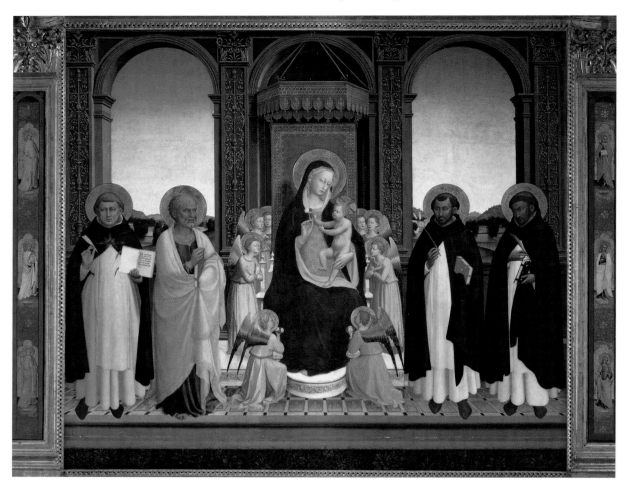

182 Fra Angelico, *Virgin and Child with Saints Thomas Aquinas, Barnabas, Dominic, and Peter Martyr*, ca. 1419–24, panel, 212 × 237 cm., San Domenico, Fiesole.

The *Annunciation* was one of three altarpieces painted by Fra Angelico for the convent's church, which was built from a donation dating from 1418 and which was dedicated in 1435. A later chronicle says that they were completed "several years" before the

 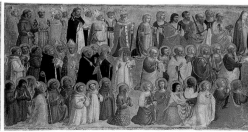

183 Fra Angelico, *Christ in Glory with Saints and Dominican Blessed*, ca. 1423–4, panel, 32 × 73 (center panel), 32 × 63.5 cm. (inner left and right panels), 32 × 22 cm. (outer panels), National Gallery, London.

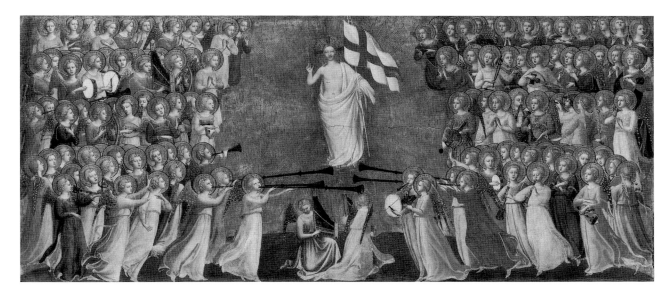

184 Fra Angelico, *Christ in Glory with Saints and Dominican Blessed*, detail of pl. 183.

consecration.[42] That over the high altar honored the three Dominican saints and the patron saint of the convent's patron, Barnaba degli Agli, showing the Virgin and Child surrounded by angels and flanked by Saints Thomas Aquinas, Barnabas, Dominic, and Peter Martyr (pl. 182). It was located behind the choir screen and the friars were its principal audience. The predella, which has Christ in Glory surrounded by the angelic host and flanked by prophets and patriarchs and the saints and blessed of the Dominican Order, presented them with a sacred genealogy of their family in Christ and an ever-present exhortation to follow the collective path of teaching, preaching, and prayer that was envisioned before them (pls. 183, 184). This was an unusual composition for a predella, which would normally have exemplary stories from the lives of the saints depicted in the main panels, scenes from the Passion, or perhaps individual figures of saints with a Man of Sorrows at the center. The decision to manifest the holy heritage of the Order in conjunction with a resplendent vision of Christ was a deliberate variation from standard elements.

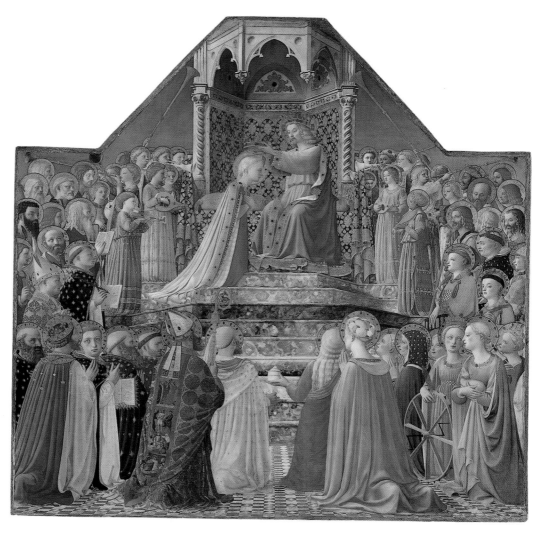

185 Fra Angelico, *Coronation of the Virgin*, ca. 1429–30, panel, 213 × 211 cm., Musée du Louvre, Paris.

Equally purposeful and creative choices were made regarding the compositions of the two altarpieces that faced the laity on the choir screen. Dedicated to major feasts of the Virgin, the Annunciation (March 25) and the Coronation (celebrated on the feast of the Assumption, August 15; pl. 185), they completed a trio manifesting the Dominicans' special devotion to the Virgin, Protectress of the Order and Abbess of all of its convents.

Both the *Annunciation* and the *Coronation* had strong iconographic traditions in Florence, based respectively on the Santissima Annunziata mural and on Giotto's *Coronation* altarpiece for the Baroncelli chapel in Santa Croce (pl. 186). The *Annunciation* possessed the numinous charge of the miracle image. The *Coronation* had the artistic imprint of Giotto, still the city's most famous painter. Fra Angelico's rethinking of these

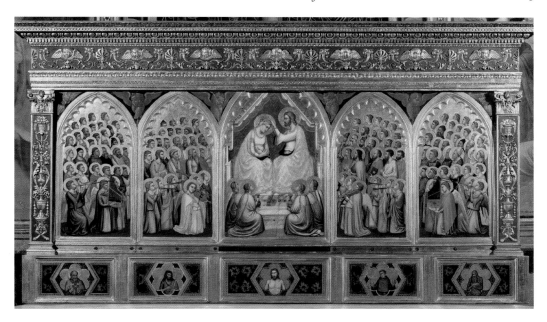

186 Giotto, *Coronation of the Virgin*, ca. 1329–32 (reframed in the fifteenth century), panel, 185 × 323 cm., Baroncelli chapel, Santa Croce, Florence.

subjects was a conscious "re-Ordering." Despite their wide diffusion, both compositions originated in other religious Orders: the Servite *Annunciation* and the Franciscan *Coronation*. Fra Angelico and his brethren would have been extremely sensitive to these sources of authority and eager to assert their identity through the paintings placed in their church.

Though newly founded, by the 1420s the community at San Domenico had attracted a bequest large enough to build a convent and church, where "an incredible multitude of devotees" flocked to hear the preaching of Antoninus Pierozzi.[43] Antoninus (1389–1459) was prior of the convent between 1421 and 1424, when "Frate Giovanni" (Fra Angelico) was among the "brothers at San Domenico."[44] He may have been responsible for setting the painter-friar the tasks of meeting the pictorial needs of the convent (liturgical books and murals). He certainly was the model of an effective preacher.

Antoninus later included a section on preachers in his *Summa Theologica* that gives some insight into Fra Angelico's training in that art. First among the required qualities was that the preacher speak clearly so as to instruct and inform the understanding of his listeners ("ut instruat intellectum auditoris"); secondly a preacher should speak in a way that charms or delights so as to dispose them ("sic moveat affectum") to hear his words with pleasure.[45] These commonplaces of persuasion contain a key concept of cognition: that understanding comes through remembering. It was believed that images stored in the memory aroused the emotions and moved the will, causing thoughts and motivating action. According to this psychological construction, memory images combined both

a cue to the matter being recollected and a response or attitude (*intentio*). *Intentio* – inclination or coloring – evoked emotion and moved the soul, leading to actions that might be prudent or imprudent. Memories were in part defined as physical affects. The objective of preaching to move the soul to spiritual conversion, that is to penance and true faith, was a task Fra Angelico translated to his paintings, using both clarity and charm to engage attention and to color memory.

This is not to make an absolute equation between styles of preaching and Fra Angelico's style of painting. Unlike the descriptions of rhetorical method, which in the course of the fifteenth century furnished a critical vocabulary for the visual arts, the technical definitions of sermon types (such as *subtilis, facilis, curiosus, devotus*) do not readily correspond to pictorial practices.[46] They relate to levels of theological display or ways of deploying authority. In rhetorical terms the grace, beauty, finish, and richness of Fra Angelico's compositions could define them as ornate. In the terms of the art of preaching, his approach could be classified as simple or devout owing to his avoidance of superfluous detail and his choice of motifs whose meaning would be accessible to his audience. A general parallel can be made between the affective goals of good preaching and Fra Angelico's powers of persuasion as he employed them to establish an emotional tone and to give clear and convincing form to exemplary gestures. There is a further correlation between the painter's and the preacher's arts in the way that almost every detail has meaning, which can be developed or glossed to support the moral and devotional significance of the image. Though "simple" in delivery, paintings like the *Annunciation* are extremely "subtle" in conception.

In the *Annunciation* the moment of the incarnation is set within the history of salvation. The angel Gabriel's message to Mary is paired with the view of Adam and Eve being driven from Paradise. To expand upon this theme, Fra Angelico chose from among the repertory of elements that were familiar signs of the Virgin's humility, purity, and holiness: light passing through openings (the loggia arcade and the window of her room), her chamber (the *thalamus virginis*), and the cloth of honor that covers her chair. The swallow perched on the rod above the Virgin is a symbol of the Incarnation. The garden refers both to Mary, whose "blossoms became glorious and abundant fruit" and to the lost paradise redeemed by the coming of Christ.[47] Jacopo da Voragine's text for the feast of the Annunciation gives a further explanation for this fertile setting, describing how "Mary returned to the home of her parents in Nazareth. Nazareth means flower. Whence Bernard says that the Flower willed to be born of a flower, in flower, and in the season of flowers."[48]

The Virgin's loggia is constructed in a "modern" style, with *all'antica* Corinthian columns. It even shows the metal rods that were part of such architecture. This places the moment of observation in the present. But the loggia has a starry vault and its floor is rendered as though made of multi-colored marble. Both indicate that this is a holy precinct: the *cielo* as ceiling is simultaneously *cielo* as heaven. In Florence illusionistically painted precious stone surfaces were conventional markers of sacred realms, found as the architectural bases of mural paintings and as part of the settings of religious scenes and devotional images.

There is a roundel with the head of God the Father above the central column. The head leans out of the frame, in a manner similar to the bust of God the Father sculpted by Donatello for the niche of Saint George at Orsanmichele (pl. 187). By imitating this sort of framing device, the fictive sculpture defines the divine presence as representational, making God the Father visible to the beholder explicitly as an image.

A related interplay of mimesis and metaphor defines the operation of light within the painting, where different forms of illumination are themselves metaphors for different levels of perception and understanding. Light is an active force that expresses the mysteries and dramas set before the viewer's eyes. A strong current of gold rays shoots across the painting, forming a path for the dove of the Holy Spirit, released by the hands of God in a golden burst of light at the top right. The Virgin is surrounded and suffused by a luminous clarity. Carefully plotted light and shadows on the wall of the interior of her house reiterate the motifs of enclosure and penetration that are the mystery of the moment of incarnation. Outside the loggia Adam and Eve walk under, but away from the globe of

187 Donatello, *God the Father*, detail of Saint George niche, ca. 1417, marble, Orsanmichele, Florence.

divine light as they are expelled from the Garden of Eden and move out from the flowery realm of the Virgin's domain. The three pink roses beneath their feet are at once reminders of the Fall (when roses become thorny signs of man's sins, while their beauty recalls the lost paradise), of Mary (the rose without thorns), and of Saint Dominic's institution of the devotion of the rosary. Behind them the sky lights up with the dawn of a new day, declaring the beginning of the time of grace attendant upon the Virgin's acceptance of her role as the handmaiden of the Lord and the mother of Christ.

Mary is shown as a model of humility, crossing her arms over her chest and bending to the will of God. Gabriel in turn bows towards her – each contained within an arch of the loggia. These emphatically framed attitudes of humility and obedience had extra resonance for Dominicans, who, as Giovanni Dominici wrote, were expected to "study how to submit their body and soul" to God to serve as examples to laymen.[49]

The loggia's columns divide the painting into three units, but not into even thirds. The division is hierarchical: the Virgin has the largest space. The blocking out of the surface and the decentralized composition allow for the progression of the interrelated histories of the Annunciation and of mankind's salvation while marking out episodic areas or memory places for the Fall, the Angelic Salutation, and the Virgin. Taken as a visual sermon, the themes of this painting are the miracle of incarnation and the Virgin's role in the redemption of mankind. It is a focus for meditation on the event of the Annunciation and on the figure of the Annunciate Virgin as mankind's primary example of humility. Although linear perspective is used to define architectural space within the painting, it does not fix the beholder's position, nor do glances or gestures invite direct participation.

Foreground elements offer a key to the meditative mode of the painting. There is a large clump of purple carnations at the lower left. The flowers are life-size. They are disproportionately large in the spatial scheme of the altarpiece. They create a disjunction in viewing that is similar to the effect of the illusionistic *Crucifixion* and altar curtain in the San Marco altarpiece. In both compositions the provocatively naturalistic elements allow for shifts of meaning from the literal to the spiritual. Etymologically, the carnation is the flower of God, *Dianthus caryophyllus*, and it was considered to be symbolic of God made flesh, tinged by drops of Christ's blood. The central pillar of the loggia functions in a similar way. The column could recollect Christ's suffering in the flagellation, his humility and humanity. It was a multivalent emblem of fortitude and a figure of virtue. Symbolically charged, it is at once part of the architecture enclosing the Virgin and framing her as she bows to the will of God and a pointer to the door, the window, the head of God, the dove, and the swallow, which are grouped around it like the symbols of Christ's torture in the meditative *Mocking of Christ* at San Marco (pls. 188, 189). These are visual signs comparable to the *signa* employed by preachers, which were verbal images used to evoke religious texts. Fra Angelico gives them a markedly Dominican inflection: Mary's chamber has the austerity of a friar's cell and the swallow's plumage is painted in the black and white of a friar's habit.

Taken didactically, the two altarpieces on the choir screen at San Domenico expound different lessons using different forms of visual organization. In the *Coronation of the Virgin* the gathered saints act as models of contemplative vision: the perspective and the positions of the figures urge the beholders to imitative devotion. In the *Annunciation*, viewers are instead set apart as witnesses, to meditate upon the mystery before them, which is colored materially and emotionally so as to move them to see it with delight and to remember its messages in a spirit of quiet reflection.

The *Annunciation* painted between 1439 and 1443 by Fra Filippo Lippi for the high altar of the church of the Benedictine nunnery, Le Murate, presents some parallels with Fra Angelico's altarpiece (pl. 190). They were both done for a new project and they were both addressed to the laity within the context of a religious community. Both of the artists were friar-painters. But the altarpiece for Le Murate was not intended to have the same level of public exposure as the paintings seen by the multitudes that came to hear the preaching of the Dominicans at San Domenico. As opposed to Fra Angelico's "clear speaking," Fra Filippo's visual rhetoric is complex and even paradoxical.

According to the standard formulas found in contracts and dedicatory inscriptions, both the artist and the client "made" the works. The common terms were *fecit* and *fecit fieri*. At Le Murate the clients were the nuns and their patron Giovanni d'Amerigo Benci. By selecting Fra Filippo they opted for an ambitiously inventive collaborator in a project that furthered collective and individual honor. The individual concerned, Giovanni Benci, was a joint-General Manager of the Medici Bank and one of Cosimo de' Medici's most able associates. He was the convent's chief supporter from 1439, when he first conferred with the Abbess about the project, until his death in 1455. He financed the acquisition of property and the construction of new buildings, spending over 10,000 florins. Of this, the considerable sum of 200 florins went to the equipping of the high altar with

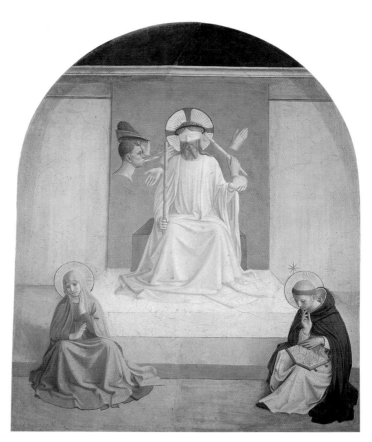

188 (ABOVE LEFT) Fra Angelico, *Annunciation*, detail of pl. 181.

189 (ABOVE RIGHT) Fra Angelico, *Mocking of Christ*, ca. 1439–45, mural, cell 7, Museo di San Marco, Florence.

its altarpiece and other apparatus. As the second wealthiest person in Florence, Giovanni could well afford this scale of expenditure, which made him regarded as the man who had built "the monastery . . . from the start . . . and through to the finish."[50] This was an investment in posterity for himself and for his lineage declared by the Benci arms placed around the nunnery, and it was one that benefited from the attention of the nuns' devotions. Praying was their profession. It was an industry thought essential to the welfare of the entire city. As one citizen commented of nuns: "They spend day and night praying for the most worthy Signoria of Florence. Open your eyes and appreciate that."[51] By

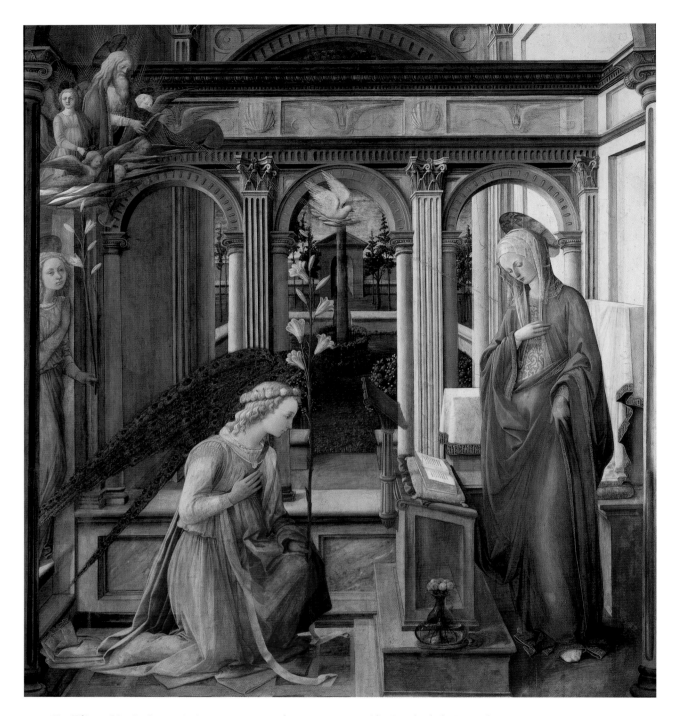

190 Fra Filippo Lippi, *Annunciation*, 1439–43, panel, 204 × 186 cm., Alte Pinakothek, Munich.

acting as the protector of such a community, Giovanni gained a share of this appreciation in addition to the good that such benefaction brought to his immortal soul.

The impetus for the commission came from the Abbess, Madonna Scolastica Rondinelli. A woman of formidable competence, she had entered the convent in 1438 after the death of her husband, Piero di Nofri dell'Antella. She managed the growth of the nunnery and protected its reputation "for extreme observance, fasting, silence, and discipline."[52] Though originating in 1390, the community that had become known as Le Murate ("the walled sisters") had only recently gained the autonomy that allowed the Abbess to embark on a program of building and decoration. Joining her desire with Giovanni's means, which she regarded as a godsend, they "gave orders to build three altars."[53]

The high altar was dedicated "to the *Annunziata* as it was the title of the monastery."[54] The church was a porous exception to the otherwise enclosed fabric of Le Murate. It could be entered by the public and probably attracted a restricted, but committed, group of worshippers involved with the convent or drawn by the nuns' fame for being as "one spirit with God."[55] The large and beautiful altarpiece supplied by Lippi played a mediating role in the devotional life of the convent by representing it to the laity.

By the early 1440s Lippi had defined his idiom in altarpiece design. He had produced the altarpiece for the sacristy chapel at Santo Spirito (pl. 167), an *Annunciation* for San Lorenzo (pl. 191), and he was engaged on the *Coronation of the Virgin* for the neighboring church of the nuns at Sant'Ambrogio (1439–47; pl. 192). These precedents could lead his clients to expect a richly textured work, charged with multiple visual "effects" (*effetti*) and cues to emotional or psychological response (*affetti*). Luscious fabrics and delicate veils, translucent glass and rich marble, materials and textures rendered through subtle gradations of color were all features of his art. They are abundantly evident in the commission for Le Murate. Clients might also expect Fra Filippo to devise a fictional space that had ecclesiastical resonance: as he did, composing the Virgin's house as a marble vaulted space divided by a tripartite screen, an internal divider or frame that was reminiscent of a choir screen. They could further anticipate a masterful, yet somewhat playful, use of perspective construction, which would both direct the gaze and divert it. So here, the composition has a strong focal point in the central symbolic elements of the enclosed garden, the door, and the tree, which are simultaneously projected to the back- and middle ground and folded together on the surface, compressing the dove, the column, and the doorway in a visual alternation of representational naturalism and formal abstraction characteristic of Lippi. Equally characteristic is the slyly asymmetrical staging of the scene. In this case, there is a doorway on the left side, with an angel at the sill, on the right side there is a wall. The ionic capitals towards the top of the painting suggest that columns have been cut off by the frame. On the left the apparition of God hovers in front of the capital, which further suggests that the frame is an arbitrary boundary of a space that continues forward towards the beholder.

Another signature feature of Lippi's works was the addition of figures to the iconographic cast of characters. Lacking scriptural sanction or intercessory function, the role of these potentially puzzling extras was to engage the viewer from within the image. The angels at the left in the San Lorenzo *Annunciation* do this with one pointing to the Virgin

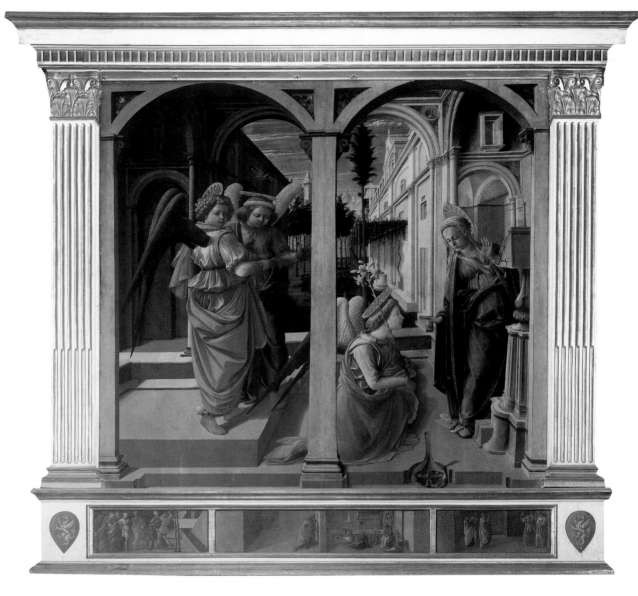

191 Fra Filippo Lippi, *Annunciation*, ca. 1442, panel, 175 × 183 cm., San Lorenzo, Florence.

while turning outwards as the pair react to Gabriel's news (pl. 191). In the Le Murate altarpiece the angel pausing at the door is also an addition to the scene. Rather than dramatizing the wonder of the event or overtly soliciting attention, however, the thoughtful, waif-like figure provides an example of quiet veneration suited to the mood of the moment and the mission of the nuns. Insubstantial, the angel brings to mind the austerity and abstinence demanded by their vocation. This wavering presence recalls their

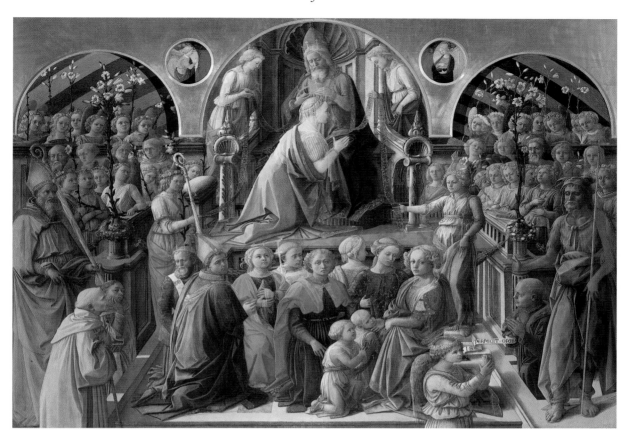

192 Fra Filippo Lippi, *Coronation of the Virgin*, 1439–47, panel, 200 × 287 cm., Galleria degli Uffizi, Florence.

virtuous denial of flesh, accentuating the miracle of Mary's virginity even as she is impregnated by the rays of the Holy Spirit. As with other such figures in Lippi's work, it offers a psychological key to the symbolic reading of the picture.

Among the virtues of the Virgin, humility is dominant in the San Domenico altarpiece. Consonant with the nuns' vocation, the symbolic vocabulary of the panel for Le Murate gives prominence to her chastity and election as "handmaiden of the Lord." The garden shown through the central arch is not the unbounded meadow of Fra Angelico's painting, but a closed garden. The closure stands both for the Virgin's purity and for the enclosure of the nuns within the walls, *le mura*, from which they derived their name, *le murate*. The setting replicates the convent garden, which had similar high, regular walls, and a single large portal. The massive stem of lilies held by Gabriel and the smaller branch carried by the second angel are signs of purity. The crystal vase at the Virgin's feet also stands for her purity and denotes her status as *vas electionis*. Fra Angelico's Virgin wears plain robes, Fra Filippo's wears a gold brocade dress, the stuff of royalty. God the Father also has an embroidered robe, while the angel's gold-edged garment is a softly shim-

193 Lorenzo Ghiberti, *The Story of Joseph*, detail of pl. 141.

194 Fra Filippo Lippi, *Annunciation*, detail of pl. 190.

mering fabric, suffused with pale pink. The sumptuousness pays tribute to Giovanni Benci's gift and is also an attribute of the *Nunziata* as bride of Christ and Queen of heaven.

A massive tree is in the center of the garden and the center of the panel. Its branches are visible through the arch over the screen. The tree refers to the verses from Ecclesiasticus used to celebrate the Virgin: "I grew tall like a cedar in Lebanon, and like a cypress on the heights of Hermon . . . Like a terebinth I spread out my branches, and my branches are glorious and graceful" (24 : 13, 16). This simile is translated to the tall and graceful figure of the Virgin in the painting. The insistently vertical rhythm of the columns and pilasters in the space that encloses and frames her and the stems of the proffered lilies reinforce her stature. The elegant elongation of her figure adopts a proportional system that Ghiberti credited to the ancient sculptor Lysippus and used in the second set of Baptistery doors, noting that it made bodies seem nobler and more beautiful (pls. 193, 194).[56]

195 Fra Filippo Lippi, *Annunciation*, detail of pl. 190.

There are, however, some disturbing passages in Lippi's pictorial homage to the Virgin's grace. Perspective projection places the cypress in the background in the center of the garden and the dove launched by God the Father in the center of the Virgin's room, but the surface pattern of the painting makes it seem as if the Holy Spirit is almost impaled by the tree, which shoots up from a ring of shrubbery (pl. 195). This shaft stands between the closed portal and the open arcade, literally pointing out the contrasting themes of closure and penetration that underlie the miracle of the Incarnation. Deliberately erotic or not, teasing was one of Lippi's attention-getting tactics, studied from Donatello. In this case the visual quan-dary seems to paraphrase the question at the heart of the mystery: "What manner of salutation this should be?"

Landino later praised Lippi's gracefulness, his artifice, and variety, noting in particular his rendering of "ornaments of every kind, whether imitated after the real or invented."[57] This remark conveys the intricacy of Lippi's paintings and suggests the way that their pictorial density impressed contemporary viewers. The term ornament may be taken to mean decorative flourishes or embellishments – the eye-catching and eye-pleasing devices that abound in this painting as in Lippi's other works. But, derived from rhetorical theory, it reveals a more significant aspect to Lippi's compositional procedure. It was held that the skillful use of ornamentation contributed to effective and memorable expression. The captivation of the viewer through dazzling descriptive passages and through unexpected juxtapositions exploited the mechanisms of delight and surprise to

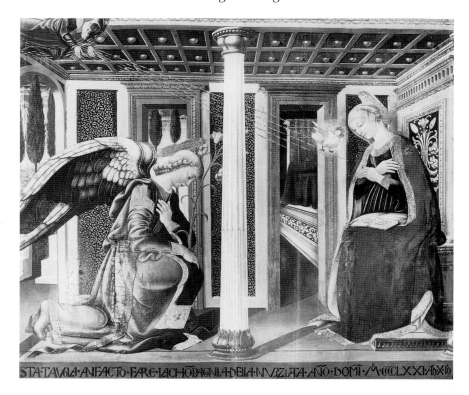

catch the attention of the eyes and mind. It had the capacity to set in motion a power-ful chain of contemplative associations as well as impressing both eyes and mind with the artist's singular talent. This was an approach that would make the beholder better disposed to pay attention to the image and to fix it in memory. It also created a visual equivalent for the delight that was itself the effect of true devotion.

It is not surprising that these friar-painters with their combination of craft and convent training were alert to the circumstances of these commissions and to the purposes of sacred art. But Neri di Bicci's formulaic responses to the task of painting the "annunci-ate Virgin and the angel and God the father with a dove in a house [*chasamento*] as is required by the said story" show how completely the conventions of devotional viewing were integrated with more routine pictorial practice (pls. 196, 197).[58] This was a common subject in Neri's repertoire. His record book documents nine commissions for paintings of the *Nunziata* between 1455 and 1471.[59] A meticulous craftsman and able shop manager, he had a ready supply of serviceable architectural motifs, fashionable ornaments, and a command of the contemporary compositional techniques. He borrowed profitably from Fra Angelico, Fra Filippo Lippi, and Ghiberti, guaranteeing his customers pleasing results, "well adorned and rich," as demanded.[60] In his renderings, as in Fra Angelico's and Fra Filippo Lippi's, the "said story" of the Annunciation is not told as a narrative. It is put before the eyes of the beholder as a compound of its significant and signifying elements. Fixed in clearly legible attitudes, each figure can be focused on separately, as

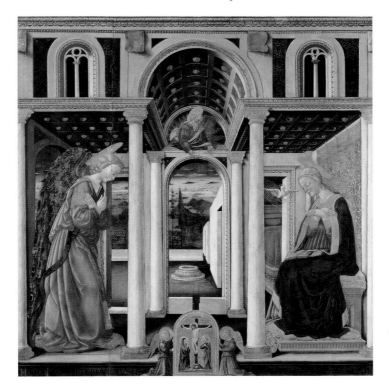

196 (FACING PAGE) Neri di Bicci, *Annunciation*, 1471, panel, Santa Lucia al Borghetto, Tavarnelle Val di Pesa.

197 Neri di Bicci, *Annunciation* ("Vettori"), 1464, panel, 186 × 178 cm., Galleria dell'Accademia, Florence.

example or inspiration. The setting is made up of well-known symbolic referents – garden, bedchamber, doors, windows – a surrounding of stock associations, turning the depicted space into a memory place.

Fifteenth-century artists did not depict doctrine or illustrate abstruse points of theology. That was not the purpose of devotional art. Its general function was to be instructive, moving, and memorable – to aid beholders in turning their mind to God, "with compassionate eyes," to find comfort and inspiration. This could be done with the subtlety of Fra Angelico or Fra Filippo Lippi or with the simpler skill of Neri di Bicci, but in all cases religious works constituted a well-defined category of artistic production. They were composed to relate to a specific set of practices, which created conditions and customs of viewing. These practices (of prayer, of meditation, of recollection and invocation) did not determine forms, but they established protocols that governed the relationships between holy images and spiritual imagination, between representation and reception. Placed before the eyes of the body in order to reach the eyes of the mind, their role was to remind viewers of spiritual obligations and to transmit the experience of spiritual conversion.

They also supplied an important component of the imaginary population of fifteenth-century Florence. Continually invoked and frequently visited, these figures were part of the daily life of the city. "I have come here twenty-five years or more to pray to you, I never gave you trouble and I promise you that I will never return to see you," is the

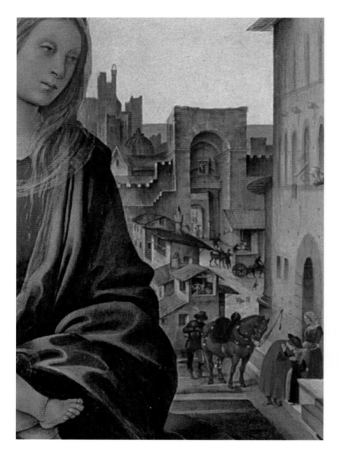

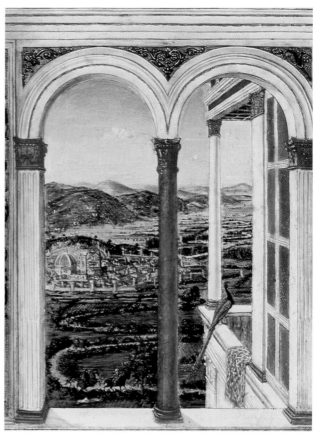

198 Filippino Lippi, Nerli altarpiece, detail of pl. 200.

199 Piero del Pollaiuolo, *Annunciation*, detail, mid-1490s, panel, whole work: 150.5 × 174.3 cm., Gemäldegalerie, Staatliche Museen zu Berlin.

angry vow made by one credulous, and mischievously deceived, worshipper to a statue of Saint John the Baptist in an anecdote told by Piero de' Medici to the roguish priest Piovano Arlotto.[61] More seriously, when Girolamo Strozzi listed his pious actions in his business records, he noted his donation of a mass and two candles "to the Angel Raphael at Santo Spirito."[62] This was probably the altar of the confraternity of the Archangel. Girolamo's shorthand conveys the way that this ritual was also routine.

In the same church Filippino Lippi's altarpiece for Tanai di Francesco de' Nerli puts the Virgin's throne room in a setting based on the neighboring area of Borgo San Frediano (pls. 198, 200). In 1455 Neri di Bicci had received an order to paint a banner for the confraternity of Saint Sebastian, with "a city resembling Florence" at his feet, so that it would seem that the saint was "praying for the city."[63] By the 1470s views of Florence or "resembling Florence" and the Arno valley were increasingly part of the panorama of the divine, notably in works by the Pollaiuolo brothers (pl. 199). This not only illustrated

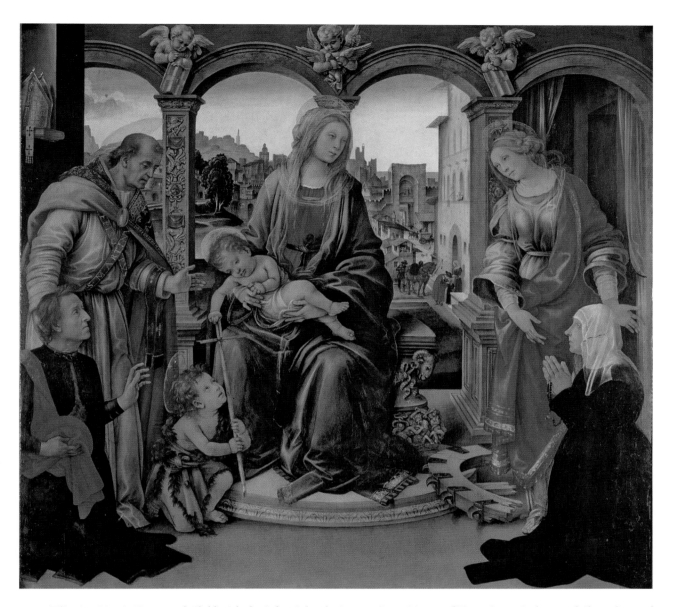

200 Filippino Lippi, *Virgin and Child with the Infant John the Baptist, Saint Martin of Tours, Saint Catherine of Alexandria and the Donors, Tanai de' Nerli and His Wife, Nanna di Neri Capponi* ("Nerli altarpiece"), ca. 1493, panel, 160 × 180 cm., Santo Spirito, Florence.

the city's protection by its holy advocates, but made it a memory place for bringing holy histories to mind.

The manifest anachronism visualizes the connection between the moment and the momentous recurrences of spiritual time, experienced through the divisions and rituals of the liturgical calendar and remembered through the recitation of the gospel and readings from the lives of the saints. But the synchronization of the sacred and the civic also gave Florentine citizens a role in the process of moral imagination. The Nerli altarpiece is an example of this dynamic.

Donor portraits, such as those of Tanai de' Nerli and his wife, Nanna di Neri Capponi, had a long tradition in religious art. They commemorated the pious bequests and the pious behavior of the donors, putting them forth to be imitated and to be remembered in prayer. This was doubtless a motive for their inclusion in this altarpiece, but the setting adds a new dimension. It specifies their exemplarity by giving it a context. Here the pairing of exterior and interior stages the difference between active and contemplative life. The desire to be other than wordly is set within the demands to attend to the matters of this world. The question of how to manage the health of one's soul and the welfare of one's family is posed. This was a quandary for all good citizens who would also be good Christians.

By contrast with the previous examples, which were institutional endowments, the Nerli altarpiece was part of the furnishing of a family chapel. As a concluding case, it adds to the repertoire of relationships between images and audiences being explored here. It also shows how innovation could simultaneously respect and test conventional patterns of perception.

Tanai's altarpiece envisions the Virgin in the midst of everyday life. Behind her a street leads from the city gate. The street is a jumble of modest buildings, consisting mainly of the low-rise tenements of the sort that housed the impoverished woolworkers of the district of San Frediano, and two women are shown spinning in the open upper story of one of them. Dogs are scrapping and tradespeople go about their business. In contrast to the rest of the ramshackle housing, there is a patrician palace at the far right, where a well-dressed man takes fond leave of a woman and child. Tanai did not live near the city gate. His house was further along the street, in the Borgo San Jacopo, but there was a Nerli family piazza in the Borgo San Frediano. This vignette, which suggests that a woman's place is in the home while men venture forth, is on the side of the picture where Tanai's wife, Nanna di Neri Capponi, praying, is presented to the Virgin by Saint Catherine of Alexandria.

The last chapter of Francesco da Barberino's book on women (*Reggimento e costumi di donna*) is about the virtue of prayer. He quotes Saint Augustine to define it as the turning of the mind towards God with proper and humble desire. He argues that prayer is a particularly useful activity for women, who should be confined mainly to the house. He advises that they should not only pray for themselves, but for all of their relations and benefactors and then for all souls, living and dead, each according to need and merit, for the condition of the entire world and for "your land."[64] Nanna, kneeling with a rosary entwined in her fingers, her head covered, her eyes uplifted, is a model of silent prayer.

201 The Nerli altarpiece shown in its original frame.

Opposite her, Tanai holds up his left hand in a wondrous gesture that is an injunction to look and to pay attention. His hand both points to the Virgin and hovers behind the head of the child Baptist, the patron saint of Florence. His right hand holds his *cappuccio*, which was the headgear of Florentine men active in public life. The predella has an inscription between Tanai's arms and those of his wife, asking for the Virgin's intercession: "Virgo Dei Genetrix Intercede Pro Nostra Omnium Que Salute" (pl. 201). This invocation gives voice to the prayers of the exemplary couple.

When read by beholders, the inscription becomes their supplication and an encouragement for them to look upwards to the Virgin, the object of the prayer. She is the largest figure in the painting. Though removed from the foreground, she is not scaled by perspectival logic, but by an optic of respect, which gives her dominance. The rather

cramped *putto* clutching the dove of the Holy Spirit just over her head contributes to the effect. Only Tanai's head, hands, and torso are of comparable size. While this calls attention to him, his own attention and gesture are fixed upon the Virgin as she gazes in Nanna's direction, as though answering her prayer. The inscription invites participation in this circuit of devotion. The text scripts the approach to the image. If read and repeated in the proper spirit, the plea for intercession establishes an active connection with the painting and opens the way to transform a physical or sensory image to a contemplative surface, which gives imaginative access to its prototypes.

This interplay has the emotional affect or color of desire and of compassionate love. It is entirely possible that Filippino literally colored his painting to express this: in the red of Tanai's *cappuccio*, the lining of Saint Martin's robe, the Virgin's dress, and Saint Catherine's mantle. The use of the color red pulls the eye around and between the figures, employing the liturgical color of love, compassion, and charity to do so. In Tanai's case red is an attribute of his citizenship, which honors him, but it also connects him visually to the Virgin. Charitable love is a theme in the chapel that had been made explicit in the window above the altarpiece, where Saint Martin was shown giving his cloak to a beggar. Now lost, the composition is known from a drawing in the Uffizi (pl. 202).

In its size, style of frame, and subject matter – the Virgin and Child enthroned with flanking saints – the painting is similar to others produced for the tribune chapels, such as the one done by Botticelli for Giovanni dei Bardi (pl. 203). There seems to have been an understanding that the overall appearance of the church's interior should be regulated to reinforce the architectural order and coherence of the ensemble. This was possibly mandated by the *operai* or board of works of the church. But throughout the tribune a degree of conformity was amply countered by assertions of specific identity. The great families represented there were allowed and expected to display their arms and emblems: on the interior and exterior walls of the chapels, on the windows, on the altarpiece frames, on candlesticks, and on vestments. Here as in other projects, corporate solidarity and personal honor operated in a dynamic tension that resulted in creative diversity. Tanai was notably insistent about enshrining the Nerli, through the portraits and through the heraldic devices on the frame of the painting and the armorial shields held by the *putti* over the Virgin's throne. Even though he was not to be buried in this chapel (his funerary

202 Filippino Lippi, *Saint Martin Giving His Cloak to a Beggar*, ca. 1493, pen and ink with wash over traces of black chalk, 38.6 × 7.6 cm., Gabinetto Disegni e Stampe degli Uffizi, Florence, 1169E.

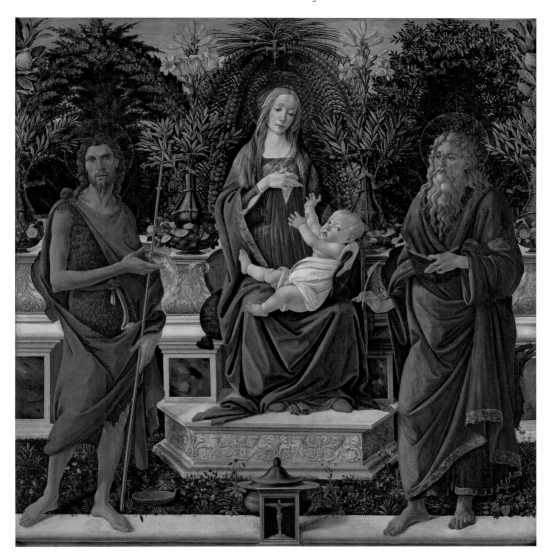

203 Sandro Botticelli, *Virgin and Child with Saints John the Baptist and John the Evangelist*, 1484–5, panel, 185 × 180 cm., Gemäldegalerie, Staatliche Museen zu Berlin.

chapel was at San Salvatore al Monte), he and his lineage were conspicuously commemorated in a prestigious position in the new church of Santo Spirito.

His choice of Filippino as an agent of memory was also very specific. The commission probably dates from around 1493, when Tanai paid 300 florins *di suggello* to endow the chapel, a year after he had been elected to Santo Spirito's board of works. Filippino had just completed the decoration of Cardinal Oliviero Carafa's chapel in Santa Maria sopra Minerva in Rome, and by this time he was one of the most famous artists of Florence, esteemed as a new Apelles and ranked with the greatest of ancient and modern

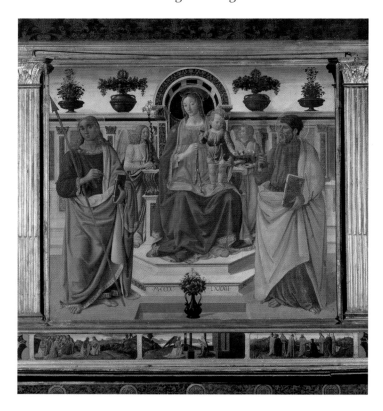

204 Cosimo Rosselli, *Virgin and Child with Saints Thomas and Peter* (originally Saint Augustine), 1482 (Augustine repainted in 1672), panel, Corbinelli chapel, Santo Spirito, Florence.

painters. And here as in other projects, Filippino applied his special pictorial intelligence to his interpretation of the project. He did not follow the popular scheme found in Cosimo Rosselli's altarpiece in the Corbinelli chapel, which combined the illusion of precious materials and the customary allusions to walls and gardens with legibility and decorous formality (pl. 204). Filippino offered a novel arrangement based on an iconography of prayer.

In his altarpiece for Piero del Pugliese, Filippino had produced a work that reproduced the experience of the saint's vision of the Virgin, accompanied by Piero's own experience of this revelatory possibility (pl. 205). In the Nerli altarpiece attentive looking is individuated in another manner. The loggia setting, with the palace behind it and with a room glimpsed through the curtain behind Saint Catherine, has a domestic character. The juxtaposition of the active life in the background and contemplation in the foreground reveals one of the dilemmas of civic existence. Good citizens, like Tanai, necessarily lived in the public realm. It was held that good conscience, however, was best served by retiring from such distractions and temptations.

As the preacher Giordano da Pisa told his congregation, "it is better to stay in your room, and think of God, and contemplate him, than to go running here and there."[65] The crowded city streets were dangerously full of the devil's agents. However good it might be to visit churches or other holy places, it was best to seek solitude. The

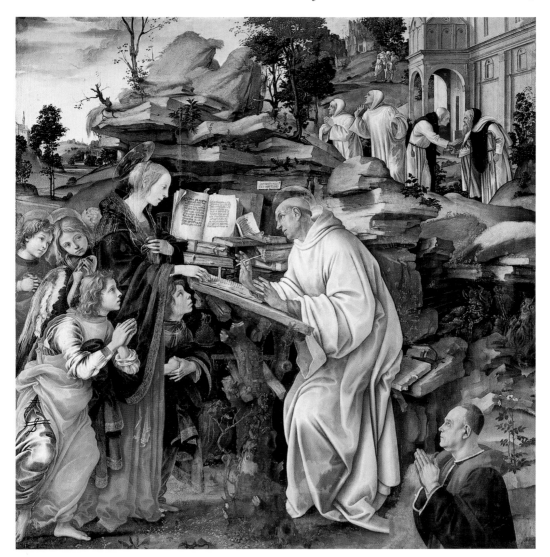

205 Filippino Lippi, *Vision of Saint Bernard*, ca. 1484–5, panel, 210 × 195 cm., Badia, Florence.

domestic setting of the Nerli's supplication to the Virgin puts the excitements of the street behind them while the worthy couple dedicate themselves to thinking of godly things.

The construction of the space puts the beholder on the side of the realm of contemplation. The well-disposed viewer can join in the work of prayer, but this response is not overtly requested. The looking within the painting does not acknowledge the person looking at the painting. There is no inviting figure. The room is notionally contiguous, but not necessarily continuous with the viewer's space. The columns of the interior

206 and 207　Filippino
Lippi, Nerli altarpiece,
details of pl. 200.

architecture are related to the pilasters of the frame (which was probably designed by Filippino), but they do not form a notional colonnade. The ornamental border around the painting inhibits the illusion. This fact of the frame's carpentry insists upon the status of the image as image. The approach is visual, not physical. There is no implied point of bodily entry. The empty space in front of the Virgin is not reserved for a worshipper. Inside the painting it is filled by the Virgin's shadow, and from the outside it would have been blocked by the altar cross, an interruption foreshadowed by the infant Christ as he toys with the Baptist's cross.

The painting has an extraordinary visual density. Filippino had learned the power of ornament to give pleasure, to charm, and at times to disconcert the beholder from his father Fra Filippo. The elements of variety – the abundance proper to the ornate style – include the activities of the city street, the beauty of the distant landscape, the sense of the moment created by the clouds passing across the sky, and the animated sculptures of the *putti* above the Virgin and the ram's head and rape scene that form the *all'antica* base of her sculpted seat (pls. 206 and 207).

The ornamentation of the throne could be taken to signify the triumph of Christianity over paganism and to justify that triumph in the contrast of angelic playfulness with bestial violence. But given the lure of the antique for Filippino and his clients, the placement of the capricious motif next to the Virgin questions the nature of their desire. It constitutes an attraction and a diversion that artfully restates the themes of the painting. Even if the detail is accepted as pleasing ornament, it remains troubling. The need to discriminate between forms of looking that is implied here is stated in one of Lorenzo de' Medici's spiritual verses where he exhorts himself to leave behind old ways and turn his eyes to "things eternal and beautiful, even more beautiful because more rare," and not to remain entrapped by the false beauty of things that are ornate.[66]

The summons to self-awareness refers the subject of the painting to the subjectivity of the viewer. The quality of attention that could transform the sensory experience to spiritual enlightenment has been made part of the picture. The contingency of meaning proposed by the composition also proposes a new type of link between the painting and its audience and therefore between the painter and his public.

Filippino's characteristically sophisticated play on boundaries illustrates the power of a paradigm, that of focused looking (Giovanni Morelli's "fissare con lo sguardo"), while betraying the tensions arising with artists' increased capacity to manipulate viewer experience. In the case of Filippino's invention, only a well-oriented gaze can create the bridge between exteriority and interiority, between body and soul, sense and intellect. Although it is about contemplation, the composition modifies the contemplative template by dramatizing sight, with respect both to seeing the painting and to the seeing within it. Like his contemporary, Leonardo da Vinci (whose works and reputation he had every reason to know), Filippino contrived his figures "in such a way that the spectator may easily recognize, by means of their attitudes, the purpose in their minds."[67] And he forged this recognition into compositional unity by having the figures respond to each other. A precedent was set by Leonardo's unfinished *Adoration of the Magi* for the convent of San Donato a Scopeto (a commission that was soon to be given to Filippino to

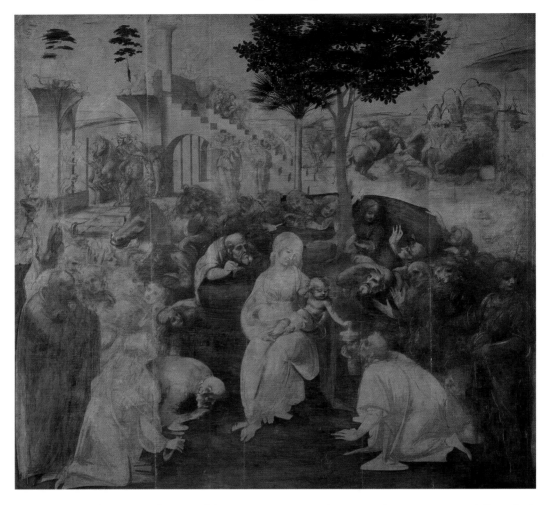

208 Leonardo da Vinci, *Adoration of the Magi*, commissioned 1481, panel, 246 × 243 cm., Galleria degli Uffizi, Florence.

realize; pl. 208). The emotional construction of the composition adds a narrative aspect. These dramatic impulses would eventually result in the breakdown of the longstanding conventions of devotional art and lead to new modes of religious depiction. The design of altarpieces became more overtly dependent on their viewers in "sacred conversations" that required beholders to complete the logic of the composition (pl. 209), to read their histories (pl. 210), or to be implicated in the event (pl. 211).

By maintaining a self-enclosed structure in the Nerli altarpiece, Filippino retained its status as an object of contemplation. He did so with a use of ornament and adornment that made the rhetoric of the object a persuasive case not only for the elevation of the soul, but for the talent of the artist.

209 (ABOVE LEFT) Andrea del
Sarto, *Virgin and Child with
Saints Francis and John the
Evangelist* ("Madonna of the
Harpies"), 1517, panel,
208 × 178 cm., Galleria degli
Uffizi, Florence.

210 (ABOVE RIGHT) Raphael,
Entombment, 1507, panel,
184 × 176 cm., Galleria Borghese,
Rome.

211 Raphael, *Transfiguration*,
ca. 1517–20, panel, 405 × 278 cm.,
Pinacoteca Vaticana, Rome.

Chapter Seven

HAPPY ENDINGS

Giannozzo di Antonio Pucci married Lucrezia di Piero di Giovanni di Jacopo Bini in 1483.[1] Four panels based on a tale from Boccaccio's *Decameron* can be connected with this marriage (pls. 213–16). From Sandro Botticelli's workshop, the paintings measure about 83 by 140 cm. each, or 1¹/₂ by 2¹/₂ Florentine *braccia*. Their size and format suggests that they were designed to be the type of decorative inset known as *spalliere*, placed above shoulder (*spalla*) height in the wainscoting of a panelled room. Vasari first mentioned them in the second edition of *The Lives*, in the palace that Giannozzo's brother, Roberto, had built on the site of the earlier family house. Descending through the family and safeguarded as heirlooms, it is probable that they were originally commissioned by Antonio, as the head of the family. Two of them include shields (pls. 215, 216), which fix the association with the Pucci–Bini marriage and locate that marriage firmly within the social and political orbit of Lorenzo de' Medici. They show the Pucci family arms, the Medici arms, and those of the Bini impaled by the Pucci.

The shields occur as part of the settings of two contrasting meals: one a rustic supper disrupted by a horrific scene of a naked woman being slaughtered by a knight, the other a sumptuous wedding feast, whose only distraction seems to be the arrival of the sweetmeats. In both, the story from Boccaccio, as painted by Botticelli and his assistants, is made part of the history of the Pucci. The concluding scene shows that history to be triumphant, magnificent, and Medicean. A sideboard draped with brocade and laden with precious vessels stands in the center foreground. The geometrical center of the panel has a torch bracket and tethering ring in the form of the Medici diamond. The Medici arms, framed by olive branches, cap the supporting pillar (pl. 212). The festive tables are set as orthogonals in a perspective projection that leads to an *all'antica* arch in the background. This is an instance where pictorial perspective and historical perspectives are conspicuously and consciously combined – the former becoming a language for expressing the latter. As described by its first theorist, Leon Battista Alberti in his treatise *On Painting*, this was a construction derived from "the basic principles of nature."[2] With this technique the geometry of optics became the basis for transforming the action of vision to that of visualization and for creating the illusion of nature on a painted surface. Nature is not to be confused with accidental and imperfect reality, however. The perspectival description of space was a means to transcribe the underlying essential perfection of

212 (facing page) Sandro Botticelli, *Wedding Feast*, detail of pl. 216, showing the Medici arms.

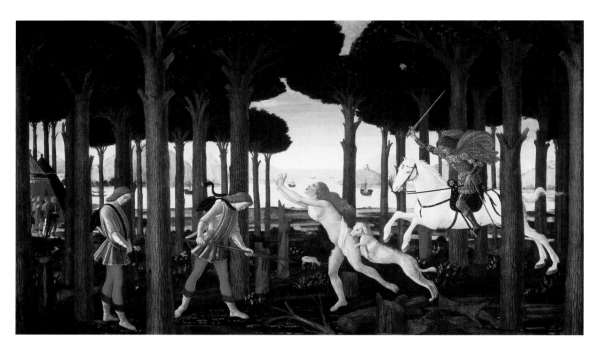

213 Sandro Botticelli, *Story of Nastagio degli Onesti*, first scene: *Nastagio in the Pine Forest of Ravenna*, 1483, panel, 83 × 138 cm., Museo del Prado, Madrid.

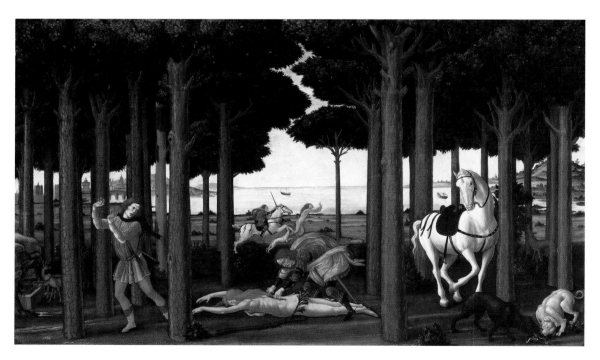

214 Sandro Botticelli, *Story of Nastagio degli Onesti*, second scene: *Nastagio Witnesses the Punishment of Guido degli Anastagi and his Beloved*, 1483, panel, 82 × 138 cm., Museo del Prado, Madrid.

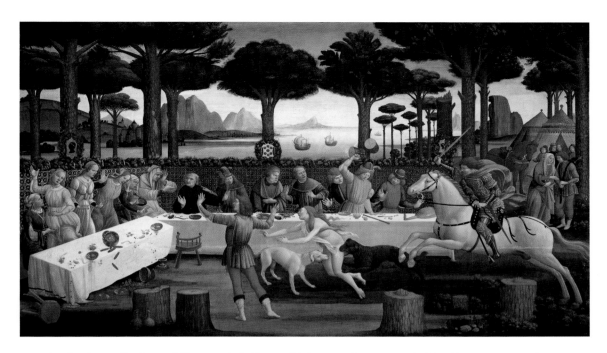

215 Sandro Botticelli, *Story of Nastagio degli Onesti*, third scene: *Banquet in the Pine Forest*, 1483, panel, 84 × 142 cm., Museo del Prado, Madrid.

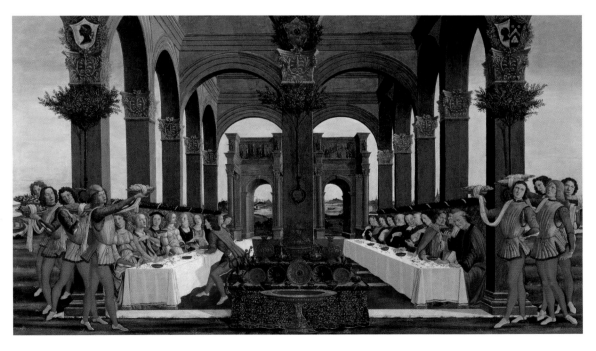

216 Sandro Botticelli, *Story of Nastagio degli Onesti*, fourth scene: *Wedding Feast*, 1483, panel 84 × 142 cm., private collection.

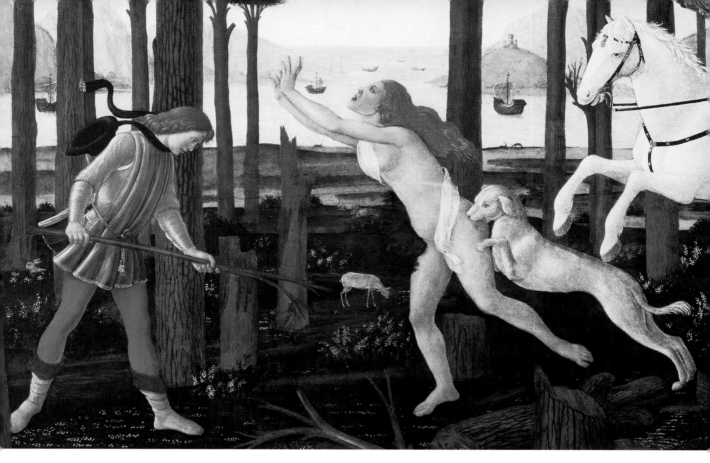

217 Sandro Botticelli, *Nastagio in the Pine Forest of Ravenna*, detail of pl. 213.

forms. Here the geometrical regularity of the composition – its order – acts as a visual metaphor for social order. Through this spatial organization the ideals of a given moment are fixed for all future viewers in a way that makes the very observation of that moment an acceptance of its terms and its truths.

The panels show the story of Nastagio degli Onesti, the eighth tale told on day five of *The Decameron*. The fifth is the day devoted to telling about lovers whose misfortunes and misadventures come to happy endings. Nastagio, a wealthy young gentleman from Ravenna, had suffered rejection by the daughter of Messer Paolo Traversari, a beautiful girl of noble birth. Nastagio employed spectacular means to turn her hate to love, so that in the end, taking her in marriage, he "lived happily with her for a long time."[3] Boccaccio frames the story as a recommendation for female compassion and as an example of the way that divine justice severely punishes cruelty. In this case the disdain of the fair maiden drove the rejected lover to suicidal despair and spendthrift extravagance. As a result Nastagio's friends and relatives became worried that he would waste his person and his finances and urged him to leave Ravenna. He agreed, but did not go very far or change very much, literally setting up camp in tents and pavilions about three miles from the city and continuing to live in a lordly fashion. One Friday in May (the

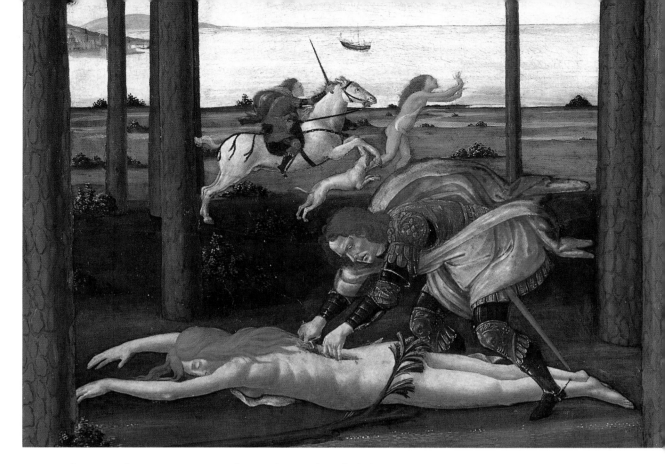

218 Sandro Botticelli, *Nastagio Witnesses the Punishment of Guido degli Anastagi and his Beloved*, detail of pl. 214.

day of penance in the season of love), Nastagio wandered alone into the pine forest thinking upon his cruel lady. His reverie was broken by the sound of a woman screaming and then the sight of that woman, running naked, pursued by mastiffs viciously snapping at her and a mounted knight threatening to kill her. Nastagio sought to defend her (pl. 217). He was stopped by the knight who explained that this horrible chase was a punishment ordained by divine justice.

The knight and naked lady are apparitions. He, Guido degli Anastagi, committed suicide out of love for the lady, who did not repent of having sinned in her cruelty. They were both condemned to perdition and punishment; his was to pursue and kill his beloved, no longer lover but enemy, and hers to suffer the pursuit and be hunted like a savage beast. Each Friday on that spot and at the appointed hour the knight pierced her through the heart, with the same rapier he used to kill himself, and then slit open her back, throwing her cold heart and entrails to the dogs. This accomplished, she would rise again and the hunt would continue (pl. 218).

Nastagio was horrified by this story, but soon decided to turn it to his advantage. He asked his friends and kin to come and dine with him on that spot, enjoining them to arrange for Messer Paolo Traversari and his wife and daughter and their womenfolk to

219 Sandro Botticelli, *Banquet in the Pine Forest*, detail of pl. 215.

be there as well. He set up a magnificent banquet in the pine forest on the spot where he had witnessed the butchering of the cruel lady, making sure that his unwilling beloved was placed where she would directly face the scene. At the feast's end the entire company was treated to the terrifying vision and to the knight's explanation (pl. 215). Stricken with terror, Nastagio's cruel lady transformed her hatred to love and declared that she was ready to do anything he desired. He preferred to combine his pleasure with her honor, by marrying her. And so they were wed the following Sunday (pl. 216).

Botticelli's illustrations follow the plot, but change the emphasis of Boccaccio's story. The nuptials, given such prominence in the Pucci panels in the form of the wedding feast, are barely mentioned in *The Decameron*. Boccaccio's narrative concentrates on the great fear aroused in the girl and her consequent willingness to submit to Nastagio's pleasure. The picture modifies the laughing last line of the story, where the author writes that this lady's fear had the further happy result that all the women of Ravenna became similarly alarmed and therefore more accommodating to the pleasures of men than previously. While the frightful fate of the rejecting girl is elaborately described both by Boccaccio and by Botticelli, in the latter's work the example of the Traversari girl's eventual consent (and by extension that of the other ladies who might hear or witness the story) is put into the context of social rather than sexual compliance. The unruly impulses that led to Nastagio's temporary exile from his city, which are embodied in the nudity

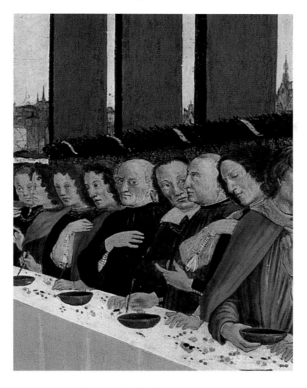

220 Sandro Botticelli, *Wedding Feast*, detail of pl. 216.

and the violation of the fleeing woman, are literally domesticated. Ordered by the ritual of marriage, that taming is celebrated by family, friends, and allies.

The first three panels of the series create a visual text that is relatively faithful to the written one. Nastagio's rustic encampment and the pine forest setting of his adventure are imagined from descriptions in the book. The loggia of the wedding feast and the triumphal arch in the background are instead Botticelli's inventions. In the first two panels the people pictured are all from Boccaccio, but as the tale turns from rejection to acceptance, the Pucci and their associates appear in the scenes through portraits and heraldry. Antonio is among the traumatized guests at the rustic banquet and is happily seated with his friends at the wedding feast (pls. 219, 220). As the moral of the story approaches, Pucci family facts are interwoven into Boccaccio's fiction: exemplary fable becomes historical example.

This is not the only case of such an intrusion in this period. In its combination of histories Botticelli's version of Boccaccio's tale participates in a politics of memory characteristic of the era. One of the features of Lorenzo de' Medici's regime was the exploitation of the visual arts to perpetuate an idealized image of the city, its inhabitants, and their virtues. Thus the inscription on the arch in the background to the right of the *Annunciation to Zacharias* in the Tornabuoni chapel celebrates "the year 1490, when the most beautiful city, blessed with treasures, victories, arts, and buildings, enjoyed abun-

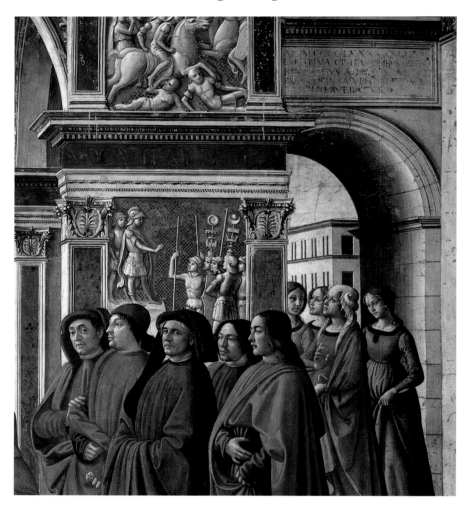

221 Domenico Ghirlandaio, *Annunciation to Zacharias*, detail of pl. 4.

dance, welfare, and peace" ("AN. MCCCCLXXXX QVO PVLCHERRIMA CIVITAS OPIBVS VICTORIIS ARTIBVS AEDIFICIIS QVE NOBILIS COPIA SALVBRITATE PACE PERFRVEBATVR"; pl. 221). Represented in proximity to a wondrous event, fathers, sons, uncles, cousins, friends, and relations of the Tornabuoni are given a place in the history of salvation, and are also seen as forming a parallel history, one combining civic with sacred order. The Baptist, the son being announced by the angel, was the patron saint of Giovanni Tornabuoni and of his city: sacred genealogy consecrates the secular lineage. The men of the clan, or *consorteria*, grouped around the altar figure the living Church and embody the ideal city. In the *Wedding Feast*, Antonio Pucci and his friends and relations witness the happy ending to the story of Nastagio degli Onesti, when cruelty is conquered by compassion and savagery cedes to civility: a conclusion depicted in terms of festive sociability. Here the secular lineage constructs the order of the living city and figures its prospects of living

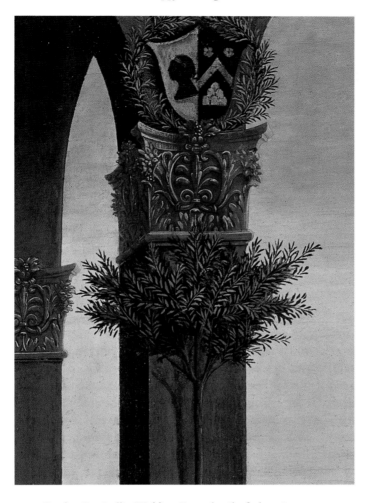

222 Sandro Botticelli, *Wedding Feast*, detail of pl. 216

happily "for a long time" as its story fuses with Nastagio's. Beneath the Medici arms and those of the families united in matrimony, those gathered at the table, like the Tornabuoni kin around the altar, celebrate "the beautiful city, blessed with treasures, victories, arts, and buildings [which enjoys] abundance, welfare, and peace," aptly symbolized by the olive branches that surround the family emblems and decorate the front of the loggia (pl. 222).

Depicting a wedding and connected with a marriage, the panels are indicative of the essential role played by marriages in creating the networks of influence that shaped social and political life in fifteenth-century Florence. An analysis of the case of Antonio Pucci and his children demonstrates the way that marriage alliances formed and secured family identity. The panels commissioned at the time of the Pucci/Bini marriage show how images had a place in commemorating important events, in formulating identity, and in

forming family memory. They also show how they worked to fashion the ideal viewer through a process of invitation and identification.

Like other paintings of the time, commissioned by the "friends" of the Medici – leading citizens with a stake in the regime, such as Giovanni Tornabuoni and Francesco Sassetti – the series participates in the cultural politics currently promoting the notion of a golden age of Florence achieved under their auspices and augured to descend to their children and their children's children (as Antonio once wrote to Lorenzo about the peace Lorenzo was negotiating with the king of Naples).[4] And like the murals decorating the Tornabuoni and Sassetti chapels (pls. 4, 90, 104), these paintings show the power that could be granted to images to affirm collective values and assert their endurance.

Destined for a domestic setting and therefore referring to the private life of the family, the panels are also reminders of that family's public role and how it was to be regulated by and regarded within the household. Not intended for general consumption, they literally expose the anxieties, the naked truths, around love and marriage, duty and desire, and graphically detail how disturbing forces must inevitably submit to ordered behavior. To define the panels as decorative is not to dismiss them as trivial. By embellishing the interior and adding to its beauty, they conveyed honor, here deliberately marked with insignia so as to be specifically remembered, not generically admired.

Though commissioned at the time of a marriage, it would be a mistake to consider them as occasional pieces. The memory is not of a single wedding, but of a series of alliances, and of the process of forging and maintaining the alliances that safeguarded the continuity of the family and its position in the city. They are intimate but significant reminders of immediate events, which, like the memoranda of family record books, were intended to create a corporate memory for the lineage, binding the present to future generations. Following the tale of Nastagio as set out by Botticelli for the Pucci, the viewer becomes a witness to the happy conclusion of a lover's trials and a participant in an important moment of family history. The outcome of that history – its moral truth – was intended to be lasting. And, though subject to fragmentation and reinterpretation, it is still present to modern viewers of the pictures. But the reality of that history also demonstrates the frailties of fiction against fact, as the happy ending, so joyously imagined, soon came to sad conclusions.

MARRIAGE AND LINEAGE

In December 1491 Piero, the youngest of the Pucci sons, wrote to Giannozzo, who was in Rome, to report on the betrothal of their brother Roberto:

> Roberto's wife is the daughter of Lorenzo Lenzi, a man of good condition and status in our city – rich, as you know, of a good family of citizens, and is well-connected with many good families and kinsfolk. And he is very loving and came to this alliance with great happiness and a joyful spirit. He has shown that he values us greatly. And he wore for the oath-taking [*giuramento*]a new scarlet cloak that flamed out happiness from a mile away. You know who the mother is, Mona Maria di Soderini, a venera-

ble woman in our city, who is honored as greatly as any other, as much for her beauty as for the nobility of her blood and for her prudence and manner of speaking as well as for the holiness of her life. I was amazed when I heard her speak. She is cousin to Lorenzo the Magnificent, sister of Paolantonio, Piero, and messer Giovanvittorio, and of the most reverend Bishop of Volterra, the daughter of messer Tommaso, for which both Messer Lorenzo [Pucci] and you should celebrate. Do so again in my name. The girl is absolutely pure, brought up as chastely as is possible, with no superstition or superfluity and without vanity, solely to say her prayers . . . Her hair is black . . . Nature has given her good proportions. She is big, fair and of good complexion and has pretty eyes. Her face is not totally feminine, it has a slightly masculine air, but she is big and beautiful. The oath-taking was held on the feast of Saint Thomas in the great hall of the palace of Lorenzo the Magnificent.[5]

Piero added that he asked Lorenzo about his own marital prospects, assuming that sooner or later the Magnifico would take care of arranging the matter for him.

Piero's letter is a direct and vivid record of an important moment in the life of his family. It describes one stage of the process of matrimony and documents key features of his family's marital behavior. Intensely personal, the account of the specific event is, nonetheless, structured by conventions and conventional modes of perception. The ordering of the narrative literally observes the ritual of matrimony. In doing so it respects the forms as it notes how they have been followed. The domestic chronicle accords with social vision in a way anticipated by Botticelli's illustration of a marriage feast.

The letter proves how marriage was far from being a matter of individual choice. Although love and mutual respect were meant to develop between a couple, such sentimental concerns were not part of making a match, whose aim was to create family alliances – *far parentado*. Thus most of Piero's letter is devoted to listing the kin acquired. He first names and ranks the bride's father, noting his political and economic status, his good character, and his new cloak. Next he writes about the girl's mother as a person commanding respect in the city. He calls her Mona Maria. The family details he proudly rehearses identify her as Margherita di Tommaso Soderini. Her piety, singled out by Piero, is documented in her own little notebook, where she wrote each day the things she had taken for "her consolation" from the sermons of the eminent Augustinian Mariano da Genazzano, who also acted as a spiritual guide to Margherita and her daughters.[6] Her immediate family was noteworthy, as Piero declares. Her father, Tommaso, had been among the most powerful men in the city. An ally of both Cosimo and Piero de' Medici, his second wife was Piero's sister-in-law, Dianora Tornabuoni. At Piero's death, his was the most influential voice for maintaining the regime under the young Lorenzo. A master of international diplomacy, as well as of political intrigue, Tommaso never sacrificed his independence of action or his interests to Lorenzo's increasing authority in the state. At the time of his death in 1485 at the venerable age of eighty-two, he was serving on one of the special magistracies (the Dieci di Balìa). Piero had every reason to recall the importance of Margherita's brothers: at the time of writing Paolantonio (1452–1499) and Piero (1452–1522) had both repeatedly held important public offices as Priors, as

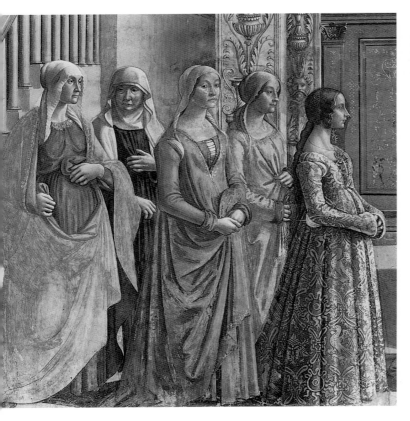

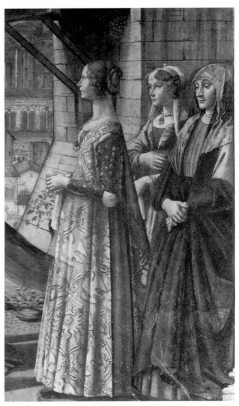

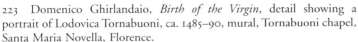

223 Domenico Ghirlandaio, *Birth of the Virgin*, detail showing a portrait of Lodovica Tornabuoni, ca. 1485–90, mural, Tornabuoni chapel, Santa Maria Novella, Florence.

224 Domenico Ghirlandaio, *Visitation*, detail of pl. 90, showing portraits of Giovanna degli Albizzi Tornabuoni and Ginevra Gianfigliazzi Tornabuoni.

members of the state councils and magistracies, as ambassadors, and as administrators of cities under Florentine domination; Giovanvittorio (1460–1528), a doctor of law, was establishing himself as one of the leading jurists of the time, and Francesco (1453–1524), Bishop of Volterra since 1478, was accruing lucrative benefices as well as influence in the papal court. As Piero notes, he was potentially very useful to the Pucci, who were working to secure clerical advancement for their brother Lorenzo, and who were very willing to rely on the contacts forged through their marriage alliances to do so, as will be discussed below. Clearly the Soderini association brought luster to the match, and Piero, at least, viewed it as an essential part of the network of affiliation being woven together that day in the Medici palace.

The girl comes at the end of this family litany. She is never named, simply described. She is the object, not the subject of the marriage – the "daughter of" about to become "wife of." In this she is like Nastagio's bride, a "daughter of messer Paolo Traversari," who is never named. The terms of Piero's description appraise her according to qualities

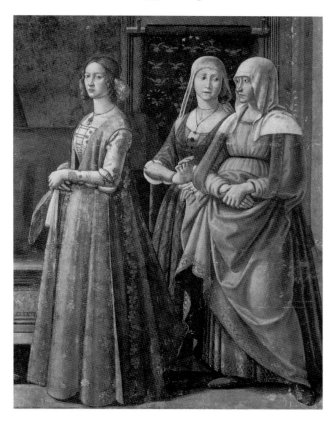

225 Domenico Ghirlandaio, *Birth of the Baptist*, detail showing a possible portrait of Giovanna Tornabuoni, ca. 1485–90, mural, Tornabuoni chapel, Santa Maria Novella, Florence.

deemed essential in a girl to be married (*da maritare*): totally pure (*purissima*) and "big and beautiful" (*bella e grande*). Chaste, healthy, and handsome, it was understood that she would therefore bring honor from her birth family to her marital family. Her physical attributes promised well for childbearing. She met a standard recommendation, such as that given by Giovanni Morelli to his sons: "choose a girl that pleases you, she should be healthy and whole and big, because of the family you expect from her."[7] Alessandra Strozzi, who wanted "to give [her sons] beautiful wives," wrote approvingly of her favorite candidate for Filippo, the daughter of Francesco di Messer Guglielmino Tanagli, that she was "big and well-made," and suited to "produce a fine family."[8] So Giovanni Tornabuoni's daughter Lodovica and the successive wives of his son Lorenzo, Giovanna degli Albizzi (who died in childbirth on October 7, 1488) and Ginevra Gianfigliazzi (married in 1491) are displayed in his family chapel, "big and beautiful," decked in the brocades and jewels of dower and bridal finery (pls. 223, 224, 225). They are not shown moving or posing as graceful, willowy nymphs, but stand solidly, as steady and modest witnesses to the holy women and the birth of miraculous children.

"The daughter of Lorenzo Lenzi" would not, however, have been a witness to the ceremony that is being recalled in Piero Pucci's letter, the *giuramento*, which was the moment when the alliance was formally agreed as the groom and the bride's father pronounced the *verba de futuro*, the declaration that obliged the couple to consent to the marriage. Intermediaries would then be appointed to determine the dowry arrangements and to resolve all the related questions, so that the marriage contract (*instrumentum sponsaliti*, *sponsalia*, *sponsalitium*) could be prepared.

The presence of bride and groom was only required at the next stage of the process, when the *verba de futuro* – the future promises – became the *verba de praesenti*. This was the "ring day" (*dì dell'anello*). In front of witnesses, a notary questioned the couple according to a formula set by the Church to secure their express agreement to the union. Their verbal consent was followed by the ritual bestowing of a ring, the symbol of matrimony, as the notary took the woman's right hand, guiding it to her husband so that he could put the ring on her finger. The importance of the gesture of bestowing the ring is demonstrated by the iconography of the episode in the life of the Virgin. In the contract for the scenes to be depicted in the Tornabuoni chapel this is specified as the "Sponsalitii et Nuptiarum Virginis Marie."[9] In the chapel, following a well-established iconographic tradition in Tuscany, the action of placing the ring on the bride's finger is at the center of the composition (pl. 226). In this case, to give the Virgin the place of honor at the priest's right, the ring is being put on her left finger; the scene is a reminder, not a record of, the usual gesture.

The episode is pictorially defined as a "giving of the ring," that is, as a marriage. The miracle of the flowering rod, God's sign that Joseph be chosen as the Virgin's husband, is illustrated by the frustrated young suitors breaking their rods. The emphasis of the holy story, which is part of the legend relating to the feast day of the Virgin's birth (it is not a gospel episode), is on God's mandate. In the iconography, instead, the emphasis is on the ritual of marriage. The exaltation of the marriage of the Virgin in devotional life corresponded to the importance of matrimony in daily life. Even the fact that the union of Joseph and Mary was between partners of unequal age – a much older man with a young maiden – had strong resonance with reality in fifteenth-century Florence.

Through this iconography, the actions pertaining to marriage, which was actually a legal and social process, took the form of holy actions, sanctioned by religion. This is not illustration: marriages were not performed or legitimated by priests in the fifteenth century. Couples could attend a mass on their ring day, but it was not until after the Council of Trent and its decrees of 1563, that the Church sought to bring marriage under its control. The consecration performed by the image is that of giving the gesture canonical form and sanctifying behavioral codes by association with the Virgin. As the example of the most gracious humility, the Virgin's submission to the will of God offered the supreme model of obedience to all prospective wives. In a mutually reinforcing process, social ritual and religious imagery operated to confirm the authoritarian mode of marriage.

In practice the event of bestowing the ring was certified by a notarial document, the *instrumentum matrimonii*, and at this point the couple were regarded as married, though

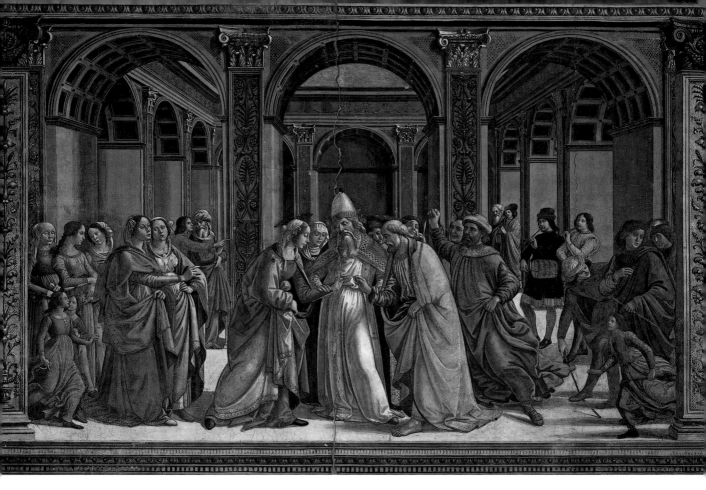

226 Domenico Ghirlandaio, *Marriage of the Virgin*, ca. 1485–90, mural, Tornabuoni chapel, Santa Maria Novella, Florence.

the public celebrations of the wedding feast, the important moment of consummation, and the final transfer of bride, her dower goods, and her dowry to her marital family were still to take place. Marriage was not a single ceremony. It was a ritual and legal process, undertaken in different stages, from the search and negotiations started by a man's decision to get married or a family's decision to marry off a daughter, through delicate stages of making contact, drawing up contracts, and staging celebrations.

Putting a daughter into the marriage market was a sensitive operation, but it seems that in the case of the *giuramento* held in the great hall of the Medici palace, Lorenzo di Anfrione Lenzi, in his bright new cloak, was manifestly pleased with the deal he had concluded. Commercial terms are not simply apt metaphors for the process of match-making in a mercantile society. They were an intrinsic part of the language of matrimony, expressing its motivations, mechanisms, and consequences. The marriageable women of Florence were a form of goods: valued and valuable in exchanges that could involve substantial sums of money (in dowries) and less tangible assets involving prestige, power, and security. The case of the Pucci demonstrates how closely their commercial interests and professional and legal affairs were bound up with their matrimonial

calculations. In-laws became business partners, guarantors and witnesses to contracts, as well as friends and allies. Pucci family policy was also an intrinsic part of the power plays of Laurentian politics. The way that Piero Pucci readily left his marital fate in the hands of Lorenzo de' Medici shows that he expected Lorenzo to perform the service of choosing his bride. He had done so for Piero's older brothers; indeed his role as architect of Pucci family alliances had already been commemorated in Botticelli's panels, painted eight years previously.

It was a role that had been anticipated by Lorenzo's grandfather. Cosimo had acted as broker for Antonio Pucci's second marriage, to Piera di Giannozzo Manetti in 1459. By that time Pucci family fortunes had been tied to the Medici for almost half a century. Their rise from minor guildsmen to major statesmen was directly linked to Medici ascendancy. Antonio's father and grandfather had been members of the woodworkers' guild (the Arte dei Maestri di Pietra e Legname). Cosimo described Puccio as one of his "closest friends."[10] This was not a simple term of endearment. To be a "friend" in fifteenth-century Florence was to be a loyal supporter, to accept obligations and to expect favors. In 1433 Puccio and his brother Giovanni were exiled soon after the Medici. Medici partisans even became known as "Puccini." After their return from exile, along with the Medici in 1434, the Pucci were able to become members of a major guild, the Cambio, a definitive change of status.

Antonio's skill in both business and politics and his unswerving allegiance to the Medici ultimately made him one of the leaders of the regime. The following detailed account of his marital politics demonstrates the crucial role of marriage in achieving this prominence. It also shows the way that individual lives were consciously and carefully woven into larger and longer histories. Antonio Pucci's marriages and those he made for his children helped to secure his own influential position and to confirm the family's place among the leading houses of the city.

His first wife, Maddalena di Berto [Bartolomeo] di Giuliano Gini, came from a prosperous family of the Santo Spirito quarter. She brought him the very respectable dowry of 1,550 florins. The division of property made by Antonio and his brothers in 1453 states that Antonio had received the dowry five years before he "took his wife home."[11] Their first child, Lucrezia, was born in 1446, which would date the match to around 1440–1.[12] Antonio was around twenty-five years old at that time, rather young to marry by the usual standards for men of his class. This was, however, a pattern he later followed in the marriages he arranged for some of his sons and daughters. Maddalena died in 1457, shortly after the birth of their seventh child, Lorenzo.[13]

By that time, Antonio, now thirty-nine years old, had acquired substantial standing, "authority" or *autorità* in the fifteenth-century understanding of the word as denoting economic and political power. He had political status, or *stato*, having begun holding civic offices when he was thirty, in 1448, acting as secretary to the Gonfaloniere in the scrutiny that year and being a Gonfaloniere di compagnia. He had twice been among the Signori, or lords of the city, being selected as of the city's twelve governing priors in 1452 and 1457. In 1458 he was part of a special commission, or Balìa, and was also appointed chief magistrate, or Podestà, of Pistoia that year. When Giannozzo Manetti decided to find husbands for his daughters, with the help of Cosimo de' Medici, Antonio

was an attractive prospect, even though Manetti had more prestige by all of the standard measures of the day. He came from an older and wealthier family, which had a long tradition of marriages with other distinguished clans. Indisputably one of the most eminent men of Florence, Giannozzo was a scholar and statesmen with a distinguished career of political and diplomatic service. He had suffered, however, in the factional dynamics of the city and had powerful enemies who were able, among other things, to engineer an accusation of treason against him. Though his arguments of innocence were accepted by the Signoria, he decided that voluntary exile would be the most prudent course of action in the face of possible ruin. In 1456 he left Florence, first going to Rome and ultimately settling in Naples. It seems that Cosimo wanted to secure his good will, or bring him into the orbit of Medici interests, and Manetti accepted the favor (the "beneficio") of Cosimo's arranging marriages for his daughters, one to Antonio and the second to another Medici partisan, Francesco di Alamanno degli Albizzi.[14] This gesture also favored Giannozzo's son, Bernardo, whose career had suffered from his father's political misfortunes. Manetti died soon after the marriages were concluded, but Antonio and his sons remained close to Bernardo.[15] Antonio and Piera's first child, a son born in 1460, was named Giannozzo.

The Pucci–Manetti alliance confirmed that Antonio – a "new man" of the Medici regime – had arrived in the upper echelons of the city's social structure. He continued to consolidate this position in choosing partners for his children. His oldest daughter Lucrezia (b. 1446) was the first to be married off, sometime around 1460, in a match with Francesco di Jacopo degli Agli, who came from an ancient feudal lineage. As described in Chapter 6, on his death in 1418 Francesco's grandfather Barnaba left 6,000 florins to build and equip the church and convent of San Domenico, which was a notable precedent for Cosimo de' Medici's subsequent sponsorship of the Observant convent of San Marco. Diverse as it was old, there were three principal branches of the degli Agli family. Two were anti-Medicean, but Francesco's branch apparently did not share these sympathies. Intellectual and affective, if not political, ties can be demonstrated between the Medici and this family. Jacopo di Barnaba's first marriage (in 1433) was to Margherita di Bernardo di Alamanno de' Medici.[16] Francesco's brother, Pellegrino, was from his youth a friend of Marsilio Ficino, Gentile Becchi, and Lorenzo de' Medici.[17]

Like the majority of the kinship links that Antonio forged for his children, the degli Agli alliance was with a prominent family of the Santo Spirito quarter. This was the case for the second daughter to be wed, Selvaggia (born ca. 1452), who was married to Luca di Giorgio Ugolini (b. 1452) in 1469. The Ugolini were established in civic life, with a longer record of office-holding than the Pucci. Luca's father, grandfather, and great-grandfather had all served repeatedly on government bodies, as Gonfalonieri for their quarter, among the priors, and the twelve Buonomini. Luca's father had been one of the Signori four times (in 1445, 1448, 1459, 1469) and held the highest office, that of Gonfaloniere, in 1464.[18] Luca was himself to hold public office repeatedly from 1484, when he was one of the Signori.

The marriage of Oretta (1456–1483) in 1471 to Michele di Bernardo di Lapo Niccolini (b. June 6, 1451) varied the geography of the previous matches, but confirmed the politics. The Niccolini were merchants resident in the Santa Croce quarter. Even though

the Niccolini clan was less ancient than the degli Agli, Michele's relations had been office-holders since the mid-fourteenth century. His father had been a partner with his brother Paolo in various companies in the wool trade. Paolo remembered Bernardo at his death, in November 1470, as having led a "laudable life," and though Paolo described him caring "little about being in office," Bernardo was twice a member of the Signori (in 1443 and 1452), he was one of the twelve Buonomini three times (1441, 1445, 1452), and his name once was "drawn out to be the Gonfaloniere of Justice" (therefore among those eligible to hold the office).[19] In addition, Paolo says, "for the greater part of his life he was at the Specchio," which was a government office.[20] If, in contemporary perception, this was the civic career of one who was relatively indifferent to public office, it is proof of how much holding public office was part of maintaining personal and familial esteem. The contrast in this case might have been with their brother, Otto, a lawyer, who was extremely active in political life, serving as an ambassador to the courts of Rome and Naples, and ultimately knighted by Pope Paul II. Otto is documented as being a close ally of Cosimo, Piero, and Lorenzo de' Medici. The latter wrote to him "as a father."[21] Otto and Antonio Pucci were friends to each other, to the Medici, and to the state. An alliance between their families tightened existing bonds.

By the early 1470s, therefore, Antonio's three surviving daughters by his first wife were well placed. They were married to young men from families securely positioned among the ruling elite. The next marriages he arranged for his children date from the 1480s, when Lorenzo took an active role in determining their marital fates. His concern for the alliances to be made for "Antonio nostro" is documented in a letter dated November 9, 1481 about a match he was trying to negotiate with one of the daughters of the Countess Princivalle da Montedoglio.[22] Her husband had served Florence as a military commander, and the fate of his heirs and his territory near Borgo San Sepolcro was of concern to Lorenzo. Similar motivations might have been behind Giannozzo Pucci's first marriage in 1480, to Smeralda di Ugolino del Marchese di Monte Santa Maria.

Lorenzo is documented as the intermediary for the marriages of Giannozzo's siblings: his older half-brother Alessandro (1454–1525) and his younger sister Elena (b. 1468). Two marriage contracts, brokered by Lorenzo, were signed in succession on January 12, 1481 by the parties gathered in the Palazzo della Signoria. The first agreed the marriage of thirteen-year-old Elena to Girolamo di Niccolò Capponi. Her dowry was 2,000 florins.[23] Antonio is described as magnificent and illustrious ("magnificus," "illustris"). These terms are fair indicators of his status by that time, as is the amount of the dowry, which was a sum afforded only by the affluent elite.

Concentrated in the quarter of Santo Spirito, the Capponi were not only "big men" in their parish (where they had three of the prime chapels in the new church of Santo Spirito), but they had a substantial presence in international trade and banking, and proud traditions of political eminence. Niccolò's tax valuations show him to be the second wealthiest in the clan.[24] He had settled his family in a house next door to his cousin Neri di Gino Capponi, which he had purchased in 1442 from Domenico di Barnaba degli Agli and enlarged. Elena must have been taken to this house, where Girolamo is still documented as living in 1534.[25]

227 Tomb of Francesco Sassetti, ca. 1479–85, black porphyry, Sassetti chapel, Santa Trinita, Florence.

228 Attributed to Andrea del Verrocchio, *Francesco Sassetti* (detail), 1464, marble, Museo Nazionale del Bargello, Florence.

The next entry in the notary's book is the marriage contract between Alessandro Pucci and Sibilla di Francesco Sassetti (pl. 233).[26] The arrangements were similar to those noted above: Lorenzo was the arbitrator and the dowry agreed was 2,000 florins *larghi*. The bride's father had made his fortune in the Medici bank, rising to become its general manager. As such he presided over its decline from the failures of the branches in Milan, Avignon, Bruges, and London between 1478 and 1480 to that of the Lyons branch in the late 1480s. Despite his seeming lack of financial acumen, he retained the trust and favor of Lorenzo (who once admitted to not understanding such matters).[27] The marriage, agreed at an apparently delicate moment, affirms their friendship. Francesco shared Lorenzo's and Antonio Pucci's interest in learning. He once wrote to Lorenzo that he "wanted to benefit all virtuous men, especially those who are engaged in humanist studies, whom I have always admired and supported."[28] He fashioned his personal and memorial iconography from the materials of humanist study, using classical gems and ancient references as sources for his funerary chapel, and commissioning a portrait bust in Roman style garb (pls. 227, 228). Antonio's daughter-in-law Sibilla had the name of the pagan prophetesses, the sibyls who form part of the chapel decoration on the vault and on the exterior wall.

Antonio Pucci's faith in Francesco is evident in a letter to Lorenzo written in 1479. Lorenzo had gone to Naples to negotiate peace with King Ferrante, hoping to end the war that had followed from the 1478 conspiracy that nearly succeeded in killing Lorenzo and that was fatal to Lorenzo's brother. Francesco was part of the special magistracy created after the emergency to manage affairs in Florence. Punning on Sassetti's name –

a *sasso* is a stone – Pucci reassured Lorenzo that he need not worry, because "il Saxetto" could cast as many stones as necessary.[29] The marital tie added to the community of interests and reinforced familial bonds. Francesco Sassetti was already allied to the Capponi through the marriage of his daughter Violante to Neri di Gino Capponi in 1474.

The conspicuous appearance of Lorenzo's arms and emblems in Botticelli's panels points towards the Magnifico as the broker for the marriage between Giannozzo and Lucrezia di Piero Bini in 1483. Lucrezia, fifteen years old at the time, was Giannozzo's second wife. His first wife had died in August 1482.[30] That he would rapidly remarry would be taken for granted, the question is why would this alliance result in such grandiose celebration?

There would hardly have been cause for Giannozzo to resort to drastic means of the type Nastagio used to induce his bride to submission. The match followed a familiar set of criteria. The Bini were a well-off family of the Santo Spirito quarter, with a tradition of office holding since the fourteenth century. Piero Bini was one of the Priors in 1462 and 1468; he had been among those in the scrutiny for Gonfaloniere di Giustizia in 1472, and was a member of the Balìe in 1466, 1471, 1480.[31] In Benedetto Dei's *Cronica* the family is listed among the 365 great lineages ("chasati") of the city, which constituted its ruling class in 1472. Dei did not, however, include the name in his inventory of the city's richest families, which is headed by the Medici, and where one finds Antonio Pucci, Niccolò Capponi, Francesco Sassetti, and Giorgio Ugolini.[32] Eminently respectable and respectably active in civic life, Piero Bini was not a public figure. Perhaps not quite of the same level of financial worth (*avere*) or political stature (*stato*) of some of the other matches Antonio made for his children, particularly the Sassetti and Capponi alliances, this one still drew from the same pool of associated families. Piero Bini had been for some time a business partner of Neri di Gino Capponi in a wool company in Pisa (and, as noted above, Neri was married to Francesco Sassetti's daughter, Violante). Bini's influence, interests, and landholdings in the area of Pisa may well have been another attraction, for it was an area also of interest to Antonio and to Lorenzo.[33] On the same day that Giannozzo received Lucrezia Bini's dowry, her brother Francesco received the dowry of his new wife, Smeralda di Alamanno di Bernardo de' Medici.[34]

In 1483 the pursuit and celebration illustrated in the panels had a wider reference than one wedding. That year Giannozzo's older half-brother Puccio (1453–1494) was married to Geronima di Pierluigi Farnese, who brought the huge dowry of 2,700 ducats. This match allied the Pucci to a family from the minor Roman nobility, with connections to the papal court. It followed the precedent set by the choice of a noble Roman bride for Lorenzo de' Medici, who had married Clarice Orsini in 1469. Far less important than the Orsini, the Farnese were nonetheless a rising force in late fifteenth-century Rome. Young Alessandro Farnese (1468–1549), Geronima's brother, was beginning a career that would culminate in his election to the papacy in 1534. Like Lorenzo, Antonio had ecclesiastical and "international" ambitions for one of his sons, Lorenzo (b. August 10, 1458). Among the lessons learned from the 1478 conspiracy against the Medici was the need to maintain good relationships with Rome and eventually to secure a position within the ecclesiastical hierarchy. During the 1480s the hunt for benefices and promotions for Lorenzo's son, Giovanni, and Antonio's son, Lorenzo, was intense. Letters between

Geronima and her Pucci in-laws, including Giannozzo's wife Lucrezia, demonstrate the usefulness of matrimonial alliances. Especially in the next decade, when her brother was made a cardinal (in 1493) and her sister Giulia was an intimate of Pope Alexander VI, Geronima worked actively to promote Pucci interests in Rome, writing to the Pucci and about them with affection.[35] Giulia herself corresponded in the warmest terms with Giannozzo, reminding him that he could rely on her, because she loved him as though he were her own brother.[36] And writing to her sister Geronima, she sent her regards to her Pucci in-laws, Alessandro and Giannozzo.[37] The Roman and Florentine sisters-in-law Geronima and Lucrezia seem to have become fond friends and correspondents as well. A long letter from Geronima addressed to her "dearest" and "beloved" Lucrezia starts with apologies for not having answered Lucrezia's letters; she had not forgotten, but both she and Puccio had been ill.[38] In this case a genuine network of regard developed between sisters and sisters- and brothers-in-law, which also usefully connected the families' affairs in Florence and Rome.

Though matrimony was the result of duty, not romance, mutual affection was certainly one of its hoped for "happy endings." Giannozzo and Lucrezia's relationship evidently got off to a happy beginning. In a letter dated February 1, 1482[83], Lucrezia answered a letter from Giannozzo (who was in Rome), writing to "my dear Giannozzo," urging him to return soon in order to be back in time for carnival as he had promised. She signed the letter, "your Lucrezia in Florence" and addressed it to her dear and beloved Giannozzo.[39]

To honor one's husband or wife was a specific obligation of marriage, but the purpose of the institution of marriage was to bring more general honor to the families concerned. A primary aim was to secure the lineage through offspring, but extended affiliations were another possible issue of a good marriage. Marriage was a powerful component of consensus. The apothecary Luca Landucci recorded in his diary that

> after the failure of the plot [against Piero de' Medici in 1466], many citizens connected with it were exiled . . . except Messer Luca Pitti, who made an alliance with Giovanni Tornabuoni, giving him his daughter as wife, and in consequence he was reprieved from exile, and they remained friends and at peace.[40]

It is thus logical that marriage broking should have been an integral part of Lorenzo's power broking. He used it to forge alliances among his supporters and to strengthen allegiances through such alliances. It was a centralizing strategy. Whereas Cosimo had operated radially, reaching out to link those who were recalcitrant or possibly dangerous to his faction (as in the case of Giannozzo Manetti), Lorenzo used marriages to concentrate and consolidate the core of power. It allowed him to shape the "private" realm of family relations just as he and his supporters were reshaping the public realm of the electoral and governing councils. This increasingly tight network had economic advantages, not only in the various companies and business associations made among the families concerned, but in the exchange of dowries. As part of each family's wealth the substantial sums assigned to their daughters as marriage portions, which they took to their marital family, were notionally (and actually) returned to them when one of their sons married a girl from the same group of interconnected households.

The cluster of marriages secured for Antonio's eligible children between 1480 and 1483 is noteworthy. Alessandro and Puccio, at around the age of thirty, and Elena at between thirteen and fourteen years old, were near the typical ages for marriage among those of their station. It was less common for young men of the elite to marry in their early twenties, as did Giannozzo. Undoubtedly motivated by the conventional desires to maintain the reputation of the family and to secure its future, these matches had a powerful secondary purpose. Mostly arranged by Lorenzo, they can be seen as part of the concentration and ordering of power defining Lorenzo's regime in the 1480s. Intermarriage among his friends closed the inner circle, isolating it perhaps, but rendering it stronger, at least for the moment.

The hindsight of history has made the Medici domination of Florence seem inevitable and, to a degree, absolute. This view has been helped by the Medici's canny use of the historical instruments at their disposal: paintings, poetry, prose, philosophic discourse, and the writing of history itself. Strategic and effective, the representations of rule promoted by successive generations of the Medici must be read against considerable, even deadly, threats to their actual position as unofficial heads of state. Enmity was as much a fact of Florentine life as friendship. Lorenzo had grown up aware of this, having witnessed an unsuccessful plot against his family's authority in 1466. The factionalism that was an abiding feature of Florentine politics, making the city "a paradise inhabited by devils," meant that no group could be sure of dominance.[41]

This had been traumatically proven to Lorenzo by the events of April 26, 1478, when an attempt was made to assassinate him and his brother, Giuliano, during high mass in the cathedral. Giuliano was killed, but Lorenzo escaped to the sacristy, bleeding from stab wounds. The conspiracy was devised by members of the Pazzi family – chiefly its head, Jacopo, and his nephew Francesco, and the Archbishop of Pisa (Francesco Salviati), along with the pope's nephews, Girolamo and Raffaello Riario, with the implicit support of the pope and the king of Naples. Though all of the assassins and some of the conspirators were eventually caught and killed, and the house of Pazzi was humbled through the punishments of exile and the sequestration of goods, the situation was hardly stable. As Machiavelli later wrote in his *Florentine Histories*, "since the change of state did not occur in Florence as the pope and king desired, they decided what they had not been able to do by conspiracy they would do by war."[42] Peace was reached in March 1480, after Lorenzo had decided to go to Naples in person, reasoning that it was necessary, "after the death of one brother and other offenses and injuries and danger to myself, to put my life at risk" so that the city might have peace.[43] There was still need to achieve order in the city, and in April 1480 constitutional reforms were instituted by means of a carefully selected Balìa. The ambassador to the Duke of Milan accurately noted, "the first will be mostly friends."[44] So they were: Antonio Pucci was among the first appointed and Piero Bini among those co-opted.

The triumphant festivities of the *Wedding Feast* portray some of those friends, happy witnesses to a fictional marriage, but themselves testimony to the order structured, sustained, and newly strengthened by their actual marriages. Particularly in light of recent events their story could be viewed, just as Nastagio's was described by its gentle narrator, Filomena, as being one "as delightful as it is full of pathos."[45]

"... FOR A LONG TIME"

The viewer is directly invited to share in the delights of the concluding scene. The servants leading the procession of sweetmeats are turned outwards, as though offering their trays in both directions (pl. 229). Disproportionately large in scale, and given great visibility by their bright red stockings, these marginal figures actually stand at the boundary of the painted and real worlds, as though serving parallel feasts, and insisting on the connection between the two realms.

229 Sandro Botticelli, *Wedding Feast*, detail of pl. 216.

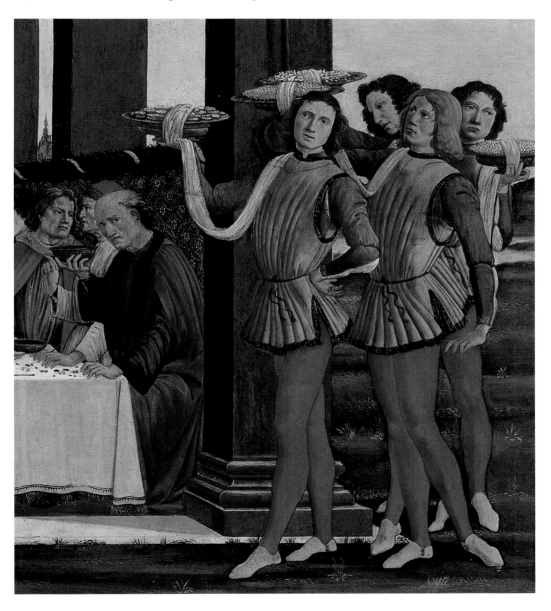

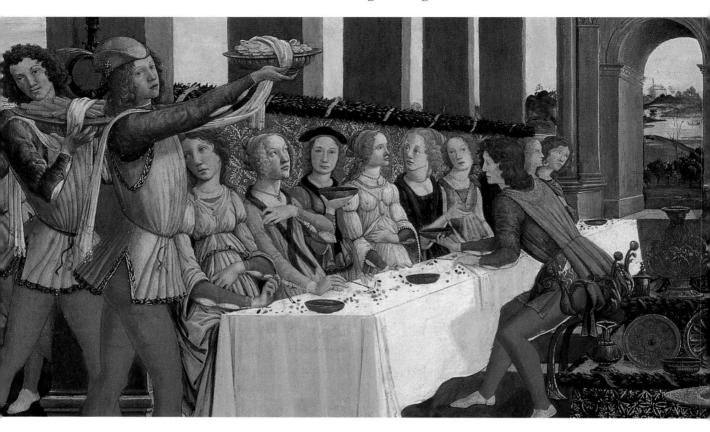

230 Sandro Botticelli, *Wedding Feast*, detail of pl. 216.

The spectator, or the unseated guest, is greeted by the gaze of Antonio Pucci (pl. 220) and by two members of the wedding party who raise their bowls and stare intently beyond the pictured space in a direction that must be imagined as continuing that space. One is a bald gentleman, the last of a trio seated at the end of the table on the viewer's right who are all dressed in the manner of clerics and of professional men of learning (pl. 231). The other is a woman seated towards the center of the table on the left, next to Nastagio's bride (pl. 230). The bride of Boccaccio's romance is depicted as a fair nymph in the style of her clothing, and with all the attributes of idealized beauty of fashionable love poetry – a long neck, high forehead, blond tresses, and distant gaze. The contrast of her behavior with that of her forthright neighbor is striking. It is heightened by the almost devout upward gaze of the woman seated further to their right, which seems reverently attracted by the Medici arms at the top of the central pillar. This woman can be compared to the figure with similarly arranged blond hair, rounded chin, and round and rather large nose, standing in the left foreground among Francesco Sassetti's daughters in the scene of the *Resuscitation of the Roman Notary's Son* in the family chapel, who has been identified as Sibilla, Alessandro Pucci's wife (pl. 233). Both the woman in the piazza

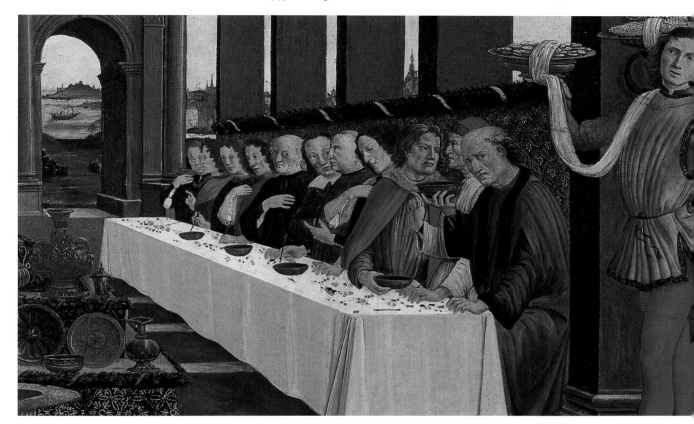

231 Sandro Botticelli, *Wedding Feast*, detail of pl. 216.

and the one seated in the loggia wear necklaces with precious jewels of the sort bestowed upon brides and permitted them by sumptuary laws, and the necklaces may be a form of proprietary marker similar to the large ruby with three pendant pearls worn by the Tornabuoni brides in the *Visitation* (pl. 224). The presence of Francesco at the opposite table (seated fifth from the viewer's right; pl. 231), as well as Sibilla's role as a recently acquired Pucci daughter-in-law would justify her presence.

The unmitigated stare and lifted bowl held by the woman next to Nastagio's bride are totally anomalous among the repertory of female gazes and feminine gestures shown at this table. Such straightforward eye contact would generally be deemed immodest, perhaps dangerously so, according to the standard precepts of female behavior. Here it is moderated, but not completely explained, by its dignified immobility. There are no signs of flirting. The woman's bearing has an interesting resemblance to that of the bride in Giotto's *Marriage at Cana* in the Scrovegni chapel (pls. 232, 234), who is also composed as a figure meant to capture attention without incurring blame. Though it might be tempting to identify the woman as the actual bride of the Pucci–Bini marriage, seated as she is next to her fictional model and at the table on the side of the Pucci–Bini arms,

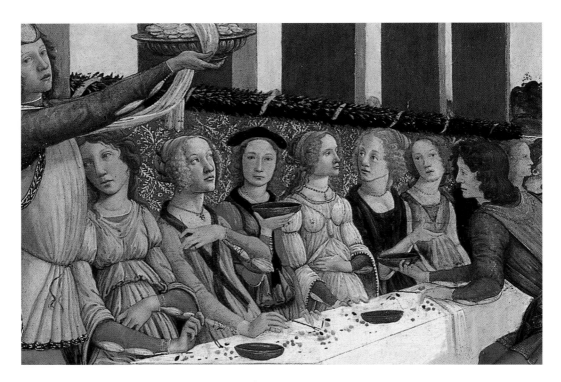

232 Sandro Botticelli, *Wedding Feast*, detail of pl. 216.

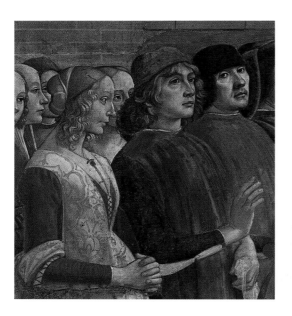

233 Domenico Ghirlandaio, *Resuscitation of the Roman Notary's Son*, detail showing Sibilla di Francesco Sassetti and Alessandro Pucci, ca. 1479–85, mural, Sassetti chapel, Santa Trinita, Florence.

234 Giotto, *Marriage at Cana*, detail, ca. 1304–6, mural, Scrovegni chapel, Padua.

this seems unlikely. Among other things, she is not dressed properly for the occasion. She lacks the finery bestowed upon brides to mark them as objects of family pride. She has a velvet hat and her hair falls in neat curls, rather than wearing the veils or head-dresses with the elaborately arranged coiffures typical of brides and worn here by her companions at table. The young lady seated to the left of Nastagio's bride (the viewer's right), gazing at her while pointing across the loggia towards the table with Antonio Pucci and his friends, is a more likely candidate to represent, if not actually portray, Lucrezia Bini (pl. 232). Given the generic features of a desired wife – big and beautiful, with full breasts noted – she carefully contemplates the example of her companion. She is positioned in a way that reminds the viewer of the relation between fictional and actual couples.

The calmly inviting woman is also put next to the conclusion of the story, as Nastagio ardently lifts his bowl towards his beloved bride. She might represent the narrator of the story, Filomena. As a pendant to the outward-looking man in the foreground, she is a reminder of the intricate play of sympathies in the tale: authored by a man, who gives the voice to a woman to warn other women of the need for compassion towards men through a story alternating cruelty and compassion towards both. Whatever her identity in the story as illustrated, her role in the picture, like that of the other outwardly turned figures, is to assert the continuity of the scene beyond its own time and space to that of any present or future beholder.

This inclusive form of address differs from that structuring the viewer's relation to the other panels, which are composed as enclosed narratives. In these scenes, the viewer is positioned as an external witness to the nightmarish recurrence of the chase and killing of the woman, to Nastagio's actions and reactions, and to those of the horrified guests at his meal in the pine wood. That does not preclude beholders from being shocked, perplexed, disgusted, or even fascinated, but they are not implicated in the outcome. Indeed the positioning does not fix a viewpoint. Although many illusionistic devices are used to compose the spaces and even to tease their boundaries, key elements of the story are placed across each picture surface, demanding a mobile gaze to follow it as it unfolds.

The internally episodic nature of the first three panels is complemented by an overall thematic and compositional unity that results from the placement of the nearly naked body of the woman close to the center of each of these panels – being caught by the vicious dogs, being disemboweled, fleeing, and being caught once again. This visual repetition expresses the fact that her awful fate has no release. The punishment will be eternally repeated. It also takes its cue from Boccaccio's repetition of the words "cruel" and "cruelty," which are used to describe the woman's behavior to her spurned lover, and once to evoke the biting of the mastiffs as they reach her. The pictured version makes this motif dominant, omitting the first quarter of the story that describes Nastagio's hopeless infatuation and the concern of his friends. As an edition of the story it is particular in the way that it eliminates the civic setting, begins in the woods, and focuses on the spectacle of cruelty. All of which might seem strange in the context of marriage celebration.

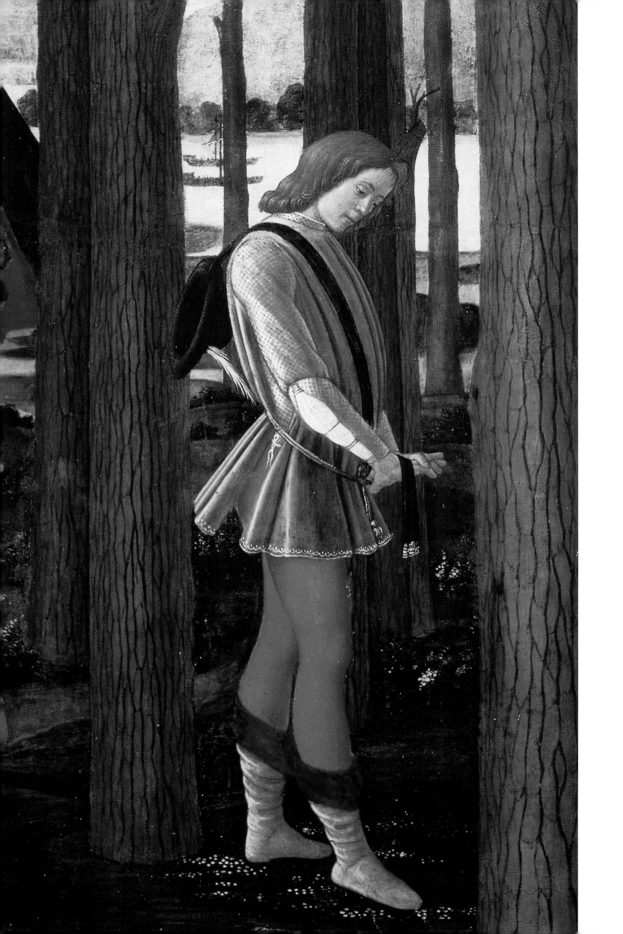

236 Attributed to Baccio Baldini, after Sandro Botticelli, *Inferno*, *Canto I*, ca. 1482–7, engraving.

As has been frequently noted, the image of a man lost in a wood, pensive, and subject to enlightening visions, is essentially Dantesque, and Botticelli's formulation of Nastagio's woodland wandering resembles the print he designed for the 1481 printed edition of *The Divine Comedy* (pls. 235, 236). Appropriate to the Boccaccio tale, which is after all a love story, the wood is less sinister than Dante's "wild and rough" forest (*Inferno*, 1.5). It is inhabited by harmless and peaceable creatures, rabbits and deer, who remain undisturbed by the turmoil visible to Nastagio and the paintings' beholders. This is not only a sign that the pictured world contains different forms of visibility, but indicates that complete visibility is accessible only to those who can appreciate the differences. Not available to simple creatures of the wood, or even to the distraught Nastagio, it can be discerned by those with the capacity and with enough detachment from mere animal existence to exercise the intellectual faculty of reason.

To activate pity through suffering and to address the intellect through the contemplation of pain were fundamental strategies of devotional practice and of sacred art, here transferred to the profane. The naked body of a beautiful woman, however, would normally be considered a sight guaranteed to provoke lust or shame. This is acknowledged by Botticelli in the way that he has coyly covered the woman's breasts and genitals with a decorously adherent piece of drapery in the scenes of her flight and added a conveniently placed branch as she lies prostrate. These are devices that could serve prurience as much as decency: her sexual attributes are literally flagged. But her exposed flesh is also mortified as it is repeatedly violated by the hounds and by the knight. Provocative and transgressive, an object of desire perhaps, the woman's body is also shamed and subjected to punishment. Botticelli's 1481 engravings to Dante and his later manuscript draw-

235 Sandro Botticelli, *Nastagio in the Pine Forest of Ravenna*, detail of pl. 213.

237 Attributed to Baccio Baldini, after Sandro Botticelli, *Inferno, Canto V, The Punishment of Lust*, ca. 1482–7, engraving.

238 Sandro Botticelli, *Inferno, Canto XXIX, The Punishment of Falsifiers*, 1490s, pen and ink, black chalk underdrawing, ca. 32.5 × 47.5 cm., Kupferstichkabinett, Berlin, cod. Hamilton 201.

ings prove that for him and for the imagination of his day, the tortured naked body was the sign of the condemned (pls. 237, 238).

The "very beautiful" young woman is hunted down and killed like a wild animal, specifically like a wild boar, a traditional symbol of lust.[46] The excessive passions that led to sin, the suicide of Guido degli Anastagi, whom she had spurned, are here signaled by the sight of the female body. Its vulnerability may arouse pity, but its unseemly exposure could only be deplored as violating all norms of modest behavior. The cause and consequence of sin are insistently pictured in the first three panels. The moral coding is well defined, but it demands some deciphering. Perplexity and horror are shown to be necessary reactions to what is pictured. These images will remain as shadows or ghosts, fantastic visions, to haunt the happy ending: ever present and always visible. But to remain fixated by the horrible vision would be to become possessed by savage cruelty. The immersion of Nastagio in the wood and his concluding emergence into an ordered world argues a triumph of rational powers. The beholder who stands apart to witness the first three scenes is strongly invited to join in the conclusion.

Through marriage Nastagio re-enters society. As the savage cedes to the civilized, settings and spatial organization based on natural forms and articulated by forest trees give way to one shaped by architectural forms. The contrast between order and disorder is purposefully made between the third and fourth panels. Even as civil usages have begun to transform the wood in the rustic feast, the skewed construction still signs a disturbing space. It allows for the full display of the chase and slaughter and it follows the model of another terrible feast, the banquet of Herod, where Salome's dance led to the Baptist's execution (pls. 215, 73). The character of the two meals is further distinguished through a small, but significant difference. In the woodland scene the guests have fine plates and bowls, for Nastagio had "magnificently" prepared the feast, but they do not have the forks, so delicately handled at the wedding banquet (pl. 239). Forks, an Italian invention, were precious status symbols and signs of genteel civility. There is only one set of silver forks, in their own chest, recorded in the 1484 inventory of the Pucci palace. They were among the guarded possessions kept in the *anticamera* to Antonio's chamber.[47] A

239 Sandro Botticelli, *Wedding Feast*, detail of pl. 216.

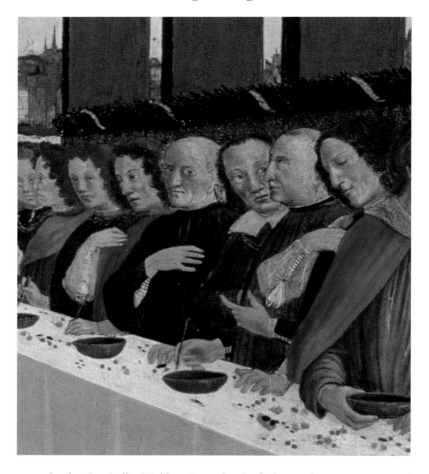

240 Sandro Botticelli, *Wedding Feast*, detail of pl. 216 showing portraits of Antonio Pucci and Francesco Sassetti with other guests.

knowing viewer could see that the banquet was decorous in every detail, a beautiful and noble feast ordered according to the customs and following the sumptuary laws of the time.

In the final panel, society is depicted as shaped by the institution of marriage and given exemplary representation by Antonio Pucci, his friends, and the alliances crafted for their children. It is a society fashioned to mirror the desires and reassure the anxieties of a powerful, but threatened, elite. It is a world of beautiful young women, well-dressed servants, and politely conversing gentlemen of all generations. It is a world shown to be generally well regulated and specifically identifiable.

The Pucci arms mark the bride's side. The men sit beneath the arms of the new Pucci–Bini kinship. Antonio is soberly dressed in dark robes, with his hand on his chest, pointing along the table to his left (pl. 240). Following his gesture in that direction, Francesco Sassetti can be identified two places away in a profile that recalls the donor portrait in his chapel (pl. 241). Their friendship, which had been sealed by the marriage

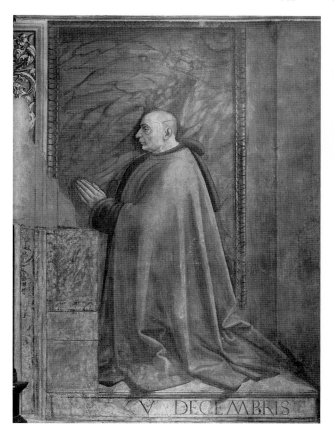

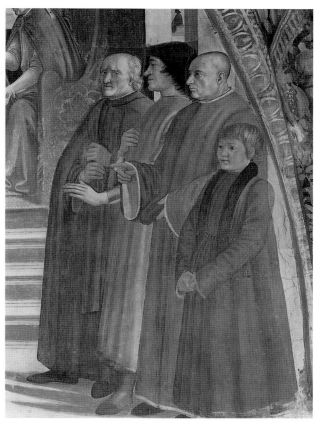

241 Domenico Ghirlandaio, portrait of Francesco Sassetti as donor, ca. 1479–85, mural, Sassetti chapel, Santa Trinita, Florence.

242 Domenico Ghirlandaio, *Confirmation of the Franciscn Rule by Pope Honorius III*, detail showing portraits of Antonio Pucci, Lorenzo de' Medici, Francesco Sassetti and his son Federigo, ca. 1479–85, mural, Sassetti chapel, Santa Trinita, Florence.

of Sibilla Sassetti to Alessandro Pucci, was also recorded in the mural of the *Confirmation of the Franciscan Rule* in the Sassetti chapel where Antonio and Francesco flank Lorenzo de' Medici (pl. 242). Lorenzo has a dominating, but purely emblematic position in Botticelli's panel through the presence of the Medici arms in the center foreground (pls. 216, 212). It is possible that the man seated between Antonio and Francesco is Piero Bini, but there are no other known portraits of Piero to prove or disprove this.

To Antonio's right there are three young men who resemble each other. This could be intended as a generic family resemblance, to suggest "sons." Antonio had the good fortune to have seven surviving legitimate sons (he had also fathered two illegitimate children, a boy and a girl). Their features are too generalized to regard them as portraits. As a group, their apparent ages do not match the actual ages of the brothers. Giannozzo was twenty-three, however, and as a type the young man seated next to Antonio, with his hand pointing towards his heart, repeating Antonio's gesture, might represent the

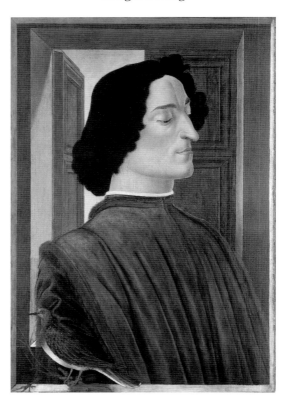

243 Sandro Botticelli, *Giuliano de' Medici*, ca. 1478, panel, 75.6 × 52.6 cm., National Gallery of Art, Washington, D.C.

groom. The group could also be there to stand for the youths of Florence, learning from the instructive example of Nastagio.

On Antonio's other side, seated opposite Nastagio and his bride and positioned between Francesco Sassetti and the group of humanists, is Giuliano de' Medici, whom Botticelli and his studio had portrayed more than once (pls. 240, 243). Given Lorenzo's role in Pucci affairs, it might seem puzzling to include the dead rather than the living Medici brother among the company. The inclusion has a dual significance: it is a reminder of the violence that threatens the polity and of the values that guarantee its civility.

Giuliano features here as he did in Poliziano's poem celebrating the 1475 joust, staged by the Medici and won by Giuliano (*Stanze de Messer Angelo Politiano cominciate per la giostra del Magnifico Giuliano di Piero de' Medici*). He represents the valiant youth who becomes love's champion. He is a form of poetic figure, the lover *par excellence* and as per the tradition of Petrarchan love lyrics. His pensive, downcast gaze repeats that of the melancholic, lovestruck Nastagio as shown in the first panel (pl. 235). With his left hand, Giuliano points to the other young men at the table, as though they might be possible future victims of the sufferings of love. Interpreted in this literary key, the presence of Giuliano reinforces the love theme of the story; he is included as one whose passion deserves compassion. His presence in this guise alludes to the cult of love in contemporary poetry, the Petrarchan sonnets by Lorenzo and others that were fashionable at the

time, and to the search for and defense of vernacular eloquence that motivated such writing.

The promotion of the vernacular might also have been a factor motivating the choice of this tale from Boccaccio. With sighs, suicidal despair, terror, amazement, compassion, and the conversion of enmity to love, it is indeed a moving narrative. But, even given this, why choose Boccaccio? While it is true that episodes taken from his works were part of the repertory of subjects chosen to decorate objects associated with marriage (wedding chests and birth trays), subjects drawn from ancient history and myth were much more common at this period. Boccaccio's story undoubtedly was a source of suitable themes and instructive lessons, but it is possible that there was more than matrimonial association involved in deciding its selection.

Antonio's revered father-in-law, Giannozzo Manetti, had written a Latin biography of Boccaccio, and one of the tales from *The Decameron*, the sad story of Tancredi and his daughter Ghismonda (the first story of the fourth day) was a focus of learned debate in his *Dialogus in symposio* (1448). Manetti's approach was to analyze Boccaccio's works in Latin and in terms of the ethical values of antiquity. A different approach to the problem of cultural continuity was taken by the next generation, which valued the vernacular in its own right. *The Decameron* had a place in the advancement of the Florentine vernacular as a literary language and with it of Florentine excellence in the liberal arts.

Lorenzo de' Medici specifically praised Boccaccio in the preface to his commentary on his own cycle of love sonnets, which is in part a defense of the vernacular. He wrote that:

> In prose and in discourse, whoever has read Boccaccio, a very learned and productive man, will easily discern that not only is his invention unique and remarkable, but also that his fluency and eloquence are as well. And, if one considers his work in the *Decameron*, for the diversity of the material, now profound [*grave*], now ordinary [*mediocre*], and now low [*bassa*], considers the way it contains all the difficulties of love and hate, fear and hope, so many new artful dodges and contrivances, and its having to express all the personalities and passions of the people that one finds in the world, without controversy one will judge no language better suited than our own for expressing them.[48]

Promoting "our language" meant to promote "our" culture. This mission inspired Cristoforo Landino in his commentary to the 1481 printed edition of the *Divine Comedy*. As noted in Chapter 5, drawings by Botticelli were the sources of the engravings in Landino's edition. In the engravings, as with the set of drawings he subsequently made for Lorenzo di Pierfrancesco de' Medici, Botticelli found a visual language suited to express the abundance and eloquence of the text. He fulfilled the same type of task when he confronted the problem of illustrating the tale from *The Decameron*; this was not only to translate the text to images, but also to demonstrate that a pictorial vernacular, a recognizably Florentine style of expression, was an expressive instrument that would be both dignified and enduring, like the artistic languages (visual and verbal) of the ancients. The juxtaposition of the *all'antica* triumphal arch with the Florentine loggia in the final episode

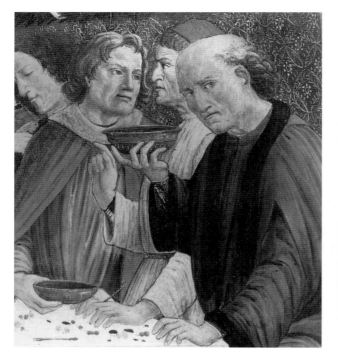

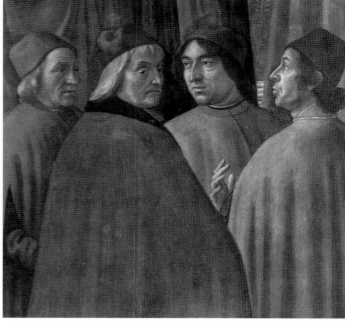

244 Sandro Botticelli, *Wedding Feast*, detail of pl. 216.

245 Domenico Ghirlandaio, *Annunciation to Zacharias*, detail of pl. 4.

was a triumphant way of manifesting the comparison and of giving the Florentine idiom predominance.

Giuliano, as poetic protagonist, refers to the explicitly cultural dimension of the paint-ing, which is furthered by the three men seated in the right foreground (pl. 244). They are similar to the four humanists in the foreground of the *Annunciation to Zacharias* in the Tornabuoni chapel in their prominence, conversational attitudes, and pictorial func-tion (pl. 245). They are learned commentators, who act as intermediaries to the onlooker. The men in the group in the Tornabuoni chapel have generally been identified as Marsilio Ficino, Cristoforo Landino, Agnolo Poliziano, and Gentile Becchi. They are not the same as those portrayed in the Pucci panel, but they were hardly the only eminent scholars of the city who can be associated with Lorenzo's circle or Pucci's acquaintances.

Educated, but not erudite, Antonio respected learning. He spoke in the 1460 debate about the best future for the Florentine university, the Studio (he supported its move to Pisa on economic and moral as well as academic grounds). His son, Lorenzo, destined for an ecclesiastical career, obtained a doctorate in canon law at Pisa in 1480. Puccio was enrolled there in 1475. He took his doctorate in civil law. Giannozzo's studies were directed to the humanities. His teachers had been the noted scholars Francesco da Diac-cetto and Giorgio Antonio Vespucci. He is documented in Pisa in 1481, enrolled as study-ing "humanis litteris."[49] It would be logical for Antonio, like Giovanni Tornabuoni and

Francesco Sassetti in their chapels, to display his support of learning to posterity through including learned men among his friends. And, after all, the discourse of civility that underlies the social ideals being commemorated in this painting was a product of their studies, their teaching, and their conversations.

But as is well known, culture does not exist without politics, and Antonio was a statesman-citizen, not a humanist, and the "valiant youth" of Poliziano's *Stanze*, the "bold Iulio," was assassinated.[50] This was an unforgettable fact for anyone seeking protection beneath the "shadow of the laurel," as it was for Lorenzo, who still had cause to fear for his life.

The Pazzi conspirators had all been severely punished, some hunted down as relentlessly as the misguided maiden of Boccaccio's tale. In *The Decameron* the story is introduced to remind women to be compassionate and to show how their cruelty is punished by divine justice.[51] The rigor of that justice is fully illustrated in the first three panels. In accordance with the social reading of the moral of the tale in these illustrations, the fourth restates this idea in terms of political ideology. Justice was chief among the civic virtues. So it is discussed in Matteo Palmieri's treatise *On Civil Life*, for example. Its place in fifteenth-century civic thinking follows from Cicero's definition in his treatise *On Moral Duties*. There justice is described as "the crowning glory of the virtues" and "the principle by which society and what we may call its 'common bonds' are maintained."[52]

The "society of men among themselves" ("societas hominum inter ipsos") and their community of interests celebrated here are related to the virtue of justice through the scenes illustrated on the triumphal arch (pl. 246). Even though they are difficult to read,

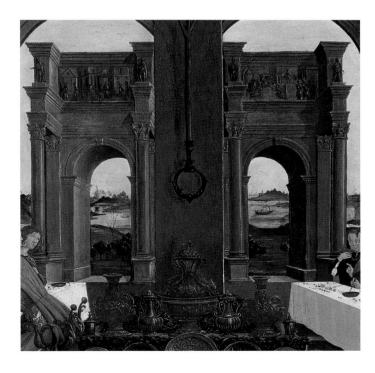

246 Sandro Botticelli, *Wedding Feast*, detail of pl. 216.

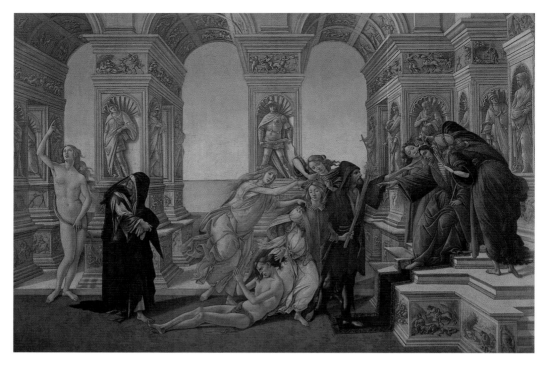

247 Sandro Botticelli, *Calumny of Apelles*, ca. 1495, panel, 62 × 91 cm., Galleria degli Uffizi, Florence.

248 (LEFT) Sandro Botticelli, *Calumny of Apelles*, detail of pl. 247.

they were probably meant to be recognized. Botticelli did not waste opportunities to add nuances to his pictorial inventions with small scenes of this type. He did so, for example, in his painting of *Calumny of Apelles*, which is a smaller painting than the Nastagio panels (it measures 62 × 91 cm. as opposed to 84 × 142 cm.). Included in the arch above the pointed finger of Truth are episodes from the story of Nastagio degli Onesti (pls. 247, 248).

The relief at the top at the right-hand side (on the "male side" of the panel) shows a story of clemency: there is a man kneeling before two men on horses, behind him there

is a statue and then five or six spectators, all in Roman-style dress (pl. 249). It follows an established Roman formula for scenes showing submission and mercy, found on sarcophagi and on arches, such as the relief that was in the church of Santa Martina in Rome during the fifteenth century (pl. 250). Botticelli's recent stay in Rome to work on the murals decorating the pope's chapel in 1481 had given him opportunity to study the city's ancient monuments. Some of the formal elements in this scene recall that study: the group with the rearing horses is based on one of the battle friezes on the Arch of Constantine (pl. 251). To conquer and to show pity to the conquered were ideals of the Roman state with urgent application to the Florentine situation. Clemency was the privilege of power. In the years following the Pazzi conspiracy questions of justice and

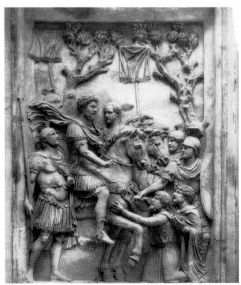

249 (ABOVE LEFT) Sandro Botticelli, *Wedding Feast*, detail of pl. 216, showing a scene of clemency.

250 (ABOVE RIGHT) *Clemency of Marcus Aurelius to Barbarians*, second century AD, marble sarcophagus, Palazzo dei Conservatori, Rome.

251 (RIGHT) Arch of Constantine, detail showing the Trajanic battle frieze with a mounted emperor overpowering a barbarian, second century AD, marble, Rome.

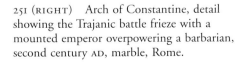

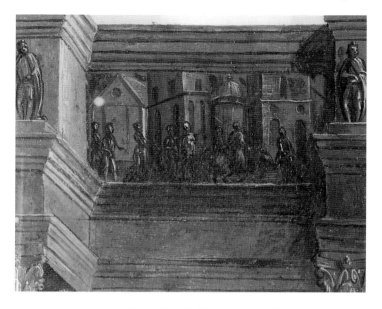

252 (ABOVE) Sandro Botticelli, *Wedding Feast*, detail of pl. 216.

253 *Leonora de' Bardi Halts the Magistrate's Procession*, 1495, title-cut of *Ypolito Buondelmonti and Dianora de Bardi*, British Library, London.

authority were fundamental to Florentines and to Lorenzo's political behavior, which was to seek to punish some quickly and without mercy, and then to pardon others.

The visual language of the clemency scene is Roman and it speaks of the solemn exercise of political authority. The panel on the female or bride's side tells a moving story in a different register (pl. 252). The setting is a cityscape with a tower in the right foreground. Towers had been the family strongholds of the warring nobility in the thirteenth century. To protect the peace of the city they had been lopped off and their height restricted to no more than 50 *braccia*. This archaic feature sets the scene in "olden times," the days of the legendary love between Leonora de' Bardi and Ippolito Buondelmonti. Their *Amorous History* was a famous and popular tale of star-crossed love between the children of feuding families. Despite the traditional enmity, the pair was able to meet, aided by the compassion of Ippolito's mother and the contrivances of a helpful abbess. One night Ippolito was apprehended as he was climbing into Leonora's room. To protect her virtue, he said that he was planning to rob the house. The magistrate was surprised, but forced to convict. As Ippolito was being led to justice, Leonora ran out from her house and seized the bridle of the magistrate, stopping the procession – the moment shown here. The maiden's dramatic recognition of her lover, which is the turning point

of the story, was also chosen as the frontispiece to an early printed version of the tale (pl. 253). Subsequently taken before the Signoria, Leonora made an impassioned speech on the subject of justice, declaring that she acted as she had, not only because Ippolito was her husband, but because "all should aid in coming to the defense of justice."[53] The story ends with a wedding, and the Bardi and the Buondelmonti, "until then enemies to the death, became friends by way of the match."[54] The couple lived happily and prosperously for a long time among friends and were blessed with beautiful children. This story was a great favorite in the fifteenth century, and was among the earliest printed books, first published in 1471 and often republished in that decade. The bold move of the young Florentine matron forms a pendant to the humble petition on the other side of the arch. The story of love that healed the factional wounds of the city, and of a lover who defended justice with honor in a difficult circumstance was highly appropriate as an exemplary tale for the times of the Pucci–Bini marriage.

The pairing of scenes also accommodates ancient and modern in one frame, reiterating the juxtaposition of the arch in the idiom of the Arch of Constantine and the loggia in the Brunelleschian language of the churches of Santo Spirito and San Lorenzo. The question of expression is posed in terms of monumental styles in the architecture that defines the space of the scene. The authority of the ancient is acknowledged, but the dignity, even the priority, of the vernacular is affirmed. In the overall scheme, the Florentine idiom articulates the happy state achieved in Antonio Pucci's time.

The *all'antica* arch and the family loggia are respectively political and social structures. Their combination as setting and background removes the conclusion of the series from the particulars of the narrative of the story (which, in any case, are almost non-existent at this point) and gives it a more general historical importance. The arch with its exemplary histories and the loggia with its exemplary company can be seen as renderings of Livy's metaphor for the purpose of history:

> What chiefly makes the study of history wholesome and profitable is this, that you behold the lessons of every kind of experience set forth as on a conspicuous monument; from these you may choose for yourself and for your own state what to imitate, from these mark for avoidance what is shameful in the conception and shameful in the result.[55]

The viewer of the panels is strongly urged to imitate the experience of the Pucci and their friends, to leave behind the shameful confusion of the first three panels and learn from the order and harmony of the concluding scene.

The ideal of the imagined happy ending was enduring, but the reality of its historical protagonists was more precarious and soon provided another type of example for posterity. Antonio died of a fever the year after the marriage, on May 12, 1484, at the time of the siege of Pietrasanta, where he had been sent "to look after finances and to give the enterprise greater importance."[56] Lorenzo died in 1492. Two years later the Medici were expelled from the city and a new political order was established in Florence.

Giannozzo remained faithful to the traditional friendship of the Pucci with the Medici. His loyalty cost him his life. In 1497 he became involved in a plot to restore Piero di Lorenzo de' Medici. The other conspirators were Niccolò Ridolfi, Bernardo del Nero,

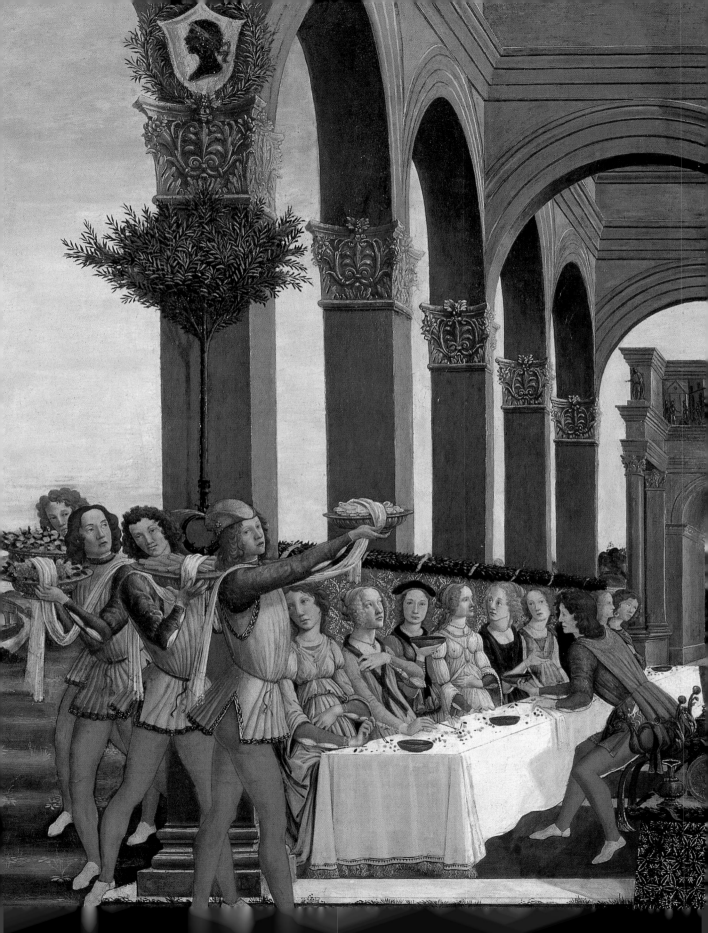

Giovanni di Bernardo Cambi, and Lorenzo di Giovanni Tornabuoni. In his diary Luca Landucci wrote:

> The *Pratica* (Court) met and sat in the *Palagio* from morning till midnight . . . the five prisoners were condemned . . . to be put to death and their property to be confiscated according to law . . . Everyone marvelled that such a thing could be done; it was difficult to realise it. They were put to death the same night.[57]

The deliberations of the Signoria record that this immediate execution was deemed necessary in order to prevent public tumult.[58] The plot and the sentence were both so threatening to public order that the right to appeal was denied the accused. The conspirators were decapitated, "sentenced by holy justice," as is recorded in the books of the confraternity of Santa Maria della Croce al Tempio, responsible for comforting condemned criminals.[59] In his *Florentine History*, Francesco Guicciardini wrote that:

> All citizens should learn a lesson from the death of men such as these, who enjoyed wealth, power, authority, family connections, and universal popularity: if a man is well off and has a reasonable share of things, he should be satisfied and not try to get more, for most of the time the attempt fails. . . . If he does try to bring about change, he must remember that if his attempts do not meet with success they end in death, or at least in exile . . . grace and universal favor are a dream.[60]

As grafted onto the immediate history of the Pucci family, the happy ending promised by the tale of Nastagio degli Onesti was also a dream. In the history of fifteenth-century Florence, the order celebrated in the *Wedding Feast* was fragile. But in the longer history of his city, Antonio's deftly crafted network of influence proved to be resilient. His heirs returned to favor and power in the new political order of ducal and grand-ducal Florence. The family gained noble status and has survived over five hundred years. Equally successful on the part of the members of the ruling elite of the fifteenth century and of the artists working in their service, was the strategic placement of the witnesses to their dominance. Being aware of appearances, they promoted a visual rhetoric that has proved persuasive over time. It articulated their authority with grace, even when showing the ruthless actions that enforced the social and political order. Against the cruel uncertainties of the future, they argued the glories of the present with a cultural language that has lived very happily for a long time.

254 Sandro Botticelli, *Wedding Feast*, detail of pl. 216.

Notes

ABBREVIATIONS

ASF Archivio di Stato, Florence
BNCF Biblioteca Nazionale Centrale, Florence

In addition to these abbreviations, please note that all references in the notes and Bibliographic Notes are given in short-title forms. Full citations are in the Bibliography.

FOREWORD

1 Varchi, *Storia fiorentina*, ed. Arbib, II, pp. 56–130, p. 56: "mi pare non meno utile che necessario, di dover fare in questo luogo una, come dicevano gli antichi nostri, incidenza, cioè digressione."

2 Vasari, *Le vite*, ed. Bettarini and Barocchi, III, pp. 37–8: "usandosi in que' tempi per le camere de' cittadini cassoni grandi di legname . . . niuno era che i detti cassoni non facesse dipignere . . . e che è più, si dipignevano in cotal maniera non solamente i cassoni, ma i lettucci, le spalliere, le cornici che ricignevano intorno."

3 Ibid., p. 38: "Delle quali cose se ne veggiono . . . in tutte le più nobili case di Firenze ancora alcune reliquie. E ci sono alcuni che attenendosi a quelle usanze vecchie, magnifiche veramente et orrevolissime, non hanno sì fatte cose levate per dar luogo agl'ornamenti et usanze moderne."

4 Varchi, *Storia fiorentina*, ed. Arbib, II, p. 56: "niuna cosa è tanto piccola in una repubblica grande, della quale, solo che possa ad alcuna cosa o giovare, o dilettare, non si debbia conto tenere."

5 Hood, *Fra Angelico at San Marco*, p. ix.

6 Vasari, *Le vite*, ed. Bettarini and Barocchi, III, pp. 597–8.

7 From the spiritual diary of Margherita di Tommaso Soderini, quoting from a sermon given by the Augustinian preacher, fra Mariano da Genazzano: "Ciercha te medesimo e chonocierai a che fine Idio t'à creato: non per le richeze né pelle ponpe del mondo, ma che tu vada a fruire quella beata Gloria" (Zafarana, "Per la storia religiosa di Firenze nel Quattrocento," *Studi medievali* [1968], p. 1019).

8 From the diary of Gregorio Dati (January 1, 1404), in *Two Memoirs of Renaissance Florence*, ed. Brucker, p. 124.

9 Writing to his brother on April 22, 1477: "Avendomi choncieduto Iddio de' beni tenporali, liene voglio essere ricordevole. E principiando dalle chose sua, potreno venire uno dì alle nostre"; quoted from Borsook, "Documenti relativi alle cappelle di Lecceto e delle Selve di Filippo Strozzi," *Antichità viva* (1970), doc. 18, p. 15.

10 Brucker, *The Civic World of Early Renaissance Florence*, p. 3.

11 Burckhardt, *The Civilization of the Renaissance in Italy*, p. 81 (the opening of Part II, "The Development of the Individual").

12 Ibid.

13 F. W. Kent, *Household and Lineage in Renaissance Florence*, pp. 13–14.

14 Goldthwaite, *Wealth and the Demand for Art*, p. 2; see also Goldthwaite, *The Building of Renaissance Florence*.

CHAPTER ONE THE IMAGERY OF IDENTITY

1 Dei, *La cronica*, ed. Barducci, p. 81: "el gror-iosissimo e potentissimo popolo fiorentino"; pp. 92–3: "a onore e riverenza dell'altissimo Iddio e a chontenplazione e piaciere del potentissimo popolo fiorentino."

2 Alberti, *The Family in Renaissance Florence (I libri della famiglia)*, ed. Watkins, p. 239.

3 This advice is quoted from Giovanni Morelli's *Ricordi*, ed. Branca, pp. 226–7 (*Mercanti scrittori*, ed. Branca, p. 177): "Pruova cento volte l'amico . . . prima te ne fidi una; e con niuno mai ti fidare di tanto ti possa disfare."

4 Alberti, *The Family in Renaissance Florence (I libri della famiglia)*, ed. Watkins, p. 266.

5 Strozzi, *Lettere*, ed. Guasti, no. 26, p. 255 (March 15, 1461[62]): "Ieri entrò messer Piero de' Pazzi en Firenze con gran trionfo e magnificenza, più che 'ntrassi cavaliere già gran tempo. Non è però da farvi su gran fondamento; chè alle volte a Firenze si dimostra una e fassi un'altra."

6 Piero del Tovaglia to Lodovico Gongaza (May 8, 1471): "E anche ho fatto questo proposto che se io ho ispeso nella chasa mia iiᵐ ducati per lla bitazione di questo mondo che ispendendo per lla bitazione de l'altro mondo fl. 500 sara buona ispesa," in B. Brown, "The Patronage and Building History of the Tribuna of SS. Annunziata," *Mitteilungen des Kunsthistorischen Institutes in Florenz* (1981), p. 126, doc. 60. Unless otherwise noted, the documents relating to Piero's involvement with this project are published by Brown in this comprehensive discussion of the tribune.

7 Ginori Lisci, *I palazzi di Firenze*, II, p. 804, quoting a reference to the document of sale for "una casa grande, atta e principiata a forma di palazzo" (Archivio dei Buonomini di San Martino, Fondo Gianfigliazzi, Filza 50, Spoglio pergamene, no. 61, fol. 246); see I, p. 141, cat. no. 7, for the palace, Lungarno Corsini 4. For a full account of the Gianfigliazzi palace and its situation, based on an exhaustive study of the documentation, see Preyer, "Around and in the Gianfigliazzi Palace," *Mitteilungen des Kunsthistorischen Institutes in Florenz* (2004), pp. 55–104. She refers to the original sale document to Gherardo Gianfigliazzi from Luigi di Giovanni Teghiacci on behalf of himself and his brothers "of the building that was to become the Gianfigliazzi Palace, still under construction, for 2,000 florins," dating from January 31, 1459[60], p. 100, doc. 7 (ASF, Notarile Antecosimiano, 8523, ser Niccolò Galeotti). At Gherardo's death in 1463 the palace was inherited by his brother Bongianni, who estimated the value of the completed palace at 5,000 florins (in his *Libro di ricordi*, fol. 6 right, in the Archivio dei Buonomini di San Martino, Preyer, p. 66). Addressing Ludovico Gonzaga, Piero del Tovaglia expressed the sum he was prepared to invest in terms of ducats rather than florins. This was a diplomatic nod to the North Italian lord – the ducat was the gold currency used at the Gonzaga court. Though exchange rates fluctuated, the ducat and the florin were roughly equal in value; for comparative rates, see Spufford et al., *Handbook of Medieval Exchange*.

8 These transactions and the relevant documents are discussed in Kevin Murphy's dissertation on "Piazza Santa Trinita in Florence" (Courtauld Institute, 1992), pp. 233–4: the bequests to the high altar chapel are in Gherardo's will, written in 1463 (ASF, Corporazioni religiose soppresse dal governo francese, 89, vol. 135, fol. 25r, recording the transfer of the bequest in Bongianni's will). See further Preyer, "Around and in the Gianfigliazzi Palace," *Mitteilungen des Kunsthistorischen Institutes in Florenz* (2004), p. 66, pp. 94–5, n. 84, for a summary of this project and the memorandum in Bongianni's record book that give estimated costs, "in tutto ragiono vi si spenda fiorini 2,600 in 2,700 larghi" for the window with the Trinity (600–700 florins *larghi*), the mural decoration (1,200 florins *larghi*), a marble altar and tomb (300 florins *larghi*), altar furnishings (200 florins *larghi*), choir stalls and an altarpiece (300 florins *larghi*; Archivio dei Buonomini di San Martino, *Libro di ricordi*, fol. 7 left). He specifies that the painting be done by a "buon maestro." Alesso Baldovinetti was given the commissions for the window design and the mural decoration (both destroyed) and the altarpiece of the *Trinity*, which is now in the Galleria dell' Accademia. Preyer, pp. 100–1, docs. 9–10, cites related documents, with excerpts from the document in which the monks and parishioners grant the patronage rights to the chapel to Bongianni dated February 16, 1463[64] (ASF, Notarile Antecosimiano, 5046, ser Pierozzo di Cerbino, *inserto* 3, fols. 71r–v) and

from Bongianni's will dated July 14, 1464 (ASF, Notarile Antecosimiano, 21083, ser Nastagio Vespucci, *inserto* 4, fols. 46–49 and fols. 55–58). Preyer has left transcripts of the documents on deposit in the library of the Kunsthistorisches Institut, Florence.

9 ASF, Corporazioni religiose soppresse dal governo francese, 119, vol. 59 (*Spogli imperfetti di memorie e ricordi attenenti alla Chiesa e Convento della Santissima Nunziata*; several notebooks bound together, without sequential pagination), *inserto* 6, fols. 35v–36r.

10 ASF, Notarile Antecosimiano, 5297 (ser Riccardo Ciardi, 1481–1500), fol. 129v, for this transaction: "amore dei et pro remedio anime pieri."

11 ASF, Notarile Antecosimiano, 5295 (ser Riccardo Ciardi, *testamenti*, 1481–1508), fol. 17v (December 2, 1484): "Item iuri legatis donavit reliquit Francisco eius fratri carnali ius patronatus unius cappelle cuius ipse testator est patronus sita in ecclesia Sancta Marie de Servis de Florentia . . . cum hac tamen conditione, quod dictus Franciscus infra sex menses proxime futuros teneatur et debeat emere tot bona immobilia ex quibus constituentur introytus florenorum decem largorum quolibet anno in perpetuum . . . qui floreni decem larghi sunt pro elemosine dicte cappelle eidem Francesco donate quam elemosinam, et que bona et yntroitum dictus testator reliquit et legavit amore dei arti Porte Sancte Marie de Florentia, cum hoc, quod consules dicte artis pro tempore existentes teneantur quolibet anno in perpetuum amore dei dare et convertere dictam quantitatem florenorum decem largorum in dotibus puellarum hospitalis de Innocentibus de Florentia pro eis maritandis amore dei et pro remedio anime dicti testatoris, in hoc senper aggravando conscientias dictorum consulorum ut predicta observent." I thank Michael Rocke for his assistance with the transcription of Piero's wills.

12 ASF, Notarile Antecosimiano, 5295 (ser Riccardo Ciardi, *testamenti*, 1481–1508), fols. 18v–19r. Piero's country holdings at this time are described in ASF, Catasto, 1004 (Santa Croce, Bue, 1480), fols. 276r–277r.

13 ASF, Notarile Antecosimiano, 5297 (ser Riccardo Ciardi, 1481–1500), fols. 135v–136r (February 18, 1484[85]): "paramentis et planetis et paliottis et aliis ornamentis pro dicta cappella" (fol. 136r). The act of donation to the Servites

and the chapter's acceptance of these terms are registered on fols. 136r–v. These agreements are also recorded in the convent's records, ASF, Corporazioni religiose soppresse dal governo francese, 119, vol. 49, *Libro di richordanze generali di varie spese 1472–94*, fol. 145r (January 13, 1486[87]), which refers to the donation of February 18, 1485.

14 ASF, Notarile Antecosimiano, 5295 (ser Riccardo Ciardi, *testamenti*, 1481–1508), fols. 13r–14v. The burial provision states: "sepelliri voluit in sepulcro eius sito in ecclesia Sancte Marie de Servis et sub tribuna cappelle maioris dicte ecclesie, et voluit portari ad dictam sepulturam cum eius veste quam habet in societate intitolata del Gesù sita in ecclesia Sancte Crucis de Florentia, vultu tamen coperto" (fol. 13r).

15 Ibid., fol. 13v, leaving his son Angelo as his portion of the estate: "unam domum cum palchis salis cameris et cum omnibus suis pertinentiis et suis habituris . . . quam ad presens habitat dictus testator, tamen sine masseritiis et bonis mobilibus in ea existentibus, quam domum eidem reliquit per estimationem florenorum mille ducentorum largorum."

16 ASF, Carte Strozziane, II, no. 11, fol. 9r.

17 Ibid., fol. 19v.

18 Translation from Strozzi, *Selected Letters*, trans. and ed. Gregory, no. 12, pp. 88–9 (September 13, 1459): "Ora si vuole porre questo [duolo] da canto; e la prima cosa, che si sodisfaccia agli obrighi che ha lasciato per l'anima sua" (Strozzi, *Lettere*, ed. Guasti, no. 18, p. 197).

19 Strozzi, *Lettere*, ed. Guasti, no. 18, p. 197: "e quello che tu ha' promesso tu, ancora si soddisfaccia. Di' che lo botasti qua all'Annunziata, di porlo di cera . . . La pianeta non so dove ti botasti di farla; e non sendo obrigato di porla più in un luogo che 'n altro, mi parrebbe, e così mi contenterei, la facessi costà, acciò che di lui vi fussi qualche memoria."

20 ASF, Carte Strozziane, III, no. 127, fol. 81v.

21 Baldini Giusti and Facchinetti Bottai, "Documento sulle prime fasi costruttive di Palazzo Pitti," in *Filippo Brunelleschi: La sua opera e il suo tempo*, II, p. 724, quoting from ASF, Provvisioni, Registri, 152, fol. 124r: "ch'egli e costrecto da necessità per la gran famiglia . . . per modo che possa in quella . . . alloggiare la sua famiglia comodamente, secondo la sua qualità."

22 Quoted from Phillips, *The Memoir of Marco Parenti*, p. 101.

23 The notary's copy is ASF, Notarile Antecosimiano, 634, *inserto* 59, original pagination fols. 326r–345r, later numbers fols. 1r–19v (May 14, 1491). Goldthwaite, *Private Wealth in Renaissance Florence*, pp. 72–3, comments on the length and detail of the will, which has an index. He lists two original copies (one on parchment) and two later copies in Carte Strozziane, v, 1162, no. 12 and a later copy on 53 folios, dated 1535, in Carte Strozziane, v, 1221 (p. 73, n. 86). An excerpt from the portion of the will regarding his funerary chapel in Santa Maria Novella and the palace is published in Gaye, *Carteggio inedito d'artisti*, 1, pp. 359–65.

24 ASF, Notarile Antecosimiano, 634, *inserto* 59, fol. 9v, should the building not be completed by 1496 (five years after the writing of the will) "lascio la cura di farla finire fra gli infrascripti anni due dopo al 1496 al magnifico Lorenzo de Medici . . . volendo detta cura, con tutta lautorita che si da di sotto a' consoli et operai et arroti infrascripti" (see Gaye, *Carteggio inedito d'artisti*, 1, p. 362).

25 F. W. Kent, " 'Più superba di quella di Lorenzo'," *Renaissance Quarterly* (1977), p. 315, quoted from a letter from Giovanni di Carlo di Pietro di Carlo Strozzi to his brother Michele, dated October 3, 1489. Caroline Elam has kindly pointed out to me that in classical Latin *superba tecta* – lofty roofs – are almost a topos and that this reference would have been recognized as part of the comparison and the compliment to Filippo's palace.

26 ASF, Catasto, 16 (Santo Spirito, Scala), fol. 324r: "Una chasa posta in Firenze nel popolo di Santa Lucia de magnoli che si dicie la chasa nuova dove habita il detto Niccolo da Uzano con volte sottrera pozzi e stalle et 1° pocho dorto con più e più masserizie secondo che alla sua chondizione si richiede."

27 ASF, Catasto, 64 (Santo Spirito, Scala), fol. 75v; for the relative meaning of this wealth in the city's population, see Herlihy and Klapisch, *Les Toscans et leurs familles*, p. 251.

28 Quoted from Brucker, *The Civic World of Early Renaissance Florence*, p. 278.

29 Bombe, *Nachlass-Inventare des Angelo da Uzzano und des Lodovico di Gino Capponi*, p. 13, no. 13: "2 forzieri grandi dipinti di braccia tre in mezzo l'uno, che l'uno è voto, nell'altro panni a uso di Nichholo cioè parte dei suoi vestimenti."

30 ASF, Carte Strozziane, 11, no. 11, fols. 14r–18r.

31 Bombe, *Nachlass-Inventare des Angelo da Uzzano und des Lodovico di Gino Capponi*, p. 16, no. 82: "più e più libri da leggere in volghare."

32 Lydecker, "The Domestic Setting of the Arts in Renaissance Florence," p. 39: "Camera di Lorenzo, bella, in su la sala in palco." Lydecker's thesis and his article on "Il patriziato fiorentino e la committenza artistica per la casa," in *I ceti dirigenti nella Toscana del Quattrocento*, pp. 209–21, document and discuss these trends in ownership in the course of the fifteenth century. For a detailed discussion of this room, see Kress, "Die *camera di Lorenzo, bella*, im Palazzo Tornabuoni," in *Domenico Ghirlandaio: Künstlerische Konstruktion von Identität im Florenz der Renaissance*, ed. Rohlmann, pp. 245–85.

33 See Caglioti, *Donatello e i Medici*, pp. 266–7, and "Nouveautés sur la *Bataille de San Romano*," *Revue du Louvre* (2001), no. 4, pp. 37–54, for these panels and an account of this episode, which he dates to sometime between 1479 and 1486, and which was reported by Damiano on July 30, 1495 to the commission hearing claims to Medici property after the expulsion of Lorenzo's sons in 1495. The three panels had been inherited in equal shares by the brothers Andrea and Damiano. Andrea, who was an agent in the Medici bank, had agreed to give his portion ($1\frac{1}{2}$ panels) to Lorenzo. Damiano refused and, hoping to keep them safe, had taken the panels from the family villa to his town house: "ex qua domo dictus Laurentius eam per modum nonullorum laboratorum et Francionis legna[i]uoli dictam storiam extrassit et eam conduxit ad domum dicti Laurentii contra voluntatem dicti Damiani" (*Donatello*, p. 267). They are now divided between the National Gallery, London, the Uffizi, and the Louvre.

34 Antonio Averlino detto il Filarete, *Trattato di architettura*, ed. Finoli and Grassi, 11, p. 687: "secondo lui mi disse, ch'egli ha l'effige e le immagine di quanti imperadori e d'uomini degni che stati sieno . . . tanto è la eccellenza loro, che commuovono grandissima voluttà e piacere al viso" (*Filarete's Treatise on Architecture*, trans. Spencer, 1, p. 320).

35 Luigi Lotti da Barberino to Niccolò Miche-

lozzi, April 28, 1487, in De Marinis and Perosa, *Nuovi documenti per la storia del Rinascimento*, p. 60: "Perchè so Lorenzo si dilecta di cose rare, però li scripsi a questi dì."

36 Ibid., p. 60, February 2, 1486[87]: "credo che tucto satisfarà a Lorenzo, maxime che se ne intende. A me pareva cosa artificiosissima."

CHAPTER TWO "DELLO SPLENDIDO VIVERE"

1 Alberti, *I libri della famiglia*, in *Opere volgari*, ed. Grayson, i, p. 210: "E accade tale ora a fare qualche spesa la quale apartenga allo onore e fama di casa, come alla famiglia nostra delle altre assai e fra molte quella una de' padri nostri in edificare nel tempio di Santa Croce, nel tempio del Carmine, nel tempio degli Agnoli e in molti luoghi dentro e fuori della terra, a Santo Miniato, al Paradiso, a Santa Caterina, e simili nostri publici e privati edificii."

2 Ibid., p. 211: "Adunque a queste spese che regola o che modo daresti voi? . . . a me pare le spese tutte siano o necessarie o non necessarie, e chiamo io necessarie quelle spese, senza le quali non si può onesto mantenere la famiglia, quali spese chi non le fa nuoce allo onore e al commodo de' suoi . . . siano quelle fatte per averne e conservarne la casa, la possessione e la bottega, tre membri onde alla famiglia s'aminista ogni utilità e frutto quanto bisogna . . . le spese non necessarie con qualche ragione fatte piaccino, non fatte non nuocono. E sono queste come dipignere la loggia, comperare gli arienti, volersi magnificare con pompa, con vestire e con liberalità."

3 D. and F. W. Kent, *Neighbours and Neighbourhood in Renaissance Florence*, pp. 150, 167–8 (ASF, Notarile Antecosimiano, 18452, ser Antonio Salomone, 1462–70 [October 3, 1463]), fol. 175r). Apollonio di Giovanni died in 1465, five years before Manno di Giovanni, so that he did not have occasion to exercise his discretion in Manno's tomb decoration.

4 Neri di Bicci, *Ricordanze*, ed. Santi: p. 57, no. 113 (May 12, 1456), for gilding the reliquary bust, a commission from don Mariano, the sacristan (lost); p. 127, no. 248 (October 23, 1459), a framed Virgin in gesso, gilt and painted, sold to don Mariano; pp. 130–1, no. 254 (November 25, 1459) for an altarpiece of the *Coronation of the Virgin*, commissioned by

the abbot (now in the Galleria dell'Accademia, Florence); p. 193, no. 383 (January 19, 1462 [63]), for painting a relief figure of the Infant Christ for don Mariano (lost); p. 303, no. 572 (July 24, 1467), an altarpiece with saints flanking a sacrament tabernacle for the chapel of Mariotto Lippi, one of the *operai* of the church (the altarpiece is still in the church); pp. 403–4, no. 753 (November 14, 1472), for an altarpiece with figures of saints and the arms of Ruberto Mezola, commissioned by Ruberto with the abbot and don Mariano (identified by Santi as in the Galerie St. James, Montecarlo). On May 5, 1460 Don Mariano is noted as having acted as the broker for the marriage of Neri's sister, then living in Neri's household (p. 142, no. 279).

5 *Giovanni Rucellai ed il suo zibaldone*, ed. F. W. Kent et al., p. 55, from fol. 63v, quoted by Kent.

6 Jones, "Palla Strozzi e la sagrestia di Santa Trinita," *Rivista d'arte* (1984), p. 91, doc. 138 (March 28, 1422): "se fo ben conto tra il mortorio di Nofri e in murare e ornare la capella e perdite che·ssi posson tocchare e dote che ò a pagare e altre cose, da poi che Nofri mancò in qua son di peggio e in tutto iti via fiorini più di trentamila" (ASF, Carte Strozziane, iii, no. 132, fol. 60).

7 Translation from Griffiths, Hankins, and Thompson, *The Humanism of Leonardo Bruni*, p. 305.

8 Ibid., pp. 305–6.

9 Ibid., p. 316.

10 Ibid.

11 Ibid.

12 Ibid.

13 Bruni, *Epistolarum*, ed. Mehus, ii, Book v, no. 2, p. 14, to Leonardus Thomae Cambiatoris: "Cum vero propter virtutem ac eius exercendae gratia tanquam instrumentum quoddam, & addiderim."

14 Poggio Bracciolini, "Oratio funebris in obitu Leonardi Arretini," in Bruni, *Epistolarum*, ed. Mehus, i, p. cxxii: "Sed morositatem parcitatemque a natura contraxit, virtutes sibi studia, ac scribendi, agendique diligentia peperunt."

15 Gregory, "Palla Strozzi's Patronage," in *Patronage, Art, and Society*, ed. Kent and Simons, p. 212, to Orsino Lanfredini, Arezzo (January 6, 1423[24]; BNCF, Fondo Principale, ii, v, 10, fol. 218). Gregory notes that in 1433 Bruni was

16 a creditor of Strozzi's bank for 1,026 florins (ASF, Catasto, 463, fol. 344r).

16 Ibid.

17 The poet Naldus Naldius quoted in Griffiths, Hankins, and Thompson, *The Humanism of Leonardo Bruni*, p. 44 (from the "Vita Janotti Manetti," in Bruni, *Epistolarum*, ed. Mehus, I, pp. xlvi–xlvii).

18 Ibid.

19 Ibid.

20 Giustiniani, "Il testamento di Leonardo Bruni," *Rinascimento* (1964), p. 260, March 17, 1438[39]: "Sepulturam vero elegit apud ecclesiam S. Crucis de Florentia, in qua sepulcrum sibi fieri et voluit in loco conuenienti sue qualitati cum lapide marmoreo puro, sine pompa."

21 Bruni, *Epistolarum*, ed. Mehus, II, Book VI, no. 5, p. 46: "Quid enim sepulcrum, quoad muta res est, juvare sapientem potest?" The letter, to Poggio Bracciolini, is partly translated and discussed by Lightbown, *Donatello and Michelozzo*, I, pp. 128–30.

22 Griffiths, Hankins, and Thompson, *The Humanism of Leonardo Bruni*, p. 317.

23 Cicero, *De officiis*, trans. Miller, II.xvi.55–7, pp. 226–9.

24 Aristotle, *Nicomachean Ethics*, IV.ii (1122a21), in *The Complete Works*, ed. Barnes, II, p. 1771.

25 Ibid. (1122a23).

26 Ibid. (1122b35), p. 1772.

27 Ibid. (1123a5–6).

28 D. and F. W. Kent, "Two Comments of March 1445 on the Medici Palace," *Burlington Magazine* (1979), p. 795, citing a letter of March 13 from Ser Alessio Galluzzi, a Medici factotum, to Cosimo's son in Rome: "del disfacimento del canto, che è disfato da chasa Zanobi fino a cha[sa] Fruosino; è sgonbro tutto, che è una magnificent[i]a a vedere" (ASF, Mediceo avanti il Principato, V, 509).

29 Palmieri, *Vita civile*, ed. Belloni, p. 147, Book IV, in the section "Della magnificenzia": "Magnificenzia è posta nelle grandi spese dell'opere maravigliose et notabili; per questo tale virtù non può essere operata se non da' richi et potenti . . . Le spese del magnifico vogliono essere in cose honorifice et piene di gloria, non private ma publice, come in edificii et ornamenti di templi, theatri, logge, feste publice, giuochi, conviti."

30 Sancti Antonini, *Summa Theologica*, IV, under *Titulus* 3, "De fortitudine," cap. iii, "De virtute magnificentiae," cols. 85–6.

31 Griffiths, Hankins, and Thompson, *The Humanism of Leonardo Bruni*, p. 316.

32 Palmieri, *Vita civile*, ed. Belloni, p. 173, "Le pecunie in loro non hanno alcuna utilità . . . ma solo sono trovate per attissimo mezo a commutare tutte le cose delle quali s'ha nella vita bisogno."

33 Ibid., p. 153: "Le richeze et abondanti faculità sono gli strumenti coi quali i valenti huomini virtuosamente se exercitono, et non agevolmente si rilievano coloro alle virtù de' quali si contrapone l'attenuato et povero patrimonio. Le virtù che hanno bisogno dell'aiuto et subsidio de' beni di fortuna sono molte et sanza quegli si truovono deboli et manche, sanza essere perfecte."

34 Ibid., p. 173, regarding "le pecunie, in nelle quali dua modi si richiede maximamente observare: prima virtuosamente acquistarle, poi con modo et ordine debito in uso conferille."

35 See Origo, *Il mercante di Prato*, p. 91, quoting a letter to the Florentine branch of Datini's business, from Giovanni Orlandini and Neri Vettori: "Dite scrivere a Vinegia ci rimettino ducati 1000, de' quali col nome di Dio e di guadagno, volete ve ne compriamo lana di Chonisgualdo: con Dio avanti a tutto, provvederemo a dar buono compimento."

36 Corti, "Consigli sulla mercatura di un anonimo trecentista," *Archivio storico italiano* (1952), p. 119: "considera che ne' danari istà ogni tuo aiuto, difesa, onore, profitto, achoncio" (BNCF, Magliabechiano, cl. VIII, no. 1397, fols. 174–6).

37 Rucellai, *Zibaldone*, ed. Perosa, pp. 7–9.

38 Palmieri, *Vita civile*, ed. Belloni, p. 164: "Questa è sopra tutte le cose attissima a conservare et mantenere le richeze, né niuna cosa è più contraria alla stabilità de' tesori et stati grandi che l'odio."

39 Strozzi, *Lettere*, ed. Guasti, no. 53, p. 470 (September 13, 1465): "Honne di questa mercatanzia tanto cerco, e avutone tanta buona informazione, che qualunche altra mi venissi alle mani, non crederrei poterne avere la metà"; and p. 570, no. 68 (February 7, 1465 [66]): "L'essere la terra, o vero e cittadini, mal d'accordo, fa gran danno a simile mercatanzia." For further remarks of this sort, see the first chapter of Fabbri, *Alleanza matrimoniale e patriziato nella Firenze del '400*, which is about the marriage market in Florence and the

businesslike approach taken to making good matches.

40 Strozzi, *Lettere*, ed. Guasti, no. 39, p. 342 (to Filippo in Naples, January 3, 1464[65]): "dicesi . . . che rimarranno richi. Hanno di molte case, e possissioni si dice e masserizie per 16 mila fiorini: sicchè in questo caso perdono più di riputazione che altro."

41 Ibid., no. 40, p. 354, to Filippo and Lorenzo in Naples (January 12, 1464[65]): "Resta ora a vedere el debito hanno in Ponente; che, secondo quello, rimarranno ricchi e poveri. Iddio gli aiuti; che oramai hanno perduto l'onor loro."

42 Palmieri, *Vita civile*, ed. Belloni, p. 152: "nostro trattato dell'utile."

43 Ibid., pp. 152–3: "Resta dunque a tractare di tre ragioni di cose utili, delle quali alquante sono che per bontà di loro natura et per utile ancora insieme misto sono disiderate da noi. Di questa ragione sono le parentele, l'amicitie, la buona fama, la sanctà, delle quali cose procede la gloria, la degnità, l'amplitudine et degnamente honorato vivere. Altre ne sono cerche per sola utilità sanza altro rispecto sia in loro, come sono maximamente le pecunie, le possessioni, il cultivare, la copia degli animali figlierecci, i servi et mercennarii delle arti mecaniche. Altre ne sono che s'eleggono non per utilità né per bontà di propria natura, ma per commodo et degnità, stimando per quelle abellirsi et farsi più degno, come sono le case magnifice, gl'edificii si fanno in publico, le masseritie pretiose, i famigli, cavalli et qualunche abondanza di splendido vivere."

44 Ibid., p. 183: "Delle tre parti in nelle quali dividemo nostro utile, parlando in privato solo resterebbe a dire d'una . . . Questa sarebbe posta in narrare del commodo et ornamento dello splendido vivere."As Lindow points out in his chapter "Splendour," in *At Home in Renaissance Italy*, ed. Ajmar-Wollheim and Dennis, pp. 306–7, a distinction was made between splendor and magnificence, here observed by Palmieri. Following prescriptions found in ancient authors, splendor was specifically connected with domestic expenditure and display. For "splendor domi," see, for example, Cicero, "Pro Cluentio," in *The Speeches*, trans. Hodge, lvi:154, pp. 390–1.

45 Palmieri, *Vita civile*, ed. Belloni, p. 183.

46 Ibid.: "Tali cose, benché da i particulari sieno fatte, nientedimeno perché sono attissime all'universale ornamento della città et fanno la bellezza civile, della quale seguita grandeza, stima et utile civile, più tosto si convengono tractare in fra l'utilità commune che infra e privati commodi."

47 Ibid., p. 194.

48 Ibid.: "ornamenti particulari et nello splendido vivere de' privati cittadini."

49 *Giovanni Rucellai ed il suo zibaldone*, ed. F. W. Kent et al., p. 13 (fol. 83v): "Due cose principali sono quelle che gl'uomini fanno in questo mondo: La prima lo'ngienerare: La seconda l'edifichare."

50 Rinuccini, *Lettere ed orazioni*, ed. Giustiniani, p. 81: "intelliget autem quam multum ad uitam ciuilem cum dignitate peragendam diuitiae conferrent, sua diligentia et honestis artibus ita rem auxit familiarem, ut non modo necessariis sumptibus abunde sufficeret, sed ad decus, ad gloriam, ad dignitatem augendam suppeditaret: quod in priuatum usum magnificae extructiones et rerum immortalis Dei cultui dicatarum amplitudo testantur, cum in reliqua uita frugalitatem et ciuilem modestiam sectaretur."

51 Palmieri, *Vita civile*, ed. Belloni, p. 5: "alquanti ne sono volgarizati in ne' loro originali sono eleganti et gravi, scripti in latino, ma dalla ignoranzia de' volgarizatori in modo corrotti, che molti ne sono da ridersene di quegli che in latino sono degnissimi. Et viepiù da ridere sarebbe di me, se io volessi dimonstrare che Tullio, Livio o Virgilio et più altri volgarizati auctori in niuna parte fussino simili a' primi, però che non altrimenti gli somigliono che una figura ritratta dalla più perfecta di Jocto per mano di chi non avesse operato stile né pennello s'asomigliasse all'exemplo."

52 From the preface to the translation of *The Ethics*, Griffiths, Hankins, and Thompson, *The Humanism of Leonardo Bruni*, p. 213.

53 Ibid.

54 Sale, "Palla Strozzi and Lorenzo Ghiberti: New Documents," *Mitteilungen des Kunsthistorischen Institutes in Florenz* (1978), p. 358, doc. 6: "per più disengni e servigi che 'l contra scritto llorenzo gli avea fatti per insino a questo dì" (ASF, Carte Strozziane, IV, no. 343, fol. 191 right).

55 Ibid., p. 355.

56 Alberti, *On Painting*, ed. Kemp, p. 34.

57 Cicero, *De officiis*, 1.42.151, trans. Miller, pp. 154–5.

58 Palmieri, *Vita civile*, ed. Belloni, Book IV, "Dell'arti," p. 187: "Ma sopra tutte l'arti sono lodate quelle dove la industria, la prudentia, et acume sono maximamente operate . . . come la medicina, la legge, l'architectura, scultori et qualunche doctrina di cose laudabili et honeste."

CHAPTER THREE THE ECONOMY OF HONOR

1 Chellini, *Le ricordanze*, ed. Sillano, p. 218, fol. 199: "Ricordo che a dì 27 d'agosto 1456 medicando io Donato chiamato Donatello, singulare e precipuo maestro di fare figure di bronzo e di legno e di terra e poi cuocerle e avendo fatto quello huomo grande che è sullo alto d'una cappella e sopra la porta di santa Reparata che va a servi e così avendone principiato un altro alto braccia nove egli, per sua cortesia e per merito della medicatura che avevo fatta e facevo del suo male, mi donò uno tondo grande quant'uno taglieri nella quale era scolpita la vergine Maria col Bambino in collo e due angeli da lato tutto di bronzo e del lato di fuori cavato per potervi gittare suso vetro strutto e farebbe quelle medesime figure dette da l'altro lato." Chellini became the family name and in modern literature Giovanni di Antonio is often referred to as Giovanni Chellini and Donatello's sculpture is called either the "Chellini Madonna" or the "Chellini tondo."

2 Ibid., pp. 133–4, fol. 161.

3 Ibid., p. 166, fol. 168: "Ricordo che a dì 15 di novembre 1445 io prestai a Ruberto di Giovanni Altoviti . . . uno nappo d'ariento grande cum fogliame dorato e nel fondo n'è levato lo smalto, fu quello mi donò già più anni Giovanni Borsieri per medicatura."

4 Castellani, *Ricordanze*, ed. Ciappelli, p. 74, fol. 18r: "E a dì *** di genaio f. uno stretto mi mandò per maestro Ugolino da Pisa che mi medicava, recò Simone da Toscanella . . . f. lb. iiij s. xiij d. vj." For a discussion of fees, prices, and alternative modes of payment, see Park, *Doctors and Medicine in Early Renaissance Florence*, pp. 112–14.

5 Neri di Bicci, *Le ricordanze*, ed. Santi, no. 124, p. 62 (August 23, 1456) and no. 501, p. 261 (January 6, 1465). Further discussion of wage rates (for the building industry) and the cost of living in Florence is to be found in Gold-thwaite, *The Building of Renaissance Florence*, pp. 317–50.

6 Park, *Doctors and Medicine in Early Renaissance Florence*, p. 114, from the *ricordanze* of maestro Polidoro d'Antonio Bracali da Pistoia (November 10, 1473): "dicendomi non melo dava per pagamento, perchè sapia non lo harei tolto, ma per memoria della buona amicitia anticha et al."

7 For these figures, see Goldthwaite, *The Building of Renaissance Florence*, p. 283. For the discussion of the consular elite, see pp. 272–6.

8 For these appointments and the professional and political careers of Antonio and Nanni di Banco, see Bergstein, "La vita civica di Nanni di Banco," *Rivista d'arte* (1987), pp. 55–82. A parallel, and literally related, case is that of the Succhielli family, also active in the cathedral works and in the guild, as discussed by Haines, "Artisan Family Strategies," in *Art, Memory, and Family*, ed. Ciappelli and Rubin, pp. 163–75. Antonio di Banco married Jacopo di Niccolò Succhielli's sister.

9 The figures about painters are summarized by Jacobsen in his article on "Soziale Hintergründe der florentiner Maler zu Beginn der Renaissance," in *L'Art et les révolutions*, pp. 3–17. Jacobsen's monumental book on *Die Maler von Florenz* contains a wealth of information about the organization of the painters' trade and about their ways of life.

10 These figures are based on the lists in the 1977 catalogue, *L'oreficeria nella Firenze del Quattrocento*, pp. 101–17.

11 ASF, Catasto, 837. The submissions for this *catasto* were made in 1457 according to the Florentine year, but early in 1458 in the modern calendar, and will be dated in modern style in the discussion that follows.

12 ASF, Catasto, 832, fol. 452r (no. 130; Quartiere San Giovanni, Gonfalone Vaio). The further information about Marco's career discussed here was published by Procacci, "Di Jacopo di Antonio e delle compagnie di pittori del Corso degli Adimari," *Rivista d'arte* (1960), pp. 3–70.

13 Published by Lightbown, *Botticelli*, I, pp. 162–4. Cecchi details the circumstances of Botticelli's family and the composition of the household, with references to supporting documentation, in the first chapter of his book on the artist (*Botticelli*, pp. 12–27).

14 Vasari, *Le vite*, ed. Bettarini and Barocchi, III,

p. 221: Piero: "gli assegnò in sul banco suo una provisione . . . e servitore et amico della casa de' Medici visse lieto e senza pensieri tutto il restante della sua vita."

15 ASF, Catasto, 17, fol. 555v, published by Mather, "Donatello debitore oltre la tomba," *Rivista d'arte* (1937), p. 187. Donatello's mother and sister also occur in the declarations of 1430 and 1433 (see Mather, pp. 189–91).

16 Vasari, *Le vite*, ed. Bettarini and Barocchi, III, p. 221: "che e' voleva innanzi morir di fame che avere a pensare a tante cose."

17 ASF, Catasto, 832, fol. 1104r and 833, fol. 1096v, for Donatello's declarations and assessments. The latter is in Mather, "Donatello debitore oltre la tomba," *Rivista d'arte* (1937), p. 192.

18 ASF, Catasto, 926 (Quartiere di San Giovanni, Gonfalone Drago), fol. 259v: "Truovomi vecchio e sanza invjamento e no[n] posso esercitare e la dona inferma." See Mather, "Documents on Florentine Painters and Sculptors," *Art Bulletin* (1948), p. 64. For this and a register of the other documents relating to Uccello's life and career, see Jacobsen, *Die Maler von Florenz*, pp. 612–14.

19 See Lightbown, *Botticelli*, I, p. 160.

20 These figures are from Borsook, *Art Bulletin* (1979), pp. 313–18.

21 Neri di Bicci, *Le ricordanze*, ed. Santi, no. 203, p. 104 (November 22, 1458): "uno fondachetto e uno palchetto in detto botegha e volta," and no. 642, p. 342 (December 8, 1469), "nel quale fondachetto è pozo, chamino, aquaio e volta e finestra, la quale dà lume a detto fondachetto."

22 Ibid., nos. 203–4, p. 104 (November 22, 1458), when he took over the "bottegha a uso di dipintore" from the current tenant, a mattress-maker, for the period from March 1, 1460 to March 1, 1465; no. 400, pp. 201–2 (April 30, 1463), recording the rental contract with Mariotto Davanzati for a five-year period at 13 florins *di suggello* a year; no. 642, p. 342 (December 8, 1469) renewing the contract from March 1470 to March 1475 at the higher annual rent of 16 florins *di suggello*.

23 Ibid., no. 544, p. 287 (November 24, 1466).

24 Ibid., no. 685, p. 365 (May 30, 1470).

25 Luca's investment is declared in his tax declaration, ASF, Catasto, 829 (Quartiere di San Giovanni, Gonfalone Chiavi), fol. 115v. His will is ASF, Notarile Antecosimiano, 5348, fols. 120r–v (February 19, 1470[71]). These docu-

ments are published by Pope-Hennessy, *Luca della Robbia*, pp. 85–9, 91–3.

26 The will, dated November 4, 1496 was drawn up in Rome and is in the Archivio del Convento di San Pietro in Vincoli. It is published in Cruttwell, *Antonio Pollaiuolo*, pp. 247–8. Wright, *The Pollaiuolo Brothers*, pp. 10–23 gives a documentary biography of both brothers, which charts their steady rise in status. She notes that Antonio's first wife, Maria di Lamberto di Luca Chalvanesi, had the handsome dowry of 500 gold florins, 17 *soldi*, and 8 *denari*, acknowledged as received in ASF, Notarile Antecosimiano, 10187 (ser Simone Grazzini), fol. 149r (February 10, 1469[70]); for this, see p. 13 and n. 108, p. 429.

27 Brucker, "Florentine Voices from the *Catasto*, 1427–1480," *I Tatti Studies* (1993), p. 15, from the 1480 *catasto*.

28 Ibid.

29 Brucker, *Giovanni and Lusanna*, p. 105.

30 Ibid., p. 102.

31 *La novella del Grasso legnaiuolo*, ed. Lanza, p. 24 of Brunelleschi, "uomo di maraviglioso ingegno ed intelletto"; p. 27 of "Donatello intagliatore (che fu della qualità ch'a ciascuno è noto)." This is the story of the unfortunate woodworker Grasso who was made to mistake his own identity; see here, p. 116.

32 Ibid., p. 23, about the "brigata e compagnia di più uomini da bene, così di regimento come maestri d'alcune arti miste e d'ingegno, quali sono dipintori, orefici, scultori e legnaiuoli e simili artefici."

33 ASF, Notarile Antecosimiano, 19856, fol. 188r (February 14, 1448[49]). I am extremely grateful to Jonathan Davies for providing me with references to maestro Giovanni's career at the Studio, as well as for the information that follows about his younger colleague, maestro Girolamo da Imola.

34 ASF, Catasto, 63, fol. 646r, gives a list of the "libri di medicina che al presente mi truovo," with their values, adding as well: "Alcuni libri da leggere per diletto," which are not to be counted.

35 Chellini, *Le ricordanze*, ed. Sillano, p. 185, fol. 172 (March 8, 1451[52]), for Giovanni's acting as godfather; p. 186, fol. 172 (March 22, 1451[52]), for Neri di Gino as marriage broker.

36 Machiavelli, *Florentine Histories*, trans. Banfield and Mansfield, VI. 6, p. 236.

37 ASF, Catasto, 715/I, fol. 294r: "Dell'arte mia

non fo ghuadangnio nessuno se non la benivolenzia de' cittadini."

38 Chellini, *Le ricordanze*, ed. Sillano, pp. 158–9, fol. 167 (records for November 1440 to December 1451) and p. 190, fol. 173 (records for October 1452 to December 1456).

39 Ibid., p. 215, fol. 198 (April 18, 1456), records the donation of land to endow the chapel: "che di nuovo ò fatta fare in detta chiesa di fondamento a tutte mie spese e de miei propri denari . . . E tutto feci e donai per amore di Dio acciò che abbi misericordia e pietà della mia anima e de miei passati e di tutto in perpetuo feci donagione."

40 Ibid., pp. 106–8, fol. 166 (July 29, 1433).

41 Ibid., p. 218, fol. 199: "per medicatura e servigi fece a Tommaso mio."

42 The rental contract is dated November 16, 1454, ASF, Notarile Antecosimiano, 5235 (ser Bartolomeo di Bambo Ciai), fols. 31v–32r. It is published by Caplow, "Sculptors' Partnerships in Michelozzo's Florence," *Studies in the Renaissance* (1974), pp. 174–5. The house was on the Canto de' Bischeri, which is where the Via del Oriuolo enters the Piazza del Duomo.

43 Chellini, *Le ricordanze*, ed. Sillano, p. 224, fol. 200 (April 12, 1457).

44 BNCF, Passerini, 171² and 189, *inserto* 17, for the Lorini. For the Lorini and maestro Giovanni, see *Le ricordanze*, ed. Sillano, p. 174, fol. 170 (Bernardo di Taddeo, October 24, 1447), p. 179, fol. 171 (Giovanni di Bernardo, August 5, 1450), p. 180, fol. 171 (Giovanni di Bernardo, January 5, 1450[51], and Checca, Giovanni's wife), p. 187, fol. 172 (Antonio, July 2, 1452, with Niccolò di Ugolino Martelli accompanying Tommaso's bride to wedding), p. 189, fol. 173 (Antonio, October 25, 1452), p. 222, fol. 200 (Bernardo, among those borrowing silver, March 12, 1456[57]), and p. 223, fol. 200 (Bernardo, April 4, 1457).

45 This characterization is in the prefatory section of Cristoforo Landino's *Comento sopra la Comedia* of 1481 (ed. Procaccioli, I, p. 242): "con grande vivacità o nell'ordine, o nel situare delle figure, le quali tutte appaiono in moto."

46 Vespasiano da Bisticci, *Le vite*, ed. Greco, II, p. 194: "Perché Donatello non andava vestito come Cosimo arebbe voluto, Cosimo gli donò uno mantello rosato et uno capuccio, et fecegli una cappa sotto il mantello, et vestillo tutto di nuovo, et una matina di festa glieli mandò a fine che le portassi. Portolle una volta o dua,

di poi gli ripose, et non gli volle portare più, perché dice gli pareva essere dileggiato."

CHAPTER FOUR SEEING AND BEING SEEN

1 Ilardi, "Eyeglasses and Concave Lenses in Fifteenth-Century Florence and Milan," *Renaissance Quarterly* (1976), p. 345, Paris, Bibliothèque Nationale, MS Ital. 1595, fol. 291 (October 21, 1462).

2 Ibid., p. 348, Archivio di Stato, Milan, Registri delle Missive, Reg. 77, fol. 89v (June 13, 1466); for the earlier order, p. 346.

3 Leonardo da Vinci, *Treatise on Painting*, ed. and trans. McMahon, I, pp. 18, 23.

4 From his dialogue, *Anuli*, quoted by Watkins, "L. B. Alberti's Emblem, the Winged Eye, and his Name, Leo," *Mitteilungen des Kunsthistorischen Institutes in Florenz* (1959–60), p. 257.

5 Lorenzo de' Medici, *A Commentary on My Sonnets*, trans. Cook, pp. 84–5, commentary on sonnet 5: "abbandonatamente lasciò el mio petto e se n'andò in quelli splendidissimi e amorosi occhi" (*Comento*, ed. Zanato, p. 180).

6 Ibid., pp. 90–1, commentary to sonnet 7: "Era già per li occhi miei discesa al cuore la imagine della bellezza di costei, e gli occhi suoi avevano fatto in esso tale impressione, che sempre gli erono presenti" (*Comento*, ed. Zanato, p. 185).

7 Ibid., pp. 86–7, commentary to sonnet 6: "con somma delettazione la guardai: perché il mirar fiso non procede se non da due cagioni, cioè o per conoscere bene quella tale cosa che si guarda, o per grande delettazione che si piglia guardandola" (*Comento*, ed. Zanato, p. 182); and the commentary to sonnet 9, pp. 98–9, "il cuore acceso d'amore già mai ha pace, e gli occhi dello inamorato tanto sono più felici, quanto il cuore ha maggiore tormento" (*Comento*, ed. Zanato, pp. 191–2).

8 Rocke, *Forbidden Friendships*, p. 59, quoting from ASF, Giudice degli Appelli e Nullità, 79 (2), fols. 44 r–v (January 13, 1435[36]).

9 Alberti, *I libri della famiglia*, in *Opere volgari*, I, ed. Grayson, Book I, p. 17: "vegghiare e riguardare per tutto, rivedere e riconoscere ogni compagnia, ed essaminare tutte le usanze e per casa e fuori."

10 Giovanni Gherardi da Prato, *Il Paradiso degli Alberti* (1425), quoted from *Images of Quattrocento Florence*, ed. Baldassari and Saiber, p. 20.

11 Leonardo da Vinci, *The Literary Works*, ed. Richter, I, p. 338, no. 571: "spesse volte nel tuo andarti a spasso vedere e considerare i siti e li atti delli omini in nel parlare, in nel contendere o ridere o zuffare insieme, che atti fieno in loro, che atti faccino i circunstati, i spartitori, i veditori d'esse cose, e quelli notare con brevi segni in questa forma su un tuo piccolo libretto, il quale tu debi sempre portar con teco."

12 Manetti, *Vita di Filippo Brunelleschi*, ed. de Robertis and Tanturli, p. 55: "e' misse innanzi ed in atto, lui propio, quello ch'e dipintori oggi dicono prospettiva" (ca. 1475); similarly Filarete in Book XXIII of his *Trattato di architettura* (ca. 1461), explaining how Brunelleschi used a mirror: "E veramente da questo modo credo che Pippo di ser Brunellesco trovasse questa prospettiva, la quale per altri tempi non s'era usata" (ed. Finoli and Grassi, II, p. 657), and Landino, in the preamble to his Dante commentary (1481): Brunelleschi "*Maxime* intese bene prospectiva; et alchuni afferman lui esserne suto o ritrovatore o inventore" (*Comento*, ed. Procaccioli, I, pp. 241–2).

13 For Landino's passage on artists in the 1481 edition of *The Divine Comedy* and a discussion of Landino's criticism, see Baxandall, *Painting and Experience in Fifteenth Century Italy*, pp. 118–51 (for the Italian text, see *Comento*, ed. Procaccioli, I, pp. 241–2). Other aspects of the commentary and its importance to understanding fifteenth-century Florentine cultural attitudes are considered below in Chapter 5; see the Bibliographic Note to Chapter 5 for further references to Landino and the 1481 *Comento*.

14 *Metaphysics*, 980a (*The Complete Works of Aristotle*, ed. Barnes, II, p. 1552).

15 Aquinas, *De anima*, Lectio 14, on Book II, par. 417; quoted from his *Commentary on Aristotle's De anima*, trans. Foster and Humphries, p. 132.

16 Sancti Antonini, *Summa Theologica*, I, *Titulus* 2, cap. ii, col. 71: "Visus autem est maxime spiritualis, quia est absque aliqua immutatione naturali organi vel objecti: & perfectior inter omnes sensus & communior."

17 *La rappresentazione di Abramo ed Isaac* (1449), in *Sacre rappresentazioni*, ed. Banfi, p. 37: "L'occhio si dice ch'è la prima porta/per la qual l'intelletto intende e gusta."

18 Baxandall, *Painting and Experience in Fifteenth Century Italy*, p. 38.

19 Ibid., pp. 36, 34.

20 Ibid., p. 152.

21 Ibid., p. 40.

22 Ibid., pp. 38–9.

23 Ibid., p. 39.

24 Baldini Giusti and Facchinetti Bottai, "Documento sulle prime fasi costruttive di Palazzo Pitti," in *Filippo Brunelleschi: La sua opera e il suo tempo*, II, p. 724, quoting from ASF, Provvisioni, Registri, 152, fol. 124r: "La quale via . . . non usa per quella, se non persone disoneste . . . che essendo quel luogo pura tra cittadini da bene, è una vergogna della città."

25 Ibid.: "sempre hanno innanzi agli occhi quelle bructure."

26 Strozzi, *Lettere*, ed. Guasti, no. 22, pp. 230–1, (March 6, 1460[61]): "Avvisoti ch' e dua panni dipinti ch' i' ho, l'uno è de' tre Magi che offersono oro al Nostro Signore; e sono buone figure: l'altro è un pagone, che mi pare gentile, ed è adorno con altre frasche. A me paiono belli: serberonne uno, che di'; perchè a quello di' per altra tua che costano, non se ne trarrebbe quí fiorini tre dell'uno; che sono piccoli panni. S' i' trovassi da vendergli bene, gli venderei tramendua. El Volto santo serberò; che è una divota figura e bella."

27 Rucellai, *Zibaldone*, ed. Perosa, p. 73: at Santo Stefano Rotondo "una cappella antica dallato, con musaico . . . con fogliami di nachere et grappoli d'uve et tarsie et altre gentileze"; p. 74, at Santa Costanza, "il quale è il più vacho, gratioso et gentile musaico non che di Roma, ma di tutto il mondo."

28 Baxandall, *Painting and Experience in Fifteenth Century Italy*, p. 80.

29 Rainey, "Sumptuary Legislation," p. 479, translated from ASF, Deliberazioni dei Signori e Collegi, Ordinaria Autorità, 42, fols. 5v–6r (September 3, 1433; transcribed by Rainey, p. 763).

30 Lucrezia Tornabuoni, *Lettere*, ed. Salvadori, no. 5, p. 56, to Piero in Florence, from Cafaggiolo (March 3, 1457[58]), ASF, Mediceo avanti il Principato, XVII, 148: "Io volevo jº lenzuolo dell'antichamera, el quale nonn è spina pesscie, e voi me n'avete mandato jº del letto della chamera."

31 Ibid., no. 10, p. 60, to Filippo Strozzi (March 18, 1464[65]), ASF, Carte Strozziane, III, n. 131,

fol. 183: "mai viddi sì bello lino né potevo rice-vere chosa che più io desiderassi."

32 Letter to Filippo in Naples (August 24, 1447), translation from Strozzi, *Selected Letters*, trans. and ed. Gregory, pp. 30–1: "E come si maritò, gli tagliò una cotta di zetani vellutato chermisi; e così la roba di quello medesimo: ed è 'l più bel drappo che sia in Firenze . . . E ordina di fare un velluto chermisi, per farlo colle maniche grandi, foderato di martore . . . e fa una cioppa rosata, ricamata di perle" (Strozzi, *Lettere*, ed. Guasti, no. 1, pp. 5–6).

33 Giovanni d'Amerigo del Bene writing to Francesco di Jacopo del Bene on February 24, 1381, quoted from Brucker, *The Society of Renaissance Florence*, p. 35; the Italian text is in Brucker, *Firenze nel Rinascimento*, p. 255: "È paruto a queste donne che lla Caterina si vesta di sciamito azzurro e facciasi una gamurra pur in sulla dota, et ànnolo diliberato per lo meglio."

34 *Vita civile*, ed. Belloni, p. 157: "L'ornamento d'ogni valente donna è la modestia et l'onestà della bene composta et ordinata vita. Gli altri ornamenti che sono de' vestiti, portature et aconcimi sieno competenti et confacciansi alle potenzie, alle facultà et conditioni di chi gl'usa, et sieno in modo regolati che manchino di merita riprehensione, della quale sempre mancherà quella che ritiene honestà."

35 *Cronica di Giovanni Villani*, ed. Dragomanni, III, Book X, chapter 108, p. 103: "ebbono più consigli e ragionamenti e avvisi, come dovesssono riformare la città di reggimento e signoria per modo comune, acciocché si levassono le sette tra' cittadini."

36 From the preface to the reform, ASF, Provvisioni, Protocolli, 6, fols. 292r–v, quoted from Najemy, *Corporatism and Consensus in Florentine Electoral Politics*, p. 102.

37 Dei, *La cronica*, ed. Barducci, p. 77: "Memoria sia a tutta Italia, e dappoi a tutto il Christianesimo, della signorìa e possa e groria che ànno e tenghono li Fiorentini . . . oggi questo dì detto di sopra [1472]. . . li quali non sanno quello si sia Firenze e no ll'anno mai visto. E a cciò che lloro possino sapere, intendere e chonsiderare e ghustare tal qual sia detta città, io Benedetto Dei fiorentino ne dò e darò plenissima notizia e di sito e di grandezza e di muraglie e di cittadini."

38 Baldassari and Saiber, eds., *Images of Quattro-cento Florence*, p. 70, translated from Parenti's *Memorie*, BNCF, Magliabechiano, XXV, 272, fols. 68–70.

39 Rocke, *Forbidden Friendships*, p. 50, from ASF, *Provvisioni, Registri*, 123, fol. 33v.

40 Pecchioli Vigni, "Lo statuto in volgare della Magistratura della Grascia," *Archivio storico italiano* (1971), p. 30 (ASF, Ufficiali della Grascia, 2, fol. 8r).

41 Mazzi, *Prostitute e lenoni nella Firenze del Quattrocento*, p. 244.

42 ASF, Podestà, 3751, from the criminal cases heard in 1400. For an assortment of such characterizations, see Brucker, *The Society of Renaissance Florence*, Parts 5 and 6, "Crime and Punishment" and "Public Mores."

43 ASF, Notarile Antecosimiano, 13498 (ser Filippo Mazzei, 1449–82), fol. 145r (August 20, 1455), from the testimony of Lusanna's sister-in-law: "domina Lusanna esse vestita de quadem gamura verde/ Johannem . . . de vel-lutato cremisi." When asked what the couple was wearing when they met at her house to have sexual relations before the death of Lusanna's husband, another witness, Giuliana Mangaldi, remembered that Giovanni was dressed "in cioppa nigra foderata" and "cappa," and Lusanna in a "gamurra turchina cum manicus de panno nigra" (fol. 121r). The case is published and analyzed by Brucker, *Giovanni and Lusanna*, see p. 20 for the description of Lusanna's dress, and p. 22 for the brown tunic she wore on a visit to the country. The case is further discussed by Kuehn in his consideration of "Reading Microhistory: The Example of *Giovanni and Lusanna*," *Journal of Modern History* (1989), pp. 512–34; see pp. 525, 522, for the descriptions noted here, part of his discussion of the way that such images were constructed in arguing cases.

44 Manetti, *La novella del Grasso legnaiuolo*, ed. Lanza, pp. 24, 27, for Brunelleschi and Donatello. The tale was extremely popular at the time. For its circulation and the ownership of some of the manuscripts, see D. Kent, *Cosimo de' Medici*, p. 81 and p. 426, n. 129 and Martines, *An Italian Renaissance Sextet*, p. 254. Martines gives a reading of this tale as historical documentation, and puts forward arguments for the story as an actual incident in Chapter 6 and pp. 254–8.

45 Manetti, *La novella del Grasso legnaiuolo*, ed. Lanza, p. 29: "Gli altri prigioni che v'erano, avendo udito lo strepito quando'e' giunse a nominarlo più volte Matteo, come fu tra loro, sanza dimandarlo altrimenti, come così avessi nome lo ricevettono, non v'essendo per aventura alcuno che 'l conoscessi se non per veduta; e udendosi e vedendo chiamare Matteo da tutti coloro a quello che occorreva, tutto invasato quasi per certo gli parve essere un altro."

46 Ibid., p. 31: "Giovanni Rucellai non mi levò mai occhio da dosso, e non mi conosce, che è ogni ora in bottega . . . Io non sono più el Grasso di certo e sono diventato Matteo."

47 Savonarola, *Trattato dell'umiltà* (1492), in *Operette spirituali*, ed. Ferrara, I, p. 152: "debbe l'umile aver gli occhi bassi in terra, *maxime* nel cospetto degli uomini."

48 Barbaro, *De re uxoria liber* (1415–16), in *Prosatori latini del Quattrocento*, ed. Garin, pp. 122–3.

49 Palmieri, *Vita civile*, ed. Belloni, p. 96: "Spesso adviene che per piccoli cenni si conosce maximi vitii et dàssi inditii veri di quello sente l'animo nostro."

50 Ibid.: "Mirabile è certo vedere quanto forza abbino le mani in significare nostre intentioni, in modo che non solo dimostrino, ma quasi parlino." The language of gesture is discussed by Baxandall, *Painting and Experience*, pp. 61–71.

51 Palmieri, *Vita civile*, ed. Belloni, pp. 96–7.

52 Savonarola, *Trattato dell'umiltà*, in *Operette spirituali*, ed. Ferrara, I, p. 152: "non col collo torto, né col capo tanto chino che lui pretenda ipocrisia, ma temperatamente, senza dimonstrazione o alcuna singularità."

53 Rocke, *Forbidden Friendships*, p. 61, quoting from ASF, Provvisioni, Registri, fol. 40r (April 14, 1458).

54 Manetti, *La novella del Grasso legnaiuolo*, ed. Lanza, p. 46, Grasso goes to Santa Maria del Fiore, "per certificarsi meglio s'egli era Grasso o Matteo de' riscontri degli uomini," and p. 47, distressed and pacing up and down, like a wounded lion "non gli parendo quivi essere veduto da che lo apuntassi."

55 Rocke, *Forbidden Friendships*, p. 61, quoting from ASF, Provvisioni, Registri, 149, fol. 40r (April 14, 1458). Donatello's statue, dating from around 1430, was made of sandstone and eroded over time. It was replaced in 1721 with

a copy by Giovanni Battista Foggini; the statue and column were destroyed with the old marketplace to make way for the Piazza della Repubblica. For bibliography and a discussion of the reproductions and illustrations of the statue, see Rosenauer, *Donatello*, catalogue no. 25, p. 107. Its iconography, impact, and afterlife are the subject of the first chapter of Randolph, *Engaging Symbols* ("Common Wealth: Donatello's *Ninfa Fiorentina*").

56 Edgerton, *Pictures and Punishment*, p. 75, translated from the *Statuto del Capitano del Popolo*, 1322–5 (*Statuti della repubblica fiorentina*, ed. Caggese, I, pp. 128–9, "De pingendo cessantes mercatores in palatio"). The statute appears with some revised wording in the 1415 statutes (*Statuta populi et communis florentiae*, I, p. 517). The Palazzo del Podestà was the headquarters of the chief magistrate; it now houses the Bargello museum.

57 *Statuta populi et communis florentiae*, I, p. 517; "ad perpetuam eius infamiam."

58 See Edgerton, *Pictures and Punishment*, p. 227; see pp. 227–30 for a transcription of the record of this decision, with a translation (from ASF, Provvisioni, Registri, 155, fols. 237v–238v).

59 Edgerton, *Pictures and Punishment*, p. 99, quoting from the Signoria's condemnation of Rinaldo degli Albizzi and seven of his family members and supporters. He gives the Latin from ASF, Commissioni, 3, fols. 665–668 (July 29, 1440): "pingantur et pingi debeant . . . infrascriptam condempnationem infamie et igniominie perpetue . . . eorum figuris et pitturis ad naturale detraendis, et literis grossis cum eorum nominibus et prenominibus."

60 ASF, Otto di Guardia e Balìa, Repubblica, 48, fol. 35v; see *Consorterie politiche e mutamenti istituzionali in età laurenziana*, ed. Timpanaro, no. 6.7, pp. 159–60, for this document, which is reproduced. It was first published by Horne, *Botticelli*, p. 63 and Appendix II, doc. 18, p. 350. The frescoes were obliterated in 1494, but they are described in a set of manuscript notes about artists, with their location given as "nella facciata, doue gia era il Bargiello, sopra la doghana" (*Il codice Magliabechiano*, ed. Frey, p. 105). This part of the building was destroyed in 1495, as part of the construction of the Sala dei Cinquecento.

61 *Consorterie politiche e mutamenti istituzionali in età laurenziana*, ed. Timpanaro, nos. 6.8, 6.9, pp. 160–1 (ASF, Otto di Guardia e Balìa,

Repubblica, 55, fols. 54v–55): "prefati Octoviri declarantes ipsum Bernardum crudelissima homicidia nefandissimum sacrilegium et sceleratissimum parricidium perpetrasse . . . deliberaverunt, declararverunt et condemnaverunt ipsum Bernardum . . . quod suspendatur ita quod moriatur . . . proxima sequenti die . . . ipsum Bernardum per ministrum iustitie de fenestris palatii . . . eo habitu quo ex Constantinopoli civitate adductum est, laqueo suspendi faciat, ita quod moriatur."

62 Ibid., p. 160: "ogni cagione che potessi in alchuno modo dedecorare il grado archiepiscopale" (ASF, Signori, Dieci di Balìa, Otto di Pratica, Legazioni e Commissarie, Missive Responsive, 10, fol. 25).

63 Landucci, *A Florentine Diary*, trans. de Rosen Jervis, p. 17 (April 29, 1478).

64 *Il codice Magliabechiano*, ed. Frey, p. 105: "Son Bernardo Bandinj, un nuovo Giuda,/Traditore 'micidale in chiesa io fuj,/Ribello per aspettare morte più cruda"; the sixteenth-century author of these notes says that the epitaphs were composed by Lorenzo de' Medici.

65 Saint Bonaventure, *Legenda maior*, xv.4, translation from Smart, *The Assisi Problem*, p. 286, who also gives the inscription beneath the scene at Assisi, which has been reconstructed as reading: "In portiuncula et cum iaceret Beatus Franciscus mortuus, Dominus Hiero-nymus doctor et litteratus celeber movebat clavos, sanctique manus, pedes et latus manibus propriis contrectabat."

66 *Legenda maior*, ix.8; Smart, *The Assisi Problem*, p. 273.

67 Smart, *The Assisi Problem*, p. 273.

68 Ibid., p. 286.

69 Dante, *The Divine Comedy*, trans. Singleton, *Paradiso* xiii.1–3, pp. 140–1: "Imagini, chi bene intender cupe/quel che'i'or vidi – e ritegna l'image,/mentre ch'io dico, come ferme rupe."

70 Borsook and Offerhaus, *Francesco Sassetti and Ghirlandaio at Santa Trinita*, doc. 12, p. 62, publish the endowment of the chapel with four plots of land (January 1, 1486[87]): "facta dipignere e ornare di sepultura e di paramenti e d'altri ornamenti necessarii, e dissiderando che perpetualmente vi sia celebrato ogni mactina l'ufitio divino della messa . . . per merito e memoria dell'anima sua e de' sua antecessori, e posteri, et per molti altri buoni rispeci che a questo lo muovono" (ASF, Notarile Antecosimiano, 393 [ser Andrea d'Angi-

olo da Terranuova, 1482–6], fol. 269v). He made additions to this endowment on July 31, 1487 (fols. 275r–v), stipulating the celebration of masses on the feast day of Saint Francis (fol. 276v).

71 Borsook and Offerhaus, *Francesco Sassetti and Ghirlandaio at Santa Trinita*, doc. 12, p. 62: "Con ciò sia cosa che poche o nessuna dell'opere humane si g[i]udicha in questa misera vita essere più accepta allo omnipotente Iddio né più laudabile agli uomini mortali che la celebratione del culto divino."

72 Alberti, *On Painting*, ii.41, 42, ed. Kemp, pp. 76–7.

73 *The Literary Works of Leonardo da Vinci*, ed. Richter, i, p. 344, no. 593: "La pictura over le figure dipinte debbono esser fatte in modo tale che li riguardatori d'esse possino con facilità conosciere mediante le loro attitudini il concetto dell'animo loro."

74 Quoted from the 1475 letter of Pietro Cennini describing the effect of the east doors of the Baptistery on foreigners "passing through Florence" (Krautheimer, *Lorenzo Ghiberti*, i, p. 17; for the Latin, see Mancini, "Il bel S. Giovanni," *Rivista d'arte* [1909], p. 221).

CHAPTER FIVE THE EYE OF THE BEHOLDER

1 Dante, *The Divine Comedy*, trans. Singleton, *Purgatorio*, x.51–3, pp. 100–1: "addorno/d'intagli sì, che non pur Policleto,/ma la natura lì avrebbe scorno."

2 Ibid., *Purgatorio*, x.93–5, pp. 104–5: "Colui che mai non vide cosa nova/produsse esto visibile parlare,/novello a noi perché qui non si trova."

3 *Commento di Francesco da Buti sopra la Divina Commedia di Dante Allighieri*, ed. Giannini, ii, p. 237: "lo parlare, secondo natura, è udibile; ma non visibile: questo era visibile, perchè finge che fusse scolpito nel marmo che è sopra natura, e questo non può fare se none Iddio; e però finge che Iddio lo producesse. Novello a noi; cioè omini che siamo nel mondo, perchè qui; cioè nel mondo, non si trova; questo parlare visibile. Ne l'altro mondo serà lo parlare visibile: imperò che ciascuno vedrà lo concetto dell'altro, sensa essere espresso con lingua; e questo medesimo addiviene a noi, quando veggiamo dipinta o sculpita una storia che a noi sia nota: pare a noi che le persone

dipinte dicano le parole, come l'angiulo ci pare che dica Ave a la Vergine Maria, quando è bene atteggiato." The commentary is dated to 1395.

4 *Comento*, ed. Procaccioli, III, p. 1208: "che una statua sia sculpita con tale artificio, che ne' gesti dimostri quello, che direbbe, se parlassi. È adunque parlare visibile, perché vedendo e gesti et non udendo la voce intendevano. Ma questo parlare, che non è nuovo a Dio . . . è nuovo a noi mortali, perché tra noi non si truova."

5 *Chiose ambrosiane* (an anonymous commentary, from the second half of the fourteenth century), *Purgatorio*, X.95: "pictura murorum libri sunt laycorum"; cited from Archivio italiano, *I commenti danteschi*, ed. Procaccioli.

6 *Purgatorio*, X.97–9, trans. Singleton, pp. 104–5: "Mentr'io mi dilettava di guardare/ l'imagini di tante umilitadi,/e per lo fabbro loro a veder care,/'Ecco di qua, ma fanno i passi radi,' . . . Li occhi miei, ch'a mirare eran contenti/per veder novitadi ond'e son vaghi,/volgendosi ver' lui non furon lenti." Landino, *Comento*, ed. Procaccioli, III, p. 1209: "Era attento Danthe a gl'exempli de l'humiltà, perché chosí conviene, che faccia la sensualità, quando vuole seguitare la ragione, et dilectavasi di guardare. Il che significa, che el senso era tanto obbediente alla ragione, che già si dilectava della virtù, et non facea l'operationi di quella con difficultà. Et dilectavasi di quelle imagini per amore del *fabbro*, cioè del maestro, che l'havea facte, et questo quanto a l'historia significa, che l'artificio et l'auctorità dell'artefice lo movea a guatarle, chome veggiamo in noi. Imperoché se guardiam la pictura, et udiamo quella essere di mano di Giotto, può molto in noi l'auctorità de l'huomo. Et allegoricamente dimostra, che guatava gl'exempli de l'humiltà per amor del maestro, cioè per l'amore di Dio."

7 *Comento*, ed. Procaccioli, III, pp. 1202–3: "sculptore molto celebrato appresso de gl'antichi . . . hebbe nome conveniente ad sé. Perché 'polycleto' in greco significa 'huomo di molta fama'."

8 *Comentum* (known in three successive versions, dating from 1375 to 1380), *Purgatorio*, X.28–33, cited from Archivio italiano, *I commenti danteschi*, ed. Procaccioli: "fuit maximus artifex statuarum, ut scribit philosophus VII Ethicorum . . . Et hic nota, quod iste Poly-cletus fuit excellentissimus statuarius graecus, de quo scribit Plinius XXXIII, naturalis historiae." The reference to Aristotle is to Book VI, Chapter 7 of the *Nichomachean Ethics* in the context of Aristotle's discussion of knowledge, where the sculptors occur as examples of "wisdom in the arts," which is ascribed "to their most finished exponents, e.g. to Phidias as a sculptor and to Polycleitus as a maker of statues, and here we mean nothing by wisdom except excellence in art" (*Complete Works*, ed. Barnes, II, p. 1801 [1141a1]). In Book XXXIV of the *Natural History* Pliny reports that "Polycleitus is deemed to have perfected this science of statuary and to have refined the art of carving, just as Phidias is considered to have revealed it" (*Natural History*, XXXIV.20.56, trans. Rackham, IX, pp. 168–9).

9 *Commentary on Aristotle's Nichomachean Ethics*, trans. Litzinger and McInerny, Book VI, lecture 5, n. 1180, p. 375.

10 *Comentum*, *Purgatorio*, X.103–5, cited from Archivio italiano, *I commenti danteschi*, ed. Procaccioli: "Et ostendit quomodo se volverit factus avidus ad verba Virgilii, dicens; gli occhi miei, scilicet intellectualis, ch'a mirar eran contenti, illas pulcras sculpturas: sic dicit Virgilius de Enea: et animum picture pascit inani." This refers to *Aeneid*, Book I, specifically line 464, where Aeneas is "feasting his soul on the unsubstantial picture" (*Aeneid*, trans. Fairclough, pp. 272–3). Virgil concludes the description of the paintings, "these wondrous sights" ("miranda") describing Aeneas as "in amazement he hangs rapt in one fixed gaze" (lines 494–6, pp. 274–5).

11 Niccoli's opinion was variously reported in texts dating from the beginning of the fifteenth century. It is voiced by Niccoli as a protagonist in Leonardo Bruni's *Dialogi ad Petrum Paulum Histrum* (datable to 1401): "ego istum poetam tuum a concilio litteratorum seiungam atque eum lanariis, pistoribus atque eiusmodi turbae relinquam" (*Prosatori latini del Quattrocento*, ed. Garin, p. 70). A variant occurs in Cino Rinuccini's *Invettiva contro a certi calunniatori di Dante e di messer Francesco Petrarca e di messer Giovanni Boccaccio*: "per mostrarsi litteratissimi al vulgo, dicono che lo egregio e onore de' poeti Dante Alighieri essere suto poeta da calzolai" (Lanza, *Polemiche e berte letterarie*, p. 264; usually dated ca. 1400–01 and composed in Latin,

Cino's invective is known only from an Italian translation). Another version is given, pointedly, but without attribution, by Domenico da Prato in the dedicatory letter of a book of his poems, ca. 1420: "Ed altri di loro dicono il libro di Dante esser da dare alli speziali per farne cartocci, o vero più tosto alli pizzicagnoli per porvi dentro il pesce salato, perché, vulgarmente scrisse" (ibid., p. 241). It was a persistent refrain in the debates between the traditional scholastic model of learning and the new *studia humanitatis*, which involved heated polemics about the merits of the vernacular. By the 1430s these arguments became politicized, with the Medicean camp associated with humanist learning. As such it was repeated, with anti-Medicean overtones, by Francesco Filelfo in the introduction (*prolusione*) to his resumption of Dante readings in the Duomo in December 1431: "il leggere di questo divino poeta chiamato dai miei ignorantissimi emuli leggiere da calzolai et da fornai" (Garin, "Dante nel Rinascimento," *Rinascimento* [1967], p. 13).

12 *Statuti della Università e Studio fiorentino*, ed. Gherardi, no. LVII, August 9, 1373, p. 162: "librum qui vulgariter appellatur *El Dante*." Payments to subsequent readers are published by Park, "The Readers at the Florentine Studio according to Communal Fiscal Records (1357–1380, 1413–1446)," *Rinascimento* (1980), pp. 249–310.

13 "Diario fiorentino di Bartolomeo di Michele del Corazza," *Archivio storico italiano*, XIV (1894), p. 291: "Addí di gennaio 1428 cominciò il maestro Antonio d'Arezzo a sporre il Dante in Santo Stefano a Ponte, e perché era poco luogo, il disse poi in Santa Maria del Fiore." These lectures were also held in the oratory of Orsanmichele, as recorded in a document from November 1412, when the confraternity responsible agreed that messer Giovanni Malpaghini da Ravenna, recently reappointed by the university to lecture in rhetoric and Dante, "possa leggere il Dante nell'Oratorio di Or Santo Michele il dì delle feste, acioè a tempo non si disturbi il divino uficio in niuno modo" (Zervas, *Orsanmichele a Firenze*, I, p. 186).

14 Manetti, *Vite di Dante, Petrarca e Boccaccio*, ed. Baldassari, pp. 24–6: "Dantem, Petrarcham et Boccacium, tres illos peregregios poetas nostros . . . usque adeo in vulgus con-

sensu omnium claruisse constat, ut nulli alii hac vulgari opinione paene illustres poetae a conditione orbis fuisse videantur."

15 Cino Rinuccini, *Invettiva contro a certi calunniatori di Dante e di messer Francesco Petrarca e di messer Giovanni Boccaccio*, in *Polemiche e berte letterarie*, ed. Lanza, p. 264: "Lo illustre ed esimio poeta Dante, il quale, sia detto con pace de' poemi greci e latini, niuna invenzione fu più bella, più utile e più sottile che la sua . . . gli umani fatti dipigne in vulgare più tosto per far più utile a' suo cittadini che non farebbe in gramatica."

16 Ibid., p. 265: "chi lo leggerà con intelletto troverrà d'ogni arte, d'ogni iscienza, d'ogni filosofia."

17 Morelli, *Ricordi*, ed. Branca, pp. 272–3 (*Mercanti scrittori*, ed. Branca, p. 200): "Tu ti potrai istare con Boezio, con Dante e cogli altri poeti, con Tulio che t'insegnerà parlare perfettamente, con Aristotile che ti insegnerà filosofia: conoscerai la ragione delle cose, e, se none in tutto, ogni piccola parte ti darà sommo piacere."

18 *The Autobiography of Lorenzo the Magnificent*, trans. Cook, p. 51; *Comento de' miei sonetti*, ed. Zanato, p. 149: "perché ogni ora più si fa elegante e gentile; e potrebbe facilmente . . . venire ancora in maggiore perfezione, e tanto più aggiugnendosi qualche prospero successo e augumento al fiorentino imperio: come si debbe non solamente sperare, ma con tutto l'ingegno e forze per buoni cittadini aiutare."

19 Alberti, *On Painting*, II.29, ed. Kemp, p. 64.

20 *Comento*, ed. Procaccioli, I, p. 241: "Fu Masaccio . . . buono componitore e puro sanza ornato . . . Fu fra Philippo gratioso e ornato et artificioso sopra modo . . . Andreino fu grande disegnatore . . . amatore delle difficultà dell'arte et di scorci."

21 *Purgatorio*, IX.70–2, trans. Singleton, pp. 90–1: "Lettor, tu vedi bene com'io innalzo/la mia matera, e però con più arte/non ti maravigliar s'io la rincalzo."

22 *Inferno*, XV.62, trans. Singleton, pp. 156–7: "quello ingrato popolo maligno."

23 Mazzei, *Lettere di un notaro a un mercante del sec. XIV*, ed. Guasti, I, p. 282: "Dice Dante: – Vuolsi così dove si puote"; see Bec, "I mercanti scrittori, lettori e giudici di Dante," *Letture classensi* (1983), p. 105, n. 17, for this and other examples from this correspondence; see also Bec, *Les Livres des florentins*, p. 107.

24 *The Autobiography of Lorenzo the Magnificent*, trans. Cook, p. 49; *Comento de' miei sonetti*, ed. Zanato, p. 149: "per li gravi e importanti effetti che li versi suoi sieno letti, come mostra . . . le frequenti allegazioni che da santi et excellenti uomini ogni dì si sentono nelle loro publiche predicazioni."

25 Sacchetti, *Il trecentonovelle*, ed. Pernicone, nos. 114 and 115. The heading to *Novella* 114 reads: "Dante Allighieri fa conoscente uno fabbro e uno asinaio del loro errore, perché con nuovi volgari cantavano il libro suo" (p. 245) and the story opens describing "Lo eccellentissimo poeta volgare, la cui fama in perpetuo non verrà meno."

26 For the da Maiano brothers and Luca della Robbia, see Pfisterer, *Donatello und die Entdeckung der Stile*, pp. 253–4, as part of his discussion of artists' familiarity with Dante. The da Maiano inventory from April 28, 1498 is published in translation by Gilbert, *Sources and Documents*, p. 43 ("A Dante bound in wood with leather cover," in Benedetto's writing room). For the inventory of Filippino Lippi's house and shop made April 24, 1504, after his death, see Zambrano and Nelson, *Filippino Lippi*, p. 627, nos. 229, 230 (ASF, Notarile Antecosimiano, 563 [ser Giovanni di ser Piero del Serra], *inserto* 4).

27 From *Purgatorio*, v.15–16, trans. Singleton, pp. 44–5: "sta come torre ferma, che non crolla/già mai la cima per soffiar li venti" ("Stand as a firm tower which never shakes its summit for blasts of winds"). See Solmi, *Scritti vinciani*, pp. 130–5, p. 154, and Parronchi, "Come gli artisti leggevano Dante," *Studi danteschi* (1966), pp. 124–6, for the citations found in Leonardo's notebooks. In his article on "The Prophetic Dream in Leonardo and in Dante," *Raccolta Vinciana* (2005), pp. 145–80, Marmor traces the results of Leonardo's close reading of Dante in his works as well as speculating on the influence of Landino on that reading.

28 *Inferno*, XI.100–6, trans. Singleton, pp. 114–15: "e se tu ben la tua Fisica note,/tu troverai, non dopo molte carte,/che l'arte vostra quella, quanto pote,/segue, come 'l maestro fa 'l discente/sì che vostr'arte a Dio quasi è nepote." The reference is to Aristotle, *Physics*, II.2.

29 *The Literary Works of Leonardo da Vinci*, ed. Richter, I, p. 367, no. 652. Similarly I, p. 38, no. 13: "Truly painting is a science, the true-born child of nature . . . to be more correct we should call it the grandchild of nature, since all visible things were brought forth by nature and these, her children, have given birth to painting. Therefore we may justly speak of it as the grandchild of nature and as related to God." See Richter's observations pp. 18–19 for Leonardo's debt to Dante for this genealogy, and its repeated occurrence in his notes on art. Leonardo was very likely to be thinking of Dante, when, in his comparison of the relative merits of poetry and painting, he wrote: "And if you say: I shall describe hell for you, and paradise or any other delights or terrors, there too the painter is your superior because he will place things before your which though silent will express such delights or terrors that will turn your courage into flight" (ibid., I, p. 64, no. 28).

30 *Inferno*, XXXIV.28, trans. Singleton, pp. 362–3: "doloroso regno."

31 *Paradiso*, XXXIII.142, trans. Singleton, pp. 380–1: "A l'alta fantasia quì mancò possa."

32 *Paradiso*, III.2–3, trans. Singleton, pp. 26–7: "di bella verità m'avea scoverto,/provando e riprovando, il dolce aspetto."

33 *Purgatorio*, X.7–8, trans. Singleton, pp. 98–9: "Noi salavam per una pietra fessa,/che si moveva e d'una e d'altra parte/sì come l'onda che fugge e s'appressa." This drawing is not finished: the stories of the *Annunciation* and *David before the Ark* have not been completely drawn in ink. Though most of the figures are resolved in both, the architectural settings are not finalized.

34 *Purgatorio*, X.43, trans. Singleton, pp. 100–1: "in atto impressa esta favella."

35 *Purgatorio*, X.57, trans. Singleton, pp. 102–3: "per che si teme officio non commesso." Landino glosses this line: "El chuore *per cui si teme officio non commesso*: perché fu punita la temerità d'Oze toccando l'arca, la quale non era commessa a llui. Et di qui si dinota, che benché l'operation sia pia et di recta volontà, nientedimeno non debba el profano toccare le cose sacre" (*Comento*, ed. Procaccioli, III, pp. 1205–6).

36 *Purgatorio*, X.64–9, trans. Singleton, pp. 102–3: "Lì precedeva al benedetto vaso/trascando alzato, l'umile psalmista,/e più e men che re era in quel caso./Di contra, effigiato ad una vista/d'un gran palazzo, Micòl ammirava/sì come donna dispettosa e trista."

37 *Purgatorio*, X.70–1, trans. Singleton, pp. 102–3:

"I' mossi i piè del loco dov'io stava,/per avvisar da presso un'altra istoria."

38 *Inferno*, II.8–9, trans. Singleton, pp. 12–13: "o mente che scrivesti ciò ch'io vidi, qui si parrà la tua nobilitate."

39 *Paradiso*, XXX.58, trans. Singleton, pp. 338–9, 48–9: "di novella vista mi raccesi" and v.5, "perfetto veder".

40 *Paradiso*, XIV.49, trans. Singleton, pp. 154–5: "onde la visïon crescer convene." As Landino set out early in his commentary, it was held: "come el corpo ha gli occhi co' quali guarda et vede, chosí l'anima ha potentia con la quale investiga et discerne. La mente adunque è l'occhio dell'anima, et la ragione è el suo sgardare, et lo intellecto è el suo vedere et discernere" (*Comento*, ed. Proccaccioli, comment to *Inferno* IV.4–6, I, pp. 406–7). Landino had collected opinions on the operation of the eye and presented them in the second book of his treatise *De Anima*, as he took pains to remind the readers of the Dante commentary (*Paradiso*, XXVI.70–8, *Comento*, ed. Proccaccioli, IV, p. 1927); for Landino's encyclopedic work, see McNair, "Cristoforo Landino's *De anima*," *Rinascimento* (1992), pp. 227–45.

41 *Inferno*, III.79, trans. Singleton, pp. 28–9, "vergognosi e bassi"; *Inferno*, XXV.145–6, trans. Singleton, pp. 268–9, "E avvegna che li occhi miei confusi/fossero alquanto e l'animo smagato."

42 *Inferno*, XXIII.85: "con l'occhio bieco/mi rimiraron"; *Inferno*, XXXIII.76: "occhi torti." For preachers and the character of eyes, see Schleusener-Eichholz, "Der 'Tractatus de oculo morali'," *Frühmittelalterliche Studien* (1978), p. 281, quoting the sevenfold division of types of eyes corresponding to sins as described in the popular preaching manual, *De oculo morali*.

43 Among the many examples: *Paradiso*, III.22–3, trans. Singleton, pp. 28–9, Dante turns his eyes "dritti nel lume della dolce guida,/che sorridendo, ardea ne li occhi santi"; *Paradiso*, III.42, trans. Singleton, pp. 28–9, "con occhi ridenti"; *Paradiso*, IV.139–42, trans. Singleton, pp. 46–7, Beatrice looks at Dante, "con li occhi pieni/di faville d'amor così divini"; *Paradiso*, XIII.106, trans. Singleton, pp. 146–7, her "occhi chiari"; *Paradiso*, XVIII.8–9, trans. Singleton, pp. 198–9, "vidi/ne li occhi santi amor." For other examples of virtuous eyes, see *Purgatorio*, XXVII.106, trans. Singleton, pp.

296–7, Rachel, the symbol of the contemplative life, as she looks at herself in the mirror: "Ell'è d'i suoi belli occhi veder vaga"; *Purgatorio*, XXVIII.56–7, Singleton, pp. 306–7, describing Matilda: "non altrimente/che vergine che li occhi onesti avvalli."

44 *Convivio*, III.8.9–11, ed. Busnelli and Vandelli, I, pp. 351–2: "Dimostrasi ne li occhi tanto manifesta, che conoscer si può la sua presente passione, chi bene là mira. Onde, con ciò sia cosa che sei passioni siano propie de l'anima umana, de le quali fa menzione lo Filosofo ne la sua Rettorica, cioè grazia, zelo, misericordia, invidia, amore e vergogna, di nulla di queste puote l'anima essere passionata che a la finestra de li occhi non vegna la sembianza, se per grande vertù dentro non si chiude."

45 *The Literary Works of Leonardo da Vinci*, ed. Richter, I, p. 57, no. 23: "L'occhio, che si dice finestra dell'anima, è la principal uia, donde il comune senso pò più copiosa et magnificamente considerare l'infinite opere di natura, e l'orecchio è 'l secondo" ("The eye, which is the window of the soul, is the chief organ whereby the understanding can have the most complete and magnificent view of the infinite works of nature; and the ear comes second"); similarly, I, p. 367, no. 653: "L'occhio che si dice finestra dell'anima, é la principale via, donde il comvne senso può piv copiosa e magnificamente considerare l'infinite opere di natura" ("The eye, which one may well call the window of the soul, is the principal means by which the central sense can most completely and abundantly appreciate the infinite works of nature").

46 Quintilian, *Institutio oratoria*, VIII:3.61, trans. Butler, III, pp. 244–5.

47 *De partitione oratoria*, VII.20, in *Cicero*, IV, trans. Rackham, pp. 326–7.

48 *Convivio*, II.3.10, ed. Busnelli and Vandelli, I, p. III: "un'arte che si chiama perspettiva." For Dante and this art, see the chapters on the *Convivio*, *Vita nuova*, and the *Divina commedia* in Akbari Conklin, *Seeing through the Veil: Optical Theory and Medieval Allegory*, Gilson's book *Medieval Optics and Theories of Light in the Works of Dante*, and Parronchi's essay "La perspettiva dantesca," in *Studi sulla 'dolce' prospettiva*, pp. 3–90.

49 *Convivio*, II.9.4–5, ed. Busnelli and Vandelli, I, pp. 167–9: "qui si vuol sapere che avvegna che più cose ne l'occhio a un'ora possano

venire, veramente quella che viene per retta linea ne le punta de la pupilla, quella veramente si vede, e ne la imaginativa si suggella solamente." Dante was conversant with both theories. As Akbari Conklin points out in *Seeing through the Veil*, p. 116, he was able to use them according to his purpose, relying on the extramission model when he wanted to emphasize the "power of the seeing subject" and the intromission model when he wanted to "stress the power of the object seen."

50 *On Painting*, i.8, ed. Kemp, pp. 43–4.

51 Ibid., i.19, p. 54.

52 *The Literary Works of Leonardo da Vinci*, ed. Richter, i, p. 325, no. 542: "noi sappiamo che 'l punto è posto a l'ochio del riguardatore della storia" ("We know that the point of sight is opposite the eye of the spectator of the scene").

53 Ibid.: "e se tu volessi dire in che modo ò a fare la uita d'uno santo conpartita in molte storie in vna medesima facia, a questa parte ti rispondo che tu debi porre il primo piano col punto all'altezza dell'ochio de' riguardatori d'essa storia, e insù detto piano figura la prima storia grande e poi, diminvendo di mano in mano le figure a casamenti insù diuersi colli e pianvre, farai tutti il fornimento d'essa storia . . . altrimenti non te ne inpacciare, ch'ogni tua opera fia falsa."

54 Ibid., p. 117, no. 13: "la prospectiva adunque à da essere preposta a tutte le trattazioni e discipline vmane."

55 *On Painting*, ii.30, ed. Kemp, p. 64; *Opere volgari*, ed. Grayson, iii, pp. 52–3: "E dove la pittura studia ripresentare cose vedute, notiamo in che mode le cose si veggano"; "Nam cum pictura studeat res visas repraesentare, notemus quemadmodum res ipsae sub aspectu veniant."

56 Manetti, *Vita di Filippo Brunelleschi*, ed. de Robertis and Tanturli, p. 55: "Così ancora in que' tempi e' misse innanzi ed in atto luj propio quello ch'e dipintori oggi dicono prospettiva, perché ella è una parte di quella scienza, che è in effetto porre bene e con ragione le diminuizioni ed acrescimenti, che appaiono agli occhi degli uomini delle cose di lungi e dapresso" (translation from *Life of Brunelleschi*, trans. Engass and ed. Saalman, p. 43). For an account of this invention, its sources, its historical importance, and an evaluation of the evidence about Brunelleschi's

lost panels, see Kemp, *The Science of Art*, pp. 11–15.

57 Pliny, *Natural History*, xxxv.36.81–2, trans. Rackham, pp. 320–3.

58 *I commentarii*, ed. Bartoli, pp. 73–4: "Tengo che questo che Prinio scrive veramente può esser vero, ma molto mi maraviglo, sendo in costoro tanta profondità d'arte, e con tutte le parti del pittore e di geometria e dello scultore, mi pare certamente una debile dimostratione, e ·ssì fatto auctore recita la pruova di costoro, parlo come scultore e certo credo dovere esser così. Ma pure io parlerò, con riverentia di ciascuno lettore, io narrerò il creder mio, conciò sia cosa che Appelle compuose e publicò libri continente dell'arte della pictura. Essendo ito a Rodi, a casa Protogine, trovando la tavola apparechiata e volendo mostrare Appelle la nobiltà dell'arte della pictura, e quanto egli era egregio in essa, tolse il pennello e compuose una conclusione in prospettiva appartenente all'arte della pictura. Tornando Protogine, subito conobbe quella essere cosa d'Appelle et egli, come docto, Protogine ne fece un'altra conclusione, rispondente a quella. Tornando Appelle . . . esso Protogine si nascose. Vide Appelle rifare un'altra conclusione di tanta perfectione e di tanta maravigla nell'arte, non era possibile a Protogine agiugnere a essa, e vergognossi d'esser vinto . . . Piacque a Protogine quella tavola, dove erano fatte le linie di mano d'Appelle, fosse veduta da tutto el popolo, overo conclusioni appartenenti alla pictura, e spetialmente da' pictori e dagli statuarii, e da quelli erano periti. Ciascuno si ·llodava maraviglosamente." The im-plications of this "revealing emendation" have been discussed by Gombrich, "The Renaissance Conception of Artistic Progress and its Consequences," *Norm and Form*, pp. 7–8.

59 *I commentarii*, ed. Bartoli, p. 74: "Aveva Appelle, per usanza e per grande occupatione, esso avesse ogni dì compuorre qualche conclusione di nuovo appartenente all'arte, e con grande studio sempre exercitava l'arte però era tanto docto in essa. Misurava l'opere sue come la natura, allato alla virtù visiva."

60 Ibid., p. 95: "Le quali istorie, molto copiose di figure, erano istorie del testamento vecchio, nelle quali mi ingegnai con ogni misura osservare in esse, cercare imitar la natura quanto a me fosse possibile, e con tutti i linimenti che

in essa potessi produrre e con egregii componimenti e dovitiosi con moltissime figure . . . Furono istorie dieci tutti in casamenti, colla ragione che l'ochio gli misura e veri in modo tale, stando remoti, da essi appariscono rilevati. Anno pochissimo rilievo et in su e piani si veggono le figure che sono propinque apparire maggiori e ·lle remote minori, come adimostra il vero. E ò seguito tutta questa opera con dette misure"; the translation quoted here is from Krautheimer, *Lorenzo Ghiberti*, I, p. 14.

61 *I commentarii*, ed. Bartoli, p. 95: "Cominciai detto lavorio in quadri." Ghiberti starts his paragraph about this commission stating that he was given the freedom to do it as he thought best ("Fummi allogata l'altra porta, cioè la terza porta di sancto Giovanni, la quale mi fu data licentia io la conducessi in quel modo ch'io credessi tornasse più perfettamente e più ornata e più riccha"). See p. 97 for his description of the outer frame of the door, still to be put in place, "Ancora va una cornice di bronzo."

62 Ibid., p. 95: "Le storie sono dieci. La prima è la creatione dell'uomo e della femina . . . contiene in detto [quadro] quattro istorie cioè effetti"; subsequently about the *Creation* and the following panel with the story of Cain and Abel, p. 96, "così in ciascuno quadro apparisce gli effetti di quattro istorie."

63 Krautheimer, *Lorenzo Ghiberti*, I, p. 14; *I commentarii*, ed. Bartoli, p. 96: "Nel quinto quadro è come a Ysaach nasce Esaù et Iacob, e come e' mandò Esaù a cacciare e come la madre amaestra Iacob, e porgeli il caveretto e la pelle, e poglele al collo e dicegli chiegga la benedictione a Isaach; e come Isaach gli cerca il collo e truovolo piloso, dagli la benedictione."

64 *Convivio*, III.2.5, ed. Busnelli and Vandelli, I, p. 265: "ciascuno effetto ritegna de la natura de la sua cagione" and III.3.11, pp. 326–7, referring to Aquinas, *De causis*: "sì come è scritto nel libro allegato de le Cagioni, ogni cagione infonde nel suo effetto de la bontade che riceve da la cagione sua."

65 Krautheimer, *Lorenzo Ghiberti*, II, p. 372, doc. 52. The letter, written sometime in the spring of 1424, is addressed to Niccolò da Uzzano and to the other members of the guild forming the committee deputed to decide about the commission ("Spettabili huomini Niccolo da Uzzano e Compagni, deputati etc."): "Bisognerà che colui, che l'ha a disegnare, sia bene instrutto di ciascuna historia . . . Ma bene vorrei essere presso a chi l'harà a disegnare per fargli prendere ogni significato, che la storia importa."

66 Ibid.: "vogliono avere due cose principalmente: l'una che siano illustri, l'altra che siano significanti. Illustri chiamo quelle che possono ben pascere l'occhio con varietà di disegno, significanti chiamo quelle che abbino importanza degna di memoria." See ibid., I, pp. 159–61, for a letter of June 21, 1424, when Ambrogio Traversari wrote ironically to Niccolò Niccoli: "I understand and approve your feelings concerning the narrative scenes (*storie*) which are to be sculptured . . . but I fear those in charge of this work are somewhat rash. I hear they have consulted Leonardo [Bruni] of Arezzo and I conjecture the rest from this glorious beginning."

67 *Purgatorio*, X.103–4, trans. Singleton, pp. 104–5: "ch'a mirare eran contenti/per veder novitadi ond'e' son vaghi"; the translation quoted above is from *The Divine Comedy*, trans. Sisson, p. 241.

68 In Canto XXIV of *Purgatory* Dante is asked by the poet Bonagiunta of Lucca if he might be the one who began the new poetic style, lines 49–57: "Ma dì s'io veggio qui colui che fore/trasse le nove rime, cominciando/'Donne ch'avete intelletto d'amore'./E io a lui 'I' mi son un che, quando/Amor mi spira, noto, e a quel modo/ch'e' ditta dentro vo significando'/'O frate, issa veggi'o', diss'elli, 'il nodo/che 'l Notaro e Guittone e me ritenne/di qua dal dolce stil novo ch'i'odo!'"; the line that Bonagiunta recites ("Donne ch'avete intelletto d'amore") is the opening of the *canzone* which, as Dante explains in the *Vita nuova*, marked a turning point in his poetry, when he made its subject the praise of his beloved Beatrice (*Vita nuova*, XVIII, ed. Sanguineti, p. 29).

69 *Dante and his Circle*, trans. Rossetti, p. 56. *Rime della "Vita nuova"*, XIV.51–4, ed. Barbi and Maggini, p. 75: "De li occhi suoi, come ch'ella li mova/escono spiriti d'amore inflammati/che feron li occhi a qual che allor la guati,/e passon sì che 'l cor ciascun retrova." For the physiology of love, see Siegel, *Galen on Sense Perception* and for the application in fifteenth-century theories of love, see Hyatte, "The 'Visual Spirits' and Body–Soul Media-

tion: Socratic Love in Marsilio Ficino's *De Amore*," *Rinascimento* (1993), pp. 213–22.

70 Lorenzo de' Medici, *A Commentary on my Sonnets*, trans. Cook, pp. 89, 91; *Comento*, ed. Zanato, pp. 184–5, sonnet 7, "Occhi, voi siete pur dentro al mio core": "Era già per li occhi miei discesa al cuore la imagine della bellezza di costei, e gli occhi suoi avevano fatto in esso tale impressione che sempre gli erono presenti."

71 *Inferno*, IV.13, trans. Singleton, pp. 34–5: "cieco mondo"; *Purgatorio* I.13–18, trans. Singleton, pp. 2–3: "Dolce color d'oriental zaffiro,/che s'accoglieva nel sereno aspetto/del mezzo, puro infino al primo giro,/a li occhi miei ricominciò diletto,/tosto ch'io usci' fuor de l'aura morta/che m'avea contristati li occhi e 'l petto."

72 *The "Opus Maius" of Roger Bacon*, Part V, first distinction, Chapter 1, trans. Burke, I, p. 41, quoting Aristotle, because, "only sight shows us the differences of things; by means of it we search our certain knowledge of everything in heaven and earth."

73 *Purgatorio* X.34–8, 97–9, trans. Singleton, pp. 100–1, 104–5: "L'angel che venne in terra . . . dinanzi a noi pareva . . . quivi intagliato in un atto soave"; and "Mentr'io mi dilettava di guardare/l'imagini di tante umilitadi,/e per lo fabbro loro a veder care." In the *Convivio*, Dante defines a "pensiero soave" as being "abbellito, dolce, piacente e dilettoso" (II.7.5, ed. Busnelli and Vandelli, I, pp. 150–1).

74 Alberti, *On Painting*, II.40, ed. Kemp, p. 75; *Opere volgari*, ed. Grayson, III, p. 68: "Sarà la storia, qual tu possa lodare e maravigliare, tale che con sue piacevolezze si porgerà sì ornata e grata, che ella terrà con diletto e movimento d'animo qualunque dotto o indotto la miri"; "Historia vero, quam merito possis et laudare et admirari, eiusmodi erit quae illecebris quibusdam sese ita amenam et ornatam exhibeat, ut oculos docti atque indocti spectatoris diutius quadam cum voluptate et animi motu detineat."

75 *Purgatorio*, IV.1–12, trans. Singleton, pp. 34–5: "Quando per dilettanze o ver per doglie,/che alchuna virtù nostra comprenda,/l'anima bene ad essa si raccoglie,/par ch'a nulla potenza più intenda . . . E però quando s'ode chosa o vede/che tegna forte a sé l'anima volta,/vassene 'l tempo e l'uom non se n'avvede/ch'altra

potenza è quella che l'ascolta,/e altra è quella c'ha l'anima intera: questa è quasi legata e quella è sciolta/ Di ciò ebb'io esperienza vera,/udendo quello spirto e ammirando."

76 Landino, *Comento*, ed. Procaccioli, III, p. 1099: "Adunque l'occhio vede alchuna chosa, che molto lo dilecti; tutta l'anima si raccoglie tanto ad epsa potentia visiva, non ministrando la sua virtú ad altra potentia, che pare, che piú non intenda, non solamente ad alchuna altra potentia sensitiva, ma né anchora memorativa, chome è apprensiva, imaginativa, et ritentiva, le quali virtú tutte sono spetie delle potentie dell'anima."

77 Aristotle, *Nicomachean Ethics*, II.3 (1104b14–15 and 1104b9–10), in *Complete Works*, ed. Barnes, II, p. 1744. The drawing is in the collection of Christ Church, Oxford (0034); see Byam Shaw, *Drawings by Old Masters at Christ Church Oxford*, I, pp. 36–7, II, pl. 10, no. 17 (verso), pen and ink, 21 × 28.9 cm., a sheet of allegories with explanations. The allegory of Pleasure and Pain is a figure with two heads and four arms, with short explanatory inscriptions directly above and below, translated as: "Pleasure and Pain are represented as twins, as though they were joined together, for there is never the one without the other; and they turn their backs because they are contrary to each other." There is a longer comment at the upper left of the sheet, with the phrase quoted here.

78 *Nichomachean Ethics*, II.3 (1105a6–7), in *Complete Works*, ed. Barnes, II, p. 1745.

79 *On the Soul*, II.3 (414b1–5), in *Complete Works*, ed. Barnes, I, pp. 659–60.

80 *Inferno*, V.28, trans. Singleton, pp. 48–9: "Io venni in loco d'ogne luce muto"; Landino, *Comento*, ed. Procaccioli, I, p. 450, "Et pone questi in luogho tenebroso, perché havendo molto peccato cho gli occhi, e quali sono guida nello amore, et havendo preso dilecto delle belleze corporali, le quali tutti consiston nel vedere, è conveniente pena che sieno privati dell'uso di quel senso, con quale hanno peccato."

81 *Metaphysics*, I.1 (980a25), in *Complete Works*, ed. Barnes, II, p. 1552.

82 *Convivio*, I.1.1, ed. Busnelli and Vandelli, I, p. 3: "Sì come dice lo Filosofo nel principio de la Prima Filosofia, tutti li uomini naturalmente desiderano di sapere"; *The Literary Works of*

Leonardo da Vinci, ed. Richter, I, p. 115, no. 10: "Naturalmente li omini boni desiderano di sapere."

83 *Commento di Francesco da Buti sopra la Divina Commedia di Dante Allighieri*, ed. Giannini, II, p. 238: "*Mentr'io*; cioè Dante, *mi dilettava di guardare l'imagini*; che erano in quello marmo scolpite, di tante umilitadi; quanto quelle scolpiture dimostravano, de le quali è stato ditto di sopra, *E per lo fabro loro*; cioè Iddio, che quive l'avea scolpite, a veder care: caro è vedere l'artificio di sì fatto maestro. Secondo la finzione de l'autore, Iddio avea fatto quella scolpitura in quello marmo quando fece lo *Purgatorio*, per dare ad intendere che quelli che sono nel *Purgatorio* ànno pensamento a le virtudi contrarie a li peccati di che si purgano, per le quali ricognosceno li loro errori et ànno debita contrizione dei lor peccati, e pazientamente portano la pena."

84 Quintilian, *Institutio oratoria*, VIII.7, trans. Butler, III, pp. 180–1: "Oratoris officium docendi, movendi, delectandi."

85 Cicero, *Brutus, Orator*, trans. Hendrickson and Hubbell, *Orator*, XX.69, pp. 356–7: "Erit igitur eloquens . . . ita dicet, ut probet, ut delectet, ut flectat."

86 *De oratore*, III.23.91, trans. Rackham, pp. 72–3.

87 Ibid., III.7.25–6, pp. 20–3; see also *De partitione oratoria*, VI.20, in Cicero, IV, trans. Rackham, pp. 326–7.

88 *Convivio*, IV.6.5–9, ed. Busnelli, II, pp. 60–1: "si prende per ogni persona degna d'essere creduta e obedita. E da questo viene questo vocabulo . . . 'autoritade' vale tanto quanto 'atto degno di fede e d'obedienza' . . . Intra operarii e artefici di diverse arti e operazioni . . . l'artefice o vero operatore di quella massimamente dee essere da tutti obedito e creduto, sì come colui che solo considera l'ultimo fine di tutti li altri fini . . . E però che tutte l'umane operazioni domandano uno fine . . . lo maestro e l'artefice che quelle ne dimostra e considera, massimamente obedire e credere si dee."

89 *Inferno*, I.85–7, trans. Singleton, pp. 38–9: "Tu se' lo mio maestro e'l mio autore/tu se' solo colui da cu'io mi tolsi;/lo bello stilo che m'ha fatto onore"; for this concept in Dante, see the articles on "autore" and "autorità" by Stabile in the *Enciclopedia dantesca*, I, pp. 456–7.

90 Bruni, *The Study of Literature*, in *Humanist Educational Treatises*, trans. and ed. Kallendorf, pp. 96–7.

91 Ibid., pp. 98–9.

92 *Commento di Francesco da Buti sopra la Divina commedia di Dante Allighieri*, ed. Giannini, II, p. 264: "nessuno è stato poi che in quell'arte sia valuto quanto elli, non che più che elli." The passage is from *Purgatorio*, XI.91–6, trans. Singleton, pp. 114–15: "O empty glory of human powers! how briefly lasts the green upon the top, if it is not followed by barbarous times! Cimabue thought to hold the field in painting, and now Giotto has the cry, so that the other's fame is dim"; "Oh vana gloria de l'umane posse!/com' poco verde in su la cima dura,/se non è giunta da l'etati grosse!/ Credette Cimabue ne la pittura/tener lo campo, e ora ha Giotto il grido,/sì che la fama di colui è scura."

93 *The Craftsman's Handbook*, trans. Thompson, p. 2.

94 *The Literary Works of Leonardo da Vinci*, ed. Richter, I, p. 372, no. 660, in a section that describes the way "that painting declines and deteriorates from age to age, when painters have no other standard than painting already done" and opens with the observation: "Siccome il pittore avrà la sua pittura di poca eccielenza se quello piglia per autore l'altrui pitture" instead of learning from nature (p. 371).

95 Quoted by Chastel, "Vasari et la légende médicéenne: l'école du jardin de Saint Marc," in *Studi vasariani*, May 9, 1490 from Vignone (as referring to the sculptor Baccio da Montelupo, an identification that has not been accepted), p. 163: "parmi persona intendente, e che si dilecti di vedere anticaglie. Vorrei che tu li facessi mostrare tutte quelle dell'orto e così delle nostre altre che sono nello scriptoio."

96 Roscoe, *The Life of Lorenzo de' Medici*, II, Appendix, LXXXI, p. 96: "li monstrai la casa, le medaglie, vasi et cammei et in summa ogni cosa per insino al giardino, di che prese grande piacere, benchè non credo s'intenda molto di scultura. Pure gli piaceva assai la notitia et l'antiquità delle medaglie, et tutti si maravigliavano del numero di sì buone cose, &c." These successive letters are mentioned by Kent, *Lorenzo de' Medici*, p. 33 and have been republished by Corti and Fusco, *Lorenzo de' Medici, Collector and Antiquarian*, docs. 136, 137.

97 *Petrarch's Remedies for Fortune Fair and Foul*, trans. Rawski, pp. 126, 134. The chapters are Book 1, 40 (*Pictis tabulis delector*) and 41 (*At delector statuis*). See Baxandall, *Giotto and the Orators* for the Latin texts (pp. 140–3) and a discussion of the importance of the *De remediis utriusque fortunae* (pp. 53–8).

98 *Petrarch's Remedies for Fortune Fair and Foul*, trans. Rawski, pp. 133–4.

99 Ibid., p. 131.

100 Kennedy, Wilder, Bacci, *The Unfinished Monument by Andrea del Verrocchio to the Cardinal Niccolò Forteguerri at Pistoia*, doc. 6, p. 78, March 11, 1477: "Ora a voi, come a nostro protectore, mandiamo e' decti modelli, perché di simili cose et d'ogni altra n'avete pienissima intelligentia." This episode has been analyzed by Milner, "The Politics of Patronage: Verrocchio, Pollaiuolo, and the Forteguerri Monument," in *Artistic Exchange and Cultural Translation in the Italian Renaissance City*, ed. Campbell and Milner, pp. 221–45, who publishes new documents and sets Lorenzo's intervention within the context of Medici "patrimonialism" over a subject city, as "premised on a mutual exchange of favours within the market place of symbolic capital" (p. 226).

101 For this letter, dated November 12, 1489 and sent by Lorenzo in Florence to Giovanni Lanfredini in Rome, see Wright, *The Pollaiuolo Brothers*, p. 19 and the transcription, n. 202, p. 432 (ASF, Mediceo avanti il Principato, LI, 252): "In questa tornata in costa di Antonio del Pollaiuolo habbiamo havuto insieme [ragionamento?] d'una altra cosa che lui vi riferirà la quale io disidero tanto quanto alcuna altra simile ne potrei recevere cosa più grata che essere compiaciuto."

102 See Manetti's biography of Brunelleschi, for the description of the 1401 competition for the first set of doors and the consultation of the deputed members of the Calimala guild with "huomini intendenti . . . com'erano orafi, dipintori ed altri scultori" (*Vita di Filippo Brunelleschi*, ed. de Robertis and Tanturli, p. 62). Ghiberti also says that his entry was awarded the prize by expert painters and sculptors: "Furono huomini molti periti, tra pictori e scultori" (*I commentarii*, ed. Bartoli, Book II, p. 93).

103 *Two Renaissance Book Hunters*, trans. Good-hart Gordon, no. LII, October 21, 1427, p. 118 and no. LXXXIV, September 23, 1430, p. 167.

104 *The Vespasiano Memoirs*, trans. George and Waters, pp. 397, 401; *Le vite*, ed. Greco, II, pp. 229, 237: "Infinite isculture et cose degne, che non erano in Firenze, col mezo di Nicolaio s'ebono. Fu molto intendente di pitura et iscultura"; "Non solo Nicolaio prestò favore a uomini litterati, ma intendendosi di pitura, scoltura, architettura, con tutti ebbe grandissima notitia, et prestò loro grandissimo favore nel loro exercicio, Pipo di ser Brunelesco, Donatello, Luca della Robia, Lorenzo di Bartoluccio, et di tutti fu amicissimo."

105 *The Vespasiano Memoirs*, trans. George and Waters, p. 399; *Le vite*, ed. Greco, II, pp. 232–3: "Aveva oltre all'altre sua singulari virtù . . . uno universale giudicio, non solo delle lettere, ma . . . di pitura e di scoltura, et aveva in casa sua infinite medaglie di bronzo, d'ariento et d'oro, et molte figure antiche d'ottone, et molte teste di marmo, et altre cose degne. Iscadè un dì che andando Nicolaio fuori di casa, vidde uno fanciullo che aveva uno calcidonio al collo, dove era una figura di mano di Policreto molto degna, che si chiamò calcidonio. Domandò il fanciullo di chi egli era figliuolo, et, inteso il nome del padre, mandò a domandare il padre glielo vendessi. Fu contento come quello che nollo conosceva e nollo istimava; mandogli cinque fiorini. Al buono uomo di che egli era, parve che gliene donassi più che la metà. Avendo di poi Nicolaio questo calcionio, lo monstrava per una figura singularissima, come ella era."

106 Spallanzani and Bertelà, eds. *Libro d'inventario dei beni di Lorenzo il Magnifico*, p. 39: "Uno chalcidonio chon una fighura intagliata di chavo meza a sedere in su uno altare, chol piè sotto e la ghamba mancho distesa, uno braccio adrieto chon uno choltello in mano, uno panno in sulla spalla et braccio ritto e in mano una fighura armata, d'oro, in chavo trasparente, sanza fondo . . . f. 1500." A plaster cast illustrated in Fusco and Corti, *Lorenzo de' Medici, Collector and Antiquarian*, fig. 3, shows that it was among the gems inscribed "LAV.R.MED." The gem given the greatest value in the inventory, 2,000 florins, was the *Ark of Noah* cameo now in the British Museum, *Libro d'invenario dei beni di Lorenzo il Magnifico*, p. 38: "Uno chammeo grande leghato in

oro, chiamato l'archa . . . f. 2000." Lorenzo's acquisition of the chalcedony is noted in his *Ricordi*, quoted by Fusco and Corti, p. 6, who give a comprehensive account of the fate and fortune of this prized gem, listing copies and variants and correcting previous discussions of its provenance and descent (pp. 247–8, n. 47). Now lost, it is traced by them to the sixteenth century when it was inherited by Margaret of Austria from her husband, Duke Alessandro de' Medici, in 1537 and inventoried among her possessions at the time of her death in 1586 (docs. 297, 313, pp. 384, 387).

107 *I commentarii*, ed. Bartoli, Book III, p. 109: "Fra l'altre egregie cose io vidi mai, è uno calcidonio intaglato in cavo mirabilmente, el quale era nelle mani d'uno nostro cittadino, era il suo nome Nicholaio Nicholi, fu huomo diligentissimo, e ne' nostri tempi fu investigatore e cercatore di moltissime et egregie cose antiche . . . Et, in fra·ll'altre cose antiche, aveva questo calcidonio el quale è perfettissimo più che cosa io vedessi mai. Era di forma ovale, in su esso era una figura d'uno giovane aveva in mano uno coltello, era con uno piede quasi ginocchioni in su un'altare e la gamba dextra era a·ssedere in sull'altare, e posava il piè in terra el quale scorciava con tanta arte e con tanto maesterio, era cosa maraviglosa a vederlo. E nella mano sinestra aveva un pannicello el quale teneva con esso uno idoletto; pareva el giovane il minacciasse col coltello, essa scultura per tutti i periti e amaestrati di scultura o di pittura, sanza scordanza nessuna, ciascuno diceva essera cosa maravigliosa con tutte le misure e le proportioni debbe avere alcuna statua o scultura, da tutti li ingegni era lodato sommissimamente."

108 BNCF, MS 2 (now P), v, 13, fol. 83v, published by Borsook, "Two Letters Concerning Antonio Pollaiuolo," *Burlington Magazine* (1973), p. 468, doc. 1: "Antonio è il principale maestro di questa città e forse per avventura non cie ne fu mai e questa è comune opinione di tutti gl'intendenti."

109 *Petrarch's Remedies for Fortune Fair and Foul*, trans. Rawski, p. 131; Baxandall, *Giotto and the Orators*, p. 141: "Cum praeterea pene ars una, vel si plures, unus (ut diximus) fons artium graphidem dico." The origin of painting in tracing lines is taken from Pliny *Natural History* (see XXXV.5.15–16, trans. Rackham, pp. 270–1).

110 *I commentarii*, ed. Bartoli, p. 47: "et ancora sia perfectissimo disegnatore, conciò sia cosa lo scultore e 'l pictore, el disegno è fondamento e teorica di queste due arti. Conviene sia molto perito in detta teorica, non può sapere né essere perfecto scultore né etiando perfecto pictore, tanto è perfecto lo scultore quanto è perfecto disegniatore, e così il pictore; detta teorica è origine e fondamento di ciascuna arte"; in the notes Bartoli quotes the passages from the first book of Vitruvius's *De architectura* (1.1.3) being followed by Ghiberti.

111 *I commentarii*, ed. Bartoli, p. 51, discussing the origins of art in a paragraph based on Pliny, he comments: "Questi furono inventori dell'arte della pictura e della scultura, mostrorono la teorica del disegno; sanza essa teorica non si può essere buono statuario né buono pittore, tanto è buono lo scultore o veramente el pittore, quanto è perito in detta teorica, cioè in detto disegno, el quale non s'aquista sanza grande studio né sanza grande disciplina."

112 These terms are from Landino's comment to *Inferno*, IV.5–6, *Comento*, ed. Procaccioli, I, pp. 406–7: "*et fiso riguardai*: è necessario, se vogliamo rectamente contemplare, che la mente tranquilla et vacua d'ogni perturbatione et passione si muova intorno, *id est* si volga a tutte le parti, et chol risguardo della ragione stia ferma et fisa, perché non basta a chi vuole trovate la verità fare discorso per tutte le chose, se non vi si volge chon ogni acume d'ingegno, et quello affisi, *id est* tengha fermo, et di quivi non lo diparta, acciochè dall'occhio et dal suo sguardare nasca il vedere, cioè lo 'ntendere et conoscere el luogho dove ci ritroviamo."

113 Palmieri, *Vita civile*, ed. Belloni, p. 46: "il fine d'ogni arte sia quella perfectamente intendere et dilectarsi nella sua vera cognitione per quiete dello intellecto che per sua natura disidera interamente sapere."

114 *Purgatorio*, XII.64–6, trans. Singleton, pp. 124–5: "Qual di pennel fu maestro o di stile/che ritraesse l'ombre e' tratti ch'ivi/mirar farieno uno ingegno sottile?"

CHAPTER SIX VISION AND BELIEF

1 Paolo da Certaldo, *Il libro di buoni costumi*, in *Mercanti scrittori*, ed. Branca, p. 8, no. 32, "Chome il corpo ha due occhi corporali, chosì l'anima de'e avere due occhi spirituali, e l'uno

tenere aperto a la groglia di paradiso e l'altro a le pene del lo 'nferno. E così facendo, mai non offenderai Iesu Christo benedetto, avendo timore de le pene de lo 'nferno e fede e speranza de' beni di vita eterna."

2 *Summa Theologiae: Pars prima et prima secundae*, ed. Caramello, p. 20, 1a–11ae, q. 3, a. 5 co.: "ideo talis operatio est maxime propria homini, et maxime delectabilis."

3 Dante, *The Divine Comedy*, trans. Singleton, *Paradiso*, xxx.56–8, pp. 338–9: "ch'io compresi/me sormontar di sopr'a mia virtute;/e di novella vista mi raccesi" and verses 97–8, pp. 340–1: "O isplendor di Dio, per cu' io vidi/l'alto triunfo del regno verace."

4 *Paradiso*, xxx.95–6, ibid., pp. 340–1: "sì ch'io vidi/ambo le corti del ciel manifeste."

5 *Paradiso*, x.6–7, ibid., pp. 106–7: "Leva dunque lectore, a l'alte rote/meco la vista," and verses 9–12, "Et li comincia a vagheggiar ne l'arte/di quel maestro che dentro a sé l'ama,/tanto che mai da lei l'occhio non parte." The notion of God's "art" or handiwork comes from Psalms, 19:1: "The heavens declare the glory of God: and the firmament showeth his handiwork."

6 *Paradiso*, x.43–5, ibid., pp. 108–9: "Perch'io lo 'ngegno e l'arte e l'uso chiami,/sì nol direi che mai s'imaginasse; ma creder puossi e di veder si brami." Dante's conception of the beatific vision and the relation between the natural desire of the intellect to see God is based on the notion of the vision of God *per essentiam* as expounded by Aquinas. For this see Torrell, "La Vision de dieu *per essentiam* selon Saint Thomas D'Aquin," *Micrologus* (1997), pp. 43–68.

7 Aquinas, *Scriptum super sententiis*, lib. 3, dist. 9, q. 1, a. 2, qc. 2, ad 3: "Fuit autem triplex ratio instituionis imaginum in Ecclesia. Primo ad instructionem rudium, qui eis quasi quibusdam libris edocentur. Secundo ut incarnationis mysterium et sanctorum exempla magis in memoria essent, dum quotidie oculis repraesentantur. Tertio ad excitandum devotionis affectum qui ex visis efficacius incitatur quam ex auditis."

8 *Decrees of the Ecumenical Councils*, ed. Tanner, p. 136: "Imaginis enim honor ad primitivum transit; et qui adorat imaginem, adorat in ea depicti subsistentiam."

9 Ibid.: "Quanto enim frequentius per imaginalem formationem videntur, tanto qui has

contemplantur, alacrius eriguntur ad primitivorum earum memoriam et desiderium . . . Non tamen veram latriam, quae secundum fidem est, quaeque solam divinam naturam decet, impartiendam."

10 Antoninus does not quote Aquinas directly; his text is based on Aquinas or a previous adaptation, expanding very slightly on some passages by way of clarification, see Sancti Antonini, *Summa Theologica*, III, *Titulus* 12, cap. ix, col. 544, *Imago qualiter debeat adorari*: "De adoratione imaginum nota secundum Thomam in 3. par. quaest. 25, art. 4, in corpore argum, quod secundum philosophum duplex est motus in imaginem. Unus est in ipsam imaginem, in quantum est quaedam res, puta lignum vel lapis & hujusmodi. Alius in imaginem, in quantum imago est repraesentativa alicujus. Et inter hos motus est ista differentia, quia primus motus, quo quis movetur in imaginem, prout est quaedam res, est alius a motu, qui est in rem, cujus scilicet est imago. Secundus motus, qui est in imaginem, in quantum imago, est unus & idem cum illo, qui est in re. Igitur, si consideramus imaginem Christi & sanctorum, in quantum est quae-dam res, puta lignum vel pictum vel sculptum; sic nulla reverentia est exhibenda, quia reverentia non debetur nisi rationali creaturae. Sed si consideremus imagines Christi vel Sanctorum repraesentatas, sic reverentiam & adorationem exhibere debemus, sicut & ipsis." For Aquinas, see *Summa Theologiae: Tertia pars*, ed. Caramello, p. 146, q. 25, a. 3 res.: "duplex est motus animae in imaginem: unus quidem in imaginem ipsam secundum quod est res quaedam; alio modo, in imaginem inquantum est imago alterius. Et inter hos motus est haec differentia, quia primus motus, quo quia movetur in imaginem prout est res quaedam, est alius a motu qui est in rem: secundus autem motus, qui est in imaginem inquantum est imago, est unus et idem cum illo qui est in re. Sic igitur dicendum est quod imagini Christi inquantum est res quaedam, puta lignum sculptum vel pictum, nulla reverentia exhibetur: quia reverentia debetur non nisi rationali naturae. Relinquitur ergo quod exibeatur et reverentia solum inquantum est imago. Et sic sequitur quod eadem reverentia exhibeatur imagini Christi et ipsi Christo." The question of forms of veneration is further addressed by Aquinas in q. 25,

a. 4 ("Utrum crux Christi sit adoranda adoratione latriae"; ed. Caramello, p. 147). For the date and purpose of Antoninus's *Summa*, see Chapter 1 of Howard's book on his preaching, *Beyond the Written Word*.

11 *Meditations on the Life of Christ*, ed. Ragusa and Green, p. 39. Since the eighteenth century the *Meditations* have been attributed alternatively to the Franciscan Giovanni de Caulibus of San Gimignano or to the Pseudo-Bonaventure, see pp. xxi–xxiii of Ragusa and Green's edition and Stallings' introduction to her edition, *Meditaciones de passione Christi*, which also discusses the diffusion of this enormously influential text.

12 *Meditations*, ed. Ragusa and Green, p. 40.

13 Ibid., p. 317.

14 Ibid., p. 2.

15 Ibid., p. 3.

16 *Giordano da Pisa e l'antica predicazione volgare*, ed. Delcorno, pp. 50–1: "Sono molti matti, calzolaiuoli, pillicciaiuoli – e vorrassi fare disponitore de la Scrittura Santa. Grande ardimento è, troppo è grave offendimento il loro! E se questo è negli uomini, si è nelle femine maggiormente, però che·lle femine sono troppo più di lungi che·ll'uomo da le Scritture e da la lettera, e trovansine di quelle ch·ssi ne fanno sponitori de la pìstola e del vangelo. Grande è la follia loro, troppo è la loro scipidezza."

17 *Prediche sopra Ruth e Michea*, ed. Romano, "Sopra Michea VII:14" (September 11, 1496), no. 25, II, p. 277: "Leggi cose di Dio e chi ti eccitino allo amore suo. Ma tu che di': – Io non so leggere –. Vuo' tu che io t'insegni uno buono libro per te, che tu lo saprai leggere? Tieni el Crucifisso in camera tua: questo sia el tuo libro. Non fare come colui che tiene figure disoneste in camera sua, che incitano a libidine. Credi a me, che noi siamo mossi da' sensi. Tieni adunque el Crucifisso per tuo libro, e leggi quello, e vedrai che questo sarà ottimo remedio a conservarti questo lume." Discussing the widely read devotional manual, the *Specchio della croce*, by the fourteenth-century Florentine Dominican Domenico Cavalca, Bolzoni considers Cavalca's application of the metaphor of Christ crucified as "open book," with references to the currency of this idea (*La rete delle immagini*, p. 107).

18 Landucci, *A Florentine Diary 1450–1516*, trans. de Rosen Jervis, pp. 11–12. *Diario fiorentino dal 1450 al 1516*, ed. del Badia, p. 13: "E a dì 11 di dicembre 1473, fu in Camaldoli, in casa una poveretta, ch'aveva parecchi fanciulle da marito, e raccomandandosi a'loro Crocifisso in casa vidono sudarlo, e, dicendolo in vicinanza, vi cominciò andare giente, e sentendolo e frati del Carmino v'andorono e tolsolo con divozione, e posolo in uno tabernacolo in quella Cappella della Croce, e fu in divozione." The crucifix, known as the *Crocifisso della Provvidenza*, was first housed in a Serragli family chapel and in 1486 was put under the care of one of the Carmine's extant confraternities, the Compagnia del Crocifisso e Sant'Alberto. Still a cult object, it is now in a chapel in the tribune of the church; see Richa, *Notizie istoriche delle chiese fiorentine*, X, pp. 47–55. I would like to thank Jill Burke for showing me a draft of her article discussing the crucifix in the context of the devotional life of the neighborhood ("Visualizing Neighbourhood in Renaissance Florence," *Journal of Urban History* [2006], pp. 693–710).

19 Quoted from Gilbert, *Italian Art 1400–1500: Sources and Documents*, p. 145 (*Regola del governo di cura familiare*, ed. Salvi, p. 131).

20 Ibid., pp. 145–6 (*Regola*, p. 132).

21 *Ricordi*, ed. Branca, p. 456 (*Mercanti scrittori*, ed. Branca, pp. 293–4): "E' si raccomandò moltissime volte a Dio e alla sua madre Vergine Maria, facendosi recare la tavola della Donna innanzi, quella abbracciando con tante invenie e con tanti prieghi e boti, che non è sì duro cuore che non fusse mosso a gran pietà di vederlo." Giovanni's ceremony is one of the cases analyzed in detail by Trexler in his chapter on "Studies in Ritual Communication," in *Public Life in Renaissance Florence*, pp. 172–86. It is also discussed by D. Kent in a section on "Vision: The Power of the Image" in *Cosimo de' Medici*, pp. 98–100.

22 *Ricordi*, ed. Branca, pp. 476–7 (*Mercanti scrittori*, ed. Branca, pp. 303–4): "con più fervore e amore disponendo l'anima e 'l corpo e tutti i miei sentimenti, dimenticando l'anima propia e ogni altro mio bene, dinanzi alla figura del crocifisso Figliuolo di Dio, alla quale esso molte volte la salute del corpo raccomandata nella sua infermità avea, a ginocchie ignude e 'n camicia, sanza avere sopra alla testa alcuna cosa, colla correggia in collo, nel mio orazione così verso di quello raguardando, incominciai prima a immaginare e raguardare in me i miei

peccati . . . E appresso, considerando con quanta dura, acerba e scura passione Yesù Cristo crocifisso, la cui figura ragguardava, avea dall'eternali pene ricomperato, non pati' a' miei occhi Lui con durezza ragguardare, ma, credo per dono di pietà per Lui a me conceduta . . . per li miei occhi il viso di lagrime si bagnava."

23 Ibid., pp. 484–6 (*Mercanti scrittori*, ed. Branca, pp. 307–8): "E quietato il cuore e la mia mente, si volsono i miei occhi sul destro lato del vero Crocifisso, dove, riguardando, a piè della croce vidi la pura e santa sua benedetta Madre. La quale considerai piena del sommo dolore e di somma tristizia; e considerando che' miei peccati l'erono cagione di tanta affrizione, non ardì la mia lingua a isciogliere alcuna parola . . . ma considerando nella mente il dolore di quella pura Vergine . . . e considerando i molti pericoli che dal dì della sua natività avea portati a utimamente innanzi a' suoi occhi morto e fragellato dai dissoluti peccatori . . . m'occorse in questa considerazione tanto dolore e tanta pena, che i' credetti veramente che l'anima dal corpo si partisse. E come istordito per ispazio d'un poco istato e ricordandomi del dolore che io avea portato del mio figliuolo, forte mi cominciai a vergognare e di poco meno che io non mi levai dall'orazione. Ma pure, come piacque a Dio, preso sicurtà; istetti fermo; e ragguardando lei ripiena di tanto dolore, cominciai a piangere e in tanta fisima venni, che per gran pezzo non poterono i miei occhi raffrenare. Ma ispirato da Dio . . . ripresi cuore e conforto; e . . . fattomi il segno della croce, dissi la Salve Regina; e quella detta, così nel mio rozzo parlare incominciai."

24 Sancti Antonini, *Summa Theologica*, III, *Titulus* 12, cap. ix ("De multiplici adoratione, scilicet latriae, & duliae, & hyperduliae"), paragraph ii, col. 543 ("De adoratione," quoting Aquinas, *Summa Theologiae*, II.II, q. 84): "Est adoratio interior, quae consistit in interiori reverentia, devotione, & subjectione mentis erga eum, qui adoratur. Et est adoratio exterior, quae consistit in honore exteriori, qui exhibetur alteri, ut in genuflexionibus, inclinationibus, munerationibus & hujusmodi: exterior ordinatur ad interiorem, quae est principalis, sicut signum interioris & ejus exercitativum."

25 *Esposizioni sopra la Comedia di Dante*, ed.

Padoan, in the Commentary to Canto XI of *Inferno*, p. 554: "Sforzasi il dipintore che la figura dipinta da sé la quale non è altro che un poco di colore con certo artificio posto sopra una tavola, sia tanto simile, in quello atto ch'egli la fa, a quella la quale la natura ha prodotta, e che naturalmente in quello atto si dispone che essa possa gli occhi de' riguardanti o in parte o in tutto ingannare, faccendo di sé credere che ella sia quello che ella non è."

26 Wohl, *The Paintings of Domenico Veneziano*, p. 340: "Hora al presente ho sentito che Chosimo a deliberato far fare, ziò dipinghiere, una tavola d'altare, et vole um magnificho lavorio" (April 1, 1438). ASF, Mediceo avanti il principato, VII, 290.

27 Ibid.: "Chè se vui sapesi el disiderio ch'io ho de fare qualche famosio lavorio et spicialmente a vui, me saristi in ziò favorevole . . . ch'io vi prometo ne receverete honore de' fatti miei."

28 Humbert of Romans, *De eruditione praedicatorum*, IV, 18, para. 228, quoted by Howard, *Beyond the Written Word*, p. 109. I would like to thank Michèle Mulchahey for discussing this with me.

29 From a sermon preached for the second Sunday in Advent in a collection in the Biblioteca Riccardiana, Florence (MS Ricc. 1301), published by Nirit Debby, *Renaissance Florence in the Rhetoric of Two Popular Preachers*, p. 232; see further Nirit Debby, "The Preacher as Goldsmith: The Italian Preachers' Use of the Visual Arts," in *Preacher, Sermon and Audience in the Middle Ages*, ed. Muessig, pp. 127–54.

30 Jacopo da Voragine, *The Golden Legend*, trans. Ryan and Ripperberger, pp. 642–3, citing the *Summa* on the office by scholastic theologian William of Auxerre (d. 1231).

31 *The Golden Legend*, trans. Ryan and Ripperberger, p. 643.

32 Ibid.

33 Ibid.

34 *Paradiso*, X.7–10 ("Leva dunque, lettore . . . comincia a vagheggiare ne l'arte), discussed above. The phrase "vagheggiare ne l'arte" is glossed by Landino as "rimirare con piacere e dilecto" (*Comento*, ed. Procaccioli, IV, p. 1708).

35 As, for example, in the contract between Benozzo Gozzoli and the Compagnia della Purificazione e di San Zanobio for the confraternity's altarpiece (the main panel is now in the National Gallery, London), which states

that Benozzo was given the panel to prepare with gesso and obliged to apply the gold and "chon ogni debita diligenza dipignere in ogni et qualunque parte et di fighure et d'ornamenti," furthermore "Benozo sia tenuto in detto dipignere operarsi in modo che detta dipintura exceda ogni buona dipintura infino a qui facta per detto Benozo, o almeno a quella si possa debitamente equiperare" (October 23, 1461); see Ahl, *Benozzo Gozzoli*, p. 278. For similar stipulations, see O'Malley, *The Business of Art: Contracts and the Commissioning Process in Renaissance Italy.*

36 Savonarola, *Prediche sopra Ruth e Michea*, ed. Romano, "Sopra Michea VII:14" (September 11, 1496), no. 25, II, p. 275: "Questa contemplazione di questo Crucifisso è contemplazione della verità, e deriva da Dio per grazia . . . e però arreca all'omo grande delettazione." In his *Summa Theologica* (III, *Titulus* 12, cap. ix, col. 546), Antoninus explained that the effect of devotion was *delectatio* (delight) or spiritual *laetitia* (joy).

37 Nirit Debby, *Renaissance Florence in the Rhetoric of Two Popular Preachers*, *Predica* 19 (delivered in the Lenten series of 1406), pp. 257–8: "la legie di Dio à in sé tre parti: la prima leggie di Dio è charità; la seconda leggie è amore; la terza leggie è dilezzione."

38 Sancti Antonini, *Summa Theologica*, III, *Titulus* 18, cap. iii, col. 1018.

39 Cicero, *Brutus, Orator*, trans. Hendrickson and Hubbell, *Orator*, XXII.71, pp. 358–9. For the application of the classical theory of *circumstantiae* to preaching, see Delcorno, "Medieval Preaching in Italy," in *The Sermon*, ed. Kienzle, pp. 458–9. See, for example, Sancti Antonini, *Summa Theologica*, III, *Titulus* 18, cap. iv, col. 1021: "Ne videlicet eamdem materiam omnibus praedicat, sed diversa diversis secundum diversitatem conditionum, morum, & statu" and cap v, col. 1023, about the sermon type, "Congruum tamen est, conformare se moribus sapientum secundum tempus & locum . . . Aliud enim servatur in uno loco, & aliud in alio: & modus variatus est etiam secundum tempora: nam alio modo se habuerunt antiqui, alio modo moderni."

40 The phrase "debito et usato ornamento" is used, for example, in Benozzo Gozzoli's commission from the Compagnia della Purificazione e di San Zanobio, cited above, which specifies how the saints should appear, "Giovanni Batista nel debito usato suo habito . . . la fighura di sancto Girolamo ginochioni chol suo debito et usato ornamento . . . Francesco chon ogni ornamento intorno a ciò consueto" (Ahl, *Benozzo Gozzoli*, p. 278).

41 For example in the payment made to Botticelli, May 5, 1481 "per una dipintura d'una Nunziata" (the mural for the Ospedale of San Martino della Scala, now in the Uffizi; Lightbown, *Botticelli*, II, cata. B28, p. 42).

42 Orlandi, *Sant'Antonino*, pp. 111–12, doc. 15: "plures annos antequam consecrata esset ecclesia predicta."

43 Howard, *Beyond the Written Word*, p. 139 (ASF, Signori, Carteggi, Missive, Prima Cancelleria, XXXII, fols. 74v–75r [May 11, 1429]).

44 Orlandi, *Beato Angelico*, doc. 8, p. 173, in a payment for painting a crucifix for the hospital of Santa Maria Nuova: "A frate Giovanni de' frati di San Domenicho da fiesole per dipintura d'una croce fine del giugnio 1423 lire dieci."

45 Sancti Antonini, *Summa Theologica*, III, *Titulus* 18, cap. iii ("Praedicator quid debet habere"), col. 1018: "Praedicator, quia ex sua praedicatione debet quaerere homines inducere ad faciendum, quod praedicat; ideo, ut efficaciter praedicet, debet clare loqui, ut instruat intellectum auditoris, & doceat. Secundo, sic debet loqui, ut delectet auditorem, ut sic moveat affectum, ut libenter audiat verbum." For an analysis of the chapters in title 18 (*De statu praedicatorum*), which constitute a treatise on preaching, and their relation to Dominican traditions of writing on the preacher's art and to the practice of that art, see Howard, *Beyond the Written Word*, Chapter 4.

46 Discussing the "distinction of various levels of preaching" commonly made in the *artes praedicandi*, Delcorno cites Humbert of Romans: "Modo loquendum est grosse cum rudibus, modo subtilius cum sapientibus" (from Humbert's *De eruditione praedicatorum*; "Medieval Preaching in Italy," in *Preacher, Sermon and Audience in the Middle Ages*, ed. Muessig, p. 470). In *Painting and Experience in Fifteenth Century Italy*, Baxandall quotes from an *Ars Predicandi* where four types of preaching are described; the fourth, devout (*devotus*) is "the most easily understood and is good for edifying and instructing the people"

(p. 150; translated from BNCF, Maglia. viii: 1412, the *Ars Predicandi et Sermocinandi* of Magister Jo. Bapt.). In both cases, which are typical of the genre, these distinctions are not about style, but about more or less complicated ways of developing the themes. *Titulus* 18, cap. iii, col. 1020 of Antoninus's *Summa Theologica*, about avoiding superfluity, is an example of how presentation is discussed. Fra Angelico's work was described as both "ornato" and "divoto" by Cristoforo Landino in his passage on artists in the commentary to the *Divine Comedy*: "Fra Giovanni Angelico et vezoso et divoto et ornato molto con grandissima facilità" (*Comento*, ed. Procaccioli, 1, p. 241): for an analysis of these terms, see Baxandall, *Painting and Experience in Fifteenth Century Italy*, pp. 147–51.

47　Ecclesiasticus, 24 : 18. In the chapter on the Feast of the Annunciation, Jacopo da Voragine explains that "Mary alone of all women is blessed, because she is virgin and fruitful" (*Golden Legend*, trans. Ryan and Ripperberger, p. 205). The garden had additional associations as a spiritual garden or garden of virtue, as explained, for example, by one of the interlocutors in the late fourteenth-century *Colloquio spirituale* by the Dominican Simone da Cascina: "Per li fiori le vertú intendono fiorite, adornante dentro l'anima, e fiorente; per l'erbe verde gli affetti de'santi pensieri, li quali co' rugiadra di divina grasia stanno pieni" (ed. Dalla Riva, p. 194). For the floral imagery and its associations as a "commonplace in literature of the Virgin," see Ladis, "Immortal Queen and Mortal Bride," *Gazette des Beaux-Arts* (1992), p. 197. Ladis also discusses the column as "an ancient Marian epithet" found in Saint Bernard and later hymns, signifying her strength and her power to support and succor the devout (p. 190).

48　Jacopo da Voragine, *Golden Legend*, trans. Ryan and Ripperberger, p. 204.

49　Colosio, "Il B. Domenici," in *Giovanni Dominici saggi e inediti* (1970), p. 33.

50　As described by Antoninus in his 1454 *Chronica Domini*, quoted from Holmes, "Giovanni Benci's Patronage of the Nunnery, Le Murate," in *Art, Memory, and Family in Renaissance Florence*, ed. Ciappelli and Rubin, p. 116. Holmes has discussed this altarpiece in the context of its patronage and its situation at Le Murate in this article and in *Fra Filippo Lippi*, pp.

231–40. The analysis that follows here owes much to her insights about the commission.

51　From a manuscript containing a list of the female convents in Florence, Biblioteca Riccardiana, MS Moreniana 103, fols. 62r–63v, quoted by Trexler, "Celibacy in the Renaissance: The Nuns of Florence," in *Dependence in Context in Renaissance Florence*, p. 343: "Stanno e giorni e notte in orazione a far preghe per la dignissima signoria di Firenze. Apri l'occhio a questo, e gusta."

52　Antoninus, *Chronica Domini*, quoted from Holmes, "Giovanni Benci's Patronage," p. 125.

53　From the *Cronache del N.N. Monastero di Santa Maria Annunciata detto le Murate di Firenze (1598)*, BNCF, II.II.509, fol. 17r, translated by Holmes, *Fra Filippo Lippi*, p. 231.

54　*Cronache*, fol. 17r, as cited by Holmes, *Fra Filippo Lippi*, p. 231.

55　Antoninus, *Chronica Domini*, in Holmes, "Giovanni Benci's Patronage," p. 125.

56　*I commentarii*, ed. Bartoli, p. 61: "fu doctissimo in tutta l'arte et universale . . . Fece costui grandissimo prò a questa arte. Faceva maravigliose e perfecte opere, capellature, faceva le teste un poco minori che gl'altri antichi statuarii, faceva i corpi un poco più gentili accioché la belleza delle membra meglo apparissono."

57　Landino, *Comento*, ed. Procaccioli, 1, p. 241: "Fu fra Philippo gratioso et ornato et artificioso sopra modo: valse molto nelle compositioni et varietà, nel colorire, nel rilievo, ne gl'ornamenti d'ogni sorte, *maxime* o imitati dal vero o ficti."

58　These were the terms of a commission from the Compagnia dell'Annunziata di San Francesco da Barberino di Valdelsa for their *Annunziata* altar: "nella quale tavola vole un' Anunziata e l'angelo e Dio Padre cholla cholonba in un chasamento chome a detta istoria si richiede"; see Neri di Bicci, *Ricordanze*, ed. Santi, no. 702, p. 374 (June 7, 1471). The painting in now in the church of Santa Lucia al Borghetto a Tavarnelle Val di Pesa (illustrated here, pl. 196).

59　*Ricordanze*, ed. Santi: no. 63, September 1, 1455, p. 33, an altarpiece with "una Nunziata cho l'angelo e inchasamento"; no. 161, October 7, 1457, p. 82, for a chapel "ò a fare uno Dio Padre mandi la cholonba all'Anunziata e dirieto all'Anunziata e al'ang[i]olo 1° chasamento chonveniente ad essa e nel mezo,

tra l'angelo e ll'Anunziata, 1° Giesù a uso di quello fe' Santo Bernardino"; no. 209, January 3, 1458[59], p. 107, an altarpiece with "un' Anunziata"; no. 355, March 13, 1461[62], p. 180, a "tabernacholuzo" with "quatro istoriette: Asunzione di Nostra Donna, Anunziazione, Natività di Xpo, e quando Santo G[i]ovanni va al diserto"; no. 380, October 2, 1462, p. 191, "un'Anunziata ginochioni e l'angelo ginochioni"; no. 427, December 17, 1463, p. 216, an altarpiece with "un'Anunziata in chasamento"; no. 431, January 9, 1463[64], p. 219, an altarpiece with "1ª Nunziata" for Angelo di Neri Vettori, for the church of Le Campora, illustrated here, pl. 197; no. 479, July 15, 1465, p. 246, an altarpiece with "l'Anunziata chol'angelo" and flanking saints; no. 702, p. 374, cited above, n. 59.

60 Ibid., no. 63, September 1, 1455, p. 33: "una Nunziata cho l'angelo e inchasamento... bene ornata e richa sichome una n'è in San Franc[esch]o a Sa[n] Miniato al Monte" (the prototype is an *Annunciation* attributed to Zanobi Strozzi, now in the National Gallery, London, identified and discussed by Gordon, *National Gallery Catalogues: The Fifteenth Century Italian Paintings*, p. 412).

61 Mainardi, *Motti e facezie del Piovano Arlotto*, ed. Folena, no. 23, pp. 40–1.

62 Girolamo di Carlo di Marco Strozzi, ASF, Carte Strozziane, ser. III, 127, fol. 81v (1471–72).

63 *Ricordanze*, ed. Santi, no. 85, November 7, 1455, p. 43: "Richordo che detto dì ò tolto a dipignere dalla Chonpagnia di San Bastiano ... 1° panno overo insegnia ... nel quale ò a fare 1° Santo Bastiano ingnudo cholle frec[i]e e da pie' 1ª città asomigliata a Firenze ... il quale Santo Bastiano paia che prieghi per detta città." The agreed price was 1 florin *largho*. Neri returned the fee to them, since he was not able to complete the commission in the time allowed (until December 22) and it was given to another master to finish.

64 Francesco da Barberino, *Reggimento e costumi di donna*, ed. Sansone, p. 257 (Chapter 20): "E dice Agostino che l'orazione si è una conversione di mente in Dio propio e umile desiderio. È dunqua di tanta eficacia e di tanta utilità l'orazione, che, spezialmente a donna la quale conviene molto conversare in casa, convie'lesi di molto usarla e di domandare orando cose

giuste e oneste ... Né si conviene sol per te pregare, ma per li tuoi congiunti e benifattori, e poi per tutte l'anime viventi e non viventi, ciascuna in suo bisogno e in possibilità di Dio, e per lo stato del mondo e, spezialmente, per lo stato della tua terra. E non far sì solenne preghiera per una leger cosa, come per tutto lo stato dell'umana generazione."

65 Giordano da Rivalto [Giordano da Pisa], *Prediche sulla Genesi*, ed. Mureni, p. 172: "E però vi dico: meglio vedi stare in camera tua, e pensare di Dio, e contemplare di Lui, che andare discorrendo qua e là."

66 Lorenzo de' Medici, *Rime spirituali*, ed. Toscani: "Capitolo dove excito et exhorto me medesimo," lines 140–5, pp. 25–6: "Deh, lascia le calcate triste strade,/e volgi gli occhi a cose eterne e belle,/tanto più belle quanto sono più rade,/non di false bellezza come quelle/ornate, che t'han dato tanto affanno/e 'l sentier tolto che guida alle stelle."

67 *The Literary Works of Leonardo da Vinci*, ed. Richter, I, p. 344, no. 593: "La pictura over le figure dipinte debbono esser fatte in modo tale che li riguardatori d'esse possino con facilità conosciere mediante le loro attitudini il concetto dell'animo loro."

CHAPTER SEVEN HAPPY ENDINGS

1 The notarial act recording the receipt of the dowry (*confessio dotis*), which marked the last step in the process of marriage, is in ASF, Notarile Antecosimiano, 4838 (ser Giovanni di Francesco Neri Cecchi, 1483–6), fol. 9r, January 15, 1483[84].

2 Alberti, *On Painting*, I:1, ed. Kemp, p. 37.

3 *Decameron*, ed. Branca, II, p. 93: "sposatala e fatte le sue nozze, con lei più tempo lietamente visse."

4 ASF, Mediceo avanti il Principato, LXI, 70, January 12, 1479[80]: "datevi in modo che si chonservi nelli figliuoli dei figliuoli nostri che qui tutto lo stato e maxime gli intrinsechi vostri sono a questa via."

5 Archivio Pucci, Filza 2, Scritture e lettere Antiche dei Signori Marchesi Pucci ... Memorie Antiche ... Libro Primo, fol. 63 (December 24, 1491); the right edge of the sheet is damaged, but there is a copy of the letter in the notebook of excerpts from family

documents in Acquisti e Doni, 301, *inserto* 1 (fol. 155v), which completes the text: "Giannozzo, la moglie di Ruberto è figliola di Lorenzo Lenzi huomo nell cipta nostra di buone conditioni et stato, riccho come saj, di buona casa populare, et coiuncto di affinità con molte buone chase et parentadi. Et è huomo molto amorevole, et è venuto ad questo parentado con grande letitia et giocondita d'animo. Ha mostro di stimarci assai: Et essi facto nel giuramento uno mantello nuovo di rosato che fiammeggiava allegrezza da lungi uno miglio. La madre tu saj chi è Mona Maria de Soderini donna nella città nostra venerabile et honoranda quanto alcuna altra, si per le bellezze sue, si per nobiltà del sangue suo sì per la prudentia che [per Dio] quando l'ho udita parlare mi ha facto stupire, si per la sanctimonia della vita sua. È cugina del Magnifico Lorenzo, sorella di Pagholo Antonio, Piero et Messer Giovan Vectorio figliola di Messer Tomaso Soderini, et del reverendissimo Vescovo di Volterra, chol quale et Messer Lorenzo et tu vi dovrete congratulare [et] fatelo ancora nomine meo. La fanciulla è purissima, allevata tanto puramente quanto si può dire, sanza alcuna superstitione o superfluità o vanità alcuna, solo a dire orazioni . . . capelli neri . . . La natura gli è facte belle proportioni di persona. È grande, biancha et belle carni, bello occhio, el viso non è in tutto feminile, ha del maschile un pocho, pure è bella et grande. El giuramento si fece el dì si san thomaso in casa del Magnifico Lorenzo: su in sala grande."

6 BNCF, MS Maglia., xxxv, 98, datable between 1484 and 1489, see Zafarana, "Per la storia religiosa di Firenze nel Quattrocento," *Studi medievali* (1968), p. 1019.

7 *Ricordi*, ed. Branca, p. 210 (*Mercanti scrittori*, ed. Branca, p. 169): "togli fanciulla che tu ti contenti, ch'ella sia sana e 'ntera e ch'ella sia grande, per rispetto della famiglia n'aspetti."

8 To Filippo and Lorenzo in Naples (November 15, 1465), *Lettere*, ed. Guasti, p. 510: "che sopra tutto vogliàno le parti più volte ragionate, e sopra tutto belle"; December 21, 1465, p. 529: "grande e ben fatta . . . pare fanciulla da bene, e da fare bella famiglia."

9 Cadogan, *Domenico Ghirlandaio*, doc. 25, p. 350 (September 1, 1485).

10 *Ricordi*, in Fabroni, *Magni Cosmi Medicei vita*, p. 100. See, for this and other documents relating to early connections between the Pucci and the Medici, D. Kent, *The Rise of the Medici*, pp. 122–3, and p. 227.

11 On December 10, 1453: "A Antonio si consegna per la dota della donna sua che sono fl. 1,550 et per frutti di 5 anni di detta dota che esso misse in casa prima che menasse la donna fl. 950 et per fl. 588 di danari di Monte & paghe ordinari & paghe sostenute che uengono da conto di Berto suocero di detto Antonio." I thank Rolf Bagemihl for this reference. Subsequent documents are confusing about Maddalena's father's name. She appears as Lena di Giuliano Bartoli in some later records, but in Antonio's 1457 tax declaration, written in his hand, she is called Mona Lena di barto di giuliano ginj (ASF, Catasto, 832, fol. 1195r). To pay dowries by installments while the bride remained with her parents was not uncommon. See, for example, the record book of Paolo di Lapo Niccolini, in Niccolini di Camugliano, *The Chronicles of a Florentine Family 1200–1470*, p. 114, where he explains how he received the dowry over a four-year period between March 29, 1429 and February 2, 1433, waiting "to have the dowry first," before bringing his wife home. To bring or take home (*menare a casa*) was the expression for this concluding phase of the marriage process.

12 A notebook quoting from various family documents in ASF, Acquisti e Doni, 301, *inserto* 1, fol. 140r, mentions the receipt of the dowry (*confessio dotis*) on September 14, 1446 notarized by ser Agnolo di Piero di Tommaso and names the sum of 1,550 florins ("Antonio prese per moglie la Lena figliuola di Benedetto di Giuliano di Bartolo Gini come nel sopradetto Lodo [a 1449 division of goods between Puccio's sons], come costa ancora per la confessione della Dote rogato ser Agnolo di Piero di Tommaso 14 settembre 1446, fiorini 1,550"; a note at the top of the page indicates that this excerpt is from the *Libro segnato di numero 68*). A seventeenth-century compilation of documents in the Pucci family archive corroborates this, noting that on September 14, 1446 Antonio "prese p.ª Lena [Giramonte, crossed out] Gini/ ser Angiolo di Piero di Tommaso," Memorie di diverse persone della famiglia Pucci, Filza 1, in notebook 74, fol. 66r. Ser Agnolo's surviving acts from 1446 (ASF, Notarile Antecosimiano, 689) do not include

this document. Lucrezia's birth that year suggests that this was a final dowry payment. This sequence of events is supported by another compilation of documents, BNCF, Poligrafo Gargani, 1626, which records a *gabella* (contract tax) in 1440 for the marriage of Antonio di Puccio di Antonio to Lena di Giuliano Bartoli and by a genealogy in the Carte Pucci in the ASF, Manoscritti, 600, I, sc. IX, 19, which gives 1440 as the date of his marriage to "Lena di Giuliano Bartoli."

13 Her death (but not her age) is recorded in the 1457 tax return, where there is a poignant series of notes, stating first that she was pregnant, then that she gave birth, and finally that she had died (ASF, Catasto, 832, fol. 1195r: "Ola donna grossa di mesi 5 Parto a di 11 dagosto ebbe nome lorenzo," written next to her name, "morta").

14 Manetti expressed his gratitude and perpetual obligation to Cosimo for this favor in a letter from Naples, dated June 16, 1459 (ASF, Mediceo avanti il Principato, CXXXVIII, 54; published in Wittschier, *Giannozzo Manetti: Das Corpus der Orationes*, pp. 46–7).

15 Bernardo is named as acting as one of the negotiators in the documents regarding the settling the division of Antonio's estate between the sons of his first and second marriages, ASF, Notarile Antecosimiano, 9638 (ser Giovanni di Marco Thomasi da Romena, 1485–86), April 26, 1486, fols. 105v–107r.

16 ASF, Manoscritti, 529, I, Carte Pucci, sc. I, 5. For Bernardo di Alamanno's Medici family loyalty, see D. Kent, *The Rise of the Medici*, pp. 46–9.

17 ASF, Mediceo avanti il Principato, XX, 107, for a letter dated November 4, 1463, from Pellegrino to Lorenzo where he uses their youthful friendship as the context for his request for support from Lorenzo. For further references, see Miccoli's entry on Pellegrino in the *Dizionario biografico degli Italiani*, I, pp. 401–2.

18 ASF, Manoscritti, 603, Carte Pucci, sc. XII, 31.

19 Niccolini di Camugliano, *The Chronicles of a Florentine Family 1200–1470*, p. 149. For further information about the family see Passerini, *Genealogia e storia della famiglia Niccolini* (tables I, VII). For an analysis of the record book of Michele's grandfather, Lapo, and the light it sheds on family identity, its

construction, and propagation, including its marital strategies, see Klapisch-Zuber, "'Kin, Friends, and Neighbors': The Urban Territory of a Merchant Family in 1400," in *Women, Family, and Ritual in Renaissance Italy*, pp. 68–93.

20 Niccolini di Camugliano, *The Chronicles of a Florentine Family 1200–1470*, p. 149.

21 For this form, see the letters from Lorenzo to Otto dating from December 9, 1469 to July 29, 1470, in ibid., pp. 308–21.

22 *Lorenzo de' Medici Lettere VI (1481–1482)*, ed. Mallett, no. 520, p. 75, Lorenzo writing to Niccolò Michelozzi: "Harai con questa lettere di credenza a Madonna Niccola [countess of Princivalle], alla quale dirai liberamente et largamente l'animo et desiderio mio, il quale non potrebbe essere maggiore per la conclusione di quello parentado con Antonio nostro, come tu sai." The match did not occur, despite Lorenzo's urgings that he use all possible diligence to settle this matter. A letter of December 9, 1480 had instructed Michelozzi to go to the recently widowed countess to offer Lorenzo's condolences and to ask her about her intentions for her daughters and if she wished him to become involved (*Lorenzo de' Medici Lettere V (1480–1481)*, ed. Mallett, no. 475, pp. 96–9).

23 ASF, Notarile Antecosimiano, 5029 (ser Pietro di Bernardo di Bartolomeo Cennini), fols. 143v–144r.

24 ASF, Catasto, 688, fols. 381r–382v (Santo Spirito, Nicchio, 1451), Catasto, 834, fol. 51r (Santo Spirito, Nicchio, 1457, *sommario dei campioni* for the quarter of Santo Spirito), and Catasto, 995, fols. 136r–137r (1480) for Niccolò's appraisals; see also F. W. Kent, *Household and Lineage in Renaissance Florence*, p. 153.

25 ASF, Catasto, 906, fol. 547r; for Girolamo, Decima Repubblicana, 3, fol. 529r and Decima Granducale, 3563, fol. 31r, quoted by F. W. Kent, *Household and Lineage in Renaissance Florence*, p. 140. I thank Caroline Elam for identifying the member of the Agli family as Domenico, and specifying the date of purchase.

26 ASF, Notarile Antecosimiano, 5029 (ser Pietro di Bernardo di Bartolomeo Cennini), fol. 144r.

27 As reported by another bank manager, Agnolo Tani, who disapproved of Sassetti's decisions regarding the London branch and who was

told by Lorenzo "che lui [Lorenzo] non se n'intendeva" (ASF, Mediceo avanti il Principato LXXXII, 163); quoted by de Roover, *The Rise and Decline of the Medici Bank*, p. 365, who outlines Sassetti's career and fortunes on pp. 361–4.

28 ASF, Mediceo avanti il Principato, XLI, 118 (May 10, 1485), in his capacity as one of the officials of the Florentine university: "Io sono desideroso di benificare tucti gli huomini virtuosi maxime quegli che danno opera agli studi di humanità: de' quali io fui sempre amatore et sectatore"; quoted by de Roover, *Il banco Medici dalle origini al declino*, p. 526, n. 28.

29 In a letter dated January 11, 1479, published in Fabroni, *Annotationes et monumenta ad Laurentii Medicis*, p. 212: "E fatti vostri qui vanno bene, & non ci pensate, che il Saxetto harà delle saxate quante vorrà."

30 ASF, Ufficiali della Grascia, 190, fol. 162r (August 8, 1482): "La moglie di giannozzo d'ant° [Smeralda di Ugolino del Marchese di Monte Santa Maria] riposta in santa maria novella a di 8 detto."

31 Nicolai Rubinstein kindly supplied me with these references; Piero's inclusion among the Priors and the Balìe are mentioned by Luzzati in the entry on his son Bernardo in the *Dizionario biografico degli Italiani*, x, p. 504.

32 Dei, *Cronica*, pp. 80–1 ("1472 e chasati"); pp. 85–6, "E magiori ricchi di Firenze dell'anno 1472." In the 1480 *catasto* the value of Bini's taxable wealth is given as 2,053 florins and 4 *denari*, with 29 florins as the tax levied (ASF, Catasto, 998, fols. 188r–189r).

33 Bini declared land in the *contado* of Pisa in 1480 (ASF, Catasto, 998, fol. 188r: "Un pezo di tera [sic] nel contado di Pisa," valued at 75 florins), and, more importantly, he had long done business in Pisa. The documentation relating to the Capponi–Bini companies is cited by Luzzati in his entry on Neri Capponi in the *Dizionario biografico degli Italiani*, XIX, pp. 75–8. I thank Rolf Bagemihl for noting the desirable features of the Pisan connection.

34 ASF, Notarile Antecosimiano, 4838 (ser Giovanni di Francesco Neri Cecchi, 1483–6), January 15, 1483[84], fol. 9r.

35 Archivio Pucci, Filza 2, fol. 48 (Geronima to Lucrezia, August 14, no year given), fol. 49 (Giulia Farnese to Geronima, September 16, 1494), fol. 51 (Giulia Farnese to Gianozzo,

January 1495), fol. 53 (Giulia to Geronima, September 1494 or 1495 [the date is cut off by the uneven edge of the bottom of the sheet]). For Geronima and Giulia see the respective entries by Arrighi and Zapperi in the *Dizionario biografico degli Italiani*, XLV, pp. 93–5, 99–102.

36 Archivio Pucci, Filza 2, fol. 51r, January 1, 1495 to "Messer Gianozo mio Amantissimo . . . per questo vo voluto scrivere questi pochi versi facendovi intendere che son tucta vostra et che de me posete desponere che . . . per amarvi da proprio fratello."

37 Archivio Pucci, Filza 2, no. 7, fol. 49r, September 16, 1494: "merecomandiate al nostro Messer Lorenzo sopra tucto ad Messer Gianozo."

38 Archivio Pucci, Filza 2, fols. 48r–v: "Lucrezia mia cara a te mi racomando io so che tu ti se maravigliata non to scritto ne factoti risposta alle tue lettere sapi none stato per non sene ricordata e ne ancora per non dengniare le lettere tue ma he stato per non avere potuto rispetto prima perche mi cominciai a sentir male io et poi comincio messer Puccio et che ti prometto Lucretia mia che poi che comincio nono mai hauto requie sempre del continouo m'è bisogniato starli presso a governarlo . . . hora ringratiato sia dio lui nona piu febre et spero che fra pochi di andra fuora . . . non mi dolga teco rispecto allamore et allaffectione ti porto"; addressed "Alla mia amata Lucretia cognata carissima."

39 Archivio Pucci, Filza 2, fol. 61r: "Al mio charo gianozo sempre mi rachomando ogi o auto la vostra dedi xxvi° . . . vi priego charamente almancho facciate desserci in p° charnasciale a ognimodo e chosi m'a promesso . . . v° Luchrezia in firenze"; addressed "Al mio charo ed amato giannozo pucci in roma" (fol. 61v). A document recording Giannozzo's testamentary wishes describes her as his dearly beloved wife ("domina Lucrezia de Binis eius dilecta et cara uxor"), appointing her to dower 10 poor girls, with 20 florins, one each year for 10 years (September 27, 1498; ASF, Notarile Antecosimiano, 21025, fol. 366v).

40 Landucci, *A Florentine Diary*, trans. de Rosen Jervis, p. 8.

41 "Un paradiso habitato da diavoli" was Agnolo Acciaiuoli's characterization of the city in 1465, not long nefore before he was exiled; see F. W. Kent, "Palaces, Politics and Society in Fif-

teenth-Century Florence," *I Tatti Studies* (1989), p. 63.

42 Machiavelli, *Florentine Histories*, VII.10, trans. Banfield and Mansfield, p. 328.

43 *Lorenzo de' Medici Lettere IV (1479–1480)*, ed. Rubinstein, no. 441, p. 260, to Bernardo Bembo and Antonio Donato, the Venetian "orators" in Florence, from San Miniato, to explain his departure (December 7, 1479): "A me è paruto necessario, da poi la perdita de uno fratello et da poi tante altre iacture et danni et pericoli mei, mettere anchora in pericolo la propria vita . . . che la città nostra habbi pace."

44 *Lorenzo de' Medici Lettere V (1480–1481)*, ed. Mallett, p. 9 (note to no. 461; April 2, 1479): "gli primi seranno pur gli più amici."

45 Boccaccio, *Decameron*, ed. Branca, II, p. 84: "una novella non men di compassione piena che dilettevole."

46 Ibid., p. 87: "una bellissima giovane ignuda." For the mode of hunting and its symbolism, see Grieco, "Le Thème du coeur mangé: l'ordre, le sauvage et la sauvagerie," in *La Sociabilité à table*, pp. 26–7.

47 ASF, Carte Strozziane, I, no. 341, insert: "1ª cassa chon undicj forchette darriento."

48 Lorenzo de' Medici, *A Commentary on my Sonnets*, trans. Cook, pp. 48–9: "In prosa e orazione soluta, chi ha letto il Boccaccio, uomo dottissimo e facundissimo, facilmente giudicherà singulare e sola al mondo non solamente la invenzione, ma la copia et eloquenzia sua; e considerando l'opera sua del *Decameron*, per la diversità della materia, ora grave, ora mediocre e ora bassa, e contenente tutte le perturbazioni che agli uomini possono accadere, d'amore e odio, timore e speranza, tante nuove astuzie e ingegni, e avendo a exprimere tutte le nature e passioni degli uomini che si trovono al mondo, sanza controversia giudicherà nessuna lingua meglio che la nostra essere atta a exprimere" (*Comento*, ed. Zanato, pp. 147–8).

49 Verde, *Lo Studio fiorentino*, III.1, p. 427; see pp. 572–3 for Lorenzo and III.2, pp. 840–1 for Puccio. See Brucker, "A Civic Debate on Florentine Higher Education (1460)," *Renaissance Quarterly* (1981), p. 530, for Antonio's participation in that debate.

50 Poliziano, *Stanze*, I.9, ed. Marconi, p. 82, "il giovene gagliardo"; I.26, p. 88, "l'ardito Iulio."

51 *Decameron*, ed. Branca, II, pp. 83–4: "Amabili donne, come in noi è la pietà commendata, così ancora in noi è dalla divina giustizia rigidamente la crudeltà vendicata."

52 Cicero, *De officiis*, I.7, trans. Miller, pp. 20–3. In addition to Palmieri, instances of widely diffused notions of justice and its importance to the state can be found in the vernacular speeches given as part of the installation ceremony of each new Gonfaloniere di Giustizia; for these, see Santini, "La *protestatio de iustitia* nella Firenze medicea del secolo XV," *Rinascimento* (1959), pp. 33–106.

53 "Istorietta Amorosa," in Alberti, *Opere volgari*, ed. Grayson, III, p. 286: "Niuno si maravigli, eccelsi Signori, di quello che io ho fatto, perchè conoscendo io la manifesta e aperta ingiustizia, non solo ad Ippolito, il quale è mio legittimo sposo e marito, ma a ciascuna strana persona arei io fatto questo che io ho fatto a lui, però che, siccome a difensione della giustizia ciascuno debb'essere coadiutore, così a propulsione dell'ingiustizia ogni uono debbe essere defensore."

54 Ibid., p. 287: "fatta una bellissima festa fermarono il parentado, e dove già dugent'anni e' Bardi e Bondelmonti erano stati nemici a morte, divennono tanto amici per lo parentado che tutti parevano d'uno sangue."

55 Livy, *Historiae ab urbe condita*, I.10, trans. Foster, pp. 6–7.

56 Guicciardini, *The History of Florence*, trans. Domandi, Chapter 7, p. 59 (*Storie fiorentine dal 1378 al 1509*, ed. Palmarocchi, p. 62: "per più riputazione della impresa e per portare ordine di danari").

57 Landucci, *A Florentine Diary*, trans. de Rosen Jervis, pp. 125–6.

58 ASF, Signori e Collegi. Deliberazioni in Forza di Ordinaria Autorità, 99, fol. 74v (August 21, 1497).

59 BNCF, Manoscritti, II, I, 138, Libro di varie notizie e memorie della venerabile Compagnia di Santa Maria della Croce al Tempio, fol. 80r: "sententiata dalla santa giustitia."

60 Guicciardini, *The History of Florence*, trans. Domandi, p. 134 (*Storie fiorentine dal 1378 al 1509*, ed. Palmarocchi, Chapter 18, p. 144: "La morte . . . può essere esemplo a tutti e' cittadini").

Bibliographic Notes

I THE IMAGERY OF IDENTITY

Describing Florence

Florentines regularly described their city and its institutions, as part of histories or chronicles and as part of family histories in record books. In 1410, the silk merchant Goro Dati added a final book to his history of Florence with a concise description of its political organization. This book, still one of the clearest outlines of Florentine institutions, is indicative of the close involvement of Florentine citizens in their city's governance (*Istoria di Firenze*, ed. Bianchini, Book IX; excerpted and translated in *Images of Quattrocento Florence*, ed. Baldassari and Saiber, pp. 44–54). Giovanni Morelli's book of *Ricordi* represents an instance of private and family records combined with public matters; for this reason it is very revealing as to how Florentines placed themselves and their family histories within the city and its political traditions (*Ricordi*, ed. Branca, also in *Mercanti scrittori*, ed. Branca). Benedetto Dei's tabulation of the city's wealth, resources, trades, and places in his 1472 *Cronica* shows another way of perceiving the city (*La cronica*, ed. Barducci).

Leonardo Bruni's *Panegyric of Florence* (*Laudatio florentinae urbis*) is a formal, humanist work that imitates a second-century Greek oration in praise of Athens. It puts eloquence to the service of demonstrating how, just as the citizens of Florence "surpass all other men by a great deal in their natural genius, prudence, elegance, and magnificence," so too has "the city of Florence . . . surpassed all other cities in its prudent site and its splendor, architecture, and cleanliness," and how in its "civil institutions and laws" it was "harmonized in all its parts, so there results a single great, harmonious constitution whose harmony pleases both the eyes and minds of men" where "everything occupies its proper place, which is not only clearly defined but also in right relation to all the other elements" (Bruni, *Opere letterarie e politiche*, ed. Viti, pp. 569–647; translated in Kohl and Witt, *The Earthly Republic*, pp. 135–75, quotations from pp. 136, 168–9). Bruni's proportional ordering of the city makes an interesting comparison with contemporary experiments in perspective construction. However this coincidence is interpreted, Bruni's rhetorical connection between demonstration and description and his insistence on seeing as proof indicates the force of appearances in arguing for civic greatness in fifteenth-century Florence.

In modern writing, Brucker's book *Renaissance Florence* is an accessible introduction to the city. Wright's essay "Florence in the 1470s," in *Renaissance Florence: The Art of the 1470s*, ed. Rubin and Wright, pp. 12–31, includes a very effective account of the city and summary of

255 (FACING PAGE) Antonio del Pollaiuolo, enameled silver plates decorating a volume of Petrarch's *Triumphs* and other works, gilded silver frame with transparent enamels, Bibliothèque Nationale. Paris, MS ital. 548.

its political institutions. Romby, *Descrizioni e rappresentazioni della città di Firenze nel XV secolo*, is an invaluable guide to the sources. The anthology edited by Baldassari and Saiber, *Images of Quattrocento Florence*, is an extremely useful collection of translated texts, with brief commentaries and bibliographic references.

"più e più masserizie"

Models of Consumption

The questions of how to account for the demand for goods and how to relate the increased consumption of luxury goods to growth in the arts and ultimately to the development of modern notions of art are forcefully posed by Goldthwaite in *Wealth and the Demand for Art in Italy*. Bringing economic history to cultural explanation, Goldthwaite discusses traditional forms of expenditure (as in the "realm of religious art") and of "material culture" (such as clothing and jewelry) as well as a "new kind of consumption of durable goods" in household furnishing, concluding that "consumption was a creative force to construct a cultural identity" (pp. 74, 239, 243). Immensely authoritative and impressively succinct, Goldthwaite's work on the subject has influenced all subsequent discussions of the links between culture and consumption in Renaissance Italy. The ideological underpinnings of Goldthwaite's view were pointed out by Martines in his review article on "The Renaissance and the Birth of Consumer Society," *Renaissance Quarterly* (1998), pp. 193–203, where he noted the connection between the commoditized Renaissance and the economic policies of the Reagan–Thatcher era.

In her article on "New, Old and Second-hand Culture: The Case of the Renaissance Sleeve," in *Revaluing Renaissance Art*, ed. Neher and Shepherd, pp. 101–14, Welch makes the case for "a more inclusive theory of consumption" that allows for "reconstruction and recirculation" of goods (often the sphere of women's material exchanges) as well as the demand for purpose-made or new goods (more often led by men, who had more financial agency). Welch was a leading member of a collaborative project based at Sussex University, the Material Renaissance Research Project. The multi-disciplinary team of researchers collected data about consumption in the Italian Renaissance, gathering information about comparative prices, the markets for domestic goods, and the type of luxury goods now classified as art in order to explore models of acquisition and patronage and the place of art objects among other commodities. The results are published in Welch and O'Malley, eds., *The Material Renaissance*, and the data-set of wages and prices is available on the Arts and Humanities Data Service History website (http://ahds.ac.uk/history, as outlined at www.sussex.ac.uk/Units/arthist/matren). Welch's own book, *Shopping in the Renaissance*, is a keen and vivid analysis of "consumer cultures in Italy," based on a wide range of newly discovered and freshly interpreted sources, including Florentine account books. The *ricordanze* of Francesco di Matteo Castellani, first published by Giovanni Ciapelli, supply one of her case studies detailing the ways that "shopping was a series of relationships, rather than a simple exchange of money for material goods" (p. 226).

In *Objects of Virtue*, Syson and Thornton offer another approach to demand, relating patterns of consumption to cultural impulses. Their concern is to show how the process of assigning value relates to questions of meaning, and how production and reception are related by contexts of interpretation and modes of appreciation.

For further bibliography relating to wealth and expenditure, see the Bibliographic Note to Chapter 2.

Investments Made for the Dwelling Place in this World and the Next

For bibliography relating to patterns and structures of patronage, see the Bibliographic Note to Chapter 2. The specific matter of the impact of patronage on liturgy is discussed by Gaston in his essay on "Liturgy and Patronage in San Lorenzo, Florence, 1350–1650," in *Patronage, Art and Society*, ed. Kent and Simons, pp. 111–33.

Trexler's book *Public Life in Renaissance Florence* is the founding text for the modern study of the ritual life of the city. Important here is the way that his examination of the "formal life" of the city indicates how ritual behavior constituted a shared social imagery, which articulated Florentine identity among the Florentines and to the external world. Klapisch-Zuber's contributions to the study of Florentine social history, informed by her quantitative work on the 1427 *catasto* (done in collaboration with Herlihy) and extensive reading of *ricordanze*, taken in an anthropological light, have immeasurably enriched the understanding of Florentine households and the rituals of domestic life and the life cycle. As its title indicates, the selected essays in *Women, Family, and Ritual in Renaissance Italy* examine kinship structures, the relations that determined roles or social personalities (of the head of the household, of women as brides, mothers, and widows, of children), and look at the ritual functions of the objects associated with the ceremonies and exchanges that defined domestic life. She has also profitably applied ethnography to pictorial iconography, illuminating, for example, the interaction between the representation of the marriage of the Virgin and marriage customs ("Zacharias or the Ousted Father," pp. 178–212).

Musacchio's book on *The Art and Ritual of Childbirth in Renaissance Italy* and Strocchia's on *Death and Ritual in Renaissance Florence* are important studies of the opposite poles of the life cycle. Johnson's chapter on "Family Values: Sculpture and the Family in Fifteenth-Century Florence," in *Art, Memory, and Family in Renaissance Florence*, ed. Ciappelli and Rubin, pp. 215–36, comments on the emergence of new sculptural forms – the Marian relief and the portrait bust – and their place in family life.

For marriage and associated objects, see the Bibliographic Note to Chapter 7.

Lydecker's thesis on "The Domestic Setting of the Arts in Renaissance Florence" has become the standard work on the arrangement of the domestic interior, on the general patterns of acquisition for its furnishing, and on the elaboration of the interior in the course of the fifteenth century. It is based on an analysis of inventories, principally those in the archive of the magistrates responsible for overseeing the estates of orphans (the *Magistrato dei Pupilli*). His article on "Il patriziato fiorentino e la committenza artistica per la casa," in *I ceti dirigenti*, pp. 209–21, is a synopsis of his findings. Lydecker's study shows that *camere* were the most highly decorated of the rooms and that they were generally furnished at the time of marriage. These ideas are briefly reviewed and developed in my essay on "The Beautiful Chamber" and the subsequent entries in *Renaissance Florence: The Art of the 1470s* ed. Rubin and Wright.

The aim of the exhibition held at the Victoria and Albert Museum in 2006–7, *At Home in Renaissance Italy*, was to put works of art and domestic objects into the contexts and rituals of daily life and to display and demonstrate the role of the interior in Renaissance culture (for this, see the catalogue edited by Ajmar-Wollheim and Dennis). In her article "Planning

for Visitors at Florentine Palaces," *Renaissance Studies* (1998), pp. 357–74, Preyer uses the examples of the Medici, Gianfigliazzi, and Corsi-Horne palaces to examine what the arrangement of their interiors reveals about "patterns of activity, often involving many people, in private homes" (p. 357). Lillie's book *Florentine Villas in the Fifteenth Century* shifts the focus from urban life to the countryside, comprehensively documenting and discussing rural holdings, building types, their contents, and their decoration. In the country as in the city, the majority of images recorded in inventories are of religious subjects.

People and Projects

PIERO DEL TOVAGLIA (CA. 1424–1487)

Piero's correspondence with Lodovico Gonzaga and his role in the building of the tribune are published and outlined by Brown in her article on "The Patronage and Building History of the Tribuna of SS. Annunziata," *Mitteilungen des Kunsthistorischen Institutes in Florenz* (1981), pp. 59–145. She has also written on the building history of the family villa in the parish of Santa Maria a Montici, where Piero purchased property in September 1470 and March 1479, which was renovated or rebuilt by his son Angelo ("Leonardo and the Tale of Three Villas: Poggio a Caiano, the Villa Tovaglia in Florence and Poggio Reale in Mantua," in *Firenze e la Toscana dei Medici nell'Europa del '500*, III, pp. 1056–8). The Gonzaga connection and the villa are mentioned in *Il giardino di San Marco*, p. 26, which gives further references to del Tovaglia in the Gonzaga correspondence.

ALESSANDRA MACINGHI STROZZI (1408–1471)

Alessandra Strozzi's letters to her sons, published by Guasti in 1877 (*Lettere di una gentildonna fiorentina del secolo XV ai figliuoli esuli*), present a vivid and moving picture of a woman and mother in fifteenth-century Florence. After the death of her husband Matteo in 1435 (or early 1436), she accepted her role as widow rather than remarrying, and cared for her children, and during their exile, for the family property and interests in Florence. Perceptive, shrewd, and affectionate, the letters are among the most revealing documents of family life to survive from the period. Gregory's introduction to her selection of letters describes Alessandra's position and outlines the family's history. Brucker's essay on "Alessandra Strozzi (1408–1471): The Eventful Life of a Renaissance Matron," in *Living on the Edge in Leonardo's Florence*, pp. 151–68, is a lively account of Alessandra, set in the political context of her times. A much more detailed consideration of these issues and the related historiographical questions is presented by Crabb in her book *The Strozzi of Florence: Widowhood and Family Solidarity in the Renaissance*.

FILIPPO DI MATTEO STROZZI (1428–1491)

The family voice is particularly strong in the record of Filippo's life: in addition to his correspondence with his mother, his son Lorenzo later wrote a biography (*Vita di Filippo il Vecchio*, ed. Bini and Bigazzi). The Strozzi are one of the four families that are the case studies in Goldthwaite's *Private Wealth in Renaissance Florence* (pp. 52–73, for Filippo). He refers to the building accounts for Filippo's palace in his articles "The Florentine Palace as Domestic

Architecture," *American Historical Review* (1972), pp. 977–1012, and "The Building of the Strozzi Palace," *Studies in Medieval and Renaissance History* (1973), pp. 99–194, and in his book *The Building of Renaissance Florence*. There is a monograph by Pampaloni, *Palazzo Strozzi*. Lillie gives an overview of the project, with a very helpful discussion of the surviving wooden model and two fragmentary models in "The Palazzo Strozzi and Private Patronage in Fifteenth-Century Florence," in *The Renaissance from Brunelleschi to Michelangelo*, ed. Millon and Lampugnani, pp. 518–21. The early reputation of the palace and its importance for Strozzi family status as reported in contemporary letters is described by F. W. Kent: "'Più superba di quello di Lorenzo': Courtly and Family Interest in the Building of Filippo Strozzi's Palace," *Renaissance Quarterly* (1977), pp. 311–23. Possible ancient sources are mentioned by G. Clarke in *Roman House – Renaissance Palaces*, pp. 147–8.

The success of Filippo's strategy to perpetuate the family name in his palace was the subject of a celebratory conference held in 1989 to mark its fifth centenary. In the volume of acts, Elam sets the palace in its urban context, discussing the evolution of the piazza and the significance of the site ("Palazzo Strozzi nel contesto urbano," in *Palazzo Strozzi metà millennio*, ed. Lamberini, pp. 183–93); Preyer analyzes the documents regarding the foundations ("I documenti sulle fondamenta di Palazzo Strozzi," pp. 195–213); and Lillie surveys Strozzi's building in the country as well as in the city ("Vita di palazzo, vita in villa: l'attività edilizia di Filippo il Vecchio," pp. 167–82). Filippo's attention to the countryside, in the acquisition of farm properties, the endowment and equipping of ecclesiastical sites (the church at Le Selve, the church and hermitage at Lecceto), and the construction of his principal villa (Santuccio) is given full consideration in her book *Florentine Villas in the Fifteenth Century*. She sets Filippo's rural investments in the framework of his wider concern to restore and to reaffirm the Strozzi presence in both town and country. His attachment of his reputation to the beauty of the works he commissioned is documented in the letters written to his brother Lorenzo in Naples in January and April 1477, concerning a proposed tomb for their younger brother Matteo. He consulted with sculptors in Florence, chiefly Antonio Rossellino, and the opinion was that though economical, the design was unworthy. He commented more than once on the honor or shame that would result from their decision and sent three alternative designs, saying that by making the tomb beautiful they would honor themselves: "faciendola bella honoriamo noi medesimi." It was also his belief that it might be necessary send a Florentine artist to do the job; these letters are published by Borsook, "Documenti relativi alle cappelle di Lecceto e delle Selve di Filippo Strozzi," *Antichità viva* [1970], no. 3, pp. 3–20, docs. 16–18, pp. 14–15.

Gregory has written on the political aspects of Filippo's career ("The Return of the Native: Filippo Strozzi and Medicean Politics," *Renaissance Quarterly* [1985], pp. 1–21). Borsook has, instead, discussed important documents relating to his commissions. In addition to the article cited above, she has published "Documents for Filippo Strozzi's Chapel in Santa Maria Novella and other Related Papers," *Burlington Magazine* (1970), pp. 737–45, 800–4, and "Ritratto di Filippo Strozzi il Vecchio," in *Palazzo Strozzi metà millennio*, ed. Lamberini, pp. 1–11). Filippo's burial chapel in Santa Maria Novella – and its murals by Filippino Lippi – is thoroughly studied in Sale's dissertation, "The Strozzi Chapel" (University of Pennsylvania, 1976), and by Zambrano and Nelson in their monograph, *Filippino Lippi*.

Strozzi's activities are summarized in my chapter "Patrons and Projects," in *Renaissance Florence: The Art of the 1470s*, pp. 43–5.

NICCOLÒ DA UZZANO (1359–1431)

Brucker outlines Niccolò's political career and defines, with extensive documentation, Niccolò's pre-eminent place in the regime, noting that both his ascent to power and his great reputation owed much to the qualities of his character and intellect (*The Civic World of Early Renaissance Florence*, particularly pp. 264–7, 278–9). Dainelli's articles on Niccolò remain the standard account of his life and activities as a statesman ("Niccolò da Uzzano nella vita politica dei suoi tempi," *Archivio storico italiano* [1932], pp. 35–86, 185–216). Among the other political honors he accrued, Niccolò was a member of the Dieci di Balìa in 1393, 1401, 1405, and 1403; he also held the highest office of the state (Gonfaloniere di Giustizia) three times: 1394, 1407, 1421). The documents regarding the palace, now the Capponi palace, are discussed by Preyer, "The 'chasa overo palagio' of Alberto di Zanobi," *Art Bulletin* (1983), pp. 392–3.

2 "DELLO SPLENDIDO VIVERE": ON NECESSARY AND HONORABLE EXPENDITURE

History of the Period

The best surveys of the events, political developments, and protagonists of the late fourteenth and fifteenth centuries are to be found in the histories written in the early sixteenth century, Guicciardini's *History of Italy* and *Florentine History* and Machiavelli's *Florentine Histories*.

The transformations of the political constitution of Florence in the course of the late fourteenth and early fifteenth centuries and the underlying social dynamics are considered by Becker in *Florence in Transition* (*The Decline of the Commune* and *Studies in the Rise of the Territorial State*), by Brucker in *The Civic World of Early Renaissance Florence*, and Najemy in *Corporatism and Consensus in Florentine Electoral Politics 1280–1400*. In *Florence and the Medici*, Hale presents an overview of the Medicean period. Detailed studies of the regime are to be found in D. Kent's *The Rise of the Medici* and Rubinstein's *The Government of Florence under the Medici*.

Definitions of the ruling elite are proposed and discussed by Molho, "Politics and the Ruling Class in Early Renaissance Florence," *Nuova Rivista Storica* (1968), pp. 401–20 and D. Kent, "The Florentine *Reggimento* in the Fifteenth Century," *Renaissance Quarterly* (1975), pp. 575–638. Class relations are studied from the opposite perspective in F. W. Kent's essay on "'Be Rather Loved than Feared'," in *Society and Individual in Renaissance Florence*, ed. Connell, pp. 13–50.

Brucker's *Renaissance Florence* is an accessible treatment of "the configurations of Florentine experience" (p. vii), including its social and political structures. The essays edited by Paoletti and Crum, *Renaissance Florence: A Social History*, take historical and art-historical approaches to study the spaces, monuments, rituals, and experiences of the city and its inhabitants. Clarke's book on *The Soderini and the Medici* has a very useful introduction that briefly sets forth the developments in the political system of fifteenth-century Florence and an equally useful glossary of related terms.

The Ethics of Expenditure

Treatises and Authors

LEON BATTISTA ALBERTI (1404–1472) AND *I LIBRI DELLA FAMIGLIA*

The edition of Alberti's treatise *On the Family* cited here is Cecil Grayson's in Alberti, *Opere volgari*, I. Grayson describes the surviving manuscripts of the entire treatise and excerpts on pp. 367–449, and outlines the history of its publication on pp. 378–80. There is a very readable English translation of the dialogue, *The Family in Renaissance Florence*, trans. Watkins (see p. 202 for the passages enumerating the places of Alberti family patronage quoted at the opening of this chapter). The introduction has a brief, helpful explanation of the circumstances of the dialogue's composition, of its circulation and publishing history, and a description of its major themes and voices. Pellegrini, "Agnolo Pandolfini e il *Governo della Famiglia*," *Giornale storico letterario italiano* (1886), pp. 1–52, was the first to elucidate the relationship of the dialogue attributed to Pandolfini to the third book of Alberti's treatise and to demonstrate that the Pandolfini version was actually an adaptation of Alberti, dating from ca. 1460. Najemy, "Giannozzo and his Elders," in *Society and Individual in Renaissance Florence*, ed. Connell, pp. 51–78, gives a spirited and suggestive analysis of the ambiguities of the voice given to this protagonist of the dialogue, which may be read as a "critique of Renaissance patriarchy."

Grayson's article in the *Dizionario biografico degli Italiani*, I, pp. 702–9, is a learned survey of Alberti's life, career, and writings. Mancini's 1911 *Vita di Leon Battista Alberti* remains a key source for Alberti's biography. Chapter 10 is about the books on the family. Overviews of Alberti's career and interests can be found in the respective monographs by Boschetto, Gadol, and Grafton, and the exhibition catalogues, *Leon Battista Alberti*, ed. Rykwert and Engel, and *L'uomo del Rinascimento*, ed. Acidini and Morolli, with further references. Alberti's will was published by Mancini, "Il testamento di L. B. Alberti," *Archivio storico italiano* (1914), II, pp. 20–52. Kuehn, "Reading between the Patrilines: Leon Battista Alberti's *Della Famiglia* in Light of his Illegitimacy," in *Law, Family, and Women*, pp. 157–75, relates Alberti's status in his family to his writing on the subject, and Baxendale, "Exile in Practice: The Alberti Family In and Out of Florence 1401–1428," *Renaissance Quarterly* (1991), pp. 720–56, analyzes the position of the Alberti family, which forms the context for Alberti's text. Alberti family history and patronage is summarized by Passerini, *Gli Alberti di Firenze*, with reference to documents. The oratory of Saint Catherine at Antella was restored between 1996 and 1998. De Vita et al., *L'oratorio di Santa Caterina*, report on the restoration of the building and the frescoes and discuss the construction and decoration of the oratory. They also publish the codicil to Benedetto di Nerozzo di Alberto degli Alberti's will (from July 11, 1387) that leaves bequests for the completion of the painting and furnishing of the sacristy at San Miniato al Monte and the painting of the oratory at Antella with the story of Saint Catherine. The history of the endowment of the Bridgetine monastery known as the Paradiso degli Alberti is told in Gregori and Rocchi, ed., *Il "Paradiso" in Pian di Ripoli*. Thomas Loughman's 2003 dissertation for Rutgers University is on "Spinello Aretino, Benedetto Alberti, and the Olivetans: Late Trecento Patronage at San Miniato al Monte." This research expanded to a wider study of the Alberti family's projects in ecclesiastical endowments around the city and of urban improvements made in the area of the family enclave. Part of this work was the subject of a talk on "Commissioning Familial Remembrance: Alberti Patronage at Santa Croce, Florence, 1304–c.1390," published in *The Patron's Payoff*, ed. Nelson and Zeckhauser.

LEONARDO BRUNI (1370–1444) AND THE (PSEUDO-)ARISTOTLE *ECONOMICS*

The prefaces to Bruni's Aristotle translations (from Greek into Latin) are in Baron, *Leonardo Bruni Aretino*. English translations of the prefaces and of parts of Bruni's notes to his translations are in Griffiths, Hankins, and Thompson, *The Humanism of Leonardo Bruni*, which also has a valuable introduction to Bruni's life, his works, and their historical and historiographic contexts, and includes an extensive bibliography on those subjects. A further authoritative guide to Bruni's writings is Hankins's *Repertorium Brunianum*. Hankins has translated Bruni's *Historiarum Florentini populi libri XII* in a parallel textedition, with a critical introduction (*History of the Florentine People*). The translation of the *Economics* and its influence are treated by Soudek, "The Genesis and Tradition of Leonardo Bruni's Annotated Latin Version of the (Pseudo-)Aristotelian *Economics*," *Scriptorium* (1958), pp. 260–8. Bruni's formal letters were published in 1741 by Mehus, *Leonardi Bruni arretini epistolarum libri VIII*. His will was published by Giustiniani, "Il testamento di Leonardo Bruni," *Rinascimento* (1964), pp. 259–64, and his petition for Florentine citizenship, with further documents relating to its acceptance and the renewal of its terms (Bruni's exemption from the burdens of taxation) are in Santini, "Leonardo Bruni Aretino e i suoi *Historiarum Florentini populi Libri XII*," *Annali della R. Scuola Normale Superiore di Pisa* (1910), pp. 1–144.

There is an informative article on Bruni's life and works by Vasoli in the *Dizionario biografico degli Italiani*, XIV, pp. 618–33. Martines, *The Social World of the Florentine Humanists*, pp. 165–76, characterizes Bruni's social and political position in Florence. Bruni's funeral and its relation to other funerary celebrations are described by Strocchia, *Death and Ritual in Renaissance Florence*, pp. 156–61. For his tomb in Santa Croce and its iconography, see Schulz, *The Sculpture of Bernardo Rossellino*, Chapter 4.

MATTEO PALMIERI (1406–1475) AND THE *VITA CIVILE*

The edition quoted here is Palmieri, *Vita civile*, ed. Belloni. There is no English translation of this treatise. The importance of Palmieri's writings in fifteenth-century Florence is indicated by Vespasiano da Bisticci's life of Palmieri (*Le vite*, ed. Greco, I, pp. 563–7).

The most substantial modern consideration of Palmieri's life is the article by Messeri, "Matteo Palmieri: cittadino di Firenze nel secolo XV," *Archivio storico italiano* (1894), pp. 256–340. Buck, "Matteo Palmieri (1406–1475) als Repräsentat des Florentiner Bürgertums," *Archiv für Kulturgeschichte* (1965), pp. 77–95, takes Palmieri as an instance of a specifically Florentine phenomenon in his combination of a business career with a dedication to humanist studies and evaluates the *Vita civile* in this light. Martines, *The Social World of the Florentine Humanists*, pp. 138–42 and 191–8, outlines Palmieri's social position and Molho gives a succinct account of his economic status in *Florentine Public Finances in the Early Renaissance*, pp. 95–9. Conti's edition of Palmieri's fiscal records, *Ricordi fiscali (1427–1474)*, also summarizes his financial fortunes. Palmieri's funeral is discussed by Strocchia, *Death and Ritual in Renaissance Florence*, pp. 190–1. Bagemihl, "Francesco Botticini's Palmieri Altarpiece," *Burlington Magazine* (1996), pp. 308–14, has published documents relating to the commission of his altarpiece and considered its placement and design. I discuss the connection of the iconography of the altarpiece to Palmieri's civic ideals in my essay on "Art and the Imagery of Memory," in *Art, Memory, and Family*, ed. Ciappelli and Rubin, pp. 78–82 and in *Renaissance Florence: The Art of the 1470s* ed. Rubin and Wright, pp. 47–8.

The Ideology of Wealth

For a chronological survey of changing concepts of wealth, see the collection of essays by Hans Baron, *In Search of Florentine Civic Humanism*, particularly vol. 1, chapters 7–9 ("Franciscan Poverty and Civic Wealth in the Shaping of Trecento Humanistic Thought: The Role of Petrarch," pp. 158–90; "Franciscan Poverty and Civic Wealth in the Shaping of Trecento Humanistic Thought: The Role of Florence," pp. 191–225; "Civic Wealth and the New Values of the Renaissance: The Spirit of the Quattrocento," pp. 226–57; see also Najemy's review essay in *Renaissance Quarterly* [1992], pp. 340–50). As the titles imply, these essays relate to Baron's notion of "civic humanism." In his highly influential book, *The Crisis of the Early Italian Renaissance: Civic Humanism and Republican Liberty in an Age of Classicism and Tyranny* (first published in 1955, rev. edn., 1966), civic humanism is characterized as a cultural response to political challenges. According to Baron it represented a change in humanist thought provoked by political events: specifically the threat to the republican liberty of the city-state of Florence by the monarchical absolutism of the duchy of Milan. The intellectual and ideological forces galvanized by these events, Baron argued, resulted in a transformation of "all ideas of man and life" (p. xxv), which explained the "sudden rise of Florence to a key position, first in Italian politics and, subsequently, in Humanism and Renaissance art" (p. 444). Neither the refinement of Baron's reasoning nor the extent of his erudition have been questioned, but his representation of Florence as a modern, republican, and secular state and its place in defining the Renaissance have been challenged. For a review of the debates surrounding civic humanism, which in themselves present new interpretations of both civic ideals and humanist thought, with further references, see Griffiths, Hankins, and Thompson, *The Humanism of Leonardo Bruni*, pp. 15–21, Hankins, "The 'Baron Thesis' after Forty Years and some Recent Studies of Leonardo Bruni," *Journal of the History of Ideas* (1995), pp. 309–38, and the 1996 *American Historical Review* forum with essays by Witt, Najemy, Kallendorf, and Gundersheimer. For another synopsis of the problematics of wealth in the period, see McGovern, "The Rise of New Economic Attitudes – Economic Humanism, Economic Nationalism," *Traditio* (1970), pp. 217–53. Questions regarding to wealth and possessions were topics in the debates on nobility; for translations of some of the key fifteenth-century texts, see Rabil, *Knowledge, Goodness, and Power*. For another view on the relationship of humanist thinkers to the political and social life of Florence, see Martines, *The Social World of the Florentine Humanists*. Bec, in *Les Marchands écrivains*, examines the learning and literary output of Florentine merchants, and in *Les Livres des Florentins (1413–1608)* seeks to quantify and qualify their ownership of books. Both investigate how the formal erudition of the professional scholars can be asociated with the general culture of the Florentine mercantile class.

The notion of magnificence as understood in Florence and as applied to the patronage activities of its leading citizens, is outlined by Fraser Jenkins, "Cosimo de' Medici's Patronage of Architecture and the Theory of Magnificence," *Journal of the Warburg and Courtauld Institutes* (1970), pp. 162–70. For further references to the subject, see my article on "Magnificence and the Medici," in *The Early Medici and their Artists*, ed. Ames-Lewis, pp. 37–49.

Economy

Molho, *Florentine Public Finances in the Early Renaissance*, appraises the financial situation at the beginning of the fifteenth century, both for the state and for individuals, including Palla Strozzi (pp. 156–61) and Matteo Palmieri (pp. 95–9). In the first part of *The Building*

of Renaissance Florence, Richard Goldthwaite explains the economic background to expenditure in the fifteenth century ("The Wherewithal to Spend: The Economic Background," pp. 29–66) and attitudes toward private spending ("The Reasons for Building: Needs and Taste," pp. 67–112). Subsequent chapters detail how money was spent on such projects and describe how money itself worked in the economy. Goldthwaite's interpretation of the performance of the economy and its relation to private spending has not been universally accepted, for a critique see Martines, "The Renaissance and the Birth of Consumer Society," *Renaissance Quarterly* (1998), pp. 197–203. For further discussions of the models for the study of the economy of the period, and the debates on the subject, see the articles edited by Goldthwaite, "Recent Trends in Renaissance Studies: Economic History," *Renaissance Quarterly*, XLII (1989), pp. 635–825, and the first chapter of Tognetti's study of the silk industry, *Un industria di lusso al servizio del grande commercio*.

Patronage and Patrons

General

Wackernagel's *The World of the Florentine Renaissance Artist* is, as its subtitle states, about "Projects and Patrons, Workshop and Art Market." First published in 1938, it is still unsurpassed as a survey of commissions, patrons, and workshop organization and practice in Florence. Luchs's 1981 translation added an extensive updated bibliography to Wackernagel's original bibliography.

Antal's *Florentine Painting and its Social Background*, which attaches stylistic change to the economic and social history of Florence, is a foundation text of Marxist art history. Antal's characterization of the class structure of the city, declared in the subtitle "The Bourgeois Republic before Cosimo de' Medici's Advent to Power," is not historically applicable. Though superseded by subsequent research on the economic and political constitution of the city and the working conditions of its artists, his observations and topics still offer many points worth considering about the operation of the arts within society.

The definition of patronage as a social phenomenon in the Italian renaissance is the subject of the essays edited by Kent and Simons, *Patronage, Art and Society in Renaissance Italy*. A historiographic overview of definitions of patronage in Florence is given by Molho, "Il padronato a Firenze nella storiografia anglofona," *Ricerche storiche* (1985), pp. 5–16. D. Kent describes "The Terms of Renaissance Patronage," in the introduction to her book on *Cosimo de' Medici*, which is devoted to his "patronage oeuvre" and its context. In her *Changing Patrons: Social Identity and the Visual Arts in Renaissance Florence*, J. Burke assesses recent approaches to the study of patronage, particularly as applied to art history, and uses specific cases (the Nasi and Pugliese) to demonstrate the links between patronage and the visual world of Florentine families.

My discussion of Donatello and Brunelleschi at Orsanmichele owes a great debt to Zervas's study *The Parte Guelfa, Brunelleschi and Donatello*, which offers a subtle and detailed examination of the relationship of patronage networks to developments in style at the beginning of the fifteenth century.

Social Patterns and Patronage

Theoretical considerations of the nature of patronage and approaches to the study of social organization are to be found in Weissman's essays "Taking Patronage Seriously: Mediterranean Values and Renaissance Society," in *Patronage, Art and Society in Renaissance Italy*, ed. Kent and Simons, pp. 25–45, and "Reconstructing Renaissance Sociology," in his book on *Persons in Groups*, pp. 39–46, Burke's introduction to her book *Changing Patrons*, and in Nelson and Zeckhauser's introductory section to the volume of essays *The Patron's Payoff*. General questions of patronage structures within Florence, with specific reference to the visual arts, are explored by F. W. Kent, in "Individuals and Families as Patrons of Culture in Quattrocento Florence," in *Language and Images of Renaissance Italy*, ed. Brown, pp. 171–92, where he sketches "a collective portrait of a grand Florentine patron of Renaissance architecture and the related arts," in order to situate those activities in the "social landscape" also charted in the article (pp. 182–7). Kent also examines the "patronal behaviour of some more socially obscure patrons" (187–8).

The operations of patronage networks in Florence are vividly evoked by Kent in his article "'Un paradiso habitato da diavoli': Ties of Loyalty and Patronage in the Society of Medicean Florence," in *Le radici cristiane di Firenze*, pp. 183–210. The ties between "kin, friends, and neighbors" (*parenti, amici, vicini*) are investigated with reference to the examples of the Niccolini family by Klapisch-Zuber, "Kin, Friends, and Neighbors: The Urban Territory of a Merchant Family in 1400," in *Women, Family, and Ritual in Renaissance Italy*, pp. 68–93.

The bonds among neighbors are discussed in general by F. W. Kent, "Il ceto dirigente fiorentino e i vincoli di vicinanza nel Quattrocento," in *I ceti dirigenti nella Toscana del Quattrocento*, pp. 63–78. Extended case studies of neighborhoods that include consideration of patronage are: D. and F. W. Kent on the district of the Red Lion in *Neighbours and Neighbourhood in Renaissance Florence* and Eckstein on *The District of the Green Dragon: Neighbourhood Life and Social Change in Renaissance Florence*.

Some instances of the patronal activities of families, as well as the definitions of familial networks of influence in all areas of endeavor are offered by Goldthwaite in *Private Wealth in Renaissance Florence: A Study of Four Families* (the Capponi, Gondi, Guicciardini, and Strozzi), F. W. Kent in *Household and Lineage in Renaissance Florence: The Family Life of the Capponi, Ginori, and Rucellai*, and P. Clarke, *The Soderini and the Medici: Power and Patronage in Fifteenth-Century Florence*.

Major Patrons

THE MEDICI

The literature on the Medici is vast and growing. Hale's book, *Florence and the Medici*, provides an introduction to the family, and has further references.

Reflections on the nature of Medici patronage are to be found in Gombrich's essays on "Renaissance and Golden Age" and "The Early Medici as Patrons of Art" in *Norm and Form*, pp. 29–34, 35–57. Both are concerned with the relation of rhetorical formulas to historical analysis, the former concentrating on the image of Lorenzo de' Medici (partly propagated by Lorenzo himself) and the latter on the diverse characterizations of Cosimo, Piero, and Lorenzo, which date back to Machiavelli and Guicciardini. Articles on specific artists and projects are in the collection edited by Ames-Lewis, *The Early Medici and their Artists*. The

history of the Medici palace and some aspects of its decoration are the subjects of the essays in Cherubini and Fanelli, ed., *Il Palazzo Medici Riccardi di Firenze*. The palace chapel is described and thoroughly and glamorously illustrated in *The Chapel of the Magi: Benozzo Gozzoli's Frescoes in the Palazzo Medici-Riccardi Florence*, ed. Acidini Luchinat. Hatfield on "The Compagnia de' Magi," *Journal of the Warburg and Courtauld Institutes* (1961), pp. 107–61, is the principal reference for this confraternity, which the Medici came to dominate and whose imagery of kingship was so important to their family chapel.

Vespasiano da Bisticci's biography of Cosimo remains a basic source (*Le vite*, ed. Greco, II, pp. pp. 167–211) and its topics include Cosimo's building projects, his endowments, and his support of artists as well as men of letters (pp. 189–90, 193–4). The essays edited by Ames-Lewis, *Cosimo "Il Vecchio" de' Medici 1389–1464*, present an excellent overview of Cosimo's activities. D. Kent's book *Cosimo de' Medici* brings a rich repertory of new material to the description of Cosimo as a patron. The problem of defining Cosimo's patronage is also examined by Molho in his article "Cosimo de' Medici: *Pater Patriae* or *Padrino?*" *Stanford Italian Review* (Spring, 1979), pp. 5–33.

Piero's brief tenure as head of the family has resulted in a diminished view of his role as a patron. The articles in *Piero de' Medici "il Gottoso" (1416–1469)*, ed. Beyer and Boucher, are a welcome reappraisal of Piero's activities. Lorenzo's magnificence has, on the other hand, never been doubted and has been a topic of history since his life time. F. W. Kent gave a series of lectures on Lorenzo's art patronage, published as essays, *Lorenzo de' Medici and the Art of Magnificence*. These are the result of research done for a study of Lorenzo that will present a comprehensive picture of his personality, his patronage, and the development and consequences of his influence on all aspects of Florentine life. Rochon's book *La Jeunesse de Laurent de Medicis* is a richly detailed, learned, and somewhat romantic description of Lorenzo's education, his teachers, friends, and associates, and of Lorenzo's early literary output. It shows the way that Lorenzo's talents and his formation prepared him to ally cultural patronage with political ambitions. The quincentenary of Lorenzo's death was the occasion for a number of international conferences; as published, the resulting contributions are a guide to Lorenzo's awesomely versatile career (*Lorenzo il Magnifico e il suo mondo*, ed. Garfagnini; *Lorenzo the Magnificent: Culture and Politics*, ed. Mallett and Mann; *Lorenzo de' Medici: New Perspectives*, ed. Toscani; *La Toscana al tempo di Lorenzo il Magnifico*). There were also a series of exhibitions held in Florence, which have a very useful set of catalogues. The most pertinent with respect to both the realities and the myths of Lorenzo's patronage are: *All'ombra del lauro: documenti librari della cultura in età laurenziana*; *L'architettura di Lorenzo il Magnifico*; *Consorterie politiche e mutamenti istituzionali in età laurenziana*; *Il giardino di San Marco*; *Le Tems revient, 'l tempo si rinuova: feste e spettacoli nella Firenze di Lorenzo il Magnifico*; *Lorenzo dopo Lorenzo: la fortuna storica di Lorenzo il Magnifico*. Fusco and Corti's *Lorenzo de' Medici, Collector and Antiquarian* publishes an extensive documentation about Lorenzo's collecting, which permits an intriguing view of his antiquarian passions, of the acquisition and dispersal of his collection, and of the ways in which his antiquities were viewed.

PALLA STROZZI (CA. 1373–1462)

Vespasiano da Bisticci's biography of Palla Strozzi in his *Vite* (ed. Greco, II, pp. 139–65) is still a primary reference for Palla's life and is an indication of the strength of his reputation in Florence even after his exile and death. Gregory, "Palla Strozzi's Patronage and Pre-

Medicean Florence," in *Patronage, Art, and Society in Renaissance Italy*, ed. Kent and Simons, puts his activities as a patron in context. Molho describes Palla's financial situation in his book *Florentine Public Finances in the Early Renaissance, 1400–1433*, pp. 157–60. His library is reconstructed by Fiocco, "La biblioteca di Palla Strozzi," in *Studi di bibliografia e di storia in onore di T. de Marinis*, II, pp. 289–310.

The documents for the Santa Trinita sacristy project were published by Jones, "Palla Strozzi e la sagrestia di Santa Trinita," *Rivista d'arte* (1984), pp. 9–106.

Kosegarten and Jones both discuss Palla's relationship with Ghiberti, in their articles in *Ghiberti nel suo tempo*, I, pp. 183–4 and II, pp. 507–21. The documents about Strozzi's loans to Ghiberti are to be found in Sale, "Palla Strozzi and Lorenzo Ghiberti: New Documents," *Mitteilungen des Kunsthistorischen Institutes in Florenz* (1978), pp. 355–8.

The altarpiece by Gentile da Fabriano is described by Christiansen in his book, *Gentile da Fabriano*, with reference to the sacristy project, the iconographical tradition of the Adoration (pp. 22–37, cat. ix, pp. 96–9) and Gentile's other works done in Florence (pp. 37–49, 92–6, 99–107). De Marchi, *Gentile da Fabriano*, has an extensive discussion of this altarpiece (pp. 135–69) and Gentile's career in Florence (pp. 169–92), including a very full description of the materials and techniques of the Strozzi *Adoration* (p. 160 and pls. 35–6). Annamaria Bernacchioni gives a compressed, but informative, account of Gentile in Florence in the book of essays *Gentile da Fabriano: Studi e ricerche*, pp. 121–32, which was produced in conjunction with the exhibition *Gentile da Fabriano e l'altro Rinascimento*. There are also articles by Andrea De Marchi on Gentile's workshop (pp. 9–54), by Robert Bellucci and Cecilia Frosinini on his style and technique (pp. 55–65), and a digest of documents regarding his clients and commissions (by Matteo Mazzalupi, pp. 68–84). The catalogue has valuable essays on Gentile's style and the progress of his career, with a section by De Marchi on Gentile's Florentine altarpieces: the Strozzi commission and two polyptychs from the church of San Niccolò Oltrarno. All of these topics have been importantly addressed in the essays by Christiansen, Strehlke, MacGregor, and Freschi about the *Adoration*, its restoration and technique, patronage and placement in *Gentile da Fabriano agli Uffizi*, with copious and detailed illustration of the painting.

GIOVANNI RUCELLAI (1403–1481)

Extensive selections from the chapbook, the *Zibaldone*, were published by Perosa in the first volume of *Giovanni Rucellai ed il suo Zibaldone*. F. W. Kent's essay on "The Making of a Renaissance Patron of the Arts" in *Giovanni Rucellai ed il suo zibaldone*, II, pp. 9–98, gives a biographical account of Rucellai, situating his patronal enterprises within the social and political context of his time. The essays by Perosa on Rucellai's *Zibaldone*, and Preyer, Sanpaolesi, and Salvini on his palace and its decoration provide substantial insight into his projects, their sources, and genesis. Although there are debates about the architect of the palace and loggia, with Alberti usually given credit, the San Pancrazio chapel and the façade of Santa Maria Novella are accepted as being designed by Alberti, and Giovanni must be acknowledged for his adventurous taste. These problems of attribution are considered by Preyer in her chapter, "The Rucellai Palace," in *Giovanni Rucellai ed il suo zibaldone*, II, pp. 192–7. Hatfield has written a comprehensive account of the façade commission in his article "The Funding of the Façade of Santa Maria Novella," *Journal of the Warburg and Courtauld Institutes* (2004), pp. 81–128. The cultural placement of Rucellai's endeavors is delineated in the article by Tarr on "Giovanni Rucellai's Comments on Art and Architecture," *Italian Studies* (1996), pp. 58–95.

Artists and Projects

In *The Parte Guelfa, Brunelleschi and Donatello*, Zervas examines the way in which Donatello's niche and statue of Saint Louis and Brunelleschi's design for the party's hall represented its image. Zervas shows how the *all'antica* style of those projects could express the party's interests as visual reminders of the comparisons between ancient Rome and modern Florence made by humanists such as Leonardo Bruni, sometimes with specific reference to the history and the role of the Guelf party. She also explores the intricate web of interrelationships between the committees, guilds, and boards of works that sponsored and supervised major projects and therefore had the power to influence choices of and developments in style.

Another consideration of the cultural forces allied to the formulation of new styles in Florence is Gombrich's, "From the Revival of Letters to the Reform of the Arts: Niccolò Niccoli and Filippo Brunelleschi," in *Norm and Form*, pp. 93–110.

Boskovits's *Pittura fiorentina alla vigilia del Rinascimento* and Fremantle's *Florentine Gothic Painters* survey painting from the fourteenth into the early fifteenth century. Their extensive examples prove that along with sponsorship of novel forms, traditional formulae were widely favored. The connections between workshop practice and the transmission and development of style are considered by Thomas in Chapter 10 of her book *The Painter's Practice in Renaissance Tuscany*.

Jacobsen, "Soziale Hintergründe der florentiner Maler zu Beginn der Renaissance," in *L'Art et les révolutions*, analyzes the 1427 *catasto* and shows that Bicci di Lorenzo's shop with Stefano d'Antonio and Bonaiuto di Giovanni was the largest and most successful at that time. These statistics are extensively discussed in Jacobsen's book on *Die Maler von Florenz*. The tax declarations of Giovanni di Marco ("dal Ponte"), which demonstrate his solid position as well as his associations with a range of other artists, including Ghiberti, were published by Horne, *Rivista d'arte* (1906), pp. 169–81.

Procacci's dense and idiosyncratic "Lettera a Roberto Salvini con vecchi ricordi e con alcune notizie su Lippo di Andrea modesto pittore del primo Quattrocento," in *Scritti di storia dell'arte in onore di Roberto Salvini*, pp. 213–26, contains references to the frescoes of saints and apostles in the Duomo, done first for the consecration of the cathedral by Pope Eugene IV on March 25, 1435[6] and then in 1439[40]. This prestigious commission involved Bicci di Lorenzo, Lippo di Andrea, Giovanni di Marco, and Rossello di Jacopo. The lengthy notes in this article, when unpacked, are a treasure trove regarding now relatively neglected painters of that generation, and are indicative of their status and involvement in major projects.

BICCI DI LORENZO (1373–1452) AND NERI DI BICCI (1419–1491)

Summaries and chronologies of Bicci and Neri's careers, from known documents, are given by Milanesi in his commentary to Vasari's Life of Lorenzo di Bicci (*Le opere*, II, pp. 63–90). Frosinini's articles on Bicci di Lorenzo and his shop offer valuable information about this shop: "Il passaggio di gestione in una bottega pittorica fiorentina del primo Rinascimento: Lorenzo di Bicci e Bicci di Lorenzo," *Antichità Viva* (1986), no. 1, pp. 5–15; "Il passaggio di gestione in una bottega pittorica fiorentina del primo '400: Bicci di Lorenzo e Neri di Bicci (2)," *Antichità viva* (1987), no. 1, pp. 5–14; "Il trittico Compagni," in *Scritti di storia dell'arte in onore di Roberto Salvini*, pp. 227–31; "Un contributo all conoscenza della pittura tardogotica fiorentina: Bonaiuto di Giovanni," *Rivista d'arte* (1984), pp. 107–31 (an assistant of

Bicci di Lorenzo, n.1 of the article has bibliography on Bicci as well); "Gli esordi del Maestro di Signa: Dalla Bottega di Bicci di Lorenzo alle prime opere autonome," *Antichità viva*, (1990), no. 5, pp. 18–25.

Frosinini's picture of Bicci's shop extends, as noted above, to the next generation, to Bicci's son Neri ("Proposte per Giovanni dal Ponte e Neri di Bicci: Due affreschi funerari del Duomo di Firenze," *Mitteilungen des Kunsthistorischen Institutes in Florenz* [1990], pp. 123–38). The survival of Neri's *ricordanze* from 1453–75 means that his practice as a painter is the best documented of the century (*Le ricordanze*, ed. santi). See Chapter 3 for the information it yields about the organization of his professional and domestic life and the Bibliographic Note to Chapter 3 for the literature on Neri's career.

DONATELLO (1386–1466)

For some guidance to the literature on Donatello, see the Bibliographic Note to Chapter 3. In his article on "Buonaccorso Pitti 'giocatore avventurato' e Niccolò di Betto Bardi," *Annali della Scuola Normale Superiore di Pisa* (1996), pp. 95–106, Gatti offers interesting views about the early patronage of Donatello, focusing on the importance of Pitti to Donatello's career.

FILIPPO BRUNELLESCHI (1377–1446)

The importance and impact of Brunelleschi's career and reputation is well recorded by his fifteenth-century biographer, Antonio Manetti. De Robertis and Tanturli's 1976 edition of the *Vita di Filippo Brunelleschi* is the best critical edition. There is a parallel text English/Italian edition by Engass and Saalman (*The Life of Brunelleschi*). For the cultural context of his activities see the essays by Befani Canfield ("The Florentine Humanists' Concept of Architecture in the 1430s and Filippo Brunelleschi," in *Scritti di storia dell'arte in onore di Federico Zeri*, I, pp. 112–21), Gombrich ("From the Revival of Letters to the Reform of Art," in *The Heritage of Apelles*, pp. 93–110), and Smith ("Originality and Cultural Progress in the Quattrocento," *Rinascimento* [1988], pp. 291–318).

Pope-Hennessy, *Italian Renaissance Sculpture*, pp. 245–7, has a synopsis of Brunelleschi's career both as architect and sculptor, and an entry on the competition relief, with further bibliography. There are many enlightening essays in the conference acts on *Filippo Brunelleschi: la sua opera e il suo tempo*. Saalman, *Filippo Brunelleschi*, is a current introduction to his architecture.

JACOPO DEL SELLAIO (CA. 1441–1493)

Sellaio's works commissioned for the church of San Frediano – the *Martrydom of Saint Lawrence* and a *Pietà* – and his identity as neighbor and confraternity member are discussed by Baskins ("Jacopo del Sellaio's 'Pietà' in S. Frediano," *Burlington Magazine* [1989], pp. 474–9) and Eckstein, *The District of the Green Dragon* (pp. 64, 74–5, 86, 113, 126–7). Rowlands sketches Sellaio's career in his entry "Jacopo del Sellaio," in *The Dictionary of Art*, XVI, pp. 847–8.

LORENZO GHIBERTI (1378–1455)

Krautheimer's biography, *Lorenzo Ghiberti*, is the abiding guide to the life and works of the artist, and the circumstances of his commissions.

The Valori tomb and other tomb slabs attributed to Ghiberti are described in the catalogue of the exhibitions held at the Accademia and the Museo di San Marco in Florence in 1978 to celebrate the 600th anniversary of Ghiberti's birth, *Lorenzo Ghiberti: "materia e ragionamenti"*, pp. 416–20, 445–7. This volume, which is a form of updated catalogue of Ghiberti's works and those influenced by Ghiberti, also has sections on Ghiberti's life, his artistic formation, and his ties with humanists. The acts of the conference held on this occasion, *Lorenzo Ghiberti nel suo tempo*, also have many important contributions to the study of Ghiberti. Wundram's article in *The Dictionary of Art*, XII, pp. 536–45, ably covers Ghiberti's career, with further references.

MARIOTTO DI NARDO (ACTIVE 1394–1431)

Boskovits outlines Mariotto's career in his book *Pittura fiorentina alla vigilia del Rinascimento*, pp. 388–402, with reference to his previous articles on the artist ("Sull'attività giovanile di Mariotto di Nardo," *Antichità Viva* [1968], no. 5, pp. 3–13, and "Mariotto di Nardo e la formazione del linguaggio tardo-gotico a Firenze negli anni intorno al 1400," *Antichità Viva* [1968], no. 6, pp. 21–31). Niccolò di Roberto Davanzati's commission for the Trinity altarpiece for the convent church of San Michele alla Doccia in Fiesole, now in Santa Trinita is discussed in Chiostrini Mannini, *I Davanzati*, pp. 78–85.

MASACCIO (1401–1428)

An extremely handy guide to Masaccio's life and works is the catalogue by Berti and Foggi (*Masaccio: Catalogo completo dei dipinti*), which also has a bibliography starting from Alberti's mention of Masaccio (along with Brunelleschi, Donatello, Ghiberti, and Luca della Robbia) in the 1436 prologue to the Italian version of his treatise *On Painting* and ending in 1989. The English edition of Baldini's and Casazza's *The Brancacci Chapel Frescoes* was published in 1992, offering a complete inspection of the newly restored paintings. A stylistic analysis of the Masaccio/Masolino partnership is given by Joannides (*Masaccio and Masolino*). In *The Panel Paintings of Masolino and Masaccio: The Role of Technique*, Strehlke, Frosinini et al. offer a fascinating interpretation of their affiliation and their place as innovatory painters based on close technical examination of their works.

Borsook, *The Mural Painters of Tuscany*, has sections on the Brancacci chapel (pp. 63–7) and the Santa Maria Novella *Trinity* (pp. 58–63). Written before the restoration of both of these works, Borsook's concise, clear, and carefully reasoned entries are still excellent guides to the monuments they describe and the related literature. The measuring and interpreting of the *Trinity* continues. The perspective construction, an early – if not the earliest – instance of the application of linear perspective to a monumental painting, is exhaustively dealt with by Field, Lunardi, and Settle in their book on *The Perspective Scheme of Masaccio's Trinity Fresco*. A briefer, but essential, discussion of the perspective system of the *Trinity*, is in Kemp, *The Science of Art*, pp. 16–21, where he argues that "the sheer sophistication of the construction . . . raises the possibility of Brunelleschi's active collaboration" (p. 21) and historically locates that type of construction in Brunelleschi's perspective experiments and the spatial compositions of Donatello and Masaccio.

3 THE ECONOMY OF HONOR: DONATELLO AND ARTISTIC PRACTICE

The Roundel

Pope-Hennessy, "The Madonna Reliefs of Donatello," in *The Study and Criticism of Italian Sculpture*, pp. 85–102, gives a personal and dramatic account of the rediscovery of the roundel, with a succinct analysis of the composition and its place in Donatello's thinking about devotional Madonnas. He dates the roundel to 1456, as made in Florence. He doubts that the mold on the reverse was designed to make a glass cast, suggesting that it might be prudent to translate the phrase "vetro strutto" in maestro Giovanni's *ricordo* to mean "glass paste" and to relate it to the production of stucco reliefs rather than casts made with molten glass (pp. 92–3). He reaffirmed these opinions (originally published in *Apollo Magazine* in 1976) in his 1993 monograph, *Donatello Sculptor*, pp. 264–7, p. 345 n. 25. Radcliffe and Avery, "The 'Chellini Madonna' by Donatello," *Burlington Magazine* (1976), pp. 377–87, also give a comprehensive account of the roundel, its provenance, technique, and relation to other Virgin and Child reliefs. The authors date the roundel to Donatello's stay in Padua (1443–53) when he might have become interested in North Italian innovations in glass-making. They include information about the modern glass casts taken from casts of the reverse of the roundel, which were made in London and in Venice following Renaissance glass-making techniques. A mid-sixteenth-century technical treatise describes working glass and mentions how it can be molded "in a hollow mould of bronze," which confirms that this technique was practiced at the time (*The Pirotechnia of Vannoccio Biringuccio* [1540], p. 130; I thank Antonia Boström for pointing this out to me). The entry by Radcliffe in the exhibition catalogue, *Italian Renaissance Sculpture in the Time of Donatello* (Detroit, 1985) has a concise summary of previous literature. The roundel is discussed in relation to Donatello's career and character as an artist in the monographs by Bennett and Wilkins, *Donatello*, pp. 49–50, 62, 122–5, 155, and Rosenauer, *Donatello*, pp. 244–6, 283, in both cases a date in Donatello's Paduan period is favored.

Donatello's Reputation

As noted in Chapter 2, in the 1436 dedication of the vernacular rendering of his treatise *On Painting* to Brunelleschi, Leon Battista Alberti named Donatello in his list of those in whom he recognized "a genius for every laudable enterprise in no way inferior to any of the ancients who gained fame in the arts" (followed by Ghiberti, Luca della Robbia, and Masaccio; *On Painting*, ed. Kemp, p. 34). Just after the middle of the century Donatello's name became attached to the topic of fame by humanist writers with increasing frequency and celebrated in comparisons with ancient artists. Donatello is included in Flavio Biondo's *Italia illustrata* (1453), as "another ornament of Florence. With a talent equal to the excellence of the ancients, he is a match for Zeuxis of Heraclea, able (in Vergil's words) to 'draw living expressions' from the marble" ("Decorat etiam urbem Florentiam ingenio veterum laudibus respondente Donatellus Heracleotae Zeuxi aequiparandus, ut vivos (iuxta Vergilii verba) ducat de marmore vultus"; 1.32, *Italy Illuminated*, ed. White, 1, pp. 74–5). This closely follows a remark about the "luster" added to the city by Leon Battista Alberti "with his noble and versatile intelligence in many good arts." In his treatise on famous men (1456) Bartolomeo Facio wrote that Donatello: "also a Florentine, who excels for his talent and no less for his technique, is

very well known for his bronze and marble figures, for he can make people's faces come to life, and in this he comes close to the ancient masters" (*De viris illustribus*, ed. Mehus, p. 51: "Donatellus et ipse Florentinus ingenii quoque, et artis praestantia excellet non aere tantum, sed etiam marmore notissimus, ut vivos vultus ducere, et ad antiquorum gloriam proxime acccedere videatur"). Lorenzo Ghiberti and his son Vittorio are the other sculptors praised in this section. Donatello's death is recorded in Bartolomeo Fonte's chronicle (*Annales suorum temporum*, ed. Galletti, p. 156: "[1466] Donatellus Florentinus Sculptor insignis sexto et septuagesimo aetatis anno Florentiae obiit iv. idus Decembris"). These and other such comments are discussed in the essay tracing Donatello's fame by Collareta, "Testimonianze letterarie su Donatello 1450–1600," in *Omaggio a Donatello 1386–1986*, pp. 7–47. The documents regarding Donatello's life and career are conveniently assembled, with excerpts, by Herzner, "Regesti donatelliani," *Rivista dell'Istituto Nazionale d'Archeologia e Storia dell'Arte* (1979), pp. 169–228.

Giovanni di maestro Antonio di Chellino da Sanminiato (ca. 1372–1462)

The man dubbed Giovanni Chellini in modern literature was known in the fifteenth century as maestro Giovanni di maestro Antonio da Sanminiato. His *ricordanze* are in the Istituto di Storia Economica, Università Bocconi, in Milan and were published in 1984 (*Le ricordanze*, ed. Sillano). There is a brief account of his life, with further references by Di Trocchio, "Chellini, Giovanni," in *Dizionario biografico degli Italiani*, pp. 417–18. His wills are summarized by Battistini, "Giovanni Chellini medico di S. Miniato," *Rivista di storia delle scienze mediche e naturali* (1927), pp. 106–17. The documents regarding his career at the *Studio* are in *Statuti della Università e Studio fiorentino*, ed. Gherardi, pp. 375, 401. Both maestro Giovanni and his father Antonio are recurrent figures in Park, *Doctors and Medicine in Early Renaissance Florence*. Maestro Giovanni's financial status in his profession in 1427 is documented in her Appendix III ("Doctors in the *Catasto* of 1427"), pp. 249–52, with a table giving a digest of doctors' tax reports, p. 250, no. 19 for maestro Giovanni. I am deeply indebted to Park's work for my discussion of the medical profession in fifteenth-century Florence.

For maestro Giovanni's tomb in the right transept of the church of San Domenico at San Miniato, see Schulz, *The Sculpture of Bernardo Rossellino*, Chapter 9, pp. 75–81, where she discusses the tomb's commission and its attribution, and proposes a reconstruction, and pp. 117–20, for the catalogue entry with further details of description, documentation, and bibliography. Caplow, *Michelozzo*, I, pp. 518–29, also reviews and publishes the documents, concluding that the commission was perhaps given to Donatello and Michelozzo in 1456 when they renewed their partnership, that the effigy is by Michelozzo, and the tomb architecture by the Rossellino shop. In his essay on "Monument and Memory in Florence," Butterfield comments on the rarity of wall monuments with effigies in Florence, pointing out that doctors of law and medicine were among the elite groups who had tombs with sculpted effigies (the others were knights and nobles, ecclesiastics or distinguished friars, and those who were honored by the city by being buried at public expense; *Art, Memory, and Family in Renaissance Florence*, ed. Ciappelli and Rubin, pp. 144–5).

In *Italian Renaissance Sculpture*, Pope-Hennessy gives particular importance to Antonio Rossellino's portrait of maestro Giovanni as the only marble bust done from a life mask, as being influenced by antique types, and as giving a sense of personality (pp. 47–8, 282). In

his 1457[58] *catasto* declaration, maestro Giovanni lists Antonio Rossellino among his creditors. The sculptor was still owed seven florins by the physician and it could be speculated that this represents payment or part payment for the bust (ASF, Catasto, no. 826 [1457], fol. 168v: "Antonio scarpellatore al proconsolo de lavorio ff. 7.").

For maestro Girolamo di messer Matteo Broccardi da Imola and his dramatic involvements with Filelfo, see Zippel, "Il Filelfo a Firenze," in *Storia e cultura del Rinascimento italiano*, pp. 215–53. I want to thank Jonathan Davies for his generosity in giving me unpublished references to maestro Giovanni and maestro Girolamo at the Studio and for supplying me with bibliography regarding maestro Girolamo.

Artistic Practice

Wackernagel's *The World of the Florentine Renaissance Artist*, trans. Luchs, is a key source on this subject. Lerner-Lehmkuhl, *Zur Struktur und Geschichte des florentinischen Kunstmarktes*, introduced the concept of the art market to the study of Florentine Renaissance art. Goldthwaite, *The Building of Renaissance Florence*, is a comprehensive and stimulating description not only of the building trades, but of the nature and structure of labor in the fifteenth century. Frick devotes the first part of her book on *Dressing Renaissance Florence* to "Guilds and Labor," placing tailors within the trades of the city, which provides an interesting comparison to the arts discussed here. For the guilds in general, see Doren, *Le arti fiorentine*, and *La grande storia dell'artigianato: arti fiorentine*, ed. Franceschi and Fossi; for the painters' guild, see Ciasca, *L'arte dei Medici e Speziali*, and for painters in their guild, Fiorilli, "I dipintori a Firenze nell'arte dei Medici, Speziali e Merciai," *Archivio storico italiano* (1920), pp. 5–74. For the profession of painting as exercised within the guild structure, see Bellucci and Frosinini, "Working Together: Technique and Innovation in Masolino's and Masaccio's Panel Paintings," in *The Panel Paintings of Masolino and Masaccio*, ed. Strehlke and Frosinini, pp. 29–31 and for Gentile da Fabriano's matriculation, see Christiansen, *Gentile da Fabriano*, doc. 7, p. 162.

There is a short section on Renaissance workshops in Camesasca, *Artisti in bottega*. In their respective essays on "L'artista: momenti e aspetti" and "L'evoluzione dell'artista," P. Burke and Conti present an overview of the art trades in the Einaudi *Storia dell'arte italiana*, Part I, vol. II, pp. 85–113 and 115–265. Thomas, *The Painter's Practice in Renaissance Tuscany*, supplies a detailed presentation of the documentary evidence on the topic and an informed definition of workshop organization. O'Malley's *The Business of Art: Contracts and the Commissioning Process in Renaissance Italy* is a comparative study of the information about this subject, which considers questions of cost, value, and the terms of practice.

In *Die Maler von Florenz zu Beginn der Renaissance*, Jacobsen presents an illuminating demographic and economic discussion of the social and commercial lives of Florentine painters in the early fifteenth century. His essay "Soziale Hintergründe der florentiner Maler zu Beginn der Renaissance," in *L'Art et les révolutions*, pp. 3–17, gives a short introduction to the project, with an analysis of the 1427 *catasto* summarizing the population of painters, where they worked, and where they lived at that time. The statistics about painters in the 1427 *catasto* in my chapter are taken from Jacobsen's article, as are some of the remarks about the distribution of painters' houses and shops. Eckstein's *The District of the Green Dragon* includes a section on "Drago's *dipintori*," which examines "the district's community of

painters" in order to illustrate the "interconnectedness" of its inhabitants and "the interweaving of the district's lay and religious cultures" (pp. 41–60, quote from p. 41). He shows how the network of local artists contributed to the neighborhood's activities and "visual culture," and characterizes their behavior in terms of wider social patterns.

Alessandro Guidotti of the University of Florence directed a series of systematic soundings of the Florentine archive for information about Florentine artists and their shops proposing models for databases on the subject; for this project, see G. C. and A. Guidotti, "Proposte per una schedatura elettronica di fonti d'archivio utili per la storia delle arti," and De Marco and Guidotti, "Spoglio ed elaborazione di dati documentari relativi a botteghe e luoghi di lavoro fiorentini," *Bollettino d'Informazioni*, Centro di Elaborazione Automatico di Dati e Documenti Storico-Artistici, Pisa, IV (1983), pp. 95–143, and VI (1985), pp. 169–213. Some of the material is presented in the 1977 catalogue, *L'oreficeria nella Firenze del Quattrocento*, which has as its topic not only goldsmiths and their shops, but also argues for the "unity and dignity" of the arts in Renaissance Florence and examines the world of the arts and artists in the widest sense. Further results are published in Cantini Guidotti, *Orafi in Toscana*.

The dense interweaving of goldsmiths' families and their shops is studied by Carl, "Zur Goldschmiedefamilie Dei," *Mitteilungen des Kunsthistorischen Institutes in Florenz* (1982), pp. 129–66. Procacci, "Di Jacopo di Antonio e delle compagnie di pittori del Corso degli Adimari," *Rivista d'arte* (1960), pp. 3–70, chronicles a series of painters' companies in the first half of the fifteenth century and provides a definition of that sort of association. Pons, "Zanobi di Giovanni e le compagnie di pittori," *Rivista d'arte* (1991), pp. 221–7, studies a further instance dating from the 1470s and 1480s. Haines, "Giuliano da Maiano capofamiglia e imprenditore," in *Giuliano e la bottega dei da Maiano*, ed. Lamberini et al., pp. 131–42, describes how a family firm operated, professionally, artistically, and socially. She traces the career of Masaccio's brother in a carefully documented study of "Il mondo dello Scheggia: persone e luoghi di una carriera," in *Lo Scheggia*, ed. Bellosi and Haines, pp. 7–33 (for this figure, see also Procacci, "Le portate al catasto di Giovanni di ser Giovanni detto Lo Scheggia," *Rivista d'arte* [1984], pp. 234–67). In her article on "Artisan Family Strategies," in *Art, Memory, and Family*, ed. Ciappelli and Rubin, pp. 163–75, Haines discusses some of the problems involved in studying artisan family identity as well as describing some revealing instances, giving insights into the sense of family in the artisan class. She also shows how family dynasties functioned as patronage networks.

Bergstein's work on Nanni di Banco is a model study, showing how family and professional structures influenced his career and status (in her book on *The Sculpture of Nanni di Banco*; her doctoral dissertation, "The Sculpture of Nanni di Banco," Columbia University, 1987; and article on "La vita civica di Nanni di Banco," *Rivista d'arte* [1987], pp. 55–82). Ferrara and Quinterio's monograph on Michelozzo systematically traces and documents his work, while F. W. Kent's book *Lorenzo de' Medici and the Art of Magnificence* gives many instances of his son, Niccolò's, importance to Lorenzo as his secretary and friend.

An intimate and detailed view of a painter's practice is afforded by the surviving record book of Neri di Bicci (*Le ricordanze*, ed. Santi). In her review of Santi's edition in *Art Bulletin* (1979), pp. 313–18, Borsook gives a helpful synopsis of Neri's activities and their general context. Thomas's *The Painter's Practice in Renaissance Tuscany* makes good use of this source and also illustrates a number of Neri's works in color, which imparts a sense of why they were so appreciated during the fifteenth century. She discusses specific commissions and

Neri's patrons in successive articles in *Rivista d'arte* (1992: the Franciscan nuns of Santa Maria a Monticelli), *Arte cristiana* (1993: the Augustinians), *Antichità viva* (1993: the nuns of Santa Monaca and the Compagnia di Miransù), *Apollo* (1997: the Spini family for their chapel at Santa Trinita), and the *Burlington Magazine* (1997: the nuns at San Niccolò dei Frieri). Many of these also have color illustrations and cumulatively supply a picture of the range of commissions offered to Neri. F. W. Kent introduces another of Neri's clients, Bartolommeo Cederni, in his article on "The Cederni Altar-piece by Neri di Bicci in Parma," *Mitteilungen des Kunsthistorischen Institutes in Florenz* (1989), pp. 378–9. These articles are complemented by Santi's summary and analysis in "Dalle 'ricordanze' di Neri di Bicci," *Annali della Scuola Normale Superiore di Pisa* (1973), pp. 169–88.

Holmes's essay "Neri di Bicci and the Commodification of Artistic Values in Florentine Painting (1450–1500)," in *The Art Market in Italy*, ed. Fantoni et al., pp. 213–23, is a model analysis of the factors involved in producing and promoting a desirable output. She both considers the question of value – commercial and aesthetic – and demonstrates the way that Neri exploited current artistic technologies to market his work. Her study of the diffusion and replication of compositions by Fra Filippo Lippi reveals developments in practice that arose to stimulate and to satisfy a variety of demands and needs "among patrons and consumers from different social ranks and urban communities" ("Copying Practices and Marketing Strategies in a Fifteenth-Century Florentine Painter's Workshop," in *Artistic Exchange and Cultural Translation in the Italian Renaissance City*, ed. Campbell and Milner, pp. 38–74, quoted from p. 39).

In an excellent, and too little-known essay "Art and Business in Renaissance Florence and Venice," in *Humanismus und Ökonomie*, pp. 135–55, Borsook surveys the subject of the financing and production of works of art in both cities. The catalogue, *Maestri e botteghe* (Palazzo Strozzi, 1992–3), contains a considerable amount of information about painters' shops in the second half of the fifteenth century. The brief article by Indrio, "Firenze nel Quattrocento: divisione e organizzazione del lavoro nelle botteghe," *Ricerche di storia dell'arte* (1989), pp. 61–70, points out the necessity of collaboration between different types of shops, such as sculptors and painters, to produce finished works. Salient features of artistic production in Florence are also noted by Padoa Rizzo and Guidotti in their article on "Pubblico e privato, committenza e clientela," *Ricerche storiche* (1986), pp. 535–56. Caplow, "Sculptors' Partnerships in Michelozzo's Florence," *Studies in the Renaissance* (1974), pp. 145–75, documents and discusses the business of art production in sculptors' shops, based on Michelozzo's career, and involving Donatello's.

The special situation of monastic artists is handled with great insight by Holmes in her *Fra Filippo Lippi: The Carmelite Painter*. The meaning of the Dominican ideals to Fra Angelico's work has received illuminating treatment by Hood, *Fra Angelico at San Marco*. Eisenberg, *Lorenzo Monaco*, is the authoritative account of that painter's career and documents and describes his training and his transactions with the Camaldolites of Santa Maria degli Angeli. Essays and entries in the beautifully illustrated catalogue of the exhibtion held at the Galleria dell'Accademia in Florence in 2006 cover the artist's activities as a painter, miniaturist, and Camaldolite, with a documentary citations and a full bibliography. Jacobsen, *Der Maler von Florenz*, pp. 143–6, also comments on this type of career.

Social Definition

The statistical analysis of the 1427 *catasto* in Herlihy and Klapisch, *Les Toscans et leurs familles*, has become the basis for the description of social patterns and structures in Florence and its territories in the fifteenth century. The question of class definition has been looked at from the perspectives of both the ruling elite at one end and the disenfranchised laborers at the other. For the former see, for example, Goldthwaite, *Private Wealth in Renaissance Florence*, F. W. Kent, *Household and Lineage in Renaissance Florence*, Martines, *Lawyers and Statecraft in Renaissance Florence*, and Molho, *Marriage Alliance in Late Medieval Florence*. For the latter, see Cohn, *The Laboring Classes in Renaissance Florence*. Degrassi, *L'economia artigiana nell' Italia medievale*, is about the artisan class, the organization of artisans' work and their social and cultural placement. Brucker, "Civic Traditions in Premodern Italy," in *Living on the Edge in Leonardo's Florence*, pp. 22–41, describes the political participation of the "middling mass" of citizens that "comprised artisans and shopkeepers from the lower guilds" as well as members of the greater guilds. All of these authors give important and carefully documented treatment to the problems attending such definition and all refer to further relevant literature. A useful and more general discussion of class structures is the answer Constable gives to the question, "Was there a Medieval Middle Class?" in *Portraits of Medieval and Renaissance Living*, ed. Epstein and Cohn, pp. 301–23.

The social distinctions made by Florentines are described by Brucker in his article on "Florentine Voices from the *Catasto*, 1427–1480," *I Tatti Studies* (1993), pp. 11–32. His book *Giovanni and Lusanna* presents an engaging tale of love and betrayal and of a law case for breach of promise based on the notarial documents relating to the case. It is a micro-history that is of importance here for its insights into the view that artisans and patricians had of themselves and their means of self-definition and self-protection. A micro-history of a different sort, D. and F. W. Kent's study of the *gonfalone* of the Red Lion (*Neighbours and Neighbourhood in Renaissance Florence*), offers an introduction to the operations of family, friends, and neighborhood and their importance. Eckstein's article on "Addressing Wealth in Renaissance Florence," *Journal of Urban History* (2006), pp. 711–28, employs the *catasto* returns of 1427 from another neighborhood – the *gonfalone* of the Green Dragon – to scrutinize the way in which levels of wealth and occupational status were configured in residential patterns.

4 SEEING AND BEING SEEN

Optics and the Definition of Sight and Seeing

Optical science in the fifteenth century closely followed the theories put forward at the turn of the eleventh century by Alhazen in his treatise *De aspectibus* and given textbook form in the 1270s by John Pecham (*Perspectiva communis*) and Witelo (*Perspectiva*), and in the fourteenth-century work by Biagio Pelacani of Parma, *Quaestiones super perspectivam*. The standard work on the subject is Lindberg's book *Theories of Vision from Al-Kindi to Kepler*. Alhazen's influential text has been translated with a commentary (*Alhacen's Theory of Visual Perception*, ed. Smith). Bacon's theories are cogently presented by Tachau in *Vision and Certitude*, and in her chapter "Seeing as Action and Passion," in *The Mind's Eye*, ed. Hamburger and Bouché, pp. 336–59, where she also comments on the theorizing of vision by theologians active in Paris in the 1220s, Robert Grosseteste and William of Auvergne. Exhaustive

references to these authors and others contributing to the different aspects of the sciences of sight are given by Schleusener-Eichholz in her article on the popular thirteenth-century book of examples for preachers, the *Tractatus de oculo morali*, which can also be read as a compendium of optical thought, both scientific and proverbial ("Naturwissenschaft und Allegorese: Der 'Tractatus de oculo morali' des Petrus von Limoges," *Frühmittelalterliche Studien* [1978], pp. 258–309). The 1997 and 1998 issues of the journal *Micrologus* are dedicated to "View and Vision in the Middle Ages." These volumes contain a number of illuminating essays about definitions given to vision and perspective in natural philosophy, theology, and their relation to the visual arts. In her article "*Perspectiva* and *Astrologia* in Late Medieval Thought," *Micrologus* (1997), pp. 201–24, Tachau opens her succinct and informative discussion of the transmission and development of "perspectivist optics" by noting the seemingly unusual inclusion of a figure of *Prospettiva* among other personifications of the Liberal Arts on the tomb of the Franciscan pope Sixtus IV (completed by Antonio del Pollaiuolo in 1493). She explains that *perspectiva* was "the only strictly medieval addition to the disciplines of the liberal arts inherited from antiquity" and that from Sixtus's point of view it could be regarded as Franciscan, given the impact of Franciscan thinkers on the subject (Robert Grosseteste, Roger Bacon, and John Pecham, pp. 201–2). The treatises by all of these authors circulated widely from the thirteenth century onward supporting an established place in the university curriculum as well as a more diffused involvement in questions of vision. Also relevant to the topics of the chapters in this and the following section of the present book is the article by Spinosa "Visione sensibile e intellettuale," pp. 119–34.

With respect to the visual arts, the significant change in the study of perspective was an interest in the practical applications of theoretical learning as artists began to study optics – *perspectiva* – with the intention of finding means of translating the action of vision to the activity of composition. The first chapter of Kemp's book on *The Science of Art* tells of the invention of linear perspective by Brunelleschi, its early implementation by Donatello and Masaccio and other artists, its first codification by Alberti, Ghiberti, and Piero della Francesca, and its investigation by Leonardo da Vinci. Artists' perspective and its invention are also treated by Edgerton, Federici Vescovini, and White in their respective books *The Renaissance Discovery of Linear Perspective*, *Studi sulla prospettiva medievale*, and *The Birth and Rebirth of Pictorial Space*. The catalogue of an exhibition held in Florence in 2001, *Nel segno di Masaccio: L'invenzione della prospettiva*, reviews the topic and includes a comprehensive bibliography. Federici Vescovini, writing on "Vision et réalité dans la perspective au XIVe siècle," gives a nuanced consideration of the term perspective and related terminology, with reference to the implications for the development of artificial perspective (*Micrologus* [1997], pp. 161–80).

The cultural consequences of these developments were affirmed by Panofsky in his essay on "Die Perspektive als 'symbolischen Form'" (in *Vorträge der Bibliothek Warburg*, pp. 258–311), which has been translated, with a very useful introduction, by Wood (*Perspective as Symbolic Form*). Wood's translation prompted a number of important reviews, which not only reacted to the book but also revisited the status of the question. These are cited by Iversen in her article on Panofsky's notion of symbolic form as it relates to Damisch's *The Origins of Perspective* in the special issue of the *Oxford Art Journal* dedicated to Hubert Damisch ("The Discourse of Perspective in the Twentieth Century: Panofksy, Damisch, Lacan," *Oxford Art Journal* [2005], pp. 191–202). Further reflections on the nature of this invention are those by Elkins (*Poetics of Perspective*), Kubovy (*The Psychology of Perspective and Renaissance Art*), and Puttfarken (*The Discovery of Pictorial Composition*).

The sources of the third book of Ghiberti's *Commentaries* (which are essentially those of Leonardo da Vinci's later notes) are analyzed by Bergdolt, *Der dritte Kommentar Lorenzo Ghibertis: Naturwissenschaften und Medizin in der Kunsttheorie der Frührenaissance*, with a summary of the sources on pp. 570–3. Federici-Vescovini has discovered an Italian translation of Alhazen available to Ghiberti, which proves the diffusion of this learning to the non-latinate reader ("Il problema delle fonti ottiche medievali del *commentario terzo* di Lorenzo Ghiberti," in *Lorenzo Ghiberti nel suo tempo*, II, pp. 349–87 and "Contributo per la storia della fortuna di Alhazen in Italia," *Rinascimento* [1965], pp. 17–49).

Two successive articles in the *Journal of the Warburg and Courtauld Institutes* treat of the nature and development of Leonardo da Vinci's study of optics: Kemp "Leonardo and the Visual Pyramid" (1977), pp. 128–49 and Ackerman, "Leonardo's Eye" (1978), pp. 108–46. Both evaluate the origins of Leonardo's optical learning, indicating the availability and diffusion of the principal authorities. Ackerman is concerned with the sources of Leonardo's ideas, while Kemp considers the progress of his thought. In *Leonardo da Vinci: The Marvelous Works of Nature and Man*, Kemp further discusses Leonardo's study of the eye, both in terms of optical perception and the process of cognition (pp. 125–34, 325–32).

A scholar and a gentleman, despite the disadvantages of his illlegitimacy, Alberti held doctorates in canon and civil law and had university training in mathematics. His access to the science of perspective was far easier than that of artisan pretenders like Ghiberti and Leonardo. His contribution to the theory and practice of what Leonardo was later to recognize as that which "painters wish to call perspective" (see Kemp, "Leonardo and the Visual Pyramid," p. 128) in Book I of *On Painting* has been amply discussed. It has been put in the context of Alberti's career and thought in Chapter 4 of Grafton's book on *Leon Battista Alberti*; specific references to perspective can be found in the books by Edgerton, Federici-Vescovini, and Kemp cited above, and in Edgerton's article "Alberti's Perspective: A New Discovery and a New Evaluation," *Art Bulletin* (1966), pp. 367–78. Greenstein, "Alberti's 'Sign': Vision and Composition in Quattrocento Painting," *Art Bulletin* (1997), pp. 669–98, "places Alberti's rule of composition in the context of late medieval and early Renaissance theories on the role of vision in providing knowledge of the material world" (p. 671). Explaining Albertian composition as a cognitive, as opposed to stylistic or rhetorical, notion, Greenstein demonstrates how these ideas can be linked to a change in the nature of art in the fifteenth century.

Summers's book on *The Judgment of Sense* includes a chapter on "Optics and the common sense," pp. 151–81, which examines the way that the interpretation of Aristotle's *De Anima* in the late Middle Ages "reconciled the physical and the psychological" (p. 153) and discusses how optical theories formulated the connections between vision and understanding, seeing and judgment, from Alhazen to Leonardo da Vinci. The relation of seeing to cognition and to the conception and construction of memory is elucidated by Carruthers in her seminal work, *The Book of Memory: A Study of Memory in Medieval Culture* and in her book *The Craft of Thought: Meditation, Rhetoric, and the Making of Images, 400–1200*. The essays in *Art, Memory, and Family in Renaissance Florence*, ed. Ciappelli and Rubin, deal with different aspects of Florentine memorial culture; links with the visual arts are investigated in my essay "Art and the Imagery of Memory" (pp. 67–85).

The "Period Eye"

In 1998 the periodical *Art History* devoted a special issue to Michael Baxandall's work and its influence; of particular relevance here is the article by Langdale on "Aspects of the Critical Reception and Intellectual History of Baxandall's Concept of the Period Eye," pp. 479–97. The connections between picturing and seeing, the definition of the eye and modes of depiction are explored by Alpers in her groundbreaking work on *The Art of Describing: Dutch Art in the Seventeenth Century*.

Problems regarding the definition of vision and various forms of visual perception have been energetically debated by art historians since the late 1960s. A distinction has been made between "vision," understood as the mechanics of sight and "visuality" – the social and cultural construction of sight; for this see Foster's preface to the essays on *Vision and Visuality* (1988) and Nelson's introduction to a collection of essays on *Visuality before and beyond the Renaissance*. Another key term in discussions of the visual nature of the visual arts is "gaze," which, in current art-historical usage, usually refers back to the psychoanalytic theories of Jacques Lacan regarding subjectivity. The heritage and some contemporary applications of this term are considered by Olin in her brief chapter on "Gaze" in *Critical Terms for Art History*, ed. Nelson and Shiff, pp. 208–19. An explicitly historical or historicized approach to the question of spectatorship in the Renaissance is taken by Shearman in *Only Connect . . .: Art and the Spectator in the Italian Renaissance*, which includes a bibliographic note with a range of references to the question of beholding and the relations between beholders and works of art (n. 3, pp. 6–7).

Sight and Social Practice

Scrutiny

The development of election by scrutiny is traced by Guidi, "I sistemi elettorali agli uffici del Comune di Firenze nel primo Trecento: il sorgere della elezione per squittino (1300–1328)," *Archivio storico italiano* (1972), pp. 345–407. The evolution of the electoral system in the fourteenth century is described by Najemy in *Corporatism and Consensus in Florentine Electoral Politics*, pp. 103–10, 180–8, 210–15, and Rubinstein in *The Government of Florence under the Medici*, pp. 4–5.

Witnessing and Vigilance: The Courts and Criminal Justice

An outline of the division of judiciary authority among the plethora of courts and authorities in Florence is supplied by Martines in Chapter 5 of *Lawyers and Statecraft in Renaissance Florence*. Florentine criminal procedure is explained by Kohler and degli Azzi, *Das florentiner Strafrecht des XIV Jahrhunderts*, Dorini, *Il diritto penale e la delinquenza in Firenze nel XIV secolo*, and Stern, *The Criminal Law System of Medieval and Renaissance Florence*. The measures of proof applied by the rectors' courts, which were set by communal statute, are described by Stern on pp. 29, 31.

Brucker's documentary study *The Society of Renaissance Florence* has a section on "Crime and Punishment," with a brief introduction to criminal procedure (pp. 139–40), followed by translated extracts from the cases recorded in the archives of the rectors' courts (transcrip-

tions of the documents in Latin and Italian are published in the Italian edition, *Firenze nel rinascimento*).

Using records of testimony in cases heard by the tribunal of the Wool Guild, Franceschi studies their structure and language in relation to notions of memory and questions of representation ("Il linguaggio della memoria: Le deposizioni dei testimoni in un tribunale corporativo fiorentino fra XIV e XV secolo," in *La parola dell'accusato*, pp. 213–32). As noted above in the chapter, both Brucker and Kuehn suggest how testimony could be strategically constructed according to stereotypes in the case of the socially mismatched lovers Giovanni and Lusanna (Brucker, *Giovanni and Lusanna* and Kuehn, "Reading Microhistory: The Example of *Giovanni and Lusanna*," *Journal of Modern History* [1989], pp. 512–34).

Magistracies

The first of the new magistracies to be mandated was the one responsible for public order – the Otto di Guardia – created in 1378. Its history in the fifteenth century is recounted by Antonelli ("La magistratura degli Otto di Guardia a Firenze," *Archivio storico italiano* [1954], pp. 3–39). The institution and functions of those responsible for public morals, the Onestà and the Officers of the Night are described respectively by Mazzi (*Prostitute e lenoni nella Firenze del Quattrocento*) and Rocke (*Forbidden Friendships: Homosexuality and Male Culture in Renaissance Florence*).

Zorzi, *L'amministrazione della giustizia penale nella repubblica fiorentina*, analyzes the transformation of the judicial system as it shifted from a reliance on foreign rectors' courts to a centralized administrative system based on citizen magistracies. His interest is in connecting this phenomenon to political developments, associating it with the formation of the territorial state and the concentration of power in a ruling class. Cohn outlines the same process in Chapter 10 of his book *The Laboring Classes*, emphasizing the way that it operated as a mechanism of social dominance.

Picturing Punishment

The history of defamatory painting in Florence is the subject of Edgerton's book *Pictures and Punishment: Art and Criminal Prosecution during the Florentine Renaissance*. He also discusses the relevant aspects of the criminal justice system and publishes transcriptions of some key documents. Ortalli, *La pittura infamante nei secoli XIII–XVI*, reviews the legal traditions behind the concepts of fame and infamy. He advances a political explanation for this form of punishment, attaching it to Guelfism and notions of the *popolo*. Importantly for the arguments here, he notes that while the practice had died out in most centers by the fifteenth century, it remained in force in Florence until the sixteenth century (p. 174). There is a succinct account of defamatory paintings done of traitors in the fifteenth century in Horne, *Botticelli*, pp. 62–5. Rocke, *Forbidden Friendships*, pp. 76–8, recalls some extremely striking instances of punishments devised to shame sodomites through the spectacle of public humiliation.

Demeanor

There is scant literature directly regarding the conventions governing masculine behavior, although it could be said that almost all descriptions of Florentine politics and social behavior are dedicated to that matter, since the patriarchal ideal assumed male visibility as the norm. There are some pertinent comments about how the "new men" of Florence defined themselves through their behavior, their dress, and their gestures in A. Brown, "Lorenzo de' Medici's New Men and their Mores: the Changing Lifestyle of Quattrocento Florence," *Renaissance Studies* (2002), pp. 113–42. Feminist studies have, on the other hand, recovered both female visibility and its restrictions, as is evident, for example, in the essays in the catalogue about Leonardo da Vinci's *Ginevra de' Benci* and female portraiture in Florence, *Virtue and Beauty*, ed. D. Brown, which offer current views on an impressive selection of topics (D. Kent, "Women in Renaissance Florence," pp. 25–48; Kirkham, "Poetic Ideals of Love and Beauty," pp. 49–82; Woods-Marsden, "Portrait of the Lady, 1430–1520," pp. 63–88; Orsi Landini and Westerman Bulgarelli, "Costume in Fifteenth-Century Florentine Portraits of Women," pp. 89–98).

Berdini, "Women under the Gaze: A Renaissance Genealogy," *Art History* (1998), pp. 565–90, refers to Baxandall and Lacan with regard to the agency of vision, arguing that women were the object of being seen, with men as the subjects. Randolph puts forward another approach to Baxandall's concept of the period eye in his article "Gendering the period eye," *Art History* (2004), pp. 538–62, taking the case of birth trays, which, he maintains, were largely addressed to female beholders as part of the rituals surrounding birth and which were held, passed around, and turned over rather than seen through the "gendered cultural window" of perspective projection (p. 549). He proposes that in the social space of the birth chamber the "visual culture of reception" was inverted, with the female gaze dominant and the feminine experience of viewing "kinaesthetic" and "haptic" (p. 558). In his chapter on "Regarding Women in Sacred Space," in *Picturing Women in Renaissance and Baroque Italy*, ed. Johnson and Matthews Grieco, pp. 17–41, Randolph instead addresses the question of seeing women and women seeing each other in public situations, citing a fascinating series of fifteenth-century comments on the dangers of eyes. Bryce's article on "Performing for Strangers: Women, Dance, and Music in Quattrocento Florence," *Renaissance Quarterly* (2001), pp. 1074–1107, demonstrates the conspicuous role of women in dances staged for public occasions and their place in expressing civic, familial, and personal honor through dance.

Frick's study *Dressing Renaissance Florence* underlines the importance of dress in affirming status in Florence and includes a chapter on "Visualizing the Republic: An Essay on Painting Clothes," which analyzes the dress codes of the Tornabuoni and Sassetti chapels. It also helpfully defines the fifteenth-century wardrobe and its materials. In his article on "Performing the Bridal Body in Fifteenth-Century Florence (*Art History* [1998], pp. 182–200), Randolph takes the case of bridal jewelry to examine "the ideology of body and decoration" and the relations between ritual exchanges of jewels connected with marriage and images including representations of such jewels. Welch takes the "Renaissance sleeve" as a case study in hierarchies of cultural and social value and their expression ("New, Old and Second-hand Culture," in *Revaluing Renaissance Art*, ed. Neher and Shepherd, pp. 101–19). In an article in the same volume Campbell examines the way that the "symbolic language of dress" could "convey models of behaviour" by looking at the clothing in domestic paintings on marriage chests showing episodes from ancient history ("Revaluing Dress in History Paintings for Quattrocento Florence," pp. 137–45).

Artists and Projects

MASACCIO (1401–1428), MASOLINO (1383–CA. 1436), AND THE BRANCACCI CHAPEL,
CA. 1423–1428

The history of the chapel, based on an analysis of documentary evidence, is told by Molho, "The Brancacci Chapel: Studies in its Iconography and History," *Journal of the Warburg and Courtauld Institutes* (1977), pp. 50–98. Borsook's entry on the chapel in *The Mural Painters of Tuscany* is a characteristically lucid summary of the history of the chapel, and the iconography and technique of the paintings, pp. 63–6. It was written before the restoration undertaken in the 1980s, which revealed a fragmentary painting of the *Martyrdom of Saint Peter* on the altar wall and sinopias probably showing *Christ's Charge to Peter: "Feed my Sheep"* and *The Remorse of Peter* on the sides of the lunette of the altar wall, and which need to be taken into account. A lavishly illustrated book by Baldini and Casazza, *The Brancacci Chapel Frescoes*, publishes the cycle after its restoration. Joannides (*Masaccio and Masolino*), Ladis (*The Brancacci Chapel Florence*), and Roberts (*Masolino da Panicale*) are additional studies of the chapel after restoration. Brancacci family history, as concerns the Carmine chapel, is detailed by Pandimiglio in a monograph about *Felice di Michele vir clarissimus e una consorteria: I Brancacci di Firenze*.

The neighborhood of the Carmine, and the role of the church and the confraternities housed there in dispensing charity in the district are described by Eckstein in *The District of the Green Dragon*. Eckstein is working on the chapel in its neighborhood context: he has published an article on "The Widows' Might: Women's Identity and Devotion in the Brancacci Chapel," *Oxford Art Journal* (2005), pp. 99–118, and is preparing a monograph. He has also edited a volume of essays based on conference about the chapel held at Villa I Tatti, Florence in 2003, *The Brancacci Chapel: A Symposium on Form, Function and Setting*. In *The Laboring Classes in Renaissance Florence* (pp. 120–9) Cohn charts the changes in residential patterns that marginalized the poor, creating a new social or "class geography" in fifteenth-century Florence. By the second half of the fifteenth century over 80 per cent of the poor lived in virtual ghettoes at the edges of the city; this class distribution is further discussed by Cohn in his 1985 article in *Studi storici* (pp. 353–71).

ANDREA DEL CASTAGNO (1419–1457) AND THE REFECTORY OF SANT' APOLLONIA,
CA. 1447–1450

As with the Brancacci chapel, Borsook's entry on Castagno's work in Sant' Apollonia is an excellent synopsis (*The Mural Painters of Tuscany*, pp. 87–90). The patronage of the nuns at Sant' Apollonia is defined by Spencer, *Andrea del Castagno and his Patrons*, pp. 102–14. Spencer publishes a list of the nuns who signed a document accepting donations in 1444, which gives an indication of their genteel status, as most were daughters of important families (p. 107). The commission is summarized, with further bibliography, in the text and catalogue entry of Horster, *Andrea del Castagno*, pp. 23–7, 175–7. The articles by Hayum, "A Renaissance Audience Considered: The Nuns at S. Apollonia and Castagno's Last Supper," *Art Bulletin* (2006), pp. 243–67, and Marchand, "Monastic *Imitatio Christi*: Andrea del Castagno's *Cenacolo di S. Apollonia*," *Artibus et historiae* (2003), pp. 31–50, evaluate the exemplary nature of these murals in terms of their place in the convent and their mode of address to their pious female viewers.

DOMENICO GHIRLANDAIO (1449–1494) AND THE SASSETTI CHAPEL AT SANTA TRINITA, 1479–1485

Memorably stating that "Florence has answers to all the questions that the cultural historian can ask, if only we never tire of asking questions, and if our questions are sufficiently narrow and specific," Warburg devoted two essays to the Sassetti chapel. He refers to the "unique abundance" of the Florentine archives in order to connect words and images so as to examine the relation between patrons and artists, the portrayer and the portrayed and to explore the cultural milieu and the "effect of the milieu on the artist." In an essay on "The Art of Portraiture and the Florentine Bourgeoisie," he remarks on the way that the differences between Giotto's mural of *The Confirmation of the Franciscan Rule* in the Bardi chapel and Ghirlandaio's version in the Sassetti chapel reveal a radical secularization of both the "social life of the Church" and of its "official visual language." The first to identify the portraits of Lorenzo de' Medici and his sons and their tutors shown in the scene, he explained the intrusion of Francesco Sassetti, his family, and Lorenzo and his family in this scene by connecting them to the practice of displaying wax effigies as votive offerings at the shrine of Santissima Annunziata (*The Renewal of Pagan Antiquity*, pp. 105–221, quotations from pp. 187, 188). In a subsequent essay on "Francesco Sassetti's Last Injunctions to His Sons," he brings archival evidence to the understanding of Sassetti's intentions as a donor, analyzing the chapel's mix of Christian and pagan symbolism (*The Renewal of Pagan Antiquity*, pp. 223–64).

Logically enough, Lillie focuses on Sassetti's country properties in her book *Florentine Villas in the Fifteenth Century*, especially Francesco's "palace" at La Pietra, with the explicit purpose of redressing the urban bias of Warburg's study. The book nevertheless adds substantially to the literature on the chapel, because of its comprehensive portrayal of Francesco's patronage, his family background, his concern for his lineage, and his role in the Medici regime.

Gombrich revised Warburg's portrait identifications in his article "The Sassetti Chapel Revisited," *I Tatti Studies* (1997), pp. 11–35, where he refers to a manuscript biography of Biagio Milanesi, who was the Abbot General of the Vallombrosans when the chapel was endowed and decorated (Santa Trinita was under his jurisdiction). Gombrich's aim, which he largely achieves, is to set the commission within the ecclesiastical politics of the time, notably with respect to Lorenzo's determined hunt for benefices for his son, Giovanni. In connection with this, he thought it "vital" to identify the first of the children in the group coming up the stairs in the foreground of the *Confirmation of the Franciscan Rule by Pope Honorius III* as Giovanni, as opposed to his younger brother Giuliano. His reasoning on this point is debatable and the more widely accepted identification of the figure as Giuliano is maintained here.

The recognition of Domenico Ghirlandaio (with his brother-in-law and collaborator, Sebastiano Mainardi) among the portraits in the *Resuscitation of the Roman Notary's Son* is made by comparison with the self-portrait he included, with his brother Davide as well as with Mainardi, in the *Expulsion of Joachim from the Temple* in the Tornabuoni chapel. Vasari names the Tornabuoni figure as Domenico (*Le Vite*, ed. Bettarini and Barocchi, III, p. 485). Vasari's informant about the Ghirlandaio shop was Domenico's nephew Ridolfo, so his identification can be accepted as reliable. In this scene the artist depicted himself striking a confident pose and sharing the piazza with an eminent family of the regime, similar to his pose and position in the Sassetti chapel mural. In *Renaissance Self-Portraiture*, Woods-Marsden

classifies this self-portrayal "as witness in religious narrative" and justifiably explains it in terms of artisan identity and assertion of status (pp. 60–2).

In her book *Domenico Ghirlandaio*, Cadogan characterizes the narrative style of the murals in relation to traditions of history painting (pp. 93–101). Her catalogue entry (no. 16, pp. 230–60) has a full bibliography and a complete description of the cycle. The iconographic program of the chapel is thoroughly treated by Borsook and Offerhaus in their book *Sassetti and Ghirlandaio*, which includes a documentary appendix and a technical discussion of the murals. They show how the Franciscan legend has been adapted or adopted by and for Sassetti in a program that represents Florence as the new Rome, a recurrent theme of the Laurentian era, promoting the dominance of the Medici and their allies in terms of an Augustan "golden age of peace and prosperity" (p. 53). They attach this to specific episodes in Florentine history and humanist historiography (principally writings by Angelo Poliziano and by Sassetti's librarian Bartolomeo Fonzio). Following Warburg, they demonstrate the way that the seemingly contradictory pagan and Christian elements of the decoration can be seen as homogeneous according to contemporary political and cultural ideals.

Rohlmann attends to the interweaving of the order and meaning of the murals in his essay on "Bildernetzwerk: Die Verflechtung von Familienschicksal und Heilsgeschichte in Ghirlandaios Sassetti-Kapelle," in *Domenico Ghirlandaio: Künstlerische Konstruktion von Identität im Florenz der Renaissance*, pp. 165–243. My article on "Domenico Ghirlandaio and the meaning of history in Fifteenth Century Florence," in *Domenico Ghirlandaio 1449–1494*, ed. Prinz and Seidel, pp. 97–108, is concerned with the forms of history that underlie the scheme and its stylistic idiom.

The murals were restored between 1967 and 1968 and significant alterations were discovered, notably the addition of a number of portraits to the scenes showing the Confirmation of the Rule and the Verification of the Stigmata. These were published by Welliver, "Alterations in Ghirlandaio's S. Trinita Frescoes," *Art Quarterly* (1969), pp. 269–81. The murals were once again under scaffolding between 2004 and 2006 to be cleaned and restored.

5 THE EYE OF THE BEHOLDER

Dante Alighieri: "primo splendore del nome fiorentino"

Cristoforo Landino's oration to the Signoria when he presented his *Comento* in 1481 reminded the governing body of Dante's place as the "first splendor" of the city and as an example to be imitated for his eloquence, probity, and learning. It took up eulogistic topics that had been established soon after the poet's death. As a "famous man," called "il nostro glorioso poeta" by Matteo Palmieri in his *Vita civile* (ed. Belloni, p. 32), Dante was part of the city's history and its iconography. The trajectory from Boccaccio's laudatory *Trattatello in laude di Dante* (1357–62; in *Le vite di Dante, Petrarca e Boccaccio, scritte fino al decimosesto secolo*, ed. Solerti) to Landino's passionate defense (1481) is marked by a series of biographical accounts in Latin and in the vernacular including a section in Filippo Villani's book on *The Origins of the City of Florence and her Famous Citizens* (1381–2; *De origine civitatis Florentie et de eiusdem famosis civibus*, ed. Tanturli) and lives by Leonardo Bruni (1436; in *Le vite di Dante e del Petrarca*, ed. Lanza) and Giannozzo Manetti (1440; *Vitae Trium Illustrium Poetarum Florentinorum*; *Lives of Three Illustrious Florentine Poets*, trans. Baldassari and Bagemihl). Villani's

book of brief biographies was the basis for epigrams applied to a series of murals painted in the 1390s in the Saletta of the Palazzo Vecchio portraying twenty-two famous citizens (Rubinstein, *The Palazzo Vecchio*, p. 52; the cycle was destroyed in later renovations, probably during the 1470s). Dating from this same celebratory moment was a project decreed in December 1396 to erect monuments in the Duomo to Dante, Petrarch, Boccaccio, and Zanobi Strada for "the honor of the city" ("prout honori civitatis flor.": ASF, Provvisioni, Registri, 85, fols. 282r–v, and n. 41). The origins and course of this enterprise are discussed by Borsook, *Mural Painters of Tuscany*, pp. 75–6 and Oy-Marra, *Florentiner Ehrengrabmäler der Frührenaissance*, pp. 13–38, 123. As has been frequently remarked, the impulse to include modern poets in a more standard repertory of famous men is a notable feature of the Palazzo Vecchio and cathedral programs, which add cultural figures to the usual "men of action," statesmen and soldiers, thereby attaching the fame of poets to civic pride. This historical tendency persisted in the fifteenth century, for example, in Leonardo Bruni's lives of Dante and Petrarch, where he connected "la fama di questi due poeti" to the "gloria della nostra città" (*Leonardo Bruni Aretino: Humanistisch-Philosophische Schriften*, ed. Baron, p. 51). The Duomo project was not realized at the time, but in January 1465 Domenico di Michelino was commissioned to paint the figure of Dante after a design by Alessio Baldovinetti, to replace an extant portrait. In the picture, completed in June, he showed the poet standing beside the city holding open his *Divine Comedy* with the circles of Heaven above him, the mountain of Purgatory behind, and the gate of Hell to his right; for this work, see Altrocchi, "Michelino's Dante," *Speculum* (1931), pp. 15–59, Poeschke, "'Per exaltare la fama di detto poeta': Frühe Dantedenkmäler in Florenz," *Deutsche Dante-Jahrbuch* (1992), pp. 63–82, and the entry by Bernacchioni in *Sandro Botticelli pittore della Divina commedia*, ed. Gentile, pp. 218–21. Between December 16, 1478 and December 21, 1480 the woodworkers Giuliano da Maiano and Francione received payments for the intarsias of the door of the Sala dei Gigli, which had portraits of Dante and Petrarch, that of Dante designed by Botticelli and that of Petrarch by Filippino Lippi (the room was inaugurated on John the Baptist's feast day in 1481; for this commission see Rubinstein, *The Palazzo Vecchio*, p. 61 and Cecchi, "Giuliano e Benedetto da Maiano ai servigi della Signoria fiorentina," in *Giuliano e la bottega dei da Maiano*, ed. Lamberini et al., p. 152).

Dante was a multivalent and not uncontroversial figure, both for his use of the vernacular and because of his place in Florentine factional politics, which had resulted in his exile from the city. His repatriation was one concern of fifteenth-century biography and eulogy, an effort that culminated in Landino's defense of the poet against his detractors in the 1481 edition. Another consistent theme in the evaluation of Dante was the accessibility of his works, which could be appreciated by those who did not have knowledge of Latin. In an often cited and extremely important overview of the fifteenth-century treatment of Dante, Dionisotti argues against the notion of Dante as a popular poet, regarding this image as part of a humanist polemic ("Dante nel Quattrocento," in *Atti del Congresso Internazionale di Studi danteschi*, 1, pp. 333–79). He characterizes Dante as the poet of the powerful and privileged – a position that is contradicted by the wide ownership and frequent citation of Dante. In his article on "Dante nel Rinascimento," *Rinascimento* (1967), pp. 3–28, Garin relates the understanding of Dante and his works to humanist and civic culture and the emerging humanist periodicization of culture. He notes that (the not terribly extensive) literature on the subject generally concentrates on literary and stylistic matters, without considering other forms of reading, such as the political and metaphysical of the Medici circle,

scientific (Leonardo), prophetic (Savonarola), or pictorial (Michelangelo). He shows the way that Dante was an emblematic figure mobilized in the service of various ideals and ideological debates. The stages and strands of Dante's fame are also traced by Rossi, "Dante nel Trecento e nel Quattrocento," in *Scritti di critica letteraria*, pp. 293–332, Bigi, "Dante e la cultura fiorentina del Quattrocento," in *Forme e significati della "Divina commedia,"* pp. 145–72, and in the acts of the international conference on *Dante nel pensiero e nella esegesi dei secoli XIV e XV*. Gilson's recent book, *Dante and Renaissance Florence*, combines a cogent overview of the reception of Dante's work in the period, examining the multi-facetted responses to his writing, with very comprehensive coverage of the literature.

In *Polemiche e berte letterarie nella Firenze del primo Quattrocento*, Lanza gives the history of the polemics between the traditionalists who championed the vernacular and the proponents of the new humanist learning at the turn of the fifteenth century, and publishes the relevant texts. Baron devotes a portion of Chapter 13 of his book on *The Crisis of the Italian Renaissance* to the role of the "Volgare School in the Transition Crisis," analyzing the dynamic between "learned Humanism" and the vernacular trend in terms of the genesis of Quattrocento thought, placing it in its historiographic as well as historical perspective. What might be viewed as a simple resistance to innovation emerges as a debate with civic, cultural, and political implications, with Dante's works playing a vital role in the formation of cultural consensus. Tanturli finds the origins of Niccolò Niccoli's notorious disparagement in a comment made by Petrarch to Boccaccio in 1359 published in Petrarch's letters. Petrarch's comment is part of a jockeying for position among fourteenth-century poets that supplies a context for the later debates about the status of poetry and the vernacular ("Il disprezzo per Dante dal Petrarca al Bruni," *Rinascimento* [1985], pp. 199–219; *Le familiari*, XXI.15.22, ed. Rossi, IV, p. 99: "nisi forte sibi [a Dante] fullonum et cauponum et lanistarum ceterorum ve, qui quos volunt laudare vituperant, plausum et raucum murmur invideam"; "unless perhaps I envied him the applause and raucous acclaim of fullers or tavern keepers or woodworkers who offend the ones whom they wish to praise," *Letters on Familiar Matters*, trans. Bernardo, pp. 205–6).

Korman, "'Danthe Alighieri Poeta Fiorentina': Cultural Values in the 1481 Divine Comedy," in *Revaluing Renaissance Art*, ed. Neher and Shepherd, pp. 57–65, explores the motivation behind Landino's edition in light of "the radical changes in the evaluation of the work and the author . . . during the 1470s and 80s" (p. 57), prompted by the cultural politics of the Laurentian era, which strongly promoted the Florentine language and Florentine excellence in the arts (discussed also by Rubinstein, *The Palazzo Vecchio*, p. 61). The background to Landino's work and the trends in philosophy (particulary Neoplatonism) and Dante commentary that inform it are set forth in Lentzen's *Studien zur Dante-Exegese Cristoforo Landinos* and Gilson in Part III of *Dante and Renaissance Florence*. Procaccioli's edition of the *Comento* makes this remarkable text available, with a full critical apparatus. His book *Filologia ed esegesi dantesca nel Quattrocento*, reveals the dual nature of the commentary, whose *Proemio* with the defense of Dante and exposition on poetry and examples of Florentine excellence is an innovation, but whose notes or *chiose* fit into the commentary tradition and owe much in particular to the *Comentum* by Benvenuto da Imola (known in three editions dating from 1375–80) and the vernacular commentary by Francesco da Buti (1395). The CD-rom corpus of *I commenti danteschi*, also edited by Procaccioli, has made comparison of the commentaries an easy task and it is an invaluable tool for the study of Dante's poem. Landino's academic involvement with Dante is detailed by Fieldin his article "Cristoforo Landino's First Lectures on Dante," *Renaissance Quarterly* (1986), pp. 16–48.

Dante's Readers

Bec's analysis of Florentine book ownership, based on the inventories in the *Magistrato dei Pupilli*, the magistracy administering the estates of orphans, proves a steady interest in Dante. Surveying the fifteenth century, Bec found that Dante's works were the most frequently owned vernacular texts in the first half of the century, with the balance shifting slightly in favor of Petrarch's *Triumphs* and *Canzoniere* in the second half, a trend that accords with the contemporary vogue for petrarchan poetizing among the Florentine elite, led by Lorenzo de' Medici and his circle (*Les Livres des Florentins*, pp. 44–5, 102–15). Ciappelli, "Biblioteche e lettura a Firenze nel Quattrocento," in *Libri, lettori e biblioteche dell'Italia medievale*, ed. Lombardi and Nebbiai dalla Guardia, pp. 425–39, notes that Bec's sample, owing to its source, is socially exclusive and also neglects the holdings of convent libraries and other major private libraries, as well as the fact that Florentines were inveterate book borrowers. D. Kent's wonderful chapter on "Compilations and the Corpus of Texts," in *Cosimo de' Medici*, adds substantially to the understanding of the circulation of texts in scrapbook compilations (p. 81 for the popularity of selections from Dante). Parronchi's essay on "Come gli artisti leggevano Dante," *Studi danteschi* (1966), pp. 97–134, expands the readership in a direction that is especially pertinent here. Barolsky's essay on "Dante and the Modern Cult of the Artist," *Arion* (2004), pp. 1–15, convincingly argues that the invention of the modern idea of the artist comes from Dante, whose artistic self-reflexivity in the *Divine Comedy* was informed by his observation of the artists of his generation and informed subsequent generations, making it a founding text of art history.

Picturing Dante

The manuscript tradition is covered by Brieger, Meiss, and Singleton in the *Illuminated Manuscripts of the Divine Comedy*. A facsimile edition of Botticelli's drawings was published in 1986, with an accompanying volume of commentary by Peter Dreyer with remarks on the commission, design, and codicological character of the drawings (*Dantes Divina Commedia mit den Illustrationen von Sandro Botticelli*). Dreyer returned to these topics in his essay in *La Divina commedia*, ed. Risset and Dreyer. He had previously written on "Botticelli's Series of Engravings 'of 1481'," *Print Quarterly* (1984), pp. 111–15. A complete set of engraved illustrations was envisioned for Landino's edition of the *Commedia*, but only 19 cantos were illustrated. The engravings are attributed to Baccio Baldini after drawings by Botticelli. The association between them is based largely on Vasari's rather disparaging remark in his collected lives of printmakers that the Florentine inventor of engraving Maso Finiguerra was followed by the goldsmith Baccio Baldini, who was endowed with limited capacity in design and who therefore based all of his works on Botticelli's invention and design (*Le vite*, ed. Bettarini and Barocchi, v, p. 3: "Fu seguitato costui [Finiguerra] da Baccio Baldini orefice fiorentino, il quale non avendo molto disegno, tutto quello che fece fu con invenzione e disegno di Sandro Botticelli"). Dreyer argues for dating them between 1482 and 1487. He suggests that work began after Botticelli's return from Rome in 1481 and was suspended by Baldini's death (the burial of "Baccio *orafo*" in San Lorenzo is recorded on December 12, 1487). This extended process explains the variant number of illustrations in known copies of Landino's edition and accords with Vasari's remark that when Botticelli returned from Florence he "wasted a great deal of time" writing a commentary on part of Dante's work, illus-

trating the *Inferno* ("comentò una parte di Dante, e figurò lo Inferno e lo mise in stampa, dietro al quale consumò dimolto tempo"; *Le vite*, ed. Bettarini and Barocchi, III, pp. 516–17).

The catalogue of the Royal Academy exhibition *Sandro Botticelli: The Drawings for Dante's Divine Comedy* has excellent essays on the commission, provenance, technique, design, and structure of the deluxe cycle of drawings made by Botticelli, most likely for Lorenzo di Pierfrancesco de' Medici mainly during the 1490s. It has a full bibliography and detailed entries on each drawing. The 92 drawings are now divided, with 7 in the Biblioteca Apostolica Vaticana (*Inferno*, Canto 1, which has the chart of Hell on its reverse, and Cantos IX, X, XII, XIII, XV, XVI) and 85 in the Kupferstichkabinett in Berlin. They are in different states of completion, in pen and ink and wash on parchment, with stylus and black chalk underdrawing. Some have been painted. Questions about the purpose and nature of the set are insightfully addressed in the essays and the entries. There is also a chapter on the engravings made for Landino's 1481 edition of the book. The drawings are carefully described by Horne and Lightbown in their respective monographs on Botticelli and Clark in his book on the *Drawings by Sandro Botticelli for Dante's Divine Comedy*. In different ways all point out how the drawings manage to translate the poem to images with an unprecedented degree of sensitivity, demonstrating the painter's ability to match the poet's imagination. Botticelli put his name on a tablet held by an angel in Canto XXVIII of *Paradise*, which depicts the highest of the material heavens where Dante experiences a symbolic vision of God surrounded by his angels in the vault of heaven – a vision manifested by the painter, who simultaneously makes himself a participant and supplicant.

The drawings for *Paradise* are the topic of Korman's dissertation, "Envisioning Narrative" (Courtauld Institute, 1999), and those for the *Inferno* of Watts's "Studies in Sandro Botticelli's Drawings for Dante's *Inferno*" (University of Virginia, 1993). Watts has published perceptive analyses of the *Inferno* drawings: "Sandro Botticelli's Drawings for Dante's *Inferno*: Narrative Structure, Topography, and Manuscript Design," *Artibus et historiae* (1995), pp. 163–201, and "Sandro Botticelli's Illustrations for *Inferno* VIII and IX: Narrative Revision and the Role of Manuscript Tradition," *Word and Image* (1995), pp. 149–73. She has also written about Botticelli, Dante, and the painter's poetic aspirations: "Artistic Competition, Hubris and Humility: Sandro Botticelli's Response to *visibile parlare*," *Dante Studies* (1996), pp. 41–78, and "The Word Imaged: Dante's *Commedia* and Sandro Botticelli's San Barnaba Altarpiece," *Lectura Dantis* (1998), pp. 203–45.

Purgatory, Canto X

Simonelli, "Il Canto X del 'Purgatorio,'" *Studi danteschi* (1955–56), pp. 121–45, surveys previous discussions and dismisses attempts to associate the reliefs with specific sculptures such as those by Nicola and Giovanni Pisano, pointing out how the reliefs operate as images within the poem, giving verisimilitude to Dante's experience and his response to the examples of humility. She notes how the pleasure associated with the sculptures can be associated with Augustine's concept of *delectatio*, the love for things that give pleasure, which requires judgment to make the choice between false and true (p. 125, quoting from the *Ennarationes in Psalmos*, IX.15). The meaning of the reliefs and their relation to the theology of humility and affective mechanisms are variously considered by Tateo, "Teologia e 'Arte' nel canto X del *Purgatorio*," in *Questioni di poetica dantesca*, pp. 137–71; Migiel, "Between Art and Theology:

Dante's Representation of Humility," *Stanford Italian Review* (1985), pp. 141–60; and Chiampi, "From Unlikeness to Writing: Dante's 'Visible Speech' in Canto Ten *Purgatorio*," *Medievalia* (1985), pp. 97–112.

Atchity's essay on "Dante's *Purgatorio*: The Poem Reveals Itself," in *Italian Literature: Roots and Branches, Essays in Honor of Thomas Goddard Bergin*, ed. Rimanelli and Atchity, pp. 85–115, is concerned with *Purgatory* as the portion of the poem that most insistently deals with the poem and the poet's art. Atchity interprets the ekphrases in *Purgatory* x and xii in light of this poetic self-reflexivity. The canto has received much attention, in part because "art is at issue" and a work of art is put within a work of art; for the intricate embedding of artistic identity within *Purgatory* x, see Vickers, "Seeing is Believing: Gregory, Trajan, and Dante's Art," *Dante Studies* (1983), pp. 67–85, and Barolini, "Re-presenting What God Presented," *Dante Studies* (1987), pp. 43–62. Problems of literary artifice and levels of style are confronted in Isella's essay on "Gli 'exempla' del Canto x del 'Purgatorio,'" *Studi danteschi* (1968), pp. 147–56, which reflects on the contrast of humility and the sublime in the canto and Dante's matching of style to the subjects described.

Pfisterer's section on Polycleitus and fourteenth- and fifteenth-century art in his book on *Donatello und die Entdeckung der Stile*, pp. 184–201, argues for the importance of Dante's reference to Polycleitus in launching that artist's reputation as a touchstone for artistic greatness. Combining erudition and incisive observation, Pfisterer explores the comparison with antiquity in terms of both imitation and emulation. He makes the case for Donatello's *Annunciation* in Santa Croce being a response to the challenge set by Canto x, which he believes established the criteria for a masterpiece (pp. 253–8). He also includes an excursus on *visibile parlare* and the reputations of both Dante and Giotto and their connection to artistic aspiration ("'Luci della fiorentina gloria': Dante und Giotto," pp. 318–322; for these ideas, see also his article on "Phidias und Polyklet von Dante bis Vasari: Zu Nachrum und künstlerischer Rezeption antiker Bildhauer in der Renaissance," *Marburger Jahrbuch für Kunstwissenschaft* [1999], pp. 61–97). In a challenging chapter on "Bild und Schatten. Dantes Bildtheorie im Wandel zur Kunsttheorie" in his book, *Bild-anthropologie*, Belting proposes that in Canto x, Dante arrives at a theory of the image that inaugurates modern concepts.

Artists' Reputations and the Reputation of the Arts

"The magnificent Giotto . . . who deserved the title of divine painter"

Landino takes Giotto's name to demonstrate authority in the arts, a choice that itself had great authority. Dante's invocation of Giotto in *Purgatory* xi.94–6, "now Giotto has the cry," which contributed to the painter's paradigmatic status, was soon followed by less equivocal affirmations. Fourteenth-century Dante commentators, like Benvenuto da Imola and Francesco Buti, took Dante's example of the fugitive nature of fame as a good choice of a famous artist. Benvenuto cites Petrarch's and Boccaccio's praise of Giotto in support of this. Among other tropes and topics applied to his talent was the comparison with Apelles, which occurs, for example, in Book xiv of Boccaccio's *Genealogie deorum gentilium* ("noster Ioctus, quo suo evo non fuit Apelles superior"; *Tutte le opere*, ed. Branca, ii, pp. 1396–7). This comparison became a commonplace. In his mid-fifteenth-century description of the churches of Florence, Domenico da Corella exclaimed about the bell-tower, "The magnificent Giotto designed it, who deserved the title of divine painter. O genius superior to all the illustrious

men of his time! He was certainly on a par with Apelles the ancient painter" (from the *Theoto-con*, in *Images of Quattrocento Florence*, trans. and ed. Baldassari and Saiber, p. 249). Flavio Biondo thought the same of "the famous painter Giotto, the equal of Apelles" (*Italy Illuminated*, trans. White, I, pp. 70–I: "Florentia Iotum habuit, pictorem celeberrimum Apelli aequiparandum"). In an interesting variation on this theme, Landino drew a parallel between Apelles portraying Alexander and Giotto portraying Dante, when commenting on the way the poet could paint what was in his mind, "because he fashioned him such that whoever saw the picture could see Dante" (about *Inferno*, II.6, "che ritrarrà la mente che non erra"; *Comento*, ed. Procaccioli, I, p. 336). Landino's statement participates in enforcement of the Giotto ideal in Laurentian Florence, which included a sculpted bust of the painter by Benedetto da Maiano with an epithet by Poliziano, installed in the Duomo in 1490 (Carl, "Il ritratto commemorativo di Giotto," in *Santa Maria del Fiore*, ed. Haines, pp. 129–47, publishes the documents for this bust and discusses its *all'antica* iconography). Poliziano wrote a number of variations on his epigram on the painter, rehearsing the favorite topics applied to the artist, "light and author," who vanquished Apelles and who revived dead painting (*Prose volgari inedite e poesie latine e greche*, ed. del Lungo, nos. lxxxvi–xc, pp. 156–9).

Giotto was the first and remained the foremost in a process that created famous artists as symbolic figures factored into the city's image and as actual models and part of a civic language of Florentine greatness. When he was made supervisor of the building works at the cathedral in 1334, the document appointing him asserted that "with this many will profit from his knowledge and learning so that no little beauty will come to this city," and soon thereafter he was recorded by the chronicler Giovanni Villani as "our fellow citizen Master Giotto: the most sovereign master of painting in his age, whose figures and gestures most resemble nature" (*Cronica di Giovanni Villani*, ed. Dragomanni, III, p. 232). Filippo Villani included him in his book *On the Famous Citizens of Florence*, as having "restored painting to its high renown and pristine dignity," and being "not only the equal of ancient painters in the glory of fame, but their superior in craft and mind" (for the appointment document and Filippo Villani, and other such texts and their contexts, see Larner, *Culture and Society in Italy 1290–1420*, pp. 275–82).

Ciccuto, "Un'antica canzone di Giotto e i pittori di Boccaccio: Nascita dell'identità artistica," *Intersezioni* (1996), pp. 403–16, examines the connections made between the perception of Giotto's ability to imitate nature and the way it stemmed from his particular intellectual gifts, with reference to his status as a literary figure, both as a writer and as a subject of writing. For further references to Giotto's reputation as it developed in historical and literary sources from his (and Dante's) time through the fifteenth century, see the section on Vasari's sources for his biography of Giotto in my book *Giorgio Vasari: Art and History*, pp. 287–99. Generally for Giotto's fame and its basis in his works, see *The Cambridge Companion to Giotto*, ed. Derbes and Sandona.

Giotto and the Orators

Baxandall's book *Giotto and the Orators* deals with the development of humanist comment on painting, the creation of a critical vocabulary for the discussion of that art, and the relation of both to visual experience. Classed as "mechanical" in the traditional hierarchy of the arts, a dynamic of appreciation and accomplishment argued for the place of the visual arts among the liberal arts, or at least for an acknowledgment of the form or forms of learning

that they contained. For an introduction to these questions in theory and in practice, see Ames-Lewis, *The Intellectual Life of the Early Renaissance Artist*. Kristeller's essay on "The Modern System of the Arts," in *Renaissance Thought and the Arts*, is a survey of the definition of art and the schemes and subdivisions that contained it from the Middle Ages to the modern age, pp. 163–227. Pfisterer's essay "Künstlerische *Potestas audendi* und *Licentia* im Quattrocento," *Römisches Jahrbuch der Bibliotheca Hertziana* (1996), pp. 109–47, presents the sources of the empowering notions of *ut pictura poesis* and poetic license and details examples of their application to artists' careers. Kemp's book *The Science of Art* treats of "optical themes" and with this one of the fundamental applications of science to art in the Renaissance, that of perspective. In a densely reasoned argument, Summers makes the case for an Aristotelian basis to the "traditions of meaning that shaped the discussion of art at its deepest levels" (*The Judgment of Sense: Renaissance Naturalism and the Rise of Aesthetics*, p. 2).

Syson and Thornton's book *Objects of Virtue* is about the significance given to art objects, understood as products of excellence according to period concepts of art, that is as including furniture, jewelry, and medals as well as painting and sculpture. Significance in this case means more than value in a material sense or meanings susceptible to iconographic interpretation, it implies the range of learning and skill involved in the conception and reception of ingenious products of art.

Elam, "Lorenzo de' Medici's Sculpture Garden," *Mitteilungen des Kunsthistorischen Institutes in Florenz* (1992), pp. 41–84, establishes that this garden, sometimes held to be a phantom projection of Medicean mythology, was a very real place, which, among other things, held antiquities that could be studied by artists and by those interested in the arts – a place for the acquisition and sharing of knowledge (further bibliography on Lorenzo's patronage is in the Bibliographic Note to Chapter 2). The letters and documents published by Fusco and Corti, *Lorenzo de' Medici, Collector and Antiquarian*, offer extensive testimony to the commerce of connoisseurship that was attached to collecting antiquities. Chastel, *Art et humanisme à Florence au temps de Laurent le Magnifique* and the essays by Warburg in *The Renewal of Pagan Antiquity*, and Gombrich in *Norm and Form* and *The Heritage of Apelles* remain fundamental and inspiring chapters in the history of cultural interpretation.

Leon Battista Alberti's Treatise On Painting

Alberti's didactic treatise, written twice – first in Latin in 1435 and dedicated to the Marquis of Mantua, Giovan Francesco Gonzaga and then in Italian by July 1436, and dedicated to Brunelleschi – programmatically applied learning to painting to create a "new science." Inspired by what he saw in Florence, what he heard, and what he could read (the better copies of Pliny's *Natural History*, Cicero's treatises on oratory, and Quintilian's *Institutio oratoria*, recently arrived in Florence due to the book-hunting passions of Poggio Bracciolini and Niccolò Niccoli), Alberti wrote this daring and original book convinced that painting was "worthy of all our attention and study" (*On Painting*, ed. Kemp, p. 60). A guide to the humanist enterprise as applied to the visual arts, it should not be read as a painter's manual or as the set text for the training of Florentine artists. The Italian version, which would have been accessible to artists, does not seem to have circulated widely – whatever Brunelleschi did with his copy, if he had one. It effectively disappeared. The first printed Italian edition, which appeared in 1547, was a translation from the Latin version. Alberti's ideas were variously transmitted, but their influence on given artists and given works of art must be traced

with care and discretion. This in no way diminishes the importance, the value, or the intel-
lectual elegance of the treatise in its formulation of a system of perspective construction and
its prescriptions for pictorial composition. It is a key to a mode of thinking. The sources and
structure of that thought are investigated variously by Baxandall, *Giotto and the Orators*, pp.
121–39, and "Alberti and Cristoforo Landino: The Practical Criticism of Painting," in *Con-
vegno internazionale indetto nel V centenario di Leon Battista Alberti*, pp. 143–54; Edgerton,
"Alberti's Colour," *Journal of the Warburg and Courtauld Institutes* (1969), pp. 109–34, and
"Alberti's Perspective," *Art Bulletin* (1966), pp. 367–78; Gilbert, "Antique Frameworks for
Renaissance Art Theory: Alberti and Pino," *Marsyas* (1943–5), pp. 81–106; Gombrich, "A Clas-
sical Topos in the Introduction to Alberti's 'Della Pittura,'" *Journal of the Warburg and Cour-
tauld Institutes* (1957), p. 173; Grafton, *Leon Battista Alberti* and "*Historia* and *Istoria*. Alberti's
terminology in Context," *I Tatti Studies* (1999), pp. 37–68; Greenstein, "Alberti's 'Sign': Vision
and Composition in Quattrocento Painting," *Art Bulletin*, (1997), pp. 669–98; and Westfall,
"Painting and the Liberal Arts: Alberti's View," *Journal of the History of Ideas* (1969), pp.
487–506. Wilde, "Alberti and the Formation of Modern Art Theory," situates the treatise
with the history of theory and the arts (in *A Companion to Art Theory*, ed. Smith and Wilde,
pp. 3–18).

For Alberti generally, see the Bibliographic Note to Chapter 2.

Artists and Projects

LORENZO GHIBERTI (1378–1455)

I commentarii, ed. Bartoli is a critical edition of the book generally called the *Commentarii*,
as it was dubbed in its first edition by Julius von Schlosser (*Lorenzo Ghibertis Denk-
würdigkeiten*). Bartoli observes that the work is better characterized as a notebook, a collec-
tion of notes about art and artists than as historical "commentaries." The first section on the
formation of painters and sculptors and the origins and inventors of those arts is largely made
up of passages transcribed and translated from Vitruvius and Pliny; the second is Ghiberti's
commentario on modern painters and sculptors, which culminates in his own career. The
autobiographical section, as Bartoli points out (p. 32), is structured on a humanist biographi-
cal model. The third book is largely about optics or perspective and is compiled from key
sources on the subject: Alhazen, *De Aspectibus*; Bacon, *Perspectiva*; Pecham, *Perspectiva Com-
munis* (analyzed in the critical edition by Bergdolt, *Der dritte Kommentar Lorenzo Ghiber-
tis*). This third section concludes with proportion and anatomy. The whole is a demonstration
of the learning Ghiberti attached to his art, and Ghiberti's heartfelt asides and acute personal
observations prove how fully he absorbed the lessons he advocated. Gombrich's article on
"The Renaissance Conception of Artistic Progress and its Consequences," in *Norm and Form*,
pp. 1–10, sets out the circumstances as well as the consequences of Ghiberti's "dimostrationi."

For bibliography on Ghiberti's works, see the Bibliographic Note to Chapter 2 and for his
contribution to the study of perspective, the Bibliographic Note to Chapter 4.

BERTOLDO DI GIOVANNI (CA. ?1430–1491)

Although much remains mysterious about Bertoldo (such as his origins, date of birth, the exact nature of his employment by Lorenzo), there is no doubt of his place as an intimate in the Medici household or as a protagonist in articulating a learned visual language for sculpture. For his activities and their context, see the monograph and catalogue Draper, *Bertoldo di Giovanni* and Syson's article on "Bertoldo di Giovanni, Republican Court Artist," in *Artistic Exchange and Cultural Translation in the Italian Renaissance City*, ed. Campbell and Milner, pp. 96–133.

ANTONIO DEL POLLAIUOLO (1431–1498)

Antonio's displays of knowledge are knowledgeably represented by Wright in *The Pollaiuolo Brothers* and in her articles "Antonio Pollaiuolo, 'Maestro di disegno,'" in *Florentine Drawing at the Time of Lorenzo the Magnificent*, ed. Cropper, pp. 131–46; "Dimensional Tension in the Work of Antonio Pollaiuolo," in *The Sculpted Object*, ed. Currie and Motture, pp. 65–86; "The Myth of Hercules," in *Lorenzo il Magnifico e il suo mondo*, ed. Garfagnini, pp. 323–40; her essays on "The Pollaiuolo Brothers" and "The Heroic and the Antique," and her entries in *Renaissance Florence: The Art of the 1470s*, ed. Rubin and Wright. Fusco's dissertation on "The Nude as Protagonist" (New York University, 1978) explicates the nature and the extent of Antonio's anatomical study. A unique first impression of the *Battle of the Nudes* is in the Cleveland Museum of Art, and an exhibition held there in 2002 brought together other states of the print to examine the development of this engraving, its motivation, and the publication of Antonio's ideas (*Battle of the Nudes*, ed. Langdale). Emison's article on "The Word Made Naked in Pollaiuolo's *Battle of the Nudes*," *Art History* (1990), pp. 261–75, treats of the inventive conception of the print as an image that does not illustrate a text, but that creates a text from its figural vocabulary.

ANDREA DEL VERROCCHIO (CA. 1435–1488)

Despite his position as Donatello's successor as one of the Medici's favored sculptors, as a leading goldsmith, painter, and sculptor, and as one of the principal masters of the city, Verrocchio has been relatively neglected in art-historical literature. Cruttwell's 1904 monograph is a useful introduction to his career, while Butterfield's 1997 monograph and catalogue cover *The Sculptures of Andrea del Verrocchio*. His career is briefly characterized in *Renaissance Florence: The Art of the 1470s*, ed. Rubin and Wright, with entries on specific works. Passavant's book, *Verrocchio: Sculptures, Paintings and Drawings*, presents a synoptic view of his work. Pisani's article about a sheet attributable to Verrocchio's shop and about "The Exchange of Models in Florentine Workshops" (*Journal of the Warburg and Courtauld Institutes* [2004], pp. 269–74) offers insights into its practices and influence. The restorations of the bronze group of *Christ and Saint Thomas* and the *David* have allowed for careful scrutiny of Verrocchio's extraordinary skill (*Verrocchio's Christ and Saint Thomas*, ed. Dolcini and *Verrocchio's David Restored*, exhibition catalogue, Atlanta, High Museum of Art).

LEONARDO DA VINCI (1452–1519)

The bibliography on Leonardo is vast and unwieldy, but major contributions relevant to the Florentine years and to introducing his thought and artistic practice include: the five-volume anthology of *Biography and Early Art Criticism of Leonardo da Vinci*, ed. Farago and the catalogue of the exhibition held in 2003 at the Metropolitan Museum of Art, *Leonardo da Vinci: Master Draftsman*, ed. Bambach; D. Brown, *Leonardo da Vinci: Origins of a Genius*; Clark, *Leonardo da Vinci*; Clark and Pedretti, *Leonardo da Vinci Drawings at Windsor Castle*; Farago, *Leonardo da Vinci's Paragone: A Critical Interpretation with a New Edition of the Text*; Fehrenbach, *Licht und Wasser: Zur Dynamik naturphilosophischer Leitbilder im Werk Leonardo da Vincis* and *Leonardo da Vinci: Natur im Übergang: Beiträge zu Wissenschaft, Kunst und Technik*, ed. Fehrenbach; Kemp, *Leonardo da Vinci: The Marvelous Works of Nature and Man* and *Leonardo*; Popham, *The Drawings of Leonardo da Vinci*, ed. Kemp; Marani, *Leonardo da Vinci*. The documents regarding Leonardo's career are assembled in a critical edition published by the Ente Raccolta Vinciana (*Leonardo da Vinci: I documenti e le testimonianze contemporanee*, ed. Villata). There are entries on early drawings by Leonardo that relate to the themes of this chapter in *Renaissance Florence: The Art of the 1470s*, ed. Rubin and Wright.

MICHELANGELO BUONARROTI (1475–1564)

Michelangelo, like Leonardo, is a daunting figure with a daunting bibliography going back to Michelangelo's lifetime. Condivi's biography, written with Michelangelo's supervision, offers a carefully edited glimpse into Michelangelo's place in the Medici household, as a protégé of Poliziano as well as of Lorenzo (*Vita di Michelagnolo Buonarroti*, ed. Nencioni). Condivi says that the humanist proposed the subject of the Rape of Deianira and the Battle of the Centaurs to the young Michelangelo and explained it in detail to him (p. 13). The relief does not illustrate the scene as described in any of the literary sources. Summarizing interpretations of the scene in her notes to Vasari's life of Michelangelo, Barocchi concludes that it does not relate to a precise source and that the artist created his own "mito arbitrario" (*La vita di Michelangelo*, II, pp. 100–1). Hirst's and Weil-Garris Brandt's informed discussions of this work are respectively in the catalogues devoted to *Il Giardino di San Marco*, catalogue entry no. 12, pp. 53–61, and *Giovinezza di Michelangelo*, pp. 75–83, and catalogue entry no. 5, pp. 195–8. Both point out the difficulties of a direct identification of the episode or its protagonists, emphasizing the inventive and artistically expressive character of the relief.

6 VISION AND BELIEF

Corporeal and Spiritual Vision: Seeing "with the Eyes of Compassion"

An early Dominican chronicle records that the friars had images of the Virgin and of the crucifix "before their eyes [which] could be looked upon by them . . . with the "eyes of compassion [*oculis pietatis*]." Honée gives a succinct introduction to the theories that justified this use of images and to their diffusion in the section on "Image and Imagination in the Medieval Culture of Prayer: a Historical Perspective," in *The Art of Devotion 1300–1500*, ed. Van Os, pp. 157–65. Lay people as well as clerics were urged to see with the "eyes of the heart" or with moral or spiritual eyes in order to contemplate the divine. The meditative

process engaged the mind's eye to move from the visible and material to the invisible in a way that involved "systems for staging the transformation of physical seeing" as they are described by Kessler in his essay "Turning a Blind Eye: Medieval Art and the Dynamics of Contemplation," in *The Mind's Eye: Art and Theological Argument in the Middle Ages*, ed. Hamburger and Bouché, pp. 413–40. In the same volume Lentes challenges a unitary concept of visual piety, insisting on "the multiplicity of gaze," discerning "forms of the gaze with regard to images and their viewing" that acknowledge gesture, behavior, and context in prayer, devotion, and liturgical practice ("Rituals of Gazing in the Late Middle Ages," pp. 360–73, quotation from p. 363); Tachau argues that theorizing was not divorced from picturing and looking ("Seeing as Action and Passion", pp. 336–59); and Carruthers examines the rhetorical definitions of picture making invoked in preaching and involved in the composition of pictures "painted in and for the mind's eye" ("Moving Images in the Mind's Eye," pp. 287–305, quotation from p. 302). Clark, "Optics for Preachers: the *De Oculo Morali* by Peter of Limoges," *Michigan Academician* (1977), pp. 329–43, and Schleusener-Eichholz, "Naturwissenschaft und Allegorese: Der 'Tractatus de oculo morali' des Petrus von Limoges," *Frühmittelalterliche Studien* (1978), pp. 258–309, identify the sources of this popular preaching treatise in medieval optical studies and show how those theories were applied to moralizing puposes.

Saint Augustine's three-tiered classification of sight and its subsequent interpretations are discussed by Hahn, "*Visio Dei*: Changes in Medieval Visuality," in *Visuality before and beyond the Renaissance*, ed. Nelson, pp. 169–96. The Augustinian tradition is also discussed by Hamburger in the conclusion to his book *The Rothschild Canticles* (pp. 162–7). Hamburger has contributed greatly and with great erudition to re-evaluations of the theology of vision and its relation to art. In addition to *The Rothschild Canticles*, his book of studies, *The Visual and the Visionary: Art and Female Spirituality in Late Medieval Germany*, his article on "Imagination and Believing," in *Imagination und Wirklichkeit*, ed. Krüger and Nova, pp. 48–68, and his chapters on "The Place of Theology in Medieval Art History" and "The Medieval Work of Art: Wherein the 'Work'? Wherein the 'Art'?" in *The Mind's Eye: Art and Theological Argument in the Middle Ages*, pp. 11–31, pp. 374–412, hold a wealth of insights about medieval and modern attitudes towards theology and art, devotional imagery and devotional practice, and modes of models of vision. In *Sight and Embodiment in the Middle Ages*, Biernoff assesses medieval ways of seeing in a lively dialogue with modern and post-modern theory. Late medieval notions of vision persisted in the fifteenth century, but were subject to reappraisal owing to the impact of humanist study and pictorial experimentation as remarked upon by Greenstein in his article "On Alberti's 'Sign': Vision and Composition in Quattrocento Painting," *Art Bulletin* (1997), pp. 669–98, where he develops this point with particular reference to "devotional vision."

Devotion: Contexts and Practices

The ecclesiastical structures that governed religious life and their relation to the city's power structures are the subject of Bizzocchi's book on *Chiesa e potere nella Toscana del Quattrocento*. *Christianity and the Renaissance*, ed. Verdon and Henderson, has a number of chapters relating to the institutions, rituals, and spectacles shaping devotion in Florence, as well as essays on art. Gaston's article on "Liturgy and Patronage in San Lorenzo, Florence," in

Patronage, Art, and Society in Renaissance Italy, ed. Kent and Simons, pp. 111–33, uses the example of San Lorenzo to demonstrate the way that lay patronage influenced liturgy. Although focused largely on the fourteenth century, Cohn's work on *The Cult of Remembrance and the Black Death* is very informative about the nature of pious bequests and testamentary commissions. Lay participation in spiritual matters, its motivations and mechanisms, is comprehensively covered in the respective books by Henderson, Weissman, and Wilson (*Piety and Charity in Late Medieval Florence, Ritual Brotherhood in Renaissance Florence*, and *Music and Merchants: The Laudesi Companies of Republican Florence*). These authors deal mainly with confraternities. The topic is treated more generally by Becker in his essay on "Aspects of Lay Piety in Early Renaissance Florence," in *Holiness in Late Medieval and Renaissance Florence*, ed. Trinkaus and Oberman, pp. 177–99. Trexler's work on *Public Life in Renaissance Florence* takes Florence as a case for the historical study of ritual forms, which shows the degree to which civic identity was fused with sacrality and sacred behavior, both personal and public. The essays collected in his book *Dependence in Context in Renaissance Florence* add further material on the clergy, confraternities, convents, and charity.

Preaching

For the sermon as a genre and the development of the thematic sermon (*sermo modernus*), see the essays published by Kienzle in *The Sermon*, especially the chapter by Delcorno on "Medieval Preaching in Italy (1200–1500)," pp. 449–560, which sets out the characteristics of preaching and sermon structures and styles. It also includes a list of modern editions of sermons. D'Avray's book, *The Preaching of the Friars*, is a fundamental work on the history of the genre; for this, see further Kienzle, "The Typology of the Medieval Sermon and its Development in the Middle Ages: Report on Work in Progress," in *De l'homélie au sermon: Histoire de la prédication médiévale*, ed. Hamesse and Hermand, pp. 83–102. The essays collected by Muessig in *Preacher, Sermon and Audience in the Middle Ages* reflect upon the performance and reception of sermons, as well as their rhetorical structure, and there is a section on "Preaching and Art." The manuals or treatises on the "art of preaching" (*ars praedicandi*) are analyzed as a genre in Briscoe, *Artes praedicandi*.

Preaching in Florence has been the focus of a number of studies. Howard's work on Archbishop Antoninus, *Beyond the Written Word*, is highly instructive about the preacher's art and habits of mind and about how preaching was addressed towards social and political as well as devotional aims, which were held to be inseparable. In his article on "The Preacher and the Holy in Renaissance Florence," in *Models of Holiness in Medieval Sermons*, ed. Kienzle, pp. 355–70, Howard links sermon styles to the changing "culture of devotion" and to the civic concerns of the city, taking account of the implications of humanism in shaping exemplars of holiness. Lesnick's chapter on "Civic Preaching in the Early Renaissance: Giovanni Dominici's Florentine Sermons" (in *Christianity and the Renaissance*, ed. Verdon and Henderson, pp. 208–25) emphasizes Dominici's "civicism," rooted in a tradition of Dominican involvement in the civic world and promotion of Christian community, in terms of civic ideals. Nirit Debby characterizes the differing modes of preaching of Dominici and San Bernardino and publishes ten of Dominici's sermons in *Renaissance Florence in the Rhetoric of Two Popular Preachers*.

In *Preaching in Medieval Florence*, Lesnick describes the centrality of the visual sense to the Franciscans. He elaborates on the way that Franciscan preachers called upon their lis-

teners to use their physical and spiritual eyes, showing how this technique was transmitted by the *Meditations on the Life of Christ*, and how it was directed to a Florentine public. Nirit Debby, "The Preacher as Goldsmith: The Italian Preachers' Use of the Visual Arts," in *Preacher, Sermon and Audience in the Middle Ages*, ed. Muessig, pp. 127–54, gives specific examples of preachers calling upon images. In her justly celebrated book *The Web of Images: Vernacular Preaching from its Origins to St Bernardino of Siena*, Bolzoni instead examines the relationships between word and image, memory and mystical vision in preaching and demonstrates the influence of preaching on both the composition and reception of images (originally published as *La rete delle immagini*).

Devotional Art

In *Painting and Experience in Fifteenth Century Italy*, Baxandall makes the point that "The painter was a professional visualizer of the holy stories" and that "each of his pious public was liable to be an amateur in the same line, practised in spiritual exercises that demanded a high level of visualization" (p. 45), setting forth some of the interpretative skills this entailed and outlining how they might have been transmitted through sermons and devotional handbooks. Bennett, "Stigmata and Sense Memory: St Francis and the Affective Image," *Art History* (2001), pp. 1–16, investigates the ways in which images interacted with memory and in which their form related to their function as memory images with emotional coloring that could both move and instruct the viewer. This line of questioning usefully complicates the notion of a straightforward mimetic relationship between viewer and image, suggesting that viewing engaged the senses in a transformative process. She refers to Carruthers's work on memory (in *The Book of Memory: A Study of Memory in Medieval Culture* and *The Craft of Thought: Meditation, Rhetoric, and the Making of Images 400–1200*) and to Arasse's essay "Entre dévotion et culture: fonctions de l'image religieuse au xvᵉ siècle," in *Faire croire: Modalités de la diffusion et de la réception des messages réligieux du XIIᵉ au XVᵉ siècle*, pp. 132–46, where he argues that fifteenth-century devotional images were ordered by a mnemonic rather than a perspectival system. A related discussion occurs in Parshall's article on "The Art of Memory and the Passion," *Art Bulletin* (1999), pp. 456–72, where he also signals some of the tensions between the mnemonic and the mimetic, the recollective, and the representational in fifteenth-century art. Like Bolzoni, Arasse and Parshall are concerned with how "techniques of belief" informed the construction and reception of images in ways that counter a naturalistic model of composition. Taking an approach inspired as much by poets as by preachers, Barolsky directs attention to the visual quality of religious painting in his articles "The Visionary Experience of Renaissance Art," *Word and Image* (1995), pp. 174–81, and "The History of Italian Renaissance Art Re-envisioned," *Word and Image* (1996), pp. 243–50.

Ringbom's *Icon to Narrative: The Rise of the Dramatic Close-up in Fifteenth-Century Devotional Painting* is a magisterial study of the theology and psychology of cult images and the creation of private devotional images in this period. Belting's books dealing with the form and function of iconic works and the problem of vision or of the devotional gaze and the relations between icon and artwork have defined both key problems and methods in the research on the representation of religious subjects and their transformation into and by art: *Das Bild und sein Publikum im Mittelalter*; *Giovanni Bellini, Pietà: Ikone und Bilderzählung in der venezianische Malerei*; and *Bild und Kult* (*Likeness and Presence: A History of the Image before the End of Art*).

The sections on sacred buildings and their decoration and on "Sacred Beauty" in *Renaissance Florence: The Art of the 1470s*, ed. Rubin and Wright, pp. 53–65, 288–311, survey the principal functions of religious patronage and the resulting works. The second part of J. Burke's book *Changing Patrons: Social Identity and the Visual Arts in Renaissance Florence* is "The Individual, the Family, and the Church," and it looks at episodes in the patronage of two families – the Nasi and the del Pugliese – to trace the dynamic between private and institutional interests in the endowment and decoration of churches and chapels. Part III, "Painted Prayers: Savonarola and the Audience of Images," confronts the changed climate of the Savonarolan period, speculating on ruptures and reorientations in patronage and attendant changes in pictorial style. A reading of Savonarola's sermons is proposed as a resource for understanding "the workings of image-led devotional practice in this period" (p. 14). D. Kent's chapter on "Popular Devotion and the Perception of Images," in *Cosimo de' Medici and the Florentine Renaissance* (pp. 95–106) samples the rich variety of sources – *ricordi*, chapbook collections, letters, poetry, and literary evidence – that show the deep involvement of the laity in devotional life and shed light on attitudes to religious imagery. Trexler's article on "Florentine Religious Experience: The Sacred Image," *Studies in the Renaissance* (1972), pp. 7–41, focuses on the cult image of the Madonna of Impruneta as evidence of the active faith of Florentines in the miraculous presence of the divine. Frugoni's chapter on "Female Mystics, Visions, and Iconography," in *Women and Religion in Medieval and Renaissance Italy*, ed. Bornstein and Rusconi, pp. 130–64, is a dense and intriguing discussion of meditative practices and the relation of mental imaging to actual images.

Commission and Design

Jacobsen, *Die Maler von Florenz zu Beginn der Renaissance*, has sections both on the contractual process of commissions for large-scale, specially designed works, such as altarpieces, and on the serial and/or speculative production of smaller-scale devotional images made for private use. The catalogue on *Maestri e botteghe: Pittura a Firenze alla fine del Quattrocento* also describes these forms of production, as well as illustrating the output of the major workshops active during the third quarter of the century. Gardner von Teuffel, "Clerics and Contracts: Fra Angelico, Neroccio, Ghirlandaio and Others: Legal Procedures and the Renaissance High Altarpiece in Central Italy," *Zeitschrift für Kunstgeschichte* (1999), pp. 190–208, while singling out the particular function of the high altar, additionally distinguishes the characteristics of subsidiary altars and reviews the commissioning process. Her careful reading of the documents alerts us to how responsibilities were divided in these different cases and to the way that *ius patronatus* operated, considering the motivations of institutions, donors, and patrons and the dynamics between them. Her collected essays, *From Duccio's Maestà to Raphael's Transfiguration: Italian Altarpieces and their Settings* explore many aspects of the interconnections between commission, design, and purpose. O'Malley, "Memorizing the New: Using Recent Works as Models in Italian Renaissance Commissions," in *Memory and Oblivion*, ed. Reinink and Stumpel, pp. 803–10, examines instances of the contractual clause referring to a prototype, pointing out that it functioned to assert associations between commissioning groups rather than guaranteeing pictorial style. Such clauses indicate, however, the way that consensus about images and their suitability could be conveyed by the images themselves as they became examples to follow. Freuler's evaluation of "The Production and Trade of Late Gothic Pictures of the Madonna in Tuscany," in *Italian Panel*

Painting of the Duecento and Trecento, ed. Schmidt, pp. 427–41, gives an account of the practice of producing private devotional paintings from a common model, which, by the late fourteenth century, "approached almost production-line proportions" (p. 427). The demand for successful formulas or close variations continued in the fifteenth century, in sculpted tabernacles as well as in paintings. As mentioned in the Bibliographic Note to Chapter 3, Holmes looks at an instance of the "Copying Practices and Marketing Strategies in a Fifteenth-Century Florentine Painter's Workshop," in *Artistic Exchange and Cultural Translation in the Italian Renaissance City*, ed. Campbell and Milner, pp. 38–74, which seems to have been a form of licensed reproduction of paintings by Fra Filippo Lippi by a painter now known as the Pseudo-Pier Francesco Fiorentino. Similar forms of subcontracting may have existed in the Botticelli workshop, which certainly became a market force in supplying private devotional paintings in the third quarter of the fifteenth century, as did the Verrocchio shop in a variety of media (for the latter, see the catalogue entries nos. 27 and 28 in *Renaissance Florence: The Art of the 1470s*, ed. Rubin and Wright, pp. 180–3).

In "Commission and Design in Central Italian Altarpieces c.1450–1550," in *Italian Altarpieces 1250–1550*, ed. Borsook and Superbi Gioffredi, pp. 201–30, I consider the evolution of the altarpiece as a work of art between the mid-fifteenth and sixteenth centuries, which saw a change in the "rhetoric of the object" (p. 211), speaking more of the invention and reputation of the artist than of its sacred purposes. The question of rhetoric, in terms of narrative construction, communicative power, and artistic ambition as it affected religious works, is also addressed in my articles on "Il contributo di Raffaello allo sviluppo della pala d'altare rinascimentale," *Arte cristiana* (1990), pp. 169–82 and "Raphael and the Rhetoric of Art," in *Renaissance Rhetoric*, ed. Mack, pp. 165–82. Ferino Pagden makes a similar point, demonstrating Raphael's role as a protagonist in changing the priorities of devotional art in her chapter "From Cult Images to the Cult of Images: the Case of Raphael's Altarpieces," in *The Altarpiece in the Renaissance*, ed. Humfrey and Kemp, pp. 165–89. Nagel's book on *Michelangelo and the Reform of Art* starts with the case of Michelangelo's *Entombment* (now in the National Gallery, London), which he analyzes as an object of contemplation that consciously obeys the conventions and follows the traditions of cult images at the moment when the challenge of the narrative mode was emerging. The common point of these studies, made briefly here as well, is that there was a fundamental change in the design of religious works at the end of the fifteenth century whereby the sacred figures become dramatized examples, which engage the beholder in a dynamic of persuasion rather than acting as objects of contemplation.

Altarpieces

Goffen, "*Nostra conversatio in caelis est*: Observations on the *Sacra Conversazione* in the Trecento," *Art Bulletin* (1979), pp. 198–222, recounts the history of the term *sacra conversazione*, from its occurrence in eighteenth-century inventories to its arrival in art history in the nineteenth century, first in Franz Kugler's *Handbuch der Geschichte der Malerei in Italien seit Constantin der Grossen* (1837) and subsequently in J. A. Crowe and G. B. Cavalcaselle's *History of Painting in North Italy* (1871). The emergence of the unified grouping of Virgin and Child with saints in a rectangular field, connected with the development of perspective, is charted by Gardner von Teuffel, "Lorenzo Monaco, Filippo Lippi und Filippo Brunelleschi: die Erfindung der Renaissancepala," *Zeitschrift für Kunstgeschichte* (1982), pp. 1–30, where it is

also connected to the new Brunelleschian churches as part of an overall project of visual unity. A document of 1434 issued by the canons of San Lorenzo, giving the requirements for the decoration of chapels endowed there, specifies that the altarpieces should be rectangular, without foliate ornament, and well painted, proving that this was an established form by that time ("tabula quadrata et sine civoriis, picta honorabiliter"; see Ruda, "A 1434 Building Programme for San Lorenzo in Florence," *Burlington Magazine* [1978], pp. 358–61). Neri di Bicci regularly refers to commissions for "una tavola d'altare . . . all'anticha, quadra, cholonne da lato e predella da pie' e di sopra architrave, freg[i]o e chronic[i]one" (*Ricordanze*, ed. Santi, p. 121 [no. 235, September 19, 1459], in this case for a silk merchant, Giovanni di Nofri del Chaccia for the convent of Cestello [lost], commissioned to be exactly like one he had done for another client, "fatta in quello propio modo d'una feci a Charlo Girolami in Santo iStefano"). Shearman, "Masaccio's Pisa Altarpiece: An Alternative Reconstruction," *Burlington Magazine* (1966), pp. 449–55, associates Masaccio's painting with the transition from polyptych to *pala*, arguing that Masaccio arranged the Virgin and Saints in a unified space. His reconstruction has not been widely accepted (for this and alternatives, see Gordon, *National Gallery Catalogues: The Fifteenth Century Italian Paintings*, pp. 209–14). Masaccio's *Trinity* at Santa Maria Novella, however, could well have been a factor in this development in Florence. The way that this mural created an illusion that involved the viewer in a "shared space" with the figures is emphasized by Shearman in Chapter 2 of his essays on *Only Connect . . . Art and the Spectator in the Italian Renaissance*.

Two books of conference proceedings are helpful compendia on the subject. In these books altarpieces are defined according to ecclesiastical legislation and function and the collected essays touch on aspects of developments in iconography, design, and usage in ways that both validate and dispute the category: *Italian Altarpieces 1250–1550*, ed. Borsook and Superbi Gioffredi; *The Altarpiece in the Renaissance*, ed. Humfrey and Kemp. Altarpiece studies as such have a distinguished origin in Burckhardt's essay, *Das Altarbild* (written between 1893 and 1895, published in 1898 in the posthumous volume *Beiträge zur Kunstgeschichte*; subsequently in translation as *The Altarpiece in Renaissance Italy*, trans. Humfrey; and, with valuable commentary in *L'arte italiana del Rinascimento*, ed. Ghelardi and Müller).

Private Devotional Works

Lydecker's thesis on "The Domestic Setting of the Arts in Renaissance Florence," documents the progressive accumulation of goods in the domestic realm, including an increase in both the number and type of devotional works. This phenomenon and its relation to family interests and forms of worshipful viewing are interrogated by Johnson in her articles on "Family Values: Sculpture and the Family in Fifteenth-Century Florence," in *Art, Memory, and Family in Renaissance Florence*, ed. Ciappelli and Rubin, pp. 215–33, and "Beautiful Brides and Model Mothers. The Devotional and Talismanic Functions of Early Modern Marian Reliefs," in *The Material Culture of Sex, Procreation, and Marriage in Premodern Europe*, ed. McClanan and Encarnación, pp. 135–62 (in the same volume and on a related topic, see Randolph, "Renaissance Household Goddesses: Fertility, Politics, and the Gendering of Spectatorship," pp. 163–89). One of the prestigious new forms was the tondo, first developed in the 1440s and fast popular as Olson notes in her book on *The Florentine Tondo*, where she counts that "thousands were produced" in the decades between the 1450s and the 1490s (p. 179). Kecks, *Madonna und Kind: das häusliche Andachtsbild im Florenz des 15. Jahrhunderts*, is a repertory

of these intimate pictures of the Virgin and Child, by far the most commonly found devotional images in Florentine households, making the Virgin a familiar presence to be invoked as advocate and protectress.

The Annunciation

For the importance of the feast of the Annunciation in Florence and its forms of celebration see Bergstein, "Marian Politics in Quattrocento Florence: The Renewed Dedication of Santa Maria del Fiore in 1412," *Renaissance Quarterly* (1991), pp. 673–719 and Newbigin, *Feste d'Oltrarno: Plays in Churches in Fifteenth-Century Florence.*

Robb, "The Iconography of the Annunciation in the Fourteenth and Fifteenth Centuries," *Art Bulletin* (1936), pp. 480–526 and Renner, *Die Darstellung der Verkundigen an Maria in der florentinischen Malerei von Andrea Orcagna (1346) bis Lorenzo Monaco (1425)*, are overviews of the subject. Both Edgerton, *"Mensurare temporalia facit Geometria spirituali*: Some Fifteenth-Century Italian Notions about When and Where the Annunciation Happened," in *Studies in Late Medieval and Renaissance Painting in Honor of Millard Meiss*, ed. Lavin and Plummer, pp. 115–30, and Spencer, "Spatial Imagery of the Annunciation in Fifteenth-Century Florence," *Art Bulletin* (1955), pp. 273–80, add to the census of images and discuss aspects of the iconography in relation to the design of the paintings. *L'Annonciation italienne: une histoire de perspective* by Arasse is a suggestive essay on the interchange between space and subject and the consequences for the visual arts. Syson refers to Arasse's remarks about the function of the setting as a form of projected memory place in his chapter "Representing Domestic Interiors," in *At Home in Renaissance Italy*, ed. Ajmar-Wollheim and Dennis, pp. 86–101. He comments on the metaphorical and symbolic function of the furnishings of the Annunciate Virgin's house, which he convincingly argues are not documents of the everyday, but devotional prompts, whose purpose was to call to mind the mystery of the Incarnation.

The first written account of the miraculous painting of the Virgin's face at Santissima Annunziata is in a dialogue written in 1465 by the Servite friar Paolo Attavanti about the origins of the Servite Order (*Dialogus de origine ordinis servorum ad Petrum Cosmae*; Biblioteca Laurenziana, Florence, *Pluteo* 23, 21). It is considered, along with the cult and the history of the image, by Holmes, "The Elusive Origins of the Cult of the Annunziata in Florence," in *The Miraculous Image in Late Medieval and Renaissance Culture*, ed. Thunø and Wolf, pp. 97–121. The history of the cult and its promotion by the Servites are described by Waźbínski, "L'*Annunciazione* della Vergine nella chiesa della SS. Annunziata a Firenze," in *Renaissance Studies in Honor of Craig Hugh Smyth*, ed. Morrogh et al., II, pp. 533–52.

Artists and Projects

Structural similarity and stylistic diversity characterize fifteenth-century Florentine altarpiece design, which also responded to the desires of individual patrons and the requirements of specific institutional settings as is demonstrated by the examples given in the chapter. The context of each can be found in the references that follow. For Domenico Veneziano's *Virgin and Child with Saints Francis, John the Baptist, Zenobius, and Lucy* (pl. 168) painted for the high altar of Santa Lucia dei Magnoli, see Wohl, *Domenico Veneziano*, pp. 32–63 and catalogue

no. 5, pp. 123–7. For Benozzo Gozzoli's *Virgin and Child with Angels and Saints John the Baptist, Zenobius, Jerome, Peter, Dominic, and Francis* (pl. 169), made for the confraternity of Santa Maria della Purificazione e di San Zenobio, which met at San Marco, see Ahl, *Benozzo Gozzoli*, pp.112–19, catalogue no. 26, pp. 224–5, and documents 11 a-c, pp. 277–8. For Botticelli's *Virgin and Child with Saints John the Baptist and John the Evangelist* (pl. 203), painted for Giovanni de' Bardi's chapel at Santo Spirito, see Lightbown, *Botticelli*, I, pp. 100–3 and II, B42, pp. 56–7. The documents for this commission are published and discussed by Blume, "Giovanni de' Bardi and Sandro Botticelli in Santo Spirito," *Jahrbuch der Berliner Museen* (1995), pp. 169–83. For Cosimo Rosselli's *Virgin and Child with the Young Saint John the Baptist and Saints James and Peter* (pl. 170), commissioned by the heirs of Jacopo d'Alamanno Salviati for the family's chapel in the Cistercian church of Cestello, see *Maestri e botteghe*, catalogue no. 3.4, p. 118, and Luchs, *Cestello*, pp. 89–91, 260, 349–50, 413–20. The bell towers visible in the background to either side of the Virgin's throne may serve as reminders of the location of the Salviati family houses between the Duomo and the Bargello (as noted by an eighteenth-century genealogist, Giovanni Battista Dei, quoted by Luchs, p. 90). This urban chronicle is closely contemporary to Filippino Lippi's depiction of the Borgo San Frediano in the Nerli altarpiece (pl. 198).

FRA ANGELICO (CA. 1400–1455)

The standard monographs on Fra Angelico are Orlandi, *Beato Angelico* (with an important appendix of documents) and Pope-Hennessy, *Fra Angelico* (with a catalogue). Ahl, *Fra Angelico* has a cogent presentation of the works treated here. Strehlke, *Angelico*, is an excellent introduction; though brief, it adds substantially to the knowledge of Angelico's early career, and specifically to patronage at San Domenico, connecting a bequest from the Gaddi family to the endowment of the *Annunciation* and the *Coronation* (pp. 17–23; see further his essay on "Fra Angelico Studies," in *Painting and Illumination in Early Renaissance 1300–1450*, ed. Kanter, pp. 31–6). Fra Angelico's career is also surveyed, with thought-provoking suggestions about his style and the chronology of his works, in the the catalogue of the exhibition, *Fra Angelico* (Metropolitan Museum of Art, 2005).

The San Marco Altarpiece

The letter dated April 1, 1438 from Domenico Veneziano to Piero de' Medici seeking the commission documents the beginning of work. The church was dedicated on the feast of the Epiphany (January 6) in 1443, with the high altarpiece in place. Moved from the church to the convent in the seventeenth century, over the course of time the work was broken up and the main panel, the *Virgin and Child Enthroned with Angels and Saints Cosmas and Damian, Lawrence, John the Evangelist, Dominic, Francis and Peter Martyr* (pl. 165), now in the Museo di San Marco, suffered serious abrasion during an early restoration using caustic soda. Two of the predella panels remain at San Marco: the *Burial of Saints Cosmas and Damian* and the *Dream of the Deacon Justinian*. The *Entombment* (pl. 166) is now in Munich, Alte Pinakothek, as are three of the scenes from the lives of Saints Cosmas and Damian (*The Saints and their Brothers before the Judge Lycias*; *Lycias Possessed by Devils and Cosmas and Damian Thrown into the Sea*; the *Crucifixion of Saints Cosmas and Damian*). The other scenes are in the National Gallery of Art, Washington (the *Healing of Palladia by Saints Cosmas and Damian*), the National Gallery of Ireland, Dublin (the *Attempted Martyrdom of Saints Cosmas and Damian by Fire*). For a description of these and other surviving components, see Pope-Hennessy, Fra Angelico, pp. 199–202.

The Altarpieces for San Domenico

Fra Angelico's works at San Domenico are the subject of Cardile's dissertation "Fra Angelico and his Workshop at San Domenico" (Yale University, 1976), which reconstructs the church and the project of its decoration. As noted in the text, a later chronicle says that the altars had been in place "several years" before the dedication of the church in 1435. There is no agreement about a precise dating for the three altarpieces, but the high altarpiece (pl. 182) is held to have been the first of the three painted. The proposals for dating this work, which range from 1419 (soon after Barnaba degli Agli's founding bequest of 1418) to 1435, are reviewed by Gordon, *The National Gallery Catalogues: The Fifteenth Century Italian Paintings*, p. 17, and further discussed by de Vries in her essay on the painting and entries on some of its components in the 2005 Metropolitan Museum exhibition catalogue, pp. 58–72. The altarpiece was updated by Lorenzo di Credi in the early sixteenth century with a rectangular frame, loggia setting, and a landscape background. De Vries assesses the technical evidence that allows for a reconstruction of the altarpiece and notes the similarities between the original composition and a documented altarpiece painted by Bicci di Lorenzo between July 1423 and April 1424 for a chapel endowed by Simone da Spicchio in the Collegiata at Empoli (now in the Museo della Collegiata di Sant'Andrea, illustrated here, pl. 46). She argues that the San Domenico altarpiece was the prototype for this and a group of related compositions. Both Gordon and de Vries suggest that the altarpiece was commissioned and begun in 1419 or soon after, which accords with a current tendency to favor an early date for this painting.

Gordon, pp. 2–25, also provides a reconstruction of the entire altarpiece, with a detailed analysis of the predella, identifying a majority of the figures.

In her entry on the Annunciation attributed to Zanobi Strozzi, which is a variant of the San Domenico Annunciation, Gordon discusses the iconography of the scene and the other derivations of the San Domenico painting produced by Fra Angelico and his shop (pp. 415–16). The extraordinary influence of the composition is demonstrated by Holmes in her article "Neri di Bicci and the Commodification of Artistic Value in Florentine Painting (1450–1500)," in *The Art Market in Italy*, ed. Fantoni et al., pp. 213–23, where she points out that how Neri based his Annunciation painted for Agnolo Vettori in 1464 (pl. 197) on Fra Angelico's work, which she describes as "an established, proven religious product" (p. 215) that Neri was able to repackage, successfully, for his generation of clients.

Fra Angelico was already known as a painter of the *Annunciation* in 1425, when he is mentioned in a testamentary bequest by Alessandro di Simone Rondinelli, specifying an altarpiece of the *Annunciation* for a chapel in San Lorenzo, which he wished to be painted by the friar from San Domenico. This document is cited by Kanter in the 2005 exhibition catalogue in connection with the dating of the *Annunciation* (pl. 181) to the mid-1420s (pp. 81–3). Hood, *Fra Angelico at San Marco*, also points out Angelico's strong association with the theme of the Annunciation in his analysis of the mural in the north corridor of the dormitory at San Marco (pp. 260–72). Didi-Huberman, *Fra Angelico: Dissemblance et figuration* removes the *Annunciation* from the realm of imitation and Albertian *istoria* to situate it in a system of correlations and of constructions that lead the viewer to spiritual elevation.

Rapturously viewed by Vasari, the *Coronation of the Virgin* (pl. 185), was more equivocally received by later art historians. My article "Hierarchies of Vision: Fra Angelico's *Coronation of the Virgin* from San Domenico, Fiesole," *Oxford Art Journal* (2004), pp. 137–51, surveys the history of its reception and shows how the work is a lesson in contemplative viewing that can be associated with the promotion of the ideals of the Dominican Observance.

FRA FILIPPO LIPPI (CA. 1406–1469)

Ruda's *Fra Filippo Lippi: Life and Work* covers Lippi's career fully and thoughtfully and includes a catalogue. (For the Le Murate *Annunciation* (pl. 190), see pp. 157–63 and catalogue no. 29, pp. 411–12). In her study of *Fra Filippo Lippi: The Carmelite Painter*, Holmes examines the Le Murate altarpiece from the perspective of the nuns, while her article on "Giovanni Benci's Patronage of the Nunnery, Le Murate," in *Art, Memory, and Family in Renaissance Florence*, ed. Ciappelli and Rubin, pp. 114–34, concentrates on the patron. I am much indebted to Holmes's research on the circumstances of this commission.

For the other altarpieces mentioned in the chapter – the *Virgin and Child with Saints Frediano and Augustine* (pl. 167), now in the Louvre, made for the Barbadori chapel in the sacristy of the old church of Santo Spirito, the San Lorenzo *Annunciation* (pl. 191), and the *Coronation of the Virgin* (pl. 192) for the high altar of Sant'Ambrogio, now Florence, Uffizi – see the respective entries in Ruda's catalogue: no. 20, pp. 392–6; catalogue no. 22a, p. 399; catalogue no. 36, pp. 392–6. The qualities of spiritual and artistic delight solicited by Fra Filippo, specifically in the case of the *Coronation*, are investigated in my article "Signposts of Invention: Artists' Signatures in Italian Renaissance Art," *Art History* (2006), pp. 563-99.

FILIPPINO LIPPI (CA. 1457–1504)

Virgin and Child with the young Saint John the Baptist, Saint Martin of Tours, Catherine of Alexandria and the donors Tanai de' Nerli and Nanna di Neri Capponi, panel, 160 × 180 cm., ca. 1493. Florence, Santo Spirito.

Filippino's works are comprehensively treated in the massive monograph by Zambrano and Nelson. The Nerli altarpiece is catalogue no. 45, pp. 590–1. It is discussed by Nelson in his section on donor portraits, showing how Tanai and Nanna represent a model couple presenting decorous modes of devotion, both obeying and conveying societal norms (pp. 459–69). The centaur relief on the Virgin's throne is mentioned in the chapter on the rebirth of antiquity, asking if the bestial violence of the scene is simply ornamental or if it may betray other impulses (p. 423). For observations on Filippino's piety and iconographic inventiveness, see my essay on "'Filippino Lippi, pittore di vaghissima invenzione': Christian Poetry and the Significance of Style in Late Fifteenth-Century Altarpiece Design," in *Programme et invention dans l'art de la Renaissance*, ed. Kliemann, Koering, and Morel.

Drawings for Tanai's chapel project, one for the window and another that has been identified as a portrait of Tanai, are published in the catalogue of the Metropolitan Museum exhibition of *The Drawings of Filippino Lippi and his Circle*: no. 70, pp. 246–7, *Niche with Saint Martin Sharing his Cloak and Two Centaurs Holding the Coat of Arts of Tanai de' Nerli*, pen and brown ink and brown wash over traces of black chalk, 38.3 × 7.6 cm., Gabinetto Disegni e Stampe degli Uffizi, 1169E; no. 71, pp. 248–9, *Head of a Man Facing Right (Tanai de' Nerli)*, metalpoint, heightened with white on pink prepared paper, 13.8 × 10.9 cm., Département des Arts Graphiques du Musée du Louvre, 2690. Alessandro Cecchi has attributed the frame to the woodworker Chimenti di Domenico del Tasso, working from a drawing by Filippino (in *Giuliano e la bottega dei da Maiano*, ed. Lamberini et al., p. 152).

Tanai di Francesco Nerli (1427–1498) acquired his chapel in the tribune of the new church of Santo Spirito in 1493 for 300 florins. He had become a member of the board of works in 1492. It is logical to date the altarpiece from the time of the chapel's endowment, when Fil-

ippino had returned from Rome; for a discussion of the dating, see Nelson in *Filippino Lippi*, pp. 460–1. For the history of the building and decoration of the new church of Santo Spirito, begun in the 1430s on a design by Brunelleschi, but only completed in 1481, see J. Burke's chapter on "Family, Church, Community. The Appearance of Power in Santo Spirito," in *Changing Patrons*, pp. 63–83. Burke recounts the way that the *opera* "policed homogeneity within the church" in the furnishing of the chapels (p. 77). The church is unusual for the number of altarpieces surviving in or near their original chapels with altar tables and painted frontals. Markowsky, "Eine Gruppe bemalter Paliotti in Florenz," *Mitteilungen des Kunsthistorischen Institutes in Florenz* (1973), pp. 105–40, and Capretti in *La chiesa e il convento di Santo Spirito*, ed. Luchinat, pursue the question of a program for this arrangement.

The Santo Spirito chapel was not Tanai's burial chapel. In the course of his career of ecclesiastical patronage Tanai endowed chapels in three churches in Florence and commissioned three altarpieces. On March 4, 1463[64] he ordered a massive altarpiece (4×5 *braccia*) from Neri di Bicci for his parish church of Santa Felicita, with the image of the saint and her seven children (*Ricordanze*, ed. Santi, no. 435, p. 221). Apparently found to be unwieldy, a somewhat reduced version was commissioned in May by the prior on behalf of Tanai (*Ricordanze*, no. 446, pp. 227–8, May 30, 1464 for 40 *lire*, $4 \times 3^1/_2$ *braccia*). The altarpiece is now in the sacristy, see Fiorelli Malesci, *La chiesa di Santa Felicita a Firenze*, pp. 227–30. In addition to manifesting devotion to the titular saint of Santa Felicita, this extraordinary familial image might have had special resonance for Tanai. Married since 1445, he and his wife had a prolific marital career, eventually producing fourteen surviving children. Tanai also established funerary chapels for himself and his descendants in the Fransciscan Observant church of San Salvatore al Monte. One – presumably the larger, north chapel, the *cappellone* – had an altarpiece by Filippino Lippi. Now lost, its subject and composition may be recalled by a drawing in Rome with *Saint Francis Giving the Rule of the Tertiary Order to King Louis IX of France (Saint Louis) and Saint Elizabeth* and a workshop painting of *Saint Francis in Glory* (now in the Memphis Brooks Museum of Art, Tennessee). See *The Drawings of Filippino Lippi*, no. 78, pp. 264–5 for the drawing in the Istituto Nazionale per la Grafica, Rome, 130452r, metalpoint, heightened with white, traces of pen and ink framing outlines on mustard-colored prepared paper, 25.9×18.6 cm. The choice of the French king, like that of Saint Martin at Santo Spirito (bishop of Tours) may in part be explained by Tanai's own French connections. He was born in Avignon during his father's exile there, coming to Florence when he was seven years old. The family maintained business ties to France. The roundel marking the tomb in the *cappellone*, "s[EPULCRUM] DESCEN[DENTIUM] TANAIS FRAN[CISCI] PHI[LIPPI] DE NERLIS," is dated 1497. I thank Jonathan Nelson for generously sharing his work on Nerli and his chapels with me, and Jill Burke for her assistance with information on the chapel endowments.

Tanai's multiple endowments were typical of elite patronage, spreading pious interests between neighborhood, parish, and prestigious positions. His reliance on Filippino in the 1490s at the very least shows his satisfaction with his choice. Filippino's cultivation of the "art of friendship" with another patron, Piero del Pugliese, is described by Burke in *Changing Patrons* (Chapter 4). In a subsequent chapter, "Differing Visions: Image and Audience in the Florentine Church," she compares two altarpieces of the *Apparition of the Virgin to Saint Bernard*, one painted by Pietro Perugino for the Nasi chapel in Santa Maria Maddalena di Cestello, and now in the Alte Pinakothek, Munich, the other being that painted by Filippino for Piero del Pugliese's chapel in the church of Le Campora, now in the Badia Fiorentina

(1484–5; 210 × 195 cm.). The Pugliese altarpiece is mentioned in this chapter as an example of Lippi's ability to picture divine revelation (pl. 205). Nelson's entry in the Palazzo Strozzi exhibition *Botticelli e Filippino*, no. 11, pp. 136–8, also stresses the way that its composition is organized around the theme of contemplative vision. Among his many other prestigious altarpiece commissions, Filippino took over the *Adoration of the Magi* for the church of the monastery of San Donato a Scopeto, which Leonardo da Vinci left unfinished in the care of the Benci family when he left Florence for Milan late in 1482 (pl. 208). For Leonardo's work, see Kemp, *Leonardo da Vinci*, pp. 67–78 and Marani, pp. 106–13. For Filippino's commission and his completed painting, now in the Uffizi, see Zambrano and Nelson, *Filippino Lippi*, pp. 469–79 and catalogue entry no. 52, pp. 594–6.

7　HAPPY ENDINGS

The Panels

The first three panels of the series are now in the Prado, Madrid (nos. 2838, 2839, 2840), the fourth has had its own "happy ending," finding its way back to the Pucci family in Florence. The first three measure respectively: 83 × 138 cm. (no. 2838); 82 × 138 cm. (no. 2839); 84 × 142 cm. (no. 2840); the fourth measures 84 × 142 cm. In the second edition of *The Lives*, Vasari says that "in the Pucci house [Botticelli] illustrated Boccaccio's story of Nastagio degli Onesti with small figures in four panels, which are very delightful and beautiful" ("in casa Pucci [Botticelli] fece di figure piccole la novella del Boccaccio di Nastagio degl'Onesti, in quattro quadri, di pittura molto vaga e bella"; Vasari, ed. Bettarini and Barocchi, III, p. 514). Though on the same site as Antonio's house, the palace visited by Vasari was not the same structure. The palace (still the Pucci palace) was built by Antonio's son Roberto in the 1530s. Drawings in the Uffizi by Antonio da Sangallo the Younger dating from ca. 1531–4, with a site plan of the old house (U764A) and a project for the new palace (U765Ar-v) are completely different in the organization of the internal spaces.

The panels do not correspond to any of the items listed in the inventory of Antonio's house made on November 10, 1484, six months after his death. Four *"spalliere* with figures" are recorded in an antechamber to Antonio's room, but they are described as three new and one old, covered in fabric (ASF, Carte Strozziane, ser. 1, no. 341, fol. 35r: "iiii spalliere a ffighure 3 nuove e una husata soppannata"). Unless the panels were painted after this date, the omission can be explained two ways: if incorporated in the wainscoting of a room instead of attached to large chests, they would have been designated as part of the fabric of the building like other paneling, therefore not to be inventoried among its movable goods; or they could have been in Giannozzo's possession – he is mentioned in one document as resident in the parish of San Felice in Piazza, in the quarter of Santo Spirito, presumably with, or near his in-laws (Archivio Pucci, Memorie di diverse persone della famiglia Pucci, Filza 3, N. 12, 1°, an insert with notes from the protocols of Bernardo di Domenico Vermigli, 1491–4, fol. 32v). Given the subsequent placement of the panels in the Pucci palace, the former seems more likely. In any event, the panels remained in the Pucci family after the deaths of Antonio and Giannozzo until 1868, when they were sold to Alexander Barker. They had been considered for the National Gallery a few years earlier, but Sir Charles Eastlake "hesitated about making an offer for them, on account of the somewhat unpleasant nature of one of the subjects – the lady being cut up!" (as recalled in a letter from Austen Henry Layard to Lady

Eastlake, November 11, 1865, published by Lightbown, *Botticelli*, 11, p. 49). Their subsequent sales, first traced by Horne, p. 127, are updated and outlined by Lightbown, 11, pp. 49–50.

In his full and careful analysis of the pictures, Horne was also the first to correctly interpret the heraldry as alluding to the marriage of Giannozzo Pucci and Lucrezia Bini (p. 127). Since the late nineteenth century, the design of the panels has been attributed to Botticelli, with the execution assigned to his workshop. The remarkable opportunity to see the *Banquet in the Pine Forest* and *The Wedding Feast* reunited in the exhibition dedicated to *Botticelli e Filippino* in the Palazzo Strozzi in 2004 in close proximity to other small-scale works by Botticelli (such as the *Judith and Holofernes* panels and the *Calumny of Apelles*) confirmed the difference in hands between the these two *Nastagio* panels and the others. It is indisputable that Botticelli delegated the execution of the Pucci panels, but to whom is still a mystery to be resolved (see *Botticelli e Filippino*, entry no. 1, pp. 102–4, for literature and attributions).

Lightbown, 11, pp. 50–1, lists the opinions on the attribution, which differ as to the distribution of hands. Ghirlandaio's associate, Bartolomeo di Giovanni, has frequently, but inconsistently, been named among the executants. Recently, Barriault has seen Bartolomeo di Giovanni's style in the first and third panels and Jacopo del Sellaio's in the second and fourth (*"Spalliera" Paintings of Renaissance Tuscany*, checklist 3.1–4, pp. 142–4). Pons, in *Maestri e botteghe*, categorically attributes the paintings to Bartolomeo di Giovanni and a collaborator after Botticelli's design (p. 223). She modifies this opinion somewhat in *Botticelli e Filippino* (p. 104), attributing the first two panels and the *Wedding Banquet* to Botticelli's design, executed by an unnamed collaborator, with the *Banquet in the Pine Forest* described as a typical work by Bartolomeo di Giovanni. She reiterates this in her section on Bartolomeo's collaboration with Botticelli in the 2004 exhibition on *Bartolomeo di Giovanni* (p. 30). Cecchi, *Botticelli* (pp. 75, 202, 218), agrees that the series was done after drawings by Botticelli, in his opinion by at least two artists. He identifies one of them as Jacopo di Domenico di Papi da San Gaggio, Botticelli's principal assistant at this time, and attributes the execution of the first two and the final panels to Jacopo. Cecchi accepts the suggestion of Bartolomeo di Giovanni as being the artist responsible for painting the third scene, the *Banquet in the Forest*.

Two aspects of this problem render speculation as to hands as relatively futile as it is absolutely fertile: the first is the need to produce a systematic comparative analysis of the technique of Botticelli's paintings. Cecchi's archival research has added substantially to the information about Botticelli's assistants and the artisans associated with his shop (*Botticelli*, Chapter 3, "La bottega nella via Nuova d'Ognissanti"), but this data and Cecchi's attributions require further study in order to arrive at a more refined understanding of the delegation and assignment of work by the master. There is no consensus about Botticelli's use of drawings or about his design practices. The second, related, issue is that the specialized production of paintings with "small figures," as Vasari called them, also needs further attention. The activities of Apollonio di Giovanni and Biagio d'Antonio, both protagonists in this market, have received monographic treatments respectively by Callmann and Bartoli, but more research is necessary to define the various forms of collaboration and association that shaped and served the demand for wedding chests (*forzieri*) and other decorative domestic works. The investigation of this type of production, fragmented in survival, is also hampered by the inadequate illustration of the works concerned, which seldom allows for a precise perception of their style or subject.

Botticelli and Boccaccio

Interest in the social dynamics of marriage, the decoration of the domestic setting, and representations of gender and sexuality has focused attention on the panels. While the resulting contributions offer insights that complement or coincide with the interpretation in the present chapter, none has explored the family background and its documentation as done here, nor have they considered the details of the paintings (portraits, subsidiary scenes) or their social and cultural implications to the degree pursued in this study.

With respect to matters of identification, it would be very tempting to find that the act of clemency on the triumphal arch in the *Wedding Banquet* was the widow pleading with Emperor Trajan – asking that he revenge the death of her son, who had been killed by the emperor's son. The story had an established place in the iconography of justice and would be have been fitting to put it in the scene as an allusion to that virtue. Botticelli knew the episode. He had illustrated it in his drawing for Canto X of *Purgatory* (pl. 130). The figure kneeling before the emperor in the fictive relief in the *Wedding Banquet* is male, however, and there is no sign of the dead son, so clearly laid out next to the supplicant mother in the *Purgatory* drawing.

The panels have featured in the monographic literature on Botticelli beginning with Horne's characteristically precise passage on the cycle (*Botticelli*, pp. 126–35. Susbsequently see, for example: Lightbown, *Botticelli*, I, pp. 69–70; Cecchi, *Botticelli*, pp. 202–18; and Zollner, *Botticelli*, pp. 101–17. Further literature interpreting the Nastagio degli Onesti cycle is noted here following the order of its publication.

In an article on the importance of iconographic evidence in family history, D. Hughes refers to the paintings as instances of social representation, part of the ritual of marriage and the construction of domesticity, showing both what was desired and what was feared ("Representing the Family: Portraits and Purposes in Early Modern Italy," *Journal of Interdisciplinary History* [Summer, 1986], pp. 7–38). The case fits well into her general argument, but she mistakenly assumes that the Nastagio story was a popular subject for wedding chests, and equally mistakenly implies that Botticelli's panels were for a chest (which she erroneously dates to 1487). Grazzini, "Botticelli interprete di Boccaccio: Osservazioni sulla storia di Nastagio degli Onesti," in *Letteratura italiana e arti figurative*, ed. Franceschetti (1988), pp. 303–16, carefully and sensitively analyzes the relations between text and image, including the proportional division of episodes. He points out how Botticelli focuses on the vision and how the wood itself becomes a form of protagonist and the way that the compositions become a moral *exemplum*. He describes the connections between Botticelli, Dante, and Petrarch and he further considers the place of the series as a celebrative cycle within Laurentian culture. Olsen, "Gross Expenditure: Botticelli's Nastagio degli Onesti Panels," *Art History* (1992), pp. 146–70, takes Dante's description of the spendthrifts and suicides in Canto XIII of the *Inferno* as a key to understanding the choice of scenes and their composition in the panels. Examining related literary and moralizing traditions, she indicates how the concluding marriage controls the disruptive and threatening forces of sexual and financial prodigality. As its title implies, Wofford's essay on "The Social Aesthetics of Rape: Closural Violence in Boccaccio and Botticelli," in *New Essays on Renaissance Literature*, ed. Quint et al. (1992), pp. 189–238, combines an analysis of the themes and structures of Boccaccio's tale with an examination of Botticelli's rendering of it. She discerns patterns of identification in both with regard to male and female readers and viewers, demonstrating Botticelli's attentiveness to the text. She highlights the painter's receptivity to the verbal echoes of Dante's *Inferno* and *Purgatorio*,

which are reiterated in the visual echoing that occurs between the Nastagio panels and his Dante illustrations. She reveals the way that violence operates in the different contexts of text and image, and relates the latter to subjects chosen for *cassone* decoration, like the Rape of the Sabine Women in which "violence against women is figured as a necessary originary moment of male control and domination that makes possible the ensuing benefits of civilization which are brought about and symbolized by the women, but only after they are subjected to their husbands" (p. 202). In an analysis with many parallels to mine, she shows how the process of civilization is marked out by the settings of Botticelli's panels, culminating in a celebration of Medici power as it triumphed over the violence of the Pazzi conspiracy and of marriage "as a cultural artifact, bringing glory to civilization" (p. 234).

In his article "Le Thème du coeur mangé: l'ordre, le sauvage et la sauvagerie," in *La Sociabilité à table*, pp. 26–7, Grieco explores another aspect of the imagery of violence, remarking that Boccaccio's description of the way that the young woman is killed (followed in detail by Botticelli) recalls boar hunting, thereby referring to the traditional association of boars with savagery, sexual excess, and the sin of *lussuria*. This association not only reinforces the social and moral messages of the story, but underlines the connection between sociability and alimentary practices (also observed by Botticelli). More literal with respect to such practices, Sebregondi, "La tavola: desinari, feste e conviti nel Rinascimento fiorentino," in *Itinerari nella casa fiorentina del Rinascimento* (1984), p. 58, links various elements in the *Wedding Feast* to documented banquets.

Baskins in "Gender Trouble in Italian Renaissance Art History: Two Case Studies," *Studies in Iconography* (1994), pp. 1–36, uses the panels, with the other known painted versions of the story, as a basis for an informative discussion of recent applications of feminist and gender theory to the study of Renaissance art. In the chapter on "Women, Men and Society: Painted Marriage Furniture," in her book on *Women in Italian Renaissance Art*, pp. 21–46, Tinagli presents a concise account of the role of marriage within society and of the role of marriage furniture in the rituals of marriage and in transmitting domestic values. She selects examples of different subjects illustrated and their exemplary messages, taking the Nastagio panels as an instance of illustrating the duties of men and women in society. There is a chapter on the panels in Ricketts, *Vizualizing Boccaccio* (1997), which examines the question of reader and viewer identification with the tale, showing how Botticelli suppresses the ambiguities of the tale and enforces its moral. She discusses the insistence on the horrible vision in terms of guilt and sympathy, within the genre of the infernal chase and within and between Boccaccio's tale and Botticelli's panels. She notes the way that Botticelli has sublimated the sexual violence of the hunt, by rendering it beautiful. She suggests ways of reading each panel according to its spatial organization, pointing out the way that Nastagio's reintegration into society is reflected by that organization. The insights of the chapter are marred by "embarrassing problems" identified by Kirkham in her review in *Renaissance Quarterly* (1998), p. 1353. Didi-Huberman's essay *Ouvrir Vénus* (1999) is a subtle philosophical and psychological study of the "phenomenology of the nude" in art and art history, which meditates upon the types of nudity (ideal, impure, guilty, cruel, psychic, and "open" or "opened"). Botticelli's nudes are the focus of five of the six chapters, with the dream-like apparition of the violated nude of the Pucci–Bini panels discussed according to the interpretation of dreams.

The figurative interpretation of Boccaccio is the subject of essays and a catalogue of known illustrations, *Boccaccio visualizzato*, ed. Branca. This collects and amplifies material assembled as a team project previously published in a series of articles in *Studi sul Boccaccio* start-

ing in 1985. Branca has a section in the introductory volume on "L'Atteone del Boccaccio e una possibile filigrana visuale per Nastagio," where he speculates on an association between the myth of Actaeon and Nastagio's tale (vol. 1, pp. 62–74; p. 69 for Botticelli's paintings). Massimiliano Rossi opens his introduction to the catalogue of Tuscan and Central Italian Renaissance illustrations ("I dipinti – Introduzione: La novella di Sandro e Nastagio") by quoting a passage from one of Francesco Sansovino's *Lettere sopra le diece giornate del Decamerone*, published in 1542, in which he compares the force of Botticelli's art to the force-fulness of Nastagio's actions. From this citation he proceeds to reviewe discusses the critical fortunes of Boccaccio's texts in the Renaissance, the thematic repertory they provided for illustration, and the influence of the comic or burlesque tradition on the notion of artists, with particular reference to Vasari's biographical construction of Botticelli (II, pp. 153–63; his catalogue entry for the panels, no. 76 is pp. 214–15).

The story of Nastagio degli Onesti emerges from this census as a rare choice for illustration, with only three other panels known. Two, by a late fifteenth-century Florentine artist, are based on Botticelli's panels: one, in the Brooklyn Museum of Art, shows Nastagio wandering in the woods and the chase and killing of the young woman (inventory no. 25.95, 70.2 × 134.9 cm.); the other, in the Johnson collection in the Philadelphia Museum of Art, shows the meal in the forest (Johnson collection, no. 64; 69.8 × 135.8 cm.). Horne recognized the arms on the second panel as being those of the del Nero family (*John G. Johnson Collection: Catalogue of Italian Paintings*, pp. 70–1, attributed to Jacopo del Sellaio); see also, *Boccaccio visualizzato*, II, catalogue no. 77 a,b, p. 219, figs. 225, 226. The third, a *cassone* panel in the Saint Louis Art Museum, showing the entire story, is held to be Ferrarese (published by Callmann, "Subjects from Boccaccio," *Studi sul Boccaccio* [1995], no. 69, pp. 52–3).

Using the inventories of the Magistrato dei Pupilli, Bec has suggested that enthusiasm for *The Decameron* declined in the second half of the fifteenth century, in favor of Boccaccio's more classicizing works, like the *Amorosa visione*, the *Teseida*, and the *Ninfale fiesolano*. That would be in line with the humanist fashions of the later century, but the statistics are based on a very restricted sample and cannot be regarded as conclusive ("Sur la lecture de Boccace à Florence," *Studi sul Boccaccio* [1975–76], pp. 247–60). The critical fortunes of *The Decameron* in the fifteenth century are treated by Branca in the second volume of his work on the *Tradizione delle opere di Giovanni Boccaccio*. Among the lost manuscripts, he cites a copy of *The Decameron* in a "note of books in Lorenzo's chamber" at Poggio a Caiano (September, 29, 1480, "Nota dei libri che erano in camera di Lorenzo"; Branca, p. 145).

Giannozzo Manetti's regard for Boccaccio is considered by Marsh, "Boccaccio in the Quattrocento: Manetti's *Dialogus in symposio*," *Renaissance Quarterly* (1980), pp. 337–50. A translation of his biography of Boccaccio is in Thompson and Nagel, *The Three Crowns of Florence*, pp. 93–102.

Marriage: Its Objectives and Related Objects

Given its key role in the life of the city as well as the lives of its citizens, it is no surprise that marriage has been the subject of much study on the part of the historians of Florence. Starting from a close, collaborative analysis of the institution of the Monte delle doti (the communal dowry fund, instituted in 1425), Kirshner and Molho have written jointly and separately on the economic structure and social construction of marriage and the marriage

market: Kirshner and Molho, "The Dowry Fund and the Marriage Market in Early *Quattro-cento* Florence," *Journal of Modern History*, (1978), pp. 403–38; Kirshner, "Pursuing Honor while Avoiding Sin: The *Monti delle doti* of Florence," *Studi senesi* (1977), pp. 177–258; and Molho, *Marriage Alliance in Late Medieval Florence*. The latter has tables with the comparative size of dowries (p. 310), proving their increase over the century and confirming that the substantial dowries mentioned in this chapter are at the top of the scale.

The legal position of women within marriage is defined by Kuehn, "Women, Marriage, and *Patria Potestas* in Late Medieval Florence," in *Law, Family, and Women*, pp. 197–212. Gregory surveys the attitudes towards daughters and the marriage arrangements made for them, "Daughters, Dowries and the Family in Fifteenth Century Florence," *Rinascimento* (1987), pp. 215–37. An introduction to "issues in the history of marriage," along with essays specifically devoted to Florentine problems is in *Marriage in Italy 1300–1650*, ed. Dean and Lowe.

Taking the Strozzi family as the basis for an extended case study, Fabbri looks in detail at the "art of marriage," through its phases (*Alleanza matrimoniale e patriziato nella Firenze del '400: Studio sulla famiglia Strozzi*). The letters of Alessandra Strozzi provide a direct and moving account of her concern for her sons' marriages and the efforts that went into finding them suitable brides (*Lettere*, ed. Guasti and *Selected Letters*, ed. Gregory).

D. Kent has a section on Medici family marriages between 1400 and 1434 in her book *The Rise of the Medici*. Her analysis of the data suggests the existence of a form of consorterial policy that relied on marriage alliances to accrue power and influence in that crucial period. The contrasting patterns of marriage-broking by Cosimo and Lorenzo have been studied by John Padgett. I thank him for sharing the preliminary results of his research with me, now available on his website in a paper on "Marriage and Elite Structures in Renaissance Florence, 1282–1500." Bruscoli presents a tabulation of marriages arranged by Lorenzo as documented in a register of notarial acts, with a discussion of his marital politics in an article on "Politica matrimoniale e matrimoni politici nella Firenze di Lorenzo de' Medici," *Archivio storico italiano* (1997), pp. 347–98. Medici marriages, particularly those arranged by Lorenzo for his children, are also discussed by Tomas in her book on *The Medici Women*.

Brucker, *Giovanni and Lusanna: Love and Marriage in Renaissance Florence*, is a micro-historical study of marriage based on the records of a lawsuit between a lower-class woman who claimed that she was the legitimate spouse of an upper-class man, who denied it. Marriage patterns among the elite have received far more attention than among the artisan and laboring classes, but marriage was no less important among those classes as an instrument of social and economic definition as well as a matter of survival, as has been established by Cohn in his book *The Laboring Classes in Renaissance Florence* and Haines in her article on "Artisan Family Strategies," in *Art, Memory, and Family in Renaissance Florence*, ed. Ciappelli and Rubin, pp. 163–75.

As well as providing great insights into their chosen topics, the cultural-anthropological studies by Klapisch-Zuber have had a profound influence on art-historical treatments of marriage, its imagery and iconography and the objects related to its rituals. The relevant essays include: "Kin, Friends, and Neighbors: The Urban Territory of a Merchant Family in 1400 [the Niccolini]," "The 'Cruel Mother': Maternity, Widowhood, and Dowry in Florence in the Fourteenth and Fifteenth Centuries," "Zacharias, or the Ousted Father: Nuptial Rites in Tuscany between Giotto and the Council of Trent," "The Griselda Complex: Dowry and Marriage Gifts in the Quattrocento," in *Women, Family, and Ritual in Renaissance Italy*,

respectively pp. 68–93, 117–31, 178–212, 213–46; "Les Coffres de mariage et les plateaux d'accouchée à Florence: Archive, ethnologie, iconographie," in *A travers l'image*, ed. Deswarte-Rosa, pp. 309–23; "Famille, religion et sexualité à Florence au moyen âge," *Revue de l'histoire des religions* (1992), pp. 381–92; "La Femme et le lignage florentin (xivᵉ–xviᵉ siècles)," in *Persons in Groups*, ed. Trexler, pp. 141–53; "Les Femmes dans les rituels de l'alliances et de la naissance à Florence," in *Riti e rituali nelle società medievali*, ed. Chiffoleau, Martines, and Paravicini Bagliani, pp. 3–22; "Les Noces Feintes – Sur quelques lectures de deux thèmes iconographiques dans le *cassoni* florentins," *I Tatti Studies* (1995), pp. 11–30; "Les Noces florentines et leurs cuisiniers," in *La Socialité à table*, pp. 193–9; "Le 'zane' della sposa: la fiorentina e il suo corredo nel Rinascimento," *Memoria* (1984), pp. 12–23.

"In the Customary Manner"

In the section on marriage in his anthology of documents, *Firenze nel rinascimento* (pp. 250–8), Brucker includes excerpts from private record books giving instances of decisions to marry or marry off a daughter, documenting dowry agreements and marriage arrangements. Among them, one father, Giovanni d'Amerigo del Bene wrote in February 1381 about his daughter's marriage. He noted that "the marriage coffer (*forzierino*) will be furnished in the customary manner, it will cost between 70 and 75 florins. They will provide the ring, so that everything will be ready at the proper time" (February 20, 1380[81], to Francesco del Jacopo del Bene in the Valdinievole: "Il forzierino si fa come s'usa: costano da 70 a 75 fiorini; e l'anella fieno fornite, siché a buon tempo ogni cosa fia in punto"; p. 254). The types and timing of such customary expenditure were neither casual nor accidental. Patterns of acquisition followed a rhythm of ritual and were an essential part of the process of declaring, assimilating, and commemorating a match.

Although many years passed between the publication of Schubring's massive corpus of *cassone* painting (*Cassoni, Truhen, und Truhenbilder der italienischen Frührenaissance*, 1923) and subsequent studies, the topos of neglect can no longer be applied to the investigation of these customs, or of the customary objects and their imagery. All have been the subject of works that have transformed our understanding of those topics. These have arisen in part from the reconsideration of the hierarchies dividing the "fine" and "decorative" arts and "major" and "minor" artists. They have also been inspired by inter- and cross-disciplinary trends in art history, which have benefited from social anthropological studies of the sort by Klapisch-Zuber noted above and from the impetus of feminist and gender studies.

Gombrich first reassessed the reputation of Apollonio di Giovanni, whose production of wedding chests and decorated furnishings (with his partner Marco del Buono) had a major role in the market in mid-century Florence, and in shaping the taste for *all'antica* subjects. His article on "Apollonio di Giovanni: A Florentine *Cassone* Workshop Seen through the Eyes of a Humanist Poet," in *Norm and Form* (1966), pp. 11–28, was followed by Callmann's 1974 monograph on the artist and her articles arguing for his place as a trendsetter: "Apollonio di Giovanni and Painting for the Early Renaissance Room," *Antichità viva* (1988), nos. 3–4, pp. 5–17; "The Growing Threat to Marital Bliss as Seen in Fifteenth-Century Florentine Paintings," *Studies in Iconography* (1979), pp. 73–92. Watson, "Apollonio di Giovanni and Ancient Athens," *Allen Memorial Art Museum Bulletin* (1979–80), pp. 3–25, comments on the nature of Apollonio;s engagement with antiquity.

Schiaparelli's 1908 book on the furnishing of Florentine houses in the Renaissance, *La casa fiorentina e i suoi arredi*, remains a fundamental study, deservedly reprinted in 1983. Lydecker's

doctoral thesis on "The Domestic Setting of the Arts in Renaissance Florence" (The Johns Hopkins University, 1987) has become a standard reference on this subject. It is based on a comprehensive analysis of archival evidence to describe and analyze the context for these furnishings in the organization and decoration of the domestic interior and its progressive elaboration over the course of the fifteenth century. These ideas are taken up and developed in the Victoria and Albert Museum's exhibition catalogue, *At Home in Renaissance Italy*, ed. Ajmar-Wollheim and Dennis. The different types of furnishing are defined by Thornton, *Italian Furniture 1400–1600*. Barriault, *"Spalliera" Paintings of Renaissance Tuscany* and G. Hughes, *Renaissance Cassoni* survey these respective furnishing types.

The trend in choice of subjects for decorating the furnishings associated with marriages over the course of the fifteenth century is generally traced as being from illustrations of amorous tales to instructive stories taken from ancient history. The following are studies of the ceremonies, related commissions, and developments in imagery (in date order): Watson, "Virtù and Voluptas in Cassone Painting," Ph.D. thesis, Yale University (1970) and *The Garden of Love in Tuscan Art of the Early Renaissance*; Jacobson-Schutte, "'Trionfo delle donne'": tematiche di rovesciamento dei ruoli nella Firenze del rinascimento," *Quaderni storici* (1980), pp. 474–96 (although her definition of *deschi da parto* – birth trays – as a form of marriage object is refuted by Ahl's archival research on *deschi* and "Renaissance Birth Salvers and the Richmond *Judgment of Solomon*," *Studies in Iconography* [1981–2], pp. 157–74); Witthoft, "Marriage Rituals and Marriage Chests in Quattrocento Florence," *Artibus et historiae* (1982), pp. 43–59; Miziolek, *Soggetti classici sui cassoni fiorentini alla vigilia del rinascimento* (1996); Witthoft, "Riti nuziali e loro iconografia," in *Storia del matrimonio*, ed. de Giorgio and Klapisch-Zuber (1996), pp. 119–48; Baskins, *Cassone Painting, Humanism, and Gender in Early Modern Italy* (1998); Randolph, "Performing the Bridal Body in Fifteenth-Century Florence," *Art History* (1998), pp. 182–200.

Baskins's book on *cassone* painting was preceded by articles on specific subjects that examine the way that those subjects are gendered and also the way that they should be read according to social practices and ideologies, which complicate simple exemplary readings: "Corporeal Authority in the Speaking Picture: The Representation of Lucretia in Tuscan Domestic Painting," in *Gender Rhetorics*, ed. Trexler, pp. 187–200; "'La festa di Susanna': Virtue on Trial in Renaissance Sacred Drama and Painted Wedding Chests," *Art History* (1991), pp. 329–44; "Griselda, or the Renaissance Bride Stripped Bare by her Bachelor in Tuscan *Cassone* Painting," *Stanford Italian Review* (1992), pp. 153–75; "Typology, Sexuality and the Renaissance Esther," in *Sexuality and Gender in Early Modern Europe*, ed. Turner, pp. 31–54.

Fahy, "The Tornabuoni–Albizzi Panels," in *Scritti di storia dell'arte in onore di Federico Zeri*, ed. Natale, I, pp. 233–47, publishes a set of *spalliera* panels made in 1487 to commemorate the marriage of (Giannozzo Pucci's friend) Lorenzo di Giovanni Tornabuoni to Giovanna degli Albizzi. Showing the subject of Jason and Medea, and also mixing fifteenth-century heraldry and Tornabuoni dynastic interests with the story being illustrated, they provide an interesting comparison with the Pucci panels. Similar in the social, political, and aesthetic values they represent, the Tornabuoni panels display Latinate erudition translated to Tuscan usage, a pendant to Botticelli's rendering of a Tuscan story with classicizing flourishes.

Bibliography

PRIMARY SOURCES

Alberti, L. B., " De Pictura," in *Opere volgare*, III, ed. C. Grayson, Laterza (Baris, 1973).

Alberti, L. B., *The Family in Renaissance Florence*, trans. R. N. Watkins, University of South Carolina Press (Columbia, S.C., 1969).

Alberti, L. B., *I libri della famiglia*, in *Opere volgari*, I, ed. C. Grayson, Laterza (Bari, 1960).

Alberti, L. B., "Istorietta amorosa," in *Opere volgari*, III, ed. C. Grayson, Laterza (Bari, 1973).

Alberti, L. B., *On Painting*, trans. C. Grayson, ed. M. Kemp, Penguin Books (London, 1991).

Alhazen, *Alhacen's Theory of Visual Perception: A Critical Edition, with English Translation and Commentary, of the First Three Books of Alhacen's De aspectibus, the Medieval Latin Version of Ibn al-Haytham's Kitab al-Manazir*, ed. A. Mark Smith, American Philosophical Society (Philadelphia, 2001).

Aquinas, Saint Thomas, *Commentary on Aristotle's De anima*, trans. K. Foster, O. P. and S. Humphries, O. P., Dumb Ox Books (Notre Dame, 1994).

Aquinas, Saint Thomas, *Commentary on Aristotle's Nichomachean Ethics*, trans. C. I. Litzinger, O. P. and R. McInerny, Dumb Ox Books (Notre Dame, 1964).

Aquinas, Saint Thomas, *Scriptum super sententiis magistri Petri Lombardi*, in *Corpus Thomisticum*, www.corpusthomisticum.org, ed. E. Alarcón, University of Navarra (Pamplona, 2000).

Aquinas, Saint Thomas, *Summa Theologiae: Pars prima et prima secundae*, ed. P. Caramello, Marietti Editori (Turin, 1952).

Aquinas, Saint Thomas, *Summa Theologiae: Tertia pars et supplementum*, ed. P. Caramello, Marietti Editori (Turin, 1956).

Aquinas, Saint Thomas, *Summa Theologica*, trans. Fathers of the English Dominican Province, 3 vols., Benziger Bros. (New York, 1947–8).

Aristotle, *The Complete Works of Aristotle: The Revised Oxford Translation*, ed. J. Barnes, 2 vols., Princeton University Press (Princeton, 1984).

Bacon, R., *The "Opus maius" of Roger Bacon*, trans. R. B. Burke, 2 vols., Thoemmes Press (Bristol, 2000).

Baldassari, S. U., and A. Saiber, eds., *Images of Quattrocento Florence: Selected Writings in Literature, History, and Art*, Yale University Press (New Haven and London, 2000).

Barbaro, F., *De re uxoria liber*, in *Prosatori latini del Quattrocento*, ed. E. Garin, Riccardo Ricciardi (Milan and Naples, 1952).

Biondo, F., *Italy Illuminated*, ed. and trans. J. A. White, The I Tatti Renaissance Library, Harvard University Press (Cambridge, Mass., and London, 2005).

Biringuccio, V., *The Pirotechnia of Vannoccio Biringuccio*, ed. and trans. C. S. Smith and M. T. Gnudi, M.I.T. Press (Cambridge, Mass., 1943).

Boccaccio, G., *Decameron*, ed. V. Branca, 2 vols., Felice Le Monnier (Florence, 1952).

Boccaccio, G., *The Decameron*, trans. G. H. McWilliam, Penguin Books (London, 1972).

Boccaccio, G., *Esposizioni sopra la comedia di Dante*, in *Tutte le opere di Giovanni Boccaccio*, ed. G. Padoan, VI, Arnaldo Mondadori (Verona, 1965).

Boccaccio, G., *Tutte le opere di Giovanni Boccaccio, VII–VIII, Genealogie deorum gentilium*, ed. V. Branca, 2 vols., Arnoldo Mondadori Editore (Milan, 1998).

Bombe, W., *Nachlass-Inventare des Angelo da Uzzano und des Lodovico di Gino Capponi*, B. G. Teubner (Leipzig and Berlin, 1928).

Bracciolini, P., "On Nobility," in *Humanism and Liberty: Writings on Freedom from Fifteenth-Century Florence*, trans. and ed. R. N. Watkins, University of South Carolina Press (Columbia, S.C., 1978).

Brucker, G., ed., *Firenze nel Rinascimento*, La Nuova Italia (Florence, 1980).

Brucker, G., ed., *The Society of Renaissance Florence: A Documentary Study*, Harper Torchbooks (New York, 1971).

Brucker, G., ed., *Two Memoirs of Renaissance Florence: The Diaries of Buonaccorso Pitti and Gregorio Dati*, trans. J. Martines, Harper & Row (New York, 1967).

Bruni, L., *The History of the Florentine People*, trans. and ed. J. Hankins, 2 vols., The I Tatti Renaissance Library, Harvard University Press (Cambridge, Mass., 2001–04).

Bruni, L., *The Humanism of Leonardo Bruni: Selected Texts*, trans. and ed. G. Griffiths, J. Hankins, and D. Thompson, Center for Medieval and Early Renaissance Studies (Binghamton, N.Y., 1987).

Bruni, L., *Laudatio florentinae urbis*, in *Opere letterarie e politiche*, ed. P. Viti, U.T.E.T. (Turin, 1996), pp. 569–647.

Bruni, L., *Leonardi Bruni arretini epistolarum libri VIII*, ed. L. Mehus, 2 vols., Bernardo Paperini (Florence, 1741).

Bruni, L., *Leonardo Bruni Aretino: Humanistisch-Philosophische Schriften*, ed. H. Baron, G. Teubner (Leipzig and Berlin, 1928).

Bruni, L., *The Study of Literature (De Studiis et litteris)* in *Humanist Educational Treatises*, ed. and trans. C. W. Kallendorf, The I Tatti Renaissance Library, Harvard University Press (Cambridge, Mass., and London, 2002), pp. 92–125.

Bruni, L., *Le vite di Dante e del Petrarca*, ed. A. Lanza, Archivio Guido Izzi (Rome, 1987).

Buti, F., *Commento di Francesco da Buti sopra la Divina Commedia di Dante Allighieri*, ed. C. Giannini, 3 vols., Fratelli Nistri (Pisa, 1860).

Caggese, R., ed., *Statuti della repubblica fiorentina*, 2 vols., Tipografia Galileiana (Florence, 1910).

Castellani, M., *Ricordanze, I: Ricordanze A (1436–1459)*, ed. G. Ciappelli, Leo S. Olschki Editore (Florence, 1992).

Cennino Cennini, *The Craftsman's Handbook: The Italian "Il libro dell'arte"*, trans. D. V. Thompson, Jr., Dover Publications (New York, 1960).

Chellini, G., *Le ricordanze di Giovanni Chellini da San Miniato medico, mercante e umanista (1425–1457)*, ed. M. T. Sillano, Franco Angeli (Milan, 1984).

Cicero, *Brutus, Orator*, trans. G. L. Hendrickson and H. M. Hubbell, Loeb Classical Library, Harvard University Press and William Heinemann (Cambridge, Mass., and London, 1971).

Cicero, *De officiis*, trans. W. Miller, Loeb Classical Library, Harvard University Press and William Heinemann (Cambridge, Mass., and London, 1975).

Cicero, *De oratore*, trans. H. Rackham, 2 vols., Loeb Classical Library, Harvard University Press and William Heinemann (Cambridge, Mass., and London, 1976–7).

Cicero, *De partitione oratoria*, in *Cicero, IV*, trans. H. Rackham, Loeb Classical Library, Harvard University Press and William Heinemann (Cambridge, Mass., and London, 1977).

Cicero, *The Speeches: Pro Lege Manilia, Pro Caecina, Pro Cluentio, Pro Rabirio Perduellionis*, trans. H. G. Hodge, LoebClassical

Library, William Heinemann and G. P. Puttnam's Sons (London and New York, 1927).

Condivi, A., *Vita di Michelagnolo Buonarroti*, ed. G. Nencioni, S.P.E.S. (Florence, 1998).

Dante Alighieri, *The Divine Comedy*, trans. C. H. Sisson, and D.H. Higgins, Oxford University Press (Oxford, 1998).

Dante Alighieri, *Il Convivio*, ed. G. Busnelli and G. Vandelli, 2 vols., Felice Le Monnier (Florence, 1954).

Dante Alighieri, *La Divina commedia*, ed. J. Risset and P. Dreyer, Diane de Selliers (Paris, 1996).

Dante Alighieri, *The Divine Comedy*, trans. and ed. C. Singleton, 6 vols., Princeton University Press (Princeton, 1970–5).

Dante Alighieri, *Rime della "Vita nuova" e della giovinezza*, ed. M. Barbi and F. Maggini, Felice Le Monnier (Florence, 1956).

Dante Alighieri, *Vita nuova*, ed. E. Sanguineti and A. Berardinelli, Garzanti (Milan, 1977).

Dante and his Circle: With the Italian Poets Preceding him (1000–1200–1300): A Collection of Lyrics, trans. D. G. Rossetti, Ellis and Elvery (London, 1892).

Dati, G., *Istoria di Firenze dall'anno MCCCLXXX all'anno MCCCV*, ed. G. Bianchini, Manni (Florence, 1735).

Decrees of the Ecumenical Councils, 1: Nicaea to Lateran V, ed. Norman P. Tanner, Sheed & Ward and Georgetown University Press (London and Washington, D.C., 1990).

Dei, B., *La cronica dall'anno 1400 all'anno 1500*, ed. R. Barducci, Francesco Papafava (Florence, 1984).

De Marinis, T., and A. Perosa, *Nuovi documenti per la storia del Rinascimento*, Leo S. Olschki Editore (Florence, 1970).

Domenici, G., *Regola del governo di cura familiare*, ed. D. Salvi, Garinei (Florence, 1860).

Facio, B., *Bartholomei Facii de viris illustribus liber*, ed. L. Mehus, C. Tanjini (Florence, 1745).

Filarete, A., *Trattato di architettura (English and Italian): Filarete's Treatise on Architecture: Being the Treatise by Antonio di Piero Averlino known as Filarete*, trans. J. R. Spencer, 2 vols., Yale University Press (New Haven and London, 1965).

Filarete, A., *Trattato di architettura*, ed. A. M. Finoli and L. Grassi, 2 vols., Edizioni il Polifilo (Milan, 1972).

Fonte, B., "Bartholomaei Fontii annales suorum temporum ab an. 1448 ad an. 1483," in *Philippi Villani Liber de civitatis Florentiae famosis civibus ex codice Mediceo Laurentiano nunc primum editus et de Florentinorum litteratura principes fere synchroni scriptores denuo in lucenm produent*, ed. G. C. Galletti, J. Mazzoni (Florence, 1847).

Francesco da Barberino, *Reggimento e costumi di donna*, ed. G. Sansone, Loescher-Chiantore (Turin, 1957).

Frey, C., ed., *Il codice Magliabechiano cl. XVII.17*, G. Grote'sche Verlagsbuchhandlung (Berlin, 1892).

Gaye, G., *Carteggio inedito d'artisti dei secoli XIV, XV, XVI*, 3 vols., Giuseppe Molini (Florence, 1839–40).

Ghiberti, L., *Der dritte Kommentar Lorenzo Ghibertis: Naturwissenschaften und Medizin in der Kunsttheorie der Frührenaissance*, ed. K. Bergdolt, VCH (Weinheim, 1988).

Ghiberti, L., *I commentarii (Biblioteca Nazionale Centrale di Firenze, II, I, 333)*, ed. L. Bartoli, Giunti (Florence, 1998).

Ghiberti, L., *Lorenzo Ghibertis Denkwürdigkeiten (I Commentari)*, ed. J. von Schlosser, Julius Bard (Berlin, 1912).

Gilbert, C., *Italian Art 1400–1500: Sources and Documents*, Prentice-Hall (Englewood Cliffs, N. J., 1980).

Giordano da Pisa e l'antica predicazione volgare, ed. C. Delcorno, Leo S. Olschki Editore (Florence, 1975).

Giordano da Rivalto, *Prediche sulla Genesi recitate in Firenze nel MCCCIV*, ed. D. Mureni, Giovanni Silvestri (Milan, 1839).

Giustiniani, V. R., "Il testamento di Leonardo Bruni," *Rinascimento*, series 2, IV (1964), pp. 259–64.

Guicciardini, F., *The History of Florence*, trans. M. Domandi, Harper & Row (New York, 1970).

Guicciardini, F., *The History of Italy*, trans. and ed. S. Alexander, Collier Books (New York, 1969).

Guicciardini, F., *Storie fiorentine dal 1378 al 1509*, ed. R. Palmarocchi, G. Laterza & figli (Bari, 1931).

Guicciardini, F., *Storia d'Italia*, ed. S. Seidel Menchi, 3 vols., Einaudi (Turin, 1971).

I commenti danteschi dei secoli XIV, XV e XVI, ed. P. Procaccioli, CD-rom, Lexis progetti editoriali (Rome, 1999).

Jacopo da Voragine, *The Golden Legend of Jacobus de Voragine*, trans. G. Ryan and H. Ripperberger, Longmans, Green & Co. (New York, London, Toronto, 1941).

Kohl, B. G., and R. G. Witt, eds., *The Earthly Republic: Italian Humanists on Government and Society*, Manchester University Press (Manchester, 1978).

Landino, C., *Comento sopra la Comedia*, ed. P. Procaccioli, 4 vols., Salerno Editrice (Rome, 2001).

Landucci, L., *Diario fiorentino dal 1450 al 1516*, ed. I. del Badia, Studio Biblos (Florence, 1969).

Landucci, L., *A Florentine Diary 1450–1516*, trans. A. de Rosen Jervis, J. M. Dent & Sons (London, 1927).

Leonardo da Vinci, *The Literary Works of Leonardo da Vinci*, ed. J. P. Richter, 2 vols., Phaidon (London, 1970).

Leonardo da Vinci: I documenti e le testimonianze contemporanee, ed. E. Villata, Ente Raccolta Vinciana (Milan, 1999).

Leonardo da Vinci, *Treatise on Painting [Codex Urbinas Latinus 1270]*, trans. and ed. A. P. McMahon, 2 vols., Princeton University Press (Princeton, 1956).

Livy, *Historiae ab urbe condita*, trans. B. Foster, Loeb Classical Library, William Heinemann and G. Putnam (London and New York, 1919–29).

Lorenzo de' Medici, *The Autobiography of Lorenzo the Magnificent: A Commentary on my Sonnets*, trans. J. W. Cook, Medieval and Renaissance Texts and Studies (Binghamton, N.Y., 1995).

Lorenzo de' Medici, *Comento de' miei sonetti*, ed. T. Zanato, Leo S. Olschki Editore (Florence, 1991).

Lorenzo de' Medici Lettere IV (1479–1480), ed. N. Rubinstein, Giunti-Barbèra (Florence, 1980).

Lorenzo de' Medici Lettere V (1480–1481), ed. M. Mallett, Giunti-Barbèra (Florence, 1989).

Lorenzo de' Medici Lettere VI (1481–1482), ed. M. Mallett, Giunti-Barbèra (Florence, 1990).

Lorenzo de' Medici, *Rime spirituali, la rappresentatione di San Giovanni e Paulo*, ed. B. Toscani, Edizioni di Storia e Letteratura (Rome, 2000).

Machiavelli, N., *Florentine Histories*, trans. L. F. Banfield and H. C. Mansfield, Jr., Princeton University Press (Princeton, 1988).

Machiavelli, N., *Istorie fiorentine*, ed. F. Gaeta, Feltrinelli (Milan, 1962).

Mainardi, A., *Motti e facezie del piovano Arlotto*, ed. G. Folena, Riccardo Ricciardi (Milan and Naples, 1953).

Manetti, A., *The Life of Brunelleschi by Antonio di Tuccio Manetti*, trans. C. Engass and ed. H. Saalman, Pennsylvania State University Press (University Park, Pa., 1970).

Manetti, A., *La novella del Grasso legnaiuolo nelle redazioni di Antonio Manetti dei codici Palatino 51 e Palatino 200 di Bernardo Giambullari e di Bartolomeo Davanzati*, ed. A. Lanza, Vallecchi Editore (Florence, 1989).

Manetti, A., *Vita di Filippo Brunelleschi preceduta da la novella del Grasso*, ed. D. de Robertis and G. Tanturli, Edizioni il Polifilo (Milan, 1976).

Manetti, G., *Lives of Three Illustrious Florentine Poets*, in *Gianozzo Manetti: Biographical Writings*, trans. and ed. S. U. Baldassari and R. Bagemihl, The I Tatti Renaissance Library, Harvard University Press (Cambridge, Mass., and London, 2003).

Mazzei, L., *Lettere di un notaro a un mercante del sec. XIV, con altre lettere e documenti*, ed. C. Guasti, Le Monnier (Florence, 1880).

Meditations on the Life of Christ: An Illustrated Manuscript of the Fourteenth Century: Paris, Bibliothèque Nationale ms. Ital. 115,

trans. I. Ragusa, ed. I. Ragusa and R. B. Green, Princeton University Press (Princeton, 1961).

Morelli, G., *Ricordi*, ed. V. Branca, Felice Le Monnier (Florence, 1956).

Morelli, G., *Ricordi*, in *Mercanti scrittori: Ricordi nella Firenze tra Medioevo e Rinascimento*, ed. V. Branca, Rusconi (Milan, 1986), pp. 103–339.

Neri di Bicci, *Le ricordanze (10 marzo 1435–24 aprile 1475)*, ed. B. Santi, 2 vols., Edizioni Marlin (Pisa, 1976).

Palmieri, M., *Ricordi fiscali (1427–1474)*, ed. E. Conti, Istituto Storico Italiano per il Medio Evo (Rome, 1983).

Palmieri, M., *Vita civile*, ed. G. Belloni, Sansoni (Florence, 1982).

Paolo da Certaldo, *Il libro di buoni costumi*, in *Mercanti scrittori: Ricordi nella Firenze tra Medioevo e Rinascimento*, ed. V. Branca, Rusconi (Milan, 1986), pp. 3–99.

Petrarch, F., *Le familiari*, I–III (*Libri I–IV*; *Libri V–XI*; *Libri XII–XIX*), ed. V. Rossi, Edizione Nazionale delle Opere di Francesco Petrarca, Sansoni (Florence, 1933–7).

Petrarch, F., *Le familiari*, IV (*Libri XX–XXIV*), ed. U. Bosco, Edizione Nazionale delle Opere di Francesco Petrarca, Sansoni (Florence, 1942).

Petrarch, F., *Letters on Familiar Matters: Rerum familiarium libri IX–XVI*, trans. A. S. Bernardo, The Johns Hopkins University Press (Baltimore, 1982).

Petrarch, F., *Letters on Familiar Matters: Rerum familiarium libri XVII–XXIV*, trans. A. S. Bernardo, The Johns Hopkins University Press (Baltimore, 1985).

Petrarch, F., *Rerum familiarium libri I–VIII*, trans. A. S. Bernardo, State University of New York Press (Albany, 1975).

Petrarch's Remedies for Fortune Fair and Foul, trans. C. H. Rawski, Indiana University Press (Bloomington, 1991).

Pliny, *Natural History*, trans. H. Rackham, Loeb Classical Library, Harvard University Press and Heinemann (Cambridge, Mass., and London, 1952).

Poliziano, A., *Prose volgari inedite e poesie latine e greche edite e inedite*, ed. I. del Lungo, G. Barbèra (Florence, 1867).

Poliziano, A., *Stanze Orfeo Rime*, ed. S. Marconi, Feltrinelli Economica (Milan, 1981).

Prosatori latini del Quattrocento, ed. E. Garin, Riccardo Ricciardi (Milan and Naples, 1952).

Quintilian, *Institutio oratoria*, trans. H. E. Butler, 4 vols., Loeb Classical Library, Harvard University Press and William Heinemann (Cambridge, Mass., and London, 1970–80).

Rabil, A., Jr., ed., *Knowledge, Goodness, and Power: The Debate over Nobility among Quattrocento Humanists*, Medieval and Renaissance Texts and Studies (Binghamton, N. Y., 1991).

Rinuccini, A., *Lettere ed orazioni*, ed. V. R. Giustiniani, Leo S. Olschki Editore (Florence, 1953).

Romby, G., *Descrizioni e rappresentazioni della città di Firenze nel XV secolo con una trascrizione inedita dei manoscritti di Benedetto Dei e un indice ragionato dei manoscritti utili per la storia di Firenze*, Libreria editrice fiorentina (Florence, 1976).

Rucellai, G., *Giovanni Rucellai ed il suo Zibaldone: I. "Il Zibaldone Quaresimale": Pagine scelte*, ed. A. Perosa, The Warburg Institute (London, 1960).

Sacchetti, F., *Il trecentonovelle*, ed. V. Pernicone, Sansoni (Florence, 1946).

Sacre rappresentazioni del Quattrocento, ed. L. Banfi, U.T.E.T. (Turin, 1963).

Sancti Antonini, *Summa Theologica*, 4 vols., Akademische Druck (Graz, 1959).

Sancti Aurelii Augustini, *Ennarationes in Psalmos, Corpus christianorum, series latina*, X.1, Brepols (Turnhout, 1956).

Savonarola, G., *Operette spirituali*, ed. M. Ferrara, 2 vols., Angelo Belardetti Editore (Rome, 1976).

Savonarola, G., *Prediche sopra Ruth e Michea*, ed. V. Romano, 2 vols., Angelo Berlardetti (Rome, 1962).

Simone da Cascina, *Colloquio spirituale*, ed. F. Dalla Riva, Leo S. Olschki Editore (Florence, 1982).

Spallanzani, M., and G. G. Bertelà, eds., *Libro d'inventario dei beni di Lorenzo il Magnifico*, Associazione "Amici del Bargello"/S.P.E.S. (Florence, 1992).

Stallings, Sister Mary Jordan, *Meditaciones de passione Christi olim Sancto Bonaventurae attributae*, The Catholic University of America Press (Washington, D.C., 1965).

Statuta populi et communis florentiae: publica auctoritate, collecta, castigata et praeposita anno salutis MCCCCXV, 3 vols., Michael Kluch (Fribourg, 1778).

Statuti della Università e Studio fiorentino dell'anno MCCCLXXXVII seguiti da un'appendice di documenti dal MCCCXX al MCCCCLXXII, ed. A. Gherardi, Documenti di storia italiana pubblicati a cura delle R. Deputazioni sugli studi di storia patria di Toscana, dell'Umbria e delle Marche, VII (Florence, 1881).

Strozzi, A., *Lettere di una gentildonna fiorentina del secolo XV ai figliuoli esuli*, ed. C. Guasti, Sansoni (Florence, 1877).

Strozzi, A., *Selected Letters of Alessandra Strozzi: Bilingual Edition*, trans. and ed. H. Gregory, University of California Press (Berkeley, Los Angeles, London, 1997).

Strozzi, L., *Vita di Filippo Strozzi il Vecchio scritta da Lorenzo suo figlio*, ed. G. Bini and P. Bigazzi, Tipografia della casa di correzione (Florence, 1851).

Thompson, D., and A. F. Nagel, trans., *The Three Crowns of Florence: Humanist Assessments of Dante, Petrarca, and Boccaccio*, Harper & Row (New York, 1972).

Tornabuoni, L., *Lucrezia Tornabuoni lettere*, ed. P. Salvadori, Leo S. Olschki Editore (Florence, 1993).

Two Renaissance Book Hunters: The Letters of Poggius Bracciolini to Nicolaus de Niccolis, trans. P. W. Goodhart Gordon, Columbia University Press (New York, 1974).

Varchi, B., *Storia fiorentina*, ed. L. Arbib, Società editrice delle storie del Nardi e del Varchi (Florence, 1843).

Vasari, G., *Le opere di Giorgio Vasari*, ed. G. Milanesi, 9 vols., Sansoni (Florence, 1906).

Vasari, G., *La vita di Michelangelo nelle redazioni del 1550 e 1568*, ed. P. Barocchi, 5 vols., Riccardo Ricciardi (Milan and Naples, 1962).

Vasari, G., *Le vite de' più eccellenti pittori scultori e architettori nelle redazioni del 1550 e 1568*, ed. R. Bettarini and P. Barocchi, 6 vols., Sansoni/S.P.E.S. (Florence, 1966–87).

Vespasiano da Bisticci, *The Vespasiano Memoirs: Lives of Illustrious Men of the XVth Century*, trans. W. George and E. Waters, Renaissance Society of America Reprint Texts, University of Toronto Press (Toronto, Buffalo, London, 1997).

Vespasiano da Bisticci, *Le vite*, ed. A. Greco, 2 vols., Istituto Nazionale di Studi sul Rinascimento (Florence, 1976).

Villani, F., *Philippi Villani De origine civitatis Florentie et de eiusdem famosis civibus*, ed. G. Tanturli, Antenore (Padua, 1997).

Villani, G., *Cronica di Giovanni Villani*, ed. F. G. Dragomanni, 4 vols. (Florence, 1844–5).

Virgil, *Aeneid*, trans. H. Rushton Fairclough, 2 vols., Loeb Classical Library, William Heinemann and G. Putnam (London and New York, 1916–18).

Le vite di Dante, Petrarca e Boccaccio, scritte fino al decimosesto secolo, ed. A. Solerti, F. Vallardi (Milan, 1904).

Watkins, R. N., ed., *Humanism and Liberty: Writings on Freedom from Fifteenth-Century Florence*, University of South Carolina Press (Columbia, 1978).

Wesselski, A., *Angelo Polizianos Tagebuch (1477–79)*, Eugen Diedrichs (Jena, 1929).

SECONDARY LITERATURE

Acidini Luchinat, C., ed., *The Chapel of the Magi: Benozzo Gozzoli's Frescoes in the Palazzo Medici-Riccardi Florence*, Thames and Hudson (London, 1994).

Ackerman, J. A., "Leonardo's Eye," *Journal of the Warburg and Courtauld Institutes*, XLI (1978), pp. 108–46.

Ahl, D., *Benozzo Gozzoli*, Yale University Press (New Haven and London, 1996).

Ahl, D., *Fra Angelico*, Phaidon Press (London and New York, 2006).

Ahl, D., "Renaissance Birth Salvers and the Richmond *Judgment of Solomon*," *Studies in Iconography*, VII–VIII (1981–2), pp. 157–74.

Akbari Conklin, S., *Seeing through the Veil: Optical Theory and Medieval Allegory*, University of Toronto Press (Toronto, Buffalo, and London, 2004).

All'ombra del lauro: Documenti librari della cultura in età laurenziana, ed. A. Lenzuni, exhibition catalogue, Florence, Biblioteca Medicea Laurenziana, Silvana Editoriale (Milan, 1992).

Alpers, S., *The Art of Describing: Dutch Art in the Seventeenth Century*, Chicago University Press (Chicago, 1983).

Altrocchi, R., "Michelino's Dante," *Speculum*, VI (1931), pp. 15–59.

Ames-Lewis, F., ed., *Cosimo "Il Vecchio" de' Medici 1389–1464*, Clarendon Press (Oxford, 1992).

Ames-Lewis, F., ed., *The Early Medici and their Artists*, Birkbeck College (London, 1995).

Ames-Lewis, F., *The Intellectual Life of the Early Renaissance Artist*, Yale University Press (New Haven and London, 2000).

Antal, F., *Florentine Painting and its Social Background: The Bourgeois Republic before Cosimo de' Medici's Advent to Power*, Kegan Paul (London, 1947).

Antonelli, G., "La magistratura degli Otto di Guardia a Firenze," *Archivio storico italiano*, CXII (1954), pp. 3–39.

Arasse, D., *L'Annonciation italienne: une histoire de perspective*, Hazan (Paris, 1999).

Arasse, D., "Entre dévotion et culture: fonctions de l'image religieuse au XVe siècle," in *Faire croire: modalités de la diffusion et de la réception des messages réligieux du XIIe au XVe siècle*, Collection de l'École Française du Rome, LI (Rome, 1981), pp. 132–46.

L'architettura di Lorenzo il Magnifico, ed. G. Morolli, exhibition catalogue, Florence, Spedale degli Innocenti, Silvana Editoriale (Milan, 1992).

Arrighi, V., "Farnese, Girolama (Ieronima)," *Dizionario biografico degli Italiani*, Istituto della Enciclopedia Italiana, XLV (Rome, 1995), pp. 93–5.

Atchity, K., "Dante's *Purgatorio*: The Poem Reveals Itself," in *Italian Literature: Roots and Branches, Essays in Honor of Thomas Goddard Bergin*, ed. G. Rimanelli and K. J. Atchity, Yale University Press (New Haven and London, 1976), pp. 85–115.

At Home in Renaissance Italy, ed. M. Ajmar-Wollheim and F. Dennis, exhibition catalogue, London, Victoria and Albert Museum, V&A Publications (London, 2006).

Avery, C., *Donatello: Catalogo completo delle opere*, Cantini (Florence, 1991).

Bagemihl, R., "Francesco Botticini's Palmieri Altar-piece," *Burlington Magazine*, CXXXVIII (1996), pp. 308–14.

Baldini, U., and O. Casazza, *The Brancacci Chapel Frescoes*, trans. L. Hochroth and M. Grayson, Thames and Hudson (London, 1992).

Baldini Giusti, L., and F. Facchinetti Bottai, "Documento sulle prime fasi costruttive di Palazzo Pitti," in *Filippo Brunelleschi: la sua opera e il suo tempo*, Centro Di (Florence, 1980), II, pp. 703–31.

Barolini, T., "Re-presenting What God Presented: The Arachnean Art of Dante's Terrace of Pride," *Dante Studies*, CV (1987), pp. 43–62.

Barolsky, P., "Dante and the Modern Cult of the Artist," *Arion* (Fall 2004), pp. 1–15.

Barolsky, P., "The History of Italian Renaissance Art Re-envisioned," *Word and Image*, XII (1996), pp. 243–50.

Barolsky, P., "The Visionary Experience of Renaissance Art," *Word and Image*, XI (1995), pp. 174–81.

Baron, H., *The Crisis of the Early Italian Renaissance: Civic Humanism and Republican Liberty in an Age of Classicism and Tyranny*, rev. edn., Princeton University Press (Princeton, 1966).

Baron, H., *In Search of Florentine Civic Hu-*

manism: *Essays on the Transition from Medieval to Modern Thought*, 2 vols., Princeton University Press (Princeton, 1988).

Barriault, A., *"Spalliera" Paintings of Renaissance Tuscany: Fables of Poets for Patrician Homes*, Pennsylvania State University Press (University Park, Pa., 1994).

Bartoli, R., *Biagio d'Antonio*, Federico Motta (Milan, 1999).

Bartolomeo di Giovanni: Collaboratore di Ghirlandaio e Botticelli/Associate of Ghirlandaio and Botticelli, ed. N. Pons, exhibition catalogue, Florence, Museo di San Marco, Edizioni Polistampa (Florence, 2004).

Baskins, C., *Cassone Painting, Humanism, and Gender in Early Modern Italy*, Cambridge University Press (Cambridge and New York, 1998).

Baskins, C., "Corporeal Authority in the Speaking Picture: The Representation of Lucretia in Tuscan Domestic Painting," in *Gender Rhetorics: Postures of Dominance and Submission in History*, ed. R. Trexler, Medieval and Renaissance Texts and Studies (Binghamton, N. Y., 1994), pp. 187–200.

Baskins, C., "'La festa di Susanna': Virtue on Trial in Renaissance Sacred Drama and Painted Wedding Chests," *Art History*, XIV (1991), pp. 329–44.

Baskins, C., "Gender Trouble in Italian Renaissance Art History: Two Case Studies," *Studies in Iconography*, XVI (1994), pp. 1–36.

Baskins, C., "Griselda, or the Renaissance Bride Stripped Bare by her Bachelor in Tuscan *Cassone* Painting," *Stanford Italian Review*, X (1992), pp. 153–75.

Baskins, C., "Jacopo del Sellaio's 'Pietà' in S. Frediano," *Burlington Magazine*, CXXXI (1989), pp. 474–9.

Baskins, C., "Typology, Sexuality and the Renaissance Esther," in *Sexuality and Gender in Early Modern Europe: Institutions, Texts, Images*, ed. J. Turner, Cambridge University Press (Cambridge and New York, 1993), pp. 31–54.

Battistini, M., "Giovanni Chellini medico di S. Miniato," *Rivista di storia delle scienze mediche e naturali*, anno xviii, IX (1927), pp. 106–17.

Battle of the Nudes: Pollaiuolo's Renaissance Masterpiece, ed. S. R. Langdale, exhibition catalogue, Cleveland, Cleveland Museum of Art (Cleveland, 2002).

Baxandall, M., "Alberti and Cristoforo Landino: The Practical Criticism of Painting," in *Convegno internazionale indetto nel V centenario di Leon Battista Alberti (Rome–Mantova–Firenze 25–29 aprile 1972)*, Accademia dei Lincei (Rome, 1974), pp. 143–54.

Baxandall, M., *Giotto and the Orators: Humanist Observers of Painting in Italy and the Discovery of Pictorial Composition 1350–1450*, Clarendon Press (Oxford, 1971).

Baxandall, M., *Painting and Experience in Fifteenth Century Italy: A Primer in the Social History of Pictorial Style*, Clarendon Press (Oxford, 1972).

Baxendale, S. F., "Exile in Practice: The Alberti Family In and Out of Florence 1401–1428," *Renaissance Quarterly*, XLIV (1991), pp. 720–56.

Bec, C., *Les Livres des Florentins (1413–1608)*, Leo S. Olschki Editore (Florence, 1984).

Bec, C., *Les Marchands écrivains: Affaires et humanisme à Florence 1375–1434*, Mouton (Paris and The Hague, 1967).

Bec, C., "I mercanti scrittori, lettori e giudici di Dante," *Letture classensi*, XII (1983), pp. 99–111.

Bec, C., "Sur la lecture de Boccace à Florence," *Studi sul Boccaccio*, IX (1975–6), pp. 247–60.

Becker, M., "Aspects of Lay Piety in Early Renaissance Florence," in *Holiness in Late Medieval and Renaissance Florence*, ed. C. Trinkaus and H. A. Oberman, E. J. Brill (Leiden, 1974), pp. 177–99.

Becker, M., *Florence in Transition*, I: *The Decline of the Commune*, The Johns Hopkins University Press (Baltimore, 1967); II: *Studies in the Rise of the Territorial State*, The Johns Hopkins University Press (Baltimore, 1968).

Befani Canfield, G., "The Florentine Humanists' Concept of Architecture in the 1430s and Filippo Brunelleschi," in *Scritti di storia dell'arte in onore di Federico Zeri*, ed. M. Natale, 2 vols., Electa (Milan, 1984), 1, pp. 112–21.

Belting, H., *Bild und Kult: eine Geschichte des Bildes vor dem Zeitalter der Kunst*, C. H. Beck (Munich, 1990).

Belting, H., "Bild und Schatten: Dantes Bildtheorie im Wandel zur Kunsttheorie," in *Bild-anthropologie: Entwürfe für eine Bildwissenschaft*, Wilhelm Fink Verlag (Munich, 2001), pp. 189–212.

Belting, H., *Das Bild und sein Publikum im Mittelalter: Form und Funktion früher Bildtafeln der Passion*, Gebruder Mann (Berlin, 1981).

Belting, H., *Giovanni Bellini, Pietà: Ikone und Bilderzählung in der venezianischen Malerei*, Fischer Taschenbuch Verlag (Frankfurt am Main, 1985).

Belting, H., *Likeness and Presence: a History of the Image before the Era of Art*, trans. E. Jephcott, University of Chicago Press (Chicago, 1994).

Bennett, B., and D. Wilkins, *Donatello*, Phaidon (Oxford, 1984).

Bennett, J., "Stigmata and Sense Memory: St Francis and the Affective Image," *Art History*, XXIV (2001), pp. 1–16.

Berdini, P. "Women under the Gaze: A Renaissance Genealogy," *Art History*, XXI (1998), pp. 565–90.

Bergstein M., "Marian Politics in Quattrocento Florence: The Renewed Dedication of Santa Maria del Fiore in 1412," *Renaissance Quarterly*, XLIV (1991), pp. 673–719.

Bergstein, M., "The Sculpture of Nanni di Banco," Ph.D. thesis (Columbia University, 1987).

Bergstein, M., *The Sculpture of Nanni di Banco*, Princeton University Press (Princeton, 2000).

Bergstein, M., "La vita civica di Nanni di Banco," *Rivista d'arte*, series 4, III (1987), pp. 55–82.

Bernocchi, M., *Le monete della Repubblica fiorentina*, III, Leo S. Olschki Editore (Florence, 1976).

Berti, L., and R. Foggi, *Masaccio: Catalogo completo dei dipinti*, Cantini (Florence, 1989).

Bessi, R., "Il modello boccacciano nella spicciolata toscana tra fine Trecento e tardo Quattrocento," in *Dal primato allo scacco: I modelli narrativi italiani tra Trecento e Seicento*, ed. G. M. Anselmi, Carocci (Rome, 1998), pp. 107–23.

Beyer, A., and B. Boucher, eds., *Piero de' Medici "il Gottoso" (1416–1469): Kunst im Dienste der Mediceer/Art in the Service of the Medici*, Akademie Verlag (Berlin, 1993).

Biernoff, S., *Sight and Embodiment in the Middle Ages*, Palgrave Macmillan (Basingstoke and London, 2002).

Bigi, E., "Dante e la cultura fiorentina del Quattrocento," in *Forme e significati della "Divina commedia"*, Cappelli (Bologna, 1981), pp. 145–72.

Bizzocchi, R., *Chiesa e potere nella Toscana del Quattrocento*, Società editrice il Mulino (Bologna, 1987).

Blume, A., "Giovanni de' Bardi and Sandro Botticelli in Santo Spirito," *Jahrbuch der Berliner Museen*, XXXVII (1995), pp. 169–83.

Bober, P. P., and R. Rubinstein, *Renaissance Artists and Antique Sculpture*, Harvey Miller Publishers (London, 1986).

Bolzoni, L, *La rete delle immagini: Predicazione in volgare dalle origini a Bernadino da Siena*, Einaudi (Turin, 2002).

Bolzoni, L., *The Web of Images: Vernacular Preaching from its Origins to St Bernardino of Siena*, Ashgate (Aldershot and Burlington, 2004).

Borsook, E., "Art and Business in Renaissance Florence and Venice," in *Humanismus und Ökonomie: Mitteilung VIII der Kommission für Humanismusforschung*, Acta Humaniora der Verlag Chemie GmbH (Weinheim, 1983), pp. 135–55.

Borsook, E., "Documents for Filippo Strozzi's Chapel in Santa Maria Novella and other

Related Papers – I," *Burlington Magazine*, CXII (1970), pp. 737–45.

Borsook, E., "Documents for Filippo Strozzi's Chapel in Santa Maria Novella and other Related Papers – II: The Documents," *Burlington Magazine*, CXII (1970), pp. 800–4.

Borsook, E., "Documenti relativi alle cappelle di Lecceto e delle Selve di Filippo Strozzi," *Antichità viva*, IX.3 (1970), pp. 3–20.

Borsook, E., *The Mural Painters of Tuscany: From Cimabue to Andrea del Sarto*, Oxford University Press (Oxford, 1980).

Borsook, E., "Neri di Bicci, *Le Ricordanze* (10 Marzo 1453–24 Aprile 1475), ed. and annotated Bruno Santi," *Art Bulletin*, LXI (1979), pp. 313–18.

Borsook, E., "Two Letters Concerning Antonio Pollauiolo," *Burlington Magazine*, CXV (1973), pp. 464–8.

Borsook, E., and J. Offerhaus, *Francesco Sassetti and Ghirlandaio at Santa Trinita, Florence: History and Legend in a Renaissance Chapel*, Davaco Publishers (Doornspijk, 1981).

Borsook, E., and F. Superbi Gioffredi, eds., *Italian Altarpieces 1250–1550: Function and Design*, Clarendon Press (Oxford, 1994).

Boschetto, L., *Leon Battista Alberti e Firenze: biografia, storia, letteratura*, Leo S. Olschki Editore (Florence, 2000).

Boskovits, M., "Mariotto di Nardo e la formazione del linguaggio tardo-gotico a Firenze negli anni intorno al 1400," *Antichità viva*, VII.6 (1968), pp. 21–31.

Boskovits, M., *Pittura fiorentina alla vigilia del Rinascimento 1370–1400*, Edam (Florence, 1975).

Boskovits, M., "Sull'attività giovanile di Mariotto di Nardo," *Antichità viva*, VII.5 (1968), pp. 3–13.

Botticelli e Filippino: L'inquietudine e la grazia nella pittura fiorentina del Quattrocento, exhibition catalogue, Florence, Palazzo Strozzi, Skira (Milan, 2004).

Branca, V., *Boccaccio visualizzato: Narrare per parole e per immagini fra Medioevo e Rinascimento*, 3 vols., Einaudi (Turin, 1999).

Branca, V., *Tradizione della opere di Giovanni Boccaccio, II: Un secondo elenco di manoscritti e studi sul testo del "Decameron" con due appendici*, Edizioni di Storia e Letteratura (Rome, 1991).

Branca, V., P. Watson, and V. Kirkham, "Boccaccio visualizzato I," *Studi sul Boccaccio*, XV (1985–86), pp. 83–188.

Branca, V., S. Marcon, P. Watson, and V. Kirkham, "Boccaccio visualizzato II," *Studi sul Boccaccio*, XVI (1987), pp. 247–306.

Branca, V., S. Marcon, and C. Reynolds, "Boccaccio visualizzato III," *Studi sul Boccaccio*, XVII (1988), pp. 99–182.

Brieger, P., M. Meiss, and C. Singleton, *Illuminated Manuscripts of the Divine Comedy*, 2 vols., Princeton University Press (Princeton, 1969).

Briscoe, M. G., *Artes praedicandi*, and B. H. Jaye, *Artes orandi*, Brepols (Turnhout, 1992).

Brown, A., "Lorenzo de' Medici's New Men and their Mores: The Changing Lifestyle of Quattrocento Florence," *Renaissance Studies*, XVI (2002), pp. 113–42.

Brown, B. L., "Leonardo and the Tale of Three Villas: Poggio a Caiano, the Villa Tovaglia in Florence and Poggio Reale in Mantua," in *Firenze e la Toscana dei Medici nell'Europa del '500*, Leo S. Olschki Editore (Florence, 1983), III, pp. 1053–62.

Brown, B. L., "The Patronage and Building History of the Tribuna of SS. Annunziata in Florence: A Reappraisal in the Light of New Documentation," *Mitteilungen des Kunsthistorischen Institutes in Florenz*, XXV (1981), pp. 59–145.

Brown, D. A., *Leonardo da Vinci: Origins of a Genius*, Yale University Press (New Haven and London, 1998).

Brucker, G., "A Civic Debate on Florentine Higher Education (1460)," *Renaissance Quarterly*, XXXIV (1981), pp. 517–33.

Brucker, G., *The Civic World of Early Renaissance Florence*, Princeton University Press (Princeton, 1977).

Brucker, G., *Firenze nel rinascimento*, La Nuova Italia (Florence, 1980).

Brucker, G., "Florentine Voices from the Catasto, 1427–1480," *I Tatti Studies*, V (1993), pp. 11–32.

Brucker, G., *Giovanni and Lusanna: Love and Marriage in Renaissance Florence*, University of California Press (Berkeley and Los Angeles, 1986).

Brucker, G., *Living on the Edge in Leonardo's Florence: Selected Essays*, University of California Press (Berkeley, Los Angeles, and London, 2005).

Brucker, G., *Renaissance Florence*, John Wiley & Sons (New York, 1969).

Brucker, G., ed., *The Society of Renaissance Florence: A Documentary Study*, Harper & Row (New York, 1971).

Bruscoli, F. G., "Politica matrimoniale e matrimoni politici nella Firenze di Lorenzo de' Medici: uno studio del Ms. Notarile Antecosimiano 14099," *Archivio storico italiano*, CLV (1997), pp. 347–98.

Bryce, J., "Performing for Strangers: Women, Dance, and Music in Quattrocento Florence," *Renaissance Quarterly*, LIV (2001), pp. 1074–1107.

Buck, A., "Matteo Palmieri (1406–1475) als Repräsentat des Florentiner Bürgertums," *Archiv für Kulturgeschichte*, XLVII (1965), pp. 77–95.

Bulman, L., "Artistic Patronage at SS. Annunziata 1440–c.1520," Ph.D. thesis (University of London, Courtauld Institute, 1971).

Burckhardt, J., *Das Altarbild – Das Porträt in der Malerei – Die Sammler: Beiträge zur Kunstgeschichte in Italien*, in *Werke: Kritische Gesamtausgabe*, VI, C. H. Beck (Munich, 2000).

Burckhardt, J., *The Altarpiece in Renaissance Italy*, trans. P. Humfrey, Clarendon Press (Oxford, 1988).

Burckhardt, J., *L'arte italiana del Rinascimento: La pala d'altare; il ritratto*, ed. and trans. M. Ghelardi and S. Müller, Marsilio Editori (Venice, 1994).

Burckhardt, J., *The Civilization of the Renaissance in Italy*, trans. S. G. C. Middlemore, Phaidon Press (London, 1965).

Burke, J., *Changing Patrons: Social Identity and the Visual Arts in Renaissance Florence*, Pennsylvania State University Press (University Park, Pa., 2004).

Burke, J., "Form and Power: Patronage and the Visual Arts in Florence, c. 1480–1512," Ph.D. thesis (University of London, Courtauld Institute, 1999).

Burke, J., "Visualizing Neighborhood in Renaissance Florence: Santo Spirito and Santa Maria del Carmine," *Journal of Urban History*, XXXII (2006) pp. 693–710.

Burke, P., "L'artista: momenti e aspetti," in *Storia dell'arte italiana*, Part I, vol. II, Einaudi (Turin, 1979), pp. 85–113.

Butterfield, A., "Monument and Memory in Early Renaissance Florence," in *Art, Memory, and Family in Renaissance Florence*, ed. G. Ciappelli and P. Rubin, Cambridge University Press (Cambridge and New York, 2000), pp. 135–60.

Butterfield, A., *The Sculptures of Andrea del Verrocchio*, Yale University Press (New Haven and London, 1997).

Byam Shaw, J., *Drawings by Old Masters at Christ Church Oxford*, Clarendon Press (Oxford, 1976).

Cadogan, J., *Domenico Ghirlandaio: Artist and Artisan*, Yale University Press (New Haven and London, 2000).

Caglioti, F., *Donatello e i Medici: Storia del "David" e della "Giuditta"*, 2 vols., Leo S. Olschki Editore (Florence, 2000).

Caglioti, F., "Nouveautés sur la *Bataille de San Romano* de Paolo Uccello," *Revue du Louvre*, LI, no. 4 (2001), pp. 37–54.

Callmann, E., *Apollonio di Giovanni*, Oxford University Press (Oxford, 1974).

Callmann, E., "Apollonio di Giovanni and Painting for the Early Renaissance Room," *Antichità viva*, XXVII.3–4 (1988), pp. 5–17.

Callmann, E., "The Growing Threat to Marital Bliss as Seen in Fifteenth-Century Florentine Paintings," *Studies in Iconography*, V (1979), pp. 73–92.

Callmann, E., "Subjects from Boccaccio in Italian Painting, 1375–1525," *Studi sul Boccaccio*, XX (1995), pp. 19–78.

Camesasca, E., *Artisti in bottega*, Feltrinelli (Milan, 1966).

Campbell, C., "Revaluing Dress in History Paintings for Quattrocento Florence," in *Revaluing Renaissance Art*, ed. G. Neher and R. Shepherd, Ashgate (Aldershot, 2000), pp. 137–45.

Cantini Guidotti, G., *Orafi in Toscana tra XV e XVIII secolo: Storia di uomini, di cose e di parole*, 2 vols., L'Accademia (Florence, 1994).

Caplow, H., *Michelozzo*, 2 vols., Garland Publishing (New York and London, 1977).

Caplow, H., "Sculptors' Partnerships in Michelozzo's Florence," *Studies in the Renaissance*, XXI (1974), pp. 145–75.

Capretti, E., "La cappella e l'altare: evoluzione di un rapporto" and "La pinacoteca sacra," in *La chiesa e il convento di Santo Spirito a Firenze*, ed. C. Acidini Luchinat, Cassa di Risparmio (Florence, 1996), pp. 229–38, 239–301.

Cardile, P. J., "Fra Angelico and his Workshop at San Domenico (1420–1435): The Development of his Style and the Formation of his Workshop," Ph.D. thesis (Yale University, 1976).

Carl, D., "Zur Goldschmiedefamilie Dei mit neuen Dokumenten zu Antonio Pollaiuolo und Andrea Verrocchio," *Mitteilungen des Kunsthistorischen Institutes in Florenz*, XXVI (1982), pp. 129–66.

Carl, D., "Il ritratto commemorativo di Giotto di Benedetto da Maiano nel Duomo di Firenze," in *Santa Maria del Fiore: The Cathedral and its Sculpture: Acts of the International Symposium for the VII Centenary of the Cathedral of Florence*, ed. M. Haines, Edizioni Cadmo (Fiesole, 2001), pp. 129–47.

Carruthers, M., *The Book of Memory: A Study of Memory in Medieval Culture*, Cambridge University Press (Cambridge and New York, 1990).

Carruthers, M., *The Craft of Thought: Meditation, Rhetoric, and the Making of Images, 400–1200*, Cambridge University Press (Cambridge and New York, 1998).

Carruthers, M., "Moving Images in the Mind's Eye," in *The Mind's Eye: Art and Theological Argument in the Middle Ages*, ed. J. F. Hamburger and A.-M. Bouché, Princeton University Press (Princeton, 2006), pp. 287–306.

Cecchi, A., *Botticelli*, Federico Motta (Milan, 2005).

Cecchi, A., "Giuliano e Benedetto da Maiano ai servigi della Signoria fiorentina," in *Giuliano e la bottega dei da Maiano: Atti del Convegno Internazionale di Studi, Fiesole 13–15 giugno 1991*, ed. D. Lamberini, M. Lotti, and R. Lunardi, Octavo (Florence, 1994), pp. 148–57.

Chastel, A., *Art et humanisme à Florence au temps de Laurent le Magnifique: Etudes sur la Renaissance et l'humanisme platonicien*, Presses Universitaires de France (Paris, 1959).

Chastel, A., "Vasari et la légende médicéenne: l'école du jardin de Saint Marc," in *Studi vasariani*, Sansoni (Florence, 1950), pp. 159–67.

Cherubini, G., and G. Fanelli, eds., *Il Palazzo Medici Riccardi di Firenze*, Giunti (Florence, 1990).

Chiampi, J. T., "From Unlikeness to Writing: Dante's 'Visible Speech' in Canto Ten *Purgatorio*," *Medievalia*, VIII (1985), pp. 97–112.

Chiostrini Mannini, A., *I Davanzati: mercanti, banchieri, mecenati*, Centro Di (Florence, 1989).

Christiansen, K., *Gentile da Fabriano*, Chatto & Windus (London, 1982).

Ciappelli, G., "Biblioteche e lettura a Firenze nel Quattrocento: Alcune considerazioni," in *Libri, lettori e biblioteche dell'Italia medievale (secoli IX–XV): Fonti, testi, utilizzazione del libro: Atti della tavola rotonda italo-francesco (Roma 7–8 marzo)*, ed. G. Lombardi and D. Nebbiai dalla Guardia, ICCU (Rome, 2001), pp. 425–39.

Ciappelli, G., and P. Rubin, eds., *Art, Memory, and Family in Renaissance Florence*, Cambridge University Press (Cambridge and New York, 2000).

Ciasca, R., *L'arte dei Medici e Speziali nella*

storia e nel commercio fiorentino dal secolo XII al XV, Leo S. Olschki Editore (Florence, 1927).

Ciccuto, M., "Un'antica canzone di Giotto e i pittori di Boccaccio: Nascita dell'identità artistica," *Intersezioni*, XVI (1996), pp. 403–16.

Clark, D. L., "Optics for Preachers: The *De oculo morali* by Peter of Limoges," *Michigan Academician*, IX (1977), pp. 329–43.

Clarke, G., *Roman House – Renaissance Palaces: Inventing Antiquity in Fifteenth-Century Italy*, Cambridge University Press (Cambridge and New York, 2003).

Clark, K., *The Drawings by Sandro Botticelli for Dante's Divine Comedy*, Thames and Hudson (London, 1976).

Clark, K., *Leonardo da Vinci: An Account of his Development as an Artist*, Penguin Books (Harmondsworth, 1959).

Clark, K., and C. Pedretti, *Leonardo da Vinci Drawings at Windsor Castle*, 3 vols., Phaidon (London, 1968).

Clarke, P., *The Soderini and the Medici: Power and Patronage in Fifteenth-Century Florence*, Clarendon Press (Oxford, 1981).

Cohn, S. K., Jr., *The Cult of Remembrance and the Black Death: Six Renaissance Cities in Central Italy*, The Johns Hopkins University Press (Baltimore and London, 1992).

Cohn, S. K., Jr., *The Laboring Classes in Renaissance Florence*, Academic Press (New York, 1980).

Cohn, S. K., Jr., "La nuova storia sociale di Firenze," *Studi storici*, XXVI (1985), pp. 353–71.

Cohn, S. K, Jr., "Women in the Streets, Women in the Courts, in Early Renaissance Florence," in *Women in the Streets: Essays on Sex and Power in Renaissance Italy*, The Johns Hopkins University Press (Baltimore and London, 1996), pp. 16–38.

Collareta, M., "Testimonianze letterarie su Donatello 1450–1600," in *Omaggio a Donatello 1386–1986: Donatello e la storia del Museo*, ed. P. Barocchi, M. Collareta, G. Gaeta Bertelà, G. Gentilini, B. Paolozzi Strozzi, exhibition catalogue, Florence, Museo Nazionale del Bargello, S.P.E.S. (Florence, 1985), pp. 7–47.

Colosio, I., "Il B. Domenici come uomo, come scrittore e come maestro di vita spirituale specialmente religiosa," in *Giovanni Dominici saggi e inediti*, Memorie domenicane, n.s., I (1970), pp. 7–48.

Connell, W. J., ed., *Society and Individual in Renaissance Florence*, University of California Press (Berkeley, Los Angeles, and London, 2002).

Consorterie politiche e mutamenti istituzionali in età laurenziana, ed. M. A. M. Timpanaro, P. Manno Tolu, and P. Viti, exhibition catalogue, Florence, Archivio di Stato, Silvana Editoriale (Milan, 1992).

Constable, G., "Was there a Medieval Middle Class? *Mediocres* (*mediani, medii*) in the Middle Ages," in *Portraits of Medieval and Renaissance Living: Essays in Memory of David Herlihy*, ed. S. A. Epstein and S. K. Cohn, Jr., University of Michigan Press (Ann Arbor, 1996), pp. 301–23.

Conti, A., "L'evoluzione dell'artista," in *Storia dell'arte italiana*, Part I, vol. II, Einaudi (Turin, 1979), pp. 115–265.

Corti, G., "Consigli sulla mercatura di un anonimo trecentista," *Archivio storico italiano*, CX (1952), pp. 114–19.

Crabb, A. M., *The Strozzi of Florence: Widowhood and Family Solidarity in the Renaissance*, University of Michigan Press (Ann Arbor, 2000).

Crowe, J. A., and G. B. Cavalcaselle, *A History of Painting in Italy: Umbria, Florence and Siena from the Second to the Sixteenth Century*, ed. L. Douglas, Florentine Masters of the Fifteenth Century, IV, John Murray (London, 1911).

Cruttwell, M., *Antonio Pollaiuolo*, Duckworth & Co. (London, 1907).

Cruttwell, M., *Verrocchio*, Duckworth & Co. (London, 1904).

Dacos, N., A. Grote, A. Giuliano, D. Heikamp, and U. Pannuti, *Il tesoro di Lorenzo il Magnifico: Repertorio delle gemme e dei vasi*, Sansoni (Florence, 1980).

Dainelli, A., "Niccolò da Uzzano nella vita politica dei suoi tempi, I: Dalla giovinezza alla morte di Maso degli Albizzi," *Archivio storico italiano*, XC, series 7, vol. XVII (1932), pp. 35–86.

Dainelli, A., "Niccolò da Uzzano nella vita politica dei suoi tempi, II: Capo dell'oligarchia," *Archivio storico italiano*, XC, series 7, vol. XVII (1932), pp. 185–216.

Damisch, H., *The Origins of Perspective*, trans. J. Goodman, MIT Press (Cambridge, Mass., 1994).

Dante nel pensiero e nella esegesi dei secoli XIV e XV: Atti del III Congresso Nazionale di Studi danteschi, Melfi, 27 Settembre – 2 Ottobre 1970, Leo S. Olschki Editore (Florence, 1975).

D'Avray, D., *The Preaching of the Friars: Sermons Diffused from Paris before 1300*, Oxford University Press (Oxford, 1985).

Dean, T., and K. J. P. Lowe, eds., *Marriage in Italy 1300–1650*, Cambridge University Press (Cambridge, 1998).

Degrassi, D., *L'economia artigiana nell'Italia medievale*, La Nuova Italia Scientifica (Rome, 1996).

Delcorno, C., "Medieval Preaching in Italy (1200–1500)," in *The Sermon*, ed. B. M. Kienzle, Brepols (Turnhout, 2000), pp. 449–560.

De Marchi, A., *Gentile da Fabriano: Un viaggio nella pittura italiana alla fine del gotico*, Federico Motta (Milan, 1992).

De Marco, M., and A. Guidotti, "Spoglio ed elaborazione di dati documentari relativi a botteghe e luoghi di lavoro fiorentini," *Bollettino d'informazioni*, Centro di Elaborazione Automatica di Dati e Documenti Storico-Artistici, Scuola Normale Superiore di Pisa, VI (1985), pp. 169–213.

De Roover, R., *Il banco Medici dalle origini al declino (1397–1494)*, trans. G. Corti, La Nuova Italia (Florence, 1970).

De Roover, R., *The Rise and Decline of the Medici Bank, 1397–1494*, Harvard University Press (Cambridge, Mass., 1963).

De Vita, M., ed., *L'oratorio di Santa Caterina: Osservazioni storico-critiche in occasione del restauro*, Giampiero Pagnini (Florence, 1998).

Derbes, A., and M. Sandona, eds., *The Cambridge Companion to Giotto*, Cambridge University Press (Cambridge and New York, 2004).

Di Trocchio, F., "Chellini, Giovanni," in *Dizionario biografico degli Italiani*, XXIV, Istituto della Enciclopedia Italiana (Rome, 1980).

Didi-Huberman, G., *Fra Angelico: Dissemblance et figuration*, Flammarion (Paris, 1990).

Didi-Huberman, G., *Ouvrir Vénus: Nudité, rêve, cruauté*, Gallimard (Paris, 1999).

Dionisotti, C., "Dante nel Quattrocento," in *Atti del Congresso Internazionale di Studi Danteschi*, Sansoni (Florence, 1965), I, pp. 333–79.

Doren, A., *Le arti fiorentine*, trans. G. B. Klein, Felice Le Monnier (Florence, 1940).

Doren, A., *Studien aus der florentiner Wirtschaftsgeschichte*, II, *Das Florentiner Zunftwesen vom 14. bis zum 16. Jahrhundert*, J. G. Cotta'sche (Stuttgart and Berlin, 1908).

Dorini, U., *Il diritto penale e la delinquenza in Firenze nel XIV secolo*, D. Corsi (Lucca, 1923).

Draper, J., *Bertoldo di Giovanni, Sculptor of the Medici Household: Critical Reappraisal and Catalogue Raisonné*, University of Missouri Press (Columbia, Missouri and London, 1992).

The Drawings of Filippino Lippi and his Circle, ed. G. Goldner and C. Bambach, exhibition catalogue, New York, Metropolitan Museum of Art (New York, 1997).

Dreyer, P., "Botticelli's Series of Engravings 'of 1481'," *Print Quarterly*, I (1984), pp. 111–15.

Dreyer, P., *Dantes Divina Commedia mit den Illustrationen von Sandro Botticelli: Codex reg. lat. 1896, Codex Ham. 201 (Cim. 33)*, 2 vols., Belser (Zurich, 1986).

Eckstein, N., "Addressing Wealth in Renaissance Florence: Some New Soundings from the *Catasto* of 1427," *Journal of Urban History*, XXXII (2006), pp. 711–28.

Eckstein, N., *The District of the Green Dragon: Neighbourhood Life and Social Change in*

Renaissance Florence, Leo S. Olschki Editore (Florence, 1995).

Eckstein, N., "The Widows' Might: Women's Identity and Devotion in the Brancacci Chapel," *Oxford Art Journal*, XXVIII (2005), pp. 99–118.

Eckstein, N., ed., *The Brancacci Chapel: A Symposium on Form, Function and Setting*, Leo S. Olschki Editore (Florence, 2007).

Edgerton, S. Y., Jr., "Alberti's Colour: A Medieval Bottle without Renaissance Wine," *Journal of the Warburg and Courtauld Institutes*, XXXII (1969), pp. 109–34.

Edgerton, S. Y., Jr., "Alberti's Perspective: A New Discovery and a New Evaluation," *Art Bulletin*, XLVIII (1966), pp. 367–78.

Edgerton, S. Y., Jr., "*Mensurare temporalia facit Geometria spiritualis*: Some Fifteenth-Century Italian Notions about When and Where the Annunciation Happened," in *Studies in Late Medieval and Renaissance Painting in Honor of Millard Meiss*, ed. I. Lavin and J. Plummer, New York University Press (New York, 1977), I, pp. 115–30.

Edgerton, S. Y., Jr., *Pictures and Punishment: Art and Criminal Prosecution during the Florentine Renaissance*, Cornell University Press (Ithaca and London, 1985).

Edgerton, S. Y., Jr., *The Renaissance Discovery of Linear Perspective*, Basic Books (New York, 1975).

Eisenberg, M., *Lorenzo Monaco*, Princeton University Press (Princeton, 1989).

Elam, C., "Lorenzo de' Medici's Sculpture Garden," *Mitteilungen des Kunsthistorischen Institutes in Florenz*, XXXVI (1992), pp. 41–84.

Elkins, J., *The Poetics of Perspective*, Cornell University Press (Ithaca and London, 1994).

Emison, P., "The Word Made Naked in Pollaiuolo's *Battle of the Nudes*," *Art History*, XIII (1990), pp. 261–75.

Enciclopedia dantesca, 6 vols., Istituto della Enciclopedia Italiana (Rome, 1970–8).

Ettlinger, L. D., *Antonio and Piero del Pollaiuolo: Complete Edition with a Critical Catalogue*, Phaidon Press (Oxford and New York, 1978).

Fabbri, L., *Alleanza matrimoniale e patriziato nella Firenze del '400: Studio sulla famiglia Strozzi*, Leo S. Olschki Editore (Florence, 1991).

Fabroni, A., *Annotationes et monumenta ad Laurentii Medicis vitam pertinentia, Laurentii Magnifici Vita*, II, Jacobus Gratiolus (Pisa, 1784).

Fabroni, A., *Magni Cosmi Medicei vita*, Jacobus Gratiolus (Pisa, 1789).

Fahy, E., "The Tornabuoni–Albizzi Panels," in *Scritti di storia dell'arte in onore di Federico Zeri*, ed. M. Natale, Electa (Milan, 1984), I, pp. 233–47.

Farago, C., *Leonardo da Vinci's Paragone: A Critical Interpretation with a New Edition of the Text in the Codex Urbinas*, E. J. Brill (Leiden, 1991).

Farago, C., ed., *Biography and Early Art Criticism of Leonardo da Vinci*, 5 vols., Garland Publishing (New York and London, 1999).

Federici Vescovini, G., "Contributo per la storia della fortuna di Alhazen in Italia: Il volgarizzamento del ms. Vat. 4595 e il 'Commentario terzo' del Ghiberti," *Rinascimento*, series 2, V (1965), pp. 17–49.

Federici Vescovini, G., "Il problema delle fonti ottiche medievali del *commentario terzo* di Lorenzo Ghiberti," in *Lorenzo Ghiberti nel suo tempo: Atti del Convegno Internazionale di Studi (Firenze, 18–21 ottobre, 1978)*, Leo S. Olschki Editore (Florence, 1980), II, pp. 349–87.

Federici Vescovini, G., *Studi sulla prospettiva medievale*, Università di Torino, Pubblicazioni della Facoltà di Lettere e di Filosofia, XVI, fasc. 1 (Turin, 1965).

Federici Vescovini, G., "Vision et réalité dans la perspective au XIV^e siècle," *Micrologus*, V (1997), pp. 161–80.

Fehrenbach, F., *Licht und Wasser: zur Dynamik naturphilosophischer Leitbilder im Werk Leonardo da Vincis*, Wasmuth (Tübingen, 1997).

Fehrenbach, F., ed., *Leonardo da Vinci: Natur im Übergang: Beiträge zu Wissenschaft, Kunst und Technik*, Wilhelm Fink Verlag (Munich, 2002).

Ferino Pagden, S., "From Cult Images to the Cult of Images: The Case of Raphael's Altarpieces," in *The Altarpiece in the Renaissance*, ed. P. Humfrey and M. Kemp, Cambridge University Press (Cambridge and New York, 1990), pp. 165–89.

Ferrara, M., and F. Quinterio, *Michelozzo di Bartolomeo*, Salimbeni (Florence, 1984).

Field, A., "Cristoforo Landino's First Lectures on Dante," *Renaissance Quarterly*, XXXI (1986), pp. 16–48.

Field, J. V., R. Lunardi, and T.B. Settle, *The Perspective Scheme of Masaccio's Trinity Fresco*, Leo S. Olschki Editore (Florence, 1989).

Filippo Brunelleschi: la sua opera e il suo tempo: Atti del Convegno Internazionale di Studi (Firenze, 16–22 ottobre 1977), 2 vols., Centro Di (Florence, 1980).

Fiocco, G., "La biblioteca di Palla Strozzi," in *Studi di bibliografia e di storia in onore di T. de Marinis* (Verona, 1964), II, pp. 289–310.

Fiorelli Malesci, F., *La chiesa di Santa Felicita a Firenze*, Cassa di Risparmio (Florence, 1986).

Fiorilli, C., "I dipintori a Firenze nell'arte dei Medici, Speziali e Merciai," *Archivio storico italiano*, LXXVIII (1920), vol. II, pp. 5–74.

Foster, H., ed., *Vision and Visuality*, Bay Press (Seattle, 1988).

Fra Angelico, ed. L. Kanter and P. Palladino, exhibition catalogue, New York, Metropolitan Museum of Art (New York, 2005).

Franceschi, F., "Il linguaggio della memoria: Le deposizioni dei testimoni in un tribunale corporativo fiorentino fra XIV e XV secolo," in *La parola dell'accusato*, Sellerio (Palermo, 1991), pp. 213–32.

Franceschi, F., and G. Fossi, eds., *La grande storia dell'artigianato: arti fiorentine*, II: *Il Quattrocento*, Giunti (Florence, 1998).

Fraser Jenkins, A. D., "Cosimo de' Medici's Patronage of Architecture and the Theory of Magnificence," *Journal of the Warburg and Courtauld Institutes*, XXXIII (1970), pp. 162–70.

Fremantle, R., *Florentine Gothic Painters from Giotto to Masaccio: A Guide to Painting in and near Florence 1300 to 1450*, Secker & Warburg (London, 1975).

Freuler, G., "The Production and Trade of Late Gothic Pictures of the Madonna in Tuscany," in *Italian Panel Painting of the Duecento and Trecento: Studies in the History of Art*, ed. V. M. Schmidt, Center for Advanced Study in the Visual Arts, Symposium Papers, no. 38, National Gallery of Art (Washington, D. C., 2002), pp. 427–41.

Frick, C. C., "Dressing a Renaissance City: Society, Economics, and Gender in the Clothing of Fifteenth-century Florence," Ph.D. thesis (University of California at Los Angeles, 1995).

Frick, C. C., *Dressing Renaissance Florence: Families, Fortunes, and Fine Clothing*, The Johns Hopkins University Press (Baltimore and London, 2002).

Frosinini, C., "Un contributo all conoscenza della pittura tardogotica fiorentina: Bonaiuto di Giovanni," *Rivista d'arte*, XXXVII, series 4, I (1984), pp. 107–31.

Frosinini, C., "Gli esordi del Maestro di Signa: Dalla Bottega di Bicci di Lorenzo alle prime opere autonome," *Antichità viva*, XXIX.5 (1990), pp. 18–25.

Frosinini, C., "Il passaggio di gestione in una bottega pittorica fiorentina del primo Rinascimento: Lorenzo di Bicci e Bicci di Lorenzo," *Antichità viva*, XXV.1 (1986), pp. 5–15.

Frosinini, C., "Il passaggio di gestione in una bottega pittorica fiorentina del primo '400: Bicci di Lorenzo e Neri di Bicci (2)," *Antichità viva*, XXVI.1 (1987), pp. 5–14.

Frosinini, C., "Proposte per Giovanni dal Ponte e Neri di Bicci: Due affreschi funerari del Duomo di Firenze," *Mitteilungen des Kunsthistorischen Institutes in Florenz*, XXXIV (1990), pp. 123–38.

Frosinini, C., "Il trittico compagni," in *Scritti di storia dell'arte in onore di Roberto Salvini*, Sansoni (Florence, 1984), pp. 227–31.

Frugoni, C., "Female Mystics, Visions, and Iconography," in *Women and Religion in Medieval and Renaissance Italy*, ed. D. Born-

stein and R. Rusconi, The University of Chicago Press (Chicago and London, 1996), pp. 130–64.

Fusco, L., "The Nude as Protagonist: Pollaiuolo's Figural Style Explicated by Leonardo's Study of Static Anatomy, Movement, and Functional Anatomy," Ph.D. thesis (New York University, 1978).

Fusco, L., and G. Corti, *Lorenzo de' Medici, Collector and Antiquarian*, Cambridge University Press (Cambridge and New York, 2006).

Gadol, J., *Leon Battista Alberti: Universal Man of the Early Renaissance*, The University of Chicago Press (Chicago and London, 1969).

Gamurrini, E., *Istoria genealogica delle famiglie nobili toscane et umbre*, 5 vols., Stamperia di Francesco Onofri (Florence, 1668–85).

Gardner von Teuffel, C., "Clerics and Contracts: Fra Angelico, Neroccio, Ghirlandaio and Others: Legal Procedures and the Renaissance High Altarpiece in Central Italy," *Zeitschrift für Kunstgeschichte*, LXII (1999), pp. 190–208.

Gardner von Teuffel, C., *From Duccio's Maestà to Raphael's Transfiguration: Italian Altarpieces and their Settings*, The Pindar Press (London, 2005).

Gardner von Teuffel, C., "Lorenzo Monaco, Filippo Lippi und Filippo Brunelleschi: Die Erfindung der Renaissancepala," *Zeitschrift für Kunstgeschichte*, LXVI (1982), pp. 1–30.

Garfagnini, G. C., ed., *Lorenzo il Magnifico e il suo mondo: Convegno internazionale di studi (Firenze, 9–13 giugno 1992)*, Leo S. Olschki Editore (Florence, 1994).

Garin, E., "Dante nel Rinascimento," *Rinascimento*, series 2, VII (1967), pp. 3–28.

Gaston, R., "Liturgy and Patronage in San Lorenzo, Florence, 1350–1650," in *Patronage, Art, and Society in Renaissance Italy*, ed. F. W. Kent and P. Simons, Clarendon Press (Oxford, 1987), pp. 111–33.

Gatti, L., "Buonaccorso Pitti 'giocatore avventurato' e Niccolò di Betto Bardi 'micidiale della persona' (per gli esordi di Donatello),"

Annali della Scuola Normale Superiore di Pisa, 4th series, *Quaderni*, 1–2 (1996), pp. 95–106.

Gentile da Fabriano agli Uffizi, ed. A. Cecchi, Silvana Editoriale (Milan, 2005).

Gentile da Fabriano e l'altro Rinascimento, exhibition catalogue, ed. L. Laurati and L. Mochi Onori, Fabriano, Spedale di Santa Maria del Buon Gesù, Electa (Milan, 2006).

Gentile da Fabriano: Studi e ricerche, ed. A. De Marchi, L. Laureati, and L. Mochi Onori, Electa (Milan, 2006).

Il giardino di San Marco: Maestri e compagni del giovane Michelangelo, ed. P. Barocchi, exhibition catalogue, Florence, Casa Buonarroti, Silvana Editoriale (Milan, 1992).

Gilbert, C., "Antique Frameworks for Renaissance Art Theory: Alberti and Pino," *Marsyas*, III (1943–5), pp. 81–106.

Gilson, S., *Dante and Renaissance Florence*, Cambridge University Press (Cambridge and New York, 2005).

Gilson, S. A., *Medieval Optics and Theories of Light in the Works of Dante*, Edward Mellen Press (Lewiston, New York, 2000).

Ginori Lisci, L., *I palazzi di Firenze*, 2 vols., Cassa di Risparmio (Florence, 1972).

Giovanni Rucellai ed il suo Zibaldone, II: *A Florentine Patrician and his Palace*, ed. F. W. Kent et al., Warburg Institute (London, 1981).

Giovinezza di Michelangelo, ed. K. Weil-Garris Brandt, C. Acidini Luchinat, J. Draper, and N. Penny, exhibition catalogue, Palazzo Vecchio, Florence, Artificio Skira (Florence and Milan, 1999).

Goffen, R., "*Nostra conversatio in caelis est*: Observations on the *Sacra Conversazione* in the Trecento," *Art Bulletin*, LXI (1979), pp. 198–222.

Goldthwaite, R., *The Building of Renaissance Florence: An Economic and Social History*, The Johns Hopkins University Press (Baltimore and London, 1980).

Goldthwaite, R., "The Building of the Strozzi Palace: the Construction Industry in Renais-

sance Florence," *Studies in Medieval and Renaissance History*, X (1973), pp. 99–194.

Goldthwaite, R., "The Florentine Palace as Domestic Architecture," *American Historical Review*, LXXVII (1972), pp. 977–1012.

Goldthwaite, R., *Private Wealth in Renaissance Florence: A Study of Four Families*, Princeton University Press (Princeton, 1968).

Goldthwaite, R., ed., "Recent Trends in Renaissance Studies: Economic History," *Renaissance Quarterly*, XLII (1989), pp. 635–825.

Goldthwaite, R., *Wealth and the Demand for Art in Italy 1300–1600*, The Johns Hopkins University Press (Baltimore and London, 1993).

Gombrich, E., "A Classical Topos in the Introduction to Alberti's 'Della Pittura,' " *Journal of the Warburg and Courtauld Institutes*, XX (1957), p. 173.

Gombrich, E., "The Renaissance Conception of Artistic Progress and its Consequences," "Apollonio di Giovanni: A Florentine *Cassone* Workshop Seen through the Eyes of a Humanist Poet," "Renaissance and Golden Age," "The Early Medici as Patrons of Art," in *Norm and Form: Studies in the Art of the Renaissance*, Phaidon (London, 1966), pp. 1–10, 11–28, 29–34, 35–57.

Gombrich, E., "From the Revival of Letters to the Reform of the Arts: Niccolò Niccoli and Filippo Brunelleschi," in *The Heritage of Apelles*, Phaidon (London, 1976), pp. 93–110.

Gombrich, E., "The Sassetti Chapel Revisited: Santa Trinita and Lorenzo de' Medici," *I Tatti Studies*, VII (1997), pp. 11–35.

Gordon, D., *National Gallery Catalogues: The Fifteenth Century Italian Paintings, Volume I*, National Gallery Company (London, 2003).

Grafton, A., *Leon Battista Alberti: Master Builder of the Italian Renaissance*, Hill and Wang (New York, 2000).

Grafton, A., "*Historia* and *Istoria*: Alberti's Terminology in Context," *I Tatti Studies*, VIII (1999), pp. 37–68.

Grazzini, F., "Botticelli interprete di Boccaccio: Osservazioni sulla storia di Nastagio degli Onesti," in *Letteratura italiana e arti figurative*, ed. A. Franceschetti, Leo S. Olschki Editore (Florence, 1988), pp. 303–16.

Greenstein, J., "On Alberti's 'Sign': Vision and Composition in Quattrocento Painting," *Art Bulletin*, LXXIX (1997), pp. 669–98.

Gregori, M., and G. Rocchi, eds., *Il "Paradiso" in Pian di Ripoli: Studi e ricerche su un antico monastero*, Centro Di (Florence, 1985).

Gregory, H., "Daughters, Dowries and the Family in Fifteenth Century Florence," *Rinascimento*, series 2, XXVII (1987), pp. 215–37.

Gregory, H., "Palla Strozzi's Patronage and Pre-Medicean Florence," in *Patronage, Art, and Society in Renaissance Florence*, ed. F. W. Kent and P. Simons, Oxford University Press (Oxford, 1987), pp. 201–20.

Gregory, H., "The Return of the Native: Filippo Strozzi and Medicean Politics," *Renaissance Quarterly*, XXXVIII (1985), pp. 1–21.

Grieco, A., "Le Thème du coeur mangé: l'ordre, le sauvage et la sauvagerie," in *La Sociabilité à table: Commensalité et convivialité à travers les âges: Actes du Colloque de Rouen (14–17 novembre 1990)*, ed. M. Aurell, O. Dumoulin, and F. Thelamon, Publications de l'Université de Rouen, no. 178 (Rouen, 1993), pp. 20–8.

Guidi, G., "I sistemi elettorali agli uffici del Comune di Firenze nel primo Trecento: il sorgere della elezione per squittino (1300–1328)," *Archivio storico italiano*, CXXX (1972), pp. 345–407.

Guidotti, G. C. and A., "Proposte per una schedatura elettronica di fonti d'archivio utili per la storia delle arti: gli inventari di beni mobili," *Bollettino d'informazioni*, Centro di Elaborazione Automatica di Dati e Documenti Storico-Artistici, Scuola Normale Superiore di Pisa, IV (1983), pp. 95–143.

Hahn, C., "*Visio Dei*: Changes in Medieval Visuality," in *Visuality before and beyond the Renaissance*, ed. R. S. Nelson, Cambridge

University Press (Cambridge and New York, 2000), pp. 169–96.

Haines, M., "L'arte della Lana e l'Opera del Duomo a Firenze con un accenno a Ghiberti tra due istituzioni," in *Opera: Carattere e ruolo delle fabbriche cittadine fino all'inizio dell'Età Moderna, Atti della Tavola Rotonda, Villa I Tatti, Firenze, 3 aprile 1991*, ed. M. Haines and L. Riccetti, Leo S. Olschki Editore (Florence, 1996), pp. 267–94.

Haines, M., "Artisan Family Strategies: Proposals for Research on the Families of Florentine Artists," in *Art, Memory, and Family in Renaissance Florence*, ed. G. Ciappelli and P. Rubin, Cambridge University Press (Cambridge and New York, 2000), pp. 163–75.

Haines, M., "Giuliano da Maiano capofamiglia e imprenditore," in *Giuliano e la bottega dei da Maiano: Atti del Convegno Internazionale di Studi, Fiesole 13–15 giugno 1991*, ed. D. Lamberini, M. Lotti, and R. Lunardi, Octavo (Florence, 1994), pp. 131–42.

Haines, M., "Il mondo dello Scheggia: persone e luoghi di una carriera," in *Lo Scheggia*, ed. L. Bellosi and M. Haines, Maschietto & Musolino (Florence, 1999), pp. 7–33.

Hale, J., *Florence and the Medici: The Pattern of Control*, Thames and Hudson (London, 1977).

Hamburger, J. F., "Imagination and Believing: the Suspicion of Sight and the Authentification of Vision in Late Medieval Art and Devotion," in *Imagination und Wirklichkeit: Zum Verhältnis von mentalen und realen Bildern in der Kunst der frühen Neuzeit*, ed. K. Krüger, A. Nova, P. von Zabern (Mainz, 2000), pp. 48–68.

Hamburger, J. F., "The Place of Theology in Medieval Art History: Problems, Positions, Possibilities," and "The Medieval Work of Art: Wherein the 'Work'? Wherein the 'Art'?" in *The Mind's Eye: Art and Theological Argument in the Middle Ages*, ed. J. F. Hamburger and A.-M. Bouché, Princeton University Press (Princeton, 2006), pp. 11–31, 374–413.

Hamburger, J. F., *The Rothschild Canticles: Art and Mysticism in Flanders and the Rheinland circa 1300*, Yale University Press (New Haven and London, 1990).

Hamburger, J. F., *The Visual and the Visionary: Art and Female Spirituality in Late Medieval Germany*, Zone Books (New York, 1998).

Hankins, J., "The 'Baron Thesis' after Forty Years and some Recent Studies of Leonardo Bruni," *Journal of the History of Ideas*, LVI (1995), pp. 309–38.

Hankins, J., *Repertorium Brunianum: A Critical Guide to the Writings of Leonardo Bruni*, I, *Handlist of Manuscripts*, Istituto Storico Italiano per il Medio Evo, Fonti per la Storia dell'Italia Medievale (Rome, 1997).

Hatfield, R., "The Compagnia de' Magi," *Journal of the Warburg and Courtauld Institutes*, XXXIII (1961), pp. 107–61.

Hatfield, R., "The Funding of the Façade of Santa Maria Novella", *Journal of the Warburg and Courtauld Institutes*, LXVII (2004), pp. 81–128.

Hayum, A., "A Renaissance Audience Considered: The Nuns at S. Apollonia and Castagno's *Last Supper*," *Art Bulletin*, LXXXVIII (2006), pp. 243–67.

Henderson, J., *Piety and Charity in Late Medieval Florence*, Oxford University Press (Oxford, 1994).

Herlihy, D., and C. Klapisch, *Les Toscans et leurs familles: Une étude du catasto florentin de 1427*, Presses de la Fondation Nationale des Sciences Politiques (Paris, 1978).

Herzner, V., "Regesti donatelliani," *Rivista dell'Istituto Nazionale d'Archeologia e Storia dell'Arte*, series 3, II (1979), pp. 169–228.

Holmes, M., "Copying Practices and Marketing Strategies in a Fifteenth-Century Florentine Painter's Workshop," in *Artistic Exchange and Cultural Translation in the Italian Renaissance City*, ed. S. J. Campbell and S. J. Milner, Cambridge University Press (Cambridge and New York, 2004), pp. 38–74.

Holmes, M., "The Elusive Origins of the Cult of the Annunziata in Florence," in *The Miraculous Image in Late Medieval and*

Renaissance Culture, ed. E. Thunø and G. Wolf, Analecta Romana Instituti Danici, Supplementum XXXV (Rome, 2004), pp. 97–121.

Holmes, M., "'Frate Filippo di Tommaso Dipintore': Fra Filippo Lippi and Florentine Renaissance Religious Practices," Ph.D. thesis (Harvard University, 1993).

Holmes, M., *Fra Filippo Lippi: The Carmelite Painter*, Yale University Press (New Haven and London, 1999).

Holmes, M., "Giovanni Benci's Patronage of the Nunnery, Le Murate," in *Art, Memory, and Family in Renaissance Florence*, ed. G. Ciappelli and P. Rubin, Cambridge University Press (Cambridge, 2000), pp. 114–34.

Holmes, M., "Neri di Bicci and the Commodification of Artistic Values in Florentine Painting," in *The Art Market in Italy (15th–17th Centuries)*, ed. M. Fantoni, L. Matthew, and S. Matthews Grieco, Franco Cosimo Panini (Ferrara, 2003), pp. 213–23.

Hood, W., *Fra Angelico at San Marco*, Yale University Press (New Haven and London, 1993).

Horne, H. P., *Alessandro Filipepi commonly called Sandro Botticelli: Painter of Florence*, George Bell & Sons (London 1908; reprint, Princeton University Press, Princeton, 1980).

Horne, H. P., "Appendice di documenti su Giovanni dal Ponte," *Rivista d'arte*, VI (1906), pp. 169–81.

Horster, M., *Andrea del Castagno: Complete Edition with a Critical Catalogue*, Phaidon/Cornell University Press (Ithaca, 1980).

Howard, P., *Beyond the Written Word: Preaching and Theology in the Florence of Archbishop Antoninus 1427–1459*, Leo S. Olschki Editore (Florence, 1995).

Howard, P., "The Preacher and the Holy in Renaissance Florence," in *Models of Holiness in Medieval Sermons: Proceedings of the International Symposium (Kalamazoo, 4–7 May 1995)*, ed. B. M. Kienzle et al., Fédération Internationale des Instituts d'Etudes Médiévales (Louvain-la-Neuve, 1996), pp. 355–70.

Hughes, D., "Representing the Family: Portraits and Purposes in Early Modern Italy," *Journal of Interdisciplinary History*, XVII (Summer 1986), pp. 7–38.

Hughes, G., *Renaissance Cassoni: Masterpieces of Early Italian Art: Painted Marriage Chests 1400–1550*, Art Books International (London, 1997).

Humfrey, P., and M. Kemp, eds., *The Altarpiece in the Renaissance*, Cambridge University Press (Cambridge and New York, 1990).

Hyatte, R., "The 'Visual Sprits' and Body–Soul Mediation: Socratic Love in Marsilio Ficino's *De Amore*," *Rinascimento*, XXXIII (1993), pp. 213–22.

Ilardi, V., "Eyeglasses and Concave Lenses in Fifteenth-Century Florence and Milan: New Documents," *Renaissance Quarterly*, XXIX (1976), pp. 341–60.

Indrio, L., "Firenze nel Quattrocento: divisione e organizzazione del lavoro nelle botteghe," *Ricerche di storia dell'arte*, XXXVIII (1989), pp. 61–70.

Isella, D., "Gli 'exempla' del Canto X del 'Purgatorio,'" *Studi danteschi*, XLV (1968), pp. 147–56.

Italian Renaissance Sculpture in the Time of Donatello, exhibition catalogue, Detroit Institute of Arts, Founders Society (Detroit, 1985).

Iversen, M., "The Discourse of Perspective in the Twentieth Century: Panofksy, Damisch, Lacan," *Oxford Art Journal*, XXVIII (2005), pp. 191–202.

Jacks, P., and W. Caferro, *The Spinelli of Florence: Fortunes of a Renaissance Merchant Family*, Pennsylvania State University Press (University Park, Pa., 2001).

Jacobsen, W., *Die Maler von Florenz zu Beginn der Renaissance*, Deutscher Kunstverlag (Munich, 2001).

Jacobsen, W., "Soziale Hintergründe der florentiner Maler zu Beginn der Renaissance," in *L'Art et les révolutions*, section 3, *L'Art et les transformations sociales révolutionnaires*, *XXVIIe congrès international d'histoire de l'art (Strasbourg, 1989)*, Actes, Société Alsacienne

pour le Développement de l'Histoire de l'Art (Strasbourg, 1992), pp. 3–17.

Jacobson-Schutte, A., "'Trionfo delle donne': tematiche di rovesciamento dei ruoli nella Firenze del Rinascimento," *Quaderni storici*, XV (1980), pp. 474–96.

Joannides, P., *Masaccio and Masolino*, Phaidon (London, 1992).

John G. Johnson Collection: Catalogue of Italian Paintings, Johnson Collection (Philadelphia, 1966).

Johnson, G. A., "Beautiful Brides and Model Mothers: The Devotional and Talismanic Functions of Early Modern Marian Reliefs," in *The Material Culture of Sex, Procreation, and Marriage in Premodern Europe*, ed. A. L. McClanan and K. R. Encarnación, Palgrave (New York, 2002), pp. 135–62.

Johnson, G. A., "Family Values: Sculpture and the Family in Fifteenth-Century Florence," in *Art, Memory, and Family in Renaissance Florence*, ed. G. Ciappelli and P. Rubin, Cambridge University Press (Cambridge and New York, 2000), pp. 215–33.

Jones, R., "Documenti e precisazioni per Lorenzo Ghiberti, Palla Strozzi e la sagrestia di Santa Trinita," in *Lorenzo Ghiberti nel suo tempo: Atti del Convegno Internazionale di Studi (Firenze, 18–21 ottobre 1978)*, Leo S. Olschki Editore (Florence, 1980), II, pp. 507–21.

Jones, R., "Palla Strozzi e la sagrestia di Santa Trinita," *Rivista d'arte*, XXXVII, series 4, I (1984), pp. 9–106.

Kecks, R. G., *Madonna und Kind: Das häusliche Andachtsbild im Florenz des 15. Jahrhunderts*, Gebruder Mann (Berlin, 1988).

Kemp, M., *Leonardo*, Oxford University Press (Oxford, 2004).

Kemp, M., *Leonardo da Vinci: The Marvelous Works of Nature and Man*, Harvard University Press (Cambridge, Mass., 1981).

Kemp, M., "Leonardo and the Visual Pyramid," *Journal of the Warburg and Courtauld Institutes*, XL (1977), pp. 128–49.

Kemp, M., *The Science of Art: Optical Themes in Western Art from Brunelleschi to Seurat*, Yale University Press (New Haven and London, 1990).

Kennedy, C., E. Wilder, and P. Bacci, *The Unfinished Monument by Andrea del Verrocchio to the Cardinal Niccolò Forteguerri at Pistoia*, Smith College (Northampton, Mass., 1932).

Kent, D., *Cosimo de' Medici and the Florentine Renaissance: The Patron's Oeuvre*, Yale University Press (New Haven and London, 2000).

Kent, D., "The Florentine *Reggimento* in the Fifteenth Century," *Renaissance Quarterly*, XXVIII (1975), pp. 573–638.

Kent, D., *The Rise of the Medici: Faction in Florence 1426–1434*, Oxford University Press (Oxford, 1978).

Kent, D. and F. W., *Neighbours and Neighbourhood in Renaissance Florence: The District of the Red Lion in the Fifteenth Century*, J. J. Augustin (Locust Valley, N. Y., 1982).

Kent, D. and F. W., "Two Comments of March 1445 on the Medici Palace," *Burlington Magazine*, CXXI (1979), pp. 795–6.

Kent, F. W., "'Be Rather Loved than Feared,'" in *Society and Individual in Renaissance Florence*, ed. W. J. Connell, University of California Press (Berkeley, Los Angeles, and London, 2002), pp. 13–50.

Kent, F. W., "The Cederni Altar-piece by Neri di Bicci in Parma," *Mitteilungen des Kunsthistorischen Institutes in Florenz*, XXXIII (1989), pp. 378–9.

Kent, F. W., "Il ceto dirigente fiorentino e i vincoli di vicinanza nel Quattrocento," in *I ceti dirigenti nella Toscana del Quattrocento: Atti del V e VI Convegno: Firenze, 10–11 dicembre 1982; 2–3 dicembre 1983*, Francesco Papafava (Florence, 1987), pp. 63–78.

Kent, F. W., *Household and Lineage in Renaissance Florence: The Family Life of the Capponi, Ginori, and Rucellai*, Princeton University Press (Princeton, 1977).

Kent, F. W., "Individuals and Families as Patrons of Culture in Quattrocento Florence," in *Language and Images of Renais-*

sance Italy, ed. A. Brown, Oxford University Press (Oxford, 1995), pp. 171–92.

Kent, F. W., *Lorenzo de' Medici and the Art of Magnificence*, The Johns Hopkins University Press (Baltimore and London, 2004).

Kent, F. W., "Palaces, Politics and Society in Fifteenth-Century Florence," *I Tatti Studies*, II (1989), pp. 41–70.

Kent, F. W., "'Un paradiso habitato da diavoli': Ties of Loyalty and Patronage in the Society of Medicean Florence," in *Le radici cristiane di Firenze*, ed. A. Benvenuti, F. Cardini, E. Giannarelli, Alinea (Florence, 1994), pp. 183–210.

Kent, F. W., "'Più superba di quello di Lorenzo': Courtly and Family Interest in the Building of Filippo Strozzi's Palace," *Renaissance Quarterly*, XXX (1977), pp. 311–23.

Kent, F. W., and P. Simons, eds., *Patronage, Art and Society in Renaissance Italy*, Oxford University Press (Oxford, 1987).

Kessler, H., "Turning a Blind Eye: Medieval Art and the Dynamics of Contemplation," in *The Mind's Eye: Art and Theological Argument in the Middle Ages*, ed. J. F. Hamburger and A.-M. Bouché, Princeton University Press (Princeton, 2006), pp. 413–40.

Kienzle, B. M., ed., *The Sermon*, Brepols (Turnhout, 2000).

Kienzle, B. M., "The Typology of the Medieval Sermon and its Development in the Middle Ages: Report on Work in Progress," in *De l'homélie au sermon: Histoire de la Prédication Médiévale; Actes de colloque international de Louvain-la-Neuve (9–11 juillet 1992)*, ed. J. Hamesse and X. Hermand, Institut d'Etudes Médiévales de l'Université (Louvain-la-Neuve, 1993), pp. 83–102.

Kirkham, V., "J.M. Ricketts, *Visualizing Boccaccio: Studies on Illustrations of* The Decameron *from Giotto to Pasolini*," *Renaissance Quarterly*, LI (1998), pp. 1352–3.

Kirshner, J., "Pursuing Honor while Avoiding Sin: The *Monti delle doti* of Florence," *Studi senesi*, LXXXIX (1977), pp. 177–258 (also published by A. Giuffrè [Milan, 1978]).

Kirshner, J., and A. Molho, "The Dowry Fund and the Marriage Market in Early Quattrocento Florence," *Journal of Modern History*, L (1978), pp. 403–38.

Klapisch-Zuber, C., "Les Coffres de mariage et les plateaux d'accouchée à Florence: Archive, ethnologie, iconographie," in *A travers l'image: Lecture iconographique et sens de l'oeuvre: Actes du Séminaire CNRS (G.D.R. 712) (Paris, 1991)*, ed. S. Deswarte-Rosa, Klincksieck (Paris, 1994), pp. 309–23.

Klapisch-Zuber, C., "Le dernier enfant: fécondité et vieillissement chez les Florentines XIVᵉ–XVᵉ siècles," in *Mélanges offerts à Jacques Dupâquier*, Presses Universitaires de France (Paris, 1993), pp. 277–90.

Klapisch-Zuber, C., "Famille, religion et sexualité à Florence au moyen âge," *Revue de l'histoire des religions*, CXXIX.4 (1992), pp. 381–92.

Klapisch-Zuber, C., "La Femme et le lignage florentin (XIVᵉ–XVIᵉ siècles)," in *Persons in Groups: Social Behavior as Identity Formation in Medieval and Renaissance Europe: Papers of the Sixteenth Annual Conference of the Center for Medieval and Early Renaissance Studies*, ed. R. Trexler, Medieval and Renaissance Texts and Studies (Binghamton, N.Y., 1985), pp. 141–53.

Klapisch-Zuber, C., "Les Femmes dans les rituels de l'alliances et de la naissance à Florence," in *Riti e rituali nelle società medievali*, ed. J. Chiffoleau, L. Martines, and A. Paravicini Bagliani, Centro Italiano di Studi sull'Alto Medioevo (Spoleto, 1994), pp. 3–22.

Klapisch-Zuber, C., "Les Généalogies florentines du XIVᵉ et du XVᵉ siècle," in *Le Modèle familial européen: normes, déviances, contrôle du pouvoir: Actes des séminaires organisés par l'Ecole Française de Rome et l'Università di Roma (1984)*, Ecole Française de Rome (Rome, 1986), pp. 101–31.

Klapisch-Zuber, C., "Les Noces Feintes – Sur quelques lectures de deux thèmes iconographiques dans le *cassoni* florentins," *I Tatti Studies*, VI (1995), pp. 11–30.

Klapisch-Zuber, K., "Les Noces florentines et

leurs cuisiniers," in *La Socialité à table: Commensabilité et convivialité à travers les âges: Actes du Colloque de Rouen (14–17 novembre 1990)*, ed. M. Aurell, O. Dumoulin, and F. Thelamon, Publications de l'Université de Rouen, no. 178 (Rouen, 1993), pp. 193–9.

Klapisch-Zuber, C., "Un salario o l'onore: come valutare le donne fiorentine del XIV–XV secolo," *Quaderni storici*, LXXIX (1992), pp. 41–9.

Klapisch-Zuber, C., *Women, Family, and Ritual in Renaissance Italy*, trans. L. Cochrane, University of Chicago Press (Chicago and London, 1987).

Klapisch-Zuber, "Le 'zane' della sposa: La fiorentina e il suo corredo nel Rinascimento," *Memoria*, XI–XII.2–3 (1984), pp. 12–23.

Kohler, J., and G. degli Azzi, *Das florentiner Strafrecht des XIV Jahrhunderts*, J. Bensheimer (Mannheim and Leipzig, 1909).

Korman, S., "'Danthe Alighieri poeta fiorentina': Cultural Values in the 1481 *Divine Comedy*," in *Revaluing Renaissance Art*, ed. G. Neher and R. Shepherd, Ashgate (Aldershot and Brookfield, Vt., 2000), pp. 57–65.

Korman, S., "Envisioning Narrative: Botticelli's Illustrations for Dante's *Paradiso*," Ph.D. thesis (Courtauld Institute of Art 1999).

Kosegarten, A., "The Origins of Artistic Competition in Italy (Forms of Competition between Artists before the Contest for the Florentine Baptistery Doors Won by Ghiberti in 1401)," in *Lorenzo Ghiberti nel suo tempo: Atti del Convegno Internazionale di Studi (Firenze, 18–21 ottobre 1978)*, Leo S. Olschki Editore (Florence, 1980), I, pp. 167–86.

Krautheimer, R., *Lorenzo Ghiberti*, 2 vols., Princeton University Press (Princeton, 1970).

Kress, S., "Die *camera di Lorenzo, bella* im Palazzo Tornabuoni: Rekonstruktion und künstlerische Ausstatung eines Florentiner Hochzeitszimmer des späten Quattrocento," in *Domenico Ghirlandaio: Künstlerische Konstruktion von Identität im Florenz der Renaissance*, ed. M. Rohlmann, Verlag

und Datenbank für Geisteswissenschaften (Weimar, 2003), pp. 245–85.

Kristeller, P. O., "The Modern System of the Arts," in *Renaissance Thought and the Arts*, Princeton University Press (Princeton, 1980), pp. 163–227.

Kubovy, M., *The Psychology of Perspective and Renaissance Art*, Cambridge University Press (Cambridge and New York, 1986).

Kuehn, T., "Reading between the Patrilines: Leon Battista Alberti's *Della Famiglia* in Light of His Illegitimacy," and "Women, Marriage, and *Patria Potestas* in Late Medieval Florence," in *Law, Family, and Women: Toward a Legal Anthropology of Renaissance Italy*, The University of Chicago Press (Chicago and London, 1991), pp. 157–75, 197–212.

Kuehn, T., "Reading Microhistory: The Example of *Giovanni and Lusanna*," *Journal of Modern History*, LXI (1989), pp. 512–34.

Ladis, A., *The Brancacci Chapel Florence*, George Braziller (New York, 1993).

Ladis, A., "Immortal Queen and Mortal Bride: The Marian Imagery of Ambrogio Lorenzetti's Cycle at Montesiepi," *Gazette des Beaux-Arts*, CXIX (1992), pp. 189–200.

Langdale, A., "Aspects of the Critical Reception and Intellectual History of Baxandall's Concept of the Period Eye," *Art History*, XXI (1998), pp. 479–97.

Lanza, A., *Polemiche e berte letterarie nella Firenze del primo Quattrocento: Storia e testi*, Bulzoni editore (Rome, 1971).

Larner, J., *Culture and Society in Italy 1290–1420*, B. T. Batsford (London, 1971).

Lentes, T., "'As far as the eye can see …': Rituals of Gazing in the Late Middle Ages," in *The Mind's Eye: Art and Theological Argument in the Middle Ages*, ed. J. Hamburger and A.-M. Bouché, Princeton University Press (Princeton, 2006), pp. 360–73.

Lentzen, M., *Studien zur Dante-Exegese Cristoforo Landinos: Mit einem Anhang bisher unveröffentlicher Briefe und Reden*, Böhlau Verlag (Cologne and Vienna, 1971).

Leon Battista Alberti, ed. J. Rykwert and A.

Engel, exhibition catalogue, Mantua, Palazzo del Te, Olivetti/Electa (Milan, 1994).

Leonardo da Vinci: Master Draftsman, ed. C. C. Bambach, exhibition catalogue, New York, Metropolitan Museum of Art, Yale University Press (New Haven and London, 2003).

Lerner-Lehmkuhl, H., *Zur Struktur und Geschichte des florentinischen Kunstmarktes im 15. Jahrhundert*, Karl Busch (Wattenscheid, 1936).

Lesnick, D., "Civic Preaching in the Early Renaissance: Giovanni Dominici's Florentine Sermons," in *Christianity and the Renaissance: Image and Religious Imagination in the Quattrocento*, ed. T. Verdon and J. Henderson, Syracuse University Press (Syracuse, 1990), pp. 208–25.

Lesnick, D., *Preaching in Medieval Florence: The Social World of Franciscan and Dominican Spirituality*, University of Georgia Press (Athens, Georgia and London, 1989).

Lightbown, R., *Donatello and Michelozzo*, 2 vols., Harvey Miller (London, 1980).

Lightbown, R., "Giovanni Chellini, Donatello, and Antonio Rossellino," *Burlington Magazine*, CIV (1962), pp. 102–4.

Lightbown, R., *Sandro Botticelli*, 2 vols., Paul Elek (London, 1978).

Lillie, A., *Florentine Villas in the Fifteenth Century: An Architectural and Social History*, Cambridge University Press (Cambridge and New York, 2005).

Lillie, A., "The Palazzo Strozzi and Private Patronage in Fifteenth-Century Florence," in *The Renaissance from Brunelleschi to Michelangelo: The Representation of Architecture*, ed. H. A. Millon and V. M. Lampugnani, Thames and Hudson (London, 1994), pp. 518–21.

Lindberg, D. C., *Theories of Vision from Al-Kindi to Kepler*, The Chicago University Press (Chicago, 1976).

Lindow, J., "Splendour," in *At Home in Renaissance Italy*, ed. M. Ajmar-Wollheim and F. Dennis, exhibition catalogue, London, Victoria and Albert Museum, V&A Publications (London, 2006), pp. 306–7.

Litta, P., et al., *Celebri famiglie italiane*, 15 vols., imprint varies (Milan, 1819–1902).

L'oreficeria nella Firenze del Quattrocento, ed. M. Grazia Ciardi Duprè dal Poggetto et al., exhibition catalogue, Florence, Chiostri di Santa Maria Novella, S.P.E.S. (Florence, 1977).

Lorenzo dopo Lorenzo: La fortuna storica di Lorenzo il Magnifico, ed. P. Pirolo, exhibition catalogue, Florence, Biblioteca Nazionale, Silvana Editoriale (Milan, 1992).

Lorenzo Ghiberti nel suo tempo: Atti del Convegno Internazionale di Studi (Firenze, 18–21 ottobre 1978), 2 vols., Leo S. Olschki Editore (Florence, 1980).

Lorenzo Ghiberti "materia e ragionamenti", exhibition catalogue, Florence, Museo dell'Accademia and Museo di San Marco, Centro Di (Florence, 1978).

Lorenzo Monaco: Dalla tradizione giottesca al Rinascimento, exhibition catalogue, ed. A. Tartuferi and D. Parenti, Florence, Galleria dell'Accademia, Giunti (Florence, 2006).

Loughman, T., "Commissioning Familial Remembrance: Alberti Patronage at Santa Croce, Florence, 1304–c.1390," in *The Patron's Payoff: Economic Frameworks for Conspicuous Commissions in Renaissance Italy,*, ed. J. K. Nelson and R. Zeckhauser, Princeton University Press (Princeton, forthcoming).

Loughman, T., "Spinello Aretino, Benedetto Alberti, and the Olivetans: Late Trecento Patronage at San Miniato al Monte, Florence," Ph.D. thesis (Rutgers University, 2003).

Luchs, A., *Cestello: A Cistercian Church of the Florentine Renaissance*, Garland Publishing (New York and London).

L'uomo del Rinascimento: Leon Battista Alberti e le arti a Firenze tra ragione e bellezza, ed. C. Acidini and G. Morolli, exhibition catalogue, Florence, Palazzo Strozzi, Mandragora /maschietto editore (Florence, 2006).

Luzzati, M., "Bini, Bernardo," *Dizionario biografico degli Italiani*, Istituto della Enciclopedia Italiana (Rome, 1966), X, pp. 503–6.

Luzzati, M., "Capponi, Neri," *Dizionario biografico degli Italiani*, Istituto della Enciclopedia Italiana (Rome, 1976), XIX, pp. 75–8.

Lydecker, K., "The Domestic Setting of the Arts in Renaissance Florence," Ph.D. thesis (The Johns Hopkins University, 1987).

Lydecker, K., "Il patriziato fiorentino e la committenza artistica per la casa," in *I ceti dirigenti nella Toscana del Quattrocento: Atti del V e VI Convegno: Firenze, 10–11 dicembre 1982; 2–3 dicembre 1983*, Francesco Papafava (Florence, 1987), pp. 209–21.

Maestri e botteghe: Pittura a Firenze alla fine del Quattrocento, ed. M. Gregori, A. Paolucci, and C. Acidini Luchinat, exhibition catalogue, Florence, Palazzo Strozzi, Silvana Editoriale (Milan, 1992).

Mallett, M., and N. Mann, eds., *Lorenzo the Magnificent: Culture and Politics*, The Warburg Institute (London, 1996).

Mancini, G., "Il bel S. Giovanni e le feste patronali di Firenze descritte nel 1475 da Piero Cennini," *Rivista d'arte*, VI (1909), pp. 185–227.

Mancini, G., "Il testamento di L. B. Alberti," *Archivio storico italiano*, LXXII (1914), vol. II, pp. 20–52.

Mancini, G., *Vita di Leon Battista Alberti*, 2nd edn., G. Carnesecchi e figli (Florence, 1911).

Marani, P., *Leonardo da Vinci: The Complete Paintings*, Harry N. Abrams Inc. (New York, 2003).

Marchand, E., "Monastic *Imitatio Christi*: Andrea del Castagno's *Cenacolo di S. Apollonia*," *Artibus et historiae*, XLVII (2003), pp. 31–50.

Markowsky, B., "Eine Gruppe bemalter Paliotti in Florenz," *Mitteilungen des Kunsthistorischen Institutes in Florenz*, XVII (1973), pp. 105–40.

Marmor, M., "The Prophetic Dream in Leonardo and in Dante," *Raccolta Vinciana*, XXXI (2005), pp. 145–80.

Marsh, D., "Boccaccio in the Quattrocento: Manetti's *Dialogus in symposio*," *Renaissance Quarterly*, XXXIII (1980), pp. 337–50.

Martines, L., *An Italian Renaissance Sextet: Six Tales in Historical Context*, Marsilio (New York, 1994).

Martines, L., *Lawyers and Statecraft in Renaissance Florence*, Princeton University Press (Princeton, 1968).

Martines, L., "The Renaissance and the Birth of Consumer Society," *Renaissance Quarterly*, LI (1998), pp. 193–203.

Martines, L., *The Social World of the Florentine Humanists, 1390–1460*, Princeton University Press (Princeton, 1963).

Mather, R. G., "Documents on Florentine Painters and Sculptors of the Fifteenth Century," *Art Bulletin*, XXX (1948), pp. 20–65.

Mather, R. G., "Donatello debitore oltre la tomba," *Rivista d'arte*, XIX, series 2, IX (1937), pp. 181–92.

Mauss, M., *The Gift: The Form and Reason for Exchange in Archaic Societies*, trans. W. D. Halls, Routledge (London, 1993).

Mazzi, S., *Prostitute e lenoni nella Firenze del Quattrocento*, Il Saggiatore, Mondadori (Milan, 1991).

McGovern, J. F., "The Rise of New Economic Attitudes – Economic Humanism, Economic Nationalism – During the Latter Middle Ages and the Renaissance, A.D. 1200– 1550," *Traditio*, XXVI (1970), pp. 217–53.

McNair, B. G., "Cristoforo Landino's *De anima* and his Platonic Sources," *Rinascimento*, series 2, XXXII (1992), pp. 227–45.

Messeri, A., "Matteo Palmieri: cittadino di Firenze nel secolo XV," *Archivio storico italiano*, series 5, XIII (1894), pp. 256–340.

Miccoli, G., "Agli, Pellegrino," *Dizionario biografico degli Italiani*, Istituto della Enciclopedia Italiana (Rome, 1960), I, pp. 401–2.

Migiel, M., "Between Art and Theology: Dante's Representation of Humility," *Stanford Italian Review*, V (1985), pp. 141–60.

Milner, S., "The Politics of Patronage: Verrocchio, Pollaiuolo, and the Forteguerri Monument," in *Artistic Exchange and Cultural Translation in the Italian Renaissance City*, ed. S. J. Campbell and S. J. Milner, Cambridge

University Press (Cambridge, 2004), pp. 221–45.

Miziolek, J., *Soggetti classici sui cassoni fiorentini alla vigilia del Rinascimento*, Instytut Sztuki Polskiej Akademii Nauk (Warsaw, 1996).

Molho, A., "The Brancacci Chapel: Studies in its Iconography and History," *Journal of the Warburg and Courtauld Institutes*, XL (1977), pp. 50–98.

Molho, A., "Cosimo de' Medici: *Pater Patriae* or *Padrino?*" *Stanford Italian Review* (Spring 1979), pp. 5–33.

Molho, A., *Florentine Public Finances in the Early Renaissance, 1400–1433*, Harvard University Press (Cambridge, Mass., 1971).

Molho, A., *Marriage Alliance in Late Medieval Florence*, Harvard University Press (Cambridge, Mass., 1994).

Molho, A., "Il padronato a Firenze nella storiografia anglofona," *Ricerche storiche*, XV (1985), pp. 5–16.

Molho, A., "Politics and the Ruling Class in Early Renaissance Florence," *Nuova rivista storica*, XLII (1968), pp. 401–20.

Muessig, C., ed., *Preacher, Sermon and Audience in the Middle Ages*, Brill (Leiden, Boston, Cologne, 2002).

Muir, E., "The Italian Renaissance in America," *The American Historical Review*, C, no. 4 (1995), pp. 1095–1118.

Murphy, K. J. F., "Piazza Santa Trinita in Florence 1427–98," Ph.D. thesis (University of London, Courtauld Institute, 1992).

Musacchio, J., *The Art and Ritual of Childbirth in Renaissance Italy*, Yale University Press (New Haven and London, 1999).

Musacchio, J., "Imaginative Conceptions in Renaissance Italy," in *Picturing Women in Renaissance and Baroque Italy*, ed. G. A. Johnson and S. Matthews Grieco, Cambridge University Press (Cambridge and New York, 1997), pp. 42–60.

Nagel, A., *Michelangelo and the Reform of Art*, Cambridge University Press (Cambridge and New York, 2000).

Najemy, J., *Corporatism and Consensus in Florentine Electoral Politics 1280–1400*, University of North Carolina Press (Chapel Hill, 1982).

Najemy, J., "Giannozzo and his Elders," in *Society and Individual in Renaissance Florence*, ed. W. J. Connell, University of California Press (Berkeley, Los Angeles, and London, 2002), pp. 51–78.

Najemy, J., "Hans Baron, In Search of Florentine Civic Humanism: Essays on the Transition from Medieval to Modern Thought," *Renaissance Quarterly*, XLV (1992), pp. 340–51.

Najemy, J., "Linguaggi storiografici sulla Firenze rinascimentale," *Rivista storica italiana*, XCVII (1985), pp. 102–59.

Nel segno di Masaccio: L'invenzione della prospettiva, ed. F. Camerota, exhibition catalogue, Florence, Uffizi, Ministero per i Beni e le Attività Culturali (Florence, 2001).

Nelson, J. K., and R. Zeckhauser, eds., *The Patron's Payoff: Economic Frameworks for Conspicuous Commissions in Renaissance Italy*, Princeton University Press (Princeton, 2007).

Nelson, R. S., ed., *Visuality before and beyond the Renaissance*, Cambridge University Press (Cambridge and New York, 2000).

Newbigin, N., *Feste d'Oltrarno: Plays in Churches in Fifteenth-Century Florence*, 2 vols., Leo S. Olschki Editore (Florence, 1996).

Niccolini di Camugliano, G., *The Chronicles of a Florentine Family 1200–1470*, Jonathan Cape (London, 1933).

Nirit Debby, B., "The Preacher as Goldsmith: The Italian Preachers' Use of the Visual Arts," in *Preacher, Sermon and Audience in the Middle Ages*, ed. C. Muessig, Brill (Leiden, Boston, Cologne, 2002), pp. 127–54.

Nirit Debby, B., *Renaissance Florence in the Rhetoric of Two Popular Preachers: Giovanni Dominici (1380–1419) and Bernardino da Siena (1380–1444)*, Late Medieval and Early Modern Studies, Brepols (Turnhout, 2001).

Nygren, B., "Fra Angelico's San Marco Altar-piece and the Metaphors of Perspective," *Source*, XXII (2003), pp. 25–32.

Olin, M., "Gaze," in *Critical Terms for Art History*, ed. R. S. Nelson and R. Shiff, Chicago University Press (Chicago, 1996), pp. 208–19.

Olsen, C., "Gross Expenditure: Botticelli's Nastagio degli Onesti Panels," *Art History*, XV (1992), pp. 146–70.

Olson, R. J. M., *The Florentine Tondo*, Oxford University Press (Oxford and New York, 2000).

O'Malley, M., *The Business of Art: Contracts and the Commissioning Process in Renaissance Italy*, Yale University Press (New Haven and London, 2005).

O'Malley, M., "Late Fifteenth- and Early Sixteenth-Century Painting Contracts and the Stipulated Use of the Painter's Hand," in *With and Without the Medici: Studies in Tuscan Art and Patronage 1434–1530*, ed. E. Marchand and A. Wright, Ashgate (Aldershot and Brookfield, Vt., 1998), pp. 155–78.

O'Malley, M., "Memorizing the New: Using Recent Works as Models in Italian Renaissance Commissions," in *Memory and Oblivion: Proceedings of the XXIXth Congress in the History of Art held in Amsterdam, 1–7 September 1996*, ed. W. Reinink and J. Stumpel, Kluwer Academic Publishers (Dordrecht, 1999), pp. 803–10.

Origo, I., *Il mercante di Prato*, trans. N. Ruffini, Biblioteca Universale Rizzoli (Milan, 1988).

Orlandi, S., *Beato Angelico: monografia storica della vita e delle opere con un'appendice di nuovi documenti inediti*, Leo S. Olschki Editore (Florence, 1964).

Orlandi, S., *Sant'Antonino*, II: *Studi bibliografici*, Edizioni il Rosario (Florence, 1960).

Ortalli, G., *". . . pingatur in Palatio . . ." La pittura infamante nei secoli XIII–XVI*, Jouvence (Rome, 1979).

Oy-Marra, E., *Florentiner Ehrengrabmäler der Frührenaissance*, Gebr. Mann (Berlin, 1994).

Padoa Rizzo, A., and A. Guidotti, "Pubblico e privato, committenza e clientela: Botteghe e produzione a Firenze tra XV e XVI secolo," *Ricerche storiche*, XXVI (1986), pp. 535–56.

Painting and Illumination in Early Renaissance Florence 1300–1450, ed. L. Kanter et al., exhibition catalogue, Metropolitan Museum of Art (New York, 1994).

Palazzo Strozzi metà millennio 1489–1989: Atti del Convegno di Studi, Firenze, 3–6 luglio 1989, ed. D. Lamberini, Istituto della Enciclopedia Italiana (Rome, 1991).

Pampaloni, G., *Palazzo Strozzi*, Istituto Nazionale delle Assicurazioni (Rome, 1982).

Pandimiglio, L., *Felice di Michele vir clarissimus e una consorteria: I Brancacci di Firenze*, Olivetti (Varese, 1990).

Panofsky, E., "Die Perspektive als 'symbolischen Form,'" in *Vorträge der Bibliothek Warburg (1924–1925)*, B. G. Teuber (Leipzig, 1927), pp. 258–311.

Panofsky, E., *Perspective as Symbolic Form* (1927), trans. C. Wood, Zone Books (New York, 1991).

Paoletti, J., and R. Crum, eds., *Renaissance Florence: A Social History*, Cambridge University Press (Cambridge and New York, 2006).

Park, K., *Doctors and Medicine in Early Renaissance Florence*, Princeton University Press (Princeton, 1985).

Park, K., "The Readers at the Florentine Studio according to Communal Fiscal Records (1357–1380, 1413–1446)," *Rinascimento*, series 2, XXI (1980), pp. 249–310.

Parronchi, A., "Come gli artisti leggevano Dante," *Studi danteschi*, XLIII (1966), pp. 97–134.

Parronchi, A., "La prospettiva dantesca," *Studi danteschi*, XXXVI (1960); reprinted in *Studi sulla "dolce" prospettiva*, Aldo Martello editore (Milan, 1964), pp. 3–90.

Parshall, P., "The Art of Memory and the Passion," *Art Bulletin*, LXXXI (1999), pp. 456–72.

Passavant, G., *Verrocchio: Sculptures, Paintings and Drawings: Complete Edition*, Phaidon (London, 1969).

Passerini, L., *Gli Alberti di Firenze: Genealogia, storia e documenti*, 2 vols., M. Cellini & Co. (Florence, 1869).

Passerini, L., *Genealogia e storia della famiglia Niccolini*, M. Cellini & Co. (Florence, 1870).

Pecchioli Vigni, M. C., "Lo statuto in volgare della Magistratura della Grascia," *Archivio storico italiano*, CXXIX (1971), pp. 3–70.

Pellegrini, F., "Agnolo Pandolfini e il *Governo della famiglia*," *Giornale storico letterario italiano*, VIII (1886), pp. 1–52.

Pfisterer, U., *Donatello und die Entdeckung der Stile 1430–1445*, Hermer Verlag (Munich, 2002).

Pfisterer, U., "Künstlerische *Potestas audendi* und *Licentia* im Quattrocento: Benozzo Gozzoli, Andrea Mantegna, Bertoldo di Giovanni," *Römisches Jahrbuch der Bibliotheca Hertziana*, XXXI (1996), pp. 109–47.

Pfisterer, U., "Phidias und Polyklet von Dante bis Vasari: Zu Nachrum und künstlerischer Rezeption antiker Bildhauer in der Renaissance," *Marburger Jahrbuch für Kunstwissenschaft*, XXVI (1999), pp. 61–97.

Pisani, L., "The Exchange of Models in Florentine Workshops of the Quattrocento: A Sheet from the Verrocchio Sketchbook," *Journal of the Warburg and Courtauld Institutes*, LXVII (2004), pp. 269–74.

Phillips, M., *The Memoir of Marco Parenti: A Life in Medici Florence*, William Heinemann Ltd. (London, 1990).

Poeschke, J., *Donatello and his World: Sculpture of the Italian Renaissance*, trans. R. Stockman, Abrams (New York, 1993).

Poeschke, J., "'Per exaltare la fama di detto poeta': Frühe Dantedenkmäler in Florenz," *Deutsche Dante-Jahrbuch*, LXVII (1992), pp. 63–82.

Pons, N., "Zanobi di Giovanni e le compagnie di pittori," *Rivista d'arte*, series 7, XLIII (1991), pp. 221–7.

Pope-Hennessy, J., *Donatello Sculptor*, Abbeville Press (New York, 1993).

Pope-Hennessy, J., *Fra Angelico*, Cornell University Press (Ithaca, 1974).

Pope-Hennessy, J., *Italian Renaissance Sculpture*, 2nd edn., Phaidon Press (London and New York, 1971).

Pope-Hennessy, J., *Luca della Robbia*, Cornell University Press (Ithaca, 1980).

Pope-Hennessy, J., "The Madonna Reliefs of Donatello," in *The Study and Criticism of Italian Sculpture*, Metropolitan Museum of Art and Princeton University Press (New York and Princeton, 1980) pp. 71–105; originally published in *Apollo*, CIII (1976), pp. 172–91.

Popham, A. E., *The Drawings of Leonardo da Vinci*, ed. M. Kemp, Pimlico (London, 1994).

Preyer, B., "Around and in the Gianfigliazzi Palace in Florence: Developments on Lungarno Corsini in the 15th and 16th Centuries," *Mitteilungen des Kunsthistorischen Institutes in Florenz*, XLVIII (2004), pp. 55–104.

Preyer, B., "The 'chasa overo palagio' of Alberto di Zanobi: A Florentine Palace of about 1440 and its Later Remodeling," *Art Bulletin*, LXV (1983), pp. 387–401.

Preyer, B., "Planning for Visitors at Florentine Palaces," *Renaissance Studies*, XII (1998), pp. 357–74.

Procacci, U., "Di Jacopo di Antonio e delle compagnie di pittori del Corso degli Adimari nel XV secolo," *Rivista d'arte*, XXXV, series 2, X (1960), pp. 3–70.

Procacci, U., "Lettera a Roberto Salvini con vecchi ricordi e con alcune notizie su Lippo di Andrea modesto pittore del primo Quattrocento," in *Scritti di storia dell'arte in onore di Roberto Salvini*, Sansoni (Florence, 1984), pp. 213–26.

Procacci, U., "Le portate al catasto di Giovanni di ser Giovanni detto Lo Scheggia," *Rivista d'arte*, XXXVII, series 4, I (1984), pp. 234–67.

Procaccioli, P., *Filologia ed esegesi dantesca nel Quattrocento: L' "Inferno" nel "Comento sopra la Comedia" di Cristoforo Landino*, Leo S. Olschki Editore (Florence, 1989).

Puttfarken, T., *The Discovery of Pictorial Composition: Theories of Painting 1400–1800*, Yale University Press (New Haven and London, 2000).

Radcliffe, A., and C. Avery, "The 'Chellini Madonna' by Donatello," *Burlington Magazine*, CXVIII (1976), pp. 377–87.

Rainey, R., "Sumptuary Legislation in Renaissance Florence," Ph.D. thesis (Columbia University, 1985).

Randolph, A., *Engaging Symbols: Gender, Politics, and Public Art in Fifteenth-Century Florence*, Yale University Press (New Haven and London, 2002).

Randolph, A., "Gendering the Period Eye: *deschi da parto* and Renaissance Visual Culture," *Art History*, XXVII (2004), pp. 538–62.

Randolph, A., "Performing the Bridal Body in Fifteenth-Century Florence," *Art History*, XXI (1998), pp. 182–200.

Randolph, A., "Regarding Women in Sacred Space," in *Picturing Women in Renaissance and Baroque Italy*, ed. G. A. Johnson and S. Matthews Grieco, Cambridge University Press (Cambridge and New York, 1997), pp. 17–41.

Randolph, A., "Renaissance Household Goddesses: Fertility, Politics, and the Gendering of Spectatorship," in *The Material Culture of Sex, Procreation, and Marriage in Premodern Europe*, ed. A. L. McClanan and K. R. Encarnación, Palgrave (New York, 2002), pp. 163–89.

Renaissance Florence: The Art of the 1470s, ed. P. Rubin and A. Wright, exhibition catalogue, London, National Gallery, National Gallery Publications (London, 1999).

Renner, S., *Die Darstellung der Verkündigen an Maria in der florentinischen Malerei von Andrea Orcagna (1346) bis Lorenzo Monaco (1425)*, Lemmens (Bonn, 1996).

Richa, G., *Notizie istoriche delle chiese fiorentine: Divise ne' suoi quartieri*, 10 vols., Stamperia di Pietro Gaetano Viviani (Florence, 1754–62).

Ricketts, J., *Visualizing Boccaccio: Studies on Illustrations of The Decameron from Giotto to Pasolini*, Cambridge University Press (Cambridge and New York, 1997).

Ringbom, S., *Icon to Narrative: The Rise of the Dramatic Close-up in Fifteenth-Century Devotional Painting*, 2nd edn., Davaco (Doornspijk, 1984).

Robb, D. M., "The Iconography of the Annunciation in the Fourteenth and Fifteenth Centuries," *Art Bulletin*, XVIII (1936), pp. 480–526.

Roberts, P. L., *Masolino da Panicale*, Clarendon Press (Oxford, 1993).

Rochon, A., *La Jeunesse de Laurent de Medicis (1449–1478)*, Société d'Edition "Les Belles Lettres" (Paris, 1963).

Rocke, M., *Forbidden Friendships: Homosexuality and Male Culture in Renaissance Florence*, Oxford University Press (Oxford, 1996).

Rohlmann, M., "Bildernetzwerk: Die Verflechtung von Familienschicksal und Heilsgeschichte in Ghirlandaios Sassetti-Kapelle," in *Domenico Ghirlandaio: Künstlerische Konstruktion von Identität im Florenz der Renaissance*, ed. M. Rohlmann, Verlag und Datenbank für Geisteswissenschaften (Weimar, 2003), pp. 165–243.

Roscoe, W., *The Life of Lorenzo de' Medici: Called the Magnificent*, 2nd edn., 2 vols., Strahan and Cadell (London, 1796).

Roselli, P., ed., *Università di Firenze, Istituto di Restauro dei Monumenti: coro e cupola della SS. Annunziata a Firenze*, Nistri-Lischi (Pisa, 1971).

Rosenauer, A., *Donatello*, Electa (Milan, 1993).

Rossi, V., "Dante nel Trecento e nel Quattrocento," in *Scritti di critica letteraria*, I: *Saggi e discorsi su Dante*, Sansoni (Florence, 1930), pp. 293–323.

Rowlands., E., "Jacopo del Sellaio," in *The Dictionary of Art*, Macmillan (London, 1996), XVI, pp. 847–8.

Rubin, P., "Art and the Imagery of Memory," in *Art, Memory, and Family in Renaissance Florence*, ed. G. Ciappelli and P. Rubin,

Cambridge University Press (Cambridge and New York, 2000), pp. 67–85.

Rubin, P., "Commission and Design in Central Italian Altarpieces c.1450–1550," in *Italian Altarpieces 1250–1550*, ed. E. Borsook and F. Superbi Gioffredi, Clarendon Press (Oxford, 1994), pp. 201–30.

Rubin, P., "Il contributo di Raffaello allo sviluppo della pala d'altare rinascimentale," *Arte cristiana*, LXXVIII (1990), no. 737–8 (March–June), pp. 169–82.

Rubin, P., "Domenico Ghirlandaio and the Meaning of History in Fifteenth Century Florence," in *Domenico Ghirlandaio 1449–1494: Atti del Convegno Internazionale, Firenze, 16–18 ottobre 1994*, ed. W. Prinz and M. Seidel, Centro Di (Florence, 1996), pp. 97–108.

Rubin, P., "'Filippino Lippi, pittore di vaghissima invenzione': Christian Poetry and the Significance of Style in Late Fifteenth-Century Altarpiece Design," in *Programme et invention dans l'art de la Renaissance: Actes du Colloque de Rome (2005)*, ed. J. Kliemann, J. Koering, and P. Morel, Académie de France à Rome/Somogy (Rome and Paris, 2007).

Rubin, P., *Giorgio Vasari: Art and History*, Yale University Press (New Haven and London, 2005).

Rubin, P., "Hierarchies of Vision: Fra Angelico's *Coronation of the Virgin* from San Domenico, Fiesole," *Oxford Art Journal*, XXVII (2004), pp. 137–51.

Rubin, P., "Magnificence and the Medici," in *The Early Medici and their Artists*, ed. F. Ames-Lewis, Birkbeck College (London, 1995), pp. 37–49.

Rubin, P., "Raphael and the Rhetoric of Art," in *Renaissance Rhetoric*, ed. P. Mack, Macmillan (London, 1994), pp. 165–82.

Rubin, P., "Signposts of Invention: Artists' signatures in Italian Renaissance Art," *Art History*, XXIX (2006), pp. 563–99.

Rubinstein, N., *The Government of Florence under the Medici*, Oxford University Press (Oxford, 1966; 2nd edn., 1997).

Rubinstein, N., *The Palazzo Vecchio 1298–1531: Government, Architecture, and Imagery in the Civic Palace of the Florentine Republic*, Clarendon Press (Oxford, 1995).

Ruda, J., "A 1434 Building Programme for San Lorenzo in Florence," *Burlington Magazine*, CXX (1978), pp. 358–61.

Ruda, J., *Fra Filippo Lippi: Life and Work*, Phaidon Press (London, 1993).

Saalman, H., *Filippo Brunelleschi: The Buildings*, Pennsylvania State University Press (University Park, Pa., 1993).

Sale, J. R., "Palla Strozzi and Lorenzo Ghiberti: New Documents," *Mitteilungen des Kunsthistorischen Institutes in Florenz*, XXII (1978), pp. 355–8.

Sale, J. R., "The Strozzi Chapel by Filippino Lippi in Santa Maria Novella," Ph.D. thesis (University of Pennsylvania, 1976).

Sandro Botticelli: The Drawings for Dante's Divine Comedy, ed. Hein-Th. Schulze Altcappenberg, exhibition catalogue, London, Royal Academy of the Arts, Royal Academy Publications (London, 2000).

Sandro Botticelli pittore della Divina commedia, ed. S. Gentile, exhibition catalogue, Rome, Scuderie Papali al Quirinale, Skira (Milan, 2000).

Santi, B., "Dalle 'ricordanze' di Neri di Bicci," *Annali della Scuola Normale Superiore di Pisa*, III, series 3 (1973), no. 1, pp. 169–88.

Santini, E., "Leonardo Bruni Aretino e i suoi *Historiarum Florentini populi Libri XII*," *Annali della R. Scuola Normale Superiore di Pisa*, XII (1910), pp. 1–144; also Nistri (Pisa, 1910).

Santini, E., "La *Protestatio di Iustitia* nella Firenze medicea del secolo XV (Nuovi testi in volgare del Quattrocento," *Rinascimento*, series 2, X (1959), pp. 33–106.

Schiaparelli, A., *La casa fiorentina e i suoi arredi nei secoli XIV e XV*, 2 vols., Sansoni (Florence, 1908).

Schleusener-Eichholz, G., "Naturwissenschaft und Allegorese: Der 'Tractatus de oculo morali' des Petrus von Limoges," *Frühmittelalterliche Studien*, XII (1978), pp. 258–309.

Schubring, P., *Cassoni, Truhen, und Truhenbilder der italienischen Frührenaissance*, 2 vols., K. W. Hiersemann (Leipzig, 1923).

Schulz, A. M., *The Sculpture of Bernardo Rossellino and his Workshop*, Princeton University Press (Princeton, 1977).

Sebregondi, L., "La tavola: desinari, feste e conviti nel Rinascimento fiorentino," in *Itinerari nella casa fiorentina del Rinascimento*, ed. E. Nardinocchi, Fondazione Herbert P. Horne (Florence, 1994), pp. 47–64.

Shearman, J., "Masaccio's Pisa Altarpiece: An Alternative Reconstruction," *Burlington Magazine*, CVIII (1966), pp. 449–55.

Shearman, J., *Only Connect . . . Art and the Spectator in the Italian Renaissance*, Princeton University Press (Princeton, 1992).

Siegel, R., *Galen on Sense Perception: His Doctrines, Observations and Experiments on Vision, Hearing, Smell, Taste, Touch and Pain, and their Historical Sources*, Karger (Basel and New York, 1970).

Simonelli, M. S., "Il Canto x del 'Purgatorio,'" *Studi danteschi*, XXXIII (1955–56), pp. 121–45.

Smart, A., *The Assisi Problem and the Art of Giotto: A Study in the "Legend of St. Francis" in the Upper Church of San Francesco, Assisi*, Clarendon Press (Oxford, 1971).

Smith, C., "Originality and Cultural Progress in the Quattrocento: Brunelleschi's Dome and a Letter by Alberti," *Rinascimento*, series 2, XXVIII (1988), pp. 291–318.

Solmi, E., *Scritti vinciani: Le fonti dei manoscritti di Leonardo da Vinci e altri studi*, La Nuova Italia (Florence, 1976).

Soudek, J., "The Genesis and Tradition of Leonardo Bruni's Annotated Latin Version of the (Pseudo-)Aristotelian *Economics*," *Scriptorium*, XII (1958), pp. 260–8.

Spencer, J., *Andrea del Castagno and his Patrons*, Duke University Press (Durham, N.C., and London, 1991).

Spencer, J. R., "Spatial Imagery of the Annunciation in Fifteenth-Century Florence," *Art Bulletin*, XXVII (1955), pp. 273–80.

Spinosa, G., "Visione sensibile e intellettuale: convergenze gnoseologiche nella semantica della visione medievale," *Micrologus*, V (1997), pp. 119–34.

Spufford, P., W. Wilkinson, and S. Tolley, *Handbook of Medieval Exchange*, Offices of the Royal Historical Society (London, 1986).

Stabile, G., "Autore," "Autorità (autoritade)," in *Enciclopedia dantesca*, Istituto della Enciclopedia Italiana (Rome, 1970), I, pp. 454–60.

Starn, R., "Florentine Renaissance Studies," *Bibliothèque d'humanisme et Renaissance*, XXXII (1970), pp. 678–84.

Stern, L. I., *The Criminal Law System of Medieval and Renaissance Florence*, The Johns Hopkins University Press (Baltimore and London, 1994).

Strehlke, C., *Angelico*, Jaca Book (Milan, 1998).

Strehlke, C., and C. Frosinini, eds., *The Panel Paintings of Masolino and Masaccio: The Role of Technique*, 5 Continents Editions (Milan, 2002).

Strocchia, S., *Death and Ritual in Renaissance Florence*, The Johns Hopkins University Press (Baltimore and London, 1992).

Strocchia S., "Death Rites and the Ritual Family in Renaissance Florence," in *Life and Death in Fifteenth-Century Florence*, ed. M. Tetel, R. G. Witt, and R. Goffen, Duke University Press (Durham, N.C., and London, 1989), pp. 120–45.

Summers, D., *The Judgment of Sense: Renaissance Naturalism and the Rise of Aesthetics*, Cambridge University Press (Cambridge and New York, 1987).

Syson, L., "Bertoldo di Giovanni, Republican Court Artist," in *Artistic Exchange and Cultural Translation in the Italian Renaissance City*, ed. S. J. Campbell and S. Milner, Cambridge University Press (Cambridge and New York, 2004), pp. 96–133.

Syson, L., "Representing Domestic Interiors," in *At Home in Renaissance Italy*, ed. M. Ajmar-Wollheim and F. Dennis, exhibition catalogue, London, Victoria and Albert Museum, V&A Publications (London, 2006), pp. 86–101.

Syson, L., and D. Thornton, *Objects of Virtue: Art in Renaissance Italy*, The British Museum Press (London, 2001).

Tachau, K., "Et maxime visus, cuius species venit ad stellas et ad quem species stellarum veniunt: *Perspectiva* and *Astrologia* in Late Medieval Thought," *Micrologus*, v (1997), pp. 201–24.

Tachau, K., "Seeing as Action and Passion in the Thirteenth and Fourteenth Centuries," in *The Mind's Eye: Art and Theological Argument in the Middle Ages*, ed. J. F. Hamburger and A.-M. Bouché, Princeton University Press (Princeton, 2006), pp. 336–59.

Tachau, K., *Vision and Certitude in the Age of Ockham: Optics, Epistemology and the Foundations of Semantics 1250–1345*, E. J. Brill (Leiden, 1988).

Tanturli, G., "Il disprezzo per Dante dal Petrarca al Bruni," *Rinascimento*, series 2, XXV (1985), pp. 199–219.

Tarr, R., "Giovanni Rucellai's Comments on Art and Architecture," *Italian Studies*, LI (1996), pp. 58–95.

Tateo, F., "Teologia e 'Arte' nel canto x del *Purgatorio*," in *Questioni di poetica dantesca*, Adriatica (Bari, n.d.), pp. 137–71.

Le Tems revient,'l tempo si rinuova: Feste e spettacoli nella Firenze di Lorenzo il Magnifico, ed. P. Ventrone, exhibition catalogue, Florence, Palazzo Medici Riccardi, Silvana Editoriale (Milan, 1992).

Thomas, A., "Neri di Bicci's *Assumption of the Virgin* for S. Trìnita, Florence: Squaring the Pyramid," *Apollo*, CXLVI (1997), pp. 42–51.

Thomas, A., "Neri di Bicci and the Franciscan Nuns of S. Maria a Monticelli: New Evidence of his Later Paintings," *Rivista d'arte*, XLIV, series 4, VIII (1992), pp. 317–30.

Thomas, A., "Neri di Bicci, Francesco Botticini and the Augustinians," *Arte cristiana*, LXXXI, no. 754; 1–2 (1993), pp. 23–34.

Thomas, A., "Neri di Bicci: The S. Sisto Crucifixion, the Mantellate Nuns of S. Monaca at Florence and the Compagnia di Miransù," *Antichità viva*, XXXII.5 (1993), pp. 5–15.

Thomas, A., "A New Date for Neri di Bicci's S. Giovannino dei Cavalieri 'Coronation of the Virgin,'" *Burlington Magazine*, CXXXIX (1997), pp. 103–6.

Thomas, A., *The Painter's Practice in Renaissance Tuscany*, Cambridge University Press (Cambridge and New York, 1995).

Thornton, P., *Italian Furniture 1400–1600*, Weidenfeld and Nicolson (London 1990).

Tinagli, P., *Women in Italian Renaissance Art: Gender, Representation, Identity*, Manchester University Press (Manchester and New York, 1997).

Tognetti, S., *Un'industria di lusso al servizio del grande commercio: il mercato di drappi serici e della seta nella Firenze del Quattrocento*, Leo S. Olschki Editore (Florence, 2002).

Tomas, N., *The Medici Women: Gender and Power in Renaissance Florence*, Ashgate (Aldershot and Burlington, Vt., 2003).

Tonini, P., *Il santuario della SS. Annunziata*, Tipografia M. Ricci (Florence, 1876).

Torrell, J.-P., "La Vision de dieu *per essentiam* selon Saint Thomas D'Aquin," *Micrologus*, v (1997), pp. 43–68.

La Toscana al tempo di Lorenzo il Magnifico: Politica, Economia, Cultura, Arte: Convegno di Studi promosso dalle Università di Firenze, Pisa e Siena, 5–8 novembre 1992, 3 vols., Pacini Editore (Pisa, 1996).

Toscani, B., ed., *Lorenzo de' Medici: New Perspectives: Proceedings of the International Conference Held at Brooklyn College and the Graduate Center of the City University of New York, April 30-May 2, 1992*, Peter Lang (New York, 1993).

Tournoy, G., "Sulle riduzioni e versioni umanistiche di novelle del 'Decameron,'" *Studi sul Boccaccio*, VIII (1974), pp. 251–72.

Trexler, R., "Celibacy in the Renaissance: The Nuns of Florence," in *Dependence in Context in Renaissance Florence*, Center for Medieval and Renaissance Studies (Binghamton, N.Y., 1994), pp. 345–72.

Trexler, R., "Florentine Religious Experience: The Sacred Image," *Studies in the Renaissance*, XIX (1972), pp. 7–41.

Trexler, R., *Public Life in Renaissance Florence*, Academic Press (New York, 1980).

Van Os, H., E. Honée, H. Nieuwdorp, B. Ridderbos, *The Art of Devotion in the Late Middle Ages in Europe 1300–1500*, trans. M. Hoyle, Merrell Holberton (London, 1994).

Vasoli, C., "Bruni (Brunus, Bruno), Leonardo (Lionardo)," in *Dizionario biografico degli Italiani*, XIV, Istituto della Enciclopedia Italiana (Rome, 1972), pp. 618–33.

Verde, A., *Lo Studio fiorentino 1473–1503: Ricerche e documenti*, 3 vols., Memorie domenicane (Pistoia, 1973–7).

Verdon, T., and J. Henderson, eds., *Christianity and the Renaissance: Image and Religious Imagination in the Quattrocento*, Syracuse University Press (Syracuse, 1990).

Verrocchio's Christ and Saint Thomas: A Masterpiece of Sculpture from Renaissance Florence, ed. L. Dolcini, exhibition catalogue, Florence and New York, Palazzo Vecchio and the Metropolitan Museum of Art, Amilcare Pizzi (Milan, 1992).

Verrocchio's David Restored: A Renaissance Bronze from the National Museum of the Bargello, Florence, exhibition catalogue, Atlanta, High Museum of Art, Giunti (Florence, 2003).

Vickers, N., "Seeing is Believing: Gregory, Trajan, and Dante's Art," *Dante Studies*, CI (1983), pp. 67–85.

Virtue and Beauty: Leonardo's "Ginevra de' Benci" and Renaissance Portraits of Women, ed. D. Brown, exhibition catalogue, National Gallery of Art (Washington, D. C., 2001).

Wackernagel, M., *Der Lebensraum des Künstlers in der florentinischen Renaissance*, E. A. Seeman (Leipzig, 1938).

Wackernagel, M., *The World of the Florentine Renaissance Artist: Projects and Patrons, Workshop and Art Market*, trans. A. Luchs, Princeton University Press (Princeton, 1981).

Warburg, A., *The Renewal of Pagan Antiquity*, ed. K. Forster, trans. D. Britt, Getty Research Institute for the History of Art and the Humanities (Los Angeles, 1999).

Watkins, R. N., "L. B. Alberti's Emblem, the Winged Eye, and his Name, Leo," *Mitteilungen des Kunsthistorischen Institutes in Florenz*, IX (1959–60), pp. 256–8.

Watson, P., "Apollonio di Giovanni and Ancient Athens," *Allen Memorial Art Museum Bulletin*, XXXVII (1979–80), pp. 3–25.

Watson, P., *The Garden of Love in Tuscan Art of the Early Renaissance*, Associated University Presses (Philadelphia, 1979).

Watson, P., "Virtù and Voluptas in Cassone Painting," Ph.D. thesis (Yale University, 1970).

Watts, B., "Artistic Competition, Hubris and Humility: Sandro Botticelli's Response to *Visibile Parlare*," *Dante Studies*, CXIV (1996), pp. 41–78.

Watts, B., "Sandro Botticelli's Drawings for Dante's *Inferno*: Narrative Structure, Topography, and Manuscript Design," *Artibus et historiae*, XVI (1995), pp. 163–201.

Watts, B., "Sandro Botticelli's Illustrations for *Inferno* VIII and IX: Narrative Revision and the Role of Manuscript Tradition," *Word and Image*, XI (1995), pp. 149–73.

Watts, B., "Studies in Sandro Botticelli's Drawings for Dante's *Inferno*," Ph.D. thesis (University of Virginia, 1993).

Watts, B., "The Word Imaged: Dante's *Commedia* and Sandro Botticelli's San Barnaba Altarpiece," *Lectura Dantis*, nos. 22–3 (1998), pp. 203–45.

Waźbínski, Z., "L'*Annunciazione* della Vergine nella chiesa della SS. Annunziata a Firenze: un contributo al moderno culto dei quadri" in *Renaissance Studies in Honor of Craig Hugh Smyth*, ed. A. Morrogh, F. Superbi Gioffredi, P. Morselli, and E. Borsook, Giunti Barbèra (Florence, 1985), II, pp. 533–52.

Weissman, R., *Persons in Groups: Social Behavior as Identity Formation in Medieval and Renaissance Europe*, Medieval and Renaissance Texts and Studies (Binghamton, N.Y., 1985), pp. 39–46.

Weissman, R., *Ritual Brotherhood in Renaissance Florence*, Academic Press (New York, 1982).

Welch, E., "New, Old and Second-hand Culture: The Case of the Renaissance Sleeve," in *Revaluing Renaissance Art*, ed. G. Neher and R. Shepherd, Ashgate (Aldershot and Brookfield. Vt., 2000), pp. 101–19.

Welch, E., *Shopping in the Renaissance: Consumer Cultures in Italy, 1400–1600*, Yale University Press (New Haven and London, 2005).

Welch, E., and M. O'Malley, eds., *The Material Renaissance*, Manchester University Press (Manchester, forthcoming).

Welliver, W., "Alterations in Ghirlandaio's S. Trinita Frescoes," *Art Quarterly*, XXXII (1969), pp. 269–81.

Westfall, C. W., "Painting and the Liberal Arts: Alberti's View," *Journal of the History of Ideas*, XXX (1969), pp. 487–506.

White, J., *The Birth and Rebirth of Pictorial Space*, Harper & Row (New York, 1967).

Wilde, C., "Alberti and the Formation of Modern Art Theory," in *A Companion to Art Theory*, ed. P. Smith and C. Wilde, Blackwell Publishers (Oxford, 2002), pp. 3–18.

Wilson, B., *Music and Merchants: The Laudesi Companies of Republican Florence*, Clarendon Press (Oxford, 1992).

Witt, R., J. Najemy, C. Kallendorf, and W. Gundersheimer, "AHR Forum [Hans Baron]," *American Historical Review*, CI (1996), pp. 107–29.

Witthoft, B., "Marriage Rituals and Marriage Chests in Quattrocento Florence," *Artibus et historiae*, V (1982), pp. 43–59.

Witthoft, B., "Riti nuziali e loro iconografia," in *Storia del matrimonio*, ed. M. de Giorgio and C. Klapisch-Zuber, Laterza (Rome and Bari, 1996), pp. 119–48.

Wittschier, H. W., *Giannozzo Manetti: Das Corpus der Orationes*, Böhlau Verlag (Cologne and Graz, 1968).

Wofford, S., "The Social Aesthetics of Rape: Closural Violence in Boccaccio and Botticelli," in *New Essays on Renaissance Literature In Honor of Thomas M. Greene*, ed. D. Quint, M. Ferguson, G. Pigman III, and W. Rebhorn, Medieval and Renaissance Texts and Studies (Binghamton, N. Y., 1992), pp. 189–238.

Wohl, H., *The Paintings of Domenico Veneziano ca. 1410–1461: A Study in Florentine Art of the Early Renaissance*, New York University Press (New York and London, 1980).

Woods-Marsden, J., *Renaissance Self-Portraiture: The Visual Construction of Identity and the Social Status of the Artist*, Yale University Press (New Haven and London, 1998).

Wright, A., "Antonio Pollaiuolo, 'Maestro di disegno,'" in *Florentine Drawing at the Time of Lorenzo the Magnificent: Papers from a Colloquium Held at the Villa Spelman, Florence, 1992*, ed. E. Cropper, Nuova Alfa Editoriale (Bologna, 1994), pp. 131–46.

Wright, A., "Dimensional Tension in the Work of Antonio Pollaiuolo," in *The Sculpted Object 1400–1700*, ed. S. Currie and P. Motture, Scolar Press (Aldershot, 1997), pp. 65–86.

Wright, A., "The Myth of Hercules," in *Lorenzo il Magnifico e il suo mondo: Convegno Internazionale di Studi (Firenze, 9–13 giugno 1992)*, ed. G. C. Garfagnini, Leo S. Olschki Editore (Florence, 1994), pp. 323–40.

Wright, A., *The Pollaiuolo Brothers: The Arts of Florence and Rome*, Yale University Press (New Haven and London, 2005).

Wright, A., "Studies in the Paintings of the Pollaiuolo," Ph.D. thesis (University of London, Courtauld Institute, 1991).

Wundram, M., "Lorenzo (di Cione) Ghiberti," in *The Dictionary of Art*, Macmillan (London, 1996), XII, pp. 536–45.

Zafarana, Z., "Per la storia religiosa di Firenze nel Quattrocento: una raccolta privata di prediche," *Studi medievali*, series 3, IX (1968), pp. 1017–1113.

Zambrano, P., and J. K. Nelson, *Filippino Lippi*, Electa (Milan, 2004).

Zapperi, R., "Farnese, Giulia," *Dizionario*

biografico degli Italiani, Istituto della Enciclopedia Italiana (Rome, 1995), XLV, pp. 99–102.

Zervas, D. F., *Orsanmichele a Firenze*, 2 vols., Franco Cosimo Pannini (Florence, 1996).

Zervas, D. F., *The Parte Guelfa, Brunelleschi and Donatello*, Villa I Tatti (Florence, 1987).

Zippel, G., "Il Filelfo a Firenze (1429–1434)," in *Storia e cultura del Rinascimento italiano*, ed. G. Zippel, Medioevo e Umanesimo, 33 (Padua, 1979), pp. 215–33.

Zollner, F., *Botticelli*, Prestel (Munich, 2005).

Zöllner, F., and J. Nathan, *Leonardo da Vinci, 1452–1519: sämtliche Gemälde und Zeichnungen*, Taschen (Cologne, 2003).

Zorzi, A., *L'amministrazione della giustizia penale nella repubblica fiorentina: Aspetti e problemi*, Leo S. Olschki Editore (Florence, 1988).

Zupko, R. E., *Italian Weights and Measures from the Middle Ages to the Nineteenth Century*, American Philosophical Society (Philadelphia, 1981).

Index

Photograph Credits

In most cases illustrations have been made from photographs and transparencies provided by the owners or custodians of the works. Those for which further credit is due are listed below.

Frontispiece, 4, 22, 23, 24, 25, 26, 59, 60, 63, 80, 83, 84, 85, 90, 107, 108, 109, 110, 123, 160, 189, 191, 216, 208, 223, 224, 225, 226, 241, 242, 244: Antonio Quattrone, Florence; 2: Paolo Tosi; 5: Kunsthistorisches Institut, Florence; 6, 7, 8, 9, 11, 18 (photo: James Austin), 20, 21, 31, 34, 36, 37, 40; 57, 58, 74, 76, 77, 96, 97, 98, 104, 108, 119, 122, 227, 228: Conway Library, Courtauld Institute of Art; 10, 29, 46, 52, 71, 73, 140, 142, 154, 155, 157, 177, 187, 197, 250: Alinari; 12, 13: The Metropolitan Museum of Art, Purchase in memory of Sir John Pope-Hennessy: Rogers Fund, The Annenberg Foundation, Drue Heinz Foundation, Annette de la Renta, Mr. and Mrs. Frank E. Richardson, and The Vincent Astor Foundation Gifts, Wrightsman and Gwynne Andrews Funds, special funds, and Gift of the children of Mrs. Harry Payne Whitney, Gift of Mr. and Mrs. Joshua Logan, and other gifts and bequests, by exchange,

1995 (1995.7) Image © The Metropolitan Museum of Art; 16, 19, 32, 42, 75, 94, 180: author; 17, 35, 47, 50, 54, 66, 67, 86, 87, 88, 92, 105, 116, 121, 138, 141, 147, 150, 175, 178, 179, 182, 192, 205: © 1990. Photo Scala, Florence; 28, 55, 106, 135, 145, 148, 149, 152, 186: © 1990. Photo Scala, Florence/Fondo Edifici di Culto – Ministero dell'Interno; 14, 30 (Daniel Arnaudet), 103 (R. G. Ojeda), 114 (C. Jean), 115 (Michèle Bellot), 146 (Le Mage), 185 (Blot/Lewandowski): © RMN; 39, 45, 163, 165, 168, 188: © 1990. Photo Scala, Florence – courtesy of the Ministero Beni e Att. Culturali; 43: trinity from Alberti; 44: © 1994. Photo Scala, Florence – courtesy of the Ministero Beni e Att. Culturali; 51, 132, 133, 170, 174, 202, 247: Soprintendenza Speciale per il Polo Museale Fiorentino; 56, 70, 72, 137, 151, 171: V&A Images/Victoria and Albert Museum; 62: © 2004. Photo Scala, Florence – courtesy of the Ministero Beni e Att. Culturali; 68: bpk/ Skulpturensammlung und Museum für Byzantinische Kunst, SMB/Reinhard Friedrich; 81, 164 (Andrew W. Mellon Collection.): © 2006 Board of Trustees, National Gallery of Art, Washington;

82, 124, 131: The Royal Collection © 2006, Her Majesty Queen Elizabeth II; 91, 203: bpk/Gemäldegalerie, SMB/Jörg P. Anders; 95: Courtauld Institute of Art; 99, 243: © 2004 Board of Trustees, National Gallery of Art, Washington; 100: © Copyright the Trustees of The British Museum; 101: © 2000. Photo Scala, Florence – courtesy of the Ministero Beni e Att. Culturali; 125, 126, 127, 128, 129, 130: bpk/Kupferstichkabinett, SMB/Philipp Allard; 134: Kunsthistorisches Institut Florenz; 139: © 1999. Photo Opera Metropolitana Siena/Scala, Florence; 153: © 2004. Photo Scala, Florence; 156: © The Cleveland Museum of Art, 2002; 160: akg-images/Electa; 166: Bayerische Staatsgemäldesammlungen, Alte Pinakothek München; 190: © Blauel/Gnamm – artothek; 196: Courtesy Ufficio Associato Servici Culturali, Commune di Barberino Val d'Elsa & Tavarnelle Val di Pesa; 199: Bildarchiv Preussischer Kulturbesitz, Berlin; 200: akg-images/Electa; 204: © 1991. Photo Scala, Florence; 251: © Bildarchiv Foto Marburg; 253: © British Library, London; 255: © Bibliothèque Nationale de France